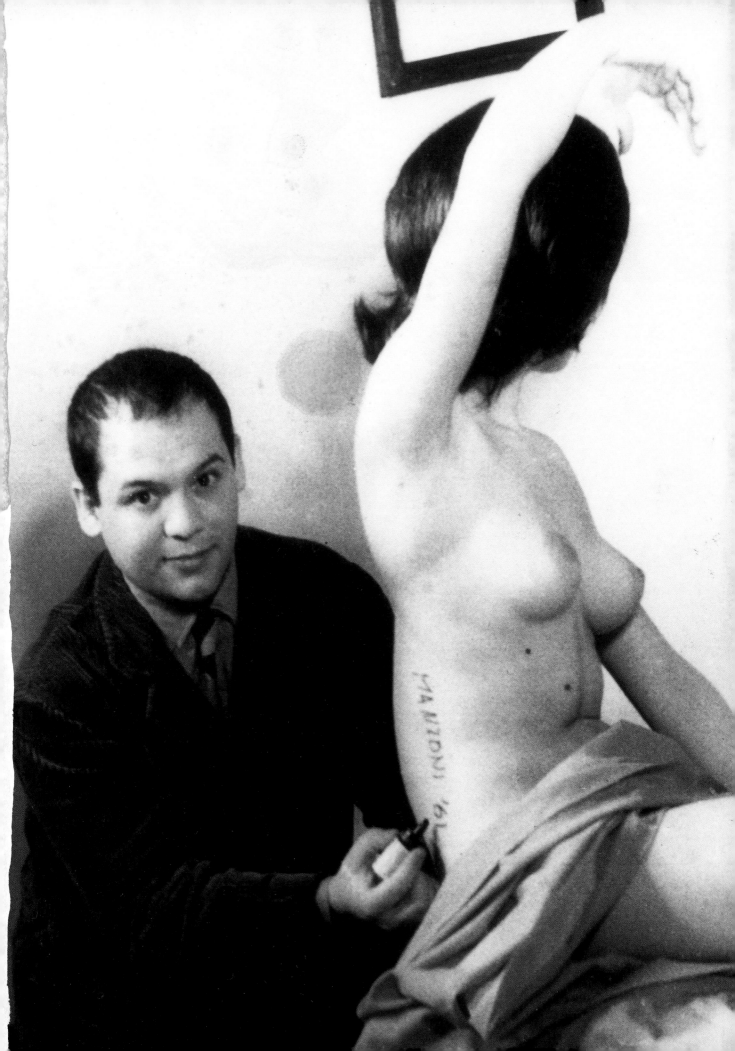

Styles, Schools

and Movements

An Encyclopaedic Guide to Modern Art

AMY DEMPSEY

With 266 illustrations, 159 in colour

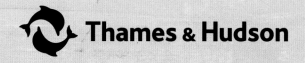

Thames & Hudson

Contents

To Justin Saunders

Page 1: Piero Manzoni,
Living Sculpture, 1961
Page 2–3 Gerhard Richter, *Abstraktes Bild
(860-3)* (detail), 1999

First published in the United Kingdom in 2002
by Thames & Hudson Ltd, 181A High Holborn,
London WC1V 7QX

www.thamesandhudson.com

© 2002 Thames & Hudson Ltd, London

British Library Cataloguing-in-Publication Data
A catalogue record for this book is available
from the British Library

ISBN 0-500-23788-3

Printed and bound in Singapore by CS Graphics

10 Preface

1860-1900
Rise of the Avant-Gardes

14 Impressionism
19 Arts and Crafts
23 Chicago School
25 Les Vingt
26 Neo-Impressionism
30 Decadent Movement
33 Art Nouveau
38 Modernisme
41 Symbolism
45 Post-Impressionism
49 Cloisonnism
50 Nabis
53 Synthetism
56 Salon de la Rose+Croix
57 Jugendstil
59 Vienna Secession
62 World of Art

1900-1918
Modernisms for a Modern World

66 Fauvism
70 Expressionism
74 Die Brücke
78 Ashcan School
80 Deutscher Werkbund
83 Cubism
88 Futurism
92 Jack of Diamonds
94 Der Blaue Reiter
97 Synchromism
99 Orphism
102 Rayonism
103 Suprematism
106 Constructivism
109 Pittura Metafisica

111 Vorticism
113 Hungarian Activism
114 School of Amsterdam
115 Dada
119 Purism
121 De Stijl

1918-1945
Search for a New Order

126 Arbeitsrat für Kunst
128 Novembergruppe
130 Bauhaus
134 Precisionism
135 Art Deco
140 Ecole de Paris
142 International Style
146 Novecento Italiano
147 Der Ring
149 Neue Sachlichkeit
151 Surrealism
155 Elementarism
156 Gruppo 7
157 M.I.A.R.
159 Concrete Art
161 Magic Realism
163 American Scene
166 Social Realism
168 Socialist Realism
170 Neo-Romanticism

1945-1965
A New Disorder

174 Art Brut
176 Existential Art
180 Outsider Art
181 Organic Abstraction
184 Art Informel
188 Abstract Expressionism
192 Lettrism
193 CoBrA
195 Beat Art

197 Kinetic Art
199 Kitchen Sink School
201 Neo-Dada
205 Combines
206 New Brutalism
208 Funk Art
210 Nouveau Réalisme
213 Situationist International
215 Assemblage
217 Pop Art
222 Performance Art
226 GRAV
228 Fluxus
230 Op Art
232 Post-painterly Abstraction

1965-today
Beyond the Avant-Gardes

236 Minimalism
240 Conceptual Art
244 Body Art
247 Installation
251 Super-realism
254 Anti-Design
256 Supports-Surfaces
257 Video Art
260 Earth Art
263 Site Works
266 Arte Povera
269 Postmodernism
274 High-Tech
276 Neo-Expressionism
281 Neo-Pop
282 Transavanguardia
284 Sound Art
286 Internet Art

289 200 Key Styles: A Dictionary
296 List of Illustrations
299 Index

International Style　142

Der Ring　147

Hungarian Activism　113

Novembergruppe　128

Arbeitsrat für Kunst　126　　Gruppo 7　156

Deutscher Werkbund　80

Bauhaus　130

Art Deco　135

Jugendstil　57　　Constructivism　106

Vienna Secession　59

De Stijl　121　　Elementarism　155

Ashcan School　78　　School of Amsterdam　114

Precisionism　134

Futurism　88

Fauvism　66　　Vorticism　111　　Novecento Italiano　146

Jack of Diamonds　92

Synchromism　97　　Purism　119

Post-Impressionism　45　　Orphism　99

Rayonism　102　　Neue Sachlichkeit　149

World of Art　62　　Cubism　83　　Ecole de Paris　140

50

Expressionism　70　　Magic Realism　161

Die Brücke　74　　Neo-Romanticism　170

49

Der Blaue Reiter　94　　Surrealism　151

Suprematism　103

53

Dada　115

Pittura Metafisica　109

Rose+Croix　56

1860 1870 1880 1890

Chicago School 23

Arts and Craft 19

Art for the People
From the Arts and Crafts, through the Bauhaus, to the International Style and beyond, a major preoccupation of designers, architects and illustrators has been to create a total living environment for the modern world.

Modernisme 38

Art Nouveau 33

Les Vingt 25

Art and Style
From Impressionism to Futurism to Abstract Expressionism, successive generations of avant-garde artists broke the rules in their search for new styles capable of expressing modern life.

Neo-Impressionism 26

Impressionism 14

Decadent Movement 30

Nabis

Art and Mind
From Symbolism, through Dada and Surrealism, to Conceptual art, experimental artists declared that the true function of art was to not to depict reality, but to represent the inner worlds of emotion, mood and sensibility.

Cloisonnism

Synthetism

Symbolism 41

Salon de la

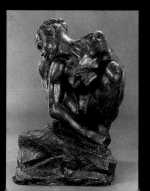

Preface

The vocabulary used to describe modern art – from Impressionism to Installation, from the Nabis to Neo-Expressionism, from Symbolism to Super-realism – has developed into a sophisticated, and often daunting, language of its own. Styles, schools and movements are seldom self-contained or simply defined; they are sometimes contradictory, often overlapping, and always complicated. Nevertheless, the concept of styles, schools and movements persists and understanding them remains crucial to any discussion of modern art. Defining them remains the best way of mapping a notoriously complex and, at times, difficult subject. This book is intended as a broad-ranging introduction, a personal survey and a guide to one of the most dynamic and exciting periods of art.

The 300 styles, schools and movements collected in this guide bring together the most significant developments in Western painting, sculpture, architecture and design. Subjects are presented in broadly chronological order, from Impressionism in the nineteenth century through to Earth Art, Sound Art and Internet Art in the twenty-first century.

The main entries of this book explore one hundred of the most significant styles and movements of modern art. They examine the claims of the artists' manifestos, the drama of the exhibitions, the judgments of the critics and the delight, or outrage,

of the public. The work is approached from a contextual angle, incorporating historical and cultural positions, biographical information, and a number of possible interpretations of the art itself. All of these types of information are useful, as art is neither created nor received in a vacuum.

At the end of each of the main entries is a concise listing of major international collections, key monuments, and up-to-date publication details of key books for further reading (published in New York or London unless otherwise noted). Copious cross-referencing within the text (indicated by an asterisk in the main entries) allows readers to compare related movements and trace various patterns of influence and developments throughout the period.

Any guide must acknowledge that classifications and boundaries are fluid and not always observed or generated by the artists themselves. Although many artists formed groups or formulated manifestos, some of the most familiar names in use today were first provided by critics, curators, collectors or patrons. Impressionism and Fauvism were labels applied by sarcastic critics. Several groups, such as Les Vingt and the Salon de la Rose+Croix, were exhibition societies, Post-Impressionism is more a time period than a style, Video a medium and the Bauhaus an educational institution.

Classifications and selections, being subject to personal choice, usually provoke debate. Whatever judgment may be implied by the inclusion or exclusion of a particular artist or style, it is important to remember that the selection of subjects and practitioners featured here is subjective, but not arbitrary. The aim is to show relative sources of influence and to provide readers with a way into the world of modern art and to equip them with the tools to seek their own conclusions.

Although the field of exploration treated here is mostly within the bounds of painting and sculpture, it is important to acknowledge the relative importance and context of an art medium to the prevailing culture of the time. Photography, which is older than the modern era itself, intervenes often and powerfully in the visual arts of the whole period, but demands fuller treatment elsewhere within its own terms; it features here more by association.

Architecture figures prominently in this book, not least because manifestos, statements and resolutions have also often defined its movements. While many architectural styles relate closely to other visual arts – for instance, the Arts and Crafts movement, Art Nouveau, Modernisme and Futurism – others demand fuller consideration as movements in their own right, such as the Chicago School, International Style, Italian Rationalism (M.I.A.R.) and High-Tech.

The main entries are also included in the foldout timeline in the beginning of the book in order to show at a glance contemporaneous shifts of style and consciousness. As the beginnings and ends of movements are often inexact, it should be noted that the duration of the movements on the timeline is expressed within approximate dates.

Three major stylistic currents have been highlighted on the timeline, serving to group together movements which share distinctive characteristics. 'Art for the People' embraces styles and movements in which the artists, architects and designers have been committed to the creation of a total living environment for the modern world. 'Art and Style' brings together groups of artists looking for new ways to describe the changing world around them. 'Art and Mind' includes experimental artists whose art aims to represent the inner worlds of emotion, mood and intellect.

At the end of the book, essential historical information is provided on a further 200 styles and movements. Many of these movements have continuing importance and interest within national traditions – for example, the St Ives group in the United Kingdom, the German Stupid Group, the Praesens Group in Poland, the BMPT group in France, the Scuola Romana of Italy, the Swedish Halmstad Group and Spain's Equipo Crónica. Their activity often throws valuable light on the major movements.

The index contains not only all the named movements, but over 1,000 artists, architects, designers, impresarios, critics, collectors and champions of modern art, linking the styles, schools and movements with the people who made them happen.

274

254

Site Works 263

228

236

230

232

244

Super-realism 251

Arte Povera 266

Sound Art 284

Internet Art 286

Earth Art 260

Postmodernism 269

-Surfaces 256

tual Art 240

Installation 247

Neo-Pop 281

Neo-Expressionism 276

Transavanguardia 282

257

30 1940 1950 1960

M.I.A.R. 157 New Brutalism 206 High-Tech

Anti-Design

Socialist Realism 168

Fluxus

Concrete Art 159 Situationist International 213

Minimalism

Op Art

Organic Abstraction 181 Post-painterly Abstraction

American Scene 163 Abstract Expressionism 188

GRAV 226

Art Informel 184 Body Art

Assemblage 215

Neo-Dada 201

Kinetic Art 197

Social Realism 166 Pop Art 217

CoBrA 193 Combines 205 Nouveau Réalisme 210

Funk Art 208

Beat Art 195

Kitchen Sink School 199 Supports

Concep

Outsider Art 180

Art Brut 174

Lettrism 192 Performance Art 222

Existential Art 176 Video Art

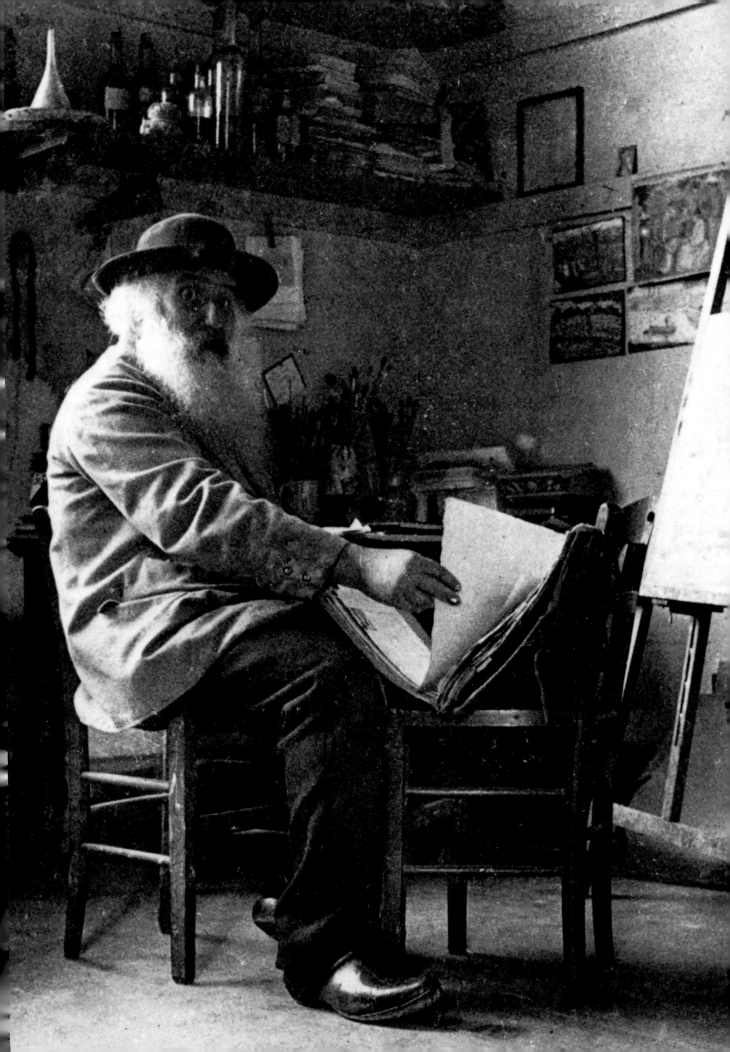

1860-1900

Rise of the Avant-Gardes

Camille Pissarro in his studio in Eragny, *c.* 1897

Impressionism

Wallpaper in its embryonic state is more finished than that seascape.

LOUIS LEROY, 1874

Impressionism was born in April 1874 when a group of young artists in Paris, frustrated with the continual exclusion of their works from the official Salons, joined together to hold their own exhibition in the studio of the photographer Félix Nadar. Claude Monet (1840–1926); Pierre-Auguste Renoir (1841–1919); Edgar Degas (1834–1917); Camille Pissarro (1830–1903); Alfred Sisley (1839–99); Berthe Morisot (1841–95) and Paul Cézanne (1839–1906, see also *Post-Impressionism) were among the thirty painters who exhibited as the Société Anonyme des Artistes Peintres, Sculpteurs, Graveurs, etc. Other important French Impressionists exhibiting later included Jean-Frédéric Bazille (1841–70), Gustave Caillebotte (1848–94), and the American Mary Cassatt (1844–1926).

The 1874 exhibition was greeted with curiosity and confusion by the public, and derision from the popular press, and the title of Monet's *Impression, Sunrise* (c. 1872), provided the scornful critic, Louis Leroy, with the name for the group, 'Impressionists'. Years later Monet recounted the story behind the naming of the picture, and the fuss that ensued from it:

> They wanted to know its title for the catalogue; [because] it couldn't really pass for a view of Le Havre. I replied, 'Use Impression.' Someone derived 'Impressionism' from it and that's when the fun began.

The sketch-like quality and apparent lack of finish to their work, to which many early critics objected, were exactly the qualities that more sympathetic critics would later identify as their strength.

What united this group of diverse artists was their rejection of the art establishment and its monopoly on what could be exhibited. Towards the end of the nineteenth century, the Academy was still promoting the ideals of the Renaissance: namely that the subject of art must be noble or

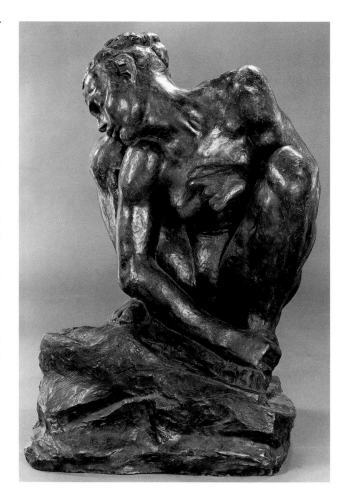

Above: **Auguste Rodin, *Crouching Woman*, 1880–82**
Like the Impressionists, Rodin avoided an appearance of finish in his work, preferring to leave something to the imagination. Monet's first success came after a joint exhibition with Rodin in 1889, and Rodin's fame contributed to the acceptance of Impressionism outside France.

Opposite: **Claude Monet, *Impression, Sunrise*, c. 1872–73**
Exhibited in 1874, the title of this view of Le Havre harbour in the morning mist provided the critic, Louis Leroy, with a name for the group, 'Impressionists'. The sketchiness and apparent lack of finish were scorned by contemporary critics.

instructive and that the value of a work of art could be judged by its descriptive 'likeness' to natural objects. The Impressionists' action – contesting the conventions and power of the traditional cultural gatekeepers by holding an independent exhibition – was a model for innovators of the following century. Likewise, the coining of an 'ism' by a sarcastic or scandalized critic to describe a radical new form of art would become standard procedure.

Since the mid-nineteenth century Paris had become the first truly modern metropolis, both physically and socially, and many Impressionist works captured this new Parisian cityscape. The role of art in a changed society was the subject of artistic, literary and social debates of the day, and the Impressionists were self-consciously modern in encompassing new techniques, theories, practices and variety in subject matter. Their interest in capturing the visual impression of

a scene, to paint what the eye saw rather than what the artist knew, was as revolutionary as their practice of working outdoors (instead of solely in the studio) to observe the play of light and colours. Their avoidance of historical or allegorical subjects, and their insistence on the fleeting moments of modern life – to create what Monet called 'a spontaneous work rather than a calculated one' – marked a definitive break with accepted subject matter and practice.

The work of Edouard Manet (1832–83) was an important influence on the Impressionists. Manet rejected the single vanishing point in favour of 'natural perspective' and his apparently illegible or incomplete subjects deliberately subverted classical ideals. He also transgressed the hierarchy of genres with his large-scale portrayal of 'insignificant' subject matter, and, above all, he insisted on portraying contemporary experience. When *Olympia* (1863) was exhibited in 1865, conservative critics were outraged by his treatment of traditional subject matter (the female nude).

The works of others, such as Camille Corot (1796–1875) and the Barbizon School, Gustave Courbet (1819–77) and the English painters of a previous generation, J. M. W. Turner (1775–1851) and John Constable (1776–1837), demonstrated to the Impressionists ways in which the visual effects of light and weather could be explored in paint. The contrast, blurring and fragmentation caused by cropping in contemporary photography also made a strong impact on them, as did Japanese prints, displaying non-Western composition, perspective, and flat areas of colour.

Throughout the 1860s, the Impressionists absorbed these lessons and developed their styles, often painting together, or meeting (at the Café Guerbois in Montmartre, for instance) to discuss their work and share their ideas. Between 1874 and 1886 the eight now famous independent shows of their work took place, at once drawing the public's attention. Critical reaction was often hostile, especially at first, but the Impressionists had influential champions, some of whom, like the writers Emile Zola and J. K. Huysmans, were also friends. They also attracted important private patrons and dealers, such as Dr Paul Gachet (later to

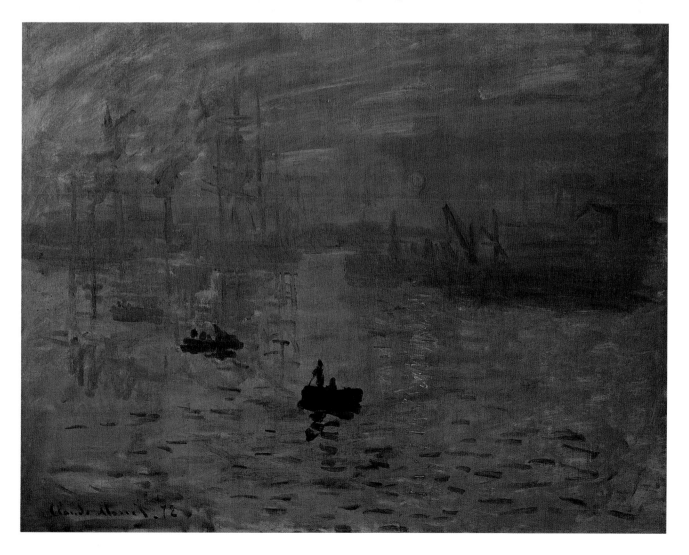

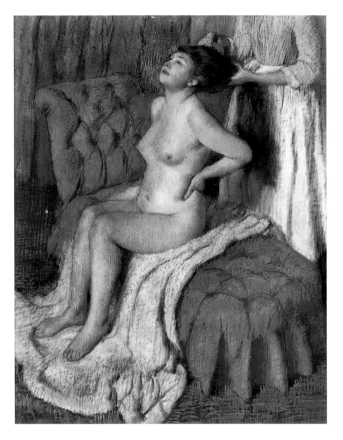

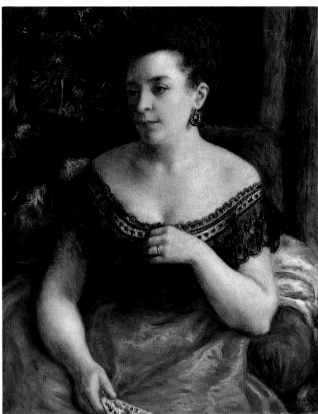

be Vincent van Gogh's physician at Auvers, see Post-Impressionism) and Paul Durand-Ruel.

It is not an exaggeration to say that throughout the 1870s most Impressionist works were concerned with the effects of light on landscapes. But a change occurred in the early 1880s, usually referred to as the 'Impressionist crisis'. Many of the artists began to feel that in trying to capture light and the ephemeral quality of atmosphere they had eroded the figure too far, and from this moment on, the movement became more diverse. Renoir, for example, turned to a more classical style of figure painting; Monet made his figures more solid, then adopted a more analytical approach to visual perception. The group began to portray a broader range of subject matter. The crisis, which also affected the younger generation exhibiting alongside the Impressionists, would later result in radical departures from the Impressionists' original ideas. Artists such as Paul Gauguin (see *Synthetism), Paul Cézanne (see Post-Impressionism), Georges Seurat and Paul Signac (see *Neo-Impressionism) eventually created their own styles.

The developments that affected the Impressionists are best seen in the work of a few leading individuals. For many, Claude Monet remains the Impressionist par excellence; his paintings of the railway station, *Gare Saint-Lazare* (1876–77), which combine and contrast the modern architecture of the station with the new, amorphous modernist

atmosphere (of steam), have been called the most representative Impressionist paintings. Monet's interest in atmosphere would become more prominent in other series which portray the same subject at different times of the day, year and climate, such as *Haystacks* (1890–92) and *Poplars* (1890–92). In the *Poplars* sequence the curvilinear arrangement of shapes simultaneously signals both depth and the flatness of the surface; the use of the S-curve suggests links with *Art Nouveau work of the same period. Towards the end of his life, from 1914 to 1923, Monet devoted himself to eight huge water lily canvases for a designated room at the Orangerie in the Tuileries, Paris. Together, they create an environment which entirely surrounds the viewer, a sense of

Above left: **Edgar Degas, *Woman Having Her Hair Combed, c.* 1886**
Degas's interest in the play of light and shade on the human form is evident in this pastel drawing. The nude made up at least a fifth of Degas's vast output.

Above right: **Pierre-Auguste Renoir, *Mme Portalis*, 1890**
Declaring that painting 'should be something pleasant, cheerful and pretty, yes pretty!', Renoir delighted in delicate, colourful representations of sumptuous materials and flesh. His later works, however, are more strongly coloured with warm reds and oranges, and more solidly sculpted.

Opposite: **Berthe Morisot, *Boats Under Construction*, 1874**
In the same year as painting this picture, Morisot married the brother of Edouard Manet. She was a deeply committed member of the Impressionist group, contributing to every Impressionist exhibition, except in 1879, the year following the birth of her daughter.

infinity – or, as Monet put it, the 'instability of the universe transforming itself under our eyes'. The brushstrokes, which must be connected in order to 'read' the works, induces the viewer to participate in creating meaning, a crucial concept for other artistic practices of the twentieth century. The abstract quality of the water lilies anticipates *Abstract Expressionist work of the 1940s and 1950s.

Although Renoir painted landscapes with Monet in the late 1860s, his primary interest was always the human figure, and his greatest contribution to Impressionism was to apply Impressionist treatment of light, colour and movement to subjects such as the crowd scene in *Dancing at the Moulin de la Galette* (1876). Declaring that painting 'should be something pleasant, cheerful and pretty, yes pretty!', Renoir returned again and again to scenes of Parisians at play, delighting in delicate, colourful representations of sumptuous materials and flesh. Around 1883 he broke definitively with pure Impressionism and began painting classical nudes in a dryer, less sensuous manner. Although

this phase was short-lived, he later combined his interest in classicism with the lessons of Impressionism. His brushstrokes became looser and more gestural, and some critics have seen Renoir's late works, as well as Monet's, as precursors of *Abstract Expressionism.

Edgar Degas's work was shown in seven of the eight Impressionist group exhibitions, but he always considered himself a realist, proclaiming:

> No art was ever less spontaneous than mine. What I do is
> the result of reflection and study of the great masters; of
> inspiration, spontaneity, temperament, I know nothing.

An accomplished draughtsman, he learned from Impressionist practice how to use light to convey a sense of volume and movement in his work. Like most of his colleagues, Degas would sketch in front of a scene, but preferred to continue work in the studio, for he felt that it was 'much better to draw what you see only in your mind. During such transformation the imagination collaborates

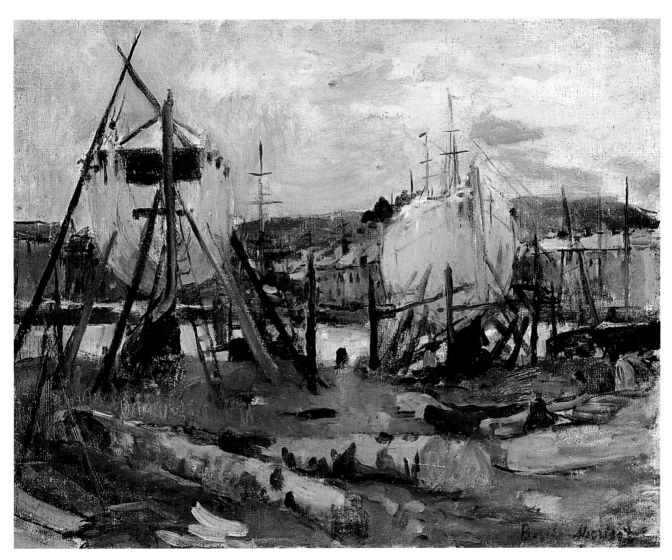

with the memory…. Then, your memory and your imagination are freed from the tyranny imposed by nature.' Degas went to cafés, theatres, circuses, racetracks and the ballet in search of his subject matter. Of all the Impressionists, Degas was the most affected by photography, with its typical shattering of the focus of the pictorial field, the sense of the fleeting moment, the fragmentation of bodies and space and the cropping of the image. In the late 1880s he began to use pastels and a 'keyhole aesthetic' to portray women in natural, intimate poses, a development which was unprecedented in the history of art. As art historian George Heard Hamilton noted in reference to these late works: 'His colours were, indeed, his last and greatest gift to modern art. Even as blindness descended, his palette passed to the *Fauves.'

Berthe Morisot and Mary Cassatt were the two most prominent women who exhibited with the Impressionists. Their use of line and painterly freedom, and their choice of intimate scenes as subject matter, display affinities with the work of Manet and Degas. Cassatt's work seems to draw on many sources – the love of line seen in Japanese prints, the bright colours of the Impressionists and the skewed perspectives and photographic cropping of Degas – to create a unique style capable of rendering her typically tender, intimate views of domestic life.

Another American expatriate, James Abbott McNeill Whistler (1834–1903, see also *Decadent Movement), was the central figure in the development of Impressionism, and of modernism in general, in Britain. Even more than the French Impressionists, Whistler advocated that, far from being descriptive, a painting was purely an arrangement of colour, form and line on a canvas. His *Nocturne in Black and Gold: The Falling Rocket* (c. 1874), which the English art critic John Ruskin famously dismissed as 'a pot of paint flung in the public's face', fuses Impressionist ideas of colour and atmosphere with the flat decorative quality of Japanese prints, creating an original and memorable image of mood and atmosphere twenty years before Monet's cathedrals. The leading British Impressionist, Walter Sickert (1860–1942), absorbed the lessons of both Whistler and Degas, and in his work the darker palette of the British landscape tradition is transformed into something more contemporary.

By the late 1880s and 1890s Impressionism was accepted as a valid artistic style, and spread throughout Europe and the USA. Around the turn of the century, Germany was particularly receptive to outside influences, and the new French techniques were grafted onto the prevailing native naturalism. Max Liebermann (1847–1935), Max Slevogt (1868–1932) and Lovis Corinth (1858–1925) remain the most famous German Impressionists. In the USA, Impressionism was enthusiastically received by the press, the public, artists and collectors, and some of the most extensive collections of Impressionism can be found today in the USA. The major practitioners of Impressionism in the USA were William Merritt Chase (1849–1916), Childe Hassam (1859–1935), Julian Alden Weir (1852–1919) and John Twachtman (1853–1902).

Despite the existence of sculpted works by Degas and Renoir, there were no sculptors directly affiliated with the movement. However, as the term came to refer to a general style, and not to the paintings of the original group, work by both the French sculptor Auguste Rodin (1840–1917) and the Italian Medardo Rosso (1858–1928) were termed Impressionist. Their sculptures take the interest in light, movement, spontaneity, fragmentation and disintegration of form by light and shadow into the third dimension. Similarly, work in other fields which seeks to capture transitory impressions is often called 'impressionist' (with more or less justification), such as the music of Ravel and Debussy or even the novels of Virginia Woolf.

The impact of Impressionism cannot be overestimated. Their actions and experiments symbolized the rejection of artistic traditions and the value judgements of criticism, and future avant-garde movements would follow their example and take a stand for artistic freedom and innovation. By painting 'vision' – not what one sees, but what seeing is – they heralded the beginning of Modernism, initiating a process that would revolutionize the conception and perception of the artistic object. Impressionism represents the beginning of the twentieth century's exploration of the expressive properties of colour, light, line and form, a particularly strong theme in modern art. Perhaps most important of all, Impressionism can be seen as the start of the struggle to free painting and sculpture from its solely descriptive duty in order to create a new language and role akin to other art forms such as music and poetry.

Key Collections
Courtauld Gallery, London
Metropolitan Museum of Art, New York
Musée d'Orsay, Paris
Musée de l'Orangerie, Paris
National Gallery of Art, Washington, D.C.
Philadelphia Museum of Art, Philadelphia, Pennsylvania

Key Books
D. Kelder, *The Great Book of French Impressionism* (1980)
T. J. Clark, *The Painting of Modern Life: Paris in the Art of Manet and his Followers* (Princeton, NJ, 1984)
B. Denvir, *The Impressionists at First Hand* (1987)
R. Herbert, *Impressionism: Art, Leisure and Parisian Society* (1988)
B. Denvir, *Chronicle of Impressionism* (1993)
B. Thomson, *Impressionism* (2000)

Arts and Crafts

*Have nothing in your houses that you do not know
to be useful or believe to be beautiful.*

WILLIAM MORRIS

The Arts and Crafts movement was a social and artistic movement, which began in Britain in the second half of the nineteenth century and continued into the twentieth, spreading to continental Europe and the USA. Its adherents – artists, architects, designers, writers, craftsmen and philanthropists – sought to reassert the importance of design and craftsmanship in all the arts in the face of increasing industrialization, which they felt was sacrificing quality in the pursuit of quantity. Its supporters and practitioners were united not so much by a style than by a common goal – a desire to break down the hierarchy of the arts (which elevated painting and sculpture), to revive and restore dignity to traditional handicrafts and to make art that could be affordable for all.

The leading exponent and propagandist of the Arts and Crafts movement was the designer, painter, poet and social reformer William Morris (1834–96). A passionate Socialist, Morris proclaimed, 'I do not want art for a few, any more than I want education for a few, or freedom for a few.' Drawing on the ideas of the architect Augustus W. N. Pugin (1812–52), who proselytized the moral superiority of the art of the Middle Ages, and the art critic and writer John Ruskin (1819–1900), who denounced the greed and self-interest of contemporary capitalist society, Morris developed the view that art should be both beautiful and functional. His ideal, the pure and simple beauty of medieval craftsmanship, was further strengthened by his friendships with the Pre-Raphaelite painters Edward Burne-Jones (1833–96) and Dante Gabriel Rossetti (1828–82), who also looked to the Middle Ages (hence 'Pre-Raphaelite') for aesthetic inspiration and moral guidance.

The Red House (1859) in Bexley Heath, Kent, marks the emblematic start of the movement. Morris commissioned it from his friend, the architect Philip Webb

(1831–1915), for himself and his new bride. The red brick house (hence the name), with its free-flowing design, the absence of pretentious façades, the concern for structure and sensitivity to local materials, traditional building methods and the particularities of location, is a landmark in the domestic revival movement. Morris himself designed the garden, and the interior was fitted and decorated by Webb, the Morrises, Rossetti and Burne-Jones, resulting in what Rossetti described as 'more a poem than a house'. It is, in

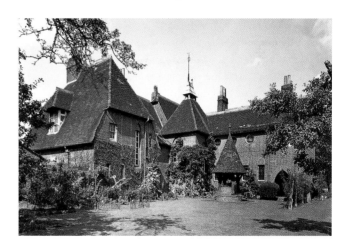

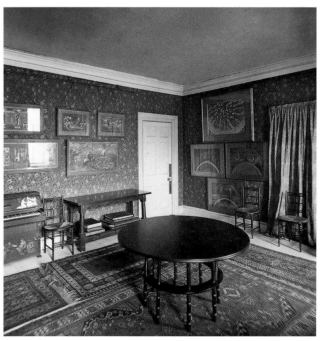

Above: **Philip Webb, The Red House, Bexley Heath, Kent, 1859**
The Red House was Webb's first job and remains one of his most celebrated. For Morris's company he also designed furniture, metalwork and stained glass.

Right: **Interior showing two Philip Webb tables, Ford Madox Brown's version of the 'Sussex' chair and William Morris's 'Fruit' wallpaper** This interior from The Grange in Fulham, London, illustrates the characteristic style and design of the movement, which harked back to medieval architecture, tapestries, illuminated manuscripts and rustic styles of decoration and furniture.

fact, the earliest example of the concept of a 'total work of art' that would become central not only to the Arts and Crafts philosophy, but to many other movements, among them *Art Nouveau and *Art Deco.

This project amongst friends soon led to a commercial venture. In 1861 Morris, Webb, Rossetti, Burne-Jones, painter Ford Madox Brown (1821–93), surveyor P. P. Marshall and accountant Charles Faulkner founded the manufacturing and decorating firm of Morris, Marshall, Faulkner & Co. (later Morris & Co.). The anti-industrial structure of the firm was based on the concept of medieval guilds, in which craftsmen both designed and executed the work. Its aim was to create beautiful, useful, affordable, applied-art objects, so that art would be a lived experience for all, not just the affluent. The members of the company turned their hands to designing and producing domestic objects, including furniture, tapestry, stained glass, furnishing fabrics, carpets, tiles and wallpaper.

However, the major innovation of the Arts and Craft movement was in their ideology, not in their style or design, which harked back to medieval architecture and tapestries, illuminated manuscripts and rustic styles of decoration and furniture. Tellingly, their themes and subjects were often drawn from Arthurian legend or the poetry of fourteenth-century poet Geoffrey Chaucer. Moreover, though the movement was successful in raising the status of the craftsman and promoting respect for native materials and tradi-

tions, it failed to produce art for the masses: its handmade products were expensive. By the 1880s it was possible to live in a house designed by Webb, decorated with Morris wallpaper, ceramics by William de Morgan (1839–1917), paintings by Burne-Jones and wear clothing based on Pre-Raphaelite dress – but only for the wealthy.

Morris himself is best known for his use of flat, formal pattern designs for wallpaper and tiles characterized by a richness of colour and complexity of design. The flowing, dynamic line of such designs, particularly those of second-generation designers Arthur Heygate Mackmurdo (1851–1942, see Art Nouveau) and Charles Voysey (1857–1941), would later influence the international Art Nouveau, in which designers would develop the look without its social program.

The architecture of Arts and Crafts was perhaps the most radical and influential aspect of the movement, and architects such as Webb, Voysey, M. H. Baillie Scott (1865–1945), Norman Shaw (1831–1912) and Charles Rennie Mackintosh (see Art Nouveau) developed principles which would later become the touchstones of twentieth-century architects. These included the belief that design should be dictated by function, that vernacular styles of architecture and local materials should be respected, that new buildings should integrate with the surrounding landscape, and that freedom from historicist styles was essential. The result was a number of buildings – especially houses for the middle class – that architectural historian Nikolaus Pevsner called 'fresher and more aesthetically adventurous than anything done at the same time abroad'.

These architectural principles fed the growing Garden City movement in Britain in the early twentieth century, which brought together on a large scale Arts and Crafts design and Morris's social reform ideals. The Garden City movement was based on the theories of Ebenezer Howard (1850–1928), as put forward in his highly influential book, *Tomorrow: a Peaceful Path to Real Reform,* 1898 (revised and retitled as *Garden Cities of Tomorrow* in 1902). Howard's social policies advocated the creation of small, economically self-sufficient cities throughout the country, with the aim of halting urban sprawl and overcrowding. Numerous such cities were built, with varying degrees of success, and the

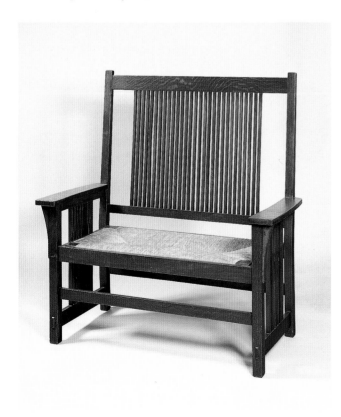

Left: **Gustav Stickley, Settee, 1905–7**
Simplicity, utility and 'honest' construction characterized Stickley's designs. By following the teaching of the English Arts and Crafts designers, particularly Morris, he wished to provide for Americans 'material surroundings conducive to plain living and high thinking'.

Opposite: **C. F. A. Voysey, Wallpaper incorporating a self-caricature as a demon, design of 1889** Voysey sold his first wallpaper design in 1883. His success helped him supplement his income in the difficult years of his architectural practice, before *c.* 1895 and after *c.* 1910.

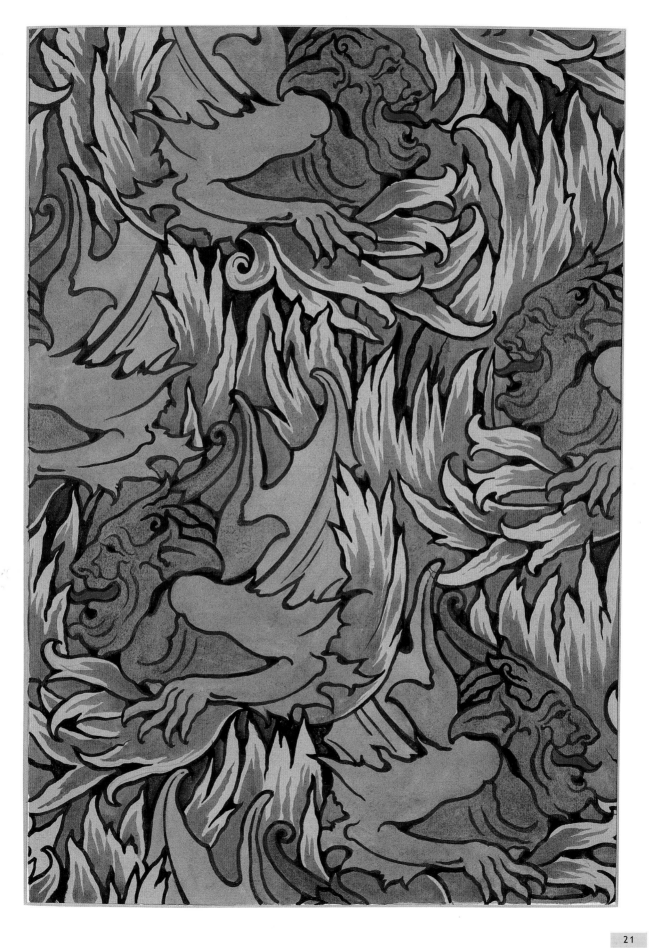

ordinary home became the focal point of progressive architects throughout the country. This revival of interest in domestic architecture, specifically Arts and Crafts design and architecture, later spread to Continental Europe. *The English House* (1904–5) by German architect Hermann Muthesius (1861–1927, see *Deutscher Werkbund), and exhibitions hosted by *Les Vingt and its successor, La Libre Esthétique, in Brussels, introduced the new British style to a Continental public.

The Arts and Crafts movement encompassed other English guilds of architects and designers. The Century Guild (founded in 1882 as a democratic collective) included as its members Mackmurdo and Selwyn Image (1849–1930), who also produced a journal, *The Hobby Horse* (1884, 1886–92). The Art Workers' Guild (founded 1884) included William Lethaby (1857–1931) and Voysey among its members; its aims were 'to advance education in all the visual arts…and to foster and maintain high standards of design and craftsmanship'. The recognition that public exposure was essential to achieve their educational goals and commercial survival (the Royal Academy would not exhibit decorative arts) prompted the establishment of the Arts and Crafts Exhibition Society in 1888 by a number of second-generation practitioners, with Walter Crane (1845–1915) as its first president. One of its members, T. J. Cobden-Sanderson (1840–1922), who coined the name for the movement in 1887, defined its core aim as bringing 'all the activities of the human spirit under the influence of one idea, the idea that life is creation'. In 1893 the magazine *The Studio* was launched to spread the message and the designs of the Arts and Crafts movement throughout Britain, Europe, and the USA.

Arts and Crafts workshops based on their British counterparts were formed in the USA in the late nineteenth century. The aesthetic of simple, unadorned furniture designs of Gustav Stickley (1857–1942) and his workshop, promoted through the periodical *The Craftsman* (1901–16), remains popular today. Simplicity, utility and 'honest' construction were the key concepts behind the designs. Unlike Morris, Stickley did not reject mass production. His products, more accessible and affordable than Morris's, were available in department stores or by mail order from catalogues, and could even be made at home from designs and instructions published in *The Craftsman*.

Arts and Crafts architectural principles – use of the vernacular, local materials and craft traditions – also flourished in America, encouraging a variety of regional domestic architecture. The exquisitely crafted homes and accompanying furniture designed by the brothers Charles (1868–1957) and Henry (1870–1954) Greene in Pasadena and Los Angeles, California, epitomize the refined West Coast

variant of American Arts and Crafts architecture. But the towering figure in American domestic architecture of the early twentieth century was Frank Lloyd Wright (1867–1959). His Prairie Houses, situated outside Chicago, featuring their distinctive horizontality, overhanging roofs and free-flowing rooms around a central chimney, show a strong Arts and Crafts influence. Wright, like many other Arts and Crafts architects embraced the concept of 'total design' and often designed built-in furniture to control the interiors. Other popular Prairie School architects included William Gray Purcell (1880–1965) and George Grant Elmslie (1871–1952).

Arts and Crafts aesthetics and ideals were also particularly successful in Germany, Austria, Hungary and Scandinavia with their strong craft traditions which continue today. Arts and Crafts principles were allied to machine production and used as an expression of national identity. Folk arts were revived, as were native types of medieval architecture. The major figures in Finland included the artist Akseli Gallen-Kallela (1865–1931) and the architect Eliel Saarinen (1873–1950); in Sweden the artist Carl Larsson (1853–1919); in Hungary Aladár Körösfoi-Kriesch (1863–1920); and in Austria, Josef Hoffmann (1870–1956, see *Vienna Secession) and Koloman Moser (1868–1918). The ideals of the Arts and Crafts movement were also the basis of many German *Jugendstil workshops and eventually the *Bauhaus, which would also strive to unite fine and applied arts in a principle of total design.

When the Arts and Crafts movement began to lose impetus, around the time of World War I, the precepts 'fitness for purpose' and 'truth to materials' continued to be influential. More recently the craft ideal of the Arts and Crafts movement lies behind the rise of the designer-maker, and since the 1950s, the Crafts Revival in Britain, the USA and Scandinavia.

Key Collections
Metropolitan Museum of Art, New York
Musée d'Orsay, Paris
Tate Gallery, London
Victoria & Albert Museum, London
Virginia Museum of Fine Arts, Richmond, Virginia
William Morris Gallery, London

Key Books
P. Davey, *The Arts and Crafts Movement in Architecture* (1980)
P. Sparke, et al., *Design Source Book* (Sydney, 1986)
G. Naylor, *The Arts and Crafts Movement. A study of its sources, ideals and influence on design theory* (1990)
E. Cumming and W. Kaplan, *The Arts and Crafts Movement* (1991)

Chicago School

I should say that it would be greatly for our aesthetic good if we should refrain entirely from the use of ornament for a period of years.

LOUIS SULLIVAN, 'ORNAMENT IN ARCHITECTURE', 1892

The Chicago School – never a self-proclaimed movement – was an informal group of architects and engineers at work in Chicago from about 1875 to 1910. Chief among them were Dankmar Adler (1844–1900), Daniel H. Burnham (1846–1912), William Holabird (1854–1923), William Le Baron Jenney (1832–1907), Martin Roche (1853–1927), John Wellborn Root (1850–91), and, primarily, Louis Sullivan (1856–1924). Their lasting legacy was the development of the skyscraper, an achievement both distinctively modern and American.

In the period following the Civil War, Chicago offered architects unique opportunities. Westward expansion had boosted the city's population and economy, and in 1871 the Great Fire razed much of its centre to the ground. Land prices were at a premium, however, and use of space restricted. The solution was the high-rise, which the invention of the elevator by Elisha Graves Otis had first made viable in 1853. Two problems remained, however: bulky load-bearing masonry, and the risk of fire.

The first problem was solved by the use of an internal metal frame. Jenney's Home Insurance Building (1883–85, extended in 1891, destroyed in 1931) was the world's first building completely supported by an internal metal frame, rather than conventional load-bearing walls. His iron and steel skeletons, clad with masonry, proved both structurally reliable, for greater height, and more heat-resistant than cast-iron frames. Technical developments were inseparable from aesthetic issues. In Holabird and Roche's Tacoma Building (1886–89, demolished) and Marquette Building (1895), and in Burnham, Root and Charles Atwood's Reliance Building (1891–95), the steel skeletons were clothed in walls of glass which both reflected the interior structure and emphasized its lightness. The use of metal frames reduced the need for supporting walls, and opened up the façades – innovations which would later sweep through the rest of the country, transforming American cities in the 1950s (see *International Style). Building exteriors also changed. The architects of the Chicago School

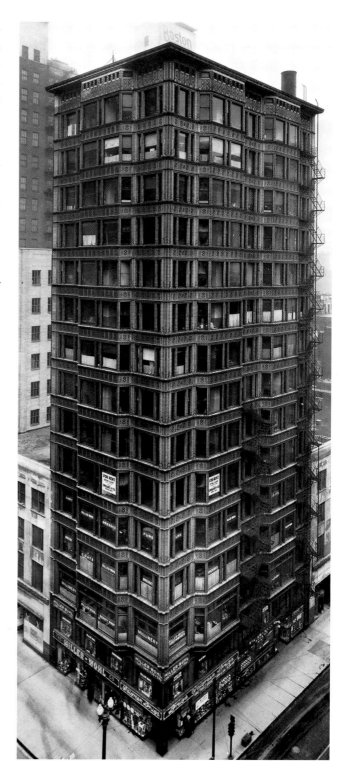

D. H. Burnham & Co., Reliance Building, Chicago, 1891–95
The 14-storey building, initially built with only four floors, was extended in 1894 by the designer, Charles B. Atwood and the structural engineer, E. C. Shankland. As a result, the building reached a height of 200 feet (61 metres), its steel frame allowing the maximum use of glass.

employed masonry cladding (often terracotta) to emphasize the frame, distinctive 'Chicago windows' appeared (large three-part windows with a central fixed pane and smaller double-sash windows on either side) and radically simplified external decoration.

More than any other partnership of the period, the team of Adler and Sullivan is synonymous with the style of the Chicago School. The urbane and cultivated Adler, whose socialist views were derived from William Morris (see *Arts and Crafts), and whose technical mastery was famous, was an ideal complement to the intransigent and visionary Sullivan, whose books sometimes give the impression of a prophet in the wilderness. Both the Wainwright Building (1890–91) in St Louis, Missouri, and the Guaranty Building (1894–95, now the Prudential Building) in Buffalo, New York, are seminal expressions of the skyscraper form. In them, the design problem posed by a vertical building composed of horizontal layers is solved with radical directness. The horizontal layers are acknowledged by the ornamentation under the windows, and the decorative frieze and bold cornice above. The verticality of the steel skeleton is stressed in the overall column-like organization of the building, with its three sections: base, shaft and capital. They demonstrate Sullivan's belief, as he famously put it in his 1896 essay 'The Tall Office Building Artistically Considered', 'form follows function'. Sullivan's conception of function was a wide one, however, encompassing structural, utilitarian and social considerations. He did not – as he said he should, and as later architects did – eschew ornamentation, but sought to integrate it into the design of the building, so that it would appear as if 'it had come forth from the very substance of the material.'

Indeed, ornamentation is conspicuous in Sullivan's masterpiece, the Schlesinger and Mayer Department Store (now Carson, Pirie, Scott & Co.) which he designed in two phases (1899 and 1903–4). The steel-skeleton grid is powerfully expressed by the external emphasis on the vertical and horizontal lines, and the office walls of the upper floors are unadorned; but on the first three floors, the large display windows of the department store are framed in lavish cast-iron *Art Nouveau-style ornamentation. No building expresses so clearly his attempts to reconcile the natural and the industrial, nor justifies his twin reputations as father of both modern functionalism and organic architecture.

The death of Adler in 1900 left Sullivan an isolated and increasingly difficult figure, and his commissions eventually dried up. At the same time the neo-classical tradition of architecture made a comeback in the USA, and the designs of the Chicago School went out of fashion. It was later in the twentieth century that their technological breakthroughs and bold designs would become so influential. Chicago itself, however, remained a fertile ground for architectural innovations. At the turn of the twentieth century, Sullivan's most gifted student, Frank Lloyd Wright, led another informal group of Chicago-based architects to revolutionize domestic architecture: the Prairie School (see Arts and Crafts).

Louis Sullivan, Carson, Pirie Scott & Co., Chicago, 1899 and 1903–4
Sullivan thought that the department store display windows were like pictures, and he therefore designed rich 'frames' for the lower façade of his building. Many of his designs were executed by George Elmslie.

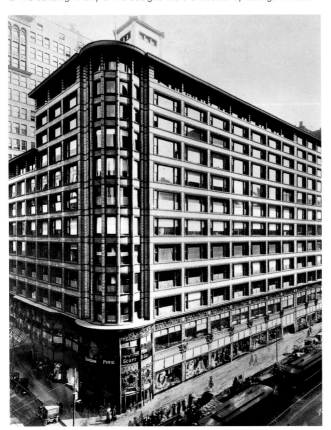

Key Monuments
Louis Sullivan, Carson, Pirie, Scott & Co. Building, State St, Chicago, Illinois
Holabird and Roche, Marquette Building, Dearborn St, Chicago, Illinois
Burnham and Root, Monadnock Block, Jackson Blvd, Chicago, Illinois
Charles Atwood, Reliance Building, State St, Chicago, Illinois

Key Books
J. Siry, 'Carson Pirie Scott' (*Chicago Architecture and Urbanism*, vol. 2, 1988)
H. Frie, *Louis Henry Sullivan* (1992)
H. Morrison and T. J. Samuelson, *Louis Sullivan: Prophet of Modern Architecture* (1998)

Les Vingt

We are believers in Art Nouveau.

L'ART MODERNE

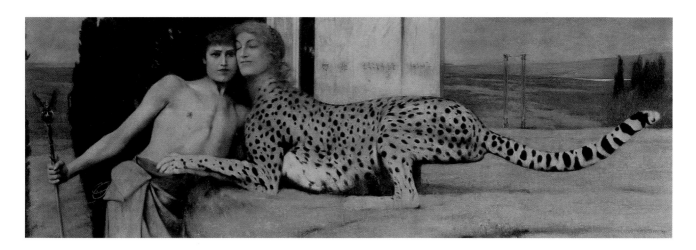

The group known as Les Vingt (The Twenty) was made up of twenty progressive painters, sculptors and writers in Brussels who joined together from 1883 to 1893 to exhibit and promote innovative art, both Belgian and foreign. The original twenty included James Ensor (1860–1949, see *Symbolism), Alfred William Finch (1854–1930), Fernand Khnopff (1858–1921), and Théo Van Rysselberghe (1862–1926). Stylistically diverse, the group was brought together by the lawyer Octave Maus (1856–1919) to provide a forum for avant-garde art, music, poetry and decorative arts.

Maus had already begun to spread his ideas concerning contemporary art through the periodical *L'Art Moderne* (1881–1914), which he started with his lawyer friend Edmond Picard (1836–1924). With this as their mouthpiece, Maus and Picard attacked the tradition-bound Academy and conservative Salons, agitating for the introduction of art into everyday life. Unnerved by the hostile critical reaction that the editors' rhetoric provoked, some of the more conservative members of Les Vingt left the group. Their places were quickly filled by others, including Belgians Anna Boch (1848–1926), Félicien Rops (1833–98), Henry Van de Velde (1863–1957, see *Art Nouveau) and Isidor Verheyden, the French sculptor Auguste Rodin (1840–1917, see *Impressionism), French *Neo-Impressionist Paul Signac (1863–1935) and Dutch

Symbolist Jan Toorop (1858–1928). In total, there were thirty-two members of Les Vingt throughout the group's ten-year existence.

With the aid of painter Van Rysselberghe and the poet and critic Emile Verhaeren, Maus organized exhibitions in February of each year, from 1884 until the group's dissolution in 1893. The inaugural exhibition set the agenda, presenting work by members of Les Vingt alongside those of established and emerging international artists, and introducing the public to new styles in modern art. Among the 126 invited artists who participated were: Rodin, Whistler, Monet, Renoir and Pissaro (see Impressionism); Redon (see Symbolism); Denis (see *Nabis); Anquetin and Bernard (see *Cloisonnism); Seurat and Signac (see Neo-Impressionism); Gauguin (see *Synthetism); Toulouse-Lautrec, Cézanne and Van Gogh (see *Post-Impressionism); and Crane (see Art Nouveau). This exchange of information prompted local versions of Symbolism by Les Vingtistes Khnopff, George Minne (1866–1941) and Rops, and a brief enthusiasm for Neo-Impressionism on the part of Boch, Finch, Georges Lemmen (1845–1916), Van Rysselberghe and Van de Velde. From 1892 onwards, the exhibitions included decorative arts, reflecting the growing interest in applied arts. As an outward-looking exhibition society for artists, Les Vingt was an important model for many groups that followed, such as the *Vienna Secession.

After the group dissolved in 1893, Maus and Van Rysselberghe continued with a new association, La Libre Esthétique (1894–1914), putting an even greater emphasis on the decorative arts. Painting, sculpture, furniture and

Fernand Khnopff, *Caresses of the Sphinx (The Sphinx)*, 1896
The moment shown is inspired by the artist's imagination, rather than any literary source. The Sphinx caresses Oedipus who resists her. He is either pondering her riddle, or has already solved it. In the post-Homeric story Oedipus solves the riddle and the Sphinx kills herself.

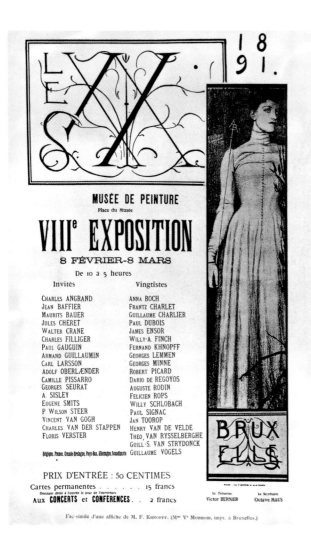

applied art were all given equal status. The first exhibition included work by the English *Arts and Crafts practitioners, William Morris, Walter Crane, T. J. Cobden-Sanderson and C. R. Ashbee and book illustrations by the *Decadent artist Aubrey Beardsley, along with paintings by Toulouse-Lautrec and Seurat. Even music was represented, Claude Debussy playing at the opening.

As a result of this experimentation and exchange of ideas, Continental Art Nouveau emerged first in Brussels, particularly in the work of the architect Victor Horta (1861–1947) and the former Vingtiste, Van de Velde. The new movement was enthusiastically supported by *L'Art Moderne*, and the editors, Maus and Picard, declared themselves 'the Art Nouveau faithful'.

Key Collections
Fine Arts Museums of San Francisco, San Francisco, California
Musées Royaux des Beaux-Arts, Brussels, Belgium
Petit Palais, Geneva, Switzerland
Kunsthaus, Zurich, Switzerland

Key Books
Belgian Art, 1880–1914
 (exh. cat., Brooklyn Museum of Art, 1980)
Impressionism to Symbolism: The Belgian Avant-garde,
 1880–1900 (exh. cat., Royal Academy of Art, London, 1994)
C. Brown, *James Ensor* (1997)

Neo-Impressionism

The Neo-Impressionist does not dot, *he divides.*

PAUL SIGNAC, 1899

At the suggestion of Camille Pissarro (1830–1903), one of the founders of the *Impressionist group, works by his son, Lucien (1863–1944), and two other young French painters, Paul Signac (1863–1935) and Georges Seurat (1859–91), were included in the last Impressionist exhibition held in 1886. The Pissarros had already met Seurat and Signac the year before, and all four were working in the style

that would soon be labelled Neo-Impressionism (New Impressionism) by the critic Félix Fénéon.

The new pictures were hung separately from the main exhibition, inviting critics to compare the old and the new styles of Impressionism. The strategy was a success and critical reaction was favourable. Fénéon's review, highlighting both the origin of the Impressionist style and the reaction to

Above: **Fernand Khnopff, *Les XX*, Poster for the 1891 exhibition**
Khnopff, who designed the logo for Les Vingt, was a book illustrator as well as a painter. His sister's likeness appears in many of his pictures of women, her entranced features suggesting a transcendental, or perhaps sexual, realm.

Opposite: **Georges Seurat, *Sunday Afternoon on the Island of La Grande Jatte*, 1883–86** Carefully constructed, with an all-over composition in which no single aspect of the painting takes precedence over another, Seurat's masterpiece creates extraordinary optical effects.

Impressionist techniques, was positive. Another critic, Paul Adam, ended his review with the assertion that 'this exhibition initiates [us] into a new art.' By the early 1880s, many of the Impressionists felt that Impressionism had gone too far in dematerializing the object and had become too ephemeral. This concern was shared by younger artists such as Seurat. In his early work, *The Bathers at Asnières* (1884), he tries to retain Impressionist luminosity while reconstituting the object. Although choosing a typical Impressionist subject – urban leisure – Seurat's carefully composed design and working method are far removed from the spontaneity associated with Impressionist paintings. In fact, Seurat made at least fourteen oil sketches for this work before coming to the final selection, which he painted, not in the open air, but in his studio.

In 1884, Signac sought out Seurat after seeing *The Bathers*, and they discovered a shared interest in colour theory and optics. They began to work together on their theory of 'divisionism'. Their research led them to scientific studies on the transmission and perception of light and colour, such as *Students' Text-book of Colour: or, Modern Chromatics, with Applications to Art and Industry* (1881) by the American physicist Ogden Rood and, most importantly, *Principle of Harmony and Contrast of Colours and Their*

Application to the Arts (1839) by Michel-Eugène Chevreul. Signac even tracked down the ninety-eight-year-old Chevreul to interview him about his discoveries. Chevreul had been the chief chemist at a tapestry factory, where he developed his 'principle of simultaneous contrasts', based on his observations of weaving. He stated that when the retinal area is stimulated by a colour, it produces an afterimage of its complementary colour, and that contrasting colours stimulate each other. Seurat and Signac seized on this. What the original Impressionists had discovered intuitively – that greater luminosity and brilliance of colour can be achieved by placing unmixed pigment directly onto the canvas – the two Neo-Impressionists now developed scientifically.

Drawing on the premise that colour is mixed in the eye, not on the palette, they perfected a technique for applying dots of colour on the canvas so that they blended when viewed at an appropriate distance. Fénéon invented the term 'pointillism' to describe this technique, though Seurat and Signac named it divisionism. Today, divisionism is used to refer to the theory and pointillism to the technique.

Seurat's seminal canvas, *Sunday Afternoon on the Island of La Grande Jatte* (1884–86), was included in the 1886 exhibition. In it one can trace Seurat's affinities with Impressionism, his critique of its limitations and his own

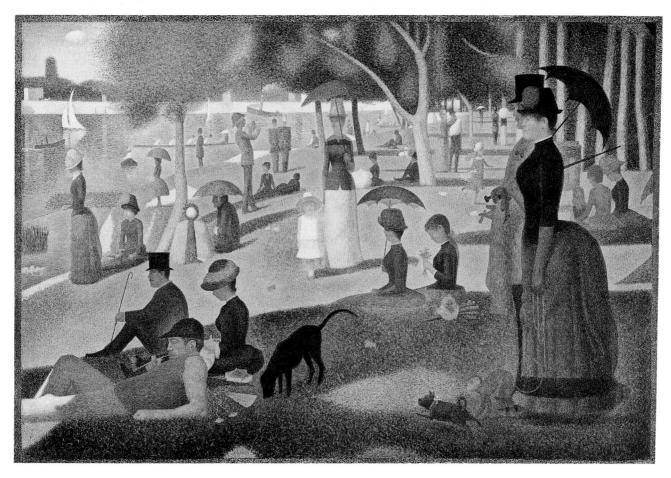

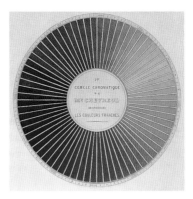

interest in light, colour and surface pattern.

As *La Grand Jatte* illustrates, the majority of Neo-Impressionist paintings are evenly composed, and the divisionist technique produces extraordinary optical effects. Since the eye is constantly moving, the dots never completely meld together, but produce a shimmering, hazy effect, like that experienced in bright sunlight. The after-effect is such that the image seems to float in time and space. This illusion is often heightened by another of Seurat's innovations: a pointillist border painted on the canvas itself, and sometimes extended to include the frame.

The group surrounding Seurat and Signac quickly expanded to include Charles Angrand (1854–1926), Henri-Edmond Cross (1856–1910), Albert Dubois-Pillet (1845–1890), Léo Gausson (1860–1942), Maximilien Luce (1858–1941) and Hippolyte Petitjean (1854–1929). Signac was also close to a number of *Symbolist writers, including Fénéon, Gustave Kahn and Henri de Régnier, who admired Neo-Impressionist work for its symbolic and expressive nature. Many Symbolists and Neo-Impressionists, such as Cross, the Pissarros and Signac, sympathized with anarchists and illustrated various anarchist publications such as *La Révolte* and *Les Temps Nouveaux*. The Neo-Impressionist painters were not, however, as militant as Fénéon, who was imprisoned for his suspected participation in the anarchist bombings in Paris in the early 1890s. They expressed their radical sympathies through their art, picturing the realities of the day – workers, peasants, factories and social inequality – and creating visions of a harmonious future, achieved through politics and the democratization of art.

Neo-Impressionist imagery was also influenced by progressive aesthetic theories of the day, such as those of Charles Henry and others, which dealt with physiological responses to lines and colours. According to their theories, horizontal lines induced calm; upward-sloping lines, happiness; downward-sloping lines, sadness. Exploration of the affective possibilities of line is evident in a work such as Seurat's *Le Chahut* (1889–90). In 1890 Seurat wrote:

> Art is Harmony. Harmony is the analogy of contrary and of similar
> elements of tone, of colour, and of line, considered according
> to their dominants and under the influence of light in gay,
> calm, or sad combinations.

Seurat died only a year later, at the age of thirty-one. His

way forward. The monumental scene is a combination of familiar Impressionist subjects – landscape and contemporary Parisians at play – but it captures not so much the fleeting moment, as a feeling of eternity. That this tension between the timely and timeless aura was intentional is confirmed in Seurat's comments about the painting: 'Phidias' Panathenaea was a procession. I want to show the moderns moving about on friezes in the same way, stripped to their essentials.' Some viewers were discomfited by the stylization of the figures, others read it as a criticism of the rigidity of the fashions and social postures of the day. Seurat himself defined painting as 'the art of hollowing out a surface', and in *La Grande Jatte* he created a deep, continuous space contrasting with the sense of flatness and shifting perspective. The work unites classic Renaissance perspective and modern

Above left: **Georges Seurat, *Final Study for 'Le Chahut'*, 1889**
Seurat's exploration of the affective possibilities of line is evident in this work: the warm colours and the upward position of the dancers' legs are intended to convey happiness.

Above right: **Michel-Eugène Chevreul, *Premier cercle chromatique*, from his study entitled *Des Couleurs et de leurs applications aux arts industriels*, 1864** Chevreul's 'chromatic circle' proved for the first time that all colours tint neighbouring colours with their own complementary colours.

Opposite: **Paul Signac, *Portrait of Félix Fénéon against a Background Rhythmic with Beats and Angles, Tones and Colours*, 1890** The anarchist and critic Félix Fénéon was the Neo-Impressionists' first great champion and patron. It was he who coined the term 'pointillism' – though the artists themselves preferred a term of their own: 'divisionism'.

friendship with Signac and Pissarro had been under strain, and there had been arguments about who invented Neo-Impressionist techniques. In the last year of his life Seurat became a recluse, and the critics seemed to lose interest in his work. His influence on future currents in art was, however, profound. His new pictorial language proved seductive, and by the time of his death, though the original practitioners were moving in different directions, his style had begun to travel beyond France.

Works by both Seurat and Pissarro were included in an exhibition organized by *Les Vingt in Brussels in 1887. Signac and Dubois-Pillet exhibited there in 1888, and Seurat again in 1889, 1891 and 1892 (a memorial exhibition). Some members of Les Vingt – Alfred William Finch (1854–1930), Anna Boch (1848–1926), Jan Toorop (1858–1928), Georges Lemmen (1865–1916), Théo Van Rysselberghe (1862–1926) and, briefly, Henry Van de Velde (1863–1957, see *Art Nouveau) – experimented with Neo-

Impressionist techniques. Divisionism also flourished in Italy, through the works of Giovanni Segantini (1858–99) and Gaetano Previati (1852–1920), where it provided a source for *Futurism.

In 1899, Neo-Impressionism was given a new lease of life in France with the publication of Signac's *From Eugène Delacroix to Neoimpressionism*. In the book he explained the Neo-Impressionists' working practice for a new generation of artists:

Now, to divide is:
To assure oneself of all the benefits of luminosity, of colouring and of harmony, by:
1. The optical mixture of solely pure pigments…
2. The separation of local colours from the colour of the light, reflections, etc…
3. The equilibrium of these elements and their proportions (according to the laws of contrast, of gradation, and of irradiation);
4. The choice of a brushstroke commensurate with the dimensions of the painting.

A wide range of artists, including Vincent van Gogh, Paul Gauguin and Henri Matisse (who painted with Signac at St Tropez in 1904), experimented with Neo-Impressionist techniques during their careers (see Post-Impressionism, Synthetism and Fauvism). Neo-Impressionism helped shape styles and movements as diverse as Art Nouveau, *De Stijl, *Orphism, *Synchromism, Symbolism, the *Surrealism of René Magritte, even, later in the century, *Abstract Expressionism and *Pop Art.

As the first of a new breed of artist-scientists, Seurat and Signac also form part of a different art history, which finds expression in Russian *Constructivism, the *Kinetic Art of László Moholy-Nagy and Jean Tinguely, *Op Art, as practised by Victor Vasarely and Bridget Riley, and experimental groups of the 1950s and 1960s, such as *GRAV.

Key Collections
Jeu de Paume, Paris
Louvre, Paris
Metropolitan Museum of Art, New York
Minneapolis Institute of Arts, Minneapolis, Minnesota
National Gallery, London
Petit Palais, Geneva, Switzerland

Key Books
R. L. Herbert, *Neo-Impressionism* (exh. cat., Guggenheim Museum, 1968)
J. Rewald, *Post-Impressionism from van Gogh to Gauguin* (1979)
R. L. Herbert, *Georges Seurat, 1859–1891* (exh. cat., Metropolitan Museum of Art, 1991)

Decadent Movement

The age of nature is past; it has finally exhausted the patience of all sensitive minds by the loathsome monotony of its landscapes and skies.

DES ESSEINTES IN A REBOURS BY JORIS-KARL HUYSMANS, 1884

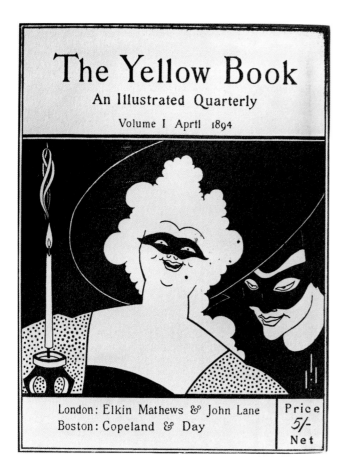

Although an informal classification, the Decadent Movement embraces literary and artistic manifestations of the late nineteenth century, overlapping in France with *Symbolism, and in Britain with the Aesthetic Movement. Both literature and art express the malaise and ennui associated with *fin-de-siècle* thought, and are typified by romantic visions of evil, the grotesque, sensationalism and of life seen as a drama. The visual art is often elegant, and fantastic; favourite motifs include exotic natural phenomena such as orchids, peacocks and butterflies, as found in James Abbott McNeill Whistler's (1834–1903) sumptuous *Peacock Room* (1876–77).

The key figure for Decadence, Symbolism and Aestheticism was the French poet and art critic, Charles Baudelaire (1821–67), whose collection of poems, *Les Fleurs du Mal* (The Flowers of Evil), published in 1857, introduced startling ideas. Essentially hostile to bourgeois society, his work betrays a strong interest in the morbid and the perverse, and a fascination with woman as an erotic and destructive force. For him, nature was inferior to the artificial for it produced evil spontaneously, whereas the good and the beautiful had to be created. Baudelaire's modern artist was an outsider aloof from society, escaping the boredom and mendacity of conventional middle-class life in the artificial world of culture. His greatest challenge was his

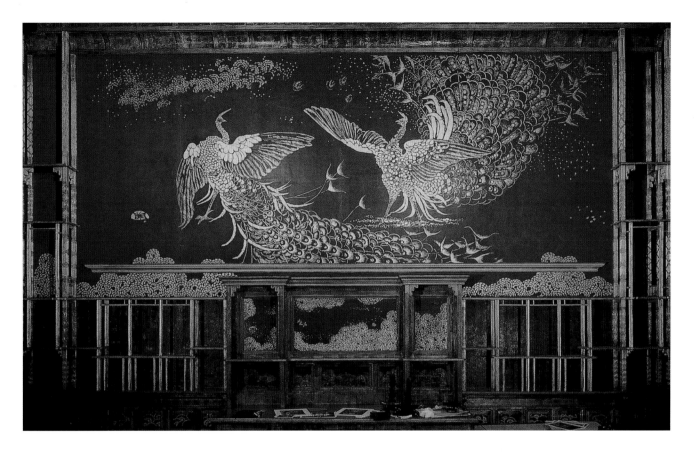

belief that art need not have a moral purpose. Baudelaire described his own book as being 'clothed in a sinister and cold beauty', a description which could be aptly applied to much Decadent work.

The developments of the Decadent Movement after Baudelaire are illustrated in the novel *A Rebours* (Against the Grain, 1884) by Joris-Karl Huysmans (1848–1907), formerly a supporter of the *Impressionists. The hero of the book, Des Esseintes, is the archetypal aesthete or decadent. He cuts himself off completely from the outside world to create his own false reality, decorating the rooms of his house with the fantastic art of Gustave Moreau and Odilon Redon (see Symbolism): 'evocative works of art which would transport him to some unfamiliar world, point out the way to new possibilities and shake up his nervous system by means of erudite fancies, complicated nightmares and suave and sinister visions.' Moreau's paintings of Salome

Above: **James Abbott McNeill Whistler, End-wall panel from *Harmony in Blue and Gold: The Peacock Room*, 1876–77**
The peacock on the right represents Frederick Leyland who commissioned the panel, and with whom Whistler quarrelled. Whistler (left) rejects the pieces of gold and silver Leyland scatters before him.

Opposite: **Aubrey Beardsley, Cover design for *The Yellow Book*, Volume 1, 1894** Walter Crane, a contemporary artist, passed judgment on Beardsley's style, saying, 'There appears to be a curious, weird Japanese-like spirit of diablerie and grotesque, as of the opium-dream, about his work.'

were singled out for their glamorous decadence and eroticism. Here, the transition is complete – the cult of nature has been replaced with the cult of the dandy, reality by fiction, practical life with the life of the mind.

In Britain, French influences were combined with the ideals of the Aesthetic Movement. Aesthetes, such as the writer Walter Pater (1839–94) and the London-based American painter Whistler, followed Baudelaire in rejecting the idea that art had to serve a moral, political or religious purpose. Like John Ruskin and William Morris (see *Arts and Crafts), they insisted on the beauty of art, but denied its social and moral use. Pater even proposed replacing religion with the 'religion of art'; his 'Aesthetic Hero' in *Marius the Epicurean* (1885), provided another model for Aesthetes and Decadents. The aesthete's aim was to heighten aesthetic experience, and 'art for art's sake' became the catchphrase of the movement.

A feature of Decadent art was its strong sense of *fin-de-siècle* despair and crisis. Artists such as Albert Moore (1841–93) and Sir Lawrence Alma-Tadema (1836–1912), fascinated by doomed, effete civilizations of the past, Hellenic Greece and the Rome of the later Emperors, created works as over-refined as the Rococo masterpieces they admired. Their message maintains that the only escape from monotony and decay lies in hedonistic sensualism. It was a deliberately shocking message in the Britain of the 1890s, a

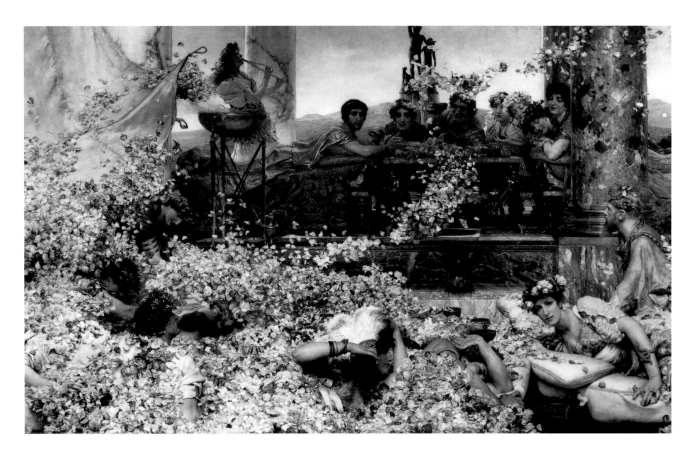

decade in which the Decadents flaunted their notoriety to an increasingly outraged middle-class, culminating in the scandal of Oscar Wilde (1854–1900). In many ways Aubrey Beardsley (1872–98) was the archetypal Decadent artist. He came to fame in 1894 with his illustrations for Wilde's drama *Salome*, and his radical decorative style of black and white astonished his contemporaries as much as the depravity of his subjects. His new style, derived partly from Japanese prints and the Pre-Raphaelite paintings of Edward Burne-Jones, was to be a decisive element in the development of the international *Art Nouveau. For a brief period he was art editor of *The Yellow Book*, a periodical containing the work of many writers and artists associated with the Decadent Movement and Art Nouveau. But it was not to last. Beardsley's alliance with Wilde had brought him fame, but it also brought about his downfall. When Wilde was convicted of sodomy in 1895, protesters attacked the offices of the publishers of *The Yellow Book* and Beardsley was dismissed. In the last three years of his life (he died at the age of twenty-five) he was employed on a new journal, *The Savoy* published by Leonard Smithers, for whom Beardsley

Lawrence Alma-Tadema, *The Roses of Heliogabalus*, 1888
Heliogabalus – the debauched Roman emperor Marcus Aurelius Antoninus – 'loaded his parasites with...flowers in a banqueting room with a reversible ceiling, in such a way that some of them expired when they could not crawl out to the surface.'

also produced pornographic illustrations in private editions of classics such as Aristophanes's *Lysistrata*.

By the mid-1890s, discussions in the arts turned from 'decadence' to 'symbolism', with an accompanying shift in focus from the sensual to the spiritual. Seductive elements of Aesthetic and Decadent thought – the notion of the artist as a higher being, the belief in the importance of art for its own sake, and art as a form of religion – would, however, continue in various guises throughout many of the avant-garde movements of the twentieth century.

Key Collections
Aubrey Beardsley Collection at Pittsburgh State University, Pittsburgh, Pennsylvania
Jeu de Paume, Paris
Louvre, Paris
Metropolitan Museum of Art, New York
National Gallery, London

Key Books
W. Gaunt, *Victorian Olympus* (1952)
—, *The Aesthetic Adventure* (1967)
P. Jullian, *Dreamers of Decadence* (1971)
J. Christian, *Symbolists and Decadents* (1977)
B. Dijkstra, *Idols of Perversity* (Oxford, 1989)

Art Nouveau

*Line determinative, line emphatic, line delicate, line expressive,
line controlling and uniting.*

WALTER CRANE, 1889

Art Nouveau (New Art) is the name given to the international movement that swept through Europe and the USA from the late 1880s until World War I. After Victorian clutter and the Victorian preoccupation with historic styles, it was a determined and successful attempt to create a thoroughly modern art, typified by an emphasis on line – whether undulating, representational, abstracted or geometric – rendered boldly and simply. The style is to be found in many different media, and indeed one of the aims of Art Nouveau practitioners was to erase the distinction between the fine and applied arts.

It was called by different names in different countries: *Jugendstil (Youth Style) in Germany; *Modernisme in Catalonia; Sezessionstil in Austria (in reference to the *Vienna Secession); Paling Stijl (Eel Style) and Style des Vingt (after *Les Vingt) in Belgium; Stil' Modern in Russia; and, in Italy, Stile Nouille (Noodle Style), Stile Floreale (Floral Style) and Stile Liberty – after Liberty's department store in London which did much to popularize the movement through its fabric prints. The international name came from the gallery La Maison de l'Art Nouveau, opened by Siegfried Bing (1838–1905) in Paris in 1895 to bring new European arts and crafts to the Parisian public.

A truly international phenomenon, it spread rapidly through Europe and America, helped by numerous new publications which sprang up in various countries – *The Studio, The Yellow Book, The Savoy, L'Art Moderne, Jugend, Pan, Art et Décoration, Deutsche Kunst und Dekoration, Ver Sacrum, The Chap-book* and *Mir Isskustva* (see *World of Art). International exhibitions, such as those held by Les Vingt in Brussels (1884–93), the Secessionists in Vienna (1898–1905), the Exposition Universelle in Paris (1900), the Esposizione Internazionale d'Arte Decorative in Turin (1902) and the St Louis World's Fair (1902) brought the new art to an eager public.

Hector Guimard, Bastille Métro station, cast iron and glass, *c.* 1900
Guimard entered a competition in 1896 to design the Paris Métro stations. Despite not winning, he was given the job by the company's president who favoured the Art Nouveau style. His stations were in production until 1913.

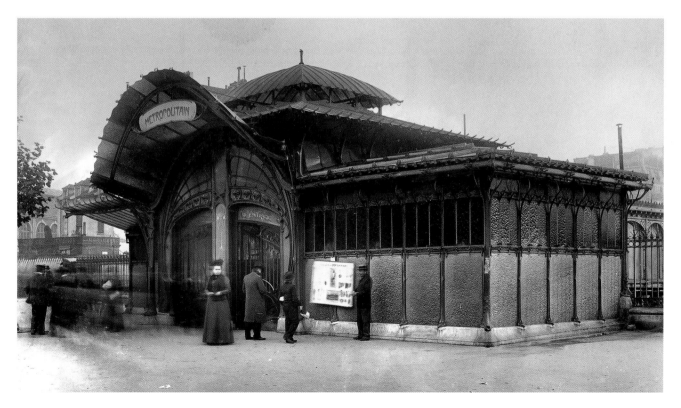

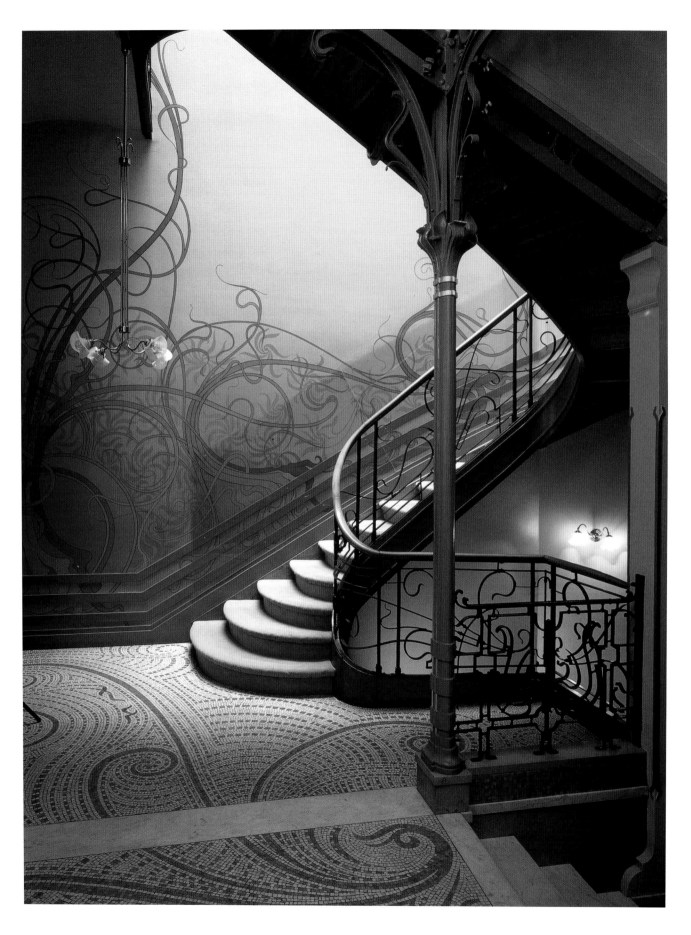

Though Art Nouveau was an explicitly modern style that rejected the academic historicism of the nineteenth century, it nevertheless drew on past models for inspiration, in particular the overlooked or the exotic, such as Japanese art and decoration, Celtic and Saxon illumination and jewelry, and Gothic architecture. Equally important was the influence of science. With the impact of scientific discoveries, especially those of Charles Darwin, the use of natural forms was no longer seen as romantic and escapist, but modern and progressive. Contemporary developments in painting were also important, and Art Nouveau artists and designers were closely in touch with avant-garde developments of the time. The expressiveness and eroticism of *Symbolists Odilon Redon and Edvard Munch, the delicate line and hedonist decadence of Aubrey Beardsley (see *Decadent movement), and the bold outlines of the *Neo-Impressionists, the *Nabis, Paul Gauguin (see *Synthetism) and Henri de Toulouse-Lautrec (see *Post-Impressionism) can all be seen in Art Nouveau work.

The origins of Art Nouveau are found in the British *Arts and Crafts movement, in particular in William Morris's evangelizing belief in the importance and dignity of good craftsmanship and his determination to erase the distinction between the fine and decorative arts. Like *Arts and Crafts, Art Nouveau encompassed all the arts, and its most successful manifestations were in architecture, graphics and applied arts, where, unlike their Arts and Crafts predecessors, Art Nouveau practitioners embraced new materials and technologies. From these beginnings two main strains developed, one based on an intricate, asymmetrical, sinuous line (France, Belgium) and the other adopting a more rectilinear approach (Scotland, Austria).

Many second-generation Arts and Crafts designers, such as C. R. Ashbee, Charles Voysey, M. H. Baillie Scott, Walter Crane and Arthur Mackmurdo are transitional figures between Arts and Crafts and Art Nouveau. Mackmurdo's chair-back and the title-page for *Wren's City Churches* (1883), are the earliest examples of work displaying the characteristics synonymous with Art Nouveau – linear simplicity, elongated, asymmetrical curving lines, boldly contrasting colours, abstracted organic forms and a rhythmic sense of movement.

If the floral style of Art Nouveau originated in Mackmurdo's work, the unique style of the Glasgow Four – Charles Rennie Mackintosh (1868–1928), his wife Margaret Macdonald (1865–1933), her sister Frances Macdonald (1874–1921) and her husband Herbert McNair (1870–1945) – played a direct part in the development of the later, more geometric version of Art Nouveau. The Four worked in a variety of media: painting, graphics, architecture, interiors, furniture, glass, metalware, book illustration and wrought iron. Their typically restrained ornamentation and subdued colours, curving vertical lines and stylized rose, egg and leaf motifs were hugely influential.

Designer and architect Mackintosh was the most prolific of the four. His collaborative working methods, no less than his linear style of grids and elongated vertical lines and curves, had an enormous impact on the Secessionists in Vienna. In fact, it is not an exaggeration to say that his integrated interiors, his pure, geometric style of furniture and architecture inspired many twentieth-century developments in art, architecture and design.

Art Nouveau quickly flourished in Belgium, where the progressive artists' group Les Vingt fostered an experimental artistic and intellectual climate, and it was in Brussels that the new style found its first major exponents in Victor Horta (1861–1947) and Henry Van de Velde (1863–1957). Horta, the 'Father of Art Nouveau architecture' is famous for the 'Belgian' or 'Horta' line, the distinctive 'whiplash' curve seen, for example, in the Hôtel Tassel (1892–93) in Brussels, a landmark in Art Nouveau architectural design. It was the first private residence in which iron was used extensively for both structural purposes and interior design. While the exterior appears relatively restrained, every element of Horta's interior is an expression of exuberant complex curving surfaces, from the stained-glass windows and mosaic tiles to the wrought-iron staircase and balustrade.

Henry Van de Velde was another major figure in European Art Nouveau, important both for his abstracted fluid curvilinear style in interiors, furniture and metalwork, and for his promotion of the ideas behind the movement. Like Morris (whose theories he had studied), Van de Velde preached the social benefits of a closer relationship between art and industry, and passionately believed in the principle of a total work of art: 'We can make our homes the direct reflection of our own wishes, our own tastes, if we will but choose.' When he built his own home outside Brussels in 1895 he brought this idea to life, designing all, from the building itself to the dinner service. In 1900 Van de Velde moved to Germany, where he was director of the School of Arts and Crafts in Weimar (1902–14) and, in 1907, a founding member of the *Deutscher Werkbund. Both positions enabled him to promote and develop his ideas. He was the first influential figure to attempt the synthesis of Arts and Crafts ideals with machine production, a development furthered by his successor, Walter Gropius, with the formation of the *Bauhaus School.

Opposite: **Victor Horta, wrought-iron staircase for the Hôtel Tassel, Brussels, 1893** Horta was given a free hand to design the house of his friend Emile Tassel, a prosperous Belgian industrialist, which 'would allow him to realize the dream which haunted him, that of achieving the effect of monumentality in private housing.'

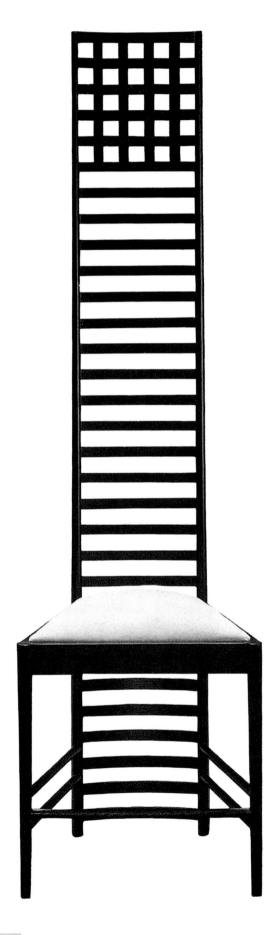

A more florid and spectacular branch of Art Nouveau blossomed in France, with examples found in Paris Métro stations designed by Hector Guimard (1867–1942), the jewelry and glassware of René Lalique (1860–1945) and the glassware of Emile Gallé (1846–1904). Here, Art Nouveau was found in two main centres – in Nancy around Gallé, and in Paris around Bing's gallery.

The productions of the Nancy School were characteristically luxurious and expensive, incorporating curvilinear structures and decoration of realistic plant and insect motifs. Besides Gallé, other important members of the group included the glassmaking brothers Auguste (1853–1909) and Antonin (1864–1930) Daum; furniture makers Louis Majorelle (1859–1929); Eugène Vallin (1856–1925) and designer Victor Prouvé (1858–1943).

In Paris, Guimard's architectural designs for the Métro stations and an apartment building, the Castel Béranger (1894–97), showed a dynamically personal interpretation of Art Nouveau principles. Although, like the artists of the Nancy School, he drew on nature for his imagery, his use of it was more eclectic, reflecting Horta's influence, whom he met in 1895. The visibility and popularity of his stations led to yet another name for Art Nouveau, Style Métro. In the fields of glassware and jewelry, the prolific Lalique was equally famous. His work, typically imaginative and inventive, reflects both the Art Nouveau and *Art Deco styles.

One of the most celebrated Art Nouveau graphic artists was the Paris-based Czech painter and designer, Alphonse Mucha (1860–1939), whose posters depicting sensuous women in luxurious floral settings, such as the celebrated actress Sarah Bernhardt, were much loved by the public. The female form was a central motif for many Art Nouveau designers, as it was for the Symbolists, Aesthetes and Decadents, though Art Nouveau women were usually more allegorical, fairy-tale figures rather than femme fatales. The fey Loïe Fuller, an American dancer in Paris, was an especially popular subject, and the source of many illustrations and sculptures.

In the USA, the major popularizer of the Art Nouveau style was Louis Comfort Tiffany (1848–1933). His sumptuous, richly coloured glass objects – lamps, bowls, stained-glass windows, vases, etc. – brought him fame in Europe as

Left: **Charles Rennie Mackintosh, Chair,** *c.* **1902**
Mackintosh's work gained a favourable reputation abroad, whereas in England works in the Continental Art Nouveau style were considered to be in bad taste. His Chair was created in the year of the Turin Exhibition, at which he showed.

Opposite: **Alphonso Mucha,** *Gismonda*, **1894**
This near life-size poster for Sarah Bernhardt's play *Gismonda* caused a stir when it first appeared in Paris. The actress herself was so impressed that she later signed Mucha to a six-year contract to design further posters, sets and costumes for her plays.

shared with Art Nouveau architects a love of detailed, vegetal, ornamentation.

For a time the Art Nouveau style seemed unstoppable, spreading east to Russia, north to Scandinavia, and south into Italy. In Denmark, the silversmith Georg Jensen (1866–1935) is well known for his ornate jewelry and objects, many of which are still in production today. In Italy, the buildings of Raimondo d'Aronco (1857–1932), Guiseppe Sommaruga (1867–1917) and Ernesto Basile (1857–1932) remain landmarks.

But the sheer popularity of Art Nouveau eventually led to its downfall. The proliferation of second- and third-rate imitators created a saturation of the market. Tastes changed, and a new age demanded a new kind of decorative art to express modernity – Art Deco. As early as 1903, Walter Crane was distancing himself from Art Nouveau, describing it as 'this strange decorative disease', and Charles Voysey was dismissing it as 'the work of a lot of imitators with nothing but mad eccentricity as a guide'.

The initial spread of Art Nouveau had been measured by the proliferation of its names. Now, in the 1920s, the only names it acquired were pejorative – Style branche de persil (stick of parsley style) and Style guimauve (marshmallow style) in France, and Bandwurmstil (tapeworm style) in Germany. Not until the late 1960s, with renewed interest in the decorative arts, would Art Nouveau be re-evaluated and appreciated once more.

Art Nouveau's far-reaching influence, however, was always undeniable. The belief of Art Nouveau practitioners in the expressive properties of form, line and colour, and their emphasis on the creation of total works of art, were inspirational. Their forays into semi-abstraction were taken further in the new century by the artists and architects developing *Expressionism, non-objective art and modernist architecture.

Key Collections
Mackintosh Collection, Glasgow, Scotland
Morse Museum of American Art, Winter Park, Florida
Mucha Museum, Prague, Czech Republic
Musée de l'Ecole de Nancy, Nancy, France
Victoria & Albert Museum, London

Key Books
L. V. Masini, *Art Nouveau* (1984)
A. Duncan, *Art Nouveau* (1994)
J. Howard, *Art Nouveau* (1996)
P. Greenhalgh, *Art Nouveau 1890–1914* (2000)

well as America. Pierre Bonnard, Edouard Vuillard and Toulouse-Lautrec were among the painters who made designs for him to turn into glassware. Other Art Nouveau practitioners who were based in the USA include graphic artist William Bradley (1868–1962); Polish-born sculptor Elie Nadelman (1885–1946); French-born sculptor Gaston Lachaise (1882–1935) and sculptor Paul Manship (1885–1966). Although Louis Sullivan's (see *Chicago School) buildings are not themselves Art Nouveau, he

Modernisme

The material will reveal itself in the wealth of its astral curves, the sun will shine through all four sides – and it will be like a vision of paradise.

ANTONI GAUDÍ ON CASA BATLLÓ

These apparently conflicting ideologies came together as Modernisme, giving rise to a great period of architecture, in which monuments became powerful symbols of popular cultural identity. Over a thousand buildings from the movement still stand in Catalonia today.

Barcelona's leading architects, including Lluís Domènech i Montaner (1850–1923), José Puig i Cadafalch (1867–1957) and Antoni Gaudí (1852–1926), were at the forefront of this separatist movement. Their buildings are characteristically eclectic and expressive, and they respect the structural and decorative properties of materials, particularly brick. Ornamentation is an essential feature, often integrated into the building itself, emphasizing the design, function and construction of the building.

Antoni Gaudí, whose fantastic architecture has become synonymous with Modernisme – and with Barcelona itself – was the outstanding figure of the movement. Influenced by the *Arts and Crafts architects, he insisted on designing every aspect of a building. He also drew on the structural theories of the French medieval-revival architect, Eugène Emmanuel Viollet-le-Duc (1814–79), in particular his recommendations of new technologies in Gothic reconstruction, and direct metal construction. As well as these outside influences Gaudí developed his own personal interest in natural forms, perhaps the most startling aspect of his organic, visionary structures.

Gaudí's first major commission, in 1833, was to complete the Church of the Sagrada Familia in Barcelona. He worked on it throughout the rest of his career and it remains unfinished today. To the existing neo-Gothic structure he added Moorish-like spires decorated with brightly coloured ceramic tiles to create a building without historical precedent. Gaudí's friendship with textile manufacturer and shipping magnate Don Eusebi Güell y Bacigalupi, led to a

Modernisme is the name of the *Art Nouveau-like movement in Catalonia, Spain, between *c.* 1880 and *c.* 1910. It grew out of two intellectual and cultural movements in Catalonia, National Romanticism and Progressivism. The former promoted the study and revival of medieval Catalan architecture and language in search of a specifically Catalan (as opposed to Spanish) identity, while the latter looked to science and technology to create a modern society.

Above: **Antoni Gaudí, Pinnacle of one of the towers of the Sagrada Familia, Barcelona, 1883–** Gaudí's masterpiece is at the same time his life's work. Begun when he was 31, he left it unfinished when he died 43 years later. Planned as a Church of Atonement, to be financed completely by donations, funds were always a problem: during World War I Gaudí personally went from door to door collecting money.

Opposite: **Antoni Gaudí, Güell Park, Barcelona,1900–14**
The past is always present in Gaudí's work, but transformed, as in a dream. The Doric columns, which support the floor of the Greek theatre above, tilt and crowd like trees in a mythical forest.

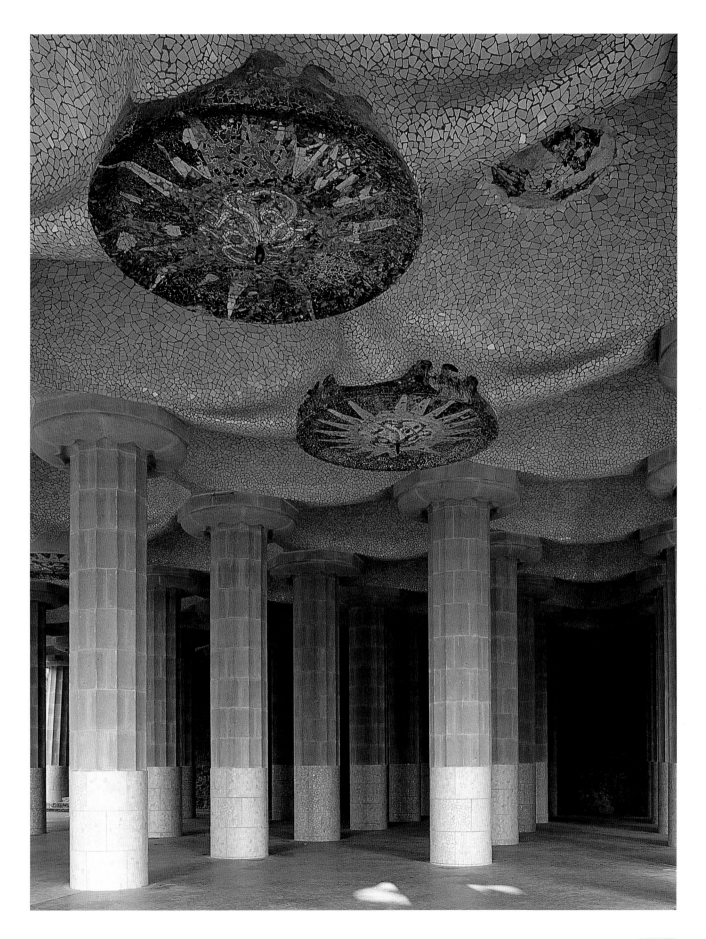

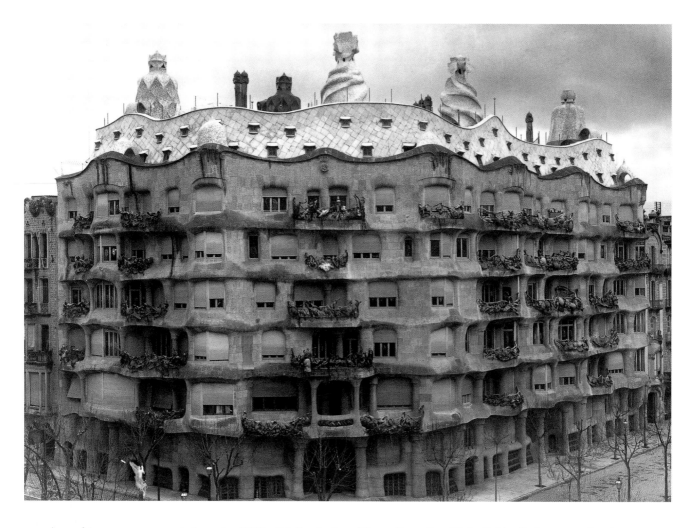

number of important commissions. In 1888, Güell asked Gaudí to design his home in Barcelona, the Palau Güell; in 1891, the Colonia Güell, a workers' community near one of his textile plants, and in 1900, the Güell Park (1900–14). The Casa Batlló (1904–6) and the Casa Milà (1906–8) followed, both apartment houses in Barcelona. Gaudí's fittings and furniture for his buildings should not be overlooked; like the buildings themselves, they displayed his interest in organic forms, typically using 'shell-and-bone' motifs. One such piece, the Calvet chair (1902), was revived by the Spanish company B. D. Ediciones de Diseño in the 1970s, reflecting the worldwide revival of interest in Art Nouveau since the 1960s.

Although Modernisme and international Art Nouveau were relatively short-lived, they set an example for artists of the twentieth century. In 1933 the painter Salvador Dalí claimed Art Nouveau, and in particular what he termed Gaudí's 'undulant-convulsive' architecture, as a precursor of

*Surrealism. Gaudí's individualistic approach – incorporating colour, texture and movement into buildings – was an inspiration to the *Expressionist architects of the 1920s and 1930s, to the *School of Amsterdam – in particular the billowing, sculptural forms of the Casa Milà – and to the architects of *Postmodernism.

Key Monuments
Güell Park, Carrer d'Olot, Gràcia, Barcelona, Spain
Palau Güell, C. Nou de la Rambla, Barcelona, Spain
Casa Batlló, Passeo de Gràcia, Barcelona, Spain
Church of the Sagrada Familia, Plaça de la Sagrada
 Familia, Barcelona, Spain

Key Books
D. Mower, *Gaudí* (1977)
J. Castellar-Gassol, *Gaudí: The Life of a Visionary*
 (Barcelona, 1984)
R. Zerbst, *Antonio Gaudí: A Life Devoted to Architecture* (1996)
L. Permanyer, *Gaudí of Barcelona* (1997)

Antoni Gaudí, Casa Milà, 1905–10
This was the last great civil work that Gaudí completed before spending his time on the construction of the Sagrada Familia. In 1984, UNESCO declared the Casa Milà a World Heritage Site.

Symbolism

The enemy of didacticism, declamation, false sensibility and objective description.

JEAN MOREAS, SYMBOLIST MANIFESTO, 1886

The Symbolists were the first artists to declare that the inner world of mood and emotions, rather than the objective world of external appearances, is the proper subject of art. In their work, private symbols are used to evoke these moods and emotions, to create images of the irrational, which, in turn, require an audience's private response. Though Symbolist work is very diverse, common themes occur, such as dreams and visions, mystical experiences, the occult, the erotic and the perverse, with the goal of creating a psychological impact. Women are usually portrayed as either virginal/angelic or sexual/threatening, and motifs of death, disease and sin are frequent.

Symbolism first announced itself as a self-aware movement in France in 1886 with the publication of its manifesto by Jean Moréas (1856–1910), but 'Symbolist' currents of thought were already apparent at least a decade earlier in the work of French Symbolist poets, such as Paul Verlaine (1844–96), Stéphane Mallarmé (1841–98) and Arthur Rimbaud (1854–91). They aimed at a suggestive, musical poetry of subjective moods using a language of private symbols. Artists followed their lead and took up their theories. The art criticism of poet Charles Baudelaire (1821–67) was an even more direct influence. His theory of synaesthesia (articulated in 'Correspondence' of 1857) postulated an art so expressive of feeling as to satisfy all the senses at once – sounds suggesting colours, colours sounds, and even ideas by the sound of colours.

In this intellectual climate, visual artists reacted against, on the one hand, the naturalism associated with *Impressionism, and on the other, the Realism of Gustave Courbet (1819–77), who preached that painting should only address 'real and existing things'. Their own work, however, remained highly individual. As much an ideology as a movement, Symbolism embraced a wide variety of artists. It included many contemporaries discussed elsewhere in this book, for example, Emile Bernard, Maurice Denis and Paul Sérusier (see *Cloisonnism and *Nabis), Georges Seurat (see *Neo-Impressionism) and Paul Gauguin (see *Synthetism). Older artists, such as Gustave

Moreau, were often claimed by the Symbolists as their own. And, on the fanatical edge, there were those who took their ideas directly from Symbolist poetry and novels, such as the artists associated with the extreme group, the *Salon de la Rose+Croix. This broad reach of Symbolism was suggested by Albert Aurier (1865–92), a Symbolist writer and art critic. In 1891 he defined the aesthetics of modern painting in the following terms:

> The work of art will be: 1. Ideist, for its unique ideal will be the expression of the Idea. 2. Symbolist, for it will express this Idea by means of forms. 3. Synthetist, for it will present these forms, these signs, according to a method which is generally understandable. 4. Subjective, for the object will never be considered as an object but as the sign of an idea perceived by the subject. 5. (It is consequently) Decorative.

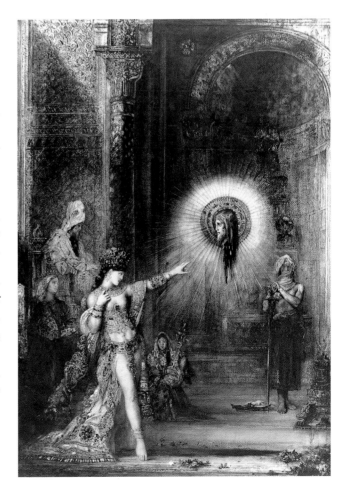

Gustave Moreau, *The Apparition*, 1876
Herod has granted Salome's wish for the head of John the Baptist, and the evidence can still be seen on the impassive soldier's sword. But visible to Salome alone, a bloody apparition transfixes her as she recoils in horror to escape it.

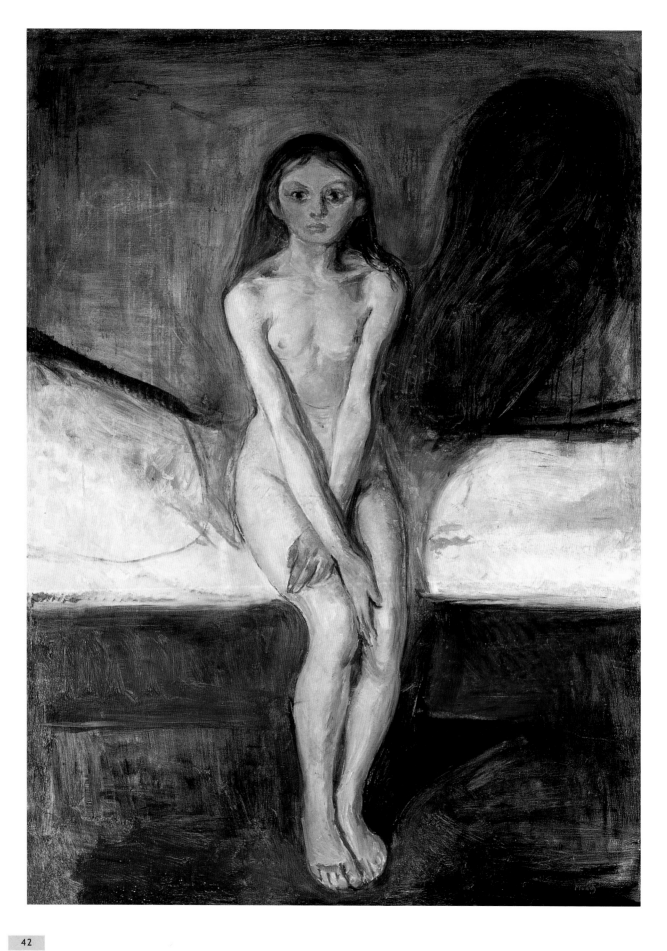

Gustave Kahn (1859–1936), another Symbolist poet, took this concept even further, writing in 1886:

> The essential aim of our art is to objectify the subjective (the externalization of the Idea) instead of subjectifying the objective (nature seen through the eyes of a temperament).

He was in effect reversing the traditional relationship of the artist and his work by saying that art should express temperament through nature, elevating the Self over Nature, in essence both an extension of Romanticism and a refutation of it.

Among those retrospectively interpreted as Symbolists were the French painters Pierre Puvis de Chavannes (1824–98) and Gustave Moreau (1826–98). Puvis's idealist, abstracted murals were admired for their neutral aesthetic. The remoteness of the muted colours and the lack of narrative created the sense that they were illustrating a mood rather than a moment from real life.

Moreau was slow to win fame. Indeed, at first, he had to face fierce criticism from official art circles. In 1869 the works he offered to the Salon were so savagely attacked that thereafter he withdrew more and more from exhibitions. However, in 1880 some of his works caught the attention of the writer, J.-K. Huysmans. In 1884, Huysmans's novel *A Rebours* appeared, containing ecstatic descriptions of Symbolist paintings by Moreau, in particular a watercolour version of *The Apparition*. A generation of young painters were influenced by Moreau's exotic, jewel-like paintings in which images of languid, doomed men and beautiful, sinister women evoke the imaginary and mythological as opposed to the real. Moreau also made a direct impact through his teaching: Henri Matisse (see *Fauvism) and Georges Rouault (see *Expressionism) were two of his pupils.

The work of the American expatriate in London, James Abbot McNeill Whistler (1834–1903), such as *Arrangement in Grey and Black, No. 1 (The Artist's Mother)* (1871), was also admired for the way in which the narrative was subordinated to the decorative (see also Impressionism and Decadent Movement). Sir Edward Burne-Jones (1833–98, see Arts and Crafts) provided another example for French Symbolism when his work was exhibited in Paris in the late 1880s and 1890s. The ethereal quality of his romantic,

Above: **Odilon Redon, Orpheus, c. 1913–16** Redon often depicted classical myths (as he did modern poetry and prose), but he interpreted them in highly personal, often unexpected ways, communicating not familiar narratives but intense depths of emotion and enigmatic interior visions.

Opposite: **Edvard Munch, Puberty, 1894** The theme of women – and women's sexuality – is prominent in Munch's work. Here, in an astonishingly direct painting, he depicts the moment of sef-discovery when a girl realizes that she is no longer a child but a woman.

ahistorical, vaguely mythological scenes captured the imagination of Symbolist poets and painters alike.

The Symbolist movement may have originated in France, but it rapidly became international, and its major exponents came from all over Europe and the United States. The French painter and graphic artist Odilon Redon (1840–1916), the painter of dreams, was one of the most characteristic figures of Symbolist painting. Like others of the time, he was influenced by Japanese prints, but he was also interested in fantastic art and literature and botany, all of which fed into his work. In the first part of his career he worked almost exclusively in black-and-white drawings, etchings and lithography, creating a world of nightmares. His aim was to turn into art the 'torments of the imagination'. He was close to the Symbolist poets, and made visual translations of many of their works, including, in 1882, a portfolio of lithographs dedicated to Edgar Allan Poe (translated by Baudelaire and Mallarmé) and illustrations for Gustave Flaubert's *The Temptation of St Anthony* in 1886. Around 1895, Redon began working in colour, and his art brightened both literally and metaphorically, as the fantasies became less morbid and more joyous. Many of the later works are of mythological scenes or flowers in rich, sumptuous colours. His works seem to tap directly into the subconscious, and both the Nabis and the *Surrealists regarded him as an influential figure.

Another painter celebrated by the Symbolists, and later seen as a precursor to both Expressionism and Surrealism, was the Belgian James Ensor (1860–1949). Like Redon, he studied the writers of fantasy, and his characteristic motifs of carnival masks, monstrous figures and skeletons combined with his violent brushwork and gruesome humour, present pictures of the dark side of life. The contrast between his subject matter and his bright Impressionist colours adds to the dissonance. Ensor was a founding member of *Les Vingt in Brussels, but works such as *The Entry of Christ into Brussels in 1889* (1888) made even that group of progressive painters uneasy and they refused to exhibit it. His work was shown in Paris in 1899 in an exhibition organized by the Symbolist journal *La Plume*. Later that year they published a special issue about him, in which the critic Blanche Rousseau identified his key strength as the ability 'to express the inexpressible of forms seen in a coma'.

Ensor's compatriot, Félicien Rops (1833–98) is another notable Symbolist, often discussed as a Decadent. Admired enormously by Joséphin Péladan (see Salon de la Rose+Croix) and Huysmans, he was notorious by the 1860s for the 'depravity' of his work. Huysmans commented: 'Between Purity, whose essence is divine, and Lust, which is the Demon himself, M Félicien Rops, with the soul of an inverted Primitive, has penetrated Satanism.'

Another foreign painter adopted by the French Symbolists was the Norwegian Edvard Munch (1863–1944). The themes of his work are often as morbid as Ensor's – emotional crises, tragedies, sexual depravity, disease and death – but he lacks Ensor's graveyard humour and sense of the absurd. His most famous work, *The Scream* (1893), is a graphic visual expression of despair and horror, both internal and external. When the painting was reproduced in the Parisian review *Revue Blanche* in 1895, Munch included the following text:

> I stopped and leaned against the balustrade, almost dead with fatigue. Above the blue-black fjord hung the clouds, red as blood and tongues of fire. My friends had left me, and alone, trembling with anguish, I became aware of the vast, infinite cry of nature.

Munch translated many of his paintings into etchings, lithographs and woodcuts, and his woodcuts in particular would be influential for the German Expressionists.

Other notable European Symbolists included the Belgian Fernand Khnopff (1958–1912, see Les Vingt), the Swiss Fernand Hodler (1853–1918), Dutchman Jan Toorop (1858–1928), and the Italians Gaetano Previati (1852–1920) and Giovanni Segantini (1858–99). Many of them showed at the Salons de la Rose+Croix. In Russia, French Symbolist ideas were introduced by the *World of Art group, whose painter and designer Mikhail Ivanovich

Vrubel (1856–1910) was the leading exponent of Symbolism there. Between 1890 and 1891 he produced illustrations for Mikhail Lermontov's poem, *The Demon*, which provided him with his central theme. Like his Western contemporaries, he left the realistic depiction of the external world to others, preferring to concentrate on the symbolic representation of his inner demons.

Two major American painters have affinities with the European Symbolists, Albert Pinkham Ryder (1847–1917) and Arthur B. Davies (1862–1928). Ryder described what he captured in his visionary landscapes and seascapes as something that 'was better than nature, for it was vibrating with the thrill of a new creation.' Many of his themes are those of madness, death and alienation in subjects taken from the literature of Shakespeare, Poe, the Bible and mythology. One of his most famous is *The Race Track (Death on a Pale Horse)*, 1890–1910. The Symbolist predilection for the romantic, the sensual, the dreamlike and the decorative is apparent in Davies's allegorical landscapes such as *Unicorns (Legend – Sea Calm)*, c. 1906. Although his work differed greatly from his friends in the *Ashcan School, Davies was a member of The Eight, and was one of the principle organizers of the Armory Show, which brought the European Impressionists, Symbolists, Nabis, Neo-Impressionists, Post-Impressionists, Fauves and *Cubists to America.

As 'movements' that appeared at the end of the century, the boundaries and distinctions between Symbolism, *Art Nouveau and Decadent Art are fluid. The same work may be hailed for its Symbolist content, its decadent subject matter and its Art Nouveau lines. An example of this, Munch's *Madonna* (1895), also brings to the fore the 'femme fatale', a prevalent theme in Symbolist, Art Nouveau and Decadent work, and one which would later resurface in *Surrealist literature and art.

Key Collections
Art Institute of Chicago, Chicago, Illinois
J. Paul Getty Museum, Los Angeles, California
Kimbell Art Museum, Fort Worth, Texas
Minneapolis Institute of Arts, Minneapolis, Minnesota
Munch Museum, Oslo, Norway
Victoria & Albert Museum, London

Key Books
A. Lehman, *The Symbolist Aesthetic in France 1885–1895* (Oxford, 1968)
E. Lucie-Smith, *Symbolist Art* (1972)
J. Christian, *Symbolists and Decadents* (1977)
B. Dijkstra, *Idols of Perversity* (Oxford, 1989)

Post-Impressionism

The Post-Impressionists consider the Impressionists too naturalistic.

ROGER FRY, MANET AND THE POST-IMPRESSIONISTS, EXHIBITION CATALOGUE, 1910

The term Post-Impressionism was coined by the English critic and painter Roger Fry (1866–1934), whose exhibition 'Manet and the Post-Impressionists' showed at the Grafton Galleries in London from November 1910 to January 1911, marking the first attempt to introduce the British public to the works of the generation that came after the *Impressionists. It contained around 150 works, including pieces by Gauguin, Van Gogh, Cézanne, Denis, Derain, Manet, Matisse, Picasso, Redon, Rouault, Sérusier, Seurat, Signac, Vallotton and Vlaminck, artists also variously called *Neo-Impressionists, *Synthetists, *Nabis, *Symbolists and *Fauves. In fact, Post-Impressionism was never a coherent movement, but a broad term applied retrospectively to cover art that Fry saw as either coming out of Impressionism or reacting against it. Following his lead, critics have subsequently used the term to cover the diversity of styles between *c.* 1880 (the final phase of Impressionism) and *c.* 1905 (the emergence of the Fauves), and to loosely describe artists not otherwise easily categorized, such as Paul Cézanne (1839–1906), Vincent van Gogh (1853–90) and Henri de Toulouse-Lautrec (1864–1901). Some of the key features of Post-Impressionist art are best seen in the work of these three painters. Two other major figures, Paul Gauguin and Georges Seurat, both claimed for Post-Impressionism in Fry's epoch-making show, are in this book considered under Synthetism and Neo-Impressionism respectively, movements with which they explicitly identified themselves.

Cézanne, the eldest of the three, studied for two years with the Impressionist Camille Pissarro, and participated in the first and third Impressionist exhibitions in 1874 and 1877. From Pissarro he learned the value of direct observation and an appreciation of the effects of light and colour. Unlike the Impressionists, however, Cézanne's interest was not in the ephemeral qualities of light and the fleeting moment, but in the structure of nature. He realized that the eye takes in a scene both consecutively and simultaneously, and in his work the single perspective gives way to a shifting view, acknowledging that perspective changes as the eyes

Above: **Henri de Toulouse-Lautrec, *Divan Japonais*, 1893**
Like Art Nouveau designers, Toulouse-Lautrec was happy to turn his hand to advertisements, theatre programmes, posters and prints; his bold designs quickly caught on, and he produced some of his most famous posters in a productive period between 1891 and 1893.

and head move, and that objects seen together participate in each other's existence. In pictures of his favourite subjects – his wife and friends, the still life and the landscape of Provence – he translates the forms of nature into the 'plastic equivalents and colours' of painting. In *Still Life with a Plaster Cupid* (*c.* 1895), for instance, the cupid is presented both frontally and from above: the third dimension is not created by traditional means of perspective and foreshortening but by changes in colour, which both unify the surface and signal depth, a radical shift in pictorial technique.

Cézanne's mature work was not known to many until his first one-man show in 1895 at the gallery of Ambroise Vollard in Paris. The exhibition included 150 works, shown in rotation, fifty pictures at a time, and was enthusiastically received by the younger generation of artists and critics, as well as by the Impressionists Monet, Renoir, Degas and Pissarro, who all bought work from the show. Emile Bernard (see *Cloisonnism), Denis and the Nabis became admirers,

as would the Fauves and the *Cubists later. Many abstractionists would also claim Cézanne as a progenitor, based on the abstract quality of some of his work and a famous statement made in conversation with Bernard in 1904: 'Treat nature in terms of its geometrical shapes of the sphere, the cylinder, and the cone'. Cézanne himself, however, thought of geometric shapes not as ends in themselves, but as ways to construct nature into a parallel world of art. Of his influence, the English art critic Clive Bell wrote in 1914: 'He was the Christopher Columbus of a new continent of form.'

Above: **Paul Cézanne,** *Mont Sainte-Victoire* **1902–4**
After 1877 Cézanne rarely left Provence, preferring to work in isolation, painstakingly developing an art that combined classical structure with contemporary naturalism, an art which he believed would appeal to the mind as well as the eye.

Opposite: **Vincent van Gogh,** *Self-Portrait,* **1889** Van Gogh's self-portraits, painted during periods of lucidity, but while he was fully aware of his recurrent bouts of insanity, convey a terrifying and terrified awareness of his condition. Such self-awareness would be a key influence on a new generation of artists.

Like Cézanne, the Dutch painter Vincent van Gogh was influenced by the Impressionists when he was a young man. After his move to Paris in February 1886 he met Pissarro, Degas, Gauguin, Seurat and Toulouse-Lautrec, and began to study Japanese woodcuts and recent Cloisonnist work. Themes of social realism disappeared from his work, and his palette brightened to produce a mature style characterized by vibrant colour savoured for its symbolic and expressive possibilities. 'Instead of trying to reproduce exactly what I have before my eyes,' he wrote, 'I use colour more arbitrarily so as to express myself more forcibly.' After a brief experiment with work in the manner of Seurat's divisionism, he soon developed the style of broad, vigorous and swirling brushstrokes for which he is known. 'In a picture', he wrote to his brother Theo, 'I want to say something as comforting as music. I want to paint men and women with that something of the eternal which the halo used to symbolize, and which we seek to give by the actual radiance and vibration of our colourings.'

Van Gogh studied nature intensely, as Cézanne did before him. Unlike Cézanne, however, whose working method was always slow, Van Gogh produced enormous numbers of pictures in flurries of activity between bouts of mental illness. After moving to Arles in February 1888 he painted more than 200 canvases in fifteen months. But his mental health deteriorated rapidly, and in 1889 a quarrel with Gauguin provoked a fit of despair in which he severed his left ear. In May of that year he entered the asylum at St Rémy. The self-expressive quality of his mature works makes them records of his life and emotions, almost self-portraits. The impact of these pictures would have to wait, however. *Red Vineyards at Arles*, bought by Belgian painter Anna Boch after being exhibited at the 1890 *Les Vingt exhibition in Brussels, was the only painting sold during his lifetime. It would be the later exhibitions – in Paris (1901); Amsterdam (1905); London (1910); Cologne (1912); New York (1913) and Berlin (1914) – that would turn him into such an enormously influential figure for the Fauves, *Expressionists and early abstractionists. Today, few artists can match his popular appeal.

Toulouse-Lautrec, in contrast, was widely celebrated in his day. He first became acquainted with Van Gogh (and painted his portrait) in 1886, when they studied in the Parisian studio of Fernand Cormon, together with the founders of Cloisonnism, Louis Anquetin and Bernard. He was interested in the Impressionists, particularly Degas, and also came into contact with Gauguin in 1888. Japanese prints influenced him strongly, and his developing style soon began to show its distinctive flat, bold patterns and calligraphic line. Pierre Bonnard, the Nabi painter whose champagne poster had just appeared, gave him advice on lithograph techniques, soon to be put to good use. Around 1888, Toulouse-Lautrec began painting the themes for which he is best known – theatres, music-halls (particularly the Moulin Rouge), cafés, circuses and brothels. Although the subject matter and interest in figures in motion is similar to Degas's own, Toulouse-Lautrec's figures are not representative types, but identifiable people, mostly his friends, painted or drawn from direct observation.

Fame came with his first poster for the Moulin Rouge in 1891. Like *Art Nouveau designers, Toulouse-Lautrec was happy to turn his hand to advertisements, theatre pro-grammes, posters and prints. His paintings and graphic work were shown regularly in Paris, Brussels and London during the 1890s, when he was at the height of his fame. Although not affiliated with any particular group or move-ment, his style displays affinities with contemporaneous Art Nouveau work, and the aura of exoticism and hedonism of his work links him with the *Decadent Movement. In 1894 he painted Oscar Wilde's portrait during a trip to London.

One of the most important American painters to be considered Post-Impressionist is Maurice Prendergast (1859–1924). During the 1890s he lived in Paris, where he absorbed the lessons of Impressionism, Neo-Impressionism and Symbolism, while evolving a highly personal style of his own. A work such as *On the Beach, No. 3* (c. 1915) exemplifies this synthesis. Prendergast was responsible for introducing Post-Impressionist ideas into America, not only in his own work, but also through his activities as a member of The Eight (see *Ashcan School). In 1913 he helped to organize the Armory Show which presented numerous developments in European modernism to the American public for the first time.

Post-Impressionism was introduced in Russia at the turn of the century by the activities of the *World of Art group and in two important exhibitions in 1908 and 1909 spon-sored by its successor, the Golden Fleece. In England, Roger Fry followed his first show with the 'Second Post-Impressionist Exhibition' (October–December, 1912), which concentrated on the younger avant-garde working in a more abstract mode. It included new Russian work by Mikhail Larionov and Natalia Goncharova (see *Jack of Diamonds and *Rayonism), and also a British section, with work by Vanessa Bell (1879–1961), Spencer Gore (1878–1914), Duncan Grant (1885–1978), Wyndham Lewis (1882–1957, see *Vorticism) and Fry himself, most associated with the Bloomsbury Group, which also includ-ed writers, such as Vanessa's sister, Virginia Woolf.

The Post-Impressionist artists worked in a broad range of styles, and held differing ideas about the role of art. However, they were all revolutionaries who sought to create an art that was other than descriptive realism, an art of ideas and emotions. The extraordinary diversity found in this period would provide much food for thought for the artists of the twentieth century.

Key Collections
Barnes Foundation, Merion, Pennsylvania
Courtauld Gallery, London
Detroit Institute of Arts, Detroit, Michigan
Metropolitan Museum of Art, New York
National Gallery, London
Van Gogh Museum, Amsterdam, the Netherlands

Key Books
J. Rewald (ed.), *The Letters of Cézanne* (1984)
G. Cogeval, *The Post-Impressionists* (1988)
B. Denvir, *Toulouse-Lautrec* (1991)
—, *Post-Impressionism* (1992)
G. S. Keyes, et al., *Van Gogh Face to Face* (2000)

Cloisonnism

We must simplify in order to disclose its [Nature's] meaning...reducing its lines to eloquent contrasts, its shades to the seven fundamental colours of the prism.

EMILE BERNARD

Cloisonnism (*cloisonner* – to compartmentalize, to partition) is a style of painting developed by the French painters Emile Bernard (1868–1941) and Louis Anquetin (1861–1932) in the late 1880s. In their paintings forms are simplified, and areas of flat, unnatural colours are separated by heavy outlines reminiscent of Gothic stained glass or cloisonné

Emile Bernard, *The Annunciation*, 1889
Saturated colours and heavy outlines typify Cloisonnist work. The Annunciation also makes obvious the debt to medieval stained glass, with its compartmentalized panels of flat bold colours and stylized lines.

enamels, emphasizing their decorative qualities. The aim is not to illustrate objective reality but to express an inner world of emotion.

Anquetin and Bernard acquired a taste for stained glass, and for Japanese woodcuts, another important influence in the mid-1880s, while they studied in the studio of Fernand Cormon. There they became friends with Vincent van Gogh and Henri de Toulouse-Lautrec, artists who would share, in their individual ways, in the experimentation of the time (see *Post-Impressionism). The most important avant-garde

artist to share the ideas of Anquetin and Bernard was Paul Gauguin (see *Synthetism). Gauguin may have seen their work displayed at the Grand Restaurant-Bouillon towards the end of 1887. Certainly, by the summer of 1888, he was working with them in Pont-Aven in Brittany, and though he never adopted the Cloisonnist practice of separating forms with heavy outlines, his key painting of the period, *Vision After the Sermon: Jacob Wrestling with the Angel* (1888), clearly shows the Cloisonnist influence in its dramatic juxtapositions of saturated colours.

Bernard and Anquetin's first paintings of 1886 and 1887 had taken urban themes, but in Pont-Aven, sharing ideas with Gauguin, they applied their new technique to scenes depicting the 'simple life' of Breton peasants, as well as classical and Biblical images, to produce full-blown Cloisonnist works. These would have a decisive influence in the history of avant-garde painting. Indeed, the painters soon acquired a group of disciples, often known as the School of Pont-Aven, and in the same year their style received its formal description when the critic Edouard Dujardin used it to describe Anquetin's contribution to a show held by the Belgian exhibition group *Les Vingt.

The international influence of Cloisonnism is evident in such exhibitions. Similarly to the *Art Nouveau artists, Bernard believed that painting should be primarily decorative, rather than interpretative, and like those involved in the *Arts and Crafts movement in England he not only produced paintings, but also woodcuts and designs for stained glass and embroidered tapestries. His belief that simplified form and colour would permit more forceful expression was shared by artists in their own experimental styles, many of whom are broadly identified as *Symbolists. It is difficult to imagine Gauguin formulating Synthetism without the precedent of the Cloisonnist style, or the *Nabis arriving at their own expressionist art. Bernard's theoretical writings also proved to be influential, and they ensured that the Cloisonnist style soon became part of the visual vocabulary of those developing a new theoretical and ideological role for painting.

During the 1890s, Bernard and Anquetin began to move in different directions. Anquetin started painting in a style influenced by Toulouse-Lautrec, then turned to a study of the Old Masters, in particular the baroque, rather florid style of Peter Paul Rubens. After the turn of the new century, Bernard turned to Italian Renaissance painting and his influence on the avant-garde waned. However, by then his role as a sponsor of Post-Impressionism was already assured.

Key Collections

Ackland Art Museum at the University of North Carolina, Chapel Hill, North Carolina

Fine Arts Museums of San Francisco, San Francisco, California

MacKenzie Art Gallery, Regina, Saskatchewan

National Gallery, London

Norton Museum of Art, West Palm Beach, Florida

Spencer Museum of Art at the University of Kansas, Lawrence, Kansas

Key Books

Gauguin and the Pont-Aven Group (exh. cat., Tate Gallery, 1966)

W. Jaworska, *Gauguin and the Pont-Aven School* (Boston, MA, 1972)

Emile Bernard: A Pioneer of Modern Art (exh. cat., Van Gogh Museum, Amsterdam, 1990)

Nabis

Remember that a painting, before it is...a nude or some anecdote or other, is essentially a flat surface covered with colours assembled in a certain order.

MAURICE DENIS, 1890

The secret brotherhood of the Nabis (Hebrew: Prophets) was founded in 1888 by French artists and theoreticians Maurice Denis (1870–1943) and Paul Sérusier (1864–1927) as a revolt against academicism. Along with the other original members – Pierre Bonnard (1867–1947), Paul Ranson (1862–1909) and Henri-Gabriel Ibels – they were refugees from the Académie Julian in Paris, disaffected by the photographic naturalism taught there. Later they were joined by Ker-Xavier Roussel (1867–1944) and Edouard Vuillard (1868–1940) from the Ecole des Beaux-Arts in Paris, and later still by foreign artists, the Swiss Félix Vallotton (1865–1925), Mogens Ballin from Denmark, Hungarian József Rippl-Rónai and Dutch Jan Verkade. A spiritual element subsisted in the ideas and practices of the Nabis, and the formation of a secret brotherhood connected them to previous groups of rebellious artists, such as the

Nazarenes in Germany and the Pre-Raphaelites in England.

Paul Gauguin was the most important mentor of the Nabis, and Sérusier's account of a morning's painting under Gauguin in the Bois d'Amour woods in the summer of 1888, vividly describes the *Synthetist influence on the development of Nabi practices: '[Gauguin said,] How do you see these trees? They are yellow. Well then, put down yellow. And that shadow is rather blue. Render it with pure ultramarine. Those red leaves? Use vermilion.' When Sérusier showed the group the resulting painting, *The Talisman (Landscape of the Bois d'Amour)* (1888), it seemed so daring and original that they believed it exuded mystical powers.

The Nabis began to meet regularly to discuss ideas, in particular three key issues: the scientific and mystical bases of art, the social implications, and the desirability of a synthesis of the arts. In formulating their ideas, they drew on the example of leading artists of the previous generation, not only Gauguin, but also Georges Seurat (see *Neo-Impressionism), Odilon Redon and Puvis de Chavannes (see *Symbolism), Paul Cézanne (see *Post-Impressionism) and Louis Anquetin (see *Cloisonnism).

In the summer of 1890, Denis published his manifesto for a new art in the periodical *Art et Critique*. The two-part article, entitled 'Definition of Neo-Traditionism', called for a complete break with the illusionistic naturalism taught at art schools. According to Denis, the revolutionary achievement of the avant-garde artists lay in the recognition and reassertion of the decorative function of art. The Nabis looked to the decorative traditions of the Egyptians and of the medieval fresco painters, which they felt had been lost to the West since the Renaissance.

The first Nabi group exhibition, organized by Denis, was held in 1891 at the château of St Germain-en-Laye. In December of the same year, the majority of the Nabis were included in the first exhibition held at Le Barc de Boutteville, Paris, entitled 'Peintres Impressionnistes et Symbolistes'. As suggested by the title, the Nabis were hailed as a new generation of Symbolists, and were embraced as colleagues by Symbolist poets. Although Denis's statement regarding 'colours assembled in a certain order' was subsequently taken up by abstract artists, the innovations of the Nabis were primarily in style and theorization. Their subject

Above: **Maurice Denis, *Homage to Cézanne*, 1900**
In a tribute which appealed to Cézanne himself, a group of painters – including Redon, Bonnard, Vuillard, Sérusier and Denis – stand before Cézanne's *Still Life with Compotier*, a picture owned by Gauguin.

Below: **Pierre Bonnard, *France-Champagne poster*, 1891**
Bonnard's winning entry in a competition for a poster advertising a brand of champagne won the young artist 100 francs, and had his father, formerly sceptical of his son's chosen profession, dancing with joy in the garden.

matter remained traditional – portraiture, domestic interiors, scenes of Paris life and, especially in the case of Denis, religious scenes.

Like the *Art Nouveau designers of the period, with whom their work shares a visual affinity, the Nabis drew on a wide range of sources and experimented in a broad range of media. As well as paintings, the group exhibited prints, poster designs, tapestry and theatre programme designs. A critic of the time commented on the group's skill in cross-fertilizing sources and media, writing that they 'transpose

and rearrange the characteristics of ancient bygone schools, whether continental or exotic, or they adapt for easel paintings forms previously reserved for such disparate art forms as stained glass, manuscript illumination, old tarot cards or theatrical décors.' A friend of the Nabi artists, actor-director Aurélien-Marie Lugné-Poë, commissioned programmes and set designs for experimental shows, and they also contributed to the Paris productions of works by Henrik Ibsen, August Strindberg and Oscar Wilde. In 1896 they were involved with Alfred Jarry's *Ubu Roi*, which was a precursor of the Theatre of the Absurd, an important influence on the genesis of *Dada and *Surrealism.

The Nabis exhibited together until 1899, after which point they separated. A devout Catholic, Denis turned his attention to religious subjects and mural paintings for religious institutions, and founded the Studio of Sacred Art. Sérusier also turned to religious imagery and religious symbolism. Bonnard and Vuillard, the best known of the Nabis, were in many ways the least characteristic of the group. Bonnard acquired fame through a poster he designed for a champagne company in 1891 (which also inspired Henri de

Opposite: **Edouard Vuillard, *Misia and Vallotton*, 1894**
Like Bonnard, Vuillard excelled at psychologically delicate interior scenes, often of friends, such as, here, Misia Godebska, hostess and muse to many contemporary artists, and fellow Nabi, the Swiss painter Félix Vallotton.

Toulouse-Lautrec to begin designing his own well-known posters). Bonnard's work depicts one of his favourite motifs, the elegant Parisienne, and a definite Japanese influence can be felt in his work, for which he was named *Nabi très japonard*. The flat, strongly patterned style of Vuillard's work of this period points to the two-fold influence of Japanese prints and Gauguin. Each continued to define his own individual style and to concentrate on intimate domestic interiors, which eventually led the artists to be called 'Intimistes'.

Key Collections
Aberdeen Art Gallery, Aberdeen, Scotland
Detroit Institute of Arts, Detroit, Michigan
Minneapolis Institute of Arts, Minneapolis, Minnesota
Montreal Museum of Fine Arts, Quebec
Musée des Beaux-Arts de Quimper, Quimper, France
State Hermitage Museum, St Petersburg

Key Books
C. Chassé, *The Nabis and their Period* (1969)
G. Mauner, *The Nabis, their History and their Art 1888–96* (1978)
P. Eckert Boyer, *The Nabis and the Parisian Avant-Garde* (New Brunswick, 1988)
C. Frèches-Thory, *Bonnard, Vuillard and their Circle* (1991)

Synthetism

Some advice: do not paint too much after nature.

PAUL GAUGUIN, LETTER TO EMILE SCHUFFENECKER, 1888

Paul Gauguin (1848–1903), Emile Schuffenecker (1851–1934), Emile Bernard (1868–1941) and their circle in France coined the term 'synthetism' (from *synthétiser*: to synthesize) to refer to their work of the late 1880s and early 1890s. Painted in a radical, expressive style, in which forms and colours were deliberately distorted and exaggerated, their pictures synthesized a number of different elements: the appearance of nature, the artist's 'dream' before it and the formal qualities of form and colour. Gauguin, the leader of the group, felt that direct observation of nature was only a part of the creative process, and that the input of mem-ory, imagination and emotion intensified those impressions, resulting in more meaningful forms.

Gauguin had exhibited with the *Impressionists in the early 1880s, but by 1885 was disillusioned with their

insistence on describing only what they saw in front of them. He sought new themes and a new painting technique to achieve 'the translation of thought into a medium other than literature.' His aim was to paint not so much what the eye saw, but what the artist felt, and consequently he eschewed both the naturalism of Impressionism and the scientific preoccupations of the *Neo-Impressionists, instead creating an art in which colour is used for dramatic, emotional or expressive effects.

Gauguin drew on many different sources for his inspiration. Like the Pre-Raphaelites in England, he studied medieval tapestries for their boldness and drama; like the Impressionists, he learned about line and composition from Japanese woodcuts. He became passionate about folk art, the stone sculptures of Breton churches and prehistoric art.

During a crucial period for Gauguin in the late 1880s he worked in Brittany, where he became familiar with the work of the Pont-Aven painters Bernard and Louis Anquetin (1861–1932), who were developing the *Cloisonnist style, an important contemporary influence on Gauguin's Synthetist work. Gauguin's key early work, *The Vision After the Sermon: Jacob Wrestling with the Angel* (1888), painted while he was in Pont-Aven, reads like a visual manifesto of his revolutionary ideas. The line and spatial organization of the picture are indebted to Japanese woodcuts (the wrestling figures were even taken from a drawing by Hokusai), and the large areas of unmodulated colour and the heavy outlines relate closely to the Cloisonnist style. But the result is uniquely Gauguin's, and synthesis is the key to its success.

In 1889 Gauguin and his new friends Bernard, Charles Laval (1862–94) and Schuffenecker organized an exhibition to show their progressive work in opposition to the official art exhibition at the fourth Paris Universal Exhibition, of which the star attraction was the Eiffel Tower. 'L'Exposition de peintures du groupe impressioniste et synthétiste' was held at the Café Volpini in Paris and included both their work and that of others with whom they had worked in Brittany, such as Anquetin and Daniel de Monfried (1856–1929). Reviewing the show, sympathetic critics, such as Albert Aurier and Félix Fénéon (see Neo-Impressionism), praised Gauguin's simplification of means and premeditation. Gauguin was launched as a leading figure of avant-garde art, to rival Georges Seurat and the Neo-Impressionists.

Gauguin was also embraced as a leader by the *Symbolist poets and artists. In later works, such as *Day of the Gods (Mahana No Atua)* (1894) or *Where Do We Come From? What Are We? Where Are We Going To?* (1898), both painted while he was living and working in Tahiti, the symbolic content was increasingly important, though the symbols remained private, provoking questions, not providing answers. In fact, Gauguin deplored literary content,

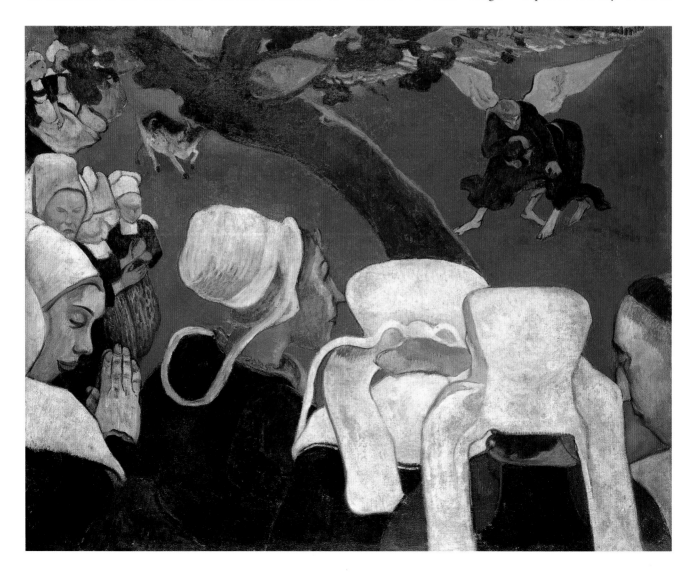

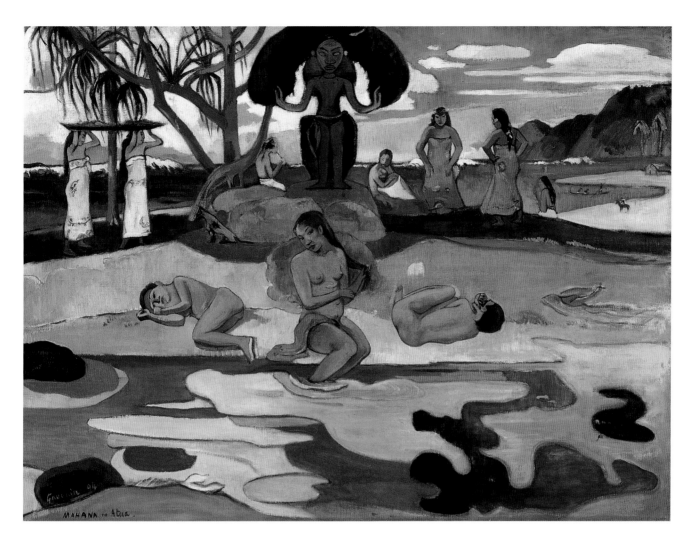

preferring the mysterious and elusive universe of sensations. In 1899 he wrote:

> Think also of the musical role colour will henceforth play in modern painting. Colour, which is vibration just as music is, is able to attain what is most universal yet at the same time most elusive in nature: its inner force.

Gauguin's art proved deeply influential to following generations of artists. During his lifetime, the example of Synthetist work provided important inspiration for the *Nabis, the Symbolists, the international *Art Nouveau and the *Fauves. Subsequently, the *Expressionists, along with various abstractionists and the *Surrealists were to credit Gauguin in the development of their work. In rejecting the idea of the artist's fidelity to the represented world, Gauguin helped pave the way for the abandonment of representation altogether.

Above: Paul Gauguin, *Day of the Gods (Mahana No Atua)*, 1894
Recently returned from Tahiti, and living up to his reputation as an exotic traveller, Gauguin produced a fantasy of ancient Tahitian ritual in which he further abstracted his decorative patterning, and intensified his colours.

Opposite: Paul Gauguin, *Vision After the Sermon: Jacob Wrestling with the Angel,* 1888 Gauguin asserted that colour and line can be expressive in themselves. The inner world of the vision and the outer world of the Breton peasants, divided by the branch, are uncompromisingly – and mysteriously – united by the red ground.

Key Collections
Manchester City Art Gallery, Manchester, England
Metropolitan Museum of Art, New York
Minneapolis Institute of Arts, Minneapolis, Minnesota
Museum of Fine Arts, Boston, Massachusetts
National Gallery, London
National Gallery of Art, Washington, D.C.

Key Books
W. Jaworska, *Gauguin and the Pont-Aven School* (Boston, 1972)
H. Rookmaaker, *Synthetist Art Theories: Gauguin and 19th Century Art Theory* (Amsterdam, 1972)
P. Gauguin, *Intimate Journals* (Minneola, NY, 1987)
B. Thomson, Gauguin (1987)
R. Kendall, *Gauguin by Himself* (Boston, MA, 2000)

Salon de la Rose+Croix

*To destroy Realism and to bring art closer to Catholic ideas,
to mysticism, to legend, myth, allegory, and dreams.*

CATALOGUE OF THE SALON DE LA ROSE+CROIX, 1892

The mood of crisis and world-weariness associated with the *fin de siècle* led many *Symbolist painters and writers to revive the Romantic trends of idealism, mysticism and exoticism. This, combined with a resurgence of Catholicism in France, led some painters (such as the *Nabis Maurice Denis and Paul Sérusier) back to organized religion, some to anti-religious beliefs (see *Decadent Movement), and others to religious cultism. One such cultic group was the Mystic Order of the Rose+Croix, founded by the Symbolist novelist and entrepreneur, Sâr (High Priest) Joséphin Péladan (1859–1918) to promote the arts, especially of an esoteric flavour, and overcome European materialism.

Péladan was a fervent believer in the occult doctrines of Rosicrucianism. While his doctrinaire approach alienated some progressive artists, such as Gustave Moreau and Odilon Redon (see Symbolism), many young painters and writers flocked to Péladan, eager to join his lodge of the brotherhood and to participate in its rituals and Salons.

Péladan decreed that only subjects inspired by religion, mysticism, legend and myth, dream, allegory and great poetry were appropriate for inclusion in his Salons. Subjects that he felt did not stress the 'nobility' of the artist-creator – scenes from modern life, naturalist landscapes, peasants, and scenes of decadence – were prohibited. His enthusiastic followers, including Edmon Aman-Jean (1860–1936); Jean Delville (1867–1953); Charles Filiger (1863–1928); Armand Point (1860–1932); Carlos Schwabe (1866–1926) and Alexandre Séon (1857–1917), were happy to oblige, with work ranging from Delville's Satanic images to Schwabe's sentimental Catholic paintings. For inspiration they turned to the writing of Edgar Allan Poe and Charles Baudelaire, Arthurian legends and the opera-dramas of Richard Wagner. Visually, the Gothic fantasies of the Swiss painter Arnold Böcklin (1827–1901), such as *Isle of the Dead* (1886), were particularly influential.

In 1891 Péladan and his associates (who included Comte Antoine de La Rochefoucauld 1862–1960) announced Salons at which visual and aural feasts of art, music and literature exemplifying Rosicrucian principles would be presented. Six Salons were held in Paris between 1892 and 1897. The first, held at Paul Durand-Ruel's gallery, featured music by Erik Satie, Giovanni Pierluigi da Palestrina and Wagner, and performances of one of

Carlos Schwabe, *The Virgin of the Lilies*, 1899
Péladan's increasingly strict rules on the subject matter of his painters eventually alienated even the ultra-Catholic Schwabe.

Péladan's plays. Later exhibitions showed the work of Fernand Khnopff (see *Les Vingt), Ferdinand Hodler (1853–1918), Jan Toorop (1858–1928) and Gaetano Previati (1852–1920). Péladan was a gifted publicist and the press and the public flocked to the see the spectacles. Although some new artists were attracted, such as Georges Rouault (see *Expressionism), many avant-garde artists began to leave the Order. Eventually Péladan found himself in financial difficulties and disbanded the society.

The impact of the Salons de la Rose+Croix has long been overshadowed by the colourful character of Péladan, described by one art historian as 'one of the most preposterous figures in the history of art'. In all, around 230 artists exhibited in the Salons, which were important as showcases for both Symbolist and non-Symbolist new work.

Key Collections

Albertina, Vienna, Austria
Detroit Institute of Arts, Detroit, Michigan
Fine Arts Museums of San Francisco, San Francisco, California
Groeninge Museum, Bruges, Belgium
J. Paul Getty Museum, Los Angeles, California

Key Books

A. Lehman, *The Symbolist Aesthetic in France 1885–95* (Oxford, 1968)
R. Pincus-Witten, *Occult Symbolism in France: Joséphin Péladan and the Salons de la Rose+Croix* (1976)

Jugendstil

We stand at the threshold of an altogether new art, an art with forms which mean or represent nothing, recall nothing, yet which can stimulate our souls.

AUGUST ENDELL, C. 1900

In Germany *Art Nouveau was called Jugendstil (Youth Style), the name taken from the popular review *Jugend* (1896–1914). There were two distinct trends in Jugendstil, a floral representational style derived from English *Arts and Crafts designs, and a more abstract one which developed after 1900, under the influence of the Belgian Henry Van de Velde (see Art Nouveau). The movement was enthusiastically popularized by a number of new publications addressing both fine and applied arts, such as *Jugend, Pan* (1895–1900), *Simplicissimus*, founded in 1896, and *Dekorative Kunst* and *Deutsche Kunst und Dekoration* in 1897. Support from wealthy industrialists and the aristocracy soon followed, allowing the spread of Jugendstil from graphic arts to architecture and applied arts.

The floral style was generally sentimental and naturalistic, drawing on natural forms and folk themes. One of the earliest examples is the embroidered tapestry of Munich-based sculptor Hermann Obrist (1863–1927). His wall hanging *Cyclamen* (1892–94), depicting a moving, flowing, looping flower, reminded one critic of 'the sudden violent curves generated by the crack of a whip', and the work subsequently became known as *The Whiplash*. Another leading exponent of the floral style was Otto Eckmann (1865–1902), who, like many Art Nouveau practitioners, had trained as a painter but moved into graphics and

applied arts. Eckmann produced numerous illustrations in his trademark calligraphic style for such influential periodicals as *Pan* and *Jugend*.

Munich was the main centre of Jugendstil until the turn of the century, with Obrist, Eckmann, August Endell (1871–1925), Richard Riemerschmid (1868–1957), Bernhard Pankok (1872–1943) and Bruno Paul (1874–1968) all based there. Jugendstil coincided with a growing interest in industrial design and applied arts and a desire to improve German products in order to compete in the international market. The example of the British Arts and Crafts movement was particularly important for its high standard of design and its concept of 'fitness for purpose' and 'honest construction'. German designers did not reject mass-production, however, but sought to create designs that were appropriate for the new technologies that were being developed. This led to simplified, functional designs with less ornamentation than those of their British counterparts, making the products affordable to many. With this in mind, the Vereinigte Werkstätten für Kunst und Handwerk (United Workshops for Art and the Handicrafts) were founded in Munich in 1897. While the designers, such as founder-members Obrist, Endell, Riemerschmid, Pankok, Paul, and Peter Behrens (1869–1940), worked closely with the producers of their designs, they did

not, however, actually produce the designs, as was the practice in Britain.

In the same year, a number of Van de Velde's interiors were exhibited at the Dresden Exhibition of Applied Arts. His original, curvilinear approach to furniture design was much admired and promoted by the German art critic Julius Meier-Graefe, founder of *Pan*, who commissioned office furniture from him. Van de Velde's popularity in Germany grew and he received numerous commissions; after settling in Berlin he lectured throughout the country.

Around this time, the transformation of the floral style into a more abstract, geometrical style began to occur in work by Endell, Obrist and Behrens. Endell's designs for the Atelier Elvira (1897–98), a photographic studio in Munich, later destroyed by the Nazis as an example of 'degenerate art', were particularly important. The whiplash lines and the plant and animal motifs seen in much Art Nouveau work were abstracted, and as a result, took on an almost surreal quality. Behren's 1898 poster *The Kiss* performed a similar trick, its flowing curvilinear elements were simplified and controlled creating an organic, ornamental, modernist style.

Around the turn of the century the Munich group dispersed, heading for Berlin, Weimar and Darmstadt. Numerous workshops were established around the country, notably in Dresden, where Riemerschmid developed a line of machine-made furniture, and in Darmstadt, where *Deutsche Kunst und Dekoration* was launched in 1897 with an appeal from its founder, Alexander Koch, for a return to craftsmanship and unification of the arts. Koch favoured the more restrained, elegant architecture and designs associated

with Charles Rennie Mackintosh (see Art Nouveau), M. H. Baillie Scott and C. R. Ashbee (see Arts and Crafts). He published an article on the Glasgow School in 1898, invited Mackintosh to enter a competition to design a home for an art lover in 1901, and featured a magazine cover designed by Margaret Macdonald Mackintosh in 1902.

The ruler of Darmstadt, Grand Duke Ernst Ludwig of Hesse, shared Koch's passion for British design and his belief that artists could play a valuable role in design reform. In 1899 he established a colony of German and Austrian architects and designers, including Behrens and Joseph Maria Olbrich (see *Vienna Secession) in Darmstadt. The project synthesized the Garden City ideals then fashionable in England, combining the principles of Arts and Crafts with Art Nouveau design. Olbrich and Behrens designed Jugendstil houses for the residents, and the Duke commissioned furniture for the colony from the Guild of Handicraft following designs by Ashbee and Baillie Scott. Members made everything from interiors to jewelry, furniture to cutlery, and participated in exhibitions in Germany, Paris, Italy and the USA. In 1901 the buildings of the colony were opened to the public, with a mystical inauguration ceremony to demonstrate the concept of a 'total work of art', and to show how one could live an ideal life surrounded by art. The group's products were expensive, however, and beyond the reach of most. In practice, the artists survived on subsidies from the Duke.

Many of the leading Jugendstil practitioners came together again in 1907 as members of the *Deutscher Werkbund, continuing the debate about how to reconcile art with industry, ornamentation with functionalism. The most important legacy of the Jugendstil in Germany was the atmosphere of experimentation it fostered and the desire for a synthesis of fine and applied arts, which would ultimately lead to the formation of the *Bauhaus.

Above: **August Endell,** *Façade of Atelier Elvira,* 1897–98
Endell's design caused a furore when first seen by the public, traditionalists criticizing a bewildering absence of connection between the extraordinary ornamentation and the relatively unremarkable structure of the building itself.

Key Collections
Aberdeen Art Gallery, Aberdeen, Scotland
Galerie Decorative Arts, München, Germany
Glasgow University Art Collection, Glasgow, Scotland
Hessiches Landesmuseum, Darmstadt, Germany
Victoria & Albert Museum, London

Key Books
Jugendstil and Expressionism in German Posters (exh. cat., Pasadena Art Museum, 1966)
S. Wichmann, *Jugendstil Art Nouveau: Floral and Functional Forms* (Boston, 1984)
W. Quoika-Stanka, *Jugendstil in Austria and Germany* (Monticello, 1987)
A. Duncan, *Art Nouveau* (1994)

Vienna Secession

…to impart appropriate form to modern perception.

JOSEF HOFFMANN, 1900

The secession, or breaking away, of young artists from official academies was a feature of the arts in the 1890s, especially in German-speaking countries. At Munich in 1892, Berlin in 1898, and later at Dresden, Dusseldorf, Leipzig and also Weimar, young artists protested against the stranglehold that their elders maintained on exhibitions and arts policies by setting up independent societies. The Vienna of the period was a centre of extraordinary and radical intellectual vitality: Sigmund Freud, composer Arnold Schönberg, novelist Robert Musil and architect Adolf Loos (see *International Style) were all based in Vienna at this time. The artists based in the city proved no less radical than their contemporaries in other fields.

The Vienna Secession was formed on 25 May 1897 by a group of nineteen artists and architects who had decided to break away from the official Viennese Artists' Association. Painter Gustav Klimt (1862–1918) and architects and designers Josef Hoffmann (1870–1956), Joseph Maria Olbrich (1867–1908) and Koloman Moser (1868–1918) remain the most famous of the founder-members. Klimt became the group's first President.

Left: **Josef Hoffmann, The logotype for the Wiener Werkstätte**
The Wiener Werkstätte was dedicated to producing sophisticated, elegant objects, characteristically simple yet luxurious, including furniture, interiors, clothing, metalware, bookbindings, ceramics, textiles and jewelry.

Below: **Gustav Klimt, *Beethoven Frieze* (detail), 1902**
The Secessionists' fourteenth show was a homage to Beethoven, to which Klimt contributed a frieze. His personal allegory (here the sufferings of feeble mankind; the well-armed strong one; Compassion and Ambition) was criticized for lacking any connection to Beethoven.

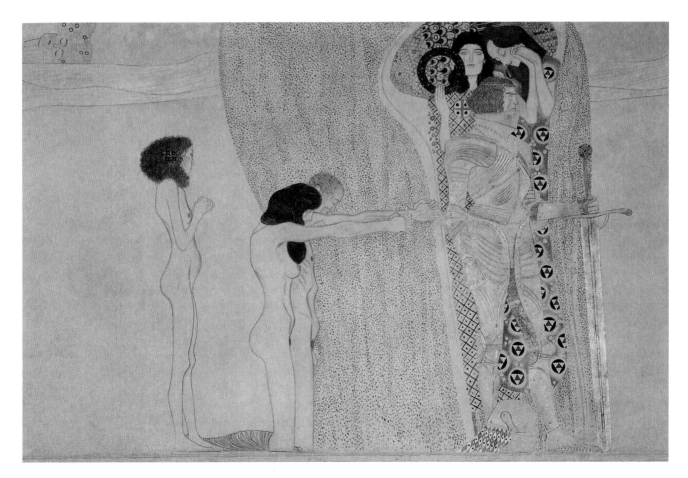

Rejecting the revivalist styles endorsed by the conservative academies, the group promoted an art that would celebrate modernity. Like William Morris and the *Arts and Crafts movement in Britain – which the members cited in their declarations – they favoured a broader definition of art which included applied arts, and believed that art could play a central role in social improvement. An early statement published by the group reads: 'We do not recognize any difference between great and minor art, between the art of the rich and that of the poor. Art belongs to all.'

Like *Les Vingt in Belgium, the group held exhibitions to promote the latest international developments in both fine and applied arts. The first exhibition included, alongside work by Secession members, recent productions by French sculptor Auguste Rodin and the Belgians Fernand Khnopff and Henry Van de Velde, all former members of Les Vingt. The exhibition was such a success that the Secessionists commissioned Olbrich to design a permanent exhibition space, the Haus der Wiener Sezession (1897–98). The modern, functional building, based on geometric forms and sparsely decorated with ornamental friezes of plant and animal motifs, boasted an inscription over the doorway that read: 'To each age its art, to art its freedom.' It was a powerful statement of both the ideals and the visual characteristics of the new art advocated by the group.

At first the Secessionists were affiliated with *Art Nouveau and *Jugendstil; indeed, in Austria Art Nouveau was called Sezessionstil. In an extraordinary coup, Vienna's leading architect, Otto Wagner (1841–1918), already established as an advocate of the Art Nouveau style with his Karlsplatz Station (1894) and Majolica House (1898), defected from the establishment to join the new group in 1899. The Vienna Secession hosted twenty-three exhibitions in the new building from 1898 to 1905, introducing the Austrian public to *Impressionism, *Symbolism, *Post-Impressionism, Japanese art, Arts and Crafts and the various strains of international Art Nouveau. From 1900, the date of the Eighth Exhibition of the Secession, at which British applied art was shown, the work of Charles Rennie Mackintosh (see Art Nouveau) was the dominant influence on Sezessionstil. Mackintosh's rectilinear designs and muted

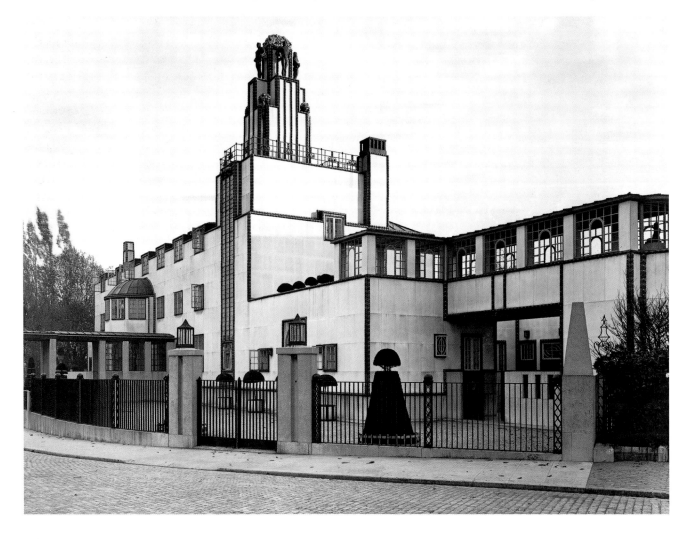

colours were favoured by the Austrians over the more rococo style of Continental Art Nouveau.

The Secession also published a periodical, *Ver Sacrum* (Latin: Sacred Spring), from 1898–1903, to publicize their Art Nouveau designs and broadcast their call for unity in the arts. The title alludes not only to the time of the founding of group (May), but also to youthful renewal and regeneration of the arts.

In 1905 there was a split in the Secession itself. The Naturalists of the group wanted to focus on fine art. The more radical artists, including Klimt, Hoffmann and Wagner, wanted to promote the applied arts and seek closer ties with industry. In the end they left to form a new group, the Klimtgruppe. In 1903, following a fact-finding mission to C. R. Ashbee's Guild of Handicraft in England, Hoffmann and fellow Secessionist Moser and banker Fritz Wärndorfer founded the Wiener Werkstätte (Vienna Workshop), a decorative arts studio, to produce Art Nouveau arts and crafts. Hoffmann defined their goals in the Workshop's programme:

> Our aim is to create an island of tranquillity in our own country, which, amid the joyful hum of arts and crafts, would be welcome to anyone who professes faith in Ruskin and Morris.

However, Hoffmann and Moser were not interested in the social reform aspects of the English Arts and Crafts workshops, nor in their German colleagues' attempts to produce inexpensive furniture (see Jugendstil). They concentrated their energies on the reform of design: beautiful objects for a wealthy clientele. The Werkstätte soon enjoyed an international reputation for progressive design, which anticipated and influenced *Art Deco. Hoffmann in particular favoured the use of cubes and rectangles in his designs, earning him the nickname of 'right-angle' Hoffmann. Within two years, over a hundred craftsmen were employed by the Werkstätte, among them Oskar Kokoschka and the young Egon Schiele (see *Expressionism), who designed women's clothing for them. The Workshop continued to produce goods for the international luxury market until its closure in 1932.

One of the Werkstätte's first commissions was for a private residence in Brussells, the Palais Stoclet (1905–11),

executed by Hoffmann. Mackintosh's bold influence can be seen in the geometric nature of the building, the stark linear design and restricted ornamentation. The murals for the dining hall, designed by Klimt and carried out in mosaic by other members of the Werkstätte, contain his most famous work, *The Kiss*. Shimmering with the all-over gold abstract design, it is as erotically charged as any work by the artists described as Symbolists or *Decadents.

Klimt, Olbrich, Moser and Wagner had all died by 1918, though their influence persisted. The functionalist approach, geometric compositions and two-dimensional quality of much of the early Vienna Secessionists' output anticipated and inspired many modernist movements in art, architecture, and design, including the *Bauhaus, the International Style and Art Deco. The defence of artistic freedom symbolized by the group was also a powerful example for emerging avant-gardes. The Secession itself continued as a group until 1939, when the growing pressures of Nazism led to its dissolution. After World War II it reformed and has continued to sponsor exhibitions, both in the (rebuilt) Secession building and elsewhere.

Above: **Joseph Maria Olbrich, Poster for the second Secession exhibition, 1898–99** Olbrich's poster features the recently built Haus der Wiener Sezession, used for Secession exhibitions, which he had designed himself on a site donated by the City of Vienna, and partly funded by the industrialist Karl Wittgenstein.

Opposite: **Josef Hoffmann, Palais Stoclet, Brussels, 1905–11** Executed in collaboration with Wiener Werkstätte craftsmen, Hoffmann oversaw every detail of his masterpiece, from the concept of the forty-room building to the design of the light fittings, door handles and cutlery.

Key Collections
J. Paul Getty Museum, Los Angeles, California
Metropolitan Museum of Art, New York
National Gallery, London
National Gallery of Art, Washington, D.C.
Secession, Vienna, Austria
Tate Gallery, London

Key Books
N. Powell, *The Sacred Spring: the Arts in Vienna 1898–1918* (1974)
P. Vergo, *Art in Vienna 1898–1918* (Oxford, 1975)
R. Waissenberger, *The Vienna Secession* (1977)
F. Whitford, *Klimt* (1990)

World of Art

The whole art of our time lacks direction…it is uncoordinated, fragmented into separate individuals.

ALEXANDRE BENOIS, 1902

The artists' society Mir Iskusstva (World of Art) was founded in 1898 in St Petersburg by Alexandre Benois (1870–1960) and Sergei Diaghilev (1872–1929). Those who joined were united by their dissatisfaction with the teaching of the Academies. The bright colours, simplified compositions and primitive elements in their work (influenced by an interest in children's drawing) linked it both to the international *Art Nouveau and to contemporary avant-garde movements in Europe, such as *Synthetism. They sought closer ties with Western Europe, and hoped to create in Russia a cultural centre resembling London or Paris. At the same time, their interest in medieval and folk art, and the use of peasant motifs in much of their work, easily identify it as Russian.

Perhaps their most distinctive achievement lay in the promotion of a synthesis of the arts. Like those involved in the *Arts and Crafts movement in England, World of Art members were concerned that rapid industrialization – occurring in Russia from the 1860s – would destroy village crafts, and sought to revitalize local traditions in the production of ceramics, woodwork and theatrical décor. The most spectacular achievement of this effort was Diaghilev's Ballets Russes, of which the productions became famous for the innovations of their stage sets and costume design as much as for their performances. Over the next ten years, European stage design was revolutionized by World of Art artists, particularly Léon Bakst (1866–1924), who joined the group in 1900. His costumes and sets in brilliant

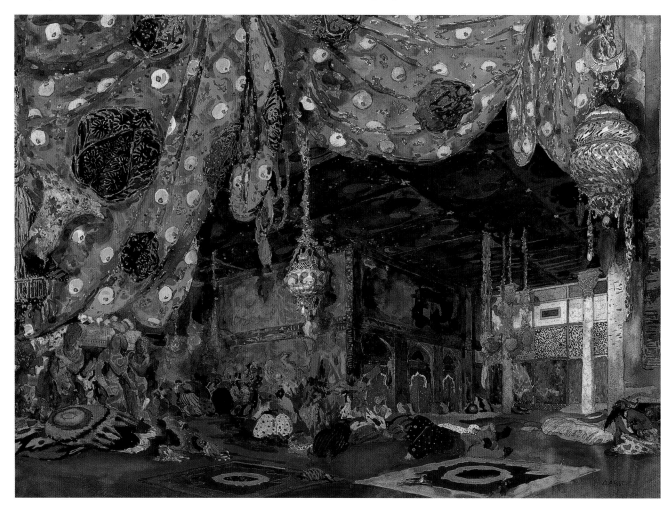

colours married Art Nouveau line with exotic orientalism.

The World of Art was also important for the way in which it spread knowledge about Western artistic trends to the Russian public. The periodical, *World of Art*, was established in 1898 under the editorship of Diaghilev, who also organized exhibitions of Western avant-garde work in Russia. He took sole responsibility for the first World of Art exhibition in January 1899 in St Petersburg, which featured works by foreign artists such as Böcklin, Degas, Monet, Moreau, Puvis de Chavannes and Whistler (see *Impressionism and *Symbolism). After 1899, exhibitions concentrated on Russian art. The final World of Art exhibition in 1906 witnessed the debuts of Mikhail Larionov and Natalia Goncharova (see *Jack of Diamonds, *Rayonism) as well as Alexei von Jawlensky (see *Der Blaue Reiter). The same year, Diaghilev invited Larionov and Goncharova to participate in the seminal exhibition of Russian art he organized in Paris. Part of the 1906 Salon d'Automne, the exhibition provided the most comprehensive representation of Russian art seen in the West, from medieval icons to the contemporary avant-garde; it filled twelve rooms in the Grand Palais, which were decorated by Bakst.

In 1906 the World of Art was disbanded as a society of artists. By this time Benois, Bakst and Diaghilev were spending most of their time in Paris. Avant-garde activities were taken over in 1907 by the Golubaya Roza (Blue Rose) group of artists who were based in Moscow, with Larionov and Goncharova as members. The Zolotoe Runo (Golden Fleece) exhibition society was formed in conjunction with the group, and the *Golden Fleece* magazine (1906–9) was published as a means to carry on the work of the World of Art group.

In 1910 the World of Art was refounded as an exhibition society, and it ran until 1924, holding twenty-one exhibitions in various Russian cities. Increasingly the emphasis was on the rising avant-garde: Marc Chagall (see *Ecole de Paris), Vasily Kandinsky (see Der Blaue Reiter) and El Lissitzky (see *Bauhaus) were among its new members. In truth, however, World of Art had never been avant-garde at heart. The articulate and measured critical comments of its members lacked the radicalism of later commentators; it is telling that they never issued a manifesto. The art itself is

characterized by technical mastery and refinement, but stops short of the extremism for which the *Suprematist and *Constructivist artists would become notorious.

Above: **Léon Bakst, *The Red Sultana*, 1910**
Bakst's costume designs directly influenced the Parisian fashion designer Paul Poiret, who translated the splendour and luxury of the productions into high fashion. Via Poiret, the Ballets Russes were crucial in the development of Art Deco.

Opposite: **Léon Bakst, Stage design for *Schéhérazade*, 1910**
Combining brilliant colours and sensual designs, marrying Art Nouveau line with the exotic orient, Diaghilev's productions of *Cléopâtre* and *Prince Igor* in 1909, and *Schéhérazade* and *Firebird* in 1910, caused a sensation when they were seen in Paris.

Key Collections
Fine Arts Museums of San Francisco, San Francisco, California
Museum of Fine Arts, Boston, Massachusetts
Museum of Modern Art Ludwig Foundation, Vienna, Austria
Norton Simon Museum, Pasadena, California
State Hermitage Museum, St Petersburg
State Russian Museum, St Petersburg

Key Books
C. Spencer and P. Dyer, *The World of Serge Diaghilev* (1974)
J. Kennedy, *The 'Mir Iskusstva' Group and Russian Art 1898–1912* (1977)
J. Bowlt, *The Silver Age: Russian Art of the Early Twentieth Century and the 'World of Art' Group* (Newtonville, MA, 1980)

1900-1918

Modernisms for a Modern World

Fauvism

Colours became charges of dynamite. They were supposed to discharge light. Everything could be raised above the real.

ANDRE DERAIN

At the 1905 Salon d'Automne in Paris, a group of artists exhibited paintings so shocking – the colours so strong and brash, their application so spontaneous and rough – that they were immediately christened *les fauves* (the wild beasts) by the critic Louis Vauxcelles. Intended as a slight, the name was accepted by the painters as an appropriate description of their methods and aims, and Fauvism has become the standard stylistic label for the ground-breaking work of this loose group of French artists working *c.* 1904–8. The most prominent of those artists were Henri Matisse (1869–1954), André Derain (1880–1954) and Maurice de Vlaminck (1876–1958), though others are often included (Vauxcelles called them 'Fauvettes'): Albert Marquet (1875–1947), Charles Camoin (1879–1965), Henri-Charles Manguin (1874–1949), Othon Friesz (1879–1949), Jean Puy (1876–1961), Louis Valtat (1869–1952), Georges Rouault (1871–1958, see *Expressionism), Raoul Dufy (1877–1953), Georges Braque (1882–1963, see *Cubism) and Dutchman Kees van Dongen (1877–1968).

Fauvism was the first of the avant-garde movements of the twentieth century to shake up the art world, but the Fauves were never a consciously organized movement with an agreed agenda, rather a loose affiliation of artists, friends and fellow students, who shared ideas about art. Matisse, the oldest and most established, soon became known as 'the king of the wild beasts'. It is in his painting *Luxe, Calme et Volupté* (Luxury, Calm and Pleasure, 1904) that many Fauve characteristics became apparent for the first time.

The scene, one to which Matisse would often like to return throughout his long career, as would other Fauves, would have been easily recognisable to the *Impressionists – but Matisse's treatment of it is very different. With its bright palette and subjective, emancipated use of colour, it creates an atmosphere and a decorative surface rather than a descriptive scene, and in stylistic terms, it is closer to the *Post-Impressionists and *Neo-Impressionists. In fact it was painted during the summer of 1904 while Matisse was in St Tropez in the south of France with Neo-Impressionists Paul Signac and Henri-Edmond Cross. Like Matisse, many of the Fauves would pass through a Neo-Impressionist phase. The title of the work is taken from a line in 'Voyage à Cythère', a poem by Charles Baudelaire (1821–67), who was also an inspirational figure for the *Symbolists and an influential critic. The Fauves shared the Symbolist attitude that art should evoke emotional sensations through form and colour, but the melancholia and moralizing of much Symbolist work was omitted in favour of a more positive embrace of life. In 'Notes of a Painter', published in *La Grande Revue* in 1908, Matisse clarified his conception of the role of art:

> What I am after, above all, is expression…. I am unable to distinguish between the feeling I have for life and my way of expressing it…. The chief aim of colour should be to serve expression as well as possible…. What I dream of is an art of balance, of purity and serenity devoid of troubling or depressing subject matter, an art which might be for every mental worker, be he businessman or writer, like an appeasing influence, like a mental soother, something like a good armchair in which to rest from physical fatigue.

Luxe, Calme et Volupté was exhibited in the spring of 1905 at the Salon des Indépendants, and Signac bought the painting immediately. Upon seeing it, Raoul Dufy was converted to Fauvism and recorded the effect it produced on him: 'In front of this picture I understood all the new principles; Impressionism lost its charm for me as I contemplated this miracle of imagination produced by drawing and colour.'

Many of the future Fauves – Matisse, Rouault, Camoin, Marquet and Manguin – studied under Gustave Moreau (see Symbolism), whose open-minded attitudes, originality and belief in the expressive power of pure colour was to

prove inspirational. Matisse said, 'He did not set us on the right roads, but off the roads. He disturbed our complacency.' His death in 1898 robbed the Fauves of sympathetic encouragement. However, in the first few years of the twentieth century, the Fauves discovered other painters, still unknown to the general public, who were to exert their own influences on their work. Paul Gauguin (see *Synthetism) was particularly important for Matisse. In the summer of 1906, Matisse and Derain saw many unknown works by Gauguin stored at the house of Gauguin's friend Daniel de Monfried, and had a chance to study the older artist's imaginative use of colour and decorative schemes.

Vincent van Gogh (see Post-Impressionism) proved an overwhelming influence on Vlaminck, by his own account. He first saw Van Gogh's work at an exhibition in 1901, and declared shortly afterwards that he loved him more than his own father. He adopted the habit of squeezing paint directly from the tube onto the canvas calling attention to the sheer physicality of the material, as in *Picnic in the Country* (1905). He later said, 'I was a tender-hearted savage, filled with violence.' Paul Cézanne (see Post-Impressionism) was also important to the Fauves, and his paintings became more widely known after the large retrospective in 1907; both his *Bathers* and his still lifes had a lasting impact on Matisse. At the same time as they were discovering the latest generation of the avant-garde, the Fauves were looking back to pre-Renaissance French art, which received new appreciation with an exhibition entitled 'French Primitives' in 1904. Derain, Vlaminck and Matisse were also among the first artists to collect African sculpture.

One of the key works on display at the 1905 Salon d'Automne was Matisse's *Woman with a Hat* (1905), a portrait of his wife. With its vibrant, unnatural colours and apparently frenzied brushwork, it caused a scandal. Much of the shock value was due to it being a portrait, a recognizable character, which drew attention to the distortion to which she was subjected. But while the public, and critics, viewed it with incomprehension, the dealers and collectors reacted swiftly and enthusiastically and Fauvist work

Above: **André Derain, *Three Figures Sitting on the Grass*, 1906**
African primitive art interested Matisse, Vlaminck and Derain; they admired and collected tribal masks and sculptures. Derain's use of heightened patches of colour recall Cézanne and Gauguin.

Opposite: **Henri Matisse, *Joy of Life (Bonheur de vivre: Joie de vivre)*, 1905–6** Matisse's bold arabesque contours recall Ingres, while his use of colour and figure drawing is fresh and distinctly modern.

suddenly became the most desirable on the market. The American critic Leo Stein began to collect Matisse's work (including *Woman with a Hat*, which he later described as 'The nastiest smear of paint I had ever seen'), followed by his sister, the writer Gertrude Stein, and his brother Michael and his wife. The dealer Ambroise Vollard bought the entire contents of Derain's studio in 1905 and of Vlaminck's studio in 1906. Soon the rush to buy Fauvist work spread outside France; Russian collectors Sergei Shchukin, who bought thirty-seven works, including Matisse's mural decorations *Dance* and *Music* of 1910, and Ivan A. Morozov were quick to establish collections.

By 1906, the Fauves had in fact come to be seen as the most advanced painters in Paris. *Joy of Life* (1905–6) by Matisse, purchased by Gertrude and Leo Stein, dominated the Salon des Indépendants, and the Salon d'Automne included work by all the participants of the group, a dazzling array of brightly coloured landscapes, portraits and figure scenes – traditional subjects interpreted anew. Derain painted a series of scenes of the river Thames in response to the scenes of London by Claude Monet (see Impressionism) which had been enthusiastically received when exhibited in Paris in 1904. While Monet's paintings are observations of light and atmosphere, the overwhelming theme found in Derain's work is the joy of colour. As in Monet's work, the atmosphere of London is vividly evoked, but its presentation is totally new. Derain combined aspects of the divisionist technique used by the Neo-Impressionists with the flat areas of colour of Gauguin and the tilted perspective of Cézanne to create a fresh new vision based on expressive colour.

Matisse's late Fauve work, *Le Luxe II* (1907–8), shows how far he had developed and signals the direction his art would take. Like the earlier *Luxe, Calme et Volupté*, the new work presents an Arcadian scene of nudes in a landscape with figures modelled by colour and line. The Neo-Impressionism of the earlier work has been replaced by a leaner style based on simplified colour and line which work together to create light, space, depth and movement, looking forward to the type of pictorial space that the *Cubists would develop. It was paintings such as this that caused the poet Apollinaire to remark later that Fauvism was 'a kind of introduction to Cubism'.

Above: **Maurice de Vlaminck, *The White House*, 1905–6**
Vlaminck's expressive use of colour and his open brushstrokes show the influence of Van Gogh and the Post-Impressionists, but also indicate the Fauves' dynamic intensity.

Opposite: **Raoul Dufy, *Street Decked with Flags (The Fourteenth of July at Le Havre)*, 1906** Dufy was born in Le Havre, where he met Friesz and Braque. Influenced by Matisse, Dufy's early use of bright colours later developed into vivacious decorative schemes and textile designs.

The Fauves' dominance in Paris was monumental but brief, as the individual artists went their own separate ways and the attention of the art world was eventually diverted to the Cubists. While it would be wrong to describe Fauvism as a coherent movement, the artists experienced a phase of exhilarating liberation, which allowed them to pursue their own personal visions of art. Derain, for example, became close to Pablo Picasso (see Cubism) and then later favoured a more classical approach. Vlaminck abandoned Fauvist colours to concentrate on landscapes in a kind of expressive realism, which brought his work close to the German Expressionists. Other Fauves, such as Van Dongen, who became a member of the *Die Brücke group in Germany, highlighted the affinities between the two movements that revolutionized art practices of the twentieth century. Matisse, the 'king of the fauves', would in a sense remain a Fauve, becoming one of the best loved and most influential artists of the twentieth century.

Key Collections
Centre Georges Pompidou, Paris
Minneapolis Institute of Arts, Minneapolis, Minnesota
Museum of Modern Art, New York
State Hermitage Museum, St Petersburg
Tate Gallery, London

Key Books
S. Whitfield, *Fauvism* (1989)
J. Freeman, with contributions by R. Benjamin, et al., *The Fauve Landscape* (1990)
R. T. Clement, *Les Fauves* (Westport, CT, 1994)
J. Freeman, *The Fauves* (1996)

Expressionism

For I have represented them, I have taken their place and put on their semblance through my visions. It is the psyche which speaks.

OSKAR KOKOSCHKA, 1912

Expressionism is a term that has been widely applied to drama, visual arts and literature at the beginning of the twentieth century, in varying senses. In its art historical sense, Expressionism filtered into common usage as an alternative to *Post-Impressionism, to refer to the new anti-Impressionist tendencies in the visual arts that were developing in different countries from around 1905. These new art forms, which used colour and line symbolically and emotively, were in a sense a reversal of *Impressionism: instead of recording an impression of the world around him, the artist impressed his own temperament on his view of the world. This concept of art was so revolutionary that 'Expressionism' became a synonym for 'modern' art in general. In a more specific categorical sense, Expressionism has come to refer to a particular type of German art produced *c.* 1909–23. Two groups in particular, *Die Brücke and *Der Blaue Reiter (discussed separately), were major manifestations of German Expressionism.

Although Expressionism as it developed in Germany was less the result of a concerted artistic programme than an ideological stance, the work that emerged shared common points of departure and broad stylistic affinities. At the time, Germany possessed a number of strong, independent centres outside Berlin, such as Munich (home of Der Blaue Reiter), Cologne, Dresden (home of Die Brücke) and Hanover. Despite the conservatism of officialdom, they were capable of providing new artists with patrons, galleries and publications. Moreover, differences of opinion between the centre and the regions created a unique atmosphere of drama and conflict in which Expressionist art thrived.

With its emphasis on subjective emotions, its roots lay in *Symbolism and the work of Vincent van Gogh (see Post-Impressionism), Paul Gauguin (see *Synthetism) and the *Nabis. In its experimentation with the power of pure colour, it also related to *Neo-Impressionism and the *Fauves. Like Fauvism, it is characterized by the use of symbolic colours and exaggerated imagery, though the German manifestations generally present a darker vision of humanity than those of the French. James Ensor and Edvard Munch (see Symbolism) were particularly important as spiritual precursors, visionaries who remained true to their belief that art must be expressive of inner turmoil in the face of an uncaring or uncomprehending world.

The most important native precursor of Expressionism in Germany was Paula Modersohn-Becker (1876–1907), who based herself in the artists' colony at Worpswede, a village near Bremen in northern Germany. Her fellow artists, German Naturalists, were in revolt against the effects of industrialization, but Modersohn-Becker developed in a different direction. Her reading of Nietzsche, her friendship with the poet Rainer Maria Rilke and her encounters with the work of the French Post-Impressionists all influenced her, and she abandoned the sentimental and idealized visions of the Worpswede artists to paint portraits, self-portraits and mother-and-child scenes using colour and pattern symbolically. Writing in her journal in 1902 she stressed that 'the principal thing is my personal vision.' Her grasp of the concept of art as a vehicle for subjective vision made her an important link from nineteenth-century Naturalism and Symbolism to modern Expressionism.

Mysticism is another significant theme in Expressionism, of which the key pioneer was Emil Nolde (1867–1956). Like many Symbolists and Post-Impressionists, he was interested in primitive art. His paintings combine simple, dynamic rhythms and dramatic colours to startling effect, and his graphic art, in which he exploits the contrasts of black and white, are equally powerful and original. They were popular with the public too; an edition of postcards made from his early drawings depicting the Alps in the form of giant old men sold 100,000 copies in ten days when it was issued in 1896. His later woodcut, *Prophet* (1912), a radically simplified composition, remains one of his best-known works today.

Nolde's work appealed to the younger artists of Die Brücke, who persuaded him to briefly become a member between 1906 and 1907. Nolde, however, continued to pursue his own interests, the deepest of which was religion. In his autobiography he describes being gripped by an 'irresistible desire to represent profound spirituality, religion and tenderness', and that to do so he had to go 'down to the mystical depth of human divine existence.' For Nolde, '*The Last Supper* and *The Pentecost* marked the change from optical, external stimuli to values of inner conviction. They became milestones – in all likelihood not only for my own work.' These two paintings, both of 1909, mark a period in

his career when his handling became looser and freer in order, as he put it, to 'make something concentrated and simple out of all this complexity.'

The new art was promoted in Berlin by the writer and composer Herwarth Walden (1878–1941), with criticism and polemic appearing in his anarchist periodical *Der Sturm* (The Storm, 1910–32) and exhibitions showing at his Sturm-Galerie (1912–24). Works by Oskar Kokoschka, the Italian *Futurists, the new French graphic artists and James Ensor were exhibited there in 1912, and by Robert Delaunay and the French *Cubists in 1913. With Walden's help, Berlin became an important centre of the international avant-garde in the years preceding World War I.

The most famous exponents of Austrian Expressionism remain Oskar Kokoschka (1886–1980) and Egon Schiele (1890–1918). Both were influenced by the German and Austrian versions of Art Nouveau (see *Jugendstil and *Vienna Secession), especially the work of Gustav Klimt, who was the leading artistic figure in Vienna at the turn of the century. Kokoschka's work quickly moved from a decorative linearism reminiscent of *Art Nouveau to a more intense Expressionism. Scandal caused by an exhibition of

Above: **Paula Modersohn-Becker, *Self-Portrait on her Sixth Wedding Anniversary*, 1906** Modersohn-Becker used dense paintwork and muted colours, and her self-portraits and mother-and-child studies express both tenderness and monumental simplicity. She died three weeks after giving birth.

Opposite: **Egon Schiele, *Nude Girl with Crossed Arms*, 1910** Schiele's draughtsmanship powerfully expresses despair, passion, loneliness and eroticism. The raw sexuality of his female figures made him a controversial artist and many of his drawings were confiscated or burned; in 1912 he was briefly imprisoned.

his early work in 1908, and the production of two of his Expressionist plays in 1909, led him to flee to Switzerland. In the same period, from 1906 to around 1910, he painted the 'psychological portraits' for which he is well known, such as *Portrait of Adolf Loos* (1909). These portraits are remarkable for their portrayal of the sitter's inner sensibility – or, more realistically, Kokoschka's own. In 1910 he moved to Berlin, and over the following two years Walden published many of these portraits in *Der Sturm*. Walden also commissioned artwork for the title-pages of the magazine from him. In an essay written for the journal in 1912 Kokoschka explained aspects of his very personal Expressionism, describing how for him, while working, 'there is an outpouring of feeling into the image which becomes, as it were, the soul's plastic embodiment.'

Schiele took the linear quality of Klimt and transformed it into an aggressive, nervous line. Eroticism is even more prominent in Schiele's work than in Klimt's. His lonely and tortured female nudes appear both erotic and repulsive,

a combination of blatant sexuality and lack of idealization which outraged Viennese public sensibilities, and led, in 1912, to his imprisonment for twenty-four days for exhibiting a 'pornographic' drawing in a place where it could be seen by children. Over a hundred of his drawings were confiscated and many burned. During his stay in prison, and throughout his short life (he died of influenza at the age of twenty-eight), he produced a series of self-portraits, which capture Schiele's narcissism and angst. There is no doubt that he relished the role of the tortured artist; in a letter to his mother in 1913 he wrote, 'I shall be the fruit which will leave eternal vitality behind even after its decay. How great must be your joy, therefore, to have given birth to me.'

Expressionism also flourished in Belgium, particularly at the artists' colony of Laethem-Saint-Martin. Constant Permeke (1886–1952), Gustave de Smet (1877–1943) and Frits van den Berghe (1883–1939) produced distinctively Expressionist art, more lyrical than neurotic. A contemporary of these Flemish Expressionists, though not a part of

their group, was Leon Spilliaert (1881–1946). The decorative composition, passionate line and symbolic undertones of a painting such as *Tall Trees* (1921), shows the intertwining of Art Nouveau, Symbolism and Expressionism. The hallucinatory world created in his haunted images anticipates *Surrealism.

Another important Expressionist outside Germany was the Frenchman Georges Rouault (1871–1958, see also Fauvism), who began his artistic career as an apprentice to a maker of modern stained glass who also restored medieval stained-glass windows. At the same time he took evening classes at the Ecole des Arts Décoratifs in Paris, and later studied with Henri Matisse under Gustave Moreau. He also became friends with two major figures of the Catholic revival in France, the Catholic writer and propagandist Léon Bloy and the writer J. K. Huysmans, at the time a new convert to Catholicism. Rouault himself was a deeply religious man and all these influences – both spiritual and artistic – can be felt in his paintings. In his early work he concentrated on the poverty-stricken, creating intense and compassionate images of the 'wretched of the earth'. His later work focused on more overtly religious images, combining moral indignation and sadness with the hope of redemption. Throughout all there is the bold decorativeness of Fauvism, Expressionist content and the luminous colours of medieval stained glass.

Expressionism was not confined to painting, but was also adopted by other media. The sculptors Ernst Barlach (1870–1938) and Wilhelm Lehmbruck (1881–1919) are usually accounted the leading sculptors of German Expressionism. Their figures and portraits combine psychological intensity with a sense of man's alienation and suffering. In both Germany and the Netherlands (see *School of Amsterdam), in the years before and after World War I, leading architects developed a style now referred to as Expressionist. The political crises of those years created a political, utopian and experimental attitude and manner. As with artists of Die Brücke, Expressionist architects, such as Hans Poelzig (1869–1936), Max Berg (1870–1948) and Erich Mendelsohn (1887–1953), saw themselves as the creators of a better future, and for this purpose many Expressionists artists and architects joined together in the *Arbeitsrat für Kunst group after World War I.

Above: **Emil Nolde, *Prophet*, 1912**
Nolde used the powerful black and white contrast produced by woodcut to great effect. His use of the medium was partly inspired by younger colleagues from Die Brücke group. His use of colour shows similar vehemence.

Opposite: **Oskar Kokoschka, *Bride of the Wind (The Tempest)*, 1914**
Kokoschka's *The Tempest* portrays something of the passionate intensity of his relationship with Alma Mahler, widow of the composer; their affair was foundering by the time the painting was finished.

The stylistic roots of Expressionist architecture lie in Art Nouveau architecture, particularly the buildings of Henry Van de Velde, Joseph Maria Olbrich and Antoni Gaudí. Expressionist buildings are characterized by a monumental quality, inventive use of brick, individuality of expression and, in not a few cases, a degree of eccentricity. Entering Poelzig's Grosses Schauspielhaus in Berlin (Great Playhouse, 1919, destroyed), an old circus building converted into a theatre-in-the-round with pillars resembling trees and stalactites hanging from the roof, would have felt like walking into a Gothic filmset. This feeling was probably not accidental, as Poelzig studied architecture under Carl Schäfer, a neo-Gothicist, and he designed an Expressionist filmset for Paul Wegener's film *The Golem* (1920). His work brought him acclaim, but the economic depression after 1929 and the political changes in Germany affected his career.

Similarly, Mendelsohn's Observatory and Astrophysics Laboratory in Potsdam, known as the Einstein Tower (1919–21, destroyed) embodies many Expressionist characteristics. A functional building, it also showed the free play of the architect's imagination and willingness to experiment with its flowing lines and windows wrapped around the corners. Although designed to be made of cast-concrete, its

engineering and technical limitations meant that it had to be fabricated in brick, then rendered in cement. Its appearance was that of an organic sculpture, and it served as a fitting monument to the celebrated scientist.

While the utopian ideals associated with Expressionism became hard to sustain through the 1920s and 1930s, the legacy of Expressionism was far-reaching in all the arts. In the short term, the ideals of the movement provided a basis for the *Bauhaus, and the subsequent disillusionment and social criticism led to *Neue Sachlichkeit. On a broader level, the liberation of art from its descriptive role, the exaltation of the artist's imagination and the extension of the expressive powers of colour, line and form affected to some extent all the art that followed.

Erich Mendelsohn, Einstein Tower, Potsdam, 1919–21
The tower was built as a symbol of the greatness of Einstein's concepts. The beginnings of its design can be traced back to letters and sketches Mendelsohn sent from the front during World War I.

Key Collections
Ackland Art Museum, University of North Carolina,
 Chapel Hill, North Carolina
Carnegie Museum of Art, Pittsburgh, Pennsylvania
Kunsthalle, Bremen, Germany
Kunstmuseum Basel, Switzerland
Leicester City Museum and Art Gallery, Leicester, England
Solomon R. Guggenheim Museum, New York
Tate Gallery, London

Key Books
W. Pehnt, *Expressionist Architecture* (1980)
J. Lloyd, *German Expressionism* (1991)
J. Kallir, *Egon Schiele* (1994)
D. Elger and H. Bever, *Expressionism* (1998)

Die Brücke

*Everyone who with directness and authenticity conveys
that which drives him to creation, belongs to us.*

ERNST LUDWIG KIRCHNER, 1906 MANIFESTO

On 7 June 1905 in Dresden, four German architecture students, Fritz Bleyl (1880–1966), Erich Heckel (1883–1970), Ernst Ludwig Kirchner (1880–1938) and Karl Schmidt-Rottluff (1884–1976) founded the 'The Artists' Group of the Bridge', or Die Brücke (The Bridge). The group would become one of the main forces of German *Expressionism.

The artists were young, idealistic and imbued with the belief that through painting they could create a better world for all. Their first manifesto, *Programm*, published as a broadside in 1906, contained Kirchner's call to arms:

'We call all young people together, and as young people, who carry the future in us, we want to wrest freedom for our actions and our lives from the older, comfortably established forces.' Like others before them, such as those in the English *Arts and Crafts movement, the artists developed a broad-ranging social ideology, encompassing not just art but all of life. They saw their role to be revolutionaries, or prophets, like the *Nabis, rather than keepers of tradition.

The name was chosen by Schmidt-Rottluff to symbolize the link, or bridge, they would form with art of the future.

In a letter inviting the older German Expressionist Emil Nolde (1867–1956) to join the group, Schmidt-Rottluff explained: 'To attract all revolutionary and fermenting elements: that is the purpose implied in the name "Brücke".' Nolde, briefly persuaded, joined the group for a few months between 1906 and 1907. The philosophical underpinnings of the group, their name and their frequent use of the bridge motif have also been linked to Friedrich Nietzsche's book *Also Sprach Zarathustra* (Thus Spake Zarathustra, 1883).

Despite their utopian aims, the group was united more by what they disliked in the art around them – anecdotal realism and *Impressionism – than by any clear artistic program of their own. Guided by the spirit of the Arts and Crafts movement and *Jugendstil (German Art Nouveau), they set up a workshop in Dresden in which to paint, carve and make woodcuts, often collaborating on projects. Part of their purpose was to advocate a greater connection between art and life, and Kirchner and Heckel made furniture and sculptures for their studios and painted wall decorations. Jugendstil graphics had an obvious influence on their work, as did Gothic German woodcuts and, later, African and Oceanic wood carvings, which were on show at the Dresden Ethnographic Museum. Vincent van Gogh (see *Post-Impressionism), Paul Gauguin (see *Synthetism) and Edvard Munch (see *Symbolism) were also important precursors, admired by Die Brücke artists for their authenticity and expressiveness. Russian and Scandinavian literature also provided inspiration, Dostoyevsky in particular.

The Brücke artists were aware of contemporaneous developments in France, and in 1908 an exhibition of Henri Matisse's work in Berlin confirmed their enthusiasm for the *Fauves. Their work shares certain visual characteristics – simplified drawing, exaggerated forms and bold, contrasting colours – and both groups insisted on the freedom of the artist to interpret sources in nature in individual ways. However, in contrast to both Fauve paintings and Die Brücke's utopian ideals, most work by Die Brücke artists, particularly their woodcuts, presents an intense, often harrowing vision of the contemporary world.

The first major influence on the Die Brücke style – and on German Expressionism in general – was *Art Nouveau. In 1903 and 1904 Kirchner studied in Munich under one of the leading designers of the Jugendstil, Hermann Obrist, and an early street scene, *Street, Dresden* (1907–8), with its

curvilinear figures in a dream-like space and bold colours, displays a debt to his Art Nouveau training. By 1913, when Kirchner completed *Five Women in the Street*, his painting displayed an awareness of the developments of *Cubism in its jagged, geometric forms, combining Fauve colour with the distortion of Gothic German art. The elongated figures with spiky feet and features are characteristic of Kirchner's mature style, as is the attempt to convey the harsh, psychologically intense atmosphere of urban life.

Above: **Erich Heckel, *Two Men at a Table*, 1912** The subject of Heckel's *Two Men at a Table* was taken from Dostoyevsky's novel *The Brothers Karamazov*, and the painting is dedicated to the author.

Right: **Ernst Ludwig Kirchner, *The Painters of Die Brücke*, 1926** The group portrait depicts the founders of Die Brücke: from left to right: Otto Mueller, Kirchner, Heckel, and Schmidt-Rottluff. The group had already been disbanded for twelve years when this was painted.

Schmidt-Rottluff was the boldest colourist of the group, producing images in a discordant, forceful style. His personal style is exemplified in his work *Midday on the Moor* (1908) in the simplification of the forms and in the balance of the work's composition. In works such as *Rising Moon* (1912) and *Summer* (1913), the two-dimensional quality and abrupt flat planes of colour reflect his style of woodcuts and exemplify many of the characteristics associated with Die Brücke artists.

From 1906 the founder members of Die Brücke were joined by other German and European artists, including Nolde and Max Pechstein (1881–1955) and the Swiss Cuno Amiet (1868–1961) in 1906, and in 1907 the Finnish artist Akseli Gallén-Kallela (1865–1931). In 1908, the Dutch Fauvist Kees van Dongen (1877–1968) joined, and in 1910 the Czech Bohumil Kubista (1884–1918) and the German Otto Mueller (1874–1930) became members.

The group organized a series of exhibitions, the first two in 1906 and 1907, held in the showroom of a lampshade factory in suburban Dresden, which Heckel had designed. Soon their work was shown annually by prominent galleries in Dresden and in travelling exhibitions throughout Germany, Scandinavia and Switzerland. These activities were supported financially by 'passive members' of the group (friends and supporters), who received a portfolio of woodcuts or lithographs each year for their contributions.

By 1911 all of the members of the group had moved to Berlin, and had begun to go their separate ways. Differences between the artists were beginning to be reflected in their work, as each moved away from the principles of style which had originally united their work. In 1913 Kirchner published *Chronik der Künstlergemeinschaft Brücke* (Chronicle of the artists' community of Die Brücke), a history of the group, and the prominence he gave to himself in it led to the formal dissolution of the group in the same year. Although short-lived, the movement's vision of life expressed through their style of hard, angular painting led to Expressionism being considered a primarily German art form. Their interest in woodcuts and the graphic arts led to a revival of printmaking as a major art form. Like the Fauve experiments in France, Die Brücke was indeed a bridge from Impressionism and Post-Impressionism to the art of

the future which would assert its independence of means and expression through colour, line, form and two-dimensionality. As Kirchner wrote about Die Brücke:

> Painting is the art which represents a phenomenon of feeling on a plane surface. The medium employed in painting, for both background and line, is colour…. Today photography reproduces an object exactly. Painting, liberated from the need to do so, regains freedom of action…. The work of art is born from the total translation of personal ideas in execution.

Key Collections
Brücke-Museum, Berlin, Germany
Kunsthaus, Hamburg, Germany
Leicester City Museum and Art Gallery, Leicester, England
Museum of Modern Art, New York
Wallraf-Richartz Museum, Cologne, Germany

Key Books
B. Herbert, *German Expressionism: Die Brücke and Der Blaue Reiter* (1983)
P. H. Selz, *German Expressionist Painting* (Berkeley, CA, 1983)
S. Barron and W. Dieter-Dube, *German Expressionism: Art and Society 1909–1923* (1997)
D. Elger and H. Bever, *Expressionism: A Revolution in German Art* (1998)

Above: **Ernst Ludwig Kirchner, *Five Women in the Street*, 1913**
The women in the picture appear as menacing creatures, like vultures ready to prey. The painting powerfully communicates the dual sense of attraction and repulsion that women, especially prostitutes, held for many artists associated with Expressionism, Symbolism and the Decadent Movement.

Opposite: **Ernst Ludwig Kirchner, *Poster: Die Brücke*, 1910**
Simplified forms and bold contours characterize much of Kirchner's work; the poster shows the influence both of Gothic woodcuts and of African carvings.

Ashcan School

What we do need is art that expresses the spirit *of the people of today.*

ROBERT HENRI, 1910

Ashcan School is a term applied (originally in derision) to American realist painters of the first decades of the twentieth century, whose preferred subject matter was the grittier and seamier aspects of urban life. At the end of the nineteenth century in America, the academic tradition supported by the establishment seemed to many to neglect the contemporary scene altogether. This state of affairs was soon to be challenged by the highly influential and charismatic Robert Henri (1865–1929). A former student of Thomas Eakins at the Pennsylvania Academy of the Fine Arts, Henri had absorbed both Eakins's style of graphic realism and his belief that painting can only 'consist of the presentation of

real and existing things'. Deeply unimpressed by the late *Impressionists on a visit to Paris in the mid-1890s, he returned to Philadelphia with a mission to create an art that engaged with life.

It is significant that Henri's first converts were originally illustrators for the *Philadelphia Press*. Working at a time before photography replaced hand-drawn illustrations in newspapers, William Glackens (1870–1938), George Luks (1867–1933), Everett Shinn (1876–1953) and John Sloan (1871–1951) were all involved in pictorial reportage. Henri persuaded them to give up their careers as illustrators and to concentrate on painting as a serious profession. The skills

which were necessary for their job – attention to detail, the ability to capture the fleeting moment, and a sharp interest in everyday subject matter – would subsequently become hallmarks of their paintings.

In 1902 Henri spread his message further afield by moving to New York, where he set up his own school on Upper Broadway. His students included George Bellows, Edward Hopper, Stuart Davis and Man Ray. Glackens, Luks, Shinn and Sloan, soon followed. For the next two decades the indefatigable Henri used a variety of means – his own work, teaching, exhibiting and writing (his book, *The Art Spirit*, was published in 1923) – to declare repeatedly his conviction that art must reflect the artist's involvement with, and love for, life. Sloan later reflected on Henri's popularity: 'His teaching was strong stuff in the Nineties of the Victorian era that put "art for art's sake" on a pedestal…Henri won us with his robust love for life.'

In 1907 events took a significant turn. Henri, a member of the selection committee for the Annual Exhibition of the National Academy of Design, resigned in protest when the jury rejected entries by his group. The National Academy, modelled on the French Academy of Arts, was extremely powerful, and, given the lack of private galleries, inclusion in its annual exhibition was considered essential for public recognition. Notwithstanding, Henri and his friends held their own exhibition. The core group of five were joined by three more: Impressionist painter Ernest Lawson (1873–1929), *Symbolist Arthur B. Davies (1862–1939) and *Post-Impressionist Maurice Prendergast (1859–1924), to form 'The Eight'. Although painting in different styles, The Eight were united by their opposition to the oppressive, proscriptive policies of the Academy and in their belief that an artist had the right to paint what he wanted.

The exhibition took place at the Macbeth Gallery, New York, in February 1908, and was a milestone in American art history. Though the subject matter was varied, there were plenty of pictures depicting The Eight's favourite subjects: prostitutes, street urchins, wrestlers and boxers. Called 'The Apostles of Ugliness', 'the revolutionary black gang'

Above: **George Bellows, *Stag at Sharkey's*, 1909** Bellow's painting is one of a famous series of six prizefights, regarded as a landmark of twentieth-century realism. They were finished in 1909, the same year in which he was elected as the youngest ever associate of the National Academy.

Right: **John Sloan, *Hairdresser's Window*, 1907** Sloan grew up and worked in Philadelphia, at first as a graphic artist for the press, before moving to New York. Scenes from the streets and urban backyards captured his attention; they have a snapshot immediacy, but also convey Sloan's sympathy and humanity.

Opposite: **Lewis W. Hine, Eight-year-old children shucking oysters** Hine's documentary photographs drew attention to child labour and the harsh lives of the urban poor, and exposed the need for social reform.

(on account of their predominantly dark palettes) and the 'Ashcan School', The Eight were derided by critics for their vulgar subject matter. But despite, or perhaps because of, the attacks in the press, the exhibition was an enormous public and financial success, travelling to nine major cities.

Though Henri was the crusader of the movement, George Luks was the most colourful figure of The Eight, famous for his tall tales and remarks. 'Guts! Guts! Life! Life!' he once expostulated. 'I can paint with a shoestring dipped in pitch and lard.' In paintings such as *The Wrestlers* (1905), it was his combination of realistic portraiture and social comment that outraged many critics.

The success of the first exhibition led to a second, larger one. The 'Exhibition of Independent Artists' in 1910 brought together over 200 artists to celebrate the artist's freedom of expression. George Bellows (1882–1925), a former student of Henri, was one of those included in the second exhibition. His painting of an illegal boxing match, *Stag at Sharkey's* (1907), is considered a landmark of realism.

With its adventurous nature and open attitude to new developments, the 1910 show anticipated other independent exhibitions in America, in particular the famous Armory Show in New York in 1913 (which members of The Eight helped to organize). A direct result of the Armory Show was that the developments in European modernism, seen for the first time by the American public, temporarily eclipsed the realism of the Ashcan School. Their influence, however, would soon be felt during the resurgence of realism in the 1930s thanks to the work of the *American Scene painters and the *Social Realists.

The interest of the Ashcan painters in social reform links them to documentary photographers such as Jacob Riis (1849–1914) and Lewis W. Hine (1874–1940), two men who used their photography to effect social change. Riis's images of the appalling conditions of slum dwellers led to the destruction of several tenement buildings, and Hine's powerful images of child-labour abuses supported the campaign to legislate against such exploitation. The innovations introduced by the Ashcan School were not in technique or style, but in subject matter and attitude. They turned a humane gaze on the urban poor, who were either invisible or sentimentalized in academic painting. Their scenes of everyday life made a strong appeal to the 'common man' and gave new vigour to a tradition of artistic protest.

Key Collections
Amarillo Museum of Art, Amarillo, Texas
Butler Institute of American Art, Youngstown, Ohio
National Gallery, London
Whitney Museum of American Art, New York

Key Books
B. B. Perlman, *Painters of the Ashcan School* (1978)
B. Perriman, *Painters of the Ashcan School:
The Immortal Eight* (1988)
V. A. Leeds, *The Independents: The Ashcan School &
Their Circle from Florida Collections* (Winter Park, FL, 1996)
R. Zurier, et al., *Metropolitan Lives: The Ashcan Artists
and Their New York* (1996)

Deutscher Werkbund

Striving for harmony, for social decency, for united leadership of work and life.

DEUTSCHER WERKBUND, FOUNDING MANIFESTO, 1907

At the close of the nineteenth century in Germany, the impact of rapid industrialization on national culture was a major topic of debate. The numerous *Jugendstil craft workshops established towards the end of the century were founded on the belief that high-quality applied arts could improve the nation's quality of life, as well as its international economic standing. Such debates gathered momentum with the formation of the Deutscher Werkbund (German Work Federation) in Munich on 9 October 1907 by architect and statesman Hermann Muthesius (1861–1927), political theorist Friedrich Naumann (1860–1919) and Karl Schmidt (1873–1954), founder of the Deutsche Werkstätte, a coalition of progressive crafts workshops. Its goal was 'the improvement of professional work through the cooperation of art, industry and the crafts, through education, propaganda, and united attitudes to pertinent questions.' Twelve craft firms and artists were invited to join,

including many leading figures in Jugendstil and the *Vienna Secession: Peter Behrens (1869–1940), Theodor Fischer (1862–1938), Josef Hoffmann (1870–1956), Wilhelm Kreis, Max Laeuger, Adelbert Niemeyer, J. M. Olbrich (1867–1908), Bruno Paul (1874–1968), Richard Riemerschmid (1868–1957), J. J. Scharvolgel, Paul Schultze-Naumburg and Fritz Schumacher.

Like many *Art Nouveau workshops, the Werkbund was loosely modelled on the British *Arts and Crafts movement, especially the functional aspects that Muthesius praised in his book *The English House* (1904–5). He believed the way forward for German design lay in high-quality, machine-made products that were at once recognizably German and modern. His goal was 'not only to change the German home and German house, but directly to influence the character of the generation…to assume leadership in the applied arts, to develop its best in freedom and to impose it on the world at the same time.'

This belief in both the moral and economic power of art and design was also behind the thinking of nationalist politician Friedrich Naumann. He argued, in articles such as

Above: **Weissenhofsiedlung, Stuttgart, 1927** Mies van der Rohe divided the site into plots on which various architects – many from the Werkbund – built 'display' houses. Among them were buildings by Behrens, Poelzig, Bruno and Max Taut, Scharoun, and Mies van der Rohe himself.

Opposite: **Peter Behrens, AEG Turbine Factory, Berlin, 1908–9** Behrens's temple to industrial power supports a faceted roof reminiscent of a barn – reflecting his aspiration that modern industry, like traditional agriculture, could instil a sense of common purpose.

'Art in the Epoch of the Machine' (1904), that craft and industry must unite – to adapt design to machine production, and to cultivate both producers and consumers in this new aesthetic. Schmidt, the third founder member, represented, along with his brother-in-law Riemerschmid, the aspirations and ideas of the group on a practical level. Riemerschmid designed a line of simple furniture derived from vernacular styles that were suitable for machine production. This *Maschinenmöbel* (machine furniture), mass-produced by the Deutsche Werkstätte, was one of the first examples of well-designed, inexpensive furniture.

In the same year as the formation of the Deutscher Werkbund, Behrens travelled to Berlin and was appointed artistic director of the Allgemeine Elektrizitäts-Gesellschaft (AEG). His role proved remarkable on a number of levels – the evolution of a house style for the company is a pioneering example of corporate identity, and the products designed by Behrens are inaugural examples of industrial design. His commission for AEG allowed him to make the transition from applied arts to industrial design, and from decoration to functionalism. The designs he produced for AEG graphics and products, inspired by machine forms, asserted industrial power as the new heroic labour of Germany. The monumental turbine factory constructed for AEG (1908–9) was the first German building in glass and steel. Its huge barn-like shape and temple-like front powerfully proclaimed that art and industry, rather than agriculture or religion, pointed the way to the future. For Behrens, form and function were of equal importance:

Don't think that even an engineer, when he buys a motor, takes it to bits in order to scrutinize it. Even he...buys from the external appearance. A motor ought to look like a birthday present.

From 1908 the Werkbund held annual conferences and published the results, first as pamphlets, later as influential yearbooks devoted to specific topics, such as 'Art in Industry and Trade' (1913) and 'Transport' (1914). These carried essays and illustrations of a variety of projects by members, including factories by Behrens, Hans Poelzig (1869–1936, see *Expressionism) and Walter Gropius (1883–1969, see *Bauhaus); steamship interiors by Bruno Paul (see Jugendstil); designs for the Garden City of Hellerau by Heinrich Tessenow (1876–1950), Riemerschmid, Fischer, Schumacher and Muthesius; tram interiors by Alfred Grenander and applied arts by the Deutsche Werkstätte.

The first Werkbund exhibition was held in July 1914 in Cologne. An enormous festival celebrating German art and industry, it demonstrated the diversity of styles of its growing membership. Belgian Henry Van de Velde (1863–1957, see Art Nouveau) designed the Werkbund Theatre in late Art Nouveau organic lines, and Muthesius, Hoffmann and Behrens designed buildings in a Neo-Classical style. A fantastic pavilion of glass and steel for the German glass industry by Bruno Taut (1880–1938, see *Arbeitsrat für Kunst) heralded the utopian Expressionist architecture of

the 1920s. The office building of a model factory complex by Gropius and Adolf Meyer (1881–1929) included exposed spiral staircases encased in a glass skin, an architectural motif that would become a feature of many modern buildings. The exhibition also featured a transport hall with a railway sleeping car by Gropius and a railway dining-car designed by August Endell (see Jugendstil), which contained built-in floor and wall cupboards, a space-saving feature which would influence post-war apartment design.

The Deutscher Werkbund expanded dramatically, from 491 members in 1908 to 1,972 in 1915 to almost 3,000 members in 1929, growing into a formidable coalition of artists, designers, architects, craftsmen, teachers, publicists and industrialists. Its members represented a wide variety of artistic tendencies and commercial concerns, from craft workshops to industrial giants such as AEG, Krupp and Daimler. There were constant debates about whether design should be dictated by the needs of industry or individual artistic expression. In his address before the assembly at the 1914 exhibition Muthesius proposed that the Werkbund advocate 'typical' objects and standardized design for industry. Van de Velde and others of the 'artists' group' – Behrens, Endell, Hermann Obrist (1862–1927), Gropius and Taut – interpreted this as an attack on artistic freedom, and forced Muthesius to withdraw his proposal.

Perhaps only the outbreak of World War I prevented the immediate implosion of the Werkbund. Its members spent the war working on propaganda exhibitions and the design of military graves, published in the Werkbund yearbook of 1916–17. After the Armistice, the Werkbund met in Stuttgart in 1919 to discuss its future and the debate over standardization – whether it should be machine-led or artist-led design – instantly resurfaced. Poelzig was elected President after a speech in which he condemned industry and advocated regeneration through hand-craftsmanship. However, support for Poelzig's radical 'Expressionist' stance was short-lived, and he was replaced as President by the more conciliatory Riemerschmid in 1921.

Throughout the 1920s the Werkbund moved further away from handicraft and Expressionism towards industry and functionalism. Members' activities focused on the social aspects of architecture and urban planning, and a large

Left: **Walter Gropius, Sleeping compartment of Mitropa carriage, c. 1914** The Mitropa Sleeping Car Company, a German firm, provided sleeping berths for all classes. The service offered a cheaper facility, but one that nevertheless rivalled the 'Orient Express'. Gropius's efficient use of limited living space inspired features that were to reappear later in modern apartment design.

Opposite: **Peter Behrens, AEG electric table-fan, 1908**
The sympathetic use of materials and functional form lent the product a bold modernity. Behrens designed almost every item in AEG's product range in the spirit of the Werkbund.

number of progressive architects who were members of *Der Ring joined the group, including Ludwig Mies van der Rohe (1886–1969). A new journal published by the Werkbund, *Die Form* (1922, 1925–34), helped to spread their modernist ideas. The group's most spectacular success, however, was the 1927 exhibition of an entire housing estate in Stuttgart. Drawing on the model of the 1901 exhibition by the Darmstadt colony (see Jugendstil), the Weissenhofsiedlung (Weissenhof Estate) presented a whole future way of living to half a million visitors. The site plan of sixty housing units in twenty-one buildings was designed by Mies van der Rohe, and sixteen leading European architects took part in the design of the buildings: Mies van der Rohe himself, Gropius, Behrens, Poelzig, Bruno and Max (1884–1967) Taut, Hans Scharoun (1893–1972) and others from Germany, J. J. P. Oud (1890–1963, see *De Stijl) and Mart Stam (1899–1986) from the Netherlands, Josef Frank (1885–1967) from Austria, Le Corbusier (1887–1965, see *Purism) from France, and Victor Bourgeois (1897–1962) from Belgium. Together they presented the first co-ordinated demonstration of the concrete, glass and steel architectural mode that would come to be known as the *International Style.

The Werkbund was dissolved in 1934 due, on the one hand, to the economic pressures of the Depression, and on the other, to the rise of Nazism. After World War II it was reconstituted, when it broadened its scope to address more political issues, including plans for post-war regeneration and environmental issues. The Werkbund's most influential years as an organization, however, lay in its first few decades. It gave rise to similar organizations in Switzerland and Austria (1910 and 1913 respectively), and inspired the founding of the Design and Industries Association in Britain (1915) and a similar institution in Sweden (1917). In 1919 Gropius, a prominent early Werkbund member, founded the Bauhaus, a school of design, art and architecture that enshrined many of the Werkbund's ideas. Above all, the Werkbund succeeded in drawing attention to the need for design reform and to the benefits of a closer relationship between art and industry. In large part it established the reputation for well-designed, high-quality products that German design still enjoys today.

Key Monuments

Ludwig Mies van der Rohe, Weissenhofsiedlung, Stuttgart,.Germany
Peter Behrens, AEG Turbine Factory, Berlin-Moabit, Germany
—, Behren's House, Alexandraweg, Darmstadt, Germany

Key Books

L. Burckhardt, *The Werkbund* (1980)
J. Campbell, *The German Werkbund: The Politics of Reform in the Applied Arts* (Princeton, NJ, and Guildford, UK, 1980)
A. Stanford, *Peter Behrens and a New Architecture for the Twentieth Century* (Cambridge, MA, 2000)

Cubism

Truth is beyond any realism, and the appearance of things should not be confused with their essence.

JUAN GRIS

The origin of Cubism, perhaps the most famous of all avant-garde movements in the twentieth century, has been the subject of enduring contention among art historians. Early historians credited the Spaniard Pablo Picasso (1881–1973) as sole progenitor; later the honours were shared between Picasso and the Frenchman Georges Braque (1882–1963, see also *Fauvism), coming categorically in favour of Braque. Picasso's claim to precedence rests on his *Les Demoiselles d'Avignon* (1907), which utilizes changes of viewpoint. Yet in the same year Braque was already engaged in an ongoing, intensive analysis of work by Paul Cézanne (see *Post-Impressionism), culminating in his L'Estaque landscapes in 1908. Braque was particularly interested in Cézanne's method of depicting three dimensions by

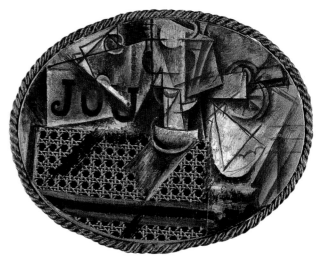

multiple viewpoints, and the way in which the older painter constructed forms out of different planes that seem to slide, or pass, through each other. This technique (*passage* in French) leads the eye to different areas of the painting, simultaneously creating a sense of depth, drawing attention to the surface of the canvas and projecting into the space of the viewer, one of the key characteristics of Cubism.

When the L'Estaque paintings were submitted to the selection jury of the 1908 Salon d'Automne, Henri Matisse (see Fauvism) supposedly dismissed them, in a conversation with the critic Louis Vauxcelles, as nothing but *petits cubes* (small cubes). The paintings were rejected by the jury and shown instead in a large solo exhibition in November at the Kahnweiler Gallery in Paris. Vauxcelles's review of the exhibition recycled Matisse's comment, claiming that Braque 'despises form and reduces everything, landscape and figures and houses, to geometric patterns, to cubes.' Cubism soon became the official, and lasting, name for the movement.

Above left: **Georges Braque, *Viaduct at L'Estaque*, 1908**
'[Braque] despises form and reduces everything, landscape and figures and houses, to geometric patterns, to cubes,' asserted critic Louis Vauxcelles in 1908. 'Cubism' became the recognized name for the movement.

Above right: **Pablo Picasso, *Still Life with Chair-Caning*, 1911–12**
In this work fragmented objects, planes and perspectives combine with illusionistic games in two and three dimensions: the rope is real, but the chair-caning is a pattern on printed oilcloth which has been pasted onto the canvas.

By 1909 Braque and Picasso had become close friends, and worked together from 1909 until 1914, when Braque went off to war. During this period the development of Cubism was a close collaborative venture and many of their works at this time are difficult to tell apart. Picasso described their alliance as a 'marriage', and Braque later said, 'We were like two mountain climbers roped together.'

For both artists Cubism was a type of realism, which conveyed the 'real' more convincingly and intelligently than the various sorts of illusionistic representation dominant in the West since the Renaissance. As well as rejecting the single viewpoint perspective, they abandoned the decorative qualities of previous avant-garde artists, such as the *Impressionists, Post-Impressionists, *Nabis and the Fauves. Instead they went to two alternative sources: Cézanne's later paintings for structure and African sculpture for its abstracted geometric and symbolic qualities. For Picasso, the challenge of Cubism was to represent three dimensions on the two-dimensional surface of the canvas. Braque, on the other hand, wanted to explore the depiction of volume and mass in space. Both these interests are evident in the new techniques they developed together.

The first phase of Braque and Picasso's output, lasting until around 1911, is often called Analytical Cubism. In this period the two artists generally avoided subjects and colours with overt emotional qualities, opting instead for subdued, often monochromatic palettes and neutral subject matter, such as still lifes. These were reduced and fragmented into quasi-abstract compositions of interpenetrating planes, in which multi-faceted solids flowed into each other, weaving together figure and background in a shimmering tapestry or web. Space in these paintings seems to move backwards, tilt upwards and towards the viewer, all this occurring simultaneously, utterly confounding traditional expectations of the representation of depth.

Such composite images of an object seen from a variety of angles – top, bottom, back, front – represent what is known about an object rather than what can be seen from a fixed point and at one time. Objects are suggested rather than described, and viewers must construct them by thought as well as by sight. It is clear that the Cubist object is not the fleeting moment of Impressionism, but a continuous one. In this it relates to intellectual theories of its day, for instance fashionable speculation about the fourth dimension, the occult and alchemy. More importantly, it shows an intriguing correspondence with the thinking of the French philosopher Henri Bergson (1859–1941), whose notions of 'simultaneity' and 'duration' posited that the past merges into the present, which in turn flows into the future in a fluid, overlapping manner, with the result that one's perception of objects is in a state of continual flux. In its emphasis on the role of the artist's imagination, Cubism seems to extend aspects of *Symbolist thought, but in its introduction of issues of time and knowledge it clearly reflects the contemporary intellectual climate.

Although much of their work from this period can be difficult to decipher, abstraction was not the goal, but a means to an end. As Braque confirmed, fragmentation was 'a technique for getting closer to the object'. And Picasso emphasized the imaginative and inventive aspect of Cubism, writing, 'in our subjects we keep the joy of discovery, the pleasure of the unexpected.' These aims were evident in the next phase of Cubism, often called Synthetic Cubism, which began between 1911 and 1912.

After flirting with non-objectivity, Braque and Picasso moved towards a mode of expression in which the subject was more recognizable, but laden with symbolism. In a sense they reversed their working procedure; instead of reducing objects and space towards abstraction, they built up pictures from fragmented abstractions assembled in arbitrary ways. The result was images in which the objective and subjective were delicately balanced, and the 'abstract' was used as a tool to create the 'real'. As the young Spaniard Juan Gris (1887–1927), who joined the older artists at this stage, explained: 'I can make a bottle from a cylinder.'

Two major innovations, both considered landmarks of modern art, occurred in 1912. Picasso incorporated a piece of oilcloth in his painting *Still Life with Chair Caning* creating the first Cubist collage (from the French *coller*, to stick) and all three artists produced *papiers collés*

(compositions of cut-out pasted papers). The works generally included a clearer subject, richer colours and textures, readymade fragments from the 'real world' and text. However, although the compositions are on the whole simpler and more monumental, the spatial relationships are often very complex. The layering and overlapping of flat shapes simultaneously creates a sense of some space in front of the picture plane and pushes other space further back. The distinction between depicted depth and literal depth collapses, lending the works an architectural feel, as if one is seeing things in both plan and elevation. The associations of meaning are more complex too. In Picasso's *Still Life with Chair Caning*, the 'real object' stuck to the canvas turns out to be itself an illusion, not actual chair caning but a piece of oilcloth machine-printed with a caning-like pattern. The letters JOU stand for JOURNAL (newspaper) which itself stands for the newspaper one might find on a café table. The whole is surrounded with a piece of rope, which both frames the still life as an art work and calls attention to the picture's existence as an object.

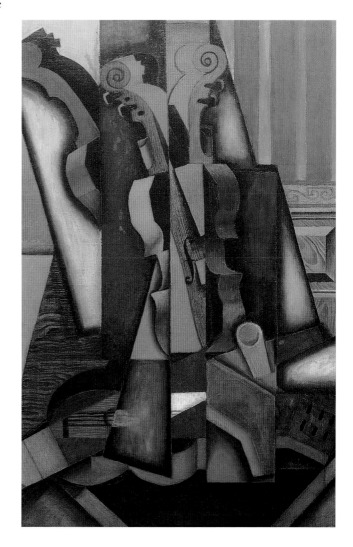

Right: **Juan Gris, *Violin and Guitar*, 1913** Gris was the purest exponent of Synthetic Cubism. His still lifes examine the object from every angle, exposing horizontal and vertical planes systematically. However, the paintings render light and colour to present a warm, naturalistic effect.

Ultimately, such questions of fact and fiction challenge belief in a single definition of reality, and open the works to multiple interpretations. They assert the primacy of the artist's imagination, and claim for art an alternative existence of its own, independent of the outside world. The very strangeness of Cubism, however, is its eloquence in commenting on a strange world. As Picasso said some years later: 'This strangeness was what we wanted to make people think about because we were quite aware that our world was becoming very strange and not exactly reassuring.'

Although Picasso and Braque preferred to conduct their experiments in relative solitude, showing little of their work publicly until after World War I, their work was well known to other artists. From around 1910 Cubism evolved from a style to a movement as other artists developed their own responses to the innovations of Braque and Picasso. Gris, Fernand Léger (1881–1955), Roger de La Fresnaye (1885–1925), Francis Picabia (1879–1953, see *Dada), Marcel Duchamp (1887–1968, see Dada) and his brother Jacques Villon (1875–1963), André Derain (1880–1954, see Fauvism), Henri Le Fauconnier (1881–1946), Polish-born Henri Hayden (1883–1970), Auguste Herbin (1882–1960), Hungarian-born Alfred Reth (1884–1966), Georges Valmier (1885–1937), Russian-born Léopold Survage (1879–1968), Polish Louis Marcoussis (1883–1941), André Lhote (1885–1962), Albert Gleizes (1881–1953) and Jean Metzinger (1883–1956) are among the best known. Of these, one of the most original was Léger, who fused Cubism with the machine aesthetic in a celebration of modern life and machine forms, a lively and humane art which translated easily into other forms, such as the theatre.

Soon Cubism had replaced Fauvism as the leading artistic movement in Paris. By 1912, it was a worldwide movement, the history of which was already being written. Gleizes and Metzinger published the enormously popular *Du Cubisme* in 1912 (fifteen printings in less than a year,

Above: **Fernand Léger, Stage model for *La Création du Monde* (The Creation of the World), 1923** Léger's set for a one-act ballet (music by Darius Milhaud, libretto by Blaise Cendrars) shows the development of his own cubist vernacular, whose figures and compositions use vibrant contrasts of colour and form.

Opposite: **Emil Králícek and Matej Blecha, Lamp-post, Prague 1912–13** The world's only Cubist lamp-post incorporates four seats into the base. Cubist architecture is itself unique to Prague.

and an English translation in 1913), followed by the French poet and critic Guillaume Apollinaire's account, *Les Peintres cubistes* (The Cubist Painters) in 1913 (see *Orphism). Cubism's revolutionary methods rapidly served as a catalyst for other styles and movements, including *Expressionism, *Futurism, *Constructivism, Dada, *Surrealism and *Precisionism. While Picasso, Braque and Gris did not themselves pursue the angle towards abstraction, other artists did, such as the Orphists, the *Synchromists, the *Rayonists and the *Vorticists.

Cubist ideas were also absorbed and subsequently adapted by those working in other disciplines such as sculpture, architecture and the applied arts. Cubist sculpture developed from collage and *papier collé*, and fed into assemblage. The new techniques not only liberated sculptors to employ new subject matter (non-human), but also prompted them to think of sculptures as built objects, not just modelled objects. The mathematical and architectural qualities found in Gris's work were particularly influential here, seen in the work of Alexander Archipenko (1887–1964) and Ossip Zadkine (1890–1966), Raymond Duchamp-Villon (1876–1918, brother of Duchamp and Villon) and Henri Laurens (1885–1954), both from France,

Lithuanian Jacques Lipchitz (1891–1973), the Hungarian-born French sculptor Joseph Csáky (1888–1971), and the Czech sculptors Emil Filla (1882–1953) and Otto Gutfreund (1889–1927).

Cubist theories were taken up enthusiastically in Czechoslovakia by artists, sculptors, designers and architects, who translated the characteristics of Cubist painting (simplified geometric forms, contrasts of light and dark, prism-like facets, angular lines) into architecture and the applied arts, including furniture, jewelry, tableware, fixtures, ceramics and landscaping. Prominent were the members of the Group of Plastic Artists, which was founded in 1911 by Filla to focus on Cubism. The group was active in Prague until 1914 and included sculptors Filla and Gutfreund, as well as architects and designers Pavel Janák, Josef Gočár (1880–1945), Josef Chochol (1880–1956), Josef Čapek, Vlastislav Hofman (1884–1964) and Otokar Novotny. Gutfreund published influential articles in the group's monthly journal.

The House of the Black Madonna (1911–12), a department store designed by Gočár, was the first piece of Cubist architecture to be built. The Grand Café Orient situated on the first floor, complete with a Cubist interior and Cubist light fixtures, rapidly became a meeting place for the avant-garde until its closure in the mid-1920s. The building is now part of the Czech Museum of Fine Arts and houses the Czech Cubism Museum, which was opened in 1994, containing a permanent exhibition of Cubist paintings, furniture, sculptures and porcelain. The Czech Cubism Museum also contains an exhibition of collages by the Czech artist and poet Jirí Kolár, who was also active in France. His ideas later introduced collage to a wider context. Paris may have been the site of the birth of Cubism, but it was in Prague that its possibilities were explored most fully, as a whole way of life.

Key Collections

Czech Cubism Museum, Prague, Czech Republic
Musée Picasso, Paris
Museum of Modern Art, New York
Solomon R. Guggenheim Museum, New York
Tate Gallery, London

Key Books

C. Green, *Cubism and its Enemies* (New Haven, CT, 1987)
J. Golding, *Cubism: A History and an Analysis 1907–1914* (1988)
A. von Vegesack, *Czech Cubism: Architecture, Furniture, Decorative Arts, 1910–1925* (1992)
L. Bolton, Cubism (2000)

Futurism

> *A roaring automobile that seems to run on shrapnel is more*
> *beautiful than the* Victory of Samothrace.

FILIPPO MARINETTI, FIRST FUTURIST MANIFESTO, 1909

Futurism was announced to the world in no uncertain terms by the flamboyant Italian poet and propagandist Filippo Tommaso Marinetti (1876–1944):

> It is from Italy that we now establish Futurism with this manifesto of overwhelming and burning violence, because we want to free this country from its fetid gangrene of professors, archaeologists, antiquarians and rhetoricians.

Marinetti published the manifesto in French on the front page of the Paris newspaper *Le Figaro* on 20 February 1909, indicating his intent that this would not be a provincial Italian development, but one of worldwide importance. His manifesto not only challenged the dominance of Paris as the site of avant-garde movements, it also rejected any notion of historical tradition in art. The manifesto included an eleven-point programme. Point nine declared, 'We will glorify war – the only true hygiene of the world – militarism, patriotism, the destructive gesture of the anarchist, the beautiful Ideas which kill and the scorn of woman.' And the tenth point continued in the same vein, 'We will destroy museums and libraries, and fight against moralism, feminism and all utilitarian cowardice.'

Although initiated by Marinetti as a literary reform movement, Futurism soon expanded to embrace other disciplines, as young Italian artists enthusiastically answered his call to arms. The unifying principle was a passion for speed, power, new machines and technology and a desire to convey the 'dynamism' of the modern industrial city.

During 1909 Marinetti collaborated with the painters Umberto Boccioni (1882–1916), Gino Severini (1883–1966), Carlo Carrà (1881–1966, see also Pittura Metafisica) and painter and composer Luigi Russolo (1885–1947) to formulate Futurist theories for the visual arts. This resulted in the 'Manifesto of Futurist Painters', dated 11 February 1910. This was followed by a second on 11 April 1910, the 'Futurist Painting: Technical Manifesto', in which they declared themselves to be 'the primitives of a new and completely transformed sensibility', and presented more concrete ideas as to how to realize this new sensibility:

> The gesture which we would reproduce on canvas shall no longer be a *fixed moment* in universal dynamism. It shall simply be the *dynamic sensation* itself.

Although they were quick to declare their intentions, it took longer for the Futurists to resolve the question of translating these ideas into paintings. The works in their opening exhibition in Milan in 1911, which contained Futurist subjects rendered in largely traditional ways, were roundly criticized for their timidity in the Florentine magazine *La Voce*. Marinetti, Carrà and Boccioni responded in typically pugilistic fashion by travelling to Florence and beating up the critic, Ardengo Soffici (1879–1964), as he sat outside a café. Despite this, Soffici, an artist and poet, joined the Futurist movement in 1913. The Futurists' preoccupation with breaking from the past insisted on a new method of representation, and they were some time discovering it. The turning point was Severini's trip to Paris in 1911, where he made contact with *Cubists Pablo Picasso, Georges Braque and others. Boccioni, Russolo and Carrà followed him to see what the Parisian avant-garde were doing, and returned to Milan full of new ideas. Although they later tried to distance themselves from the Cubists, the Futurists owed

Above: **Carlo Carrà, *Horse and Rider* or *The Red Rider*, 1913**
In the Futurist Manifesto of 1911, under the heading 'The Painting of Sounds, Noises and Smells', Carrà called for artists to use 'all the colours of speed, of joy, of carousings and fantastic carnivals' in their representations of urban life.

Opposite: **Giacomo Balla, *Rhythm of a Violinist*, 1912**
Balla experimented with new ways of depicting movement, and was much influenced by photographic studies, superimposing a succession of images. His work tended increasingly towards abstraction.

them a debt. At a time when Cubism was largely unknown outside Paris, they used Cubist geometric forms and intersecting planes combined with complementary colours. In a sense, they put Cubism into motion.

Other influences also inspired the Futurists. Giacomo Balla (1871–1958), an older and more cautious signatory of the first manifesto of 1910, pursued a divisionist method of painting, influenced by Giovanni Segantini (see *Neo-Impressionism). He also experimented with the depiction of sequential movement, influenced by the photographic studies of animal and human locomotion by American Eadweard Muybridge (1830–1904), and by the 'chrono-photographs' of French physiologist Etienne-Jules Marey (1830–1904). The Futurists also shared the powerful contemporary concern with 'simultaneity', as posited by the enormously popular and influential French philosopher Henri Bergson (1859–1941). Bergson's theories about the fluidity of consciousness and the role of intuition in processing experiences and memory had a profound impact on a whole generation of artists and intellectuals (see also *Cubism and *Orphism). In his *Introduction to Metaphysics* (1903), Bergson wrote:

Consider the movement of an object in space. My perception of the motion will vary from the point of view, moving or stationary, from which I observe it…when I speak of an absolute movement, I am attributing to the moving object an inner life and, so to speak, states of mind.

After a major exhibition in Paris in 1912, which subsequently travelled widely, Futurist art and theory spread quickly throughout Europe, Russia and the USA, and it became a significant participant in the international avant-garde. In the exhibition catalogue the Futurists introduced a concept – 'lines of force' – that would become an identifying characteristic of Futurist work. 'Objects reveal in their lines calm or frenzy, sadness or gaiety', they declared.

Boccioni refined the colour theory and divisionist techniques of his teacher Balla to observe the abstract effects of light. He used colour to create a dramatic interaction between objects and space, which he termed 'dynamic abstraction'. After studying the work of sculptors associated with Cubism, Boccioni published his influential 'Futurist Manifesto of Sculpture' in 1912 in which he called for the use of non-traditional materials and for the sculptor to

'open the figure like a window and enclose within itself the environment in which it lives.'

The Futurists were active in other disciplines too, their work accompanied, as always, by their manifestos. In 1912 photographer and filmmaker Antonio Giulio Bragaglia (1889–1963) published his manifesto on 'photodynamics', and he later made a Futurist film, *Perfido Incanto* (roughly, Treacherous Enchantment). Also in 1912, Marinetti published his theory of 'free-word' poetry, in which words are liberated from conventional grammar and layout to assume new meanings from experimental typography and unorthodox layout. Russolo, meanwhile, was creating Bruitism, a form of music using *intonarumori* (noise machines), explained in his manifesto, 'The Art of Noises' (1913), and later explored by members of the *Dada group. On 11 March 1915 Balla and Fortunato Depero (1892–1960) published their manifesto 'Futurist Reconstruction of the Universe', proposing the creation of a more abstract Futurist style applicable to fashion, furnishings, interiors, in fact to a whole way of life. Rather improbably, given the misogynist nature of the movement, there was even a 'Manifesto of Futurist Women', written by a Frenchwoman, Valentine de Saint-Point (1875–1953): 'drive your sons, your men, to excel themselves. You create them. You can do everything with them!'

Architects Antonio Sant'Elia (1888–1916) and Mario Chiattone (1891–1957) joined the movement in 1914, and exhibited drawings for the cities of the future (*Città Nuova*) that captured wide attention. Sant'Elia's 'Manifesto for Futurist Architecture' (1914) demanded a new architecture for the new age – one built of the newest materials, using

Futurism lost their lives on military service – Boccioni fell from his horse while on exercise, and Sant'Elia was killed on the front line with the Lombardy Volunteer Cyclist Battalion. Their deaths marked the end of the most creative phase of the movement, which had begun with the call to glorify war. Marinetti continued his association with Mussolini, but led the Futurists in their withdrawal from Fascism in May 1920. He would later insist that Futurism expressed the 'dynamic spirit' of Fascism.

The momentum of the movement had been lost by the middle of World War I. As mechanized slaughter engulfed Europe, the cult of the machine became hard to sustain. Throughout the 1920s and 1930s, second-generation Futurists attempted to extend Futurist ideology and practice to installation, theatre design, graphics and advertising, with some success. Capturing the sensation of flight was even claimed by Futurism, with the 'Manifesto of Aeropittura' in 1929, which signalled the beginning of the movement's final phase.

Although primarily an Italian movement, and though short-lived, Futurist theory and iconography had a lasting impact on the international avant-garde. *Vorticism in Britain and *Rayonism in Russia were explicitly indebted to the Italian Futurists. Many ideas developed by the *Blaue Reiter group, Dada and the Russian *Constructivists originated with the Futurists. In the USA, Joseph Stella (1877–1946) is credited with introducing Futurist ideas. He became friends with Severini while living in France and Italy between 1909 and 1912, and on returning home he found the Futurist vocabulary one in which he was able to express his sense of urban America. His painting *Battle of Lights, Coney Island, Mardi Gras* (1913–14) shows how Futurist techniques were easily adopted in other countries to fulfil their aim of conveying the 'violent, dangerous pleasures' and the 'hectic mood' of the modern urban experience.

the latest technologies and conceived around the needs of modern living. Although Sant'Elia was killed before his new city could be realized, Matté Trucco's 40-hectare Fiat Works, Turin (1915–21) – which made innovative use of its flat concrete roof by incorporating a test track, where cars roared day and night above the production lines – would be a valid contemporary example of his visionary architecture.

Politics and Futurism were closely intertwined. Carrà's collage of 1914, *Words in Freedom: Interventionist Demonstration,* which is both a collage and a 'free-word' poem, conjures up the carnival-like atmosphere of a political demonstration. Many of the Futurists took part in demonstrations between 1914 and 1915 calling for Italy to enter the war. Marinetti cultivated a friendship with Mussolini, and they were both arrested in 1915 with Carrà after interventionist speechmaking. The campaign succeeded, and Italy joined the war against Germany and Austria-Hungary. In 1916 two of the most inventive exponents of

Above: **Sant'Elia, *La Città Futurista* from 'Manifesto of Futurist Architecture', 1914** Sant'Elia projected Futurist architectural fantasies into the popular imagination; his drawings were enormously influential. His buildings, however, exist only on paper; he was killed in 1916 at the age of twenty-eight.

Opposite left: **Marinetti and Marchesi in Turin with Marinetti's portrait by Zatkova** Marinetti was Futurism's dandyish founding visionary. He called himself *la caffeina dell' Europa,* the caffeine of Europe, and transmitted his own formidable energy into the cultural and political transformation of his age.

Opposite right: **Umberto Boccioni, *Unique Forms of Continuity in Space,* 1913** Boccioni, whose paintings had already earned him considerable distinction, turned his attention to sculpture in 1912, saying: 'Let us discard the finite line and the closed form statue. Let us tear the body open.'

Key Collections
Depero Museum, Rovereto, Italy
Estorick Collection of Modern Italian Art, London
Museum of Modern Art, New York
Pinoteca di Brera, Milan, Italy
Tate Gallery, London

Key Books
C. Tisdall and A. Bozzolla, *Futurism* (1978)
Italian Art in the 20th Century: Painting and Sculpture 1900–1988 (exh. cat., Royal Academy of Arts, London, 1989)
R. A. Etlin, *Modernism in Italian Architecture, 1890–1940* (Cambridge, MA, 1991)
R. Humphreys, *Futurism* (Cambridge, England, 1999)

Jack of Diamonds

*Aren't pictures like fabulous unknown countries stretching out at your feet;
aren't you the high-flier of contemporaneity?*

DAVID BURLIUK, 1912

The Jack of Diamonds, also translated as Knave of Diamonds (from the Russian, *Bubnovyi Valet*), was an artists' association founded in Moscow in 1910 to present exhibitions of new European and Russian art. Its membership included some of the most important avant-garde artists in pre-Revolutionary Russia: Mikhail Larionov (1881–1964); Natalia Goncharova (1881–1962) who was Larionov's lifelong partner; Piotr Konshalovsky (1876–1956); Aristarkh Lentulov (1878–1943); Robert Falk (1886–1958); Ilya Mashkov (1884–1944); Alexander Kuprin (1880–1960), and the brothers David (1882–1967) and Vladimir Burliuk (1886–1917). The name of the group was chosen to highlight their interest in popular graphic arts and to signal their irreverence for tradition. All the artists were influenced by avant-garde developments in Western art, such as *Post-Impressionism, *Fauvism and *Cubism, which were well known in Russia through the activities of the *World of Art and the Golden Fleece.

The first exhibition organized by the group in Moscow in December 1910 brought together contemporary works by both European and Russian avant-garde artists, among whom were the Paris-based Cubists Henri Le Fauconnier (1881–1946), André Lhote (1885–1962), Albert Gleizes (1881–1953) and Jean Metzinger (1883–1956); Russian artists working in Munich, Vasily Kandinsky (1866–1944) and Alexei von Jawlensky (1864–1941, see *Der Blaue Reiter); and Russians working in Russia, mostly members of the Jack of Diamonds. The Russian work fell into two distinct categories: those characterized by bright Fauve-like colours and simplified forms, by Lentulov, Konchalovsky, Falk and Mashkov, who were known as 'the Cézannists'; and Neo-Primitive works by Larionov, Goncharova and the Burliuk brothers. This studied Russian 'primitivism' was a

Above: **Ilya Mashkov, _Portrait of a Boy in an Embroidered Shirt_, 1909** Mashkov was one of a group of young Russian artists who rebelled against the Moscow Art School in 1909, exhibiting paintings influenced by Cézanne, the Post-Impressionists and the Fauves.

Opposite: **Mikhail Larionov, _The Soldiers_ (second version), 1909** Larionov's _Soldiers_ series of 1909–10, which he painted during his military service, caused a scandal, with their deliberate affront to the dictates of accepted taste in traditional academic painting, both Russian and French.

synthesis of European traditions and an interest in children's art and native Russian art – icon paintings, peasant wood-cuts and folk art.

After this exhibition, the Russian artists split into two camps. Accusing their former colleagues of being dominated by the 'cheap orientalism of the School of Paris', and of being followers of 'decadent Munich', Larionov and Goncharova founded the Donkey's Tail group in 1911. Its name was chosen after Larionov read an article concerning a group of French art students who had exhibited a painting that was made by tying a brush to a donkey's tail. The only exhibition of the Donkey's Tail group took place in March 1912, the first large all-Russian avant-garde show of its kind, representing a conscious break with European traditions in favour of work inspired by native Russian sources. Works by Kasimir Malevich (1878–1935) and Vladimir Tatlin (1885–1953), the founders of *Suprematism and *Constructivism respectively, were included. Most of the works exhibited were in the Neo-Primitivist style. Goncharova's religious paintings, denounced as blasphemous in such a setting, led to a public outcry. Shortly afterwards, the group disbanded, and the indefatigable Larionov and Goncharova founded *Rayonism.

The Jack of Diamonds existed as an exhibition society until 1918, promoting the European avant-garde. The second and third shows held in 1912 and 1913, organized by the Burliuks, included German *Expressionist paintings and work by Robert Delaunay (see *Orphism), Henri Matisse (see Fauvism), Pablo Picasso (see Cubism) and Fernand Léger. Many of the Russian artists involved developed a Cubo-Futurist style of painting, and exhibitions of 1914–16 included pioneering work by Liubov Popova (1889–1924). David Burliuk's enthusiastic lecturing and events organization earned him the title of the 'father of Russian Futurism'.

Key Collections
Fine Arts Museums of San Francisco, San Francisco, California
Los Angeles County Museum of Art, Los Angeles, California
State Russian Museum, St Petersburg
Tate Gallery, London
Tretyakov Gallery, Moscow

Key Books
The Avant-Garde in Russia, 1910–1930: New Perspectives (exh. cat., Los Angeles County Museum of Art, Los Angeles, 1980)
C. Gray, _The Russian Experiment in Art 1863–1922_ (1986)
J. E. Bowlt, _Russian Art of the Avant Garde: Theory and Criticism_ (1988)

Der Blaue Reiter

Our object is to show, in the variety of forms represented, how the inner desire of artists realizes itself in multiple fashion.

VASILY KANDINSKY, PREFACE, FIRST EXHIBITION OF THE EDITORS OF THE BLAUE REITER, 1911

Der Blaue Reiter (The Blue Rider), a group of Munich-based artists active from 1911 to 1914, was – with *Die Brücke – the most important movement within German *Expressionism. Der Blaue Reiter was a larger and looser association than Die Brücke, and its activities as a group, and the innovations of particular members, such as the Russian Vasily Kandinsky (1866–1944) and the Swiss Paul Klee (1879–1940), had an even greater impact on the international avant-garde. Other members included Germans Gabriele Münter (1877–1962, Kandinsky's partner), Franz Marc (1880–1916) and August Macke (1887–1914), and the Austrian Alfred Kubin (1877–1959). Kandinsky recounted in 1930 how the group's name came to be chosen:

> Franz Marc and I chose this name as we were having coffee one day on the shady terrace of Sindelsdorf. Both of us liked blue, Marc for horses, I for riders. So the name came by itself.

The group organized two important exhibitions and produced an almanac, *Der Blaue Reiter* (1912). They were united not by a common style but by an ideology – an unswerving and passionate belief in the unfettered creative freedom of the artist to express his personal vision in whatever form he deemed appropriate.

Kandinsky's ideas provided much of the early impetus of Der Blaue Reiter. By the time the group was formed, his work, increasingly abstract, was already well known throughout Europe. The 1912 almanac was an important statement of artistic intent, presented in a strikingly innovative way. It included essays on various media (including essays on music and text by the composer Arnold Schönberg and on Russian art by David Burliuk, see *Jack of Diamonds), and juxtaposed pictures by Blaue Reiter artists with those of artists from other cultures and periods to create a new picture of the history of art. It also showed their interest in mysticism, which identified them as late *Symbolists, and in primitive art, folk art, children's art, and the art of the mentally ill, all of which they embraced as valuable sources of inspiration. Most important of all, in essays by Kandinsky, Marc and Macke, the artists declared their belief in the symbolic and psychological efficacy of abstract forms. In the seminal essay 'On the Problem of Form', Kandinsky argued that art should be sacramental, an

outward and visible sign of an inward spiritual grace, and he defended the artist's freedom to choose his mode of expression, whether abstract, realist, or one of the 'many combinations of different harmonies of the abstract and the real'. The same year saw the publication of Kandinsky's deeply influential book *On the Spiritual in Art*, which developed the idea of art as a sort of spiritual autobiography, through which viewers might get in touch with their own spirituality. He sought a synthesis of intellect and emotion, and intended his painting to be as directly expressive as music. Indeed, his later visual work became a kind of *Abstract Expressionism, in which spiritual conflict is communicated and resolved in whirling forms, lines and colours released from any objectively descriptive role.

If Kandinsky's belief system can be described as an analytical spiritual mysticism, then Franz Marc's was a

Above: **August Macke, *Lady in a Green Jacket*, 1913**
Macke's landscapes are painted using a harmonious patchwork of colours reminiscent of the Orphist Robert Delaunay, a co-exhibitor at the Blaue Reiter shows in Munich in 1911 and 1912.

Opposite: **Franz Marc, *The Large Blue Horses*, 1911**
Marc's mature work uses Cubist and Futurist forms with dazzling colours and light to create images in which the animals have become one with nature. He regarded painting as a spiritual activity.

pantheistic philosophy, combining religious belief with a deep feeling for animals and nature. Originally a theology student, Marc took up painting as a spiritual activity. In 'Aphorisms, 1914–1915' he wrote: 'The art to come will be giving form to our scientific convictions. This art is our religion, our centre of gravity, our truth.' Animals were his obsession; in them he saw a purity and communion with nature that man had lost. Through them, or rather through their eyes (he wrote an essay entitled 'How Does a Horse See the World?'), he sought to make art that would lead him to a purer, more harmonious relationship with the world. Influenced by his younger friend August Macke, he used broad expanses of rich colour to express both conflict and harmony. In a letter to Macke in December 1910 he wrote:

> Blue is the male principle, astringent and spiritual. Yellow is the female principle, gentle, gay and spiritual. Red is matter, brutal and heavy and always the colour to be opposed and overcome by the other two.

Macke's own work is contrastingly urban. His joyful city scenes, painted in harmonies of expressive colour, make his work closer to that of his French contemporaries, the *Fauves and *Orphists, and remind us that it was never the purpose of Der Blaue Reiter artists to create a homogenous style. Klee too experimented with colour after Macke's example, but remained strongly individual. His watercolours in particular achieve a lyrical, semi-abstract quality, at once delicate and expressive. Like his friends

Kandinsky and Marc, Klee outlined his thoughts on the spiritual nature of art in 1920 in his 'Creative Credo', which includes his famous statement, 'Art does not reproduce the visible; rather, it makes visible.' He also wrote that 'Art is a simile of the Creation. Each work of art is an example, just as the terrestrial is an example of the cosmic.' At the other end of the spectrum, Kubin's work appears more Gothic in its Expressionism, presenting fantasies and nightmares reminiscent of the Symbolists and the *Decadents.

The 'First Exhibition of the Editors of the Blaue Reiter' (from December 1911 to January 1912) was hosted by the Thannhauser Gallery in Munich. It then became the inaugural exhibition of Herwarth Walden's Sturm-Galerie in Berlin and travelled to Cologne, Hagen and Frankfurt. Works by the Blaue Reiter artists were complemented by those of several others, including Heinrich Campendonk (1889–1957), Elizabeth Epstein (1879–1956), J. B. Niestlé (1884–1942), the Czech artist Eugen Kahler (1882–1911), the American Albert Bloch (1882–1961), the Russians David and Vladimir Burliuk, the Frenchmen Robert Delaunay (1885–1941, see Orphism) and Henri Rousseau (1844–1910) and drawings by the Austro-Hungarian Schönberg.

The 'Second Exhibition of the Editors of the Blaue Reiter' (from February to April 1912), held at the Goltz Gallery in Munich, was even more ambitious. Restricted to watercolours, drawings and printed graphics, it comprised

315 examples of new graphic art by thirty-one German, French and Russian artists, including Nolde, Pechstein, Kirchner, Heckel, Klee, Kubin, Arp, Picasso, Braque, Delaunay, Malevich, Larionov and Goncharova. These exhibitions created a sensation among artists, but almost completely confounded the critics and the public. Kandinsky's disappointment is apparent in his preface to the second edition of the almanac, which appeared in 1914:

One of our aims – in my eyes one of the main ones – has hardly been attained at all. It was to show, by examples, by practical juxtaposition and by theoretical demonstration, that the question of form in art is secondary, that the question in art is predominantly one of content... Perhaps the time is not yet ripe for 'hearing' and 'seeing' in this sense.

The outbreak of World War I brought an end to the group. Kandinsky was forced to return to Russia, Macke

Below: **Vasily Kandinsky,** *Improvisation 'Klamm',* **1914**
Preoccupations with colour and form appeared greater than the wish to represent objects, but between 1912 and 1914 Kandinsky's paintings are not fully abstract – recognizable shapes draw the viewer's attention.

Opposite: **Paul Klee,** *The Föhn Wind in the Marcs' Garden,* **1915**
'I must one day be able to fantasize on the colour-piano of neighbouring watercolour pans' (Diary, March 1910). After his visit to Tunis with Macke in 1914, Klee explored the translucent qualities of watercolour.

1915 102

Expressionism. Later, in 1924, two artists affiliated with Der Blaue Reiter (but not actually members), the Russian Alexei von Jawlensky (1864–1941) and the American Lyonel Feininger (1871–1956), founded Die Blaue Vier (The Blue Four) with Kandinsky and Klee. Again, the purpose of the association was to publicize their work and ideas through exhibiting together. Jawlensky, like Kandinsky, was convinced of the interrelationship of colours and sounds, describing some of his paintings as 'songs without words'. His warm passionate paintings characterized by simplification, bold colours and a sense of intense inner force, also point to the religious mysticism he shared with Marc and Kandinsky. Art, he declared was 'nostalgia for God'. Feininger's paintings, mostly of the city and its architecture, shift between abstraction and representation, combining strong straight lines with romantic colour. In their future careers, Kandinsky, Feininger and Klee would also play important roles as teachers in another avant-garde, the *Bauhaus.

Key Collections

Norton Simon Museum, Pasadena, California
Solomon R. Guggenheim Museum, New York
Stedelijk Museum, Amsterdam, the Netherlands
Tate Gallery, London

Key Books

A. Meseure, *Macke* (Bonn, 1993)
S. Barron and W. Dieter-Dube, *German Expressionism: Art and Society 1909–1923* (1997)
D. Elger and H. Bever, *Expressionism: A Revolution in German Art* (1998)
Paul Klee Foundation, *Paul Klee Catalogue Raisonné*, Vol. 1 (1998)

was killed in the first few weeks of the war, and Marc in the trenches at Verdun in 1916. Though Marc and Kandinsky had been working on a second volume of the almanac, it was never completed. Kandinsky wrote, 'The Blaue Reiter was the two of us: Marc and myself. My friend is dead, and I do not want to continue alone.'

Although the group did not survive World War I, its activities and accomplishments were far-reaching, eventually leading to fantasy art, *Dada, *Surrealism and *Abstract

Synchromism

Our dream for colour is of a nobler task. It is the very quality of form that we mean to express and reveal through it.

MORGAN RUSSELL AND STANTON MACDONALD-WRIGHT, 1913

Synchromism (derived from the Greek meaning 'with colour') was founded by two American painters, Morgan Russell (1886–1953) and Stanton MacDonald-Wright (1890–1973). Both men began as figurative painters, but

while living in Paris they became drawn to abstraction; influenced by avant-garde artists such as Henri Matisse (see *Fauvism), Frantisek Kupka and Robert Delaunay (see *Orphism) and Vasily Kandinsky (see *Der Blaue Reiter),

they began to explore the properties and effects of colour. They both studied under Ernest Percyval Tudor-Hart, a Canadian painter whose colour theory was closely linked to musical harmonies.

Russell and MacDonald-Wright sought to develop the structural principles of *Cubism and the colour theories of the *Neo-Impressionists, and their experiments in colour abstraction were close to those of the Orphists. So similar were they, in fact, that in 1913 the Synchromists issued a manifesto – one of the few groups of American artists to do so – proclaiming their originality, and stating that to see them as Orphists was to 'take a tiger for a zebra, on the pretext that both have a striped skin'. Regardless of who was first, what is striking is the similarity in interest of different groups of artists attempting to identify and define a language and vocabulary for abstract painting in its own right. Both strove to formulate a system in which meaning or significance did not rely on resemblance to objects in the outside world, but was derived from the results of colour and form on canvas.

Russell was also a musician and his intention was to formulate a colour theory in which the relationships between colours and forms would create rhythms and musical relationships. This desire to create 'sound' using colour

Above: **Morgan Russell, *Synchromy in Orange: To Form*, 1913–14**
Russell first used the word 'Synchromy' to describe a work in 1913, indicating the importance of the concept over subject matter. His own colour studies persisted after 1916, when Synchromism began to wane as a movement.

and shape – a form of 'synaesthesia', producing a mental sense-impression relating to one sense by stimulation of another – had been a concern of the French *Symbolists in the late nineteenth century, as well as of Kupka and Kandinsky. The musical analogy, and other Synchromist features, are visible in Russell's monumental painting *Synchromy in Orange: To Form* (1913–14). Here, chromatic combinations and Cubist structures are brought alive by free-flowing rhythms and arcs that create a sense of movement and dynamism.

The Synchromists exhibited in Munich, in Paris at the Bernheim-Jeune gallery – during which they attracted the attention of the critics Guillaume Apollinaire and Louis Vauxcelles – and in New York in 1913 and 1914 to uproar and controversy. But though they scandalized the public, they were enormously influential on American artists, particularly after their inclusion in the seminal Armory Show in New York in 1913, the moment when European modernism arrived in the USA. Thomas Hart Benton (1889–1975, see *American Scene), Patrick Henry Bruce (1880–1937) and the Symbolist Arthur B. Davies (1862–1928) are amongst those who were called Synchromists at some point during their careers. Many of the Synchromists were included in 'The Forum Exhibition of Modern American Painters' in New York in 1916, an exhibition organized by Stanton's brother, Willard Huntington Wright.

By the end of World War I Synchromism had almost entirely died out, with many of its practitioners returning to figuration. Disillusionment with Europe caused by the war, led to a rejection of European modernism and a renewal of interest in work that seemed more 'American' (see American Scene and *Social Realism). However, MacDonald-Wright eventually returned to Synchromist paintings following Russell's death in 1953.

Key Collections
Montclair Art Museum, Montclair, New Jersey
Frederick Weismant Art Museum, University of Minnesota, Minneapolis, Minnesota
Whitney Museum of American Art, New York

Key Books
W. C. Agee, *Synchromism and Color Principles in American Painting* (1965)
The Art of Stanton MacDonald-Wright (exh. cat., Washington, D.C., 1967)
G. Levin, *Synchromism and American Color Abstraction* (1978)
M. S. Kushner, *Morgan Russell* (1990)

Orphism

Orphic Cubism...is the art of painting new structures out of elements...created entirely by the artist himself, and...endowed with the fullness of reality.

GUILLAUME APOLLINAIRE, LES PEINTRES CUBISTES: MEDITATIONS ESTHETIQUES, 1913

Orphism – or Orphic Cubism – was coined by the critic-poet Guillaume Apollinaire (1880–1918) in 1913 to describe what he regarded as a 'movement' within *Cubism. Unlike Cubist works by Pablo Picasso or Georges Braque, these new abstract paintings were bright lozenges and swirls of saturated colour dissolving into each other. Apollinaire at various times labelled the artists Marcel Duchamp (1887–1968, see *Dada), Francis Picabia (1879–1953, see Dada), Fernand Léger (1881–1955, see Cubism), Frantisek Kupka (1871–1957), and Robert (1885–1941) and Sonia Delaunay (1885–1979) as Orphists, identifying in their work a tendency towards further fragmentation of Cubism through colour.

'Orphic' was a favourite adjective of the *Symbolist poets (including Apollinaire), referring to the myth of Orpheus, the legendary Greek poet and lyre-player, whose music could tame wild beasts. For those poets, Orpheus was the archetypal artist, standing for the irrational power of art, a power at once romantic, musical and hypnotic, drawing on mysticism and even occultism in its alchemy. Of particular interest to Apollinaire was the possible fusion of music and the other arts, symbolized by Orpheus. Encouraged by his friendship with Picabia and his wife Gabrielle Buffet-Picabia, a musician, and by Vasily Kandinsky's (see *Der Blaue Reiter) recently published *On the Spiritual in Art* (1912), he developed the analogy between music and painting, and applied it to the new painters. He thought that their pure colour abstractions, lyrical and sensual, worked directly on the sensibilities of viewers, as music did. 'They are thus driving themselves', he wrote, 'toward an entirely new art which will be to painting, as known up until now, what music is to poetry.'

The Czech painter Kupka had no doubts about the 'musical' powers of his art, and often signed his letters as 'colour symphonist'. Arguably the most important aspect of Kupka's work, however, is its mysticism. Kupka was attuned to the spiritual from an early age. As a youth in Bohemia, he was apprenticed to a saddler who was also the local medium. Later, studying art in Prague and Vienna, he came under the influence of the Nazarene religious painters, and enthusiastically adopted their doctrine of spiritual symbolism in art. He would adhere to this doctrine throughout his career, seeking to release spiritual significance through abstract

colour and shape. In 1896 he settled in Paris, where he earned a living as an illustrator and spiritualist. His interest in the physical properties of colour and in the depiction of movement was developed through contact with the Cubists and the chronophotographic theories of the French physiologist Etienne-Jules Marey (1830–1904), resulting in ground-breaking abstract work, such as *Disks of Newton (Study for Fugue in Two Colours)* of 1912. He wrote:

> It is necessary for an artist to seek and find a means by which he may express the material likeness of all movements and states of his inner life and through which he may capture all abstractions.

The two painters most enduringly associated with Orphism are the French painter Robert Delaunay and his Russian wife Sonia. Both were pioneers of colour abstraction. Prior to marrying Robert in 1910, Sonia had been painting intensely coloured *Fauve-like paintings, but between 1912 and 1914 she made her first abstract paintings in the Orphist style. One of her most important projects at this time was her collaboration with the poet Blaise Cendrars on the book of his poem *Prose on the Trans-Siberian Railway and of Little Jehanne of France.*

Robert studied *Neo-Impressionism, optics and the interrelationships of colour, light and movement. He arrived at the conclusion that 'the breaking up of form by light creates coloured planes' and this led directly to works

Above: **Roadster painted in imitation of a design by Sonia Delaunay, and model wearing a matching coat and hat, 1925**
Delaunay employed the principles of colour abstraction in various works of applied art; she designed clothes, both for the Ballets Russes and for her own thriving workshops and the Boutique Simultanée (1925).

such as *Simultaneous Contrasts: Sun and Moon* (1913), in which the principal means of expression lies in the composition of colour rhythms. Apollinaire called Delaunay's pictures 'coloured Cubism', but for Delaunay himself his work was a logical development of *Impressionism and Neo-Impressionism, and he even invented his own term 'simultanism' to describe it.

> I had the idea of a type of painting which would be technically dependent on colour alone, and on colour contrast, but would develop in time and offer itself to simultaneous perception.... I used Chevreul's scientific term of simultaneous contrasts to describe this.

The belief of the Orphists in the musical properties and spiritual power of their work made them natural allies of the German *Expressionists, especially the Blaue Reiter group. In 1911 Kandinsky invited Robert to participate in the Blaue Reiter's first exhibition, where his paintings exerted a considerable influence on Franz Marc, August Macke and Paul Klee, who then visited Robert in Paris in 1912.

Orphism made its Paris debut in March 1913 at the Salon des Indépendants. Apollinaire, once again, was its champion. He went on to triumphantly proclaim in the Orphic magazine *Montjoie!*, 'If Cubism is dead, long live Cubism. The kingdom of Orpheus is at hand!' By this time

the Delaunays had become popular and were the centre of a large circle of avant-garde artists and writers who supported their work. They went weekly to a dance-hall named Bal Bullier, which Sonia described as being 'what the Moulin de la Galette had been for Degas, Renoir and Lautrec.' It was for these outings that she made her first clothing inspired by their paintings.

It was Robert Delaunay's term 'simultanism', however, that would provoke the group's final arguments. The concept of simultaneity briefly became one of the most frequent topics of debate in the years leading up to World War I, not only in the visual arts but also in music and literature. Apollinaire adopted the term to describe his own 'Calligramme' poems, and in his book *Les Peintres cubistes* (The Cubist Painters) of 1913 he explained its meaning by saying that the 'works of the Orphic artist must simultaneously give a pure aesthetic pleasure, a structure which is self-evident, and a sublime meaning, that is, the subject.' This reflected the popular interest in the philosophical and psychological notions of the 'continuous present' and the role of intuition in artistic experience as presented in works such as Henri Bergson's influential book *Introduction to Metaphysics* which appeared in 1903.

But Robert Delaunay and Apollinaire could not agree on the precise meaning of 'simultanism' for art. In 1914 the two men fell out; Robert bitterly resented Apollinaire dubbing him a 'French Futurist'. Apollinaire no longer used the term 'simultanism' in his art criticism, and turned his attention to the Italian *Futurists. The other painters he had designated Orphists threw off the classification, and the term fell into disuse.

While Robert continued in his quest for 'pure painting', Sonia, in order to support her family during and after World War I, concentrated on the applied arts for which she became best known. Her strong sense of colour and design and the clothes she created for famous women, such as Hollywood actress Gloria Swanson and socialite and writer Nancy Cunard, made her an influential figure in the world of international textile design and fashion. During the war the Delaunays met the impresario Sergei Diaghilev (see *World of Art) in Madrid, and he commissioned them to design the costumes and sets for the Ballets Russes revival of

Cleopatra. Later, during the 1920s, both Sonia and Robert made paintings and designs in the *Art Deco style. In 1930 Sonia returned to painting, becoming a member of the Abstraction-Création association, where she was joined a year later by Kupka.

Above: Sonia Delaunay, cover design (1912) of fabrics for a book
In her multiple activities – painting, illustration, collage, clothing design and decorative book binding – Delaunay contrasted her husband Robert's 'scientific' attitude with her own intuitive approach.

Opposite: Robert Delaunay, *Formes circulaires, Soleil Lune (soleil et lune, simultané n. 2)*, 1913 (dated 1912 on painting)
Robert Delaunay used colour to create rhythmic relationships within near-abstract compositions. He described his paintings as 'simultaneous contrasts', in conscious reference to terms used by French chemist and colour theorist M. E. Chevreul.

Key Collections
Gallery of Modern Art, Prague, Czech Republic
Musée National d'Art Moderne, Paris
Museum of Modern Art, New York
Tate Gallery, London

Key Books
R. Shattuck, *The Banquet Years: The Origins of the Avant Garde in France, 1885 to World War I* (1968)
V. Spate, *Orphism* (1979)
S. A. Buckberrough, *Robert Delaunay* (Ann Arbor, MI, 1982)
S. Baron and J. Damase, *Sonia Delaunay: the Life of an Artist* (1995)

Rayonism

We declare the genius of our days to be: trousers, jackets, shows, tramways, buses, aeroplanes, railways, magnificent ships – what an enchantment...

RAYONIST MANIFESTO, 1913

Rayonism, or Rayism (from the Russian *luch*: ray), was launched by the painter-designers Mikhail Larionov (1881–1964) and Natalia Goncharova (1881–1962) in Moscow in March 1913 with an exhibition entitled 'The Target'. The exhibition featured Rayonist works which they had been developing since 1911, alongside their Neo-Primitive work and Cubo-Futurist canvases by Kasimir Malevich (1878–1935). The Rayonist Manifesto appeared in April 1913.

Like many of their contemporaries (see *Der Blaue Reiter, *Cubism, *Futurism, *Synchromism, *Orphism , *Vorticism), the Rayonists were engaged in creating an abstract art complete with its own terms of reference; as Larionov acknowledged, their art can be considered a 'synthesis of Cubism, Futurism and Orphism'. 'If we wish to paint literally what we see,' he declared, 'then we must paint the sum of rays reflected from the object.' According to Larionov, Rayonist paintings depict not objects but the

intersection of rays reflected from them. As rays are represented by paint, Rayonism logically becomes a 'style of painting independent of real form', creating what he termed a 'fourth dimension'. The use of a dynamic line to convey movement, and the declamatory wording of their manifesto, related the Rayonists to the Italian Futurists, and they displayed the same passion for the machine aesthetic.

Larionov and Goncharova had already been instrumental in the Russian avant-garde with the *Jack of Diamonds group, which promoted a unique fusion of Western avant-garde developments and native Russian folk art. A synthesis of different influences also lay behind Rayonism: on the one hand were the 'broken', jewel-like surfaces found in the

Natalia Goncharova, *Airplane over a Train*, 1913
Goncharova shared the Futurist passion for machines and mechanized movement. She and Larionov published a Rayonist manifesto, which profoundly influenced the next generation of the Russian avant-garde.

work of the Russian *Symbolist, Mikhail Vrubel (1856–1910); on the other hand lay Larionov's interest in science, optics and photography (he discovered the contemporaneous development of a technique called 'ray gum' by a Moscow photographer, A. Trapani).

To promote their new art, the Russian Rayonists and Futurists often painted their faces with Rayonist designs for public appearances, such as in parades or at lectures. Larionov explained:

> We have joined art to life. After the long isolation of artists, we have loudly summoned life and life has invaded art, it is time for art to invade life. The painting of our faces is the beginning of the invasion. That is why our hearts are beating so.

Larionov and Goncharova's Neo-Primitive and Rayonist work appeared in exhibitions and was debated in journals, and it quickly became well known throughout Russia and Europe. Between 1912 and 1914, their work was exhibited in London, Berlin, Rome, Munich and Paris, and a huge solo exhibition of over 700 pieces by Goncharova in Moscow in 1913 attracted wide international attention. The French poet and critic Guillaume Apollinaire championed their work and the Russian poet Marina Tsvetayeva identified Goncharova's work as 'the meeting point of West and East, Past and Future, people and an individual, labour and talent.'

By the time of the 1917 revolution in Russia, Larionov and Goncharova were already settled in Paris and they had abandoned Rayonism in favour of their more 'primitive' style. Their attention turned to designing costumes and sets for dance productions, notably for Sergei Diaghilev's Ballets Russes. Although short-lived, Rayonist work and theory proved influential on the next generation of avant-garde Russian artists, particularly Malevich and the *Suprematists, and was instrumental in the development of abstract art in general.

Key Collections
Centre Georges Pompidou, Paris
Fine Arts Museums of San Francisco, San Francisco, California
Guggenheim Museum, New York
Tate Gallery, London

Key Books
C. Gray, *The Russian Experiment in Art 1863–1922* (1986)
J. E. Bowlt, *Russian Art of the Avant Garde: Theory and Criticism* (1988)
A. Parton, *Mikhail Larionov and the Russian Avant-garde* (Princeton, NJ, 1993)
Y. Kovtun, *Mikhail Larionov* (1997)

Suprematism

To the Suprematist the visual phenomena of the objective world are, in themselves, meaningless; the significant thing is feeling.

KASIMIR MALEVICH, 1927

Suprematism was an art of pure geometrical abstraction devised by the Russian painter Kasimir Malevich (1878–1935) between 1913 and 1915. Malevich had previously been working in Neo-Primitive and Cubo-Futurist styles, and had been part of the circle around Mikhail Larionov and Natalia Goncharova (see *Jack of Diamonds and *Rayonism). But by 1913 he had arrived at a new radical position. As he explained later: 'In 1913, trying desperately to liberate art from the ballast of the representational world, I sought refuge in the form of the square.' Geometric shapes, particularly the square, found neither in Nature nor in traditional painting, symbolized for Malevich the supremacy of a world greater than the world of appearances. Malevich was a Christian mystic, and like his compatriot

Vasily Kandinsky (see *Der Blaue Reiter), believed that the making and reception of art was an independent spiritual activity, divorced from any notions of political, utilitarian or social purposes. He felt that this mystical 'feeling', or 'sensation' (as opposed to human emotions) could best be conveyed by the essential components of painting – purified form and colour.

Suprematism soon emerged as one of two radical art movements based on geometric abstraction in pre-Revolutionary Russia. The other was *Constructivism, led by Vladimir Tatlin, who believed, in direct opposition to Malevich, that art must serve a social purpose. The ideological split between the two groups created a tense rivalry between their two strong-willed leaders, which actually

culminated in a fist fight before a joint exhibition in December in St Petersburg in 1915, the 'Last Futurist Exhibition of Pictures: 0–10'. As a result, the work of the two groups was shown in separate rooms.

The exhibition itself was a triumph, showing over 150 works by fourteen artists. It was the public debut of Suprematist painting, which was accompanied by manifestos and pamphlets, including Malevich's leaflet 'From Cubism and Futurism to Suprematism: The New Realism in Painting', in which he explained Suprematism and claimed authorship of it. The famous *Black Square* (c. 1915) has been the subject of much critical debate. In his own manifesto Malevich described the black square as the 'zero of form' and the white background as 'the void beyond this feeling', and placed it in the context of his credo:

> Only when the habit of one's consciousness to see in paintings bits of nature, madonnas and shameless nudes has disappeared, shall we see a pure-painting composition…. Art is moving towards its self-appointed end of creation, to the domination of the forms of nature.

Like others of his generation (see *Futurism, *Orphism and *Synchromism), Malevich believed in the power of art to express the feelings of sounds, the spirit of scientific achievements, and what he called the 'sensation of infinity'. After his initial works of simple geometric shapes painted in black, white, red, green and blue, he began to include more complicated shapes and a broader range of colours and shadows, creating an illusion of space and movement as the elements seem to float in front of the canvas. This is reflected in the titles of many of the paintings of the period, such as *Suprematist composition: Airplane Flying* (1914–15) *Suprematist composition expressing the feeling of wireless telegraphy* (1915), and *Suprematist composition conveying the feeling of a mystic 'wave' from outer space* (1917). His search for a pictorial language that could communicate directly to the subconscious culminated in the *White on White* series of 1917–18. He presented this highly reductive series of white squares faintly etched on a white background with the statement: 'I have broken the blue shade of colour boundaries and come out into white. Behind me comrade pilots swim in the whiteness. I have established the semaphore of Suprematism. Swim!' The *White on White* paintings can also be seen in the context of the antagonism between the Suprematists and

Constructivists (almost immediately Alexander Rodchenko responded with his *Black on Black*, metaphorically obliterating Malevich's work).

Suprematism attracted many followers, including Liubov Popova (1889–1924), Olga Rozanova (1886–1918), Nadezhda Udaltsova (1886–1961), Ivan Puni (1894–1956) and Kseniya Boguslavaskaya (1882–1972). After the October Revolution of 1917, despite Malevich's resistance to the idea that art should serve a utilitarian purpose, Suprematism flourished. By 1918, a newspaper had reported: 'Suprematism has blossomed throughout Moscow. Signs, exhibitions, cafes, everything is Suprematist. One may with assurance say that Suprematism has arrived.'

The Revolution had been supported whole-heartedly by most avant-garde artists; for a while the new regime embraced experimental art. In 1919 Malevich's *White on White* series was exhibited in the 'Tenth State Exhibition. Abstract Creation and Suprematism', a major show of 220 abstract works of various tendencies, which announced non-representational art as Soviet art. It was the high point of Suprematism.

Malevich moved to Vitebsk, and devoted his time to teaching, writing and architecture (making models for futuristic homes and cities). He ousted Marc Chagall as director of the Vitebsk art school and founded the group Unovis (Champions of the New Art), which included Ilya Chashnik (1902–29), Vera Eermolaeva (1893–1938), El Lissitzky (1890–1947), Nikolai Suetin (1897–1954) and Lev Yudin (1903–41). They applied Suprematist designs to porcelain, jewelry, textiles and, for the third anniversary of the Revolution in 1920, to walls all over the city.

Malevich's drawings and models of buildings and cities were not designed with function or practicality in mind, but as abstractions to capture the essence, or 'idea', of the project. His insistence on 'pure art' soon fell out of favour, as artists turned to utilitarian art and industrial design. Suprematism was superseded first by Constructivism, then, as the period of state support for experimental abstract art came to an end in the late 1920s, by *Socialist Realism. Although he stayed in the Soviet Union until his death in 1935, Malevich's personal reputation dwindled. By this time, however, Malevich's ideas and designs had reached Central and Western Europe. A major retrospective of his

work in Poland and Germany in 1927, and the publication of a collection of his essays, *The World of Non-Objectivity*, by the *Bauhaus in the same year, made his ideas widely known. Suprematism became a starting point for others – influencing not only the development of European Constructivism, but also the design teaching of the Bauhaus, the *International Style of architecture and the *Minimalist art of the 1960s.

Above: Kasimir Malevich, *Suprematist Painting*, 1917–18
Malevich's paintings gathered an extraordinary following. Despite their radical idiom, their paint-on-canvas mode of representation roots them in a traditional form, distinct from Constructivism's 'culture of materials'.

Opposite: Kasimir Malevich's paintings exhibited at the 0–10 exhibition, St Petersburg, 1915 Malevich's *Black Square* hangs in the manner of an icon across the corner of the gallery. Puni and Boguslavaskaya's 'Suprematist Manifesto' declared: 'A picture is a new conception of abstracted, real elements, deprived of meaning.'

Key Collections
Fine Arts Museums of San Francisco, San Francisco, California
Museum of Modern Art, New York
Stedelijk Museum, Amsterdam, the Netherlands
Tretyakov Gallery, Moscow

Key Books
Annely Juda Fine Art Gallery, *The Suprematist Straight Line* (1977)
C. Gray, *The Russian Experiment in Art 1863–1922* (1986)
J. E. Bowlt, *Russian Art of the Avant Garde: Theory and Criticism* (1988)
C. Douglas, *Malevich* (1994)

Constructivism

Art into Life!

VLADIMIR TATLIN

Around 1914, as Kasimir Malevich was formulating *Suprematism, Vladimir Tatlin (1885–1953) made his first constructions, instigating the Constructivist movement (though at first the artists called themselves Productivists), which six years later would oust Suprematism as the leading style in Russia.

At the exhibition which launched Suprematism, the 'Last Futurist Exhibition of Pictures: 0–10' (St Petersburg, December 1915), Tatlin exhibited his radical abstract geometric painting-reliefs and corner reliefs. These extraordinary assemblages were made from industrial materials – such as metal, glass, wood and plaster – and incorporated 'real' three-dimensional space as a sculptural material. This introduction of 'real' materials and 'real' space into sculpture had as revolutionary an effect on future art practices as did Malevich's paintings.

Both Suprematism and Constructivism drew on the ideas of *Cubism and *Futurism. Like the latter, they celebrated mechanized culture. But although their work shares certain visual characteristics – both are abstract and geometric – Malevich and Tatlin held opposing ideas about the role of art. Malevich believed that art was a separate activity without social or political obligations. Tatlin, on the other hand, believed that art could, and should, have an impact on society. Not only did this ideological conflict prevent a single unified movement of non-objective art in Russia, it also eventually divided the Constructivists themselves.

By 1917, Tatlin had been joined by a number of other artists, including the brothers Naum Gabo (1890–1977, Naum Neemia Pevsner) and Anton Pevsner (1884–1962) and the husband and wife team of Alexander Rodchenko (1891–1956) and Varvara Stepanova (1895–1958). Calling themselves Productivists, they set out to explore the artistic qualities inherent in materials, such as form and colour, and to capture the spirit of the technological modern age.

The Bolshevik Revolution in 1917 provided them with a great opportunity. The socialist Productivists were keen to be involved in the creation of the new society preached by the politicians of the new regime, and they relished the chance to work alongside workers, scientists and engineers. The regime, for its part, was pleased to find artists who wanted to support the Revolution. Tatlin in particular responded to the situation with evangelical energy, and his Monument to the Third International embodies the vision of both politicians and artists. The Monument, commissioned by the Revolutionary Department of Fine Arts in 1919, is actually a model of a building for the Third International Communist Congress to be held in Moscow in 1921. It was an audacious and visionary design, but it was never built – it could not have been built in the technologically backward Soviet Union. However, it still stands as a powerful, if poignant, monument to the utopian Soviet dream and the passionate belief that the modern artist-engineer could play an integral role in fashioning such a society.

During the immediate post-Revolutionary period there were endless debates about the role of art and the artist in the new Communist society. Tatlin's tower, which he described as the 'union of purely artistic forms (painting, sculpture and architecture), for a utilitarian purpose', indicated the shift towards active social involvement. Not all Productivists were happy with this. In August 1920 Gabo and Pevsner broke ranks. Their 'Realistic Manifesto', which

Left: **Konstantin Melnikov, the Rusakov Club, Moscow, 1927**
Melnikov's architecture displayed 'geometrically progressive' structures, contrasting with the logarithmic spiral of Tatlin's famous tower (right). He exploited modern materials to monumental effect.

Opposite: **Vladimir Tatlin, Monument to the Third International, 1919** An enormous iron spiral tower, with a high-tech information centre, open-air screens to transmit news and propaganda, and a facility for projecting images onto clouds. Tatlin is shown in front, holding a pipe.

West, where it became known as European or International Constructivism.

In Russia, Productivism, or Soviet Constructivism, was still gathering pace and gaining new recruits. In 1921 in the exhibition '5 x 5 = 25', Rodchenko, Stepanova, Liubov Popova (1889–1924), Alexander Vesnin (1883–1959) and Alexandra Exter (1884–1949) each contributed five works and statements to the catalogue announcing the death of easel painting and their forthcoming dedication to production art. The same year, Rodchenko, Stepanova, Konstantin Medunetsky (1899–1935), brothers Vladimir (1899–1982) and Georgii (1900–33) Stenberg, Karl Ioganson (c. 1890–1929) and Alexei Gan (1893–1940) formed the First Working Group of Constructivists. Gan, a graphic artist, was also the main theorist of the group. He wrote:

> Taking a scientific and hypothetical approach to its task, the group asserts the necessity to fuse the ideological component with the formal component in order to achieve a real transition from laboratory experiments to practical activity.

Much Constructivist theory took the form of slogans, such as 'Down with Art! Long live technology!' and Tatlin's favourite, 'Art into Life!'. Constructivist manifestos were published in the avant-garde journals *Lef* (Left Front of the Arts) and its successor *Novyi Lef* (New LEF), and Gan promoted the Constructivist ideology in his book, *Constructivism* (1922).

The early and mid-1920s were the heyday of Constructivism. In the service of the new society Constructivist artists in Russia devoted themselves to designing everything from furniture and typography to ceramics and costumes. Olga Rozanova (1886–1918), Gustav Klutsis (1895–1944), Georgii Yakulov (1884–1928) and El Lissitzky (1890–1947) all strove to apply the language of abstract art to practical objects. In particular, pioneering contributions were made by Popova and Stepanova in textile design; by Vesnin, Popova, Yakulov and Exter in stage design; by Lissitzky in typography, exhibition and book design, and by Rodchenko in photography and poster design. Lissitzky invented 'proun' – an abbreviation of 'Pro-Unovis' (the school for new art). The term served as the title of many of his abstract paintings aimed at defining a new realm of two- and three-dimensional art. In 1923

accompanied an outdoor exhibition of their work in Moscow, established five principles of a new constructive abstract art. Many of their statements (the renunciation of descriptive uses of colour, line, mass and volume, the call to use 'real' industrial materials) were uncontentious, but they could not accept Tatlin's view that art must have a direct social and political dimension. The result was an ideological clash between two factions of Productivists, both of which, confusingly, now called themselves Constructivists. Gabo dismissed Tatlin's model of the Monument to the Third International ('Not pure constructive art, but merely an imitation of the machine'), and Tatlin, Rodchenko and Stepanova published the 'Programme of the Productivist Group', in which they reaffirmed their commitment to the 'production art' of the artist-engineer. This approach was better suited to the Communist regime, and many of those supporting the 'pure' art approach, such as Gabo and Pevsner left Russia. Gabo emigrated in 1922, and Pevsner in 1923, spreading their version of Constructivism to the

Above: **El Lissitzky,** *Beat the Whites with the Red Wedge,* **1919–20**
Lissitzky's famous civil war propaganda poster delivers its starkly legible message with simple but powerful graphic symbols, instead of using words and pictures in a conventional arrangement.

Left: **Spread from** *Lef,* **no. 2, 1923**
Varvara Stepanova, designs for sports clothes (left); Alexander Rodchenko, logo designs (right). Stepanova, like Popova, was a pre-eminent textile designer. The Constructivist designer was not a mere artist, but a creative technician dedicated to a social purpose.

Lissitzky exhibited the Proun Room, a small cell with a continuous relief over all its surfaces, at the Grosse Berliner Kunstausstellung (Great Berlin Art Exhibition).

Constructivist architecture – often designed but not built – flourished. Ivan Leonidov (1902–59), Konstantin Melnikov (1890–1974) and the brothers Alexander, Leonid (1880–1933) and Victor Vesnin (1882–1950) were among the earliest practitioners of a style of bold designs that used modern materials and emphasized the transparency of the function and construction of the different parts of a building. These became the main characteristics of Constructivist architecture in the Soviet Union and eventally part of the architectural vocabulary of the *International Style. In 1929 Lissitzky described these qualities, writing about A. Vesnin's design for the Pravda building in Moscow (1923):

> All accessories…such as signs, advertising, clocks, loudspeakers and even the elevators inside, have been incorporated as integral elements of the design and combined into a unified whole. This is the aesthetic of Constructivism.

The reign of Soviet Constructivism as the unofficial style of the Communist state had ended by the late 1920s with the introduction of Stalin's five-year plans and then the subsequent prescription of *Socialist Realism as the official style of Communism. By this time, however, the gospel of the Russian abstract movements had already been spread, thanks to exiles such as the Pevsner brothers and Lissitzky.

Between 1921 and 1928 Lissitzky spent time in Germany, the Netherlands and Switzerland, making contact with numerous groups of avant-garde artists (including *Dadaists George Grosz in Berlin and Kurt Schwitters in Hanover) and collaborating with them on Constructivist publications and exhibitions. He organized and designed a major exhibition of abstract Russian art in Berlin and Amsterdam in 1922 which included Suprematist and Constructivist work by Lissitzky, Malevich, Rodchenko and Tatlin. Russian modern art was influential for *De Stijl artists and architects and the *Bauhaus.

Despite their differing ideological agendas, the visual vocabulary of abstract, geometrical forms initiated by the Suprematists and Constructivists had a profound impact on painting, sculpture, design and architecture throughout the world. Similarly, the debate between 'art for art's sake' and 'art for life's sake', which was played out between these two groups, and within the Constructivists themselves, persists throughout the history of art.

Key Collections
Museum of Modern Art, New York
State Russian Museum, St Petersburg
Tate Gallery, London
Tretyakov Gallery, Moscow

Key Books
J. Milner, *Vladimir Tatlin and the Russian Avant-Garde* (New Haven, CT, 1983)
S. Lemoine, *Alexandre Rodchenko* (1987)
C. Mount, *Stenberg Brothers* (1997)
John E. Bowlt and Matthew Drutt (eds), *Amazons of the Avant-Garde* (exh. cat., Solomon R. Guggenheim Museum, New York, 1999)

Pittura Metafisica

To become truly immortal a work of art must escape all human limits: logic and common sense will only interfere.

GIORGIO DE CHIRICO, 1913

Pittura Metafisica (Metaphysical Painting) is the name given to the style of painting that was developed from around 1913 by Giorgio de Chirico (1888–1978) and later by the former *Futurist, Carlo Carrà (1881–1966). In contrast to the noise and movement of Futurist works, Metaphysical paintings are quiet and still. They are recognizable by a number of characteristics, notably the architectural scenes with classical trimmings, distorted perspectives, and strange dream imagery; the juxtaposition of incongruous objects, such as gloves, portraits busts, bananas, trains; and, above all, their disquieting air of mystery. Human presence – and absence – which is suggested by classical statues or featureless mannequins, is no less unsettling.

The Metaphysical painters believed in art as prophecy and in the artist as the poet-seer who, in 'clear-sighted' moments, could remove the mask of appearances to reveal

the 'true reality' that lay hidden behind. Their strategy was to transcend the physical appearance of reality, to unnerve or surprise the viewer with indecipherable or enigmatic images. Although they were not interested in naturalistic representation, nor in recreating any specific time or place, they were fascinated by the eeriness of everyday life, and – like the *Surrealists, by whom De Chirico was later canonized – aimed to create an atmosphere that captured the extraordinary of the ordinary. As De Chirico wrote in 1919: 'Although the dream is a very strange phenomenon and an inexplicable mystery, far more inexplicable is the mystery… our minds confer on certain objects and aspects of life.'

Many of his paintings show a desolate city square or claustrophobic interior painted in sombre colours with theatrical lighting and ominous shadows. Some may have been based on scenes in Turin and Ferrara, where De Chirico lived. Describing his own work, he spoke of the loneliness created when 'still lifes come alive or figures become still'.

On the other hand, Carrà's pictures generally show a lyrical approach to the same type of iconographical images, with more light, brighter colours and occasional humour. While his works are disconcerting they are seldom sinister; they are more in the spirit of the 'theatre of the absurd' than the 'theatre of cruelty'.

Carrà and De Chirico met in 1917 at the military hospital in Ferrara, where both were recovering from nervous breakdowns; they soon began working closely together. Carrà joined De Chirico, his brother, Alberto Savinio (1891–1952), a writer and composer, and Filippo de Pisis (1896–1956), a poet and later a painter to form the Scuola Metafisica (Metaphysical School). Much of their thinking was informed by the brothers' interest in the German

Above: **Giorgio de Chirico, *Place d'Italie*, 1912**
Typical of De Chirico's paintings are the brooding classical statue, the lengthening shadows, the passing train and deserted city square, all of which contribute to the sense of loneliness and mystery.

philosophers Arthur Schopenhauer (1788–1860) Friedrich Nietzsche (1844–1900) and Otto Weininger (1880–1903), whose work they had read while living in Munich from 1906 to 1908. Schopenhauer's idea of intuitive knowledge, Nietzsche's theory of the enigma, and Weininger's notion of geometric metaphysics all supported and fed into the artists' own ideas.

Another important influence and source of support was Guillaume Apollinaire (1880–1918), the French poet and art critic, who was the first to call De Chirico's painting 'metaphysical' in 1913. They met regularly between 1911 and 1913 while De Chirico was living in Paris. This was the period when Apollinaire was involved with *Orphism, and certain Orphic themes (the redemptive qualities of art, the idea of art as a mystical or esoteric activity) can be felt in the work of the Metaphysical School.

The School only lasted until around 1920, when a bitter argument between De Chirico and Carrà as to who had initiated the movement split the group. By that time the style of the Pittura Metafisica had been spread by the publication *Valori plastici* (Plastic Values, 1918–20), which also sponsored travelling shows. In 1921, the exhibition entitled 'Young Italy' was dominated by the metaphysical paintings of Carrà, De Chirico and Giorgio Morandi (1890–1964) who had adapted aspects of the styles.

Although the Scuola Metafisica proved to be short-lived, the Pittura Metafisica style was highly influential throughout the 1920s. In Italy the artists who found inspiration in it included members of the *Novecento Italiano, such as Felice Casorati and Mario Sironi; in Germany it made a significant impact on artists such as George Grosz (see *Neue Sachlichkeit), Oskar Schlemmer (see *Bauhaus) and Max Ernst (see Surrealism); in Paris De Chirico was hailed as a notable precursor of Surrealism.

Key Collections
Fine Arts Museums of San Francisco, San Francisco, California
Museum of Modern Art, New York
Pinacoteca di Brera, Milan, Italy
Staatsgalerie, Stuttgart, Germany

Key Books
G. de Chirico, *Giorgio de Chirico* (1979)
P. Gimferrer, *Giorgio de Chirico* (1989)
G. de Chirico, *Giorgio de Chirico and America* (1996)
K. Wilkin and G. Morandi, *Giorgio Morandi* (1999)

Vorticism

At the heart of a whirlpool is a great silent place where all the energy is concentrated. And there, at the point of concentration, is The Vorticist.

WYNDHAM LEWIS

Vorticism was founded in 1914 by the writer and painter Wyndham Lewis (1884–1957) to reinvigorate British art with an indigenous movement intended to rival continental European *Cubism, *Futurism and *Expressionism. Almost immediately engulfed by the onset of World War I, Lewis and his colleagues nevertheless managed to produce an impressive body of work which included paintings characterized by slashing blocks of colour, sculptures mechanical and alien, and writings in which unbounded scorn mingled with passionate enthusiasm.

Lewis had formerly been a member of Roger Fry's Omega Workshops, but left after a quarrel with Fry and founded the Rebel Art Centre in 1914 as a rival group. He was joined by a number of other artists also dissatisfied with Fry's *Post-Impressionist aesthetics and Arts and Crafts

principles: Frederick Etchells (1886–1973), Edward Wadsworth (1889–1949) and Cuthbert Hamilton (1884–1959). They were soon joined by Jessica Dismorr (1885–1939); Helen Saunders (1885-1963); Lawrence Atkinson (1873–1931), William Roberts (1895–1980) and French sculptor and painter Henri Gaudier-Brzeska (1891–1915). Other artists who were also affiliated with Vorticism included David Bomberg (1890–1957), Jacob Kramer (1892–1962), British Futurist Christopher (C. R. W.) Nevinson (1889–1946), photographer Alvin Langdon Coburn (1882–1966) and the American-British sculptor Jacob Epstein (1880–1959).

The American poets T. S. Eliot (domiciled in Britain) and Ezra Pound were important literary allies, as was the philosopher T. E. Hulme (1883–1917). Hulme helped

Above: **Wyndham Lewis, *Timon of Athens*, 1913**
Although machines and factories were more commonly the subjects of Vorticist work, classical and literary themes also appealed to Lewis, especially those that lent themselves to his characteristic ruthless, mechanistic style.

prepare the way for the group with articles and lectures early in 1914, in which he expressed his belief that modern art should be 'angular...hard and geometrical [with] the presentation of the human body...often entirely non-vital, and distorted to fit into stiff lines and cubical shapes', an apt description of many Vorticist works.

Lewis and the Rebel Art Centre artists wanted to drag British art out of the past and create a contemporary, edgy abstraction that related to the world around them. Pound and Lewis founded the periodical *Blast: Review of the Great English Vortex* in 1914 to expound their ideas about the new movement which Pound christened 'Vorticism'. Pound saw the vortex as 'the point of maximum energy' and defined it as 'a radiant node or cluster...from which, and through which, and into which, ideas are constantly rushing.' Lewis wrote that the 'artist of the modern movement is a savage...this enormous, jangling, journalistic, fairy desert of modern life serves him as nature did more technically primitive man.'

Engagement with the machine age was an important feature of the rhetoric and imagery of the Vorticists. The Vorticists wanted their art to embrace 'the forms of machinery, factories, new and vaster buildings, bridges and works.' They employed an angular style and machine-like forms, but unlike the American *Precisionists, they did not choose overt machine imagery.

The only Vorticist exhibition was held in June 1915 at the Doré Gallery, London. Lewis continued his diatribe in the accompanying catalogue, defining Vorticism as:

(a) Activity as opposed to the tasteful Passivity of Picasso;

(b) Significance as opposed to the dull and anecdotal character to which the Naturalist is condemned;

(c) Essential Movement and Activity (such as the energy of a mind) as opposed to the imitative cinematography, the fuss and hysterics of the Futurists.

Like many of the European movements that preceded 1914, Vorticism was a casualty of the war. Gaudier-Brzeska and Hulme were killed in action, and most of the other members were absent from England on active duty. Lewis, Wadsworth, Roberts and Nevinson served as official war artists and applied the geometrical style to unflinching portrayals of the tragedies of the war.

Throughout the war Pound made a valiant attempt to sustain the movement. He published a memoir on Gaudier-Brzeska, wrote articles about the movement, and supported Coburn in his quest to create a form of abstract photography, which they called Vortography. Pound also convinced the New York collector John Quinn to collect Vorticist work and to host an exhibition of it in New York in 1917.

Although brief in duration, Vorticism made its mark and laid the ground for future developments in British abstract art. In the 1920s and 1930s something of the Vorticist style entered the mainstream – and popular consciousness – with Edward McKnight Kauffer's (1890–1954) posters for London Transport.

Key Collections
Imperial War Museum, London
London's Transport Museum, London
Museum of Modern Art, New York
Tate Gallery, London

Key Books
W. Wees, *Vorticism and the English Avantgarde* (Manchester, 1972)
R. Cork, *Vorticism and Abstract Art in the First Machine Age* (1975)
D. Peters-Corbett, *Wyndham Lewis and the Art of Modern War* (Cambridge, UK, 1998)
P. Edwards, *Wyndham Lewis* (2000)

Hungarian Activism

The journal MA *does not want to establish a new art school,
but a completely new art and world conception.*

IVÁN HEVESY, ART CRITIC FOR MA

Hungarian Activism was an avant-garde artistic, literary and political movement initiated in Budapest around 1914 by the poet, novelist, writer and theoretician Lajos Kassák (1887–1967). Kassák gathered together progressive artists, writers, critics and philosophers to join him in his attempts to reform the arts and create a socialist society. The artists included Sándor Bortnyik (1893–1976), József Nemes Lampérth (1891–1924), László Moholy-Nagy (1895–1946), László Perí (1899–1967), János Máttis Teutsch (1884–1960) and Lajos Tihanyi (1885–1938). No single style identified the group, but the artists were united by their rejection of the somewhat staid *Post-Impressionism which was holding sway in Hungary at the time. In their attempts to create a radical, modern art, they turned to newer international developments, such as *Cubism, *Futurism, *Expressionism, and later, *Dada and *Constructivism.

Activism's social and artistic message was spread through the journal *A Tett* (Action) edited by Kassák, seventeen issues of which were published from November 1915 to September 1916. *A Tett* was subsequently banned for printing 'propaganda hostile to the nation', but Kassák immediately responded with a new journal, *MA* (Today), published in Budapest from November 1916, until it too was banned in July 1919. *MA* was edited by Kassák and his brother-in-law Béla Uitz (1887–1972), a painter and graphic artist.

The group organized exhibitions of their work in Budapest from 1917 to 1919, when they supported the short-lived Hungarian Soviet Republic of 1919. With the crushing of the 133-day Republic, many of the Activists, including Kassák, Lampérth and Uitz, were arrested and most of them were forced to emigrate, settling in Austria, Germany, France and the Soviet Union.

From Vienna, Kassák relaunched *MA* in May 1920 as an international art review, and it rapidly became a focus for Hungarian exiles. Until it ceased publication in 1926 it was a forum for continuing Activist discussions about the role of art in society. Both the magazine and the group became more closely allied with the art and architectural debates of their Constructivist, Dada, *Bauhaus and *De Stijl contemporaries, all bent on similar radical reform. In 1921 Kassák added visual arts to his personal repertoire of activities. He began making a new type of pure geometric art, related to *Suprematism and Constructivism, based on the principles of modern architecture, which he called *Bildarchitektur* (Pictorial Architecture).

The following year, Kassák and Moholy-Nagy published *Buch neuer Künstler* (Book of New Artists), an illustrated survey of Constructivist, Futurist and *Purist art and architecture, which also carried illustrations of cars, aeroplanes and machines, highlighting their admiration of machine forms, and their belief in the power of functional architecture to transform society. Kassák's Activist-Constructivist theories influenced many of his contemporaries, including Bortnyik, Moholy-Nagy and Perí. Through Moholy-Nagy his ideas reached the Bauhaus. In 1926 Kassák ended his exile, and returned to Hungary, where he continued to play an important role in avant-garde movements.

Above: **Lajos Kassák, *Bildarchitektur* (Pictorial Architecture), 1922**
Kassák announced his paintings in the Activist manifesto of 1921, declaring: 'Architecture is the synthesis of the new order....
The absolute picture is Bildarchitektur. Art transforms us and we become capable of transforming our surroundings.'

Key Collections
Hungarian National Gallery, Budapest, Hungary
Janus Pannonius Museum, Pécs, Hungary
J. Paul Getty Museum, Los Angeles, California
National Museum of American Art, Washington, D.C.

Key Books
L. Neméth, *Modern Art in Hungary* (Budapest, 1969)
The Hungarian Avant Garde, The Eight and the Activists
 (exh. cat., Hayward Gallery, London, 1980)
Lajos Kassák (exh. cat. Matignon Gallery, New York, 1984)
László Moholy-Nagy, 1895–1946 (exh. cat., J. Paul Getty
 Museum, Los Angeles, 1995)

School of Amsterdam

I stand by my reconciliatory programme....
Function plus dynamics is the challenge.

ERICH MENDELSOHN

From around 1915 until approximately 1930, a group of Dutch architects, working mainly in Amsterdam, developed their own type of *Expressionist architecture characterized by strikingly innovative brick buildings which were firmly within local Dutch traditions. Like the German Expressionist architects, with whom they had a close affinity, they believed in the power of architecture to enhance quality of life. Unlike the contemporaneous *De Stijl architects, they rejected the glass and steel of modernism.

The leading architects of the School of Amsterdam were Michel de Klerk (1884–1923), Pieter Lodewijk Kramer (1881–1961) and Johann Melchior van der Mey (1878–1949). The common point of departure for their ideas and practice was the 'rationalist' architecture of the father of modern Dutch architecture, Hendrik Petrus Berlage (1856–1934), embodied in his Stock Exchange building in Amsterdam (1897–1903). While the School of Amsterdam rejected the sobriety of Berlage's work, it embraced his belief in the expressive possibilities of indigenous brick (red from Leiden, grey from Gouda and yellow from Utrecht) in buildings demonstrating an inventive use of exposed brick and concrete. They also drew on the example of *Art Nouveau architects, such as the Belgian Henry Van de Velde and the Catalan Antoni Gaudí (see *Modernisme), and, like them were receptive to 'exotic', non-European influences and natural forms. Their whimsical, playful buildings integrate architecture with an almost sculptural brickwork.

The Scheepvaarthuis (1911–16), an office building constructed to house six shipping companies, reflects both the architectural ideas of the School of Amsterdam and the function of the building itself. Designed by van der Mey, with the collaboration of de Klerk and Kramer, the richly decorated exterior of brick and concrete covers a reinforced concrete frame. The nature of the companies using the building is expressed in the maritime iconography of the decoration, and the dramatic character of the building is further heightened by a diagonal entrance. The fantastic

result recalls the buildings of Gaudí, and stands in stark contrast to the rational architecture of the period that can be found elsewhere.

Amsterdam's socialist city council, faced with the pressing need to provide more housing for its rapidly growing population, embraced the style of the School of Amsterdam as one that they considered would lend dignity and humanity to their projects. Important commissions began to follow from housing associations and through their work, van der Mey, Kramer and de Klerk made a lasting impact on urban development in Amsterdam.

The mature style of the School of Amsterdam is noticeably more restrained than that of the earlier Scheepvaarthuis. Many of these projects were collaborations, such as the design for the Eigen Haard Estate (1913–20), which was led by de Klerk and received input from the other architects. The housing estates designed by the architects of the School of Amsterdam also display affinities with the organic, 'thatched roof' vernacular architecture of Hendricus Theodorus Wijdeveld, though they display a more thorough structural approach. Wijdeveld spread the ideas of the School of Amsterdam through the magazine he edited, *Wendingen* (Turnings, 1918–36), the most influential Dutch architectural journal of its day. The tendency of the School of Amsterdam architects to create undulating brick surfaces earned their style the nickname of *schortjesarchitectuur* (apron architecture).

Despite de Klerk's death in 1923, the School of Amsterdam continued to attract attention throughout the 1920s, and to influence architectural projects in other cities, at

Michel de Klerk, Eigen Haard Estate, Amsterdam, 1913–20
Housing was dealt with holistically and adventurously by the School of Amsterdam. For a brief period, while budgets remained sufficient, and clients allowed them free rein, the architects created a visual spectacle which remains a prominent part of the city's appeal.

home and abroad. Erich Mendelsohn (see Expressionism) visited Amsterdam in the early 1920s at the invitation of Wijdeveld, and visited the Eigen Haard and Dageraad housing schemes, which were then under construction. The impact of his visit was felt immediately in his next project, the hat factory designed in Luckenwalde between 1921 and 1923 in a style modelled on de Klerk's Eigen Haard Estate.

Charles Holden (1875–1960), chief architect for London Transport, travelled to Amsterdam in 1930 in search of inspiration for a new style of station for his extension of the London Underground. He admired the brick buildings of the School of Amsterdam and imported aspects of its style, combining it with native elements, to create the classic architecture of the London Underground of the 1930s. In stations such as Sudbury Town and Arnos Grove the Dutch influence can be seen in the undisguised brickwork, the simple forms and restrained ornamentation. In the opinion of Nikolaus Pevsner, art and design historian, Holden's

Underground stations were 'more effective than any other English buildings designed between 1930 and 1935.'

Key Monuments

Michel de Klerk, Dageraad Estate, Amsterdam South, the Netherlands

—, Eigen Haard Estate, Amsterdam West, the Netherlands

Eric Mendelsohn, Steinberg, Hermann & Co. Hat Factory, Luckenwalde, Berliner Tageblatt, Berlin, Germany

Johann Melchior van der Mey, Scheepvaarthuis, Pr. Hendrikkade, Amsterdam, the Netherlands

Key Books

W. Pehnt, *Expressionist Architecture* (1980)

W. de Wit, *The Amsterdam School: Dutch Expressionist Architecture* (1983)

S. S. Frank, *Michel de Klerk 1884–1923* (Ann Arbor, MI, 1984)

M. Bock, et al., *Michel de Klerk (1884–1923)* (Rotterdam, 1997)

Dada

The good thing is that you cannot and probably should not understand dada.

RICHARD HUELSENBECK, MEMOIRS OF A DADA DRUMMER, 1974

Above: **Marcel Duchamp, *Fountain*, 1917, replica 1963**
Duchamp's porcelain urinal signed 'R. Mutt' famously took the art world to task for its supposed open-mindedness, while simultaneously making a pointed commentary on the weight a signature has in the valuation of a work of art.

Dada was an international, multi-disciplinary phenomenon, as much a state of mind or way of life as a movement. Dada ideas and activities developed in New York, Zurich, Paris, Berlin, Hanover, Cologne and Barcelona during and after World War I, as young artists banded together to express their anger at the war. For them, the escalating horrors of the war proved the failure and hypocrisy of all established values. They targeted not only the political and social establishments, but also the art establishment, aligned in bourgeois society with a discredited socio-political status quo. They believed that the only hope for society was to destroy those systems based on reason and logic and replace them with ones based on anarchy, the primitive and the irrational.

Employing deliberately outrageous tactics, they violently attacked the received traditions of art, philosophy and literature in their demonstrations, poetry readings, noise concerts, exhibitions and manifestos. Their venues were typically small and intimate; at the Cabaret Voltaire in Zurich, Alfred Stieglitz's Photo-Secession Gallery, the apartment of collectors Walter and Louise Arensberg and Marius de Zayas's Modern Gallery in New York and at the Club Dada in Berlin, they gathered to vent their rage and agitate for the annihilation of the old to make way for the new.

The term Dada was coined in Zurich in 1916. In true Dada fashion there are conflicting accounts as to the word's 'discovery'. Poet Richard Huelsenbeck (1892–1974) plausibly claimed that he chose the word at random with painter and musician Hugo Ball (1886–1927) from a German-French dictionary. Jean (Hans) Arp (1887–1966) took the opportunity to be a little more entertaining:

I hereby declare that Tristan Tzara found the word on February 6, 1916, at six o'clock in the afternoon; I was present with my twelve children when Tzara for the first time uttered this word which filled us with justified enthusiasm. This occurred at the Café de la Terrasse in Zurich, and I was wearing a brioche in my left nostril.

The Dadaists were pleased with the elasticity of the word. Ball recorded in his diary that 'Dada means in Romanian "Yes, Yes", in French a rocking- or hobby-horse. In German it is a sign of absurd naivety.' Other important Dadaists who were based in Zurich included Ball's wife, singer Emmy Hennings (1919–53), Romanian poet Tristan Tzara (1896–1963), Romanian painter and sculptor Marcel Janco (1895–1984), German painter and filmmaker Hans Richter (1888–1976), Arp and his future wife, Swiss painter, dancer and designer Sophie Taeuber (1889–1943). They established their base, the Cabaret Voltaire, in a seedy

part of Zurich near the river. It was there that the Dadaists held nightly performances of singing, music, dancing, puppetry and recitations (including the infamous occasion when poetry was read simultaneously in three languages accompanied by noise-music). Ball read his sound poems (chants of nonsense words 'zimzim urallala zimzim zanzibar'), and Tzara and Arp made their 'chance' works (either poems or collages) by ripping up pieces of paper and letting them scatter. Tzara's account of an evening in 1916 leaves no doubt as to the chaos and confusion of Dada events:

> Boxing resumed: Cubist dance, costumes by Janco, each man his own big drum on his head, noise…gymnastic poem, concert of vowels, bruitist poem, static poem chemical arrangement of ideas… More outcries, the big drum, piano and impotent cannon, cardboard costumes torn off the audience hurls itself into puerperal fever interrupt.

But there was nevertheless method in their madness. As Ball explained: 'Since no art, politics or religious faith seems adequate to dam this torrent, there remain only the *blague* and the bleeding pose.' Absurdist provocations such as these, whether aggressive or irreverent (which echoed the conscious outrageousness and theatricality of Marinetti and the *Futurists), challenged the status quo via satire, irony, games and word play. It was a tactic to be refined by the Dadaists in New York.

During the war, a group of Dadaists established themselves in New York, among them French-born Marcel Duchamp (1887–1968); French-born Cuban Francis Picabia (1879–1953); American *Precisionist and Dadaist Morton Schamberg (1881–1918) and American Man Ray (1890–1977). Picabia's *Portrait of Cézanne* (1920), a stuffed monkey as a group portrait of Cézanne, Renoir and Rembrandt, and Duchamp's *L.H.O.O.Q.* (1919) – the Mona Lisa with a beard and a moustache – are bold, iconoclastic attacks on the undisputed heroes of the art world. Duchamp's Mona Lisa employs the sort of visual and verbal joke so loved by Duchamp and his friends: the vandalism of the gesture is heightened by the obscene pun of the title: when pronounced letter by letter in French it may be read as *Elle a chaud au cul* (She's got a hot ass). The delight in paradox and interaction of the visual and the verbal are also integral features of Schamberg's blasphemous

Left: **Jean (Hans) Arp, *Collage Made According to the Laws of Chance*, 1916** Arp used chance to annihilate the past. 'We searched for an elementary art that would save mankind from the furious folly of these times.'

Opposite: **Hannah Höch, *Cut with the Cake Knife*, c. 1919** Höch's montages often included pictures of her friends or the famous. Here, Baader appears (with Lenin) just above the inscription 'Die grosse dada', and Höch's partner, Raoul Hausmann, hangs below with the body of a robot.

God (*c.* 1917), a plumbing trap on a box, and Man Ray's famous iron with spikes, *Gift* (1921), works which convey the aggression, humour and irreverence so central to Dada. Man Ray photographed Duchamp with a star shaved into his head, *Marcel Duchamp (Haircut for de Zayas)*, 1921 – an early example of *Body Art, perhaps, that demonstrates the collaborative, sometimes playful nature of Dada work during this period.

Duchamp dubbed the manufactured objects presented as art 'readymades'. He claimed his selection was never dictated by taste, but was 'based on a reaction of visual indifference'. This Dadaist practice of dislocating objects from their familiar context and presenting them as art radically altered the conventions of visual art.

Dada activity increased after World War I as its members dispersed to sites in Germany and Paris. Huelsenbeck formed the Club Dada in Berlin, whose major figures were John Heartfield (Helmut Herzfelde, 1891–1968) and his brother Wieland Herzfelde (1896–1988), Johannes Baader (1876–1955), Raoul Hausmann (1886–1971), George Grosz (1893–1959, see *Neue Sachlichkeit) and Hannah Höch (1889–1979). Their works are characterized by a fascination with machines and technology, and a willingness to use readymade materials. The political character of their works was significantly more pronounced than that of the Zurich or New York Dadaists. The incorporation of graphic fragments from everyday life recalls techniques employed by the *Cubists. Montage was their technique of choice, whether in the photomontages of Heartfield and Höch, or in an assemblage such as Hausmann's *Mechanical Head: Spirit of our Age* (1919–20).

The political nature of their work was prominent.

Above: Raoul Hausmann, *First International Dada Fair*, 1920
Hausmann's spoof attack on the show ('these individuals spend their time making pathetic trivia from rags') anticipated the actual outrage in the press. The uniformed dummy with the pig's head earned Grosz and Heartfield (standing on right) a fine for defaming the military.

Heartfield, who later became an outspoken critic of Nazism, changed his name from the German 'Herzfelde' in 1916 as an act of protest against anti-English wartime propaganda. His use of photomontage twisted the 'reality' of photographs into a fierce polemical tool. Höch's photomontages, such as *Cut with the Kitchen Knife through the Last Weimar Beer-Belly Cultural Epoch of Germany* (1919–20) and *Dada-Ernst* (1920–21), also express something of the turbulence and violence of the age – the experiences of speed, technology, urbanism and industrialization; but above all, she addressed the experience of the modern woman. The tumultuous political climate of post-war Berlin, the tensions between the Dada-revolutionary world and the anti-Dada world of the Weimar government leaders provide the context, but her subject is the New Woman and her struggle to establish a legitimate female sphere of her own. Höch tried to establish her own identity in a relationship with Haussman, which despite his 'feminist' theories and calls for a sexual revolution, was psychologically and physically violent. She took media images of beautiful, exotic and subservient women, and cut them up, reassembling them to show their true fragmented, powerless conditions. Höch's work anticipates the work of artists at the end of the twentieth century, such as Barbara Kruger and Cindy Sherman (see *Postmodernism).

The Cologne branch of Dada was started in 1919 by Arp and Max Ernst (1891–1976, see *Surrealism). Ernst held the first Dada Exhibition in Cologne. Attached to one of his own sculptures was an axe, placed there for the convenience of any visitor who wished to attack the work. In Hanover Dada was represented by Kurt Schwitters (1887–1948). To describe this one-man splinter group Schwitters used the word *Merz*, supposedly derived from a fragment of the word *Kommerz* (commerce) in one of his collages of 1919. The word reappeared to describe poetry (*Merzgedichte*), pictures, and a magazine (*Merz*, 1923–32), to which Arp, El Lissitzky and Theo Van Doesburg (see *Constructivism and *De Stijl) were among the contributors. In his collages, reliefs and building-constructions (*Merzbau*), he lovingly transformed the detritus of civilization into art, a process which would have an influence on Junk Art, *Assemblage and *Arte Povera. His first *Merzbau*, begun in 1920, was built in his home in Hanover. The extraordinary sculpture-accumulation of plaster and junk had sections dedicated to his friends Mondrian, Gabo, Arp, Lissitzky, Malevich, Richter, Mies van der Rohe and Van Doesburg. By the time he left Germany in 1935 it had grown into the second floor. In 1943 it was destroyed by Allied bombs.

By 1921, many of the originators of Dada, including Tzara, Arp, Ernst, Man Ray, Duchamp and Picabia,

converged on Paris, where they were joined by a number of poets, notably Louis Aragon, Philippe Soupault, Georges Ribemont-Dessaignes and the French poet André Breton (see Surrealism), and the artists Suzanne Duchamp (1889–1963, Marcel's sister), her husband Jean Crotti (1878–1958) and the Russian Serge Charchoune (1888–1975). Dada in Paris took on a more literary and theatrical nature, with cabarets and festivals. The popularity of these events with the public soon turned these revolutionary 'anti-artists' into celebrities. However, differences of opinion between members were already creating difficulties, and in 1922 internal fighting between Tzara, Picabia and Breton led to the dissolution of Dada.

Dada might have dissolved, but its activity did not cease. Many Dadaists turned to Surrealism, producing Surrealist work that developed from Dadaist beginnings. There also continued to be activities that could only be called Dada, of which the anarchic film, *Entr'Acte* (Intermission) and the ballet, *Relâche* (Closed, or No performance tonight), of 1924 are two of the most extraordinary examples, ironically dating from after the movement's demise. The film was written by Picabia, directed by René Clair (1889–1981), featured a soundtrack by composer Erik Satie (1866–1925) and starred Man Ray, Duchamp, Satie and Picabia. Originally shown in the intermission of the ballet, the short, silent film (lasting thirteen minutes) confounded the 'bourgeois conventions' of cinematic story-telling and of accepted notions of causality, time and space as completely as Dadaist art objects had confounded the conventions of art. *Relâche*, performed by Rolf de Maré's Ballets Suédois on a spectacular set designed by Picabia, featured Man Ray in a dancing role against a backdrop of brilliant light bulbs which were intended almost to blind the audience. Fernand Léger (see Cubism) approved of the ballet's intentions. 'To hell with the scenario,' he said, '*Relâche* is a lot of kicks in a lot of backsides whether hallowed or not.'

Dada's influence has proved seminal and long-lasting.

With the publication in 1951 of an anthology edited by the American painter and writer Robert Motherwell, *The Dada Painters and Poets*, Dada received fresh attention during the 1950s. The liberated artistic approach and absurdist irony captured the imagination of a new generation of artists and writers (see *Neo-Dada, *Nouveau Réalisme and *Performance Art). The most pervasive and lasting legacies of Dada, however, were its attitudes of freedom, irreverence and experimentation. The presentation of art as idea, its assertion that art could be made from anything and its questioning of societal and artistic mores, irrevocably changed the course of art. As Richter so aptly observed in his own account of the movement, *Dada. Art and Anti-Art* (1964):

> It was not an artistic movement in the accepted sense; it was a storm that broke over the world of art as the war did over the nations. It came without warning, out of a heavy, brooding sky, and left behind it a new day in which the stored-up energies released by Dada were evidenced in new forms, new materials, new ideas, new directions, new people – and in which they addressed themselves to new people.

Key Collections
Centre Georges Pompidou, Paris
Museum of Modern Art, New York
Philadelphia Museum of Art, Philadelphia, Pennsylvania
Tate Gallery, London

Key Books
R. Motherwell (ed.), *The Dada Painters and Poets: An Anthology* (Cambridge, MA, 1989)
M. Lavin, *Cut with the Kitchen Knife: the Weimar Photomontages of Hannah Höch* (1993)
H. Richter, *Dada: Art and Anti Art* (1997)
A. Schwartz, *The Complete Works of Marcel Duchamp* (1997)
D. Ades, N. Cox and D. Hopkins, *Marcel Duchamp* (1999)

█ Purism

The picture is a machine for the transmission of sentiments.

AMEDEE OZENFANT AND LE CORBUSIER

Purism was a post-Cubist movement launched with the publication of a book, *Après le Cubisme* (After Cubism, 1918), by French painter Amédée Ozenfant (1886–1966) and Swiss-born painter, sculptor and architect Charles-

Edouard Jeanneret (1887–1965), better known by his pseudonym, Le Corbusier (see *International Style). The two were disillusioned with what they saw as the decline of *Cubism into a form of elaborate decoration. They called

for 'the reconstitution of a healthy art' based on clear,
precise representation, using an economy of means and
proportional harmonies. They were inspired by the purity
and beauty they found in machine forms, and guided by
their belief that classical numerical formulae could produce
a sense of harmony and consequently, joy.

The first exhibition of Purist paintings took place in
1918 at the Galerie Thomas in Paris. The subjects – every-
day objects, musical instruments, etc. – were Cubist, but
became more recognizable in their new Purist incarnations.
The emphasis was not on breaking down an object but in
celebrating its geometry and simplicity. Strongly composed
images of shape-related objects with well-defined contours
were shown in two clear views – depth and silhouette – and
were painted in subdued colours in a smooth, cool fashion.

The two artists' unswerving conviction that order is a
basic human need led them to develop an all-encompassing
Purist aesthetic that embraced architecture and product
design as well as painting. It developed into a missionary

campaign for order, conducted through the pages of
their own avant-garde art and literary magazine *L'Esprit
Nouveau* (The New Spirit, 1920–25), and in books such
as *Towards a New Architecture* (1923) and *Modern Painting*
(1925). In their essay 'Le Purisme', which appeared in
L'Esprit Nouveau (January 1921), the two artists wrote:
'We think of the painting not as a surface, but as a
space…an association of purified, related and architectured
elements.'

When Le Corbusier declared in 1924 that, 'Thanks to
the machine, to the identification of what is typical, to the
process of selection, to the establishment of a standard, a
new style will assert itself' – he envisioned a functional style
from which ornament would be purged. This new style was
asserted in the Pavillon de L'Esprit Nouveau (Pavilion of the
New Spirit) for the Exposition des Arts Décoratifs in Paris
in 1925. Le Corbusier's Purist two-storey house contained
sculptures by Henri Laurens and Jacques Lipchitz, and
industrially produced *objets types* (type-objects) which
expressed humanist functionalism, such as Thonet bent-
wood furniture.

In 1922 he opened a studio in collaboration with his
cousin, Pierre Jeanneret (1896–1967), with whom he
worked on numerous architectural, urban planning and

design projects, even producing a prototype for a car, in 1928. From 1927, Le Corbusier and Jeanneret began to design pieces of furniture in collaboration with Charlotte Perriand (1903–99), a number of which, such as the tubular steel and black leather armchair and chaise-longue, are now considered design classics.

Although Purism did not develop into a school of painting as such, there were many who shared the machine-inspired aesthetic of Ozenfant and Le Corbusier, notably Fernand Léger (see Cubism), the members of the *Bauhaus and the *Precisionists. By the time Ozenfant and Le Corbusier began to move apart, from around 1926, Purist ideas – some of the most important formative influences on modern architecture and product design – had already been disseminated.

Key Collections
Fine Arts Museums of San Francisco, San Francisco, California
Museum of Modern Art, New York
Öffentliche Kunstsammlung, Basel, Switzerland
Solomon R. Guggenheim Museum, New York

Key Books
C. Green, *Cubism and its Enemies* (New Haven, CT, 1987)
K. E. Silver, *Esprit de Corps: The Art of the Parisian Avant-Garde and the First World War, 1914–1925* (Princeton, NJ, 1989)
W. Curtis, *Le Corbusier* (1992)
Jean Jenger, et al, *Le Corbusier: Architect, Painter, Poet* (1996)

De Stijl

Art is only a substitute while the beauty of life is still deficient. It will disappear in proportions, as life gains in equilibrium.

PIET MONDRIAN, 1937

De Stijl (The Style) was an alliance of artists, architects and designers brought together by the Dutch painter and architect Theo Van Doesburg (1884–1931) in 1917. Despite its neutrality, the Netherlands had suffered during World War I, and the group mission of De Stijl was to create a new, international art in the spirit of peace and harmony. The original members were Van Doesburg, Dutch painters Bart Van der Leck (1876–1958) and Piet Mondrian (1872–1944), Belgian painter and sculptor Georges Vantongerloo (1886–1965), Hungarian architect and designer Vilmos Huszár (1884–1960), Dutch architects J. J. P. Oud (1890–1963), Robert Van't Hoff (1887–1979) and Jan Wils (1891–1972), and poet Antony Kok.

Van Doesburg, Mondrian, Vantongerloo and Van der Leck had already worked together in an attempt to create an abstract visual vocabulary which could be put to practical purposes, and which would communicate their desire for a better society. The use of horizontal and vertical lines, right angles, and rectangular areas of flat colours characterize their work of the period. In due course, their palette would

eventually be reduced to the use of the primary colours, red, yellow and blue, and the neutral colours of white, black and grey. To describe this reductive style, Mondrian coined the term 'neo-plasticism.' In 1917 he wrote:

> These universal plastic means were discovered in modern painting by the process of consistent abstraction of form and colour: once these were discovered there emerged, almost of its own accord, an exact plastic of pure relationship – thus the essence of all emotion of plastic beauty.

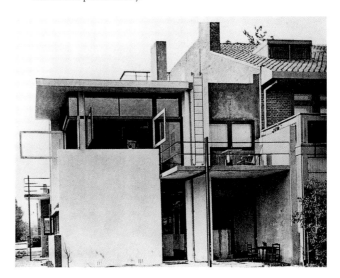

Right: **Gerrit Rietveld, Schröder House, Utrecht, 1924**
Rietveld's masterpiece reads as an abstract composition of interlocking planes. The upstairs living space has integrated furniture and walls that move at right angles to allow the space to change from a single large space to a collection of smaller ones.

That Mondrian and Van Doesburg believed that they had arrived at the definitive formula for the new art is indicated in the name of the group – *The* Style – and in the catchphrase of the group, 'The object of nature is man, the object of man is style.'

Van Doesburg and Mondrian were the main theorists of the group, and Van Doesburg launched the periodical *De Stijl* in 1917 to publicize their ideas. They believed that

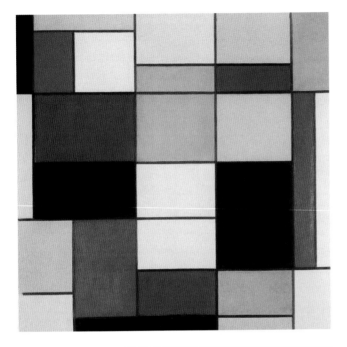

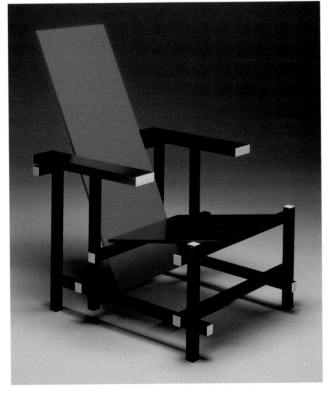

*Cubism had not gone far enough in developing abstraction, and that *Expressionism was too subjective. Though they admired *Futurism, they distanced themselves from it after Italy's entrance into the war. Like the members of the *Bauhaus and the *Constructivists, they wanted to use art to alter society. The war, in their opinion, had discredited the cult of personality, and they sought to replace it with a more universal and ethical culture. As Van Doesburg put it, they were dedicated to the 'absolute devaluation of tradition…the exposure of the whole swindle of lyricism and sentiment.' The means to do this was the reduction – the purification – of art to its basics (form, colour and line). 'Art', Van Doesburg wrote, 'develops forces of sufficient strength to enable it to influence all culture.' A simplified and ordered art would in turn lead to a renewal of society, and when art was fully integrated into life it would no longer be necessary.

At the core of much De Stijl thinking lay a spiritual, even mystical, attitude. It was no coincidence that many of its members came from a Dutch Calvinist background, and De Stijl artists were interested in the spiritual aspects of other thinkers, such as the neo-Platonic philosopher M. J. H. Schoenmaekers, a close friend of Mondrian's, and Vasily Kandinsky, whose significant book *On the Spiritual in Art* (see *Der Blaue Reiter) was an important text for them. Schoenmaekers' writings postulated a fundamental geometric ordering of the universe and metaphysical meanings for the three primary colours, a theory which recalls the thinking of the *Neo-Impressionists.

The group's aesthetic principles were expounded in an eight-point manifesto which appeared in *De Stijl* in November 1918, signed by Van Doesburg, Mondrian, Huszár, Vantongerloo, Van't Hoff, Wils and Kok. Editions of the manifesto were published in Dutch, French, German and English, indicating at an early date their international aspirations. The following year, architect-designer Gerrit Rietveld (1888–1964) joined the group, an important development that was to have a significant impact on both their ideas and output. Rietveld's Red-Blue Chair, with its

Above: **Piet Mondrian, *Composition A; Composition with Black, Red, Grey, Yellow and Blue*, 1920** In 1917, Mondrian wrote: 'The new plastic cannot be cloaked in what is characteristic of the particular, natural form and colour, but must be expressed by means of the straight line and determinate primary colours.

Left: **Gerrit Rietveld, Red-Blue Chair reconstruction, *c.* 1923** Rietveld's famous chair not only projected De Stijl painting into three dimensions, but also inspired Van Doesburg and Mondrian to take the final step of restricting themselves to primary colours.

Opposite above: **Photographs and sketches from Theo Van Doesburg's *Principles of Neo-Plastic Art*, 1925** Taking one of the great themes of Dutch painting, Van Doesburg wittily illustrated the process of abstraction.

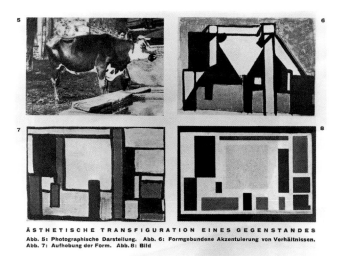

ÄSTHETISCHE TRANSFIGURATION EINES GEGENSTANDES
Abb. 5: Photographische Darstellung. Abb. 6: Formgebundene Akzentuierung von Verhältnissen.
Abb. 7: Aufhebung der Form. Abb. 8: Bild

black frame and primary colours highlighting the elements of its construction, was the first use of neo-plastic design theory in applied arts.

De Stijl architecture shows a similar clarity, austerity and order to De Stijl painting, and the geometric abstract language of neo-plasticist painting – straight lines, right angles and clean surfaces – found expression in three dimensions. Like their opponents, the Expressionist architects of the *School of Amsterdam, De Stijl architects drew on two other sources: Hendrik Petrus Berlage (1856–1934), whose buildings provided them with examples of a congenial rationalism, and Frank Lloyd Wright (see *Arts and Crafts), whose concept of the home as the product of 'total design' fed directly into their own ideas. To this was added their admiration for the vision of Antonio Sant'Elia (see Futurism). The result was an architectural idiom of flat roofs, plain walls and flexible interior spaces that would become synonymous with the *International Style.

Rietveld's extraordinary Schröder House in Utrecht (1924) is in many ways the masterpiece of the whole De Stijl movement. Here, as nowhere else, the De Stijl goal of creating a total living environment was achieved. Rietveld designed the building in collaboration with his client, the interior designer Truus Schröder-Schräder, who herself subsequently became a member of the group. The overall effect of the play between the lines, angles and colours in the house is that of living in a De Stijl painting. As Rietveld explained: 'We didn't avoid older styles because they were ugly, or because we couldn't reproduce them, but because our own times demanded their own form, I mean, their own manifestation.'

Throughout the 1920s, De Stijl group and its journal developed to become more self-consciously international. Van Doesburg travelled widely, arranging exhibitions and lecturing. While in Germany, in 1920 and 1921, he made a major impact on the Bauhaus. His travels also brought him into contact with *Dada, with which he was briefly affiliated, and Russian Suprematism and Constructivism through El Lissitzky (see Constructivism).

Van Doesburg's new international orientation affected both his artistic and theoretical development, and as a result, De Stijl movement as a whole. By 1921, certain members such as Van der Leck, Vantongerloo, Van't Hoff, Oud, Wils and Kok had left the group, and other figures of the international avant-garde, including Lissitzky, Italian Futurist Gino Severini, Austrian architect Frederick Kiesler and German Dadaists Jean (Hans) Arp and Hans Richter joined. Around 1924, Van Doesburg began to introduce the diagonal into his work, a modification of neo-plasticism which he called *Elementarism, and this led to Mondrian's resignation from De Stijl. 'After your high-handed improvement (?) of neo-plasticism any co-operation is impossible for me', Mondrian wrote to his old friend. Both were to move in new directions. Mondrian continued to explore and refine his conception of pure colour and form in his work and writings, becoming one of the most important artists of the first half of the century and an important touchstone for all types of abstract artists. Van Doesburg went on to investigate the possibilities of the diagonal with Elementarism, and then with his manifesto of 1930, 'The Basis of Concrete Art', became the founder of *Concrete Art, which would be developed more fully after his death in 1931.

The final issue of *De Stijl* (number 90) published in 1932 was a memorial to Van Doesburg. Although De Stijl movement effectively died with him, its influence was immense, and it continues to provide inspiration to artists, designers and architects. Many of De Stijl artists and architects went on to become members of other international avant-garde groups such as Abstract-Création and CIAM (see International Style).

Key Collections
Carnegie Museum of Art, Pittsburgh, Pennsylvania
Museum of Modern Art, New York
Kimbell Art Museum, Fort Worth, Texas
Kröller-Müller Museum, Otterlo, the Netherlands
Stedelijk Museum, Amsterdam
Tate Gallery, London

Key Books
H.L.C. Jaffe, *De Stijl, 1917–1931* (Cambridge, MA, 1987)
S. Lemoine, *Mondrian and De Stijl* (1987)
H. Holtzman and M. S. James (eds), *The New Art – The New Life. The Collected Writings of Piet Mondrian* (1987)
P. Overy, *De Stijl* (1991)

1918-1945

Search for a New Order

Le Corbusier with a model of the Palace of the Soviets, 1931

Arbeitsrat für Kunst

Art and the people must form an entity. Art shall no longer be a luxury of the few, but should be enjoyed and experienced by the broad masses.

MANIFESTO OF THE ARBEITSRAT FÜR KUNST, 1919

The Arbeitsrat für Kunst (Workers' Council for Art) was founded in Berlin in December 1918 by architect Bruno Taut (1880–1938) and architectural critic Adolf Behne (1885–1948). Their immediate aim was to create a group of artists capable of exerting political pressure on the new government in Germany, along the lines of the powerful councils for workers and soldiers. Their long-term goal was to bring about a utopian architecture for the new society emerging after the destruction of World War I. The work they created is characterized by the use of glass and steel,

ICON AND REVOLUTION
POLITICAL AND SOCIAL THEMES IN GERMAN ART 1918–1933

almost science-fiction-like forms, and a feeling of religious intensity, even in non-ecclesiastical buildings.

There were soon around fifty members of the group: radical artists, architects, critics and patrons living in the Berlin area, many of them already members of the *Deutscher Werkbund and *Die Brücke, most affiliated with *Expressionism.

Although the Arbeitsrat represented all the arts, architecture was the area of greatest activity. Prominent members included architects Otto Bartning (1883–1959), Walter Gropius (see *Bauhaus), Ludwig Hilbersheimer (1885–1967) and Erich Mendelsohn (see Expressionism); painters Lyonel Feininger (see Bauhaus and *Der Blaue Reiter), Hermann Finsterlin (1887–1973), Erich Heckel (see Die Brücke), Käthe Kollwitz (see *Neue Sachlichkeit), Emil Nolde (see Expressionism), Max Pechstein (see Die Brücke), Karl Schmidt-Rottluff (see Die Brücke); and sculptors Rudolph Belling (1886–1972), Georg Kolbe (1877–1947) and Gerhard Marcks (1889–1981). Many were members of the *Novembergruppe, which was dedicated to promoting modernism. The aspirations of the Arbeitsrat für Kunst were, however, more political, and its members sought changes to the systems of management in the arts and architecture.

Taut was the leading figure, wielding influence as founder. Through him the group adopted the utopian tendency of the period. Their preference for glass and steel betrays the influence of both Taut and his mentor, the glass fantasist and poet, Paul Scheerbart. Scheerbart's text of 1914, *Glasarchitektur* (Glass Architecture), dedicated to Taut, expressed the utopian, futuristic belief that a

Above left: **Illustration for a pamphlet issued by the Arbeitsrat für Kunst, April 1919** This woodcut illustration was probably executed by the German painter and printmaker Max Pechstein who was a prominent member of the group founded a few months previously.

Left: **Bruno Taut, Glashaus, Deutscher Werkbund exhibition, Cologne, 1914** Taut's glass pavilion was one of the main attractions of the exhibition, and existed only for a few weeks in the summer of 1914 before being dismantled at the close of the exhibition.

Opposite: **Bruno Taut, Glashaus, stairs, Deutscher Werkbund exhibition, Cologne, 1914** Quotations – such as 'Glass brings a new era', 'Coloured glass destroys hatred' – from Paul Scheerbart's book *Glasarchitektur* (Glass Architecture) were inscribed on the fabric of the building and illuminated by the facets of the glass-brick walls and of the Gothic-style cupola.

new architecture was needed in order to transform culture:

> This, however, we can only do by introducing a glass architecture, which admits the light of the sun, of the moon, and of the stars into the rooms, not only through a few windows, but through as many walls as feasible, these to consist entirely of glass – of coloured glass.

Scheerbart's claims found literal embodiment in Taut's Glashaus (Glass Pavilion) for the 1914 Deutscher Werkbund exhibition in Cologne.

But political events were not favourable. In January 1919, following a fortnight of armed conflicts in Berlin, two members of the Spartacus League, German Communists Karl Liebknecht and Rosa Luxemburg, were executed. The Arbeitsrat für Kunst could no longer hope to achieve any political power, and a disillusioned Taut resigned as leader of the group, to be replaced by Gropius. From then on, the activities of the Arbeitsrat were mainly limited to discussions and exhibitions. In April 1919, the 'Exhibition of Unknown Architects' included deliberately visionary works by several of its members and a catalogue with an introduction by Gropius which captured the utopian aims of the group:

> Painters, sculptors, break down the barriers around architecture and become co-builders and comrades-in-arms towards art's ultimate goal: the creative idea of the Cathedral of the Future, which will once more encompass everything in one form – architecture and sculpture and painting.

In the same period Taut began a 'utopian correspondence' circle, Die Gläserne Kette (The Glass Chain), with fourteen leading figures of the art world, mainly architects, including Gropius, Finsterlin, Hans (1890–1954) and Wassili Luckhardt (1889–1972) and Hans Scharoun (1893–1972). Their aim was to explore – and ultimately achieve – a new type of architecture. 'Everyone of us will draw or write down at brief intervals of time, informally and as the spirit moves him… those ideas which he would like to share with our circle.' The correspondence proved a vital forum for the discussion of new ideas. It continued until December 1920, and much of it was published in Taut's magazine *Frühlicht* (Early Light). The magazine urged architects to find fundamental, organic forms as sources for architecture, and to put into practice an Expressionist belief in the importance of the creative unconscious.

Other exhibitions organized by the Arbeitsrat für Kunst took place in 1920 – showing art by workers and children (in January), of avant-garde architecture (in May) and of German contemporary art in Amsterdam and Antwerp – but they were not financially viable. On 30 May 1921, the group was formally dissolved. Many of the architects went on to develop more functional and rational styles throughout the 1920s (see *Der Ring and *International Style), and continued their endeavour to create precisely what the Arbeitsrat had urged: a new architectural vision of the future.

Key Monuments
Hans Häring, Gut Garkau, Lübeck, Germany
Eric Mendelsohn, Steinberg-Herrmann Hat Factory, Luckenwalde, Germany
Hans Poelzig, Grosse Schauspielhaus, Berlin
Bruno Taut, Steel Industry Pavilion, Leipzig, Germany

Key Books
P. Scheerbart and B. Taut, *Glass Architecture and Alpine Architecture* (1972)
I. Whyte, *Bruno Taut and the Architecture of Activism* (Cambridge, UK, 1982)
—, *The Crystal Chain Letters: Architectural Fantasies by Bruno Taut and his Circle* (Cambridge, UK, 1985)

Novembergruppe

Radical in the rejection of previous forms of expression – radical in the use of new expressive techniques.

NOVEMBERGRUPPE EXHIBITION CATALOGUE, 1919

The Novembergruppe (November Group), named after the German Revolution of November 1918, was formed in Berlin on 3 December 1918, and existed until it was banned by the Nationalist Socialist government in September 1933. It was initially led by the *Expressionist painters Max Pechstein (1881–1955, see *Die Brücke) and César Klein (1876–1954), who invited all 'revolutionaries in spirit' to join them in reorganizing the arts.

They soon attracted over one hundred members from various avant-garde movements, forming themselves into

Novembergruppe 'chapters' all over the country. Among its members were the painters and sculptors Heinrich Campendonck (1889–1957), Lyonel Feininger (see *Bauhaus, *Der Blaue Reiter), Otto Freundlich (1878–1943), Vasily Kandinsky (see Der Blaue Reiter), Paul Klee (see Der Blaue Reiter), Käthe Kollwitz (see *Neue Sachlichkeit); architects Walter Gropius (see Bauhaus, *International Style), Hugo Häring (see *Der Ring), Erich Mendelsohn (see Expressionism) and Ludwig Mies van der Rohe (see *Deutscher Werkbund, International Style); composers Alban Berg and Kurt Weill, and the playwright Bertolt Brecht.

Many members of the Novembergruppe also belonged to the more politically orientated *Arbeitsrat für Kunst; they sought radical change in the arts through the former, and expressed their political sympathies through the latter. Both associations were informed by the same Expressionist ideology, that art and architecture could create a better world, and both promoted modernism. Throughout the 1920s, the group organized exhibitions of progressive art and architecture, with nineteen in Berlin alone. It arranged travelling exhibitions to Rome, Moscow and Japan, and sponsored concerts of new music, lectures and poetry readings. It assisted experimental film-makers, such as the Swede Viking Eggeling (1880–1925) and the German Hans Richter (see *Dada), and published pamphlets – *An alle Künstler, Der Kunsttopf, NG* – and graphic portfolios. Towards the end of its existence the group's radicalism weakened, but for much of the 1920s it continued to play an active role in making Berlin one of the most important centres in Europe for artistic and intellectual experimentation.

Hans Richter, *Vormittagsspuk* (Ghosts before breakfast), 1928
Hans Richter was one of the film-makers assisted by the Novembergruppe. In this, Richter's fifth silent film, objects and people undergo surrealistic happenings, and the motif of the flying hats recurs throughout the film.

Key Monuments
Walter Gropius, Dammerstock Estate, Karlsruhe, Germany
Ludwig Mies van der Rohe, Wolf House, Guben, Germany
—, Hermann Lange House, Krefeld, Germany
—, Weissenhofsiedlung, Stuttgart, Germany

Key Books
A. Drexler, *Ludwig Mies van der Rohe* (1960)
J. Fitch, *Walter Gropius* (1960)
Die Novembergruppe (exh. cat., Berlin, 1977)
K. Frampton, *Modern Architecture* (1992)

Bauhaus

Let us create a new guild of craftsmen, *without the class-distinctions which raise an arrogant barrier between craftsman and artist!*

WALTER GROPIUS, BAUHAUS MANIFESTO, 1919

The Bauhaus ('house for building, growing, nurturing') was a school established in Weimar, Germany, in April 1919, under the directorship of the architect Walter Gropius (1883–1969). It was formed by combining the existing Weimar Academy of Fine Art and the School of Arts and Crafts, in order to train students in both the theory and the practice of the arts, to enable them to create products that were both artistic and commercial. Gropius envisioned a community in which teachers and students would live and work together; this concept is reflected in the name of the group, which contains the allusion to medieval masons' lodges (*Bauhütten*). On one level the Bauhaus was intended to make artists, designers and architects more socially responsible. On another level it aspired to nothing less than the improvement of the cultural life of the nation and to the betterment of society. With these utopian aims the Bauhaus

is best seen in the context of debates held in Germany (and elsewhere) since the end of the nineteenth century (see, for instance, *Jugendstil and *Deutscher Werkbund). In the manifesto accompanying the programme of the new school, Gropius wrote:

> Let us together desire, conceive and create the new building
> of the future, which will combine everything – architecture *and*
> sculpture *and* painting – in a *single form* which will one day rise
> towards the heavens from the hands of a million workers as the
> crystalline symbol of a new and coming faith.

Gropius's belief in the transformative power of art and architecture links him to contemporary groups that shared those beliefs, the *Arbeitsrat für Kunst, of which he was Chairman, the Deutscher Werkbund, the *Novembergruppe and Bruno Taut's Glass Chain (see Arbeitsrat für Kunst), all

of which he was a member. He was also close to the *Expressionist painters, and it was no coincidence that for the cover of the Bauhaus manifesto he chose a woodcut by Lyonel Feininger (1871–1956), a painter associated with *Der Blaue Reiter. He also acknowledged, in his essay 'Concept and Development of the State Bauhaus' of 1924, the influences on his thinking: John Ruskin and William Morris of the *Arts and Crafts movement, Henry Van de Velde (see *Art Nouveau) and Peter Behrens (see Jugendstil), describing them as people who 'consciously sought and found the first ways to the reunification of the world of work with the creative artists.' Gropius gathered together an extraordinary group of artist-teachers for the new school. 'We must not start with mediocrity', he explained. 'It is our duty to enlist powerful famous personalities whenever possible, even if we do not yet fully understand them.' Between 1919 and 1922 Gropius hired Feininger; Swiss painters Johannes Itten (1888–1967) and Paul Klee (1879–1940, see Der Blaue Reiter); Germans Gerhard Marcks (1889–1981), Georg Muche (1895–1987), Oskar Schlemmer (1888–1943) and Lothar Schreyer (1886–1966); and Russian painter Vasily Kandinsky (see Der Blaue Reiter).

Itten developed the celebrated Preliminary Course which was compulsory for all students. It was designed to rid students of pre-conceived classical notions of art training, and to unlock their creative potential. The course included studies in materials, tools and colour theory, analysis of the pictorial structure of Old Masters, meditation and breathing exercises. The most important theoretical courses were those on colour and form taught by Kandinsky and Klee. Itten's insistence on practical experience, derived from the American philosopher John Dewey's progressive educational theory of 'learning by doing', became a model followed by art and design schools the world over.

Having successfully completed the Preliminary Course,

Opposite: **Walter Gropius, Bauhaus building between the main building and technical teaching block, Dessau, 1925–26** The functional building of steel, glass and reinforced concrete designed by Gropius and Meyer was photographed on the new school's opening day in December 1926.

Below left: **Joost Schmidt, Poster for the Bauhaus exhibition, July–September 1923** Following changes in management and policy, the poster (designed by Schmidt when he was a Bauhaus student) was worlds apart from the Expressionist woodcut on the original manifesto. The exhibition was a success, attracting over 15,000 visitors.

Below: **Oskar Schlemmer as Türke in his *Triadic Ballet*, 1922** The 1923 Bauhaus exhibition opened with a special 'Bauhaus Week' during which Schlemmer's *Triadic Ballet* and *Mechanical Ballet* were performed, along with lectures, films and concerts.

students moved on to workshops where they were taught by an artist and a trained craftsman. By 1922, despite limited resources, there existed workshops in cabinetmaking (Gropius); wood and stone carving (Schlemmer); mural painting (Kandinsky); glass painting and bookbinding (Klee); metalworking (Itten); ceramics (Marcks); weaving (Muche); printing (Feininger) and theatre (Schreyer). At this stage, the Bauhaus still lacked an architecture department, although Gropius lectured on 'Space', and Gropius's partner in his architectural practice, Adolf Meyer (1881–1929), taught technical drawing on a part-time basis until 1922.

Despite these efforts, little headway had been made towards a closer working relationship with outside industry: only the ceramics and weaving workshops successfully gained outside commissions. It was a conspicuous failing. In 1922, the Bauhaus was heavily criticized by the Dutch periodical *De Stijl*, which called for a change of management. The root of the problem was that some of the original

teachers (in particular Itten) preached the idea of art as a spiritual activity divorced from the outside world. Art had been fused with craft, but not with industry. For the Bauhaus to flourish, the artist would have to transform himself from Expressionist, mystical visionary to *Constructivist engineer-technician. Artists from *De Stijl, such as El Lissitzky (who visited the school in 1921) and Theo Van Doesburg, (who taught independent courses on the principles of De Stijl in Weimar between 1921 and 1923) threw the weight of their influence behind this transformation. After a brief struggle Itten resigned in 1923, to be replaced by the Hungarian László Moholy-Nagy (1895–1946), a technologically oriented artist whose work and ideas reflected his links with *Hungarian Activism, De Stijl and Constructivism. Moholy-Nagy, and former Bauhaus student Josef Albers (1888–1976) shifted the emphasis of the Preliminary Course, encouraging the students to take a more practical approach to their work, experimenting with new techniques and new media. Moholy-Nagy also changed the output of the metal workshop from one-off, handmade craft objects (which one student referred to as 'spiritual samovars and intellectual doorknobs') to practical designs of prototypes for industry. Similar changes followed in the theatre workshop where Schlemmer replaced Schreyer in 1923.

This new phase was publicized by an important Bauhaus exhibition organized by Gropius in 1923. The change of policy was made clear by the title of Gropius's public address, 'Art and Technology – A New Unity'. A highlight of the exhibition itself was the Experimental House designed by Muche and Meyer, a prototype of functional, cheap, mass-produced housing constructed using the latest materials (steel and concrete) and furnished with custom-designed carpets, radiators, tiles, lights, kitchen and furniture made in the Bauhaus workshops.

However, just as the state-funded school began to flourish, the political climate in Weimar moved to the right, and the Bauhaus, which upheld socialist policies, immediately suffered. In 1925 the nationalist majority in the Weimar government withdrew the school's funding. In the same year the school moved to socialist Dessau, where it was given the resources to build specially designed buildings for the school, students and staff.

Following the school's relocation to Dessau, Gropius

Above: **Peter Keler, Cradle, 1922**
Bauhaus student Peter Keler's cradle shows the impact of the form theories of Itten, Kandinsky and Klee. Its simplicity and use of geometric shapes became characteristic features of Bauhaus design.

Left: **Marianne Brandt and Hein Briedendiek, Bedside lamp designed for Körting and Mathiesen, 1928**
The work produced in the Dessau workshops gradually gave the Bauhaus a clear visual identity and earned it a reputation for sleek, functional industrial design.

hoped that the Bauhaus would finally be able to focus on architecture. A statement made at the same time summarized the principles later espoused by the *International Style:

> We want to create a clear, organic architecture, whose inner logic will be radiant and naked, unencumbered by lying facades and trickeries; we want an architecture adapted to our world of machines, radios and fast motor cars, an architecture whose function is clearly recognizable in the relation of its form.

Another important development in Dessau was the hiring of six former students as full-time teachers – Marcel Breuer (1902–81); Herbert Bayer (1900–85); Gunta Stölzl (1897–1983); Hinnerk Scheper (1897–1957); Joost Schmidt (1893–1948) and Albers. As the first Bauhaus-trained staff, they were versatile, competent in both theory and practice and in a number of disciplines and materials. The work produced in their workshops and in the new architecture department, established in 1927 under the Swiss architect Hannes Meyer (1889–1954), created a new Bauhaus design, characterized by simplicity, refinement of line and shape, geometric abstraction, primary colours and the use of new materials and technologies. Examples include Bayer's lower-case sans-serif type, used as the house style, Breuer's tubular steel furniture, and the social housing project undertaken by the architecture department at Dessau-Törten (1927–28).

Having devoted nine years of his life to the administration and defence of the school, Gropius was anxious to return to his private practice. He resigned in 1928 and appointed Meyer as his successor. But Meyer's uncompromisingly left-wing agenda did not endear him to his colleagues. Moholy-Nagy, Breuer and Bayer all resigned, complaining that community spirit had been replaced by individual competition. Thereafter, the school developed into a vocational institution for the training of architects and industrial designers. New courses were added, including town planning by Ludwig Hilbersheimer (1885–1967) and photography under Walter Peterhans (1897–1960). Guest lecturers gave talks on sociology, Marxist political theory, physics, engineering, psychology and economics. Under Meyer's directorship, the school became a commercial success for the first time in its history. Körting and Mathiesen began manufacturing lamps designed in the metal workshop led by Marianne Brandt (1893–1983), a former student at the school. Wallpaper designed in the mural workshop also went into production, and the weaving, furniture and advertising workshops were successful in obtaining outside commissions.

Meyer's Marxist politics, however, soon alienated him from the local government and he was forced to resign in 1930, to be replaced by architect Ludwig Mies van der Rohe (1886–1969, see also Deutscher Werkbund and *Der Ring). Mies van der Rohe introduced stricter discipline and endeavoured to distance the school from politics. But it was too late. With the victory of the National Socialists in the 1931 local elections, the school was accused of being too cosmopolitan and not sufficiently 'German', and in 1932, its grant was cancelled. A last-ditch attempt was made to save the school by moving it to Berlin as a private institution. This only lasted until April 1933 when the Nazis finally closed it down, declaring that it was 'one of the most obvious refuges of the Jewish-Marxist conception of "art".'

The Nazis unwittingly ensured the fame of the school. While the Bauhaus as an institution came to an end in 1933, the Bauhaus as an idea gained momentum. Its ideology and reputation had already reached a wide audience through its periodical *Bauhaus* (1926–31) and through the series of fourteen Bauhaus Books on art and design theory, co-edited by Gropius and Moholy-Nagy between 1925 and 1930. The enforced emigration of many of its staff and students carried its ideas around the globe.

Most of the star staff of the Bauhaus emigrated via London to the USA, where they were welcomed as heroes. Gropius and Breuer joined the faculty at Harvard University; Moholy-Nagy opened the New Bauhaus in Chicago in 1937, which evolved into the Chicago Institute of Design; Mies van der Rohe became Dean of Architecture at the Armour Institute in Chicago (later the Illinois Institute of Technology); Albers taught at the experimental Black Mountain College in North Carolina; and Bayer organized and designed a major exhibition of Bauhaus work at the Museum of Modern Art, New York, 1938–39. Such developments ensured that, although not as much Bauhaus work made it into mass production as its leaders would have liked, the Bauhaus ethos of good functional design became one of the defining influences of the twentieth century.

Key Collections

Bauhaus-Archiv, Museum für Gestaltung, Berlin
Busch-Reisinger Museum, Harvard University, Cambridge, Massachusetts
Fine Arts Museums of San Francisco, San Francisco, California
Minneapolis Institute of Arts, Minneapolis, Minnesota
Paul Klee Centre, Bern, Switzerland

Key Books

J. Itten, *Design and Form. The Basic Course at the Bauhaus* (1964)
G. Naylor, *The Bauhaus* (1968)
E. Neumann, *Bauhaus and Bauhaus People* (1970)
F. Whitford, *Bauhaus* (1984)

Precisionism

Our factories are our substitute for religious expression.

CHARLES SHEELER

Precisionism, also called Cubist-Realism, was a type of American modernism of the 1920s. Its identifying characteristics are the use of *Cubist composition and the machine aesthetics of the *Futurists applied to specifically American iconography – the farms, factories and machinery that were an integral part of the American landscape. The name was coined by Charles Sheeler (1883–1965), a painter and photographer, and it aptly describes both his sharp-focus photography and quasi-photographic style of painting.

In the 1913 Armory Show, Sheeler exhibited paintings influenced by Paul Cézanne (see *Post-Impressionism) and Henri Matisse (see *Fauvism), whose work he had seen on earlier visits to Europe. He was also interested in the work of Pablo Picasso and Georges Braque (see Cubism). From about 1910 he and another Precisionist, Morton Schamberg (1881–1918), rented a Bucks County farm, where he developed a fascination with agricultural machinery, images of which found their way into his work. Sheeler was also keen to develop his photography, and indeed wanted to merge painting and photography in order to 'remove the method of painting from being a hindrance in seeing.'

In the eyes of many Americans in the 1920s, the machine was an object of glamour, and the possibilities of mass-production (symbolized by Henry Ford's assembly line, which he famously proclaimed would allow everyone to afford their own car) seemed to herald the liberation of mankind. Sheeler himself, hired by the Ford Motor Company in 1927 to photograph its River Rouge Plant in Detroit, was seduced by the American industrial dream, and his paintings of factories and machines endow them with the dignity, monumentality and soaring nobility of cathedrals and ancient monuments.

Perhaps the most famous Precisionist painting is a work by Charles Demuth (1883–1935), *The Figure 5 in Gold* (1928). It is both a poster-portrait of his friend, the poet William Carlos William, and an interpretation of William's poem, 'The Great Figure', which describes a firetruck rushing to the scene of a fire. Demuth included his friend's name and initials in the painting along with his own. Precisionism

Charles Demuth, *Modern Conveniences*, 1921
Demuth combines bold, clean horizontals, verticals and diagonals in the structure of his paintings. His use of 'ray lines' to define the interaction of light and surfaces recall the Futurists' techniques. The effect here, however, is cool and monumental.

in general, and this painting in particular, with its emphasis on American imagery and common subject matter, anticipates *Pop Art, and Demuth himself was the subject of a tribute by Pop artist Robert Indiana in *The Demuth Five* of 1963.

Like the Precisionists, the *Dadaists were also fascinated with machinery. Marcel Duchamp's *Chocolate Grinder* paintings of 1913 and 1914 and Francis Picabia's machine portraits were important examples for the Precisionists. After the founding of New York Dada in 1915, whose members included fellow Precisionist Morton Schamberg, avant-garde artists from both groups met together regularly for discussions at the apartment of collectors Walter and Louise Arensberg. Other Precisionists included Preston Dickinson (1891–1930), Louis Lozowick (1892–1973) and Ralston Crawford (1906–78).

Although primarily known for her biomorphic abstractions of flowers, plants and landscapes, the Cubist-Realism of Georgia O'Keeffe's (1887–1986) paintings of New York skyscrapers, such as *Radiator Building – Night, New York* of

1927, allies her work with that of the Precisionists. A friend of Demuth, she first learned to paint in a two-dimensional style influenced by Japanese art, and, later became interested in photography. The photographer Alfred Stieglitz (1864–1946), whom she married, promoted her work in his gallery, and she used photographic techniques learned from him, such as cropping and close-up, in her mature work.

Precisionism was the most important development in American modernism of the 1920s. Its influence can be felt in many later generations of both realist and abstract artists. Fernand Léger's machine Cubism of the 1940s is one example. The simplified, abstracted shapes, clean lines and surfaces and industrial and commercial subject matter, anticipate both Pop Art and *Minimalism. The smooth suppression of brushstrokes and respect for careful craftsmanship prefigure the *Super-realism of the 1970s.

Key Collections
Butler Institute of American Art, Youngstown, Ohio
Carnegie Museum of Art, Pittsburgh, Pennsylvania
Metropolitan Museum of Art, New York
Museum of Modern Art, New York
Whitney Museum of American Art, New York

Key Books
A. Ritchie, *Charles Demuth, with a tribute to the artist by Marcel Duchamp* (1950)
A. Davidson, *Early American Modernist Painting, 1910–1935* (1981)
K. Lucic, *Charles Sheeler and the Cult of the Machine* (1991)

Art Deco

Simplicity of form contrasts at the present time with richness of materials… Modern simplicities are rich and sumptuous.

ALDOUS HUXLEY, 1930

The 'Jazz Age' of F. Scott Fitzgerald's *The Great Gatsby* (1925) conjures up an era of flappers, the charleston and the tango: a time when people wanted to forget the traumas of the Great War, enjoy themselves, and look to the future. Speed, travel, luxury, leisure and modernity were what this fashion-conscious culture craved, and Art Deco gave them the images and objects that reflected their desires.

The term Art Deco was not used in the 1920s and 1930s. In France it was referred to as Style moderne or Paris 1925, following the 'Exposition Internationale des Arts Décoratifs et Industriels Modernes' held in the same year. It was this exhibition that first showed the new style of design in applied arts and architecture that subsequently captured imaginations around the world. Eventually, in the mid-1960s, it gave us the name we now use.

For a long time Art Deco was considered the antithesis of both *Art Nouveau and modernism in general, but it shares affinities with both. Ideologically, like their predecessors in the *Arts and Crafts and Art Nouveau movements, Art Deco designers aimed to erase the distinction between fine and decorative arts, reasserting the importance of the role of the artist-craftsman in design and production. Although the lavish ornamentation of Art Deco was criticized by followers of the more austere modernism of Le Corbusier and the *Bauhaus, they shared an appreciation of the machine, of geometric forms, and of new materials and technologies.

Generally speaking, Art Deco originated in France as a luxurious, highly decorated style, which spread rapidly throughout the world – most dramatically in the USA – becoming more streamlined and modernistic during the 1930s. The 1925 Paris exhibition was a government-sponsored initiative, conceived in 1907 with the aim of encouraging cooperation and collaboration between artists, artisans and manufacturers, and of promoting export markets for French applied arts. Throughout the exhibition's long preparation its designers were alive to dramatic developments both in and outside the art world. The impact of *Fauvism, *Cubism, *Futurism, *Expressionism and abstraction are reflected in the lines, forms and colours of Art Deco. The geometric motifs and rectilinear designs of Art Nouveau practitioners, such as Charles Rennie Mackintosh and Josef Hoffmann, made a great impact on the Art Deco designers.

Events outside the art world proved even more stimulating. The exotic sets and costumes of Sergei Diaghilev's Ballets Russes, and in particular those of Léon Bakst (see *World of Art), introduced the fashion for Oriental and Arabian dress. The discovery of Tutankhamen's tomb in 1922 marked the beginning of a vogue for Egyptian motifs and shimmering

(1892–1990) and Charles Martin (1884–1934) were all active in this period. The painter Raoul Dufy (see Fauvism) worked for the Atelier Martine as a textile designer and contributed fourteen wall-hangings to Poiret's show at the 1925 exhibition. Poiret's exhibits were housed in three spectacular flower-painted barges moored underneath the Alexandre III bridge.

French furniture of the period was similarly popular. In 1919 Süe and decorator André Mare (1887–1932) founded La Compagnie des Arts Français, and quickly became famous for their traditionally inspired furniture made from rich, sumptuous materials. Their pavilion for the 1925 exhibition, 'Un Musée d'Art Contemporain', which displayed their gilt-wood furniture in an elaborate music room, received much attention, as did the Hôtel du Collectionneur, an opulent display of the furniture of Jacques-Emile Ruhlmann (1879–1933). His superbly designed and elegant pieces of furniture, finished with rare, exotic veneers, epitomize the more extravagant strain of Art Deco. Other renowned Art Deco furniture makers in France included Irish-born Eileen Gray (1879–1976); the illustrator Iribe; André Groult (1884–1967); Jean Dunand (1877–1942); Paul Follet (1877–1941) and Pierre Chareau (1883–1950). Some of them were also involved in interior design, textile design, jewelry, metalware, sculpture, tapestry, lighting, glass and ceramics, which were brought together in various pavilions at the 1925 exhibition.

Designers and architects may be among the most famous practitioners of the Art Deco style, but painters also contributed to Art Deco, including, among others, Paris-based Polish artist Tamara de Lempicka (1902–80); René Buthaud (1886–1986); Raphaël Delorme (1885–1962); Jean Gabriel Domergue (1889–1962); André Lhote (1885–1962) and Jean Dupas (1882–1964), whose painting *The Parrots* was included in the Hôtel du Collectionneur in 1925. Avant-garde artists Robert Delaunay (see *Orphism) and Fernand Léger (see Cubism) painted panels and murals for the 1925 exhibition, and Robert's wife, the artist Sonia Delaunay (1885–1980, see Orphism), created Art Deco clothing, furnishings and textiles designs. Her contribution to the exhibition was a collaboration with the furrier Jacques Heim, the Boutique Simultanée.

metallic colours. American jazz culture, and dancers such as Josephine Baker, captured imaginations, as did African 'primitive' sculpture.

Fashion designers and architects took a lead. Designer Paul Poiret (1879–1944) and architect and designer Louis Süe (1875–1968) visited the Wiener Werkstätte (see Vienna Secession), and were impressed by the elegant, linear designs of Art Nouveau and the overall concept of total design practised by its members. On their return to Paris they opened prototype Art Deco studios, where their early designs already displayed the distinctive geometric rendering of the natural forms prevalent in Art Nouveau. In 1911 Poiret founded his Ecole d'Art Décoratif Martine and Atelier Martine to produce Cubist-inspired furniture, floral furnishings and textile designs. Bright colours, natural forms and a melange of exotic influences soon characterized the Martine Style. Poiret was even more revolutionary in fashion. He created a new look for women, disposing entirely of the corset in the process. Illustrations of his designs by Paul Iribe (1883–1935) and Georges Lepape (1887–1971), which appeared in French magazines, such as *Gazette du Bon Ton* and *Modes et Manières d'Aujourd'hui*, ensured the popularity of his enterprise. Indeed, fashion illustration provided some of the most striking art works of the period. George Barbier (1882–1932), Umberto Brunelleschi (1879–1949), Erté

Above left: **Tamara de Lempicka, *Self-portrait (Tamara in a Green Bugatti), c.* 1925** Lempicka's society portraits are characterized by bold, angular forms and metallic colours, capturing the later, more streamlined Art Deco look, a world of sleek young men and women at ease in their ultra-stylish surroundings.

Opposite: **A. M. Cassandre, *Normandie*, 1935** Cassandre's elegant posters for various transport companies brilliantly convey the era's romance with speed, travel and luxury. Similar themes recur in the chic portraits of the English photographer Madame Yevonde (1893–1975), such as *Ariel*, 1935.

Art Deco's simplified forms and strong colours were particularly well suited to the graphic arts. Ukrainian-born French artist Adolphe Jean-Marie Mouron (1901–68), known as Cassandre, was the most prominent poster artist of the era, winning the 'Grand Prix' for poster design at the 1925 Paris Expo.

The 1925 exhibition proved to be internationally popular and influential, and nowhere more so than in the USA. While the Art Deco style began to decline in France shortly after the exhibition, it took on a new life in America. New York's Metropolitan Museum of Art made a number of purchases directly from the exhibition, and these, along with other pieces loaned from the Paris exhibition, toured a number of major American cities in 1926. Other shows, held by the Metropolitan Museum of Art and by department stores, followed during the 1920s and 1930s; in 1933 the Museum of Modern Art's exhibition in New York, 'American Sources of Modern Art (Aztec, Mayan, Incan)', brought other 'exotic' sources to the public's attention. The Art Deco style that developed in the USA incorporated these

influences as well as the French style. Most striking, however, was the new emphasis placed on the aesthetic of the machine. American Art Deco is notably more geometric and streamlined in style than earlier French manifestations.

American architect William Van Alen (1883–1954) and designer Donald Deskey (1894–1989) were two important visitors to the 1925 Paris exhibition. On their return to New York they fused exotic Art Deco decoration and its concept of total design with the quintessentially American form, the skyscraper. The simple, rich motifs of Art Deco design were easily adapted to architectural use. Deskey noted that, in Art Deco design 'ornamental syntax consisted almost entirely of a few motifs such as the zig-zag, the triangle, fawnlike curves and designs.' These few details, applied to new buildings, transformed the New York skyline in the 1930s.

A great example is Van Alen's Chrysler Building (1928–30). With its distinctive metallic-faced semi-circular pinnacles, simultaneously referring to the function of the company and glamourizing the skyscraper, it has become an icon of Art Deco architecture. The design and the materials,

Above left: **William Van Alen, Chrysler building, New York, 1928–30**
With a sense of showmanship typical of the building, the 27-ton spire was assembled in secret inside the building, and lifted entire out of the top of the dome, like 'a butterfly from its cocoon', to the amazement of the crowd gathered below.

Above right: **The New York Skyline at the Bal des Beaux Arts, 1932**
Less than a year after the completion of the Chrysler building it was topped by the even taller Empire State, but in terms of style – as even these party-goers seem to acknowledge – it remained unsurpassable.

Opposite left: **Sloan & Robertson, Washroom, Chanin building, New York, 1928–29** The 56-storey Chanin building, dedicated to Irwin Chanin, a prominent New York developer, was erected in just 205 days. This award-winning washroom is on the 52nd floor of the building.

Opposite right: **Oliver Bernard, Entrance foyer of the Strand Palace Hotel, London, 1930** Several London hotels, including the Savoy and Claridge's, feature Art Deco interiors from the 1930s, but for its elegant spatial arrangements none surpassed the Strand. This interior was dismantled in 1968.

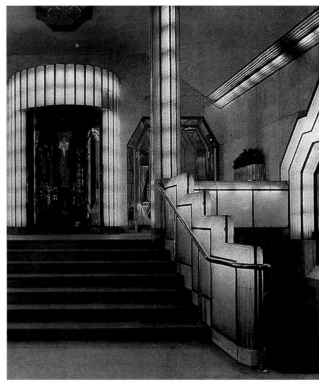

used consistently throughout the building, celebrate the theme of the skyscraper itself. The seductive and peculiarly American hybrid – Art Deco combined with a skyscraper aesthetic – also found its way into art forms other than architecture. John Storr's (1885–1956) sculptures, the cocktail service and serving tray by industrial designer Norman Bel Geddes (1893–1958) and Paul T. Frankl's (1879–1962) skyscraper furniture are three examples.

Art Deco interiors have also provided celebrated examples of the style. The interior of Radio City Music Hall in New York's Rockefeller Center (1930–32), home of the Rockettes, was designed by Deskey to be 'completely and uncompromisingly contemporary in effect, as modern in its design of furniture, wallpapers and murals as it will be in technical devices for stage presentations.' Rooms were created around themes, decorated with murals by contemporary artists, and each detail was coordinated, from the furniture and wallpaper down to the light fixtures. New materials, such as Bakelite, Formica, mirrored glass, aluminium and chrome were used throughout his Art Deco masterpiece.

From New York, Art Deco ornamentation of façades, entranceways and interiors quickly spread throughout the USA with little variation in each region, except in Miami Beach, Florida, where architecture united the Art Deco and modernist idiom with bright tropical colours. It was a popular, democratic architecture, built as a holiday resort for those who did not have the money or status to be admitted to the exclusive Palm Beach. Elsewhere too, the modern style reached a broad public, both in the USA and Europe, as it was adapted for the numerous cinemas built during the 1920s and 1930s, earning it the nickname of Odeon style.

Art Deco stylization was pervasive and popular, finding its way into the design of everything from jewelry and cigarette lighters to film sets, from the interiors of ordinary homes to cinemas, luxury steamliners and hotels. Its exuberance and fantasy captured the spirit of the 'roaring twenties' and provided an escape from the realities of the Depression during the 1930s.

Key Collections

Cooper-Hewitt Museum, New York
Metropolitan Museum of Art, New York
Musée de la Publicité, Paris
Victoria & Albert Museum, London
Virginia Museum of Fine Arts, Richmond, Virginia
Whitney Museum of American Art, New York

Key Books

B. Hillier, *Art Deco of the 20s and 30s* (1968)
A. Duncan, *Art Deco Furniture: the French Designers* (1984)
—, *American Art Deco* (1986)
P. Frantz Kery, *Art Deco Graphics* (1986)
A. Duncan, *Art Deco* (1988)

Ecole de Paris

*Expatriates, linked by common bonds of age or race,
fell in love with Paris and established themselves there.*

PIERRE CABANNE AND PIERRE RESTANY, 1969

Ecole de Paris (School of Paris) is a term used to refer to the community of artists, both French and foreign, working in Paris during the first half of the twentieth century, rather than to a strictly defined style, school or movement. It is, in fact, an acknowledgment of Paris as the centre of the art world (until World War II), and as a symbol of cultural internationalism. At various times the School of Paris has claimed any artist associated with modern art movements originating in Paris, from *Post-Impressionism to *Surrealism; in a narrower sense, however, it refers to the international community of modernist artists living and working in Paris between the two world wars.

Paris was attractive to foreign artists for a number of reasons: its lack of political repression, its relative economic stability, the presence of the great masters of modern art – Picasso, Braque, Rouault, Matisse and Léger (see *Fauvism, *Cubism and *Expressionism) – and a booming art world with galleries, critics and collectors to support the artists. The cross-fertilization of ideas between artists, and the pluralism of styles, were also important features of the

things, be it creation, flight, life or death. 'Simplicity', he said, 'is at bottom complexity, and one must be weaned on its essence to understand its significance.'

Italian painter Amedeo Modigliani (1884–1920), who also produced sculptures (prompted by a meeting with Brancusi in 1909), Russian Chaim Soutine (1894–1943), Bulgarian Jules Pascin (1885–1930) and Frenchman Maurice Utrillo (1885–1955) formed a subgroup of the School of Paris known as *les maudits* (the cursed ones) on account of their miserable lives, cursed as they were by poverty, illness, despair and self-destructive behaviour. If Modigliani was the archetypal bohemian, Soutine was the tortured eccentric. His obsessive, frenzied manner of painting and his spectacular lack of hygiene were notorious. Soutine's intense colours and violently expressive brushwork mark him as a kindred spirit of early Expressionists, such as Emil Nolde or Oskar Kokoschka. While Soutine's paintings express an inner turbulence and anguish, the paintings of another School of Paris painter, Soutine's friend and countryman, Marc Chagall (1887–1985) could not be more different. His synthesis of Fauvist colour, Cubist space, images from Russian folklore and his own imagination produced fantastic images lyrically expressive of his love of life and humanity.

The magical cosmopolitan world of the School of Paris came to an abrupt end with the Nazi invasion. American art critic Harold Rosenberg captured the essence of the informal group in his essay 'The Fall of Paris' (1940), which was essentially an obituary for a lost period:

> In the 'School of Paris', belonging to no one country, but world-wide and world-timed and pertinent everywhere, the mind of the twentieth century projected itself into possibilities that will occupy mankind during many cycles of social adventure to come.

School of Paris. Artists who do not conveniently fit into any other specific category have often been included, such as the Hungarian photographers Brassaï (1899–1984) and André Kertész (1894–1985), sculptors such as Catalan Julio Gonzalez (1876–1942), Ukranian Alexander Archipenko (1887–1964), and, above all, the Romanian Constantin Brancusi (1876–1957).

Brancusi, one of the most influential sculptors of the twentieth century, is known for his exquisitely refined sculptures, which are simplified almost to the point of abstraction. However, they retain a sense of their origins in natural forms, revealing Brancusi's quest for the essence of

Above: **Amedeo Modigliani, *Seated Nude*, 1912** Modigliani's life is the stuff of legend. His poverty and illness, exacerbated by drugs and alcohol, his drunken exhibitionism and fights with his girlfriends are almost as well known as his elegant hypnotic portraits and nudes.

Opposite: **Marc Chagall, *Birthday*, 1915** Chagall's marriage in 1915 to Bella Rosenfeld provided him with inspiration for a series of paintings of lovers. In this dreamlike painting the couple's love for each other raises them into the air.

Key Collections
Albright-Knox Art Gallery, Buffalo, New York
Art Institute of Chicago, Chicago, Illinois
Centre Georges Pompidou, Paris
J. Paul Getty Museum, Los Angeles, California
Metropolitan Museum of Art, New York
National Gallery of Art, Washington, D.C.

Key Books
B. Dorival, *The School of Paris in the Musée d'Art Moderne* (1962)
J. Cassou, *Chagall* (1965)
The Circle of Montparnasse: Jewish Artists in Paris (exh. cat., Jewish Museum, New York, 1986)

International Style

The prime architectural symbol is no longer the dense brick, but the open box.

HENRY-RUSSELL HITCHCOCK AND PHILIP JOHNSON, THE INTERNATIONAL STYLE, 1932

The International Style – or International Modernism – was the dominant style in Western architecture of the mid-twentieth century, coming into its own in the 1920s and holding sway through the 1950s. It is characterized by neat rectilinear forms, flat roofs, open interior spaces, lack of ornamentation and use of new materials and technologies. Two familiar designs typify the style: Le Corbusier's gleaming white concrete houses of the 1920s (see *Purism), and the glass skyscrapers of Mies van der Rohe (see *Bauhaus) of the 1940s and 1950s.

The International Style represents a remarkable convergence of individual interests in Europe and the USA. Drawing on influences, such as those of Louis Sullivan and the *Chicago School, Frank Lloyd Wright and the Prairie School, and the *Arts and Crafts movement, a number of European avant-garde architects began to develop a similar style which they thought suitable to modern life. Their pursuit of new architectural forms was linked to their interest in new social forms. Broadly speaking, they were socialist in outlook and utopian in their aims. Many were affiliated with progressive movements in their own countries, for instance the *Deutscher Werkbund, *De Stijl, *Der Ring, the Bauhaus, Purism, *Arbeitsrat für Kunst, *Gruppo 7 and *M.I.A.R. Three architects – sometimes referred to as 'the trinity' – stood at the heart of the International Style: Walter Gropius (1883–1969), Le Corbusier (1887–1965) and Ludwig Mies van der Rohe (1886–1969).

Around 1910, by coincidence, all three were working in the Berlin office of Peter Behrens (1868–1940, see also Deutscher Werkbund). Behrens was particularly interested in the relationship between industry and the arts. His turbine hall for AEG (Allgemeine Elektrizitäts-Gesellschaft, – the German General Electric Company, 1908–10), with its combination of glass and steel, provided an important example for later architects to follow. At around the same time, the Czech-born architect Adolf Loos (1870–1933), was developing private housing along new and startling lines. Loos had spent three years in Chicago with Louis Sullivan, absorbing some of Sullivan's hostility to ornament, and he expressed this in his 1908 landmark essay, 'Ornament and Crime'. His Steiner House in Vienna (1910), one of the first private houses to use reinforced concrete, was built in a bare, purified style soon to be taken up by others.

Gropius played a key role throughout the 1920s. The Fagus shoe factory (1911) and the Bauhaus building in Dessau (1926), both designed in collaboration with Adolf Meyer (1881–1929), are exemplary; their features (steel-framed structures, glass walls, strip windows) were much imitated by later architects. Equally influential, in different ways, were his publications and his teaching, first at the Bauhaus and later at Harvard University in the USA.

At the same time in Paris, Le Corbusier extended his machine aesthetic – first developed in his Purist paintings –

Above: **Adolf Loos, Kärntner Bar, Vienna, 1907**
In the Kärntner bar, also known as the American Bar, Loos used many of his favourite materials including marble and mirrors; by placing them overhead he created an illusion of greater space.

Opposite: **Le Corbusier, Villa Savoye, Poissy, France, 1929–31**
In this house, Le Corbusier fully realized his 'five architectural points'. Soon after its completion, however, the house was abandoned and fell into disrepair. Declared a 'monument historique' on 16 December 1965, it was restored over a period of twenty years.

to architecture and the applied arts. A theorist as well as a practitioner, Le Corbusier's influence on the modern movement was facilitated by two seminal publications, his declaration 'Five Points for a New Architecture' (1926) and *Towards a New Architecture* (1923) in which he famously wrote 'The house is a machine for living in.' In both works he stressed the desirability of spaciousness, increased light and air, and rational, flexible design.

Two well-known examples of Le Corbusier's work are the Villa Savoye in Poissy (1929–31) and the Pavillon de L'Esprit Nouveau shown at the 'Exposition Internationale des Arts Décoratifs et Industriels Modernes', Paris, 1925 (the exhibition that gave its name to *Art Deco). It was in the sphere of town planning, however, that Le Corbusier applied his most radical thinking. His notorious Plan Voisin (1924–25) proposed the destruction of a huge area of Paris between Montmartre and the Seine, to be replaced by eighteen gigantic skyscrapers.

Le Corbusier was also involved in the foundation of CIAM (Congrès Internationaux d'Architecture Moderne) in June 1928 at La Sarraz, Switzerland, a forum for both discussion and policy making, involving modernist architects worldwide. Convening regularly, the forum contributed to the rise and spread of the International Style in no small measure: by the time of the last meeting held in 1959, there were affiliated groups in over thirty countries and around

3,000 members. German architects dominated discussions in the first phase (1928–c. 1933), which tended to centre on issues of low-cost social housing, efficient use of land and materials and minimum standards of living. After the Athens Charter of 1933, the emphasis shifted to town planning, reflecting Le Corbusier's increasing influence within the organization. This ultimately led to the design of the new administrative capital of Brazil, Brasilia (1956), planned by Lúcio Costa (1902–98), with the main buildings by Oscar Niemeyer (b. 1907).

During the late 1920s and 1930s, the type of building seen en masse at the 1927 Deutscher Werkbund exhibition in Stuttgart, and publicized by CIAM after 1928, spread rapidly throughout Europe and the USA. The Municipal Library, Viipuri (1930–35), by Finnish architect Alvar Aalto (1898–1976), reflected the expansion of the style northward, while the Italian Giuseppe Terragni's Casa del Fascio (1932–36, see M.I.A.R.) demonstrated that the International Style was not exclusive to socialism. In Britain, modernist buildings were designed by émigrés, the most influential being the Russian architect Berthold Lubetkin (1901–90), whose firm Tecton (1932–48) was responsible for Highpoint I, Highgate, London (1935). The most important export, however, was to the USA.

The 1932 exhibition entitled 'Modern Architecture: International Exhibition', held at the Museum of Modern

Art, New York (MoMA), was a key moment in the history of the style. It was finally given a name by Philip Johnson (b. 1906) and Henry-Russell Hitchcock (1903–87), authors of *The International Style: Architecture since 1922*, which accompanied the exhibition. Johnson and Hitchcock concentrated on introducing the look and language of European modernism rather than its utopian socialist ideological background. They focused on the rejection of historicist eclecticism, on the use of mass-produced steel and concrete for primary structures instead of brick and stone, glass as sheathing, free plan, and the 'conception of architecture as volume rather than mass'. Purity and discipline were the characteristics they admired, and the dictum they arrived at (with a nod to Louis Sullivan) was 'less is more'.

The USA already boasted a few modernist buildings. Viennese émigrés Rudolph M. Schindler (1887–1953) and Richard Neutra (1892–1970) were influenced by both Adolf Loos and Frank Lloyd Wright, as demonstrated in Schindler's Lovell Beach House in Newport Beach (1925–26), and in Neutra's Lovell Health House in Griffith Park, Los Angeles (1927–29). But it was during the decade following the MoMA exhibition that the International Style really took hold in the USA, partly due to the exodus of avant-garde architects from Europe, especially from Germany and Italy, who were under pressure from

hostile nationalistic governments. Gropius, Marcel Breuer (1902–81, see Bauhaus) and Martin Wagner (1885–1957, see Der Ring) took up teaching positions at Harvard (where Philip Johnson studied to become an architect during the early 1940s), and Mies van der Rohe went to teach in Chicago.

Mies van der Rohe, whose name soon became synonymous with international modernism, adapted, regularized and reduced the International Style, rendering it distinctive, refined and geometric. Replacing the interlocking spaces and asymmetry of early European modernism with bold, monumental symmetry, he arrived at the 'Miesian formula', an exposed metal-framed glass box based on a grid. Early examples of his low horizontal buildings are the campus and buildings for the Illinois Institute of Technology (1940–56), and the Farnsworth House in Plano, Illinois (1946–50). In his famous Lake Shore Drive Apartments in Chicago (1948), he adapted the steel and glass tower block to residential use, and the following decade he built perhaps his most influential work, the Seagram Building in New York (1955–58) with Johnson. By now, Mies van der Rohe was the leading architect in the USA, and was widely regarded as the rightful heir of Sullivan and the Chicago School.

The Miesian glass box may seem to be the last word in the International Style, but architects contrived to invent

Above: **Philip Johnson, Glass House, New Canaan, CT, 1949**
Johnson's transparent Glass House is a personal variation on Mies van der Rohe's general glass box design and an individual take on Mies's Farnsworth House. The solid brick stack contains the bathroom.

Left: **Ludwig Mies van der Rohe, Lake Shore Drive Apartments, Chicago, 1948–51** In these 'Glass Houses' Mies van der Rohe adapted the steel and glass tower block to residential use. In 1996 they became his first buildings to receive Chicago Landmark status.

Opposite: **Oscar Niemeyer, National Congress building, Brasilia, 1960** It was while working on a project with Le Corbusier that Niemeyer met Juscelino Kubitschek who would later become President of Brazil. As President, Kubitschek appointed Niemeyer to be the chief architect of Brasilia.

personal variations on its general design. Notable examples include Johnson's transparent Glass House (1949) and the General Motors Technical Center in Warren, Michigan (1948–56), designed by Finnish architects Eliel Saarinen (1873–1950) and his son Eero (1910–61). The Pirelli Building in Milan (1956) by Gio Ponti (1891–1979, see Novecento Italiano), Pier Luigi Nervi (1891–1979) and others, is another remarkable example of a corporate 'glass box' with a twist.

By the late 1950s, however, the International Style had come under attack. This originated partly from within, and matters came to a head at the tenth congress of CIAM in 1956. A group of young radical architects called Team X, many of whom were associated with *New Brutalism, blamed modernism as endorsed by CIAM for not taking into account such issues as place and human emotional needs, declaring their revolt against 'mechanical concepts of order'. Three years later, CIAM was formally dissolved.

Many of the older architects had themselves grown dissatisfied with the minimalist style. Since the late 1940s, Le Corbusier had moved away from his earlier precisionist style towards an anti-rational architecture both expressive and fantastic, exemplified by his pilgrimage chapel of Ronchamp (1950–54), with its silo-like white tower and floating brown concrete roof curving to a peak. As Philip

Johnson remarked later, in an interview in 1996: 'Our so-called modern architecture was too old and icy and flat. Frank Lloyd Wright used to call it flat-chested – no breasts.' Johnson and others responded by subverting the purity and severity of the glass box with humour and historical references. The AT&T corporate headquarters designed by Johnson in New York (1978–84), a glass skyscraper featuring a pediment which resembles a Chippendale bookcase, is now considered one of the first 'masterpieces' of *Postmodernism.

Key Monuments
Le Corbusier, Villa Savoye, Poissy, France
Ludwig Mies van der Rohe, Lake Shore Drive Apartments, Chicago, Illinois
—, Seagram Building, New York

Key Books
H.-R. Russell and P. Johnson, *The International Style* (1932)
R. Banham, *The Age of the Masters* (1975)
K. Frampton, *Modern Architecture* (1985)
D. Sharp, *Twentieth-Century Architecture: A Visual History* (1991)

Novecento Italiano

The word Novecento shall resound through the world as gloriously Italian again as the Quattrocento.

MARGHARITA SARFATTI

The Novecento (nine hundred) was an Italian art movement founded in 1922 to promote the work of a group of young artists associated with the Pesaro Gallery in Milan: Anselmo Bucci (1887–1955), Leonardo Dudreville (1885–1975), Achille Funi (1890–1972), Gian Emilio Malerba (1880–1926), Piero Marussig (1879–1937), Ubaldo Oppi (1889–1946) and Mario Sironi (1885–1961). The name, which refers to twentieth-century art, was chosen specifically for its association with other great periods of Italian art, such as the Quattrocento and the Cinquecento, thus announcing their own era as the latest great epoch in Italian art. The reference to the past also emphasized their admiration for Italian classicism, which they aimed to modernize in an attempt to revitalize Italian art, or, as Sironi stated, to produce art that 'would not imitate the world created by God but would be inspired by it.'

The group was led by the writer and art critic Margharita Sarfatti (1880–1961), Benito Mussolini's lover. Mussolini

was the inaugural speaker at the group's first exhibition at the Pesaro Gallery in 1923, and Sarfatti secured the group's inclusion in a number of high-profile exhibitions, such as the Venice Biennale in 1924, at which their work was declared to be 'a pure Italian art, drawing inspiration from the purest sources, determined to cast off all imported "isms" and influences, which have so often falsified the clear essential traits of our race.'

Sarfatti disbanded the Novecento early in 1925 and reconstituted it as the Novecento Italiano, complete with a directive committee charged with promoting their work at home and abroad. Sarfatti presented the new style as quintessentially 'Italian', and the style that best represented the new

Mario Sironi, *Urban Landscape*, 1921
Classically massed but ominously deserted scenes of factories and tenement blocks are frequent subjects in Sironi's early career. An outspoken supporter of the Fascists, he used his pictures to criticize the liberal government that was shortly to be swept aside by Mussolini.

Italy of the Fascist regime. Her relationship with Mussolini and her reputation as 'dictator of the visual arts' allowed her to draw other major artists (of a variety of tendencies) into the movement, such as Carlo Carrà (1881–1966), formerly a leading figure of both *Futurism and *Pittura Metafisica; Massimo Campigli (1895–1971); Felice Casorati (1883–1963); Marino Marini (1901–80); Arturo Martini (1889–1947) and Arturo Tosi (1871–1956).

The first major exhibition of the new group, which included over a hundred participating artists, took place in Milan in 1926, and was opened by Mussolini. It inaugurated a brief period during which Italian art was dominated by the Novecento. However, the very size of the new group dissipated its coherence as an artistic movement. Overexposure was counter-productive. Sironi commented that 'there are too many exhibits, even the Gioconda [Mona Lisa] would lose all value if seen every day.' Despite Sarfatti's considerable efforts, Mussolini refused to sanction the style as the official art of Fascism. These factors, combined with attacks from political and cultural enemies, and the deterioration of Sarfatti's personal relationship with Mussolini led to the dissolution of the movement between 1932 and 1933.

However, the movement did influence and give its name to related architecture and design movements of the period which were termed novecentismo. These centred around the activities of a group of Milanese architects who began collaborating in 1926: Giovanni Muzio (1893–1982); Mino Fiocchi (1893–1983); Emilio Lancia (1890–1973); Gio Ponti (1891–1979); Aldo Andreani (1887–1971); Piero Portaluppi (1888–1976), amongst others. Their ideas and designs were disseminated through the influential architecture and design magazine *Domus*, founded by Ponti in 1928.

Inspired by the neo-classicism of the Novecento artists and the dream-like world of the Pittura Metafisica painters, such as Giorgio de Chirico, the architects sought to reinterpret Italian classical forms in opposition to the machine cult of pre-war Futurism. It was, as Muzio admitted, anti-Futurist, and he argued that classical forms would always be appropriate: 'Are we not perhaps anticipating a movement whose imminent birth is announced throughout Europe by hesitant but widespread symptoms?' This key remark draws attention to the fact that, though the Novecento Italiano movement is often described as Fascist, it is perhaps best to consider it as part of the pan-European trend after World War I, a phenomenon that Jean Cocteau referred to as a *rappel à l'ordre* (return to order). This search for stability and order, the rejection of modern developments, the return to indigenous, more representational sources, is a widespread feature found in art of the period: see for example, American Scene, Purism, Socialist Realism and Neue Sachlichkeit.

Key Collections
Marini Museum, Milan, Italy
Museo di Arte Moderna e Contemporanea, Trento, Italy
Museum of Fine Arts, Houston, Texas
Palazzo Montecitorio, Rome, Italy
Pinoteca di Brera, Milan, Italy

Key Books
R. A. Etlin, *Modernism in Italian Architecture, 1890–1940* (1991)
Italian Art in the 20th Century: Painting and Sculpture 1900–1988 (exh. cat., Royal Academy of Arts, London, 1989)

Der Ring

The struggle for the new dwelling is but part of the larger struggle for a new social order.

LUDWIG MIES VAN DER ROHE, 1927

Der Ring (The Ring) was an architectural association founded in Berlin in 1923 or 1924 with the aim of promoting modernism in Germany. It began as a group of ten architects who called themselves the Zehnerring (the Ring of Ten). Otto Bartning (1883–1959); Peter Behrens (1869–1940); Hugo Häring (1882–1958); Erich Mendelsohn (1887–1953); Ludwig Mies van der Rohe (1886–1969, see *International Style); Bruno Taut (1880–1938) and Max Taut (1884–1967) were among the original members. As the name suggests, they thought of themselves not as a hierarchical organization, but as a group of equals. Many of them were involved in other collective enterprises at the same time, such as the *Deutscher Werkbund, *Arbeitsrat für Kunst and the *Novembergruppe.

In 1926, believing that their small size was inhibiting their success, the association expanded its membership to twenty-seven and called itself Der Ring, with Häring as general secretary. Those who joined its fee-paying membership included Walter Gropius (1883–1969, see *Bauhaus), Otto Haesler (1880–1962), Ludwig Hilbersheimer (1885–1967), the Luckhardt brothers, Hans (1890–1954) and Wassili (1889–1972), Ernst May (1886–1970), Adolf Meyer (1881–1929), Hans Scharoun (1893–1972), Martin Wagner (1885–1957) and critic Walter Curt Behrendt (c. 1885–1945). In order to 'prepare the ground for the new architecture of the new scientific and social epoch', they involved themselves in all aspects of architecture, publicizing their views on matters of housing and planning (particularly through the Deutscher Werkbund's magazine *Die Form*, of which Behrendt was the editor), contributing to exhibitions and conducting research into new materials and construction techniques.

After 1926, when Martin Wagner replaced the anti-modernist municipal city architect, Ludwig Hoffmann, members of Der Ring began to receive civic commissions in Berlin. In projects such as the Siemensstadt (1929–30), designed for the electrical company Siemens by Scharoun, Bartning, Gropius, Häring and others, and the Hufeisensiedlung (Horse-shoe Estate, 1925–30) by Bruno Taut and Wagner, architects of Der Ring created a model for social housing – five- or six-storey apartment blocks with large windows for natural light, integrated into green open spaces. In 1927 they were also involved in the perma-

Bruno Taut, The Hufeisensiedlung (Horse-shoe Estate), Berlin, 1925–30 Martin Wagner initiated the construction of the estate, named for its shape. It was one of the first large-scale residential developments built in Berlin during this period for which the rent was subsidized.

nent exhibition of buildings at the Weissenhofsiedlung (Weissenhof estate) in Stuttgart (see Deutscher Werkbund), where some of the earliest examples of the International Style were seen.

The dominance of the modernist vision of Der Ring at the Stuttgart exhibition did not go undisputed. When a site plan that was based on traditional pitched-roof housing was rejected, the two architects, Paul Bonatz (1877–1956) and Paul Schmitthenner (1884–1973), withdrew in protest and formed a counter-association of more traditionally oriented architects, Der Block (The Block). Members of Der Block, including German Bestelmeyer and Paul Schultze-Naumburg, advocated an architecture that was traditional, rural and based on vernacular forms (anti-urban and anti-modern, and by extension, anti-international), in a manifesto stressing 'German-ness'.

While Der Block itself only existed as a group until 1929, the premises of their beliefs and the forms they represented foreshadowed the core of the attacks made by the Nazis on modernist (international) architecture and architects. The conflict between different 'schools' of architects (symbolically the flat-roofed modernists versus the pitched-roof traditionalists) took on greater significance in the 1930s, as the state-sponsored, modern domestic architectural forms of the Weimar Republic were replaced with supposedly more 'German' pitched-roof forms under the Third Reich.

Economic restraints caused by the depression and the political shift towards the right in Germany weakened the impact of Der Ring and the group disbanded in 1933. Its ideology spread, however, when many of its members, including Gropius, Hilbersheimer, Wagner, Mies van der Rohe, Mendelsohn, May and Meyer, emigrated in the late 1930s, ensuring that their version of modernism became international.

Key Monuments

Scharoun, et al., Siemensstadt, Berlin, Germany
Bruno Taut and Martin Wagner, Hufeisensiedlung,
 Berlin-Neukölln, Germany
Ludwig Mies van der Rohe, Weissenhofsiedlung, Stuttgart,
 Germany

Key Books

B. M. Lane, *Architecture and Politics in Germany,
 1918–1945* (Cambridge, MA, 1968)
K. Frampton, *Modern Architecture: A Critical History* (1992)
K. James, *Erich Mendelsohn and the Architecture of
 German Modernism* (Cambridge, UK, 1997)

Neue Sachlichkeit

My pictures are a reproach to God for all that he does wrong.

MAX BECKMANN, 1919

Neue Sachlichkeit (New Objectivity) was the term coined in 1924 by Gustav F. Hartlaub, the director of the Kunsthalle in Mannheim, to describe the realistic tendency in painting that came to the fore in Germany during the 1920s. The 'Neue Sachlichkeit' exhibition of 'artists who have retained or regained their fidelity to positive, tangible reality', was held at the museum in 1925. The idealism and utopianism associated with German *Expressionism (see, for example, *Die Brücke, *Der Blaue Reiter and *Arbeitsrat für Kunst) immediately after World War I rapidly turned to disillusionment and cynicism as German politics shifted to the right. To many artists it seemed that circumstances demanded an anti-idealistic, socially engaged realistic style of painting. This was part of a wider movement, the so-called *rappel à l'ordre*, or return to order, seen also in the work of the *American Scene Painters and *Social Realists in the USA.

Like Expressionism, Neue Sachlichkeit found natural bases in German cities – Berlin, Dresden, Karlsruhe, Cologne, Düsseldorf, Hanover and Munich. Unlike Expressionist artists, the artists of the Neue Sachlichkeit did not band together in groups: they worked as individuals. The best known of them, Käthe Kollwitz (1867–1945), Max Beckmann (1884–1950), Otto Dix (1891–1969), George Grosz (1893–1959), Christian Schad (1894–1982), Conrad Felixmüller (1897–1977) and Rudolf Schlichter (1890–1955), worked in different styles, but shared many themes: the horrors of war, social hypocrisy and moral decadence, the plight of the poor and the rise of Nazism.

Older than both the Expressionist and Neue Sachlichkeit artists, Kollwitz was producing powerful images of the oppressed (first in etchings, later in lithographs and sculptures) from the 1890s. Sequences of prints of war victims, such as *The Peasants' War* (1902–8) and *War* (1923), made her highly respected. Beckmann was first a member of the Berlin Secession (see *Vienna Secession), and later an Expressionist of sorts (until a well-publicized disagreement with Franz Marc conducted in the pages of *Pan* in 1912); but he was always a somewhat isolated figure. After World War I (during which he suffered a nervous breakdown while serving in the medical corps), he did not return to Berlin, or his wife, but began a new life in Frankfurt. His harsh, symbolic Gothic-Expressionist portrayals of tortured figures in monumental scenarios, often laid out in medieval triptychs, convey with religious intensity a desire to communicate spiritual values at a time of spiritual and moral bankruptcy.

Expressionist angst in the work of Kollwitz and Beckmann turns to bitter cynicism in the pictures of Dix and Grosz. Their distorted realism is savagely satirical. Like Beckmann, Dix served in the war, and his paintings in the 1920s (*Trench Warfare*, 1922–23, destroyed 1943–45, and the book of etchings, *The War*, 1924) were described by art historian G. H. Hamilton as being 'perhaps the most powerful as well as the most unpleasant anti-war statements in modern art.' The same unflinching critical gaze was turned upon individuals and society in Dix's psychological portraits of the era.

Right: **George Grosz, *Daum Marries Her Pedantic Automaton George in May 1920; John Heartfield Is Very Glad of It*, 1920**
With a nod to Heartfield's mordant and hilarious photomontages for Dada, Grosz brings together the mechanistic capitalist, his head full of numbers, with the prostitute who sells her passion.

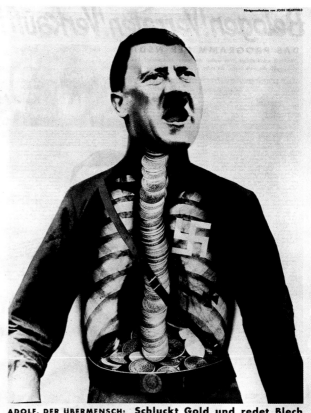

ADOLF, DER ÜBERMENSCH: **Schluckt Gold und redet Blech**

Fat-cat politicians and businessmen received no gentler treatment from Grosz, who described himself as being 'dictated by absolute misanthropy'. His brutal caricatures laid bare the realities of a decaying and decadent society. In his search for the most direct expression of feeling, he even went so far as to copy the drawings on the walls of public urinals. Before the war Grosz had been a member of Berlin *Dada, and his satire recalls the photomontages of other Berlin Dadaists, such as John Heartfield, as well as the images of American Social Realists, such as Ben Shahn. As he wrote in 1925: 'I drew and painted out of a spirit of contradiction, trying in my works to convince the world that it was ugly, sick and mendacious.' He was always provocative (he joined the Communist Party and made a long visit to Russia in 1922, and later in the decade his work was the subject of a

blasphemy trial), but in the mid 1920s he was a success, his work shown in solo exhibitions in several German cities.

The rise of Nazism changed all that, for Grosz and the other Neue Sachlichkeit artists. In the early 1930s all were stripped of the official positions they held, their work confiscated and held up to ridicule at the notorious 'Degenerate Art' exhibition of 1937. By the beginning of World War II, the Weimar Republic had disappeared, and with it the artists of the Neue Sachlichkeit.

Above: **Otto Dix, *Cardplaying War-Cripples*, 1920**
Dix was a furious satirist of the Weimar Republic. The war cripple was a familiar figure throughout Germany after World War I, but here he is violently transformed into a symbol of a mutilated, dehumanized and corrupt society.

Above right: **John Heartfield, *Adolf the Superman Swallows Gold and Spouts Junk*, 1932** Heartfield (who had anglicized his name from Herzfelde as an anti-Nazi gesture) was one of the most politically involved of artists. This montage was enlarged and posted up throughout Berlin shortly after the National Socialists narrowly failed to win a majority in the Reichstag.

Key Collections
Fine Arts Museums of San Francisco, San Francisco, California
Kunsthaus, Zurich, Switzerland
Minneapolis Institute of Arts, Minnesota
Museum Kunst Palast, Düsseldorf, Germany
Palazzo Grassi, Venice, Italy

Key Books
P. Gay, *Weimar Culture: The Outsider as Insider* (1969)
J. Willett, *The New Sobriety, Art and Politics in the Weimar Period, 1917–1933* (1984)
M. Eberle, *World War I and the Weimar Artists. Dix, Grosz, Beckmann, Schlemmer* (1985)

Surrealism

Nothing but the marvellous is beautiful.

ANDRE BRETON, 'WHAT IS SURREALISM', 1934

Surrealism was launched by the French poet André Breton (1896–1966) in 1924. Although the term had been in use since the critic Guillaume Apollinaire coined it in 1917 to describe something that exceeded reality, Breton successfully co-opted it to describe his own vision of the future. In the 'First Manifesto of Surrealism' (1924), Breton defined Surrealism as, 'Thought expressed in the absence of any control exerted by reason, and outside all moral and aesthetic considerations.'

With Surrealism, Breton intended to bring about a revolution as profound as the ones of those he claimed as ideological precursors: Sigmund Freud (1856–1939), Leon Trotsky (1879–1940) and the poets Comte de Lautréamont (Isidore Ducasse, 1846–80) and Arthur Rimbaud (1854–91). Marxism, psychoanalysis and occult philosophies were all important influences on Breton, and his model of the artist as a visionary in revolt against society was drawn from Lautréamont and Rimbaud. A phrase from Lautréamont provided the Surrealists with their motto, articulating their belief that beauty, or the marvellous, could be found in unexpected chance encounters in the street: 'As beautiful as the chance meeting on a dissecting table of a sewing machine and an umbrella.' In sharp contrast to the chaos and spontaneity of *Dada from which it sprang, Surrealism under Breton – nicknamed the 'Pope of Surrealism' – was a highly organized movement with doctrinaire theories. In fact, Breton revolutionized art criticism: from now on, the critic as charismatic leader of an avant-garde group would be a familiar figure. By the time of his death in 1966, Breton had seen Surrealism become one of the most popular

Max Ernst, *At the Rendezvous of Friends*, 1922 While André Breton (13) gives his blessing to the assembled Surrealist poets and artists, Max Ernst sits on the knee of Dostoevsky, another of the Surrealists' presiding spirits, and gives his beard a tweak.

movements of the twentieth century. The Surrealists' optimism formed another contrast with Dada, which stood for the negation of art. The Surrealists aimed at nothing less than the total transformation of the way people think. By breaking down the barriers between their inner and outer worlds, and changing the way they perceived reality, Surrealism would liberate the unconscious, reconcile it with the conscious, and free mankind from the shackles of logic and reason, which thus far had led only to war and domination.

Surrealism exerted an enormous appeal for artists. Many of the original Surrealists, such as Max Ernst (1891–1976), Man Ray (1890–1977) and Jean (Hans) Arp (1887–1966) were drawn from the ranks of Dada. New members included Antonin Artaud (1896–1948), André Masson (1896–1987), Joan Miró (1893–1983), Yves Tanguy (1900–55) and Pierre Roy (1880–1950, see *Magic Realism). Later, through the 1920s and 1930s, new members included Tristan Tzara (see Dada), Salvador Dalí (1904–89), Luis Buñuel (1900–83), Alberto Giacometti (1901–66), Matta (Roberto Matta Echaurren, b. 1911) and Hans Bellmer (1902–75). Other artists stayed on the fringes of Surrealism, such as the Belgian René Magritte (1898–1967, see Magic Realism). Still others were claimed for Surrealism, whether they liked it or not, such as Pablo Picasso (see Cubism), Marc Chagall (see *Ecole de Paris) and Paul Klee (see *Der Blaue Reiter).

Dada remained, in its techniques and its determination to break down boundaries, the Surrealists' great example. Important too were the dream-like paintings of Giorgio de Chirico (see *Pittura Metafisica). But perhaps the most important intellectual influence on the Surrealists was Freud. The unconscious, dreams and a number of key Freudian theories were used by the Surrealists as repertoires of repressed images to exploit at will. In particular they were interested in Freud's ideas about castration anxiety, fetishes and the uncanny. The Surrealists drew on these ideas in a variety of ways: in their attempts to make the familiar unfamiliar; in their experiments with automatic writing and drawing; in their use of chance and strange juxtapositions; in their notion of the devouring female; and in the breaking down of boundaries, between genders, between man and animal, and between fantasy and reality. In Surrealist work, the Dada love of machines turned into fear of the dehumanizing automaton, a horror of the dead coming to life; masks, dolls and

Above: **Salvador Dalí, _Lobster Telephone_, c. 1936**
Dalí worked in a variety of media, but common to all his work is the ability to make arresting associations – a lobster and a telephone – which is, Dalí said, 'a spontaneous method of irrational knowledge'.

Opposite: **Joan Miró, _Summer_, 1938**
Though he never formally joined the Surrealists, Miró exhibited with them, and his bold and delicate paintings, which teem with imaginary life, brilliantly display the classic Surrealist transformation of the real into the marvellous.

mannequins are recurring images. Bellmer's photographs of dismembered dolls, for example, disturb so profoundly because they seem to erase the line between the animate and inanimate. Most Surrealist work (as the so-called 'organic' Surrealism of Miró, Masson, Matta and Arp, or the 'dream' Surrealism of Dalí, Magritte, Tanguy and Roy) addresses such disquieting drives as fear, desire and eroticization.

Max Ernst, who dealt with a range of ideas in different media, is a key figure. Paintings such as _The Blind Swimmer_ (1934) or _Two Children Threatened by a Nightingale_ (1924) possess dream-like qualities reminiscent of the 'uncanny' of Rimbaud and Freud. It is difficult to say what they are about: they are incongruous and unsettling. The image in _The Blind Swimmer_ could be either male or female sex organs, prompting thoughts of both procreation and castration. The ambiguous effects of juxtaposition and chance were important to Ernst and all the Surrealists. In 1925, staying in a French seaside hotel, Ernst discovered _frottage_ by taking a rubbing of the wooden floor with black crayon. In the markings he had produced he was excited to see 'contradictory images that came, one on the other, with the persistence and speed of erotic dreams.' Later, around 1930, he began a series of 'collage novels', of which the most famous is _Une Semaine de Bonté_ (A Week of Plenty). Cutting up and re-arranging Victorian steel engravings, literally desecrating the past, he produced bizarre fantasies out of the safe bourgeois world in which he himself had grown up.

Giacometti created masterpieces of Surrealist sculpture, such as _Woman with Her Throat Cut_ (1932), a bronze construction of a dismembered female corpse, and _The Invisible Object (Hands Holding the Void)_ (1934–35). Both portray the body of the female as inhuman and dangerous. The work brings together two ideas important to many Surrealists: the idea of the dehumanizing mask (African masks, gas masks, industrial masks), and the idea of the female preying mantis who kills and decapitates the male while copulating. As such, the strange, sad figure in _The Invisible Object_ could be the 'killer female', representing the fear of women and death and

the thrill of dangerous sex. For Breton, the piece was 'the emanation of the desire to love and to be loved'.

Man Ray was the first Surrealist photographer; others included Bellmer, Brassaï (1899–1984), Jacques-André Boiffard (1902–61) and Raoul Ubac (1909–85). With darkroom manipulation, close-ups and unexpected juxtapositions, photography proved an adept medium for isolating the surreal image present in the world. Photography's dual status as both document and art strengthened the Surrealist claim that the world is full of erotic symbols and surreal encounters. Man Ray worked successfully in the seemingly incompatible worlds of the Parisian avant-garde and commercial photography. His photographs were published in both specialist and popular periodicals – from *Vogue* and *Vanity Fair* to *La Surréalisme au service de la révolution* (1930–33) and *La Révolution surréaliste* (1924–29) – often with images from the same series appearing in both. For Surrealism, as for fashion, the mannequin symbolized woman as object, constructed and manipulated, violating the boundaries of alive and not alive. Despite the misogyny implicit in much Surrealist work there were several important women

Man Ray, *Anatomies*, 1929 The photograph exposes an unsettling male/female ambiguity: the camera unexpectedly turns the neck and chin of a female model into a phallic image. The Surrealist association with Freudian theories is evident; the picture hints at fears of decapitation or castration.

Surrealists, notably Leonora Carrington (b. 1917); Leonor Fini (1908–96); Jacqueline Breton (b. 1910); Dorothea Tanning (b. 1910); Valentine Hugo (1887–1968); Eileen Agar (1899–1991) and Meret Oppenheim (1913–85), whose fur-covered cup and saucer, *Object* (1936), is one of the most readily recognized Surrealist objects.

Surrealism burst onto the international stage during the 1930s with major exhibitions in Brussels, Copenhagen, London, New York and Paris. It soon became a worldwide popular phenomenon, with groups forming in England, Czechoslovakia, Belgium, Egypt, Denmark, Japan, the Netherlands, Romania and Hungary. Although its poetic and cerebral aspirations may not have been grasped, its images captured the public imagination. Its strange juxtapositions, whimsy and dream imagery found its way into everything from film to the high fashion designs of Elsa Schiaparelli (1890–1973), to advertising, window-display and applied art (Dalí's lobster telephone and Mae West lips sofa, for example). The same desire for glamour and escapism during the 1930s that led to the popularity of *Art Deco also drew the public to Surrealism. By the outbreak of World War II, most of the major Surrealists, including Breton, Ernst and Masson, were in America, where they gained new recruits such as Tanning, Frederick Kiesler (1896–1965), Enrico Donati (b. 1909), Arshile Gorky (1905–48) and Joseph Cornell (1903–73). However, when Breton returned to Paris after the war he found Surrealism under attack from former members such as Tzara, and the new leader of the avant-garde, Jean-Paul Sartre (see *Existential Art), who damned it for 'its pretty stupid optimism'. Despite this, major Surrealist exhibitions were held in Paris in 1947 and 1959, and Surrealist ideas and techniques made their mark on many of the post-war art movements, including the *Informel and *Abstract Expressionism, *CoBrA, *Nouveau Réalisme and *Performance Art.

Key Collections
Chrysler Museum, Norfolk, Virginia
Fine Arts Museums of San Francisco, San Francisco, California
Joan Miró Foundation, Barcelona, Spain
Kunstmuseum, Düsseldorf, Germany
Salvador Dalí Museum, St Petersburg, Florida
Tate Gallery, London

Key Books
W. Rubin, *Dada and Surrealist Art* (1969)
D. Ades, *Dada and Surrealism Reviewed* (1978)
R. Krauss and J. Livingston, *L'Amour fou: Photography and Surrealism* (1985)
R. Martin, *Fashion and Surrealism* (1989)

Elementarism

We must understand that art and life are not separate domains.
This is why the idea of art as an illusion must disappear.

THEO VAN DOESBURG AND COR VAN EESTEREN, 1924

Elementarism was a variation of *De Stijl neo-plasticism invented around 1924 by one of De Stijl's most active and vociferous members, Theo Van Doesburg (1883–1931). Retaining neo-plasticist right angles and primary colours, Van Doesburg tilted his compositions 45 degrees, in order to give them an element of surprise and dynamism lacking in the strictly horizontal-vertical paintings associated with other De Stijl artists, such as Piet Mondrian. The move was calculatedly polemical, and it led, almost immediately, to a rift between Mondrian and Van Doesburg, and, within a few months, Mondrian's resignation from De Stijl.

Van Doesburg called his new paintings 'counter-compositions'. There is a superficial relation with both the *Futurists and *Vorticists, who used the diagonal in their paintings to express the energies of contemporary life, but Van Doesburg's own interests led him to architecture and design. The *Bauhaus artists and the *Constructivists were important influences. Like them, Van Doesburg was interested in the synthesis of the arts, and the practical application of art in daily life. In 1920 and 1921 he visited the Bauhaus at Walter Gropius's invitation, and attacked the expressionist and mystical approach then being promoted by Johannes Itten. He even set up his rival studio next to the Bauhaus, and

Theo Van Doesburg, Café L'Aubette, Strasbourg, 1928–29
The last, and perhaps greatest, work of Neo-Plastic architecture comes closest to achieving Van Doesburg's aim of fully integrating painting and architecture. 'Painting without architectural construction,' Van Doesburg wrote, 'has no further reason for existence.'

wrote exultantly to a friend: 'I have radically turned every-thing upside down in Weimar…everywhere I scattered the poison of the new spirit.' He enjoyed a less combative relationship with El Lissitzky (see Constructivism), whom he met in 1921. Lissitzky had already theorized about the ways in which art and architecture could be brought together, and his influence on Van Doesburg was to be decisive.

Essays and manifestos accompanied Van Doesburg's new practical and theoretical developments. In 'Towards a Collective Construction' (1924), Van Doesburg and Cor van Eesteren (1897–1988) wrote: 'We have established the true place of colour in architecture and we declare that painting, without architectural construction (that is, easel painting) has no further reason for existence.' They elaborated the principles of Elementarism in the 'Manifesto of Elemen-tarism', published in *De Stijl* in 1926, and throughout 1926 to 1928. For Van Doesburg, counter-compositions were 'the purest and at the same time most direct means of expression of the human spirit…yet always in revolt against, in opposi-tion to, nature.' But in many ways his most interesting plans were to synthesize Elementarist painting and architecture, to create a tension between the diagonals of the paintings and the horizontal-vertical structure of architecture.

These plans were realized in the renovation of the Café L'Aubette, Strasbourg in 1928 by Van Doesburg, Jean

(Hans) Arp (1887–1966, see *Dada) and Sophie Taeuber-Arp (1889–1943, see Dada). Van Doesburg planned the overall scheme and each artist decorated a room. The interior surfaces were covered with boldly coloured, shallow diagonal abstract reliefs, in contrast to the horizontal-vertical lines of its construction, and a sense of movement was created by contrasting features, integration of colour and lighting. It was Van Doesburg's last major project; he died in 1931, and, with his death, the driving force of Elementarism was lost.

Key Collections
Art Gallery of New South Wales, Australia
Museum of Modern Art, New York
Portland Art Museum, Portland, Oregon
Stedelijk Museum, Amsterdam, the Netherlands
Tate Gallery, London

Key Books
R. Banham, *Theory and Design in the First Machine Age*
 (1960)
Theo van Doesburg 1883–1931 (exh. cat., Eindhoven 1968)
J. Balieu, *Theo van Doesburg* (1974)
S. A. Mansbach, *Visions of Totality* (Ann Arbor, MA, 1980)
E. van Straaten, *Theo van Doesburg: Painter and Architect*
 (The Hague, 1988)

Gruppo 7

The hallmark of today's youth is a desire for lucidity and wisdom.

GRUPPO 7 MANIFESTO, 1926

Gruppo 7 was an association of avant-garde architects founded in Milan in 1926 to promote modern architecture in Italy. Its members were Luigi Figini (1903–84), Guido Frette (b. 1901); Sebastiano Larco (b. 1901); Adalberto Libera (1903–63); Gino Pollini (1903–91); Carlo Enrico Rava (1903–85) and Giuseppe Terragni (1904–41). They issued a four-part manifesto in the magazine *La Rassegna Italiana* between 1926 and 1927, outlining their stance. They were critical of both the *Futurists ('a vain, destructive fury') and the tame revivalist styles of the *Novecento archi-tects ('a contrived impetus'), saying, 'We do not intend to

Giuseppe Terragni, Novocomum flats, Como, 1927–28
This simple, white, symmetrical five-storey building, with four storeys cut away at the corner to expose the glass cylinders, was the first important rationalist building in Italy, combining Italian classicism with the structural clarity promoted by the Russian Constructivists.

break with tradition…the new architecture, the real architecture, must develop from a strict adherence to logic and rationality.' Like their Novecento contemporaries, the Gruppo 7 architects were searching for an 'Italian' version of modern architecture, but they did not turn their back on international modernism. On the contrary, they planned to use the 'universal' elements of the *International Style to forge a specifically Italian modern style.

The group first came to attention with their inclusion in the 1927 Biennale in Monza, a state-sponsored exhibition of modern architecture and the decorative and industrial arts. Gruppo 7's machine-inspired designs and models were shown alongside those of the neo-classical Novecento, as both groups vied for Mussolini's attention. Later in the year, some of their work transferred to the *Deutscher Werkbund exhibition in Stuttgart, where they joined other rationalist architects on the international stage.

Terragni was one of the most important architects of Gruppo 7. He produced the first important rationalist building in Italy, a block of flats called the Novocomum – now known as the Transatlantico – in Como (1927–28). The building provoked a heated debate in architectural circles. It acknowledged a wide range of sources, from the machine aesthetic of Le Corbusier (see International Style and Purism) and the Russian *Constructivists, to the timeless poetic 'Italianness' of the *Pittura Metafisica painters. It was Terragni's achievement to synthesize a variety of international and indigenous sources, and create a new style to demonstrate Gruppo 7's unique approach, both rationalist and nationalist. Terragni's new building made claims to be the type of architecture appropriate for the Fascist regime, and public attention led to a larger exhibition the following year in Rome. It was here, at the first Esposizione dell'Architettura Razionale, organized by Libera and critic Gaetano Minnucci, that the architects of Gruppo 7 first exhibited with other Italian rationalists. The outcome was the formation of a new, larger association, the Movimento Italiano per l'Architettura Razionale (*M.I.A.R.), into which the Gruppo 7 was absorbed, to mount a more widespread promotion of rationalist Italian architecture.

Key Monuments
Novocomum (Transatlantico), Como, Italy

Key Books
G. R. Shapiro, 'Il Gruppo 7', Oppositions 6 and 12 (1978)
A. F. Marciano, Giuseppe Terragni Opera Complet 1925–1943 (1987)
D. P. Doordan, Building Modern Italy: Italian Architecture, 1914–1936 (1988)
R. Etlin, Modernism in Italian Architecture, 1890–1940 (1991)

▌M.I.A.R.

The will to pursue the struggle against the claims of an 'anti-modernist' majority.

EDOARDO PERSICO, 1934

The Movimento Italiano per l'Architettura Razionale (Italian Movement for Rational Architecture – M.I.A.R) was founded in 1930. It grew out of the Milanese *Gruppo 7, with former members Luigi Figini (1903–84), Adalberto Libera (1903–63), Gino Pollini (1903–91) and Giuseppe Terragni (1904–41), who were joined by other rationalist architects from around the country, such as Luciano Baldessari (1896–1982), Giuseppe Pagano (1896–1945) and Mario Ridolfi (1904–84). Its mission was to expand the work begun by Gruppo 7 in promoting modern rationalist architecture over the neo-classical architecture of the *Novecento architects. Their task in Fascist Italy was not easy. The neo-classical style, based on Italian models, fitted in naturally with the nationalist ideology, whereas Modernist architecture was the style of international architects soon to be labelled 'degenerate' by Fascist states.

To further their aims, in 1931 they organized an 'Esposizione dell'Architettura Razionale' in the Galleria d'Arte in Rome which was owned by art critic Pietro Maria Bardi. Bardi's pamphlet 'Report to Mussolini on Architecture' and the 'Manifesto per l'architettura razionale' accompanied the exhibition, which was opened by Mussolini. But all their efforts of persuasion were undone by the inclusion of *Tavola degli orrori* (Table of Horrors), a

satirical photomontage of works by respected neo-classical architects such as Marcello Piacentini (1881–1960), Mussolini's closest architectural adviser. The government-backed National Union of Architects, which had previously stayed out of the modernity versus tradition debate, withdrew its support, and in the same year the group was dissolved.

The rationalist cause was kept alive by a number of buildings erected between 1932 and 1936. Terragni's Casa del Fascio (now the Casa del Popolo) in Como (1932–36), is both his masterpiece and a landmark of Italian rationalism. The white cube, designed geometrically around a glass-roofed interior court, and clad in marble, simultaneously asserts its Italian character, its modernity and its political function (as the local Fascist administration building). The partnership of Figini and Pollini and the firm BBPR also continued to build in a Rationalist style, most notably for the industrialist Adriano Olivetti (1901–60). Figini and Pollini realized a number of residential and industrial projects for Olivetti at Ivrea (1934–42), and in 1935 they collaborated with Xanti Schawinsky (1904–79), a former *Bauhaus student, on the design of the classic 'Studio 42' Olivetti typewriter.

From 1930, the Rationalists enjoyed the support of the architectural journal *Casa Bella* run by Pagano and his co-editor, art critic and designer Edoardo Persico (1900–36),

Giuseppe Terragni, Casa del Fascio, Como, 1932–36
Reflecting the political function of the Fascist headquarters, glass doors between the foyer and the piazza opened electronically to allow the flow of mass demonstrations from outside into the heart of the building.

who insisted that Rationalism was not incompatible with Fascism. But in the late 1930s it became clear that Piacentini and the recently founded Raggruppamento Architetti Moderni Italiani had the upper hand. Italy adopted an anti-modern stance in line with Nazi Germany. *Casa Bella* was suppressed, and many of the Rationalists joined the anti-Fascist underground. Gianluigi Banfi (1910–45) of BBPR and Pagano were arrested for their activities and deported to German prison camps where they died in 1945. With the early death of Persico in 1936, followed by that of Terragni in 1941 and his pupil Cesare Cattaneo in 1943, Italian rationalism effectively came to an end. Not until the 1970s, with the buildings of the New York Five and the Tendenza movement, would its influence be felt on the international scene.

Key Monuments
Casa del Fascio (now Casa del Popolo), Como, Italy
Olivetti Factory, Via Jervis, Ivrea, Italy
Piazza del Popolo, Como, Italy

Key Books
A. F. Marciano, *Giuseppe Terragni Opera Completa 1925–1943* (1987)
D. P. Doordan, *Building Modern Italy: Italian Architecture, 1914–1936* (1988)
R. Etlin, *Modernism in Italian Architecture, 1890–1940* (1991)
F. Garofalo, *Adalberto Libera* (1992)
T. L. Schumacher, *Surface and Symbol: Giuseppe Terragni and the Architecture of Italian Rationalism* (1991)

▌Concrete Art

The dazzling domination of human reason, the triumph of man over chaos.

DENISE RENE

Theo Van Doesburg, Dutch artist and theorist, founder of *De Stijl and *Elementarism, defined Concrete Art in the manifesto 'The Basis of Concrete Art', which appeared in the first and only issue of *Art Concret*, April 1930:

We declare: 1. Art is universal. 2. The work of art should be entirely conceived and formed by the mind before its execution. It should receive nothing from nature's formal properties or from sensuality or sentimentality. We want to exclude lyricism, dramaticism, symbolism, etc. 3. The picture should be constructed entirely from

purely plastic elements, that is to say planes and colours. A pictorial element has no other significance than 'itself' and therefore the picture has no other significance than 'itself'. 4. The construction of the picture, as well as its elements, should be simple and controllable visually. 5. Technique should be mechanical, that is to say exact, anti-impressionistic. 6. Effort for absolute clarity.

The concept of abstract art, as outlined in the manifesto, remained the main starting point for numerous artists who called their work 'Concrete', from the 1930s to the 1950s.

The manifesto succinctly differentiated Concrete Art from a whole range of new figurative styles (see *American Scene, *Novecento Italiano and *Surrealism), from certain forms of abstract art, such as the expressive abstraction of Vasily Kandinsky (see *Der Blaue Reiter), and works abstracted from nature, or abstracted nature (such as *Cubism, *Futurism and *Purism).

There was to be nothing sentimental, nationalistic or romantic in Concrete Art. Its roots lay in *Suprematism, *Constructivism, De Stijl and Van Doesburg's Elementarism. Its aim was to be universally clear, the product, not of the irrational mind, as the Surrealists claimed, but of the conscious, rational mind of an artist free from illusionism or symbolism. The art was to be an entity in itself rather than a vehicle for spiritual or political ideas. In practice, the term became a synonym for geometrical abstraction in both painting and sculpture. In the works of art there exists an emphasis on real materials and real space, a love of grids, geometric shapes and smooth surfaces. The artists were often inspired by scientific concepts or mathematical formulae.

Concrete Art gained considerable momentum despite Van Doesburg's death in 1931. First, the Abstract-Création group supported it, until its demise in 1936, when the term and concept were taken up and elaborated by Max Bill (1908–94), a Swiss artist and architect, and former *Bauhaus student. Among those working in geometrically abstract styles during the 1930s were French artists Jean Gorin (1899–1981), Jean Hélion (1904–87) and Auguste Herbin (1882–1960); Italian Alberto Magnelli (1888–1971); Dutch César Domela (1900–92); English Ben Nicholson (1894–1982) and Barbara Hepworth (1903–75); Americans Ilyá Bolotowsky (1907–81) and Ad Reinhardt (1913–67); and Russian expatriates Anton Pevsner (1886–1962, see Constructivism) and Naum Gabo (1890–1977).

After World War II Paris became the most important centre for Concrete Art. In 1944, Denise René opened her gallery to promote Concrete Art, *Kinetic Art and *Op Art. The following year, the 'Art Concret' exhibition, assembled with the help of Nelly Van Doesburg (Theo's widow), was held at the Galerie René Drouin in Paris, and in 1946 the Salon des Réalités Nouvelles was established to exhibit geometrical abstraction. Concrete Art continued to gather international recruits during the late 1940s and 1950s, with groups forming in Argentina, Brazil, Italy and Sweden. New practitioners of geometrical abstraction elsewhere included Mary Martin (1907–69), Kenneth Martin (1905–84) and Victor Pasmore (1908–98) in England, and in the USA, sculptors such as José de Rivera (1904–85) and Kenneth Snelson (b. 1927).

Post-war debates regarding abstract art concentrated on the relative merits of 'cold' (geometrical) and 'hot' (gestural) abstraction; in the 1950s the latter dominated, in the form of *Abstract Expressionism and *Informel Art. Once again, Concrete Art defined itself in opposition to the mainstream, upholding the utopian heritage of geometric abstraction against the new 'Existential' attitude to matter and gesture. It remained cool, impersonal and precise. From this position, a new generation of Concrete Artists emerged, which continued to expand its forms and possibilities with work eventually leading to *Post-painterly Abstraction, *Minimalism and Op Art.

Key Collections
Foundation for Constructivist and Concrete Art, Zurich, Switzerland
National Museum of Women in the Arts, Washington, D.C.
Sintra Museu de Arte Moderna, Sintra, Portugal
Tate Gallery, London
Tate St Ives, England
Yale Center for British Art, New Haven, Connecticut

Key Books
Theo van Doesburg 1883–1931 (exh. cat., Eindhoven 1968)
J. Balieu, Theo van Doesburg (1974)
E. van Straaten, Theo van Doesburg: Painter and Architect (The Hague, 1988)
N. Lynton, Ben Nicholson (1993)

Max Bill, *Rhythm in Four Squares*, 1943
The emphasis of Bill's rigorously composed painting is on real materials and real space. Artists such as Bill often took as their starting points scientific concepts or mathematical formulae, resulting in characteristic arrangements of grids and geometric shapes.

Magic Realism

The art of painting is an art of thinking.

RENE MAGRITTE, 1949

The term Magic Realism was first used by German art critic Franz Roh in 1925 to differentiate between representative and expressionist tendencies in contemporary art. In Germany it was superseded by the term *Neue Sachlichkeit (New Objectivity). Others took up the label – along with 'Precise Realism' and 'Sharp-Focus Realism' – to describe a style of painting popular in the USA and Europe from the 1920s to the 1950s. In general, the works are characterized by a meticulous, almost photographic rendering of realistic-looking scenes endowed with mystery and magic through ambiguous perspectives and unusual juxtapositions, largely derived from the *Pittura Metafisica paintings of Giorgio de Chirico. Like the *Surrealists, Magic Realists used free association to create a sense of wonder in everyday subjects, but they rejected Freudian dream imagery and automatism.

Paul Delvaux, *The Hands (The Dream)*, 1941
The hypnotic trance-like state of the women in Delvaux's world after dark suggests the fantasies of dreams or fairytales, provoking in the viewer a voyeuristic sense of being allowed special access to them.

The US-based artists Peter Blume (1906–92), Louis Guglielmi (1906–56), Ivan Albright (1897–1983) and George Tooker (b. 1920) were among those called Magic Realists. In Blume's famous painting *The Eternal City* (1934–37), he created a kind of 'social surrealism' by amalgamating *Precisionist technique, the protest contained in *Social Realist works and the hallucinatory visual vocabulary of the Surrealists, the end result being a powerful critique of Mussolini and Italian Fascism.

European Surrealists who were also known as Magic Realists included the Frenchman Pierre Roy (1880–1950), the Belgians Paul Delvaux (1897–1994) and René Magritte (1898–1967). All three were influenced by De Chirico, particularly Delvaux, as seen in his paintings of quiet cities peopled by sleepwalking nudes.

Magritte is the most widely known of the Magic Realists, as are his painstakingly realistic 'fantasies of the commonplace'. His pictures raise questions about the reality of representation, set up oppositions between real space and fictive space and challenge the concept of a painting as a window on the world. His techniques – incongruous juxtapositions, paintings within paintings, combinations of the erotic and the ordinary, and disruptions of scale and perspective – translate everyday objects into images of mystery. Magritte was interested in the relationship between objects, images and language. *The Treachery (or Perfidy) of Images* (1928–29) is a celebrated poster depicting a pipe that is not a pipe ('Ceci n'est pas une pipe'), because it is a painting of a pipe, a mere representation of reality. Much of Magritte's work draws attention to the role of vision, the ways in which our intellect and emotions condition our perception of reality, and, ultimately, questions the reality we see.

Magritte's work particularly appealed to the Surrealists. Magritte himself, however, discouraged psychoanalytic readings: 'The true art of painting is to conceive and realize paintings capable of giving the spectator a pure visual perception of the external world.' The external world presented by Magritte is full of contradictions, dislocations, enigmas and strange juxtapositions; it is, in short, a mystery. Contrary to the Surrealist doctrine of automatism, Magritte (like De Chirico) asserted that the visible world is as valid a source of the marvellous as is the internal world of the subconscious.

Magritte's cover for the Surrealist publication *Minotaure* of 1937 conveys the sinister side of Surrealism and Magic Realism (the minotaur of Greek mythology lived off human flesh). As the minotaur came to stand for Nazism, Magritte's image could be read as an omen of what was to come, an urgent warning to the orthodox Surrealists and to the general public to wake up from their dreams.

The Magic Realists' strategies, in particular the blending of realistic imagery and magical content, have exerted considerable influence on later artists, such as those associated with *Nouveau Réalisme, *Neo-Dada, *Pop Art and *Super-realism.

René Magritte, Cover of *Minotaure*, 1937
Magritte's cover for the Surrealist publication *Minotaure* conveys the sinister side of Magic Realism. Read as a symbol of Nazism, the Minotaur serves as a warning to orthodox Surrealists to beware not only the beast within, but also the beast without.

Key Collections
J. Paul Getty Museum, Los Angeles, California
Minneapolis Institute of Arts, Minneapolis, Minnesota
Museum of Modern Art, New York
National Museum of American Art, Washington, D.C.
Norton Museum of Art, West Palm Beach, Florida
Tate Gallery, London

Key Books
S. Menton, *Magic Realism Rediscovered, 1918–1981* (1983)
D. Sylvester, *Magritte* (1992)
M. Pacquet, *René Magritte* (Cologne, 1994)
Magritte (exh. cat., Musée des Beaux-Arts, Brussels, 1998)

American Scene

*Real American art...which really springs from American soil
and seeks to interpret American life.*

MAYNARD WALKER, 1933

In the 1930s, America saw a revival of the native tradition of realism which stemmed from the *Ashcan School earlier in the century. The stock market crash of 1929, the Great Depression and the rise of Fascism in Europe prompted a period of national self-examination and of growing isolation from Europe, both in politics and in the arts. In the eyes of many Americans, the abstraction of European modernist art symbolized a growing decadence in Europe, prompting a turn towards a realistic art which embraced the specifically American imagery developed earlier in the 1920s by the *Precisionists. Along with the *Social Realists, the American Scene painters (also called American Gothic painters and Regionalists) produced images of America that ranged from gloomy isolation to the pride and splendour of a new rural Eden.

Scenes of rural and small-town vernacular architecture by Charles Burchfield (1893–1967), and desolate images of urban and suburban America by Edward Hopper (1882–1967), convey a strong sense of loneliness and despair. Burchfield's fantastical, expressionist manner gives a decayed look to his paintings, and provoked a critic to call them 'songs of hate'. Hopper wrote that his friend's work expressed 'the boredom of everyday existence in a provincial

Edward Hopper, *Approaching a City*, 1946
Hopper's subjects, though ordinary and anonymous and painted in a straightforward, even workmanlike manner, nevertheless produce extraordinary psychological atmospheres, often, as here, suggesting transitory lives made up of arrivals and departures.

community', and praised him for capturing 'a quality that we may call poetic, romantic, lyric or what you will.'

Hopper's remarkable use of light, which one critic described as a light that 'illuminates but never warms', makes his own images particularly mysterious. His aim was to evoke, 'all the sweltering, tawdry life of the American small town, this sad desolation of our suburban landscape'. After studying at the New York School of Art under Robert Henri, one of the fathers of American Realism, Hopper embarked on his first trip to Europe, with the long-held ambition of studying in Paris. He returned after several months there, having also visited London, Amsterdam, Berlin and Brussels. He claimed – perhaps somewhat self-consciously – that his experience in Paris had little effect:

> Whom did I meet? Nobody. I'd heard of Gertrude Stein, but I don't remember having heard of Picasso at all. I used to go to the cafés at night and sit and watch. I went to the theatre a little. Paris had no great or immediate impact on me.

He visited Europe twice more, in 1909 and 1910, but although he had been influenced at some level by his travels, he concentrated on the work with which he eventually won his reputation – American subjects. 'America seemed awfully crude and raw when I got back,' he said. 'It took me ten years to get over Europe.'

While the rural and small-town America of Burchfield and Hopper may have appeared monotonous and depressing, the same subject matter was given a more optimistic, nostalgic hue by the Regionalists. In 1933 Maynard Walker, a journalist and art dealer, held an exhibition at the Kansas City Art Institute entitled 'American Painting Since Whistler', which included works by Thomas Hart Benton (1889–1975), John Steuart Curry (1897–1946) and Grant Wood (1892–1942). Walker was a plain-spoken promoter of realistic American art. In his introduction to the exhibition catalogue, he appealed to collectors to support this art instead of the 'shiploads of rubbish that have just been imported from the School of Paris' (see *Ecole de Paris). Henry Luce of *Time* magazine enthusiastically supported the idea of a patriotic American art upholding wholesome 'American values'. The cover of the 1934 Christmas issue of *Time* featured a work by Benton, and contained colour

reproductions and laudatory reviews of other Regionalist art. The Regionalist myth was born, with Benton, Curry and Wood in the starring roles; as Benton later recalled:

> A play was written and a stage erected for us. Grant Wood became the typical Iowa small-towner, John Curry the typical Kansas farmer, and I just an Ozark hillbilly. We accepted our roles.

In the first half of the 1930s, Grant Wood's paintings of Midwestern landscapes, small-town citizenry and stoical, puritanical Iowan farmers were immensely popular. His famous work, *American Gothic* (1930), which gave its name to the gaunter aspect of American Scene painting, has become a national icon, celebrating the endurance of hard-working Middle Americans beyond the period of the Depression for which it was intended.

More outspoken than Maynard Walker, Thomas Hart Benton became the mouthpiece of Regionalism. His nationalism bordered on xenophobia. 'A windmill, a junk heap and a Rotarian have more meaning to me than Notre Dame or the Parthenon.' His particular scorn was reserved for big cities – especially New York – which he called 'coffins for living and thinking', and for European modernism, or 'aesthetic colonialism'. His own energetic, heroic style was well suited to the series of public murals, painted after 1930, which portrayed the idealized social history of the people of the Midwest in a muscular figuration reminiscent of Michelangelo.

Benton studied in Paris under the American *Synchromist Stanton MacDonald-Wright, but, once converted to Realism and to the promotion of the American rural Golden Age, he destroyed the majority of his early abstract works. 'I wallowed in every cockeyed ism that came along, and it took me ten years to get all that modernist dirt out of my system.'

During the 1930s he taught at the Arts Students League in New York where he became the teacher and friend of the young Jackson Pollock, who would later transform the flowing lines and epic scale of Benton's work into a new breed of modernism; he claimed: 'My work with Benton was important as something against which to react very strongly, later on.' By the early 1940s, the popularity of Regionalism was in decline, and the *Abstract Expressionists,

a group of artists centred around Pollock, were attracting formidable attention.

The main heirs of the Regionalists, at least in terms of nostalgic portrayals of America, were Norman Rockwell (1894–1978) and Andrew Wyeth (b. 1917). Both have proved immensely popular. Rockwell's illustrations and paintings of the ideal American family made him a household name in the 1950s, and *Christina's World* (1948) by Wyeth vies with *American Gothic* for the position of America's favourite painting.

Above: Norman Rockwell, *Freedom from Want*, 1943
During the Cold War, Rockwell's images of domestic America – solid, dependable, prosperous and, above all, free – gave a whole generation of Americans an immensely appealing and persuasive view of their traditional values.

Opposite: Grant Wood, *Stone City*, Iowa, 1930
In the first half of the 1930s, Wood's paintings of Midwestern landscapes, small-town citizenry and stoical, puritanical Iowan farmers were enormously popular, celebrating the endurance of hard-working Middle Americans.

Key Collections
Butler Institute of American Art, Youngstown, Ohio
Cedar Rapids Museum of Art, Cedar Rapids, Iowa
Knoxville Museum of Art, Knoxville, Tennessee
National Museum of American Art, Washington, D.C.
Swope Art Museum, Terre Haute, Indiana

Key Books
W. M. Corn, *Grant Wood: The Regionalist Vision* (1983)
T. Benton, *An Artist in America* (1983)
D. Lyons, *Edward Hopper and the American Imagination* (exh. cat., Whitney Museum of American Art, New York, 1995)
R. Hughes, *American Visions: The Epic History of Art in America* (1997)
W. Schmied, *Edward Hopper: Portraits of America* (1999)

Social Realism

Yes, paint America, but with your eyes open. Do not glorify Main Street. Paint it as it is — mean, dirty, avaricious.

MOSES SOYER

Two defining events of the 1930s, the Great Depression and the rise of Fascism in Europe, prompted many American artists to turn away from abstraction and to adopt realistic styles of painting. For Regionalists (see *American Scene), this meant the promotion of an idealized, often chauvinistic vision of America's agrarian past. Social Realists, however, felt the need for a more socially conscious art.

The painters often referred to as 'urban realists' – Ben Shahn (1898–1969); Reginald Marsh (1898–1954); Moses (1899–1974) and Raphael Soyer (1899–1987); William Gropper (1897–1977) and Isabel Bishop (1902–88) – documented the human cost of the political and economic tragedies of the day. Their themes link them with photographers Dorothea Lange (1895–1965), Walker Evans (1903–75) and Margaret Bourke-White (1904–71), who achieved the same characteristic blend of reportage and biting social commentary, creating some of the most enduring images of inter-war America.

Shahn was a photographer as well as a painter. Like many of his colleagues, he depicted the victims of miscarriages of justice. He became well known in the early 1930s for his paintings depicting the trial, imprisonment and execution of Italian immigrants Nicola Sacco and Bartolomeo Vanzetti, who were widely seen as victims of American xenophobia. With other artists and photographers of the 1930s, Shahn worked for the Farm Security Administration, recording conditions of rural poverty to agitate for Federal assistance.

Many Social Realist painters held Marxist principles, but became disillusioned with Communism after the Moscow show trials (1936–37) and the signing of the Hitler-Stalin Nonaggression Pact in 1939. While depicting similar subject matter, the harsh gaze and gritty realism of the Social Realists separate their work from the heroic peasants of Soviet *Socialist Realism. Comparisons could be drawn with the work of their contemporaries in Germany, such George Grosz and Otto Dix (see *Neue Sachlichkeit).

Inspiration for the Social Realists came from the *Ashcan School (many of them had studied with Ashcan artist John Sloan at the Art Students League in New York) and from the work of the Mexican Muralists. Diego Rivera (1886–1957), José Clemente Orozco (1883–1949) and David Alfaro Siqueiros (1896–1974), who all painted major murals in the USA, provided an example of a popular figurative art with social content. By the early 1940s, new forms of art, in particular *Abstract Expressionism, were attracting the attention of the critics and the public.

Above: **Margaret Bourke-White, *At the Time of the Louisville Flood*, 1937** Bourke-White's photographs, which have left us with some of the most enduring images of inter-war America, are characteristic of the Social Realists' blend of reportage and biting social commentary.

Opposite: **Ben Shahn, *Years of Dust*, c. 1935** Shahn, and other artists and photographers during the 1930s (including Lange and Evans), worked for the Farm Security Administration, recording the conditions of the rural poor in order to agitate for Federal assistance for them.

Key Collections

Art Institute of Chicago, Chicago, Illinois
Butler Institute of American Art, Youngstown, Ohio
Modern Art Museum of Fort Worth, Texas
Oakland Museum of California, Oakland, California
Springfield Museum of Art, Springfield, Ohio
Whitney Museum of American Art, New York

Key Books

D. Shapiro, *Social Realism: Art as a Weapon* (1973)
J. Treuherz, *Hard Times* (1987)
F. K. Pohl, *Ben Shahn* (1989)
H. Yglesias, *Isabel Bishop* (1989)

Socialist Realism

Artistic portrayal must be in harmony with the objective of the ideological alteration and education of the workers.

STATUTE OF THE UNION OF SOVIET WRITERS, 1934

Socialist Realism was declared to be the official artistic style of the Soviet Union in 1934 at the First All-Union Congress of Soviet Writers in Moscow. Similar congresses followed for the other arts, proclaiming Socialist Realism as the only type of art acceptable in the Soviet Union. The decision finally brought to an end the debate between the supporters of figurative art and those of abstract art, who had argued since the 1920s about the best sort of art to serve the revolution (see *Suprematism and *Constructivism), and effectively ended the 'modern' (abstract) movement in the Soviet Union. From 1934, all artists had to join the state-controlled Union of Soviet Artists and produce work in the accepted mode.

The three guiding principles of Socialist Realism were party loyalty (*partiinost*), presentation of correct ideology (*ideinost*) and accessibility (*narodnost*). Artistic merit was determined by the degree to which a work contributed to the building of socialism; work that did not was banned. Realism, more easily understood by the masses, was the style of choice. It was not so much a critical realism (as in the work of the *Social Realists), as an inspirational and educational one.

Socialist Realism was intended to glorify the state and celebrate the superiority of the new classless society being built by the Soviets. Both subjects and their representation in art were carefully monitored. Paintings approved by the State typically showed men and women at work or playing sports, political assemblies, political leaders and the achievements of Soviet technology, all portrayed in a naturalistic idealized fashion, in which the people were young, muscular, happy members of a progressive, classless society, and the leaders heroes. Socialist Realist works are usually monumental in scale and convey an air of heroic optimism. Prominent Socialist Realist artists included Isaak Brodsky (1884–1939), Alexander Deineka (1899–1969), Alexander Gerasimov (1881–1963), Sergei Gerasimov (1885–1964), Alexander Laktionov (1910–72), Boris Vladimirsky (1878–1950) and Vera Mukhina (1889–1953).

Vera Mukhina, *Industrial Worker and Collective Farm Girl*, 1937
Much Socialist Realist art, executed in a naturalistic, idealized fashion, showed men and women playing sports, or attending political assemblies, or, as here, at work – young, muscular, happy members of a progressive, classless society.

In the mid-1930s the most popular subjects of Socialist Realist paintings were the collective farms and industrialized cities, presenting the idealized outcome of Stalin's five-year plans. By the late 1930s, portraits of Stalin himself had become more prevalent, reflecting the growing 'cult of personality', which accompanied the successful completion of the first period of intense purges. One of Stalin's favourite painters, Alexander Gerasimov, made this clear in an address to the Artists' Union in 1938:

> Enemies of the people, Trotskyist-Bukharinite rabble, Fascist agents who have been active on the art front and who have attempted in every way to brake and hinder the development of Soviet art, have been unmasked and neutralized by our Soviet secret service.

At the end of World War II, Andrei Zhdanov (1896–1948), Stalin's cultural spokesman since 1934, formulated a set of even more restrictive resolutions, which were adopted by the Central Committee of the Communist Party in 1946. In these he promoted a particularly Russian nationalistic art, banned all foreign influences, particularly those of the West, and called for tighter government control of the arts. Between 1946 and 1948, Zhdanov purged all writers, musicians, artists, intellectuals and scientists who were deemed guilty of 'neglect of ideology and subservience to Western influence'. Although restrictions eased after Stalin's death in 1953, Socialist Realism remained the house style of the Soviet Union and its satellites until Mikhail Gorbachev's *glasnost* (openness) campaign in the mid-1980s.

The first General Congress of the Union of Soviet Architects in 1937 called on members to apply Socialist Realist principles in the realm of architecture. It called for the construction of buildings that drew on the appropriate local vernacular for each building type, using the newest building techniques and breaking with the traditions of the obsolete bourgeois past. The results needed to be suitably nationalistic and monumental. The Moscow underground system was considered uniquely important enough to continue being built when all other work halted at the outbreak of war.

Since the 1970s, a number of unofficial Russian artists, notably Vitali Komar (b. 1943) and Alexander Melamid

(b. 1945), who then emigrated to the USA during the 1970s, have fused the visual vocabulary of Socialist Realism and *Pop Art into a style they call 'Sots Art'. This witty combination of styles allows them to take on the myths and realities of the Soviet Union and the USA using the artistic styles that had been used to portray them during the Cold War.

Vitali Komar and Alexander Melamid, *Double-Portrait as Young Pioneers,* **1982–83** Komar and Melamid's witty juxtapositions allow them to take on the myths and realities of the Soviet Union through the same artistic styles used to construct and reflect them during the Cold War.

Key Collections
Dia Center for the Arts, New York City
State Russian Museum, St Petersburg
Tretyakov Gallery, Moscow

Key Books
V. Komar, *Komar/Melamid: Two Soviet Dissident Artists* (Carbondale, Ill. 1979)
M. Cullerne Bown, *Art under Stalin* (1991)
D. Ades and T. Benton, *Art and Power* (1996)
T. Lahusen and E. Dobrenko (eds), *Socialist Realism Without Shores* (Durham, N.C., 1997)
A. Julius, *Idolizing Pictures* (2001)

Neo-Romanticism

A world of private mystery.

JOHN CAXTON, 1941

Neo-Romanticism is used to describe two related but distinct groups of painters: a group in Paris during the 1920s and 1930s, and a group in England at work between the 1930s and 1950s. The key figures in Paris included the Frenchman Christian Bérard (1902–49), the Russian émigrés Pavel Tchelitchew (1889–1957) and the Berman brothers, Eugene (1899–1972) and Leonid (1896–1976). Their fantastic images show bleak landscapes inhabited by sad, tragic or horrifying figures, and it is easy to trace the influence of the *Surrealists, and of Giorgio de Chirico (see *Pittura Metafisica) and René Magritte (see *Magic Realism) in the visionary and mysterious scenery. Symbolically, they convey loss and alienation, and, considering the exile of the Russian émigrés, nostalgia for other places and other times.

One of the English Neo-Romantics, John Minton (1917–57), studied in Paris under Tchelitchew, and admired the brooding sorrow of the Parisian group's work; but, in general, the English artists – including Paul Nash (1889–1946), John Piper (1903–92), Graham Sutherland (1903–80), Keith Vaughan (1912–77) and Michael Ayrton (1921–75) – consciously drew on native themes and styles in their work. At a time of impending war, they anglicized European modernism to suit their needs. Important to them were William Blake, Samuel Palmer, the Pre-Raphaelites, Arthurian legends, the architecture of parish churches and cathedrals, and the English landscape tradition.

Generally speaking, the works they produced are emotionally and symbolically charged, and in them nature is

presented as a source of both strangeness and beauty. Objects in the landscapes, whether natural or manmade, are depicted as characters with their own personalities. This fusion of Surrealist imagery with the English landscape tradition (in which the elements are humanized, be they trees, buildings or even wrecked aircraft) is suggested in Nash's comments concerning one of his most famous World War II paintings, *Totes Meer* (Dead Sea, 1940–41), which depicts a site of wrecked German planes he saw near Oxford.

> The thing looked to me, suddenly, like a great inundating sea…. By moonlight…one could swear they began to move and twist and turn as they did in the air. A sort of rigor mortis? No, they are quite dead and still. The only moving creature is the white owl flying low over the bodies of the predatory creatures.

Nash's painting, in which the 'dead sea' is formed from the 'bodies' of the aggressor/victim, brings to mind a number of different elements – the visionary landscapes of Emil Nolde (see *Expressionism), the Surrealist interest in the link between animate and inanimate, and the battle between machines and nature.

English Neo-Romantic artists favoured watercolour and pen and ink, and their work proved popular during the war and afterwards in illustration and book design. Henry Moore (1898–1986, see *Organic Abstraction) is also sometimes associated with the Neo-Romantics; his wartime drawings are characteristically haunting.

Paul Nash, *Totes Meer* (Dead Sea), 1940–41
Nash's 'dead sea', formed from the 'bodies' of the aggressor/victim, recalls the Surrealist interest in the link between animate and inanimate and the battle between machines and nature, in which nature, specifically the English countryside, metaphorically prevails.

Key Collections
Aberdeen Art Gallery, Aberdeen, Scotland
Fine Arts Museums of San Francisco, San Francisco, California
Museum of Modern Art, New York
National Gallery of Art, Washington, D.C.
Tate Gallery, London

Key Books
S. Gablik, *Magritte* (1985)
B. Kochno, *Christian Bérard* (1988)
N. Yorke, *The Spirit of the Place: Nine Neo-Romantic Artists and their Times* (1988)
L. Kirstein, *Tchelitchew* (Santa Fe, CA, 1994)

1945-1965

A New Disorder

Jackson Pollock painting in his studio, East Hampton, Long Island

Art Brut

*Art springing from pure invention and in no way based,
as cultural art constantly is, on chameleon or parrot-like processes.*

JEAN DUBUFFET

Art Brut (Raw Art) was the term coined in 1945 by French artist and writer Jean Dubuffet (1901–85) to describe the collection he was building of paintings, drawings and sculptures made by people other than trained artists (see also *Outsider Art). He considered these individuals – children, visionaries, mediums, the untutored, prisoners and the insane – innocent of the deadening effects of both academic training and social conventions, and therefore free to create works of true expressiveness. World War II had just ended and much of Europe was in ruins. Traditions and values, no less than cities and towns, seemed to have been reduced to rubble, and artists, like everyone else, were forced to begin again. Dubuffet's interest was stimulated by the pre-war *Surrealists' interest in the work of the insane, by a number of exhibitions of children's art held during the Occupation, and by the large post-war exhibitions of patients' work at the St-Anne psychiatric hospital in Paris in 1946 and 1950. Dubuffet also read Berlin psychiatrist Dr Hans Prinzhorn's pioneering study, *Artistry of the Mentally Ill* (1922), and in 1945 he visited psychiatric hospitals in Switzerland.

In 1948 Dubuffet and critics André Breton (see Surrealism) and Michel Tapié (see *Art Informel), amongst others, established the *Compagnie de l'Art Brut*, a non-profit company to collect and study Art Brut, which, until then, had existed outside, but parallel to, the official art world, 'untamed and furtive as some wild creature'. One of the most celebrated Art Brut artists in the collection was the Swiss schizophrenic Adolf Wölfli (1864–1930). For around thirty years, in his cell in an asylum, he worked on his enormous autobiography, which combines the real and the imaginary into a fantastic voyage told through elaborately detailed text and illustrations. Another artist was English housewife and medium Madge Gill (1884–1961), who was guided by 'an unseen force' (which she called Myrninerest) in her drawings of girls' faces enclosed by flowing, intricate patterns of intertwining shapes.

Although people suffering from mental disorders made much of the work in the Art Brut collection, Dubuffet did not believe that there was such a thing as a 'psychiatric' art. He did not draw a line between the art of the insane and untrained or self-taught artists, but celebrated both as the work of Everyman, as proof of the democratic nature of creativity. What he particularly admired was the sheer force and uninhibited expressiveness of Art Brut. In the luxurious catalogue accompanying the first exhibition of the collection at the Galerie René Drouin in Paris in 1949, *L'Art brut préféré aux arts culturels* (Art brut preferred to cultural arts), he wrote: 'The artistic function is identical in all cases, and there is no more an art of the insane than there is an art of dyspeptics and people with sore knees.'

The Art Brut collection eventually travelled to the USA, where it was installed at the Long Island home of artist and writer Alfonso Ossorio (1916–90) from 1952 to 1962. While there, it was seen by visiting artists, and by the public at large when exhibited at the Cordier-Warren Gallery in New York in 1962 before returning to Paris. In 1972 the collection of over 5,000 pieces was donated to the city of Lausanne, where it was given a permanent home as the Collection de l'Art Brut in the Château de Beaulieu. Since the establishment of the institution, in theory, Art Brut refers only to works in the Lausanne Collection. 'Outsider Art' and 'Visionary Art' are more commonly used terms in English.

The term Art Brut is also often employed to describe Dubuffet's own art. He was not himself an outsider, though

Above: **Madge Gill, *Untitled, c.* 1940**
Spiritualism was a comfort and a stimulant for Madge Gill. Her 'unseen force' (which she called Myrninerest) guided her obsessive and sometimes chaotic drawings of girls' faces enclosed by flowing, intricate patterns of intertwining shapes.

Opposite: **Jean Dubuffet, *The Cow with the Subtile Nose*, 1954**
Absurd yet touching, Dubuffet's cow breaks from the European tradition of painted cows and bulls, with their noble, natural symbolism: of fertility, or even macho heroism, of the kind shown by Picasso's Minotaurs. Naïvety and humour invite a fresh and honest response.

he came to a career in art late in life, having been a wine merchant until the age of forty-one. He was influenced by the discovery of the Lascaux cave paintings in 1940 and by the anonymous graffiti on the walls of Paris, captured in photographs by Brassaï (1899–1984), both of which contributed to his belief in mankind's primal urge to mark and create, as well as to his personal visual vocabulary. He himself aimed at a raw and uninhibited art at once farcical, satirical, crude and absurd. *The Cow with the Subtile Nose* (1954), ridiculous but touching, could not be further removed from the European tradition of painted cows and bulls, with their bucolic airs and steaming potency: it seems to have escaped into an innocence of its own.

Unlike his friend Antonin Artaud (1896–1948) – playwright, artist, critic, mystic and one-time Surrealist – Dubuffet had the fortune to observe madness without having to experience it himself. For Artaud, however, writing and drawing were a means of defying his insanity: not a luxury, but catharsis. He said himself, in his influential text, 'Van Gogh, the Man Suicided by Society' (1947), 'No one

has ever written, painted, sculpted, modelled, built, or invented except literally to get out of hell.' Artaud's tragic descent into hell is forcefully visualized in his anguished self-portraits, which he made by attacking the paper with his crayons. 'He worked with rage, broke crayon after crayon, enduring the throes of his own exorcism', wrote a friend. Dubuffet too believed that art was born out of a bodily struggle between the artist and his media. His extraordinary *haute pâte* works of the 1940s and 1950s are relief-like objects in which images have been brutally scratched, or graffitied, into a mud-like material mixed with sand, tar and gravel. Manipulating this paste, which Tapié described as a 'sort of living matter working its perpetual magic', he created the effect of figures rising out of the primordial sludge. His later work, although appearing very different from his early work, explored similar themes. The *Hourloupe* series, which he worked on from 1962 to 1974, was inspired by the semi-conscious doodles one makes with a ballpoint pen while on the telephone. Starting from the tool that modern man uses to make his mark, Dubuffet created an imaginary,

puzzle-like world of paintings, sculptures and environments.

With his own art and through his sponsorship and promotion of Art Brut, Dubuffet attempted to subvert received notions about art – how it could be made, what it could be made from and who could make it. His work and theories align him with many post-war art movements. The emphasis he placed on the intuitive, primal source of art was shared with artists associated with Art Informel, *Existential Art, *CoBrA and *Abstract Expressionism. His exploration of new materials and techniques was a liberating example for a whole variety of artists, such as *Pop artist Claes Oldenburg, who wrote in 1969: 'Jean Dubuffet influenced me to ask why art is made and what the art process consists of, instead of trying to conform to and extend a tradition.'

Key Collections

Adolf Wölfli-Stiftung, Kunstmuseum, Bern, Switzerland
Collection de l'Art Brut, Château de Beaulieu,
 Lausanne, Switzerland
Fine Arts Museums of San Francisco, San Francisco, California
Kreeger Museum, Washington, D.C.
Musée des Arts Décoratifs, Paris
Museum of Fine Arts, Boston, Massachusetts

Key Books

Parallel Visions: Modern Artists and Outsider Art, (exh. cat.,
 Los Angeles County Museum of Art, 1992)
Susan J. Cooke, et al., *Jean Dubuffet 1943–1963* (exh. cat.,
 Hirshhorn Museum, Washington, D.C., 1993)
J. Dubuffet, *Jean Dubuffet: The Radiant Earth* (1996)

Existential Art

It is true that only one thing has ever been asked of our generation –
that it should be able to cope with despair.

ALBERT CAMUS, 1944

Existentialism was the most popular philosophy of the post-war era in Continental Europe. It took the position that man is alone in the world without any pre-existing moral or religious systems to support and guide him. On the one hand he is forced to a realization of his solitariness, of the futility and absurdity of existence; on the other he has the freedom to define himself, to reinvent himself with every action. Such themes captured the mood of the immediate post-war years and exerted a powerful influence on artistic and literary developments in the 1950s – the fashionable youth culture of St-Germain-des-Prés, the counter-culture of the Beat Generation and the 'Angry Young Men' of Britain.

The French writers Jean-Paul Sartre (1905–80) and Albert Camus (1913–60), heroes of the Resistance during the Second World War, were two of the intellectual heroes of the post-war period. Sartre's Existentialist philosophy was first laid out in his treatise, *L'Etre et le néant* (Being and Nothingness), published in occupied Paris in 1943, and in the years after the war there followed what French writer Simone de Beauvoir (1908–86) called the 'existentialist offensive': a spate of books, plays and articles by Camus, Sartre, De Beauvoir and Jean Genet (1910–86), enthusiastically received by a public disillusioned by the war. As De Beauvoir said in 1965, Existentialism seemed to 'authorize them to accept their transitory condition without renouncing a certain absolute, to face horror and absurdity while still retaining their human dignity.' Existentialism was a philosophy which quickly coloured the arts, in particular literature and visual art. There were very close ties between writers – such as André Malraux (1901–76), Maurice Merleau-Ponty (1908–61), Francis Ponge (1899–1988), Samuel Beckett (1906–89) among others – and artists of the period. The language of Existentialism – authenticity, angst, alienation, absurdity, disgust, transformation, metamorphosis, anxiety, freedom – became the language of art criticism, as the writers put into words the experience of confronting the work. For Sartre and others, the artist, viewed as one who continually searches for new forms of expression, constantly enacted the Existential predicament of man.

It is the mood and thought in works of art, not the style, that give them their Existential flavour. Works by the *Abstract Expressionists, the *Informel and *CoBrA, the French Homme-Témoin (Man as Witness) group, the British *Kitchen Sink School and the American *Beats are all sometimes described as Existential, abstract and figurative alike. So, too, are many artists who do not fit easily into any group: the French artists Jean Fautrier (1898–1964), Germaine Richier (1904–59) and Francis Gruber (1912–48); Swiss artist Alberto Giacometti (1901–66);

Dutch Bram Van Velde (1895–1981); and British artists Francis Bacon (1909–92) and Lucian Freud (b. 1922).

Fautrier's most famous series of paintings and sculptures, *Hostages*, was made while he was hiding out during the war at a mental asylum on the outskirts of Paris, where he could hear the screams of prisoners being tortured and executed by the Nazis in the surrounding forest. This harrowing experience is reflected in the works themselves. His manipulation of the materials, with their layered and scored surfaces, lend the appearance of mutilated flesh to the truncated body parts. Although he produced pictures of such explicit violence, Fautrier stopped short of completely obliterating the human figure. His mix of figuration and abstraction powerfully conveys both the human origin of the victims and the abstract quality of anonymous victims found in mass graves. They also reveal an obsessive desire to commemorate the victims, as well as to record the atrocities inflicted upon them. When the *Hostages* works were first exhibited at the Galerie René Drouin in Paris in 1945 they caused an uproar. The paintings were hung in tight rows, furthering the association with mass executions, and many of them were coloured with powdery pastels, giving them a shocking erotic prettiness. Malraux, in the preface to the catalogue of the exhibition, saw the series as 'the first attempt to dissect contemporary pain, down to its tragic ideograms, and force it into the world of eternity.'

Like Fautrier, Richier was praised for her 'authenticity' (a key notion of Existential thought), and her sculptures were seen as either hopeful or pessimistic – as images of the horrors of war or of the power of man to transcend it. The features of her figures may be obliterated or flayed, but they are survivors, they retain a certain dignity and sense of life. The Existential anguish is clear in Richier's work, but it can also be seen in the context of *Expressionism, in the violence of her artistic language, and *Surrealism, in the richness of her work's mystery; it is in the combination of these features that it stands so pertinently for the mood of the post-war period.

For many of the writers, such as Genet, Sartre and Ponge, Giacometti, a former Surrealist, was the archetypal Existentialist artist. His obsessive reworking of the same subject and his fragile figures lost in wide open spaces expressed man's

Above right: **Germaine Richier, *Water*, 1953–54**
Richier's sculptures were seen as either hopeful or pessimistic – as images of the horrors of war or of the power of man to transcend it. The features of her figures may be obliterated or flayed, but they are survivors, and they retain a certain dignity and sense of life.

Right: **Jean Fautrier, *Hostage*, 1945**
Fautrier's harrowing personal experience is reflected in the *Hostages* series, where the manipulation of his materials, with their layered and scored surfaces, lend the appearance of mutilated flesh to the images of truncated body parts.

isolation and struggle, and of the continual need to return to the beginning and start again. Genet, in 1958, wrote: 'Beauty has no other origin than the particular wound that every man carries within himself….Giacometti's art seems to me to be aiming at exposing this secret wound in every being and even in every thing, thus allowing it to enlighten them.' Sartre also wrote about Giacometti. His catalogue essay for Giacometti's first post-war exhibition at the Pierre Matisse Gallery in New York in 1948, 'The Search for the Absolute', helped introduce Existentialist ideas in the USA and Britain.

The Existentialist 'misery' – and the myth of the Existentialist artist – had become fashionable by the 1950s, adopted by the style-conscious youth in the cafés, basements and jazz bars of St-Germain-des-Prés. The *misérabiliste* mode of the Homme-Témoin group of painters, including

Opposite: **Francis Bacon,** *Figure in Movement*, **1976**
The theatricality, violence and claustrophobic atmosphere of Bacon's paintings, with their refusal to offer easy, or indeed any, consolations, have led many to claim his work as the most unforgiving and anguished of all Existentialist Art.

Below: **Alberto Giacometti,** *Man Walking III*, **1960**
Abstract Expressionist Barnett Newman said Giacometti's figures looked 'as if they were made out of spit – new things with no form, no texture, but somehow filled.' Emphasizing the immensity of the space around them, the figures seem fragile, isolated and exposed.

Bernard Buffet (1928–99), Bernard Lorjou (b. 1908) and Paul Rebeyrolle (b. 1926), was particularly popular. Their manifesto of 1948, written by critic Jean Bouret, declared: 'Painting exists to bear witness, and nothing human can remain foreign to it.' The style adopted was a dramatic realism. Buffet's stylized linear figures in scenes of post-war austerity and grief made him an overnight celebrity and one of the most successful painters of the 1950s. Existentialist ideas had also become part of the language of English art criticism by the 1950s, primarily through exposure to Sartre's essay on Giacometti, which proved important for the English critic David Sylvester and the circle of British artists he was close to, first in Paris, then in London, such as Bacon, Reg Butler (1913–81), Eduardo Paolozzi (b. 1924) and William Turnbull (b. 1922). The theatricality, violence and claustrophobic atmosphere of Bacon's paintings have led many to claim him as the most anguished Existentialist artist. Similarly, the brooding atmosphere of Lucian Freud's hyper-realist portraits of the 1940s led critic Herbert Read to call him 'the Ingres of Existentialism'.

By the end of the 1950s, Existentialism had become a widespread phenomenon. In 1959 many European 'Existentialist' artists were brought together with their American counterparts, such as Abstract Expressionist Willem de Kooning, in an exhibition curated by Peter Selz at the Museum of Modern Art in New York. The title of the exhibition 'New Images of Man', indicated the popularity of Existentialism as an intellectual framework for the interpretation of visual art. By the 1960s, however, alienation and individualism were seen to have degenerated into egocentrism, and the Existentialist worldview was challenged by a new generation who sought to create art in communion with others and their environment (see *Neo-Dada, *Nouveau Réalisme and *Pop Art).

Key Collections
Beyeler Foundation Collection, Basel, Switzerland
California State University Library, Northridge, California
Fine Arts Museum of San Francisco, San Francisco, California
Moderna Museet, Stockholm, Sweden
Stedelijk Museum of Modern Art, Amsterdam, the Netherlands
Tate Gallery, London

Key Books
C. Juliet, *Giacometti* (1986)
R. M. Mason, *Jean Fautrier's Prints* (1986)
H. Matter, *Alberto Giacometti* (1987)
R. Hughes, *Lucian Freud: Paintings* (1989)
D. Sylvester, *Looking Back at Francis Bacon* (2000)

Outsider Art

*Their work is made out of vital needs, obsessions, and compulsions
and their motivations are honest, pure and intense.*

ANDY NASISSE

Outsider Art, a term often used interchangeably with *Art
Brut, describes art created by non-artists. It has a wider
application, however, encompassing not only the Art Brut
collection in Lausanne, Switzerland, but any art produced by
those outside the art system. The term began to be used
widely after the publication of critic Roger Cardinal's
influential book, *Outsider Art*, in 1972. Cardinal was
searching for a label that would stress the maker's creative
independence rather than his marginal social or mental
status: outsider artists are outside the art world, but not
necessarily outside society. Visionary Art, Intuitive Art and
Grassroots Art are other terms used for the same reasons
of neutrality.

Some of the most impressive works of outsider art are
monumental structures built over many years. One is the
Palais idéal (Ideal palace) in Hauterives, France, begun in
1879 by the French postman Le Facteur (Ferdinand) Cheval
(1836–1924), and completed thirty-three years later. The
bizarre structure, which is reminiscent of Indian temples,
Gothic cathedrals and Cheval's memories of the pavilions of
the Paris World's Fair of 1878, became a tourist attraction
in his own lifetime, and many of the *Surrealists made
pilgrimages to it in the 1930s. Watts Towers, Los Angeles
(1921–54), by Italian construction worker Simon Rodia
(c. 1879–1965), built out of steel and coloured cement, and
decorated with tiles, shells and stones, is another celebrated

monument. Like Cheval, Rodia laboured on his building for thirty-three years, and then, having made over the deeds to a neighbour, left the city and refused to return, saying, 'there's nothing there.' During the 1960s, the towers became an important source of inspiration for the *Assemblage artists. The Rock Garden of Chandigarh (begun in 1958) by Indian roads inspector Nek Chand (b. 1924) is still in progress. All these structures have provided mainstream artists with examples of untutored visual and stylistic forms. Of equal importance, they present the seductive model of the artist as one who is compelled to create – the notion of art making as necessity, not choice. Outsider artists are admired for their sincerity and perseverance, as Andy Nasisse (b. 1946), one of many contemporary artists who study, collect and are inspired by Outsider Art, has explained.

The growing public recognition and appreciation for Outsider Art has brought it into the mainstream. One of the most prominent examples is that of the American, Reverend Howard Finster (b. 1916), whose work has become familiar to millions through the album covers he designed for two bands, Talking Heads (*Little Creatures*, 1985) and R.E.M. (*Reckoning*, 1988), among other high-profile commissions. Outsider artists have acquired gallery representation, commissions, their works have entered major museums, and their monuments and environments are protected by being placed on historical registers. When the authorities discovered Chand's illegal secret garden, instead of destroying it, he was given a salary and staff to help in its building. It now spreads over twenty-five acres and receives more than 5,000 visitors a day.

Key Monuments

Howard Finster, Paradise Garden, Pennville, Georgia
Le Facteur (Ferdinand) Cheval, Palais Idéal,
 Hauterives, France
Nek Chand, The Rock Garden of Chandigarh,
 Chandigarh, India
Simon Rodia, Watts Towers, 107th Street, Los Angeles,
 California

Key Books

R. Cardinal, *Outsider Art* (1972)
B.-C. Sellen and C. J. Johanson, *20th Century American Folk,
 Self-Taught, and Outsider Art* (1993)
B. Goldstone, *The Los Angeles Watts Towers*
 (Los Angeles, CA, 1997)
C. Rhodes, *Outsider Art* (2000)

Opposite: **Nek Chand, *Massed Villagers, second phase of the Rock Garden*, 1965–66** The Rock Garden in the north-eastern edge of the city of Chandigarh was built from discarded objects and industrial waste. The status of Outsider artists has recently improved and Chand was given financial for the upkeep of the secret garden. A foundation was set up for its completion and preservation.

Organic Abstraction

In the contemplation of Nature we are perpetually renewed.

BARBARA HEPWORTH, 1934

Organic abstraction is the name given to the use of rounded abstract forms based on those found in nature. Also called Biomorphic Abstraction, it was not a school or movement, but a striking feature of the work of many different artists, such as Vasily Kandinsky (see *Der Blaue Reiter), Constantin Brancusi (see *Ecole de Paris) and the artists of the *Art Nouveau. But it is most commonly applied to work of the 1940s and 1950s, particularly by *Surrealists Jean (Hans) Arp, Joan Miró and Yves Tanguy and the British sculptors Barbara Hepworth (1903–75, see also *Concrete Art) and

Right: **Isamu Noguchi, *Table*, c. 1940**
Noguchi considered all his work to be sculpture, and he consistently favoured biomorphic forms, particularly during the 1940s. His table captures the sculptural elegance and refinement of materials characteristic of his work as a whole.

Henry Moore (1898–1986, see also *Neo-Romanticism).

The shapes of the sculptures of Arp, Miró and Moore show obvious affinities with natural forms, such as bones, shells and pebbles. Their work achieved huge popularity, and, writing in 1937, Moore recorded his belief that 'there are universal shapes to which everybody is subconsciously conditioned and to which they can respond if their conscious control does not shut them off.' This appeal extended not only to other artists – such as Alexander Calder (1898–1976, see *Kinetic Art), Isamu Noguchi (1904–88) and the *Abstract Expressionists – but also to a whole generation of furniture designers, especially in the USA, Scandinavia and Italy. While nature itself was a critical source of inspiration for Hepworth, Moore and Arp, it was more the 'rounded', free-flowing shapes of their sculptures, admired as 'drawings in space', that were crucial for the designers of the 1940s and 1950s.

Prominent furniture designers in the USA included Charles Eames (1907–78) and his wife Ray Eames (1912–88), Noguchi and the Finn Eero Saarinen (1910–61). Charles Eames and Saarinen came to prominence in 1940 when their collaborative designs for living room furniture

won first prize in the 'Organic Design in Home Furnishings Competition' by the Museum of Modern Art in New York. Eames went on to become the first designer ever given a solo show at the museum in 1946. The example of avant-garde artists and industrial designers (especially in the aircraft and automobile industries) and innovative technological developments (such as new bending techniques and new laminates of various materials) allowed furniture designers to create increasingly organic designs. This, combined with the general perception that rounded shapes were more comfortable, made organic furniture appear both cutting edge and welcoming.

The 1955 rosewood and leather lounge chair and footstool by the Eameses, originally designed as a birthday present for film director Billy Wilder, is one of their most celebrated designs. Describing it, Charles said he wanted it to have the 'warm receptive look of a well used first baseman's mitt.' Saarinen also designed landmark chairs, whose very names point to their 'organic' sources: his 1946 Womb chair and 1956 Tulip chair. Biomorphic forms also featured in his architectural projects of the period, in particular the TWA airline building at JFK airport in New York (1956–62). Noguchi, for his part, considered all of his work to be sculpture, be it a lamp, playground, stage set, garden or public work of art, and all tended to take biomorphic forms, particularly during the 1940s. His famous coffee table with a glass top resting on a gently curved wooden base of 1947 captures the sculptural elegance and refinement of materials characteristic of his work as a whole.

In Italy, design with a strongly organic feel played a major role in post-war reconstruction. With the straight geometrical lines of rationalism tainted by association with Fascism (see *M.I.A.R.), designers turned to the curve. Fusing aspects of American design, Surrealism and the sculptures of Moore and Arp, a distinctive organic aesthetic appeared throughout Italy, from industrial design – cars, typewriters and Vespas – to interior design and furniture. The bentwood and metal furniture of Carlo Mollino (1905–73), for example, shows a debt to those sources as well as to an earlier pioneer of organic design, Antoni Gaudí (see *Modernisme), to whom he paid homage with his Gaudí chair of 1949. Achille Castiglioni (b. 1918) also made furniture that

Left: **Achille Castiglioni,** *220 Messadro,* **1957**
Made from a tractor seat, Castiglioni's chair neatly restates the recurring debate, active since the days of the Deutscher Werkbund and the Bauhaus, about the relationship between art and design, and design and technology.

Opposite: **Henry Moore,** *Reclining Figure,* **1936**
Writing a year after this piece was completed, Moore recorded his belief that 'there are universal shapes to which everybody is subconsciously conditioned and to which they can respond if their conscious control does not shut them off.'

specifically referred to avant-garde art – *Dada and Surrealism, and the practice of the use of the 'found object'. His 1957 Sella (saddle) stool – made from a bicycle seat – and Mezzadro chair – made from a tractor seat – neatly restate the recurring debate about the relationship between art and design, and design and technology (see for instance, the *Deutscher Werkbund and the *Bauhaus).

Scandinavia was another home of organic abstraction in the 1940s and 1950s. The Finn Alvar Aalto (see also *International Style) and his wife Aino Marsio Aalto (1894–1949) and Danish architect and designer Arne Jacobsen (1902–71) all produced internationally regarded work. Like Saarinen, Jacobsen's organic sources are revealed in the titles of his best-known chairs, Ant (1951), Swan (1957) and Egg (1957).

While the tendency towards organic abstraction was particularly visible in the 1940s and 1950s, it has continued to be one of many strains apparent in art and design since, in the work of sculptors as varied as Linda Benglis (b. 1941), Richard Deacon (b. 1949), Eva Hesse (1936–70), Anish

Kapoor (b. 1954), Ursula von Rydingsvard (b. 1942) and Bill Woodrow (b. 1948), and designers Ron Arad (b. 1951), Verner Panton (1926–98) and Oscar Tusquets (b. 1941).

Key Collections

Bolton Art Gallery, Bolton, England
Cornell Fine Arts Museum at Rollins College, Winter Park, Florida
National Museum of Women in the Arts, Washington, D.C.
Tate Gallery, London
Tate St Ives, England

Key Books

Bruce Altshuler, *Isamu Noguchi* (1994)
P. Curtis, *Barbara Hepworth* (1998)
P. Reed (ed.), *Alvar Aalto* (1998)
J. Wallis, *Henry Moore* (Chicago, Ill., 2001)

Art Informel

Art Informel (art without form) was a name given in Europe to the type of gestural abstract painting which dominated the international art world from the mid-1940s until the late 1950s. It was coined by French writer, sculptor and jazz musician Michel Tapié (1909–87), though it had to compete with other terms, including Lyrical Abstraction, Matter Painting and Tachism. This proliferation of names, which tend to intersect and confuse, rather than clarify, arose from the intense competition between French critics in the post-war period to locate and define a new avant-garde.

The term Lyrical Abstraction, coined by Georges Mathieu (b. 1921), drew attention to the physical action of painting in his own work and the work of artists such as Frenchmen Camille Bryen (1907–77); Hungarian-born Simon Hantaï (b. 1922); Czech-born Iaroslav Sossuntzov, known as Serpan (1922–76); Germans Hans Hartung (1904–89) and Alfred Otto Wolfgang Schulze, known as Wols (1913–51).

Matter Painting stressed the evocative powers of materials – often unusual ones – used by French artists such as Jean Dubuffet (see *Art Brut), Jean Fautrier (see *Existential Art); Dutchmen Jaap Wagemaker (1906–75) and Bram Bogart (b. 1921); Italian Alberto Burri (b. 1915); and Catalonian Antoni Tàpies (b. 1923). Tachism (from the French *tâche*, blot, stain) focused on the expressive gesture of the artist's mark by artists such as British painter Patrick Heron (b. 1920), Frenchman Pierre Soulages (b. 1919) and Belgian Henri Michaux (1899–1984).

What all the theoreticians of the new art agreed upon was that the work of these artists signalled a radical break from the dominant art practices of the immediate post-war era, summed up by critic Geneviève Bonnefoi as the 'twin terrors of *Socialist Realism and geometric abstraction'. Both the vocabulary of realism and the intellectualism of geometric abstraction (see *Concrete Art, *De Stijl and *Elementarism) were considered inadequate to the task of addressing the realities of the post-war experience; the poverty, suffering and anger, which, they argued, could not be depicted, only expressed.

Influenced by the Existentialism of the era, Informel artists were celebrated for their individualism, authenticity, spontaneity and emotional and physical engagement in the process of creating images which depicted the artist's 'inner being'. Mathieu described his own process as 'Speed, intuition, excitement: that is my method of creation.' He often gave grandiose public demonstrations, such as one held in the Théâtre Sarah-Bernhardt, Paris, in 1956, where he

Left: **Hans Hartung, *Untitled*, 1961**
Hartung was one of the European painters exhibited by Tapié alongside American Abstract Expressionist artists, such as Willem de Kooning and Jackson Pollock, to show that gestural abstraction was an international tendency.

Opposite: **Wols, *The Blue Phantom*, 1951**
In 1963, long after the artist's death, Jean-Paul Sartre wrote that 'Wols, human and Martian together, applies himself to seeing the earth with inhuman eyes: it is, he thinks, the only way of universalizing our experience.'

painted a canvas measuring 12 x 12 metres (39 x 39 feet) in less than thirty minutes, using eight hundred tubes of paint.

For Tapié, it was the immediate post-war exhibitions of Fautrier's *Hostages*, Dubuffet's *Haute Pâtes*, and Wols's drawings and watercolours in 1945 that signalled the beginning of the Informel adventure. All three took place at the Galerie René Drouin in Paris, an important site for the new type of work. As with Fautrier's *Hostages* exhibition, Drouin's installation of Wols's small evocative works in black box frames, individually lit, added to the intensity of the viewing experience. Writing in 1953, Tapié claimed Wols as the 'catalyst of a lyrical, explosive, anti-geometrical and unformal non-figuration'.

Wols was a major source of inspiration for artists and writers alike, such as Jean-Paul Sartre, who wrote in 1963, long after the artist's death, that, 'Wols, human and Martian together, applies himself to seeing the earth with inhuman eyes: it is, he thinks, the only way of universalizing our experience.' Wols's dissolute lifestyle – beset by poverty, depression and alcoholism – and his early death from food poisoning, also led Sartre to present him as the archetypal Existential artist who sacrificed himself in an obsessive struggle to make sense of the world.

In the two months following his wife's accidental death, poet and painter Michaux made over 300 drawings, in order to work through the grief, or, as he put it, 'to undo the world of confused, conflicting things in which I am plunged.' These were shown at Drouin's gallery in 1948 and, again, the tight hanging of the works enhanced their impact, leading one critic, René Bertelé, to describe the walls of the

gallery as looking as 'though they had been splattered when some uncontrollable wave had broken'.

With many others of the period, Michaux was interested in Eastern philosophies, such as Taoism and Zen, and in Chinese and Japanese calligraphy, a result of his research into the fundamentals of communication, both visual and verbal. Many of these interests came together in his series of calligraphic-like Indian ink drawings, collectively known as 'Movements', published in 1951. In the statement accompanying them, Michaux wrote: 'I see in them a new language, spurning the verbal, and so I see them as *liberators*.' For Michaux, who was as well known for his writing as his painting, both were tools to self-discovery. In 1959 he wrote: 'I paint just as I write. To discover, to rediscover myself, to find what is truly mine, that which unbeknown to me, has always belonged to me.'

While many critics and artists were attempting to establish another *Ecole de Paris, Tapié was more interested in gestural abstraction as an international tendency, and he looked beyond the French capital to the American *Abstract Expressionists, the German groups Zen 49 and Quadriga,

Above: **Patrick Heron, *Cadmium with Violet, Scarlet, Emerald, Lemon and Venetian*, 1969** Nature was Heron's stimulus, yet his work became abstract. Colour was his major theme and preoccupation. In 1962, Heron wrote: 'Painting has still a continent to explore, in the direction of colour (and in no other direction).'

Opposite: **Georges Mathieu, *Mathieu from Alsace goes to Ramsey Abbey*** In the preface to the 'Véhémences Confrontées' (Opposing Forces) exhibition catalogue in 1951, Mathieu dismissed the art world's abstraction versus figuration debates, proclaiming 'The adventure is elsewhere and other.'

the Canadian Automatistes, the Italian Arte Nucleare painters and the Japanese Gutai association. With the flamboyant painter and propagandist Mathieu, he organized exhibitions in Paris convening a wide variety of practitioners, such as 'Véhémences Confrontées' (Opposing Forces) at the Galerie Nina Dausset in 1951, which brought together the American Abstract Expressionist artists Willem de Kooning and Jackson Pollock with Europeans such as Hartung, Bryen and Wols. In the preface to the exhibition's catalogue, Mathieu completely dismissed the relevance of the art world's abstraction versus figuration debates of the 1940s, proclaiming 'The adventure is elsewhere and other.' In 1952 Tapié took this further in his manifesto-like book *Un art autre* (a different, other art). Writing of a need for 'temperaments ready to break up everything', he explained that 'true creators know that the only possible way for them to express their unavoidable message is through the extraordinary – paroxysm, magic, total ecstasy.' Various influences on the Informel are clarified by the book. Pre-war Surrealism is one, with its emphasis on the unconscious, or pre-conscious, as the seat of artistic inspiration. *Expressionist abstraction is another, particularly the work of Vasily Kandinsky (see *Der Blaue Reiter). Tapié's interpretation of Informel artists' work (that it exhibits the primal urge of man to create) also points

to his involvement with Art Brut, his interest in Existentialist art and philosophy and the relationship of the Informel to other contemporary trends, such as *Lettrism. Like Lettrism, Tapié's *Un art autre* can also be seen as part of the recuperation of *Dada; for, like the Dada adventure, Art Autre was a return to ground zero, an involvement with the 'real' – an unformed, indefinite space based on an awareness of the discoveries of science, mathematics, physics and space. The shared interest in calligraphy and the problems of communication also underlined the converging attitudes between many Lettrist and Informel artists, in their attempt to create a visual poetry.

Tapié's conceptualization of this 'other art', which emphasized an attitude rather than a particular style, also covered artists whose work appeared to reconcile, or discount, the abstraction-figuration and/or the geometric-gestural conflict, such as France-based Roger Bissière (1888–1964), Maria Elena Vieira de Silva (1908–92), Nicolas de Staël (1914–55) and Germaine Richier (see Existential Art); Austrian Friedrich Stowasser, known as Hundertwasser (b. 1928); and British painters Roger Hilton (1911–75), Peter Lanyon (1918–64) and Alan Davie (b. 1920) and the *CoBrA artists. Still others, whose work showed an interest in psychic sources of creativity, such as Russian expatriates Serge Poliakoff (1900–69) and André Lanskoy (1902–76), Austrian Arnulf Rainer (b. 1929) and Italian Emilio Vedova (b. 1919), could also be included under Tapié's term.

Further exhibitions of Art Informel followed throughout the 1950s in Europe, the Far East and North America, and the sheer popularity of expressive gestural abstraction led to Abstract Expressionism and the Informel becoming an international style of painting of the post-war period. However, by the late 1950s there appeared a new generation of artists (see *Neo-Dada, *Nouveau Réalisme and *Pop Art), to question its stature and dominance.

Key Collections
Centre Georges Pompidou, Paris
Fine Arts Museums of San Francisco, San Francisco, California
Museum of Modern Art Ludwig Foundation, Vienna, Austria
Tate Gallery, London
University of Montana Museum of Fine Arts, Missoula, Montana

Key Books
Lyrical abstraction (exh. cat., Whitney Museum of American Art, New York, 1971)
S. J. Cooke, et al., *Jean Dubuffet 1943–1963* (exh. cat., Hirshhorn Museum, Washington, D.C., 1993)
J. Mundy, *Hans Hartung: Works on Paper* (1996)
M. Leja, J. Lewison, et al., *The Informal Artists* (1999)
H. Michaux, *Henri Michaux, 1899–1984* (exh. cat., Whitechapel Art Gallery, London, 1999)

Abstract Expressionism

The need is for felt experience – intense, immediate, direct, subtle, unified, warm, vivid, rhythmic.

ROBERT MOTHERWELL, 1951

Although the term Abstract Expressionism had been used during the 1920s to describe the early abstractions of Vasily Kandinsky (see *Der Blaue Reiter), it has since come to refer to a group of American or US-based artists who were prominent during the 1940s and 1950s, including William Baziotes (1912–63), Willem de Kooning (1904–97), Arshile Gorky (1905–48), Adolph Gottlieb (1903–74), Philip Guston (1913–80), Hans Hofmann (1880–1966), Franz Kline (1910–62), Robert Motherwell (1915–91), Lee Krasner (1911–84), Barnett Newman (1905–70), Jackson Pollock (1912–56), Ad Reinhardt (1913–67), Mark Rothko (1903–70), Clyfford Still (1904–80) and Mark Tobey (1890–1976).

Like the *Expressionists, they felt that the true subject of art was man's inner emotions, his turmoil, and to this end they exploited the fundamental aspects of the painting process – gesture, colour, form, texture – for their expressive and symbolic potential. With their European contemporaries (see *Existential Art and *Art Informel), they shared a romantic vision of the artist as alienated from mainstream society, a figure morally compelled to create a new type of art which might confront an irrational, absurd world.

The term was introduced by critic Robert Coates in an article in 1946 about the work of Gorky, Pollock and De Kooning, though it was only one of many terms of the period. Others included New York School, American-Type

Painting, Action Painting and Colour-Field Painting, each describing a different aspect of Abstract Expressionism. 'Action Painting', a phrase coined by critic Harold Rosenberg (1906–78) in his seminal essay, 'The American Action Painters' (*ARTnews*, December 1952), drew attention to the assertive bodily engagement of the artist in Pollock's drip paintings, De Kooning's violent brushwork and Kline's bold, monumental black and white forms. It also conveyed the artists' commitment to the act of creation in the face of continual choice, tying their work to the prevailing climate of the immediate post-war era, in which a painting was not merely an object, but a record of the existential struggle with freedom, responsibility and self-definition.

Despite the diversity of their styles, the artists shared many experiences and beliefs. Growing up during the Depression and World War II had led to a loss of faith in prevailing ideologies and the artistic styles associated with them, be it socialism and *Social Realism, nationalism and Regionalism (see *American Scene) or utopianism and geometric abstraction (see *De Stijl and *Concrete Art). A number of exhibitions at various American venues presented other influential European avant-garde work – *Fauvism, *Cubism, *Dada and *Surrealism – as well as Aztec, African and American Indian arts.

These visual experiences were complemented by a new generation of teachers such as Hofmann, who had gained firsthand experience of the European avant-garde before moving to New York and opening the Hans Hofmann School of Fine Arts in 1934. He was joined by other European artists seeking refuge during World War II, notably the Surrealists André Breton, André Masson, Roberto Matta, Yves Tanguy and Max Ernst. This was a defining moment in the development of Abstract Expressionism. The Surrealists' concept of 'psychic automatism', as a means of gaining access to repressed images and creativity, made a huge impression on the young American painters. This coincided with a growing interest in Jungian psychoanalysis in New York (Pollock spent two years, from 1939 to 1941, in Jungian

Above: **Mark Rothko, *Black on Maroon (Two Openings in Black over Wine)*, 1958** Rothko always insisted his paintings should be hung close together, near ground level, in order to engage the viewer as directly as possible. 'I'm not an abstract artist', he said. 'I'm interested only in expressing human emotions.'

Below: **Willem de Kooning, *Two Standing Women*, 1949** This painting stands at the beginning of De Kooning's great series of female nudes, ambiguous kaleidoscopic figures of enormous surging vitality. 'Flesh', he said, 'was the reason why oil paint was invented.'

Opposite: **Arshile Gorky, *The Liver is the Cock's Comb*, 1944** Gorky's vibrant contours of plant and animal forms, which seem so spontaneous, derive in fact from prolonged scrutiny of nature and meticulous preparatory drawings, in order to achieve the effect of 'the pulsation of nature as it throbs'.

analysis). Like Sigmund Freud, Carl Jung (1875–1961) believed in uncovering the unconscious, but disputed Freud's emphasis on sex and individual neuroses. He posited the existence of a 'collective unconscious', the pre-existing knowledge of mankind as a species, which is made up of archetypes – shared unlearned myths, symbols and primordial images. This powerful intersection of cultural and intellectual influences translated the act of the artist into an Existentialist act of engagement, with heroic implications. The spontaneity of automatism was not only a voyage of self-discovery for the artist, but the disclosure of universal myths and symbols, an act at once personal and epic. Art and the artist were not only necessary, but exalted.

The new generation of artists rose to the challenge with

astonishing and dramatic works. Arshile Gorky, claimed by Breton as a Surrealist, might also be counted the first Abstract Expressionist. He was particularly influenced by the *Organic Abstraction of Kandinsky and Joan Miró, whose biomorphic forms fed into his major paintings: vivid, suggestive yet ambiguous pictures completed in the few years before his suicide at the age of forty-four. His close friend, De Kooning, who acknowledged Gorky's example, also painted biomorphic abstractions, but is best known for his attention to the human figure, specifically the American pin-up girl images familiar from advertising hoardings all over the country. He became notorious for his *Woman* series in the 1950s, in which the expressive violence of his brushstrokes created a monstrous but memorable image of sexual anxiety.

The best-known action painter remains Jackson Pollock. Captured at work on film and in Hans Namuth's photographs for *Life* magazine, 'Jack the Dripper' became the archetype of the new artist. It was his radical innovation, in the 1950s, to lay his canvases on the floor, dripping paint onto them straight from the can or with a stick or trowel, creating labyrinthine images he described as 'energy and motion made visible'. Far from being slapdash, they are tightly disciplined, and show an assured sense of harmony and rhythm, reminding some critics of Pollock's training under Thomas Hart Benton (see American Scene). Pollock's Jungian analysis fed into his paintings, in which there are many references to aspects of myth: altars, priests, totems and shamans.

Another constant theme in Pollock's work, the American landscape, finds expression in the paintings of both Clyfford Still and Barnett Newman, large canvases which evoke the rugged mountains and vast plains of the West, once again in 'heroic' terms. Newman's signature was the 'zip' in his

paintings, the vertical line which, to some critics, symbolized American transcendentalism, a moment of illumination. The most religious of the Abstract Expressionists, however, was Mark Rothko. His mature paintings, executed at the height of American consumerism, evoke notions of spirituality and invite contemplation. The stacked horizontal fields of intense colours seem to float and shimmer, illuminated with an ethereal glow. In his last major series of canvases, produced for the Rothko Chapel at Houston and completed shortly before his suicide, he sought to create an awe-inspiring environment as powerful as the greatest religious art.

Both the critics and the artists themselves gave the works heroic, noble interpretations. Newman, in an interview in 1962, commented that if people only read his paintings properly 'it would mean the end of all state capitalism and totalitarianism.' While many of their works are abstract, the artists themselves insisted that they were not devoid of subject matter. On the contrary, they explicitly stressed the importance of subject matter in their work. In a manifesto-like letter to the *New York Times* in 1943, Rothko, Gottlieb and Newman jointly declared: 'There is no such thing as good painting about nothing. We assert that the subject is crucial and that only subject matter is valid which is tragic

Above: **Jackson Pollock, *Blue Poles*, 1952**
Arguably the most revolutionary break with traditional compositional techniques of all avant-garde styles, Pollock's drip paintings were first seen in January 1948, when De Kooning commented that 'Jackson's broken the ice.'

Opposite: **David Smith, *Cubi XVIII*, 1964**
The series of twenty-eight Cubi, unfinished at the time of Smith's early death, represents a unique achievement in sculpture, each of the huge structures (made of shining, superhard T-304 steel) strong enough to assert itself against its natural background.

and timeless.' In 1948 'The Subjects of the Artist' school was founded by Baziotes, Motherwell, Rothko and sculptor David Hare (1917–91), and according to Motherwell, the name was specifically chosen to 'emphasize that our painting was not abstract, that it was full of subject matter'. What the artists were ultimately after was subjective and emotional; it was 'basic human emotions' (Rothko); 'only myself, not nature' (Still); 'to express my feelings rather than illustrate them' (Pollock); 'a search for the hidden meaning of life' (Newman); 'to put some order into ourselves' (De Kooning); 'to wed oneself to the universe' (Motherwell).

During the 1940s and 1950s the work of the Abstract Expressionists was championed by numerous critics, including Harold Rosenberg and Clement Greenberg, and exhibited at Peggy Guggenheim's Art of This Century gallery and at other venues dedicated to contemporary art. The movement received institutional recognition in 1951 with the exhibition 'Abstract Painting and Sculpture in America' held in New York at the Museum of Modern Art. At the time of the Cold War, when the Soviet Union was sanctioning *Socialist Realism and conservative politicians and critics in the USA were attacking abstract art as 'communistic', its supporters held up Abstract Expressionism as proof of artistic freedom and integrity.

Though Abstract Expressionism is primarily considered a movement of painters, the abstract photography of Aaron Siskind (1903–92) and the sculptures of Herbert Ferber (1906–91), Hare, Ibram Lassaw (b. 1913), Seymour Lipton (1903–86), Reuben Nakian (1897–1986), Newman, Theodore Roszak (1907–81) and David Smith (1906–65), can also be considered Abstract Expressionist. Such work ranges from the emotive to the serene, with subjects ranging on the personal to the universal. Smith was the major sculptor of the period, working in iron and steel. In his large sculptures, he exploited the different colours and surfaces for their expressive potential. He painted some sculptures, used polished stainless steel for other outdoor pieces to incorporate the changing colours and sunlight of the surrounding landscape into the works, and allowed others to rust to attain a deep red. For Smith this rust red 'is the red of the east's mythical west – it is the blood of man, it was one culture symbol of life.' Polished or rusted, the works were burnished with a wire brush, producing delicate swirls that provide a striking contrast with their architectural mass. Smith's early accidental death was much mourned, as conveyed in Motherwell's impassioned address: 'Oh, David, you were as delicate as Vivaldi and as strong as a Mack truck.'

Abstract Expressionism received international recognition after the MoMA's 1958–59 travelling exhibition, 'The New American Painting', which toured eight European countries. By this time, however, not only was the work no

longer particularly new, but the stance outlined in the catalogue introduction – that 'John Donne to the contrary, each man is an island' – was viewed sceptically by a new generation of artists (see *Neo-Dada, *Nouveau Réalisme and *Pop Art) weary of the seemingly formulaic alienated angst of their predecessors. The dominance of Abstract Expressionism did, however, make it an important point of departure for those who followed. Different aspects and interpretations of the work fed into movements as varied as *Post-painterly Abstraction, *Minimalism and *Performance Art.

Key Collections
Aberdeen Art Gallery and Museums, Aberdeen, Scotland
Carnegie Museum of Art, Pittsburgh, Pennsylvania
Modern Art Museum of Fort Worth, Texas
Montclair Art Museum, Montclair, New Jersey
Seattle Art Museum, Seattle, Washington
Tate Gallery, London

Key Books
D. Anfam, *Abstract Expressionism* (1990)
S. Polcari, *Abstract Expressionism and the Modern Experience* (Cambridge, UK, 1991)
M. Auping, *Arshile Gorky* (1995)
P. Karmel (ed.), *Jackson Pollock* (2000)
J. Weiss, *Mark Rothko* (New Haven, CT, 2000)

Lettrism

The emotive powers of letters, pure letters, letters ripped out of all context.

ISIDORE ISOU, THE FORCE FIELDS OF LETTRIST PAINTING, 1964

Lettrism was an idealistic literary and artistic movement founded by a young Romanian poet, Isidore Isou (b. 1925), in Bucharest in the mid-1940s. Believing that the only hope for a better society lay in a complete renewal of the exhausted forms of language and painting, he sought to create a visual vocabulary of signs and letters – somewhat like hieroglyphs – that could communicate to all.

There was a strong missionary character to Isou and his art. Through the act of creation, Isou believed, the artist came closest to God, and his choice of letters as his starting point seemed to have divine approval in the text 'In the beginning was the Word.' A number of influences acted on him. The discovery of the Lascaux cave paintings in 1940 fed into his belief that the will to create was a fundamental one; more important, however, were aspects of *Dada and *Surre-

alism, movements which Isou sought to challenge and supersede with his own movement, Lettrism. This challenge is implicit even in the choice of his new name (he was born Samuel Goldstein), which refers to Isidore Ducasse, the Surrealists' hero, and, in its alliteration, deliberately recalls the name of his countryman, founding Dadaist Tristan Tzara. The young Romanian seems to have been keen to announce the second coming of the Dadaist aesthetic in himself, throwing down a direct challenge to both Tzara and André Breton, the 'Pope' of Surrealism.

Above: **Isidore Isou, *Traité de bave et d'éternité* (Treatise on Drivel and Eternity), 1950–51** This black-and-white film featured among others Isidore Isou, Marcel Achard, Jean-Louis Barrault, Danielle Delorme, Jean Cocteau and Maurice Lemaître, who was also the assistant producer.

He arrived in Paris in January 1945 denouncing *Socialist Realism and the Surrealist poets, and in January 1946 he publicly stated: 'Dada is dead. Lettrism has taken its place.' Maurice Lemaître (b. 1926), François Dufrêne (1930–82, see Nouveau Réalisme), Guy Debord (1931–94), Roland Sabatier (b. 1942) and Alain Satié (b. 1944) were among those who joined Isou, making Lettrist poetry, paintings and films. Initially the artists restricted themselves to the use of Latin letters, but after 1950 they included all types of alphabets and signs, real or invented, to create 'Hypergraphics'. Although Lettrism still exists today, its greatest impact was between 1946 and 1952. In that year internal disputes led to a split, with dissenting members forming the Lettrist International, which eventually evolved into the *Situationist International, a group which would develop many of Isou's ideas in an even more radical manner.

Key Collections
Archives de la Critique d'Art, Châteaugiron, France
Centre Georges Pompidou, Paris
Getty Research Institute, Los Angeles, California
Sintra Museu de Arte Moderna, Sintra, Portugal

Key Books
J.-P. Curtay, *Letterism and Hypergraphics* (1985)
S. Home, *The Assault on Culture: Utopian Currents from Lettrisme to Class War* (1993)
L. Bracken, *Guy Debord: Revolutionary* (Venice, CA, 1997)
A. Jappe, *Guy Debord* (Berkeley, CA, 1999)

CoBrA

Life demands creation and beauty is life!

CONSTANT, 1949

The CoBrA group was an international collective of primarily Northern European artists who joined together from 1948 to 1951 to promote their vision of a new expressionist art for the people. The major figures were the Dutchmen Constant (Constant A. Nieuwenhuys, b. 1920) and Karel Appel (b. 1921); Dutch-Belgian Corneille (Corneille Guillaume van Beverloo, b. 1922); Danish painter Asger Jorn (1914–1973); Belgian painter Pierre Alechinsky (b. 1927) and Belgian poet Christian Dotremont (1924–1979). The name is derived from the first letters of their home towns – Copenhagen, Brussels, and Amsterdam.

In the climate of despair after the end of World War II, this group of young artists demanded an art of immediacy that could convey both the inhumanity of man and the hope for a better future. They were vehemently opposed to the rational, analytic principles of geometric abstraction, the dogmatism of *Socialist Realism, and the gentility associated with the *Ecole de Paris. They rejected the traditions of both figurative and abstract painting, instead utilizing aspects of both with the aim of enlarging the boundaries of art and

Left: **Corneille, Atelier Rue Santeuil, Paris, 1961**
Ten years after the dissolution of the group, CoBrA still exerted an influence on younger artists who followed their leads in developing methods of collaboration, themes of fantasy and techniques of abstracted figuration.

creating a universal, popular art to liberate the creativity of all mankind. To spread their vision of the future of art and life they published manifestos and ten issues of the review *CoBrA*, in which they also published a number of their word-paintings – collaborations between artists and poets. The group practised what they preached – at least some of the time – and they and their families lived and worked together on collaborative pieces, including the interiors of friends' homes.

In their drive for complete freedom of expression, a freedom which would allow them to portray both the horror and humour of reality, the CoBrA artists drew inspiration from a number of sources. In prehistoric art, primitive art, folk art, graffiti, Norse mythology, children's art and the art of the insane (see *Art Brut and *Outsider Art) they found a lost innocence and confirmation of man's primordial need to express his desires, whether beautiful or violent, celebratory or cathartic. In certain respects the CoBrA painters continued the project begun by the *Surrealists, to unleash the unconscious and escape the 'civilizing' influences of art and society discredited after the war. Their works also hark back to the paintings of early *Expressionists such as Edvard Munch and Emil Nolde. With the use of strong primary colours and expressive brushstrokes, CoBrA works share

some visual affinities with early American *Abstract Expressionism, but the two were nevertheless totally separate developments and each had widely differing aims, techniques and ideology. By the 1950s, with the continuity of wars and the development of the Cold War, the utopian optimism of the group was difficult to sustain. Their disillusionment and fury can be felt in a number of the works of the late 1950s, such as Appel's *Exploded Head* of 1958. Although the group officially disbanded in 1951, many of the artists continued to paint in a CoBrA-esque manner and to support and participate in revolutionary ventures in life and art, such as *Situationist International.

Karel Appel, *Questioning Children*, 1949 Appel's violently coloured works on the theme of questioning children provoked an uproar in Amsterdam in 1949. A mural painted in the city hall canteen was wallpapered over after complaints from staff that they were unable to eat in its presence.

Key Collections
The Cobra Museum for Modern Art Amstelveen, Amstelveen, the Netherlands
Solomon R. Guggenheim Museum, New York
Stedelijk Museum, Amsterdam, the Netherlands
Tate Gallery, London

Key Books
K. Appel, *Karel Appel* (1980)
E. Flomenhaft, *A CoBrA Portfolio* (1981)
J.-C. Lambert, *CoBrA* (1983)
COBRA, 40 Years After (exh. cat., Amsterdam, 1988)
W. Stokvis, *CoBrA: An International Movement in Art after the Second World War* (1988)

Beat Art

How to live seems to them much more crucial than why.

JOHN SLELLON HOLMES, NEW YORK TIMES MAGAZINE, 1952

Although literary achievements are generally the focus of discussions about the Beat Generation, it was in fact an interdisciplinary social and artistic movement, with a strong visual art dimension that included painting, sculpture, photography and film. The term was coined by novelist Jack Kerouac (1922–69) in 1948 when asked by fellow novelist, John Clellon Holmes (1926–88) to describe their discontented generation. Holmes made their views public in his 1952 *New York Times* article, 'This is the Beat Generation'. The Beats, he explained, had known nothing other than a world of shattered ideals, and they took it for granted. Sometimes called the American *Existentialists, they felt alienated,

but, unlike the earlier 'Lost Generation', they did not want to change society, only to elude it – to make their own counterculture. Drugs, jazz, night life, Zen Buddhism and the occult all went into the creation of Beat culture.

The Beat Generation soon swelled to encompass a whole range of avant-garde writers, visual artists and film-makers in New York, Los Angeles, San Francisco and at Black Mountain College in North Carolina. Among those associated with the movement were writers William Burroughs (1914–97), Allen Ginsberg (b. 1926), Kenneth Koch (b. 1925) and Frank O'Hara (1926–66), and artists such as Wallace Berman (1926–76), Jay DeFeo (1929–89), Jess

(Collins, b. 1923), Robert Frank (b. 1924), Claes Oldenburg (b. 1929) and Larry Rivers (b. 1923). 'Beat' became a point of intersection for visual artists usually categorized in other 'groups', such as *Neo-Dada, *Assemblage, Happenings (see *Performance Art) and *Funk Art. They wanted to break down the boundary between art and life, for art to be a lived experience in cafés and jazz clubs rather than just museums. They also wanted to break down the boundaries between different arts. Artists wrote poetry and writers painted (Kerouac claimed he could probably paint better than Franz Kline). Performance was a key element in their work, whether it was the 1952 'Theater Event' at Black Mountain College, or Kerouac typing *On the Road* in 1951 in one sitting on a 100-foot (31 metres) roll made up of pieces of paper taped together. What they shared was a contempt for the conformist, materialist culture, a refusal to ignore the dark side of American life – its violence, corruption, censorship, racism and moral hypocrisy – and a desire to create a new way of life based on rebellion and freedom.

Berman's work brings together many strains in Beat Art, particularly in his verifax collages made on a photocopier: montages of popular culture, the commonplace and the mystical. *The Rose* (1958–66) by DeFeo is another seminal work. She worked on the massive painting-assemblage in an almost ritualistic fashion for seven years, until it had grown to

8 x 11 feet (24 x 33 metres), with areas up to 8 inches (20 centimetres) thick and weighing a ton. Friends and family described it as a 'living being'. Jess's series of *Tricky Cad* collages from 1954 to 1959, made from Dick Tracy comic strips, present a vision of a world gone mad.

Contrary to the nostalgic view of the 1950s as a time of conformity and bliss, Beat works portray the 'American way of life' with all its hopes and failures. Subjected to obscenity trials during the 1950s, Beat works had been absorbed into the mainstream by the 1960s, with Beatniks featuring in television shows and popular magazines. The influence of the Beat Generation, however, survived, its nonconformity continuing to inspire generations of youth and artists.

Key Collections
Kemper Museum of Contemporary Art, Kansas City, Missouri
Modern Art Museum of Fort Worth, Fort Worth, Texas
Spencer Museum of Art at the University of Kansas,
 Lawrence, Kansas
Whitney Museum of American Art, New York

Key Books
B. Miles, *William Burroughs* (1993)
L. Phillips, et al., *Beat Culture and the New America* (1995)
M. Perloff, *Frank O'Hara* (Chicago, Ill. 1998)
R. Ferguson, *In Memory of My Feelings: Frank O'Hara and*
 American Art (Los Angeles, 1999)

Above: **Jess, *Tricky Cad, Case I,* 1954**
Jess's comic-book collages, which play on the name of fictional private detective Dick Tracy, present a confused, tense world in which characters cannot communicate, and comment obliquely on the arms race, the McCarthy hearings and political corruption.

Kinetic Art

Everything moves continuously. Immobility does not exist.

JEAN TINGUELY, 1959

Kinetic Art is art that moves, or appears to move. According to novelist Umberto Eco, it is a 'form of plastic art in which the movement of forms, colours and planes is the means to obtain a changing whole', a definition which covers not only

Alexander Calder, *Four Red Systems (Mobile)*, 1960
The element of chance, an important factor for the mobiles Calder made after 1934, suggests the influence of his Dada friends. His friendship with Joan Miró and Jean (Hans) Arp, however, engaged his interest in developing organic shapes.

the most straightforward type of Kinetic Art – incorporating actual movement into an art object – but also a variety of other types: art involving virtual movement created optically (see *Op Art); art relying on the spectator's movement for the illusion of movement; and art which incorporates constantly changing lights (such as the neon works of American artist Bruce Nauman, see *Body Art, and the members of Zero, see *GRAV).

Although Kinetic Art came into its own in the 1950s,

many artists of the early twentieth century experimented with movement. The main lines of development were provided by *Constructivism on the one hand and *Dada on the other. The interest in science and technology, which was a part of the Constructivists' project, has been a constant theme in Kinetic Art. As early as 1919, Vladimir Tatlin designed a building incorporating moving components (Monument to the Third International), and in the same year fellow Constructivist Naum Gabo began Kinetic Construction (or Standing Wave). The Dadaists were more interested in the elements of play and chance inherent in Kinetic Art. Marcel Duchamp's first readymade, *Bicycle Wheel* (1913), a bicycle wheel attached to a kitchen stool that could be spun by hand, is an early example.

Further developments, taking place in the late 1920s and 1930s, were the work of two other artists, the Hungarian-American László Moholy-Nagy (1895–1946, see also *Bauhaus) and American Alexander Calder (1898–1976). Moholy-Nagy's extraordinary *Light-Space Modulator* (1930), an electronically powered rotating sculpture of metal, glass and light beams, transforms its surrounding space through the play of light reflecting and deflecting off moving elements of different shapes and materials. Calder, meanwhile, was also incorporating real movement into his

sculptures: his wire *Circus* 'performed' for a captivated Parisian avant-garde in his studio in 1926. After a visit in 1930 to Piet Mondrian's Parisian studio, which was decorated like his *De Stijl paintings, Calder wrote to Duchamp of his desire to make 'moving Mondrians'. It was Duchamp who dubbed his early abstract hand- and motor-driven sculptures 'mobiles' – to which Jean Arp replied, 'What were those things you did last year – stabiles?'

Numerous artists began to use movement in art during the 1950s, and Kinetic Art became a commonly used classification. The defining exhibition was 'Le Mouvement' at the Galerie Denise René, Paris, in 1955, which included works by the historical predecessors Duchamp and Calder alongside contemporary artists Israeli Yaacov Agam (b. 1928); Belgian Pol Bury (b. 1922); Danish Robert Jacobsen

Above left: **László Moholy-Nagy,** *Light Space Modulator,* **1930**
Recording his own impressions of seeing the modulator work for the first time, Moholy-Nagy said, 'I felt like the wizard's apprentice. Its co-ordinated movements and the articulations of the light-and-shade sequences were so surprising I almost started believing in magic.'

Above right: **Jean Tinguely,** *Homage to New York,* **1960**
A hilarious and moving spectacle, Tinguely's machine self-ignited, played a piano, turned on a radio, spooled out rolls of text, lit smoke signals, set off klaxons, exploded stink bombs, and finally 'committed suicide' by falling in on itself.

(1912–93); Venezuelan Jesús Raphael Soto (b. 1923); Swiss Jean Tinguely (1925–91, see also *Nouveau Réalisme) and Victor Vasarely (see Op Art). In 1961 this was expanded into a major international museum survey of Kinetic and Op Art by seventy-five artists, 'Movement in Art', which showed to huge audiences across Europe. Throughout the 1960s and 1970s, across the world, many different artists produced kinetic work of great variety, among them the Brazilian Abraham Palatnik (b. 1928); Americans George Rickey (b. 1907) and Kenneth Snelson (b. 1927); German Hans Haacke (b. 1936); New Zealander Len Lye (1901–80); Filipino David Medalla (b. 1942); Greek Takis (b. 1925) and Hungarian-French Nicolas Schöffer (1912–92).

The variety in Kinetic Art is very marked, from hypnotic slow-moving works by Bury to gracefully swaying outdoor kinetic sculptures by Rickey, and from cybernetic works by Schöffer to Takis's telemagnetic sculptures of objects suspended in air. But perhaps the best-loved body of work is Jean Tinguely's collection of weird and wacky junk machines. In the mid-1950s, his *Meta-Malevichs* and *Meta-Kandinskys* made good Calder's ambition to produce 'moving Mondrians', and at the end of the decade he became a sensation with his 'meta-matics' – drawing machines that made abstract art – a witty take on the high seriousness and originality associated with the prevailing generation of abstractionists (see *Art Informel and *Abstract Expressionism). Fountains that sprayed abstract designs followed, as did his famous self-destructing machines, such as *Homage to New York*, which performed and destroyed itself on 17 March 1960 at the Museum of Modern Art in New York, an event which Robert Rauschenberg (see *Neo-Dada and *Combines) described 'as real, as interesting, as complicated, as vulnerable, as loving as life itself.'

Movement continues to appeal to contemporary artists, witness the LED installations by Japanese Tatsuo Miyajima (b. 1957), the robots of American Chico MacMurtrie (b. 1961), the changing light stacks of Briton Angela Bullock (b. 1964) and British Cornelia Parker's (b. 1956) *Cold Dark Matter: An Exploded View* (1991). Both artists and audiences respond to an art that, in Miyajima's phrase, aspires to 'keep changing, connect with everything, continue forever.'

Key Collections

Centre Georges Pompidou, Paris
Fine Art Museums of San Francisco, San Francisco, California
Museum Jean Tinguely, Basel, Switzerland
Museum of Fine Arts, Houston, Texas
Tate Gallery, London
Whitney Museum of American Art, New York

Key Books

Kinetic art (exh. cat., Glynn Vivian Art Gallery, Swansea, Wales, 1972)
C. Bischofberger, *Jean Tinguely: Catalogue Raisonné* (Zürich, 1990)
J. Morgan, *Cornelia Parker* (Boston, MA, 2000)
Force Fields: Phases of the Kinetic (exh. cat., Hayward Gallery, London, 2000)

▍Kitchen Sink School

Doom being in and Hope being out…the atomic theme is unravelled: the existentialist railway station to which there is no more arrival.

JOHN MINTON, 1955

Kitchen Sink School was the name given to a group of British painters, including John Bratby (1928–92), Derrick Greaves (b. 1927), Edward Middleditch (1923–87) and Jack Smith (b. 1928), whose figurative, realist work achieved great popularity in Britain during the mid-1950s. The painters trained in London at the Royal College of Art and exhibited at the Beaux Arts Gallery, London, where they came to the attention of critic David Sylvester, who coined the name in an article in 1954. A number of the artists originally came from the north of England (Greaves and Smith grew up in the same street in Sheffield, and Middleditch lived there later), where there was a tradition, as in the work of L. S. Lowry (1887–1976) and others, of industrial and working-class themes. The Kitchen Sink School made these themes their own. Their work depicted drab, unheroic scenes of post-war austerity, the commonplace subject matter of daily life: cluttered kitchens, bombed-out tenements and back-yards. An affronted public compared these deliberately unglamorous subjects to the literary work of the 'angry young men', such as John Wain, Kingsley Amis and John Osborne (whose play *Look Back in Anger* was first performed in 1956).

Though the work of the School was distinctively British, it also formed part of a general tendency towards social realism prevalent throughout Europe in the late 1940s and early 1950s, and apparent in the work of Italian painters such as Armando Pizzinato (b. 1910) and Renato Guttoso (1912–87) and the French artists of the Homme-Témoin

Above: John Bratby, *Table Top*, 1955
Turning temporarily to novel writing after the Kitchen Sink School had been eclipsed by Abstract Expressionism, Bratby wrote in *Breakdown* (1960) that painters of his generation had sought to express the anxiety of the nuclear age.

group led by Bernard Buffet (see *Existential Art). In fact, their work sometimes betrays the classic Existential angst that was being explored on the Continent at that time. One of the group's champions, Marxist critic John Berger, portrayed Bratby as the archetypal Existential artist in an article in 1954:

Bratby paints as though he had only one more day to live. He paints a packet of cornflakes on a littered kitchen table as though it were part of the Last Supper; he paints his wife as though she were staring at him through a grille and he was never to see her again.

The work of Bratby and others also reflected the contemporary mood generated by the Cold War and the threat of the atomic bomb, capturing what the *Neo-Romantic painter John Minton described in 1955 as the 'chic of contemporary *désespoir* [despair]'.

The work of the Kitchen Sink School painters was often exhibited alongside that of another group of British painters, later referred to as the School of London, which included Francis Bacon and Lucian Freud (see Existential Art), Frank Auerbach (b. 1931) and Leon Kossoff (b. 1926). The two latter artists were pupils of David Bomberg (see *Vorticism), who taught at Borough Polytechnic in London. Like the Kitchen Sink School, they painted the grittier side of cityscapes, notably the sprawl of unfashionable areas of London. Their technique and approach, however, differ greatly from the Kitchen Sink School (their canvases are densely worked and expressionistic), but Kossoff's series of paintings on the Kilburn Underground station and the metropolitan district of Hackney in London, along with Auerbach's depictions of city building sites, nevertheless share themes with the work of the Kitchen Sink School.

The painters of the Kitchen Sink School, who were Britain's representatives at the Venice Biennale of 1956, enjoyed a brief vogue. By the end of the decade, the post-war mood had changed as a newly prosperous London began to swing.

Key Collections

Graves Art Gallery, Sheffield, England
National Portrait Gallery, London
Tate Gallery, London
The Lowry, Salford Quays, Manchester, England

Key Books

E. Middleditch, *Edward Middleditch* (1987)
L. S. Lowry, *L. S. Lowry* (Oxford, 1987)
M. Leber and J. Sandling, *L. S. Lowry* (1994)
L. Norbert, *Jack Smith* (2000)

Neo-Dada

Art, instead of being an object made by one person, is a process set in motion by a group of people. Art's socialized.

JOHN CAGE, 1967

Never an organized movement, Neo-Dada was one of several labels (including New Realists, Factual artists, Polymaterialists and Common-Object artists) applied in the late 1950s and 1960s to a group of young experimental artists, many based in New York City, whose work attracted fierce controversy. At that time there existed a major tendency in art towards formal purity, as illustrated in the work of the *Post-painterly Abstractionists. In deliberate opposition to this, the Neo-Dadaists set out to mix materials and media in a spirit of humour, wit and eccentricity. Neo-Dada is sometimes applied as a general term covering a number of new movements that came about during the 1950s and 1960s, such as *Lettrism, *Beat Art, *Funk Art, *Nouveau Réalisme and *Situationist International.

For artists such as Robert Rauschenberg (b. 1925), Jasper Johns (b. 1930), Larry Rivers (b. 1923), John Chamberlain (b. 1927), Richard Stankiewicz (1922–83), Lee Bontecou (b. 1931), Jim Dine (b. 1935) and Claes Oldenburg (b. 1929), art was to be expansive and inclusive, appropriating non-art

Rauschenberg in his Front Street studio, New York, 1958
A student under John Cage at Black Mountain College in the early 1950s, Rauschenberg established himself as a protean, inventive figure, whose experiments with painting, objects, performance and sound opened the way for many of his contemporaries.

materials, embracing ordinary reality and celebrating popular culture. They rejected the alienation and individualism associated with the *Abstract Expressionists in favour of a socializing art which laid emphasis on community and the environment. Collaboration was a feature of their work. The Neo-Dadaists worked on projects with poets, musicians and dancers, and engaged with other like-minded artists, such as the Nouveaux Réalistes. The result was a new aesthetic based on experimentation and cross-fertilization.

During this period there was a revival of interest in the *Dada movement and in Marcel Duchamp's works, particularly in America. The Dada attitude of 'anything goes' was certainly embraced by the artists, who, like the original Dadaists, used unorthodox materials in protest against the traditions of high art. The collages of Pablo Picasso and of Kurt Schwitters, Duchamp's readymades and the efforts of the *Surrealists to turn the 'marvellous' of everyday objects into a shared public language were all important sources of inspiration for them. The ideas of the new art were also in tune with new critical ideas. Jackson Pollock's work (see Abstract Expressionism) was reinterpreted by the artist Allan

Kaprow (see *Performance Art) as pointing towards the world of everyday life, rather than towards pure abstraction.

Influential contemporaries included composer John Cage, inventor Buckminster Fuller and media theorist Marshall McLuhan. In an age of intense nationalism, McLuhan's concept of a 'global village' and Fuller's idea of 'Spaceship Earth', which presented the world as a single entity, seemed to many to provide a more hopeful way forward than that offered by the often fatalistic contemporary social critique and existential philosophy. Like much Neo-Dada work, Cage's mixed-media compositions and his collaborations with the dancer Merce Cunningham

Above: **Larry Rivers, *Washington Crossing the Delaware*, 1953** Rivers's target was well chosen. An outstanding example of nineteenth-century patriotism, Emanuel Leutze's 1851 painting of the same title had been familiar to generations of American schoolchildren by the time of Larry Rivers's political attack.

Opposite: **Jasper Johns, *Flag, Target with Plaster Casts*, 1955** Using 'things the mind already knows' (flags, targets, numbers) Johns created ambiguous and unsettling works, simultaneously abstract paintings and conventional signs. Ambiguity and socio-political engagement, both learned from Dada, were typical of the Neo-Dadaists.

sources, enabling comparisons with *Postmodernist work.

Johns achieved instant fame with his first exhibition at the Leo Castelli Gallery in New York in 1958, when eighteen of the twenty works on show were sold by the time the exhibition closed. The real-life quality of his flags – a familiar object seen afresh – caused people to query its status: was it a flag or a painting? Likewise, Rauschenberg's innovations questioned and stretched the boundaries of art. Although creating very different works, Rauschenberg, Johns and Rivers are united by their transformation of Abstract Expressionist handling, their irreverence for tradition and their use of American iconography. The influence of these three artists on later art, such as *Pop, *Conceptual, *Minimalist and Performance, is considerable.

The touchingly optimistic collaborative work by Larry Rivers and the Nouveau Réaliste Jean Tinguely, *Turning Friendship of America and France* (1961), is in many ways typical of the Neo-Dada project. Rotating like the earth, it presents the possibility and desirability of peaceful coexistence, and celebrates the use of commerce (symbolized by images of cigarette packages) in establishing cultural exchanges at all levels. Similarly, Johns's Fuller map provides a potent image of this new, interconnected art world and of the spirit of collaboration between art and technology.

For all their heterogeneity, the Neo-Dada artists have been deeply influential. Their visual vocabulary, techniques and, above all, their determination to be heard, were adopted by later artists in their protest against the Vietnam War, racism, sexism and government policies. The emphasis they laid on participation and performance was reflected in the activism that marked the politics and Performance Art of the late 1960s; their concept of belonging to a world community anticipated the sit-ins, anti-war protests, environmental protests, student protests and civil rights protests which followed later.

promoted the use of accident and experiment, and celebrated the social environment.

Key Neo-Dada works include Rivers's *Washington Crossing the Delaware* (1953), Rauschenberg's *Combines of 1954–64, Johns's *Map (Based on Buckminster Fuller's Dymaxion Air Ocean World)*, 1967–71, as well as his flags, targets and numbers. Rivers's reworking of the well-known nineteenth-century history painting by Emanuel Leutze was greeted with scorn by the New York art world when first exhibited. With its Abstract Expressionist-like handling and all-over composition 'contaminated' by unfashionable history painting and figuration, Rivers was seen as irreverently taking on both past and present masters. In general, his works display a willingness to draw on widely different

Larry Rivers and Jean Tinguely, *Turning Friendship of America and France*, 1961 Part machine, part painting, the collaboration (a typical feature of Neo-Dadaist work) playfully acknowledges a community of artists across national borders, at a time when the preoccupation with borders was a disturbing feature of international politics.

Key Collections
Centre Georges Pompidou, Paris
Museum of Modern Art, New York
Stedelijk Museum of Modern Art, Amsterdam,
 the Netherlands
Whitney Museum of American Art, New York

Key Books
L. Rivers with A. Weinstein, *What Did I Do?* (1992)
K. Varnedoe, *Jasper Johns: A Retrospective* (exh. cat.,
 New York, The Museum of Modern Art, 1996)
Robert Rauschenberg: A Retrospective (exh. cat., New York,
 Guggenheim Museum, 1997)
A. J. Dempsey, *The Friendship of America and France*, Ph.D.
 (Courtauld Institute of Art, University of London, 1999)

Combines

*Painting relates to both art and life. Neither can be made.
(I try to act in the gap between the two.)*

ROBERT RAUSCHENBERG, 1959

In the summer of 1954, the American artist Robert Rauschenberg (b. 1925) coined the term Combine to refer to his new works that had aspects of both painting and sculpture. Those intended to be mounted on a wall, such as *Bed* (1955), were termed Combine paintings, and free-standing works, such as *Monogram* (1955–59), 'Combines'. These two are perhaps Rauschenberg's most famous, or infamous, works for the reactions they provoked when exhibited.

In 1958, *Bed* was selected to be included in an exhibition of young American and Italian artists at the Festival of Two Worlds in Spoleto, Italy. The officials of the Festival, however, refused to exhibit the combine painting and removed it to a storeroom. The following year, when *Monogram* was exhibited in New York, a wealthy collector offered to buy it for the Museum of Modern Art in New York, but the gallery refused the donation.

Rauschenberg describes the decision to paint on the quilt in *Bed* as one of necessity – he had run out of canvas. The combination of real objects, nail polish, toothpaste and *Abstract Expressionist-like painting scandalized the New York art world at the time. While the art world debated the innovation of putting a bed on a wall, Rauschenberg thought it 'one of the friendliest pictures I've ever painted. My fear has always been that someone would want to crawl into it.' Others, however, found it distressing, feeling that it recalled the scene of a rape or murder. Regardless of reaction, the work does provide insight into Rauschenberg's inspirations – merging aspects of Kurt Schwitters's collages of everyday detritus and Marcel Duchamp's readymades (see *Dada) and Abstract Expressionist brushwork into unique assemblages (see *Assemblage).

In the late 1950s and 1960s Rauschenberg and other artists of his generation, such as Jasper Johns and Larry Rivers, were often described as *Neo-Dada for their affinities with Dada and their Dadaist irreverence for tradition. These artists were searching for a way to assimilate and move beyond the powerful influence of the Abstract Expressionists. While retaining aspects of expressionist brushwork, they

Robert Rauschenberg, *Bed*, 1955
Rauschenberg described his decision to paint on the quilt as one of necessity – he had run out of canvas and could not afford to buy any more at the time. The pillow, he said, was added for structural reasons – to balance the composition.

incorporated images from everyday life, from the media and common references, to create works which would have a profound influence on future art practices, such as *Pop Art.

Although dismissed by many critics as a 'prankster', Rauschenberg's popularity grew rapidly with both artists and the public, and he became the subject of a number of museum retrospectives in the early 1960s, notably at the Jewish Museum, New York, in 1963 and at the Whitechapel Art Gallery, London, in 1964. In the same year, a London critic described him as 'the most important American artist since Jackson Pollock', and he was awarded the International Grand Prize for painting at the Venice Biennale. After 1964, Rauschenberg moved away from Combines to experiment with silkscreens, technology, dance and Performance. He is considered by many to be one of the most inventive and influential artists of the second half of the twentieth century.

Key Collections
Moderna Museet, Stockholm, Sweden
Museum Ludwig, Cologne, Germany
Museum of Contemporary Art, Los Angeles
Museum of Modern Art, New York
Stedelijk Museum of Modern Art, Amsterdam,
 the Netherlands

Key Books
C. Tomkins, *Off the Wall: Robert Rauschenberg and the Art World of Our Time* (1980)
M. L. Kotz, *Rauschenberg: Art and Life* (1990)
Robert Rauschenberg: A Retrospective (exh.cat., Guggenheim Museum, New York, 1997)
S. Hunter, *Robert Rauschenberg* (1999)

New Brutalism

Brutalism tries to face up to a mass-produced society, and drag a rough poetry out of the confused and powerful forces which are at work.

ALISON AND PETER SMITHSON, 1957

New Brutalism was the name given in the 1950s to an architectural reform movement initiated by the British husband-and-wife team of architects, Alison (1928–93) and Peter (b. 1923) Smithson. The term appeared in print for the first time in an article in the December 1953 issue of *The Architectural Review*, and it was chosen to allude to Le Corbusier's use of rough concrete (*béton brut*) in buildings such as the Unité d'Habitation, Marseilles (1947–52), and to the raw expression of materials of Jean Dubuffet's *Art Brut. The Smithsons adopted the term to describe their own work, in which they rejected the sleekness and sterility of late *International Style modernism as well as the nostalgic gentility of British post-war architecture promoted by the Welfare State. Their aim was to provide powerful and clear industrial design for the housing and schools desperately needed in Britain after the war, by engaging more directly with the real needs of people living and working in them.

The Smithsons selectively reclaimed the values of modernist pioneers, such as Louis Sullivan's holistic vision of 'functionalism' (see *Chicago School) and the social aspirations of Walter Gropius, Le Corbusier and Ludwig Mies van der Rohe (see International Style). But they also worked with an awareness of the emerging mass culture that was to inform *Pop Art and design. New Brutalism was an attempt to make

functional, forceful buildings that were integrated into their surroundings and endowed with the seductive powerful clarity of modern industrial design and advertising.

The Smithsons' Hunstanton Secondary Modern School, Norfolk (1949–54), with its exposed materials and services and austere design is considered the first example of New Brutalism; in the USA the Yale University Art Gallery, New Haven (1951–53) by Louis I. Kahn (1901–74) and Douglas Orr is considered one of the most important examples of the style. Both buildings express the ethic of New Brutalism – the 'honesty' of its use of industrial materials and its *Existential ethos, a sort of anti-aesthetic. The Smithsons admired the work of Mies and his ruthless commitment to the expression of the structure of a building.

Le Corbusier was an even more influential figure for many architects, and in particular for those who came to prominence during the 1950s, such as William Howell (1922–74), the Smithsons, James Stirling (1926–92) and Denys Lasdun (1914–2001) in Britain; Aldo van Eyck (1918–99) and Jacob Bakema (1914–81) in the Netherlands; Kenzo Tange (b. 1913) in Japan; and Kahn and Paul Rudolph (b. 1918) in the USA. Le Corbusier's expressionistic take on International Style functionalism, his attention to site, context and use of vernacular forms and building

methods, made him a major source of inspiration. Following the example of his late work, the New Brutalists employed glass, brick and concrete for their expressive qualities. Poured concrete emphasized the structural elements in their buildings, asserted the nature of the materials and construction and avoided polish and refinement. As Kahn explained, 'I believe that in architecture, as in all art, the artist instinctively keeps the marks which reveal how a thing was done.' New Brutalism represented a loosening of the rigid formulae of orthodox modernism, exhibiting a new freedom that would be explored even further by *Postmodern architects.

Jack Lynn and Ivor Smith, Park Hill, Sheffield, 1961
Built along the lines of the Smithsons' Golden Lane project, Park Hill follows the topology of the site closely. Considerations for internal circulation, and for continuity between high-density housing blocks and outside space, were paramount.

Key Monuments
Louis Kahn, Kimbell Art Museum, Fort Worth, Texas
Louis Kahn with Douglas Orr, Yale University Art Gallery, New Haven, Connecticut
Denys Lasdun, National Theatre, Southbank Centre, London
Alison and Peter Smithson, Hunstanton Secondary Modern School, Norfolk
—, Golden Lane housing, London
Kenzo Tange, National Gymnasiums, Tokyo

Key Books
R. Banham, *The New Brutalism* (1966)
L. I. Kahn, *Louis I. Kahn: Writings, Lectures, Interviews* (1991)
W. Curtis, *Denys Lasdun* (1994)
J. Rykwert, *Louis Kahn* (2001)

Funk Art

Organic, usually biomorphic, nostalgic, anthropomorphic, sexual, glandular, visceral, erotic, ribald, scatological.

HAROLD PARIS, 'SWEET LAND OF FUNK', ART IN AMERICA, 1967

During the late 1950s, works by a number of artists in California, such as Bruce Conner (b. 1933), George Herms (b. 1935) and Ed Kienholz (1927–94), were described as 'funky' – bad smelling. The term referred to their use of junk materials, or as Kienholz put it, 'the leftovers of human experience'. Funk artists expressed a reaction to the unacceptably monumental and abstracted qualities of many *Abstract Expressionists. They aimed to reinstate a measure of realism and social responsibility into the contemporary art scene.

Kienholz, Conner, Paul Thek (1933–88), Lucas Samaras (b. 1936) and British artist Colin Self (b. 1941) used shock tactics to highlight issues too often ignored, such as abortion, violence, capital punishment, mental illness, fear of illness, ageing and death, miscarriages of justice, the 'business as usual' nature of war, fear of nuclear war and the victimization of women.

Their work carried on the tradition of social critique and protest of the *Social Realists and the *Magic Realists of the 1930s, and intersected with *Neo-Dada and *Beat Art. While artists of all these 'movements' shared the belief that art must be in and of this world, not an escape from it, Funk Art exhibits a greater moral outrage than most Neo-Dada work and is devoid of the spiritual or mystical dimension of much Beat Art.

Conner and Kienholz, in particular, confronted the socio-political issues of the day with an angry earnestness. Conner's assemblages of torn clothing, battered furniture and broken knick-knacks resemble lost lives turned into art. *BLACK DAHLIA* (1959) comments on the enduring voyeuristic interest in the unsolved and sensational murder in 1947 of aspiring actress Elizabeth Short, nicknamed the Black Dahlia (later the subject of James Ellroy's novel of the same name). *The Child* (1959–60) points to parental

neglect: not the smiling child of glossy magazines but a typical Conner figure constructed of rags and filth. Kienholz's *Roxy's* (1961) tackles misogyny and moral hypocrisy. A large-scale recreation of a renowned Las Vegas brothel as it was in 1942, containing furniture made out of women, and women made out of animal bones; it depicts women as lovers, objects, commodities, victims, animals and predators.

Both Conner and Kienholz were drawn to specific events which seemed to have been omitted from official histories. Both produced works about the 1960 execution of Caryl Chessman, which went ahead because a judicial stay of execution failed to reach the executioners in time. Conner's rotten-looking assemblage with a telephone wire, *Homage to Chessman* (1960), was begun on the day the execution occurred as a protest against the event. The punning title of Kienholz's vulgar piece, *The Psycho-Vendetta Case* (1960), questions the sanity of capital punishment – as a mode of state-endorsed revenge – and specifically aligns Chessman's execution with another infamous miscarriage of justice, the 1927 Sacco-Vanzetti case, which was the subject of work by Social Realist Ben Shahn in the 1930s.

Conner and Kienholz's unremitting gaze was also turned on such issues as the fear and reality of mental illness, the alienation of modern life, the tragedy of backroom abortions, the continuity of wars and the fear of nuclear war. The disintegrating, dismembered body on a blood-stained sofa in Conner's *Couch* (1963) is a particularly horrific image of such a possibility. In *The Portable War Memorial* (1968), Kienholz presents the hideous truth that war has become a part of everyday life and that we are surrounded by an infinite number of interchangeable war memorials that no longer move us or change our actions. It was precisely these 'unmoved spectators' that the Funk Artists were trying to reach.

During the 1960s Funk Art also came to refer to another group of artists, many of whom were based in San Francisco, including Robert Arneson (1930–92), William T. Wiley (b. 1937), David Gilhooly (b. 1943) and Viola Frey (b. 1933). Their vision was less grim and more humorous, more like a regional *Pop-Funk hybrid. Many worked in ceramics, fusing high art and craft, and dealt in

Right: **Bruce Conner, *BLACK DAHLIA*, 1959**
BLACK DAHLIA commented on a sensational contemporary murder case. The work is a composition of photographs and fetishistic objects (sequins, feathers, lace, nylon stockings) that play on private taboos and public exposure.

Opposite: **Ed Kienholz, *Portable War Memorial*, 1968**
The tableau is divided into two, the left side filled with what the artist called 'propaganda devices' – icons of war and patriotism – and the right depicting unmoved spectators in a snack bar: 'business as usual'. The blackboard, chalk and eraser allow victims' names to be updated.

visual and verbal puns. Arneson's revisions of national icons – such as replacing the image of George Washington with that of his own on a quarter in *In God We Trust* (1965) – are more witty than scathing.

A number of younger British artists, such as Jake (b. 1966) and Dinos (b. 1962) Chapman, Sarah Lucas (b. 1962) and Damien Hirst (b. 1965), also address man's inhumanity to man, death and the objectification of women by means of macabre or grotesque assemblages. The Chapman brothers' *Hell* (1999–2000), Lucas's *Bunny* (1997) and Hirst's *A Thousand Years* (1990) – which consists of a rotting cow's head with maggots – are three examples that seem to bring together the biting social critique of Kienholz and Conner with the black humour of the later California Funk Artists.

Key Collections
Moderna Museet, Stockholm, Sweden
Norton Simon Museum, Pasadena, California
Saatchi Collection, London
San Francisco Museum of Modern Art, San Francisco, California

Key Books
R. L. Pincus, *On a Scale that Competes with the World* (Berkeley, CA, 1994)
L. Phillips, *Beat Culture and the New America, 1950–65* (1995)
T. Crow, *The Rise of the Sixties* (1996)
Kienholz: A Retrospective (exh. cat., Whitney Museum of American Art, New York, 1996)
2000 BC: The Bruce Conner Story Part II (exh. cat., Walker Art Centre, Minneapolis, 1999)

Nouveau Réalisme

This is Nouveau Réalisme: new perceptive approaches to the real.

PIERRE RESTANY, 1960

Work by the European Nouveaux Réalistes (New Realists), produced in the late 1950s and 1960s, is notably diverse and covers such widely different art as the torn posters of French artist Raymond Hains (b. 1926), the trap paintings of Swiss Daniel Spoerri (b. 1930) and the 'accumulations' of the Frenchman Arman (b. 1928). What all these works have in common, however, is the sharp and deliberate contrast they constitute with the mainstream modernism of the time.

By the late 1950s, with the proliferation of second- and third-generation practitioners, *Abstract Expressionism and *Art Informel seemed to many to be out of touch with social realities. The conditions of deprivation and austerity in which the first generation of post-war artists had worked had been replaced by a new society of increasing affluence, technological advance and rapid political change. It was this world that the Nouveaux Réalistes explored.

In October 1960 at the Parisian home of Yves Klein (1928–62), the French art critic Pierre Restany officially founded the Nouveau Réaliste group. He and eight artists – Frenchmen Klein, Hains, Arman, François Dufrêne (1930–82), Martial Raysse (b. 1936) and Jacques de la Villeglé (b. 1926) and the Swiss artists Spoerri and Jean Tinguely (1925–91) – signed the above declaration. This basic platform provided an identity for collective activity and encompassed the very different work of these artists, and of others who joined later, including France's César

(1921–99) and Gérard Deschamps (b. 1937), Italy's Mimmo Rotella (b. 1918) and Franco-American Niki de Saint Phalle (b. 1930). Bulgarian-born Christo (b. 1935) participated in a number of exhibitions and festivals of the Nouveaux Réalistes early in his career, but does not consider

Above: **Arman, *Accumulation of Cans*, 1960**
Arman has said, 'I didn't discover the principle of "accumulation"; it discovered me. It has always been obvious that society feeds its sense of security with a pack-rat instinct demonstrated in its window displays, its assembly lines, its garbage piles.'

Opposite: **Yves Klein, *Anthropometries of the Blue Period*, 9 March 1960** In front of an audience, Klein's models smeared themselves with his own patented paint (International Klein Blue) and pressed themselves against surfaces at the artist's personal direction, to the sound of his Monotone Symphony.

himself to have been a Nouveau Réaliste (see *Installation and *Earth Art for discussions of Christo and Jeanne-Claude's work).

Nouveau Réalisme is generally presented as the French counterpart to American *Pop Art, but the artists relate more closely, in fact, to the *Neo-Dadaists. Like them, the Nouveaux Réalistes drew inspiration from *Dada, Marcel Duchamp's readymades, the *Surrealists' appreciation of the 'marvellous' in the ordinary, and the *Cubist machine aesthetics of Fernand Léger's 'new realism'. They were also united in their rejection of the cult of the artist associated with the abstract painters, and in their encouragement of audience participation in their work.

Restany was one of the first to notice the growing friendships between many of the American and European artists. In 1961 he organized an exhibition in Paris entitled

Niki de Saint Phalle, *Venus de Milo*, **1962**
In a performance-event in New York in 1962, a Venus containing bags of paint was wheeled on stage and shot at by Saint Phalle with a rifle, turning an idealized representation of femininity into a 'murdered', paint-spattered corpse.

'Le Nouveau Réalisme à Paris et à New York', which included work by the Nouveaux Réalistes and the Americans Robert Rauschenberg, Jasper Johns, John Chamberlain, Chryssa, Lee Bontecou and Richard Stankiewicz. From then, until the last Festival of Nouveau Réalisme held in Milan in 1970, the artists Restany labelled Nouveaux Réalistes participated together in numerous exhibitions, festivals and performances in both Europe and the USA.

Yves Klein remains the best known of the Nouveaux Réalistes, and his varied output has been influential in many different areas of late twentieth-century art: multimedia, multidisciplinary art, collaboration, *Performance Art, *Minimalism, *Body Art, *Conceptualism, etc. Paradoxically, though he satirized the notion of the unique in art, his own personality vivified all he did. In 1957 he painted a number of identical monochromes in a shocking ultramarine (later patented as 'IKB': International Klein Blue), and sold them at different prices. The following year he exhibited a totally empty space at the Iris Clert Gallery in Paris, and sold areas of the emptiness on the grounds that they contained his sensibility. At his 1960 *Anthropometries*, a performance in which nude women, smeared in IKB paint, pulled each other across a large canvas on the floor, an orchestra played Klein's *Symphonie Monotone* (a single note played for twenty minutes alternated with twenty minutes' silence) and an audience dressed in dinner jackets and evening dresses watched in respectful silence.

Works such as César's compressions and Arman's accumulations also look forward to future developments. César's directed readymades, for example, anticipate the industrial 'cubes' of Minimalists. But they are interesting also for their very direct and provocative relation to contemporary social issues, one of the key features of Nouveau Réaliste art. César's compressions – in which scrapped automobiles have been recycled and given new life as art – can be read as critiques of the commodity culture and its consumption and waste, or interpreted more positively as acknowledging the vital role of machines. Arman's collections of objects represent advanced exercises in anti-art, subverting accepted artistic values and purposes. His *poubelles* (trash cans) are displays of the contents of waste baskets; his *colères* (fits of rage) present an array of smashed objects. His accumulations are objects collected together in a box, for instance, with the aim of prompting the viewer to reconsider the status of the object in the age of

mass consumption. Arman frequently refers to historical themes. *Home Sweet Home* (1960), an accumulation of gas masks, brings the viewer face to face with the horrors of the Holocaust as well as with the tragedy of the continuity of wars and genocide.

Many works by Nouveaux Réalistes embrace 'creative destruction' and are results of actions or performances. Klein's *Anthropometries*, Arman's *colères* and Niki de Saint Phalle's *tirs* (shooting paintings) are but a few examples. Saint Phalle has described her shooting assemblages as symbolic acts of protest against the stereotypical image of women imposed by contemporary society. This focus on the female figure and its representation in art presages both the imagery and the topics of feminist discussion which would become prevalent in the 1970s.

Key Collections
Centre Georges Pompidou, Paris
Museum of Modern and Contemporary Art, Nice
Museum of Modern Art, New York
Tate Gallery, London
Whitney Museum of American Art, New York

Key Books
P. Restany, *Yves Klein* (1982)
M. Vaizey, *Christo* (1990)
J. Howell, *Breakthroughs: Avant-Garde Artists in Europe and America, 1950–1990* (1991)
A. J. Dempsey *The Friendship of America and France: A New Internationalism, 1961–1965*, Ph.D (Courtauld Institute of Art, University of London, 1999)

Situationist International

There can be no situationist painting or music, but only a situationist use of these means.

INTERNATIONALE SITUATIONNISTE NO 1, JUNE 1958

The Situationist International (SI – no relation to the British Situation artists of the early 1960s) was formed in Cosio d'Arroscia, Italy in 1957 as an alliance of groups of avant-garde artists, poets, writers, critics and filmmakers devoted to both modern art and radical politics. They believed that artistic practice was a political act: through art the revolution could be achieved. In their theories and practices they consciously took up the ideals of *Dada, *Surrealism and *CoBrA.

The collective was initially formed by members of the Paris-based Lettrist International (a breakaway group from *Lettrism), including filmmaker and theorist Guy Debord (1931–94), his wife, collage artist Michèle Bernstein and Gil J. Wolman (1929–95); from members of the International Movement for an Imaginist Bauhaus (a group formed after the dissolution of CoBrA), including former CoBrA artist Dane Asger Jorn (1914–73) and Italian Giuseppe Pinot-Gallizio (1902–64); and British artist Ralph Rumney (b. 1934) who called himself the delegate from the 'London Psychogeographic Committee'. Other prominent artists, such as former CoBrA artist Constant (b. 1920), joined and soon the SI included seventy members from Algeria, Belgium, Britain, France, Germany, the Netherlands, Italy and Sweden. Annual conferences were held and a journal *Internationale Situationniste* (1958–69), was published.

Their work revolved round a number of key strategies. The 'constructed situation' was one. By engineering constructed situations, rather than making traditional art objects, the Situationists believed they could rescue art from commercialization which threatened to turn it into just another high-status commodity. Accordingly, Pinot-Gallizio produced his 'industrial paintings', massive canvases up to 148 feet (45 metres) in length, made using new materials and techniques (spray guns, industrial paint, resin) and sold by the metre, flouting the conventions of the art market which confers originality and exclusivity upon works of art. (The art market was not deterred, however. When Pinot-Gallizio arbitrarily raised his prices, demand increased.) The Situationists also believed that artistic intervention in the everyday environment could awaken people to their surroundings and lead to a transformation of society. Pinot-Gallizio intended his huge paintings to be made on a scale to drape entire cities, transforming them into more pleasurable, dynamic environments. His *Cavern of Anti-Matter* (1959), a multi-media, multi-sensory installation sought to engage and empower the viewer into realizing his or her input into the creation and manipulation of an atmosphere. Another of their key ideas was what they called 'Psychogeography', the study of the psychological impact of the city on its inhabitants. Unlike Le Corbusier's functional city (see

*International Style), Constant's project for an ideal city, New Babylon, (1956–74), was based on the premise that the individuals living in it would be able to change it to their own desires. In the 1960s and 1970s, it exerted a strong influence on architecture and design practices, such as Archigram and Archizoom (see *Anti-Design).

Détournement (subversion or corruption) was another important concept for the Situationists. By appropriating and altering existing art they questioned and subverted old ideas and created new ones. Jorn's 'Modifications', begun in 1959, were made by overpainting second-hand canvases found at flea markets. In the same year he collaborated with Debord on a book of subverted images and texts, *Memoires*, which was bound in sandpaper to disrupt the practice of filing it away like any other book.

From 1957 to 1961 Situationist artists produced numerous artworks, situations, exhibitions, films, models, plans, pamphlets and journals. But the cooperation between radical art and politics was short-lived. Internal fighting led to exclusions and resignations, and by 1962 most of the professional artists had left. The remaining Paris-based members, led by Debord, focused more on political theory and activism. Their ideas fed directly into the student revolts of 1968, culminating in the general strike and occupation of Paris in May 1968. With SI slogans such as 'the beach is under the pavement' and 'consumption is the opium of the

people' appearing on walls around Paris, the fame of the movement had never been greater, but ironically it was the beginning of its downfall. Internal disagreements, and the fear of being consumed by the 'society of the spectacle' as their celebrity grew, led Debord to disband the group quietly in 1972.

There are striking parallels with other artists of the period (see *Nouveau Réalisme, *Performance Art, *Fluxus, *Beat Art and *Neo-Dada), and outside the art world SI techniques have become commonplace in advertising and fanzines. Issues associated with *Postmodernism, such as the politicization of urban landscapes, the role of media representations, the commodification and fetishization of art, and the relationship between art and politics, were all raised earlier by the SI.

Key Collections
Centre Georges Pompidou, Paris
Fine Arts Museums of San Francisco, San Francisco, California
Sintra Museu de Arte Moderna, Sintra, Portugal
Tate Gallery, London

Key Books
K. Knabb (ed.), *Situationist International* (Berkeley, CA, 1981)
A. Jorn, *Asger Jorn* (exh. cat., Solomon R. Guggenheim Museum, New York, 1982)
E. Sussman (ed.), *On the passage of a few people through a rather brief moment in time* (Cambridge, MA, 1991)
M. Wigley, *Constant's New Babylon: The Hyper-Architecture of Desire* (Rotterdam, 1998)
A. Jappe, *Guy Debord* (Berkeley, CA, 1999)

Pinot-Gallizio, *Le Temple des Mécréants* (The Infidels' Temple)
1959 This installation, an oil on canvas environment, was exhibited in Paris in 1989 at the Centre Georges Pompidou. It constituted part of the Situationists' attempt to change the commercialized status of the art object.

Assemblage

All forms of composite art and modes of juxtaposition.

WILLIAM C. SEITZ, 1961

Researching an exhibition on the history of collage at the beginning of the 1960s, an American curator at the Museum of Modern Art (MoMA) in New York, William C. Seitz, found his attention turning to recent work that did not fit into the traditional categories of art – painting and sculpture. The eventual result was the seminal 'Art of Assemblage' exhibition of 1961, which established a genre for previously uncategorizable work. 'What originated as an historical exhibition,' he wrote, 'evolved by its own logic and the pressure of events into a survey of an international wave at its moment of breaking.'

The term he adopted had been used by Jean Dubuffet (see *Art Brut) since 1953 to describe types of his own work. Writing that the exhibition was an 'attempt to follow one among the many threads that lead through the labyrinth of twentieth-century styles', Seitz presented a whole range of historical and contemporary works which shared the following physical characteristics:

1. They are predominantly *assembled* rather than painted, drawn, modeled, or carved. 2. Entirely or in part, their constituent elements are preformed natural or manufactured materials, objects, or fragments not intended as art materials.

Louise Nevelson, *Royal Tide IV*, 1959–60 Much of Nevelson's work was created using wood she scavenged from the streets of New York, often at three or four o'clock in the morning. She would then assemble sculptural murals painted uniformly. Later works (in more prosperous years) made use of metal and plexiglass.

The exhibition included 252 works by 138 Assemblage artists from twenty nations, many of them already well known as *Cubists, *Futurists, *Constructivists, *Dadaists and *Surrealists. Significant Dadaist exhibits were Marcel Duchamp's readymades and Kurt Schwitters's *Merzbau* and collages made from detritus and *objets trouvés* (found objects). Surrealism had inspired with its theatrical possibilities – dramatic juxtapositions and appreciation of the 'marvellous' in the everyday. This was readily apparent in the work of the small intimate boxes of Joseph Cornell (1903–72) and the large-scale environmental wall-like constructions of Louise Nevelson (1899–1988), two early American masters of Assemblage.

The contemporary sections of the show brought together American and European artists working in a sympathetic vein, such as the *Nouveaux Réalistes and artists also labelled *Beat, *Funk, Junk, *Kinetic and *Neo-Dada. Other important Assemblage artists included in the exhibition were the Americans Jean Follett (b. 1917), Marisol (b. 1930), Richard Stankiewicz (1922–83), Lucas Samaras (b. 1936) and H.C. Westermann (1922–81); Italians Enrico Baj (b. 1924), Alberto Burri (1915–95) and Ettore Colla (1896–1968); and Britons John Latham (b. 1921) and Eduardo Paolozzi (b. 1924). Across this varied work there were a number of

Joseph Cornell, *L'Egypte de Mlle Cléo de Mérode: cours élémentaire d'Histoire Naturelle*, 1940 Cornell assembled a box containing symbols of Egypt (sand, wheat, messages on paper) that the Khedive of Egypt might have presented to a celebrated French courtesan of the 1890s, whom he wished to woo.

different strains: Junk sculptures and reliefs by Lee Bontecou (b. 1931), Stankiewicz and others; three-dimensional collages by George Herms (b. 1935), Robert Rauschenberg (see *Combines), Daniel Spoerri (b. 1930) and others; box-like constructions incorporating readymades by Cornell, Nevelson, Arman (see Nouveau Réalisme) and others; and satirical wooden figures made by Marisol and Westermann. The common thread uniting these various artists was a shared interest in the use of everyday objects, an engagement with the environment and a rejection of the expressive abstraction dominant since the war (see *Art Informel and *Abstract Expressionism).

Part of the purpose of the MoMA exhibition was to present work which cannot be easily categorized. A symposium held in conjunction with the exhibition featured Duchamp, Richard Huelsenbeck, Rauschenberg, art historian Roger Shattuck and critic Lawrence Alloway on the panel, and the high-profile critical debate helped the term Assemblage achieve rapid international renown. The exhibition brought the work of Duchamp, Schwitters and Dada into new light for fresh evaluation. Seitz's exhibition also helped to break down the rigid classifications in place since the nineteenth century.

Assemblage took collage into three dimensions, and Assemblage artists Jim Dine (b. 1935), Allan Kaprow (b. 1927), Ed Kienholz (1927–94), Claes Oldenburg (b. 1929), Samaras and Carolee Schneemann (b. 1939) expanded it into whole environments with their *Installations and *Performances. Though the attention of the art world soon turned to *Pop Art and *Minimalism in the later 1960s (movements which both owed something to Assemblage artists' interest in popular culture and the use of readymade materials), Assemblage has become established as a flexible technique favoured by many contemporary artists.

Key Collections
Centre Georges Pompidou, Paris
Museum of Modern Art, New York
Stedelijk Museum, Amsterdam
Tate Gallery, London
Whitney Museum of Modern Art, New York

Key Books
W. Seitz, *The Art of Assemblage* (exh. cat., Museum of Modern Art, New York, 1961)
K. McShine, *Joseph Cornell* (1980)
J. Elderfield (ed.), *Studies in Modern Art 2: Essays on Assemblage* (1992)
J. Cornell, *Theater of the Mind* (1993)
A. J. Dempsey, *The Friendship of America and France*, Ph.D. (Courtauld Institute of Art, University of London, 1999).

Pop Art

Popular; Transient; Expendable; Low Cost; Mass Produced; Young; Witty; Sexy; Gimmicky; Glamorous; and Big Business.

RICHARD HAMILTON, 1957

The term Pop first appeared in print in an article by the English critic Lawrence Alloway (1926–90) in 1958, but the new interest in popular culture, and the attempt to make art out of it, was a feature of the Independent Group in London from the early 1950s. Meeting informally at the Institute of Contemporary Arts (ICA), Alloway, Alison and Peter Smithson (see *New Brutalism), Richard Hamilton (b. 1922), Eduardo Paolozzi (b. 1924) and others discussed the growing mass culture of movies, advertising, science fiction, consumerism, media and communications, product design and new technologies originating in America, but now spreading throughout the West. They were particularly fascinated by advertising and graphic and product design, and wanted to make art and architecture that had a similar popular appeal. As early as 1947 Paolozzi (always interested in *Dadaist and *Surrealist tactics) included the word Pop in his collage *I was a Rich Man's Plaything*, and his collages of the late 1940s and early 1950s are usually referred to as 'proto-pop'. His lecture and slide show, 'Bunk', given at the ICA in 1952, was innovative in presenting a range of images from mass culture for serious appreciation.

Three artists studying at the Royal College of Art in London (where both Paolozzi and Hamilton had short-term teaching contracts), Peter Blake (b. 1932), Joe Tilson (b. 1928) and Richard Smith (b. 1931), all produced early Pop Art, but Richard Hamilton's collage, *Just what is it that makes today's homes so different, so appealing?* (1956) was the first work to achieve iconic status. Made from American magazine advertisements, it was produced for a group exhibition, 'This is Tomorrow', organized by the Independent Group in 1956 at the Whitechapel Art Gallery in London. With celebrity body-builder Charles Atlas and a pin-up glamour girl as the new domestic couple, it seems to usher in a new era. A comic strip and a can of ham take the place of a painting and sculpture, and a portrait of John Ruskin (see *Arts and Crafts) hanging on the wall announces the 'American way of life' as the latest manifestation of art as a lived experience, which the Arts and Crafts movement had advocated.

The next generation of students at the Royal College of Art – including US-born R. B. Kitaj (b. 1932), Patrick Caulfield (b. 1936), David Hockney (b. 1937) and Allen Jones (b. 1937) – also incorporated motifs from popular

culture into their collages and assemblages, and in the period 1959–62 achieved public notoriety, especially through the annual 'Young Contemporaries' exhibitions. Their work drew on ubiquitous urban imagery, such as graffiti and advertising, sometimes appearing in scuffed graphics reminiscent of Jean Dubuffet's *Art Brut (as in Hockney's drawings), sometimes in slick and glossy images which deliberately evoked fashion or pornographic magazines (such as Jones's paintings and, later, sculptures). Unlike most of the first-generation British Pop artists, whose work was firmly figurative, those of the second generation introduced abstract passages into their work, happy to use not only American-style consumerism as their subject but also techniques associated with the American abstract painters (see *Abstract Expressionism and *Post-painterly Abstraction).

Meanwhile, in America itself, the *Neo-Dada, *Funk, *Beat and *Performance artists were shocking the art world

Richard Hamilton, *Just What Is It That Makes Today's Homes So Different, So Appealing?* 1956 This small, densely filled collage became an icon of Pop. Comic strips, TV, advertising, billboards and brand names – together with the absurdly idealized couple – all challenge the viewer to become critically detached.

in the 1950s with works which included articles of mass culture, such as Ray Johnson's (1927–95) celebrity collages of James Dean, Shirley Temple and Elvis. The Neo-Dada works of Jasper Johns, Larry Rivers and Robert Rauschenberg were particularly important to a group of artists who emerged in New York in a number of solo exhibitions in 1961 and 1962, including Billy Al Bengston (b. 1934); Jim Dine (b. 1935); Robert Indiana (b. 1928); Alex Katz (b. 1927); Roy Lichtenstein (1923–97); Marisol (b. 1930); Claes Oldenburg (b. 1929); James Rosenquist (b. 1933); George Segal (b. 1924); Andy Warhol (1928–87) and Tom Wesselmann (b. 1931). In the early 1960s the public saw for the first time work that has since become internationally famous: Warhol's silk screens of Marilyn Monroe, Lichtenstein's comic-strip oils, Oldenburg's huge vinyl burgers and ice-cream cones and Wesselmann's nudes set in domestic settings which incorporate real shower curtains, telephones and bathroom cabinets. A large international exhibition was mounted at the Sidney Janis Gallery in New York (31 October–1 December 1962), under the heading 'New Realists'. Works by British, French, Italian, Swedish and American artists were grouped around the themes of the 'daily object', 'mass media', and 'repetition' or 'accumulation' of mass-produced objects. It was a defining moment. Sidney Janis was the leading dealer in blue-chip European moderns and Abstract Expressionists, and his exhibition consecrated the work as the next art historical movement to be discussed and collected.

Critical coverage was both for and against the new art. Some critics were so affronted by the acceptance of 'low culture' and commercial art techniques that they dismissed Pop as non-art or anti-art. Max Kozloff was one such critic, denouncing the Pop artists in 1962 as 'new vulgarians', 'gum-chewers' and 'delinquents'. Others took it to be a new type of *American Scene painting or *Social Realism. Many critics found the work difficult to discuss at all, finding the apparent lack of social commentary or political critique unnerving. For Kozloff, however, reconsidering in 1973, it

Opposite: **David Hockney, *I'm in the Mood for Love*, 1961** Hockney became a leading Pop artist soon after winning the Gold Medal at the Royal College of Art, London, in 1961. He brought a sense of American vitality and pleasure to the London art scene after visiting the USA, where he settled.

Above: **Andy Warhol, *Orange Disaster*, 1963** Warhol's Disaster paintings allude to sensationalism and voyeurism; their newsprint quality and coloured tints put a coolly ironic distance between the viewer and the subject. The combined effect is to draw attention to our moral indifference in the face of daily disaster.

was just this combination of 'highly flagrant themes of crimes, sex, food, and violence' without any 'political *partis pris*' that gave the work its 'insurrectionary value'. This detachment, above all, linked it with other art forms of the period, such as the French Nouveau Roman (New Novel), Nouvelle Vague (New Wave) cinema, *Minimalism and Post-painterly Abstraction.

At this stage the work was still called by many names, including New Realism, Factual art, Common-Object Painting and Neo-Dada. But critics were uncomfortable with the term 'realist', which had political and moral connotations (e.g. Socialist Realism and Social Realism), and fell back on the British term Pop Art. Alloway, now a curator at the Guggenheim Museum in New York, helped popularize the term in the USA, and its use became more specific, employed as a fine art term rather than to refer to popular culture and the mass media.

Los Angeles was a particularly receptive site for the new art, with its less entrenched artistic traditions and young, wealthy population eager to collect contemporary art. Just prior to the New York 'New Realist' exhibition, the Pasadena Art Museum put on a show titled 'The New Painting of Common Objects' (25 September–19 October, 1962), featuring the work of Dine, Lichtenstein, Warhol and Californian artists Robert Dowd, Joe Goode (b. 1937),

Phillip Hefferton, Edward Ruscha (b. 1937) and Wayne Thiebaud (b. 1920). Also in 1962 the Dwan Gallery showed Neo-Dada and Pop artists in an exhibition entitled 'My Country 'Tis of Thee', and Warhol was given his first major exhibition at the Ferus Gallery in Los Angeles, where thirty-two of his Campbell's Soup paintings were displayed. Pop subjects (comic strips, consumer products, celebrity icons, advertising or pornography) and Pop themes (the elevation of 'low' art, Americana, suburbia, the myths and realities of the American dream) were as quickly identified and established on the West coast as on the East.

Pop Art spread throughout the rest of the USA and Europe via numerous gallery and museum exhibitions. Other artists of the period who made Pop-related work included the French artists Martial Raysse (b. 1936), Jacques Monory (b. 1934) and Alain Jacquet (b. 1939); Italian Valerio Adami (b. 1935) and Swede Öyvind Fahlström (1928–76). By 1965, the meaning of the term had expanded again to include all aspects of urban popular culture. Two meanings of Pop survived: the limited meaning for the fine arts and the broader, cultural definition covering pop music, pop fiction, pop culture, etc.

As Pop Art had been inspired by commercial design and popular culture, so it fed back into commercial design, advertising, product, fashion and interior design. Two of the

Abstraction), to its logical conclusion, with a nod to the soft sculptures of Oldenburg.

With hindsight, Pop art and design seem part of the larger reaction to the long-term dominance of the post-war modernist styles. They rejected the high seriousness, angst and elitism associated with the international style of abstraction (see Abstract Expressionism and *Art Informel) and the anonymity and coldness of the architecture and design of the *International Style. It also arose during a time of economic prosperity and an expanding international art market.

During the early 1960s, the relationship of the avant-garde to its public was changing, as was the role of the critic, particularly in the USA. Traditionally the avant-garde had spurned the bourgeoisie; now the *Nouveaux Réalistes, Neo-Dadaists and Pop artists embraced the middle classes and their interest in all that was new and modern. Though this caused problems to some critics, the dealers and collectors were quick to take to the new art. Gallerists such as Leo Castelli, Richard Bellamy, Virginia Dwan and Martha Jackson made their move without waiting for critics to legitimize the new art, depriving the critic of the role of cultural 'gatekeeper'. The artist's role changed too, enlivened by associations of glamour and celebrity. As Larry Rivers explained in 1963, 'For the first time in this country, the artist is "on stage." He isn't just fooling around in a cellar with something that maybe no one will see. Now he is there in the full glare of publicity.' The impact of this change is still felt today.

The popularity of Pop Art has waned little since its inception, though the attention of the art world was soon diverted to other movements, such as *Op Art, *Conceptual Art and *Super-realism – each of which owed something to Pop Art. The Pop Art phenomenon itself received new attention and interest during the 1980s (see *Neo-Pop).

most famous Pop graphics were designed by Milton Glaser (b. 1929) of Push Pin Studio, founded in New York in 1954: the Indianaesque 'I Love New York' sticker with a heart, and his Dylan poster of 1967. The Dylan poster also shows the impact of a renewal of interest in *Art Nouveau and *Art Deco during the 1960s, which fused with youth drug culture and music and Pop Art into psychedelia. Pop-inspired furniture was made by designers such as the Dane Verner Panton (1926–98) and the Italian design team of Jonathan De Pas (1932–91), Donato d'Urbino (b. 1935) and Paolo Lomazzi (b. 1936), known for their inflatable 'Blow' chair of 1967 and their 'Joe Sofa' of 1971, a gigantic baseball mitt. The 'Joe Sofa', named after Joe DiMaggio, seems to take the desire of the father of organic design, Charles Eames (who wanted his chair to be as comfortable as a baseball mitt, see *Organic

Above: **Roy Lichtenstein,** *Mr Bellamy*, **1961** Lichtenstein painted comic-strip frames, imitating their cheap printing techniques by hand. The banality of the image, blown up onto canvas, takes on a sense of allegory and monumentality. It is both a parody and a question: what sort of pictures do we take seriously and why?

Opposite: **Jonathan De Pas, Donato d'Urbino and Paolo Lomazzi, 'Joe Sofa', 1971** Charles Eames said he wanted his chair to be as comfortable as a baseball mitt. The 'Joe Sofa' – named after Joe DiMaggio – makes his wish come true. Pop artists turned household names, objects and brands into art – and vice versa.

Key Collections
Andy Warhol Museum, Pittsburgh, Pennsylvania
Fine Arts Museums of San Francisco, San Francisco, California
Museum of Contemporary Art, Chicago, Illinois
Phoenix Art Museum, Phoenix, Arizona
Sintra Museu de Arte Moderna, Sintra, Portugal
Tate Gallery, London

Key Books
L. R. Lippard, *Pop Art* (1988)
J. Katz, *Andy Warhol* (1993)
J. James, *Pop Art* (1996)
M. Livingstone, *David Hockney* (1996)
M. Livingstone and J. Dine, *Jim Dine* (1998)
L. Bolton, *Pop Art* (Lincolnwood, Ill., 2000)

Performance Art

The young artist of today need no longer say 'I am a painter' or 'a poet' or 'a dancer.' He is simply an 'artist.'

ALLAN KAPROW, 1958

Performance was an important component of many twentieth-century avant-garde schools and movements, including *Futurism, the Russian avant-gardes (see *Rayonism and *Constructivism), *Dada, *Surrealism and the *Bauhaus. During the 1950s, the performative aspect of art became increasingly pronounced, in the work of *Kinetic artists, the 'Action Painters' of *Abstract Expressionism and *Art Informel, the Japanese Gutai Group and the *Beat artists. In the post-war period, American composer John Cage (1912–92) began collaborating with pianist David Tudor (1926–96) and choreographer and dancer Merce Cunningham (b. 1919) to create performance projects, and in 1952, at Black Mountain College in North Carolina, they staged the seminal 'Theater Event'. In 'An Autobiographical Statement' (1990) Cage described the event:

> Disparate activities, dancing by Merce Cunningham, the exhibition of paintings and the playing of a Victrola by Robert Rauschenberg, the reading of his poetry by Charles Olsen or hers by M. C. Richards from the top of a ladder outside the audience, the piano playing of David Tudor, my own reading of a lecture that included silences from the top of another ladder outside the audience, all took place within chance-determined periods of time within the overall time of my lecture.

Even in the days of Dada, nothing quite like it had been seen before, and news of the performance quickly spread. Soon aspects of it – the assault on the senses produced by the combination of media and disciplines, the non-narrative structure, the collaboration between different sorts of artists – became key features of what were known as 'Happenings' put on by a number of New York artists: Allan Kaprow (b. 1927), Red Grooms (b. 1937), Jim Dine (b. 1935), and Claes Oldenburg (b. 1929), amongst others.

Kaprow was one of the first to describe the development. His manifesto, 'The Legacy of Jackson Pollock' (1958), traces the beginnings of Happenings to the 'action painting' of Abstract Expressionism: 'Pollock's near destruction of this tradition [painting] may well be a return to the point where art was more actively involved in ritual, magic and life.' Kaprow's own first public happening, *18 Happenings in 6 Parts*, took place the following year at the Reuben Gallery in New York, a collage of experiences for both performers and spectators, who were considered part of the cast.

Performance continued to gain momentum during the 1960s, with an explosion of different forms. These ranged from the 'action-spectacles' of the *Nouveaux Réalistes, in which the performance was part of the creation of the art work, such as Yves Klein's famous *Leap into the Void* (1960) and Niki de Saint Phalle's shooting paintings, to the self-contained Happenings, which were themselves the 'art work'; from jazz and poetry performances to the multimedia collaborative events by many artists, including Cage and Cunningham, the *Neo-Dada artists, Nouveaux Réalistes,

Above: **Yves Klein, *Leap into the Void*, 1960** Klein's aim was to detach the spirit of creation from the world of objects and commerce – signified by his apparent attempt to fly. For Klein, his own patented colour, International Klein Blue (IKB), expressed the same cosmic ambition.

Opposite: **Carolee Schneemann, *Meat Joy*, 1964** Performed in Paris and New York, this piece sought to bring together touch, smell, taste and sound in a work of art. The bodies of the actors were covered in the blood of meat carcasses, and they interacted with the raw fish and chicken carcasses and sausage.

members of E.A.T. (Experiments in Art and Technology), *Fluxus and the Judson Dance Theater. Performance also figured in the work of many *Minimalist and *Conceptual artists.

Performance events rapidly achieved popularity. The sense of liberation, for both artists and spectators, was infectious. Kaprow said, 'We felt the freedom to put the real world together in weird ways', and dance critic Jill Johnston recalled:

> Anyone can do it. During the 1960s, this idea swept through the art
> world like a brushfire.... Artists made dances. Dancers made music.
> Composers made poetry. Poets made events. People at large
> performed in all these things, including critics, wives, and children.

Sometimes different performances were brought together in festivals. One was the 'New York Theater Rally', produced by dancer Steve Paxton and curator Alan Solomon in New York in 1965. It was an interdisciplinary event of twenty-two performances in seven programs including: Oldenburg's Happening *Washes* (1965); an installation by Robert Whitman (b. 1935), *Shower* (1965); Robert Morris's *Site* (1964, see Minimalism); and two performances by Rauschenberg (see Neo-Dada and *Combines), *Pelican* (1963), with Cunningham dancer Carolyn Brown and Fluxus artist Per Olof Ultvedt (b. 1927), and *Spring Training* (1965), with dancers Trisha Brown, Barbara Lloyd, Viola Farber, Deborah Hay, Paxton, Rauschenberg's son Christopher and, most improbable of all, turtles with flashlights strapped to their backs. The juxtaposition of elements and mosaics of images and sounds in Rauschenberg's performances led reviewers to see them as 'live collages', or indeed, his combines brought to life, which nicely connects Performance Art to the spirit of much three-dimensional work of the period.

Lest anyone seek to impose art-historical traditions on the new art form, Rauschenberg wrote what amounted to a manifesto in 1966:

> We call ourselves Bastard Theater to correctly represent our
> relationship to traditional theater (classical and contemporary).
> Our influences are questionable and our breeding impure.
> Our misbegotten aesthetics permit us maximum working
> freedom and flexibility. Our fickleness is supported by a
> constant refusal to serve any single meaning, method,
> or media. We have no last name and enjoy it.

The multi-disciplinary, hybrid events of the period drew on currents from within and outside of the theater, from within and outside the traditions of art. This experimentation and cross-fertilization between theater, dance, film, video and visual art was essential for the development of Performance Art. Performance, whether called Actions, Live Art or Direct Art, allowed artists to traverse and blur the boundaries between media and disciplines, and between art and life.

Performance as a mode of expression continued to gain momentum during the late 1960s and 1970s, often taking the form of *Body Art. Since then, as well as exploring issues relevant to the art world, Performance artists have been creating work that directly addresses the broader socio-political issues of the day. Sexism, racism, wars, homophobia, AIDS and a variety of cultural and social taboos were, and continue to be, explored by performance artists in vividly new and often unsettling ways. Key works were created by Vito Acconci and Carolee Schneemann (see also Body Art); the Viennese artists of Aktionismus; Rebecca Horn (b. 1944); Jacki Apple (b. 1942); Martha Wilson (b. 1947); Eleanor Antin (b. 1935); Adrian Piper (b. 1948); Yayoi Kusama (b. 1940); Karen Finley ((b. 1956); Diamanda Galas (b. 1952) and Ron Athey (b. 1961), among others.

That many performance pieces were programmatically sensational and harrowing for the audience is stressed by Performance Art's chronicler, US-based RoseLee Goldberg, who commented: 'Performance artists have shown us things

we won't see twice, and sometimes things we wish we had never seen at all.'

Humour and satire have also been a part of Performance Art from the beginning, and in the 1960s many events made fun of the pretentiousness of the art world, as in work by the Canadian group General Idea (A. A. Bronson, Felix Partz and Jorge Zontal) and London-based Scottish artist Bruce McLean (b. 1944). In 1972 McLean, Paul Richards, Gary Chitty and Robin Fletcher formed 'Nice Style, The World's First Pose Band', and published a book of proposals for pose pieces such as *Waiter, Waiter There's a Sculpture in my Soup, Piece* or *He Who Laughs Last Makes the Best Sculpture*.

Autobiographical issues, such as individual and collective memory and identity, could be explored in performance more intimately than in other media. The entertaining, story-telling aspect of many of these, from Spalding Gray's monologues (b. 1941) to Eric Bogosian's (b. 1953) cabaret-like performance pieces and Laurie Anderson's (b. 1947) multimedia spectacles, made a distinct contrast to the esoteric, cerebral nature of many Minimal or Conceptual performances. Performance Art was increasingly accessible throughout the 1980s, particularly thanks to artists such as Anderson, whose sophisticated fusion of high art and popular culture brought Performance Art to a large, international audience.

Performance Art had grown out of a wide range of sources – art, music hall, vaudeville, dance, theatre, rock 'n' roll, musicals, film, circus, cabaret, club culture, political activism, etc. – and by the 1970s it became an established genre with its own history. As a result, it began to exert its influence on developments in theatre, film, music, dance and opera. The large-scale theatrical productions conceived during the late 1970s and 1980s, by artists including Robert Longo (b. 1953), Robert Wilson (b. 1941) and Jan Fabre (b. 1958), such as Wilson's famous *Einstein on the Beach* (1976), a five-hour multi-disciplinary production bringing together a number of performance artists such as Philip Glass and Lucinda Childs, have been particularly influential.

The indefinable nature of Performance Art is its strength. As veteran Performance artist Joan Jonas (b. 1936) explained in an interview given in 1995:

What attracted me to performance was the possibility of mixing sound, movement, image, all the different elements to make a complex statement. What I wasn't good at was making a single, simple statement – like a sculpture.

It accounts for the continuing appeal of Performance as the medium of choice for many artists. Work by John-Paul Zaccarini (b. 1970), such as *Throat* (1999–2001), brings together many of the previous strains in Performance Art. Zaccarini uses a wide variety of art forms – circus, dance, spoken work, text, sound, clowning and film – and incorporates autobiography, social commentary and humour.

Key Collections
Dia Center for the Arts, Beacon, New York
Modern Art and Contemporary Art Museum Collection, Nice, France
New Museum of Contemporary Art, New York
Tate Gallery, London
The Sherman Galleries, Sydney, Australia

Key Books
R. Kostelanetz, *The Theatre of Mixed Means* (1968)
S. Banes, *Greenwich Village 1963: Avant-Garde Performance and the Effervescent Body* (1993)
R. Goldberg, *Performance: Live Art since 1960* (1998)
—, *Performance Art: From Futurism to the Present* (2001)

Above: **Laurie Anderson, *Wired for Light and Sound*, from *Home of the Brave*, New York, 1986** The artist constructed a special light bulb and microphone to place in her mouth which lit up her cheeks and allowed her to emit singing noises resembling the sound of a violin.

Opposite: **Yayoi Kusama, 'Anti-War' Naked Happening and Flag Burning at Brooklyn Bridge, 1968** Important locations were targeted in New York City, including Central Park and Wall Street, by Kusama for her performances. She aimed at making them anti-war and anti-establishment. Here the performers are 'signed' by Kusama's polka dots.

GRAV

*Works of art are like picnic areas or Spanish inns,
where one consumes what one takes there oneself.*

FRANÇOIS MORELLET

Many artists in the 1960s explored specific aspects of painting and sculpture such as optical illusions, movement and light. At the time such groups of artists were collectively called 'la Nouvelle Tendance' (the New Tendency). One group that fell under this heading was the Groupe de Recherche d'Art Visuel (Group for Research in Visual Art), or GRAV, founded in Paris in 1960 and formally disbanded in 1968.

GRAV was a collective of artists of differing nationalities. Eleven artists originally signed the manifesto. These included, amongst others, the Frenchmen François Morellet (b. 1926), Joel Stein (b. 1926) and Jean-Pierre Vasarely (son of Victor Vasarely, see *Op Art), known as Yvaral (b. 1934), the Argentinians Horacio García-Rossi (b. 1929) and Julio Le Parc (b. 1928) and the Spaniard Francisco Sobrino (b. 1932). The year following the group's foundation the members published 'Assez de Mystifications!' (Enough Mystifications!) in which they explained their efforts to engage the 'human eye' and denounce the elitism inherent in traditional art. Like many artists of their generation, they rejected the angst, egoism and self-indulgence associated with the gestural abstraction of *Art Informel and *Abstract Expressionist painters, and were determined to break with the elitist tradition that viewed art as special and sacred. Their goal was to involve the public in the artistic process. Proceeding from a belief that art and science, far from being diametrically opposed, could be united, the GRAV artists utilized both artistic strategies and technological methods to create dynamic, democratic works which they believed would ultimately create a better world. In order to assess the suitability and relevance of their works to the aims of the group as a whole, individual members of GRAV submitted their works to the judgment of others in the group.

GRAV work has affinities with Op Art and *Kinetic Art. Victor Vasarely (1908–97), the Hungarian-French father of Op Art, was an inspirational figure, and indeed many of Morellet's works appear to take Vasarely's geometric abstractions into the third dimension. One of the most inventive and successful of the GRAV artists was the Paris-based Argentinian artist, Julio Le Parc, whose aim was to disorient the viewer and shake him from his apathy. His work *Continual Mobile, Continual Light* (1963), in which suspended mirrors are blown by fans and lit by moving lights, exploits the effects of movement, light, illusion and chance on the perception of the viewer. Other works of his directly involve the viewer by requiring him or her to turn on equipment or wear distorting glasses. For his considerable experimentation and fertile imagination, Le Parc was awarded the Grand Prize for painting at the 1966 Venice Biennale.

The GRAVists' optimism and faith in the marriage of art and technology links them with two contemporaneous groups of artists, the Zero Group in Germany and E.A.T. (Experiments in Art and Technology) in the USA. Group Zero was formed in 1957 in Düsseldorf by the artists Otto Piene (b. 1928) and Heinz Mack (b. 1931). Their primary interests were in the possibilities of light and movement, seen in Piene's *Light Ballet* which toured a number of European museums in 1961. E.A.T. was founded in New York in 1966 by Robert Rauschenberg (b. 1925, see *Neo-Dada and *Combines) and the engineers Billy Klüver and Fred Waldhauer. Their collaborative performances, staged internationally, involved artists, dancers, composers and scientists to create works which were not solely the domain of art, science or industry, but a result of the interaction between all three.

Key Collections
Albright-Knox Art Gallery, Buffalo, New York
Groninger Museum, Groningen, the Netherlands
Museo de Arte Moderno, Bogotá, Colombia
Sintra Museu de Arte Moderna, Portugal
Tate Gallery, London

Key Books
J. Le Parc, *Continual Mobile, Continual Light* (1963)
J. Van der Marck, *François Morellet: Systems* (Buffalo, NY, 1984)
S. Lemoine, *François Morellet* (Zurich, 1986)
P. Wilson, *The Sixties* (1997)

Opposite: **Julio Le Parc, *Lunettes pour une vision autre*, 1965**
Le Parc's work was often designed with viewer participation in mind, such as putting on various kinds of spectacles that produced special effects. Like other GRAV artists, he explored the power of optical illusions to change the way we see the world – literally.

Fluxus

Fluxus is what Fluxus does – but no one knows whodunit.

EMMETT WILLIAMS

Whether taking the form of *Performance Art, mail art, *Assemblages, games, concerts or publications, the fundamental idea behind Fluxus activity is that life itself can be experienced as art. The term Fluxus was invented by George Maciunas (1931–78) in 1961 to highlight the ever-changing nature of the group and to establish links between its varied activities, media, disciplines, nationalities, genders, approaches and professions. For Maciunas, Fluxus was 'the fusion of Spike Jones, vaudeville, gag, children's games and Duchamp.' Most of the work of this informal international group involved collaboration, either with other artists or with the viewer, and Fluxus soon developed into an ever-expanding community of artists of various disciplines and nationalities working together. As George Brecht (b. 1925)

explained, 'For me, Fluxus was a group of people who got along with each other and who were interested in each other's work and personality.' They included Maciunas, Brecht, Robert Filiou (1926–87), Dick Higgins (1938–98), Alison Knowles (b. 1933), Yoko Ono (b. 1933), Nam June Paik (b. 1932), Dieter Roth (1930–98), Daniel Spoerri (b. 1930), Ben Vautier (b. 1935; known as Ben), Wolf Vostell (1932–98), Robert Watts (1923–88), Emmett Williams (b. 1925) and La Monte Young (b. 1935).

Fluxus can be seen (as its own members saw it) as a strain of the *Neo-Dada movement of the 1950s and 1960s, related to *Lettrism, *Beat Art, *Funk Art, *Nouveau Réalisme and the *Situationist International. Like their contemporaries, Fluxus artists sought a closer integration of

*Video artist Paik went so far as to describe his career as 'nothing but an extension of one memorable event at Darmstadt '58'.

Fluxus work ranged from the absurd to the mundane to the violent and often incorporated elements of socio-political critique, with the aim of ridiculing the pretensions of the art world and of empowering the viewer and the artist. A 'do-it-yourself' nature permeated Fluxus work, much of which existed as written directions to be carried out by others. Throughout the 1960s and 1970s there were numerous Fluxus festivals, concerts and tours, Fluxus newspapers, anthologies, films, food, games, shops, exhibitions and even Fluxdivorces and Fluxweddings. As Higgins explained on a rubberstamp, 'Fluxus is: a way of doing things, a tradition, and, a way of life and death.' In the same way that Cage allowed any sound to become music, Fluxus allowed anything to be used for art. In a 1965 manifesto, Maciunas asserted the same, that the job of the artist was to 'demonstrate that anything can be art and anyone can do it.'

Many Fluxus goals were realized by the collage artist and father of mail art Ray Johnson (1927–95). During the 1950s, he began sending letters and drawings to artists and celebrities whom he admired, either as gifts or with instructions to 'add to and return to Ray Johnson'. By 1962, the network had evolved into the New York Correspondance [*sic*] School (NYCS), with reference to self-study art and dance courses. With his freely distributed art works, which could only be received, not bought or sold, Johnson created an international network of collectors and collaborators outside the art market. Both Fluxus and mail art continue to develop today, after their heyday in the 1960s and 1970s, and they are able to take advantage of new technologies, such as the internet.

art and life and a more democratic approach to creating, receiving and collecting art. They were anarchic activists (as the *Futurists and *Dadaists had been before them) and utopian radicals (like the Russian *Constructivists). More immediate influences were Robert Motherwell's anthology, *The Dada Painters and Poets* (1951), and the experimental composer John Cage (1912–92, see Neo-Dada and Performance Art). Many of the American Fluxus composers and visual artists knew Cage personally or studied with him, either at Black Mountain College or at the New School for Social Research in New York. Higgins recalled: 'the best thing that happened to us in Cage's class was the sense he gave that "anything goes", at least potentially…'. Cage's influence spread internationally with his European tour conducted between 1958 and 1959, during which he gave a 'concert' of questions. For the future Nouveau Réaliste and Fluxus artist Spoerri, it proved deeply inspirational. He stated that it was 'the first performance I saw that was completely different. It changed my life.' Fluxus and

Above: **Yoko Ono, *A Grapefruit in the World of Park...*, 24 November 1961** Ono stands behind the poster advertising her appearance at the Carnegie Hall in New York, where she performed work for 'strawberries and violin', featuring both text and sound.

Opposite: **George Maciunas, Dick Higgins, Wolf Vostell, Benjamin Patterson, Emmet Williams performing Philip Corner's *Piano Activities* at Fluxus Internationale Festspiele Neuester Musik, Wiesbaden, September 1962** The first of the Fluxus festivals took place at Wiesbaden, where Maciunas was employed as a designer by the American airforce base.

Key Collections
Gallery of Contemporary Art, Hamburger Kunsthalle
Queensland Art Gallery, South Brisbane, Australia
Tate Gallery, London
Whitney Museum of American Art, New York

Key Books
J. Hendricks, *Fluxus Codex* (1988)
E. Williams, *My Life in Flux- and Vice Versa* (1992)
E. Armstrong and J. Rothfuss, *In the Spirit of Fluxus* (exh. cat., Walker Art Center, Minneapolis, 1993)
E. Williams and A. Noël, *Mr. Fluxus: A Collective Portrait of George Maciunas 1931–1978* (1997)

Op Art

To experience the presence of a work of art is more important than to understand it.

VICTOR VASARELY

While all art relies to a certain extent on optical illusions, Op Art specifically employs optical phenomena to confound the normal processes of perception. Composed of precise geometric patterns in black and white, or of juxtapositions of high-keyed colours, Op Art paintings vibrate, dazzle and flicker, creating moiré effects, illusions of movement or afterimages.

By the mid-1960s, the fashion-conscious art world of New York was already announcing the demise of *Pop Art, and the search was on for a replacement. In 1965 an exhibition entitled 'The Responsive Eye', curated by William C. Seitz (see also *Assemblage) at the Museum of Modern Art in New York, provided the answer. Although it included work by *Post-painterly Abstractionists, *GRAV and *Concrete artists, it was the work of those Seitz called 'perceptual abstractionists' that stole the show. For Americans Richard Anuszkiewicz (b. 1930) and Larry Poons (b. 1937), Britain's Michael Kidner (b. 1917) and Bridget Riley (b. 1931) and Hungarian-French artist Victor Vasarely (1908–97), it was the beginning of a period of intense media attention.

Prior to the opening of the exhibition their work had been dubbed Op Art (an abbreviation of 'optical art', with a ringing reference to Pop), not by the artists or critics, but by the media. The name first appeared in an unsigned article for *Time* magazine in October 1964, and was in common usage by the time of the 1965 exhibition. It rapidly caught the popular imagination – visitors arrived at the preview of 'The Responsive Eye' dressed in Op Art-inspired clothing – and the new style spread to fashion, interiors and graphics. As with Pop, this instant popularity did not endear it to the critics, particularly in the USA, where the supporters of *Abstract Expressionism, *Minimalism and Post-painterly Abstraction dismissed Op Art as a gimmick. The artists themselves were ambivalent about the popularity of their work. Bridget Riley, whose works were enthusiastically received by the public, once threatened one manufacturer of 'Riley' dresses with a lawsuit. She also stated publicly that the 'commercialism, bandwagoning and hysterical sensationalism' were responsible for alienating the art world. Riley's striking use of geometric shapes in black and white create an effect of rhythm and distortion. Her later works moved away from black and white to include contrasting colours and tonal variations.

Although perceived as totally new, optical art did have its antecedents, especially in Europe – where the critics treated it more seriously – and its origins can be found in the traditional technique of *trompe l'oeil* (French: deceives the eye). Twentieth-century artists associated with the *Bauhaus, *Dada, *Constructivism, *Orphism, *Futurism and *Neo-Impressionism had also been interested in optical perception and illusion. As early as 1920, the Dadaists Marcel Duchamp and Man Ray had explored optical illusions with their *Rotary Glass Plates (Precision Optics)*. László Moholy-Nagy (see *Kinetic Art and *Bauhaus) and Josef Albers (see Bauhaus) also researched the visual effects produced by light, space, movement, perspective and colour relationships, and their work became widely known in Europe and the USA.

Above: **Bridget Riley, *Pause*, 1964**
Although the fashion industry made them instantly chic (somewhat to the artist's regret), Riley's early black-and-white paintings were anything but comforting; on the contrary, they exert a threatening, subversive feeling of dislocation and disorientation.

Opposite: **Victor Vasarely, *Vega-Gyongiy-2*, 1971**
Vasarely believed that the viewer's intellectual apprehension of his work was less important than the physical effect it had on him. For his paintings, which are based on multi-dimensional illusion, he coined the term Cinetic Art, expressing virtual, rather than actual, movement.

For Victor Vasarely, the most influential Op artist, the illusion of movement was always the central concern. Vasarely studied in Budapest under the *Hungarian Activist Sándor Bortnyik in 1929, and, like the other Hungarian Activists and GRAV artists whom he later inspired, Vasarely aimed at inventing an art that would be expansive, collective and utopian. He wished to create designs that could be realized by other people or by machines, and that could be integrated into architecture and urban planning. His ultimate goal was to establish a new society, the 'new city – geometrical, sunny and full of colours'. He considered his 'Planetary Folklore' series to contribute to this aim through their application to architecture and urban planning. Throughout the 1950s, Vasarely and other European Op artists were supported in Paris by the Galerie Denise René, and a number of their works were included in 'Le Mouvement', a landmark exhibition held in 1955.

Op Art requires the viewer's participation to 'complete' it. In this sense, the works are 'virtual' works which prompt the viewer to consider the processes of perception and thought, and to question the illusory nature of reality. These concerns link Op Art to a number of contemporary movements, such

as *Fluxus, *Super-realism and GRAV, as well as to gestalt theories in psychology (the whole is perceived as greater than the sum of its parts) and to new discoveries in the psychology and physiology of perception. The illusion of movement or metamorphosis inherent in Op Art is also an important feature of Kinetic Art.

Although Op Art rapidly went out of fashion, its imagery and techniques were revived during the 1980s by a new generation of artists such as American Philip Taaffe (b. 1955) and Dutchman Peter Schuyff (b. 1958). This reawakening of interest also led to a renewed appreciation of the work of committed Op Art practitioners such as Riley, American Julian Stanczak (b. 1928) and Britain's Patrick Hughes (b. 1939), who has been creating three-dimensional relief paintings since 1964.

Key Collections
Dia Center for the Arts, Beacon, New York
Fondation Vasarely, Aix-en-Provence, France
Henie Onstad Art Center, Høvikodden, Norway
Museum of Modern Art, New York
Tate Gallery, London

Key Books
K. Moffett, *Larry Poons* (exh. cat., Museum of Fine Arts, Boston, 1981)
M. Kidner, *Michael Kidner* (1984)
V. Vasarely, *Vasarely* (1994)
B. Riley, *Bridget Riley* (2000)

Post-painterly Abstraction

What you see is what you see.

FRANK STELLA, 1966

The term Post-painterly Abstraction was coined in 1964 by the influential American critic, Clement Greenberg (1909–94), for an exhibition he curated at the Los Angeles County Museum of Art. His term incorporated other individual styles, such as Hard-Edge Painting, used to describe the work of Al Held (b. 1928), Ellsworth Kelly (b. 1923), Frank Stella (b. 1936) and Jack Youngerman (b. 1926); Stain Painting, which covered the work of Helen Frankenthaler (b. 1928), Joan Mitchell (1926–92) and Jules Olitski (b. 1922); Washington Color Painters, such as Gene Davis (1920–85), Morris Louis (1912–62) and Kenneth Noland (b. 1924); Systemic Painting, which referred to the work of Josef Albers (1888–1976), Ad Reinhardt (1913–67), Stella and Youngerman; and Minimal Painting, in connection with the work of Robert Mangold (b. 1937), Agnes Martin (b. 1912), Brice Marden (b. 1938) and Robert Ryman (b. 1930).

All these different types of American abstract painting grew out of *Abstract Expressionism in the late 1950s and early 1960s, and in some ways reacted against it. In general, the new abstract artists shunned the overt emotionalism of Abstract Expressionism and rejected the expressive gestural brushstrokes and tactile surfaces of Action Painting in favour of cooler, more anonymous styles of handling. Though they shared certain visual characteristics and painting techniques with the Abstract Expressionist artists

Barnett Newman and Mark Rothko, they did not share the older artists' transcendental beliefs concerning art. Instead, they tended to stress painting as object rather than illusion. Shaped canvases stressed the unity between the painted image and the form and size of the canvas. Influenced by Reinhardt's attitude of 'art for art's sake', they spurned

the social, utopian aspirations of *Concrete artists, whose work sometimes resembles their own.

Stella's black stripe paintings were exhibited at the Museum of Modern Art in New York in 1959. The immediacy and directness of his images declared that they were painted objects, not *Existential experiences or vehicles for social commentary. In the opinion of some critics, Stella was a 'smart aleck' or a 'juvenile delinquent'; his dismissal of the cherished romantic, painterly qualities of Abstract Expressionism was 'a slap in the face'. For others, however – especially artists – he offered a way out of the impasse of Abstract Expressionism.

For Greenberg, the most vocal champion of Post-painterly Abstraction, the history of modern art from *Cubism through Abstract Expressionism to Post-painterly Abstraction was one of purist reduction. He believed that each art form should restrict itself to those qualities essential only to itself; therefore painting, a visual art, should restrict itself to visual or optical experiences, and avoid any associations with sculpture, architecture, theatre, music or literature. Works of Post-painterly Abstraction that stressed their formal qualities, exploiting the purely optical qualities of pigment, emphasizing the shape of the canvas and the flat-

ness of the picture plane, represented for Greenberg the superior art form of the 1960s. He dismissed other styles of the same era, such as *Pop Art and *Minimalism, as 'novelty arts' – though in fact artists of all three styles shared an objective, anti-expressionist attitude and a distrust of what Jasper Johns (see *Neo-Dada) called the 'stink of artists' egos'.

Greenberg's influence proved to be considerable and Post-painterly Abstraction dominated museum exhibitions of the 1960s and 1970s. The backlash occurred during the 1970s, following the rise of various strains of *Post-modernism, when Greenbergian modernism was challenged by artists and critics alike. As critic Kim Levin wrote in the article 'Farewell to Modernism' (*Arts Magazine*, 1979), 'The mainstream trickled on, minimizing and conceptualizing itself into oblivion, but we were finally bored with all that purity.'

Above: **Frank Stella, *Nunca Pasa Nada*, 1964**
Large canvases of stripes painted freehand over a precise geometric drawing with raw canvas showing between, the Black Stripe paintings brought together aspects of gestural and geometric abstraction, and seemed to mock both, purifying the one, and sullying the other.

Opposite: **Kenneth Noland, *First*, 1958**
Noland preferred to use clearly defined contours, simple motifs and pure colours (often in acrylic rather than oil paint). His staining technique, which dyed the unprimed canvas, helped to remove the sense of the artist's hand and any tactile surface qualities.

Key Collections
Kemper Museum of Contemporary Art, Kansas City, Missouri
Museum of Contemporary Art, San Diego, California
National Museum of American Art, Washington, D.C.
Portland Art Museum, Portland, Oregon
Tate Gallery, London

Key Books
W. Rubin, *Frank Stella: Paintings from 1958 to 1965* (1986)
K. Wilkin, *Kenneth Noland* (1990)
R. Armstrong, *Al Held* (1991)
B. Haskell, *Agnes Martin* (1992)
W. Seitz, *Art in the Age of Aquarius* (1992)
D. Waldman, *Ellsworth Kelly: A Retrospective* (1996)

1965-today

Beyond the Avant-Gardes

Minimalism

Minimalism came to the attention of the New York art world between 1963 and 1965 following solo exhibitions of work by Donald Judd (1928–94), Robert Morris (b. 1931), Dan Flavin (1933–96) and Carl Andre (b. 1935). Although not an organized group or movement, Minimalism was one of the many labels (including Primary Structures, Unitary Objects, ABC Art and Cool Art) applied by critics to describe the apparently simple geometric structures that these artists and others were producing. The artists themselves did not like the label because of the negative implication that their work was simplistic and devoid of 'art content'.

Minimalist artists paid notable attention to the work of the Russian *Constructivists and *Suprematists, especially to those whose work tended towards single-minded abstraction. Suprematist Kasimir Malevich's *Black Square* (c. 1915, see p. 104) was an important indicator of a new mode of art that was intentionally non-utilitarian and non-representational.

Minimalism was established as a movement with the major survey exhibition 'Primary Structures: Younger American and British Sculptors', held at the Jewish Museum in New York in 1966. Shortly afterwards, the term Minimalist began to be applied to works by the American sculptors Andre, Richard Artschwager (b. 1923), Ronald Bladen (1918–88), Larry Bell (b. 1939), Flavin, Judd, Sol LeWitt (b. 1928), Morris, Beverly Pepper (b. 1924), Richard Serra (b. 1939) and Tony Smith (1912–80), Britain's Sir Anthony Caro (b. 1924), Phillip King (b. 1934), William Tucker (b. 1935), Tim Scott (b. 1937), and paintings by the *Post-painterly Abstractionists.

Judd, who had studied both philosophy and art history at Columbia University in New York, became one of the most interesting commentators on the art that he and

Left: **Donald Judd, *Untitled*, 1969**
'Three dimensions are real space. That gets rid of the problem of illusionism and of literal space, space in and around marks and colours...the several limits of painting are no longer present.'
Donald Judd, 'Specific Objects', 1965

Opposite: **Dan Flavin, *Fluorescent light installation*, 1974**
Flavin used fluorescent light tubes, and regarded the space in which they are installed as integral to the work. With the effect of light and space taking the place of the conventional art object, the work becomes 'dematerialized'.

other Minimalists were producing. In his seminal article of 1965 entitled 'Specific Objects', Judd wrote:

> Actual space is intrinsically more powerful and specific than paint on a canvas…The new work obviously resembles sculpture more than it does painting, but it is nearer to painting…. Colour is never unimportant, as it usually is in sculpture.

The artists that Judd was referring to – Frank Stella (see Post-painterly Abstraction), *Neo-Dadaists Robert Rauschenberg, John Chamberlain and Claes Oldenburg, and *Nouveau Réaliste Yves Klein – were producing work that did not fit the established categories of painting or sculpture, but combined aspects of both (see also Assemblage). Judd called them 'specific objects', a term often used in relation to his own work. Since 1961, he had been working in three dimensions. In his wall stacks he confounds the traditional presentation of painted works (flat on a wall) and of sculpture (on a pedestal), prompting the basic

question: are the wall stacks painting or sculpture? The stacks use colour, as do painted works, but they protrude from the wall, so that the wall itself becomes a part of the work. Moreover, they consist of materials seldom used by sculptors, such as plywood, aluminium, plexiglas, iron and stainless steel. These apparently simple structures raise a number of complex issues. A constant theme is the interplay between negative and positive spaces in actual objects, and the interaction of objects with their immediate environment, such as the museum or gallery space. In 1971 Judd took complete control of the issue by moving to Marfa, Texas, and converting a number of buildings into permanent installations of both his work and that of others.

Morris's cube boxes of 1965 point to similar concerns. The large mirrored objects, the viewers and the gallery space all interact and constitute part of an ever-changing work which dramatizes the viewing experience, the act of perception and the expression of space and movement. Such themes

relate Minimalism to *Performance and *Earth Art, areas in which Morris has also worked. But a statement Morris made in 1966 emphasizes the paradox of simplicity:

> Simplicity of shape does not necessarily equate with simplicity of experience. Unitary forms do not reduce relationships. They order them.

Flavin explored themes related to space and light; he is known especially for his fluorescent light sculptures or environments, such as *Pink and Gold* of 1968. These works seem to embody a particular Minimalist tendency: to represent the object in its own right. However, in their use of light and their exploitation of the space in which they are installed (the neon tubes illuminate or reflect on surrounding surfaces), Flavin's work appears to approach a dematerialized state independent of the object itself. 'Symbolizing is dwindling – becoming slight', wrote Flavin about Minimalism in 1967. Like Judd, Flavin studied art history at Columbia University, and always acknowledged his many art historical references, which included Marcel Duchamp and his readymades (see Dada), and the Constructivists. Flavin's *Monument to V. Tatlin* (1964) is an arrangement of neon tubes that recalls

Vladimir Tatlin's earlier efforts to wed aesthetics and technology. He also acknowledged the example of one of Constantin Brancusi's soaring *Endless Columns* (*c.* 1920, see *Ecole de Paris): his *Diagonal of May 25, 1963*, a single yellow neon tube hung at 45 degrees from the horizontal, was dedicated to Brancusi. Flavin's work shares something of the transcendental aura of Brancusi's sculpture, and his installations have been noted for their 'sacred character'.

Brancusi's modular sculptures also provided an important inspiration for Andre, as did the internal symmetry of Stella's stripe paintings. He experimented with the different colours and weights of an array of metals and other materials, questioning the rightful position of sculpture and its relationship with the human body. In *37 Pieces of Work*, made in 1969 for the Guggenheim Museum in New York, thirty-six individual pieces combine to form the thirty-seventh. Unlike traditional sculpture, the work is not vertical or placed on a pedestal, but horizontal – laid on the floor like a carpet. The spectator is invited to interact with the work by walking on it and experiencing, both physically and visually, the different characteristics of each type of metal.

When Minimalist art first began to appear, many critics and a vocal public found it cold, anonymous and unforgiving. The industrial prefabricated materials often employed did not resemble 'art'. However, as the definition of 'art' expanded in the second half of the twentieth century, many of the early attacks now seem hard to understand; Judd, for example, may have had his works fabricated for him, but they are recognizable as 'Judds'. Furthermore, the sheer sensuality of the materials and surfaces of many Minimalist pieces appear anything but cold. Flavin's light installations transform a gallery or museum space into an ethereal environment; Judd's wall sculptures cast a reflected light on the wall that is more reminiscent of stained-glass windows in a church than those of a factory, and many of Andre's floor pieces evoke shimmering mosaics or quilts. By restricting the elements at work in each object, complex rather than minimal effects are created.

The apparent rejection of overt sentimentality links Minimalism with other art forms of the 1950s and 1960s, from the French Nouveau Roman (New Novel) and New Wave cinema to Neo-Dada, *Pop Art and Post-painterly

Above: **Carl Andre, *Equivalent VIII*, 1978** When this arrangement of bricks was purchased by the Tate Gallery, London, it provoked fierce criticism in the British press. The claim that basic industrial materials, painstakingly installed in a museum or gallery, could assume a fresh identity, did not convince everyone.

Opposite: **Foster and Partners and Sir Anthony Caro, Millennium Bridge, London, 2000** This very shallow suspension bridge – which its makers have called a 'minimal intervention' – achieves the lightness and simplicity of its original concept sketch, despite the considerable technical difficulties of using little available space on either riverbank.

Abstraction. The detachment of the artist from the manufacture of his art and the appeal made to the viewer's intellect recall aspects of *Conceptual Art. In recent years the term Minimalist has also been applied to interior, furniture, graphics and fashion designers whose work contains clean, strong lines and sparse decoration (paradoxically often calculated to produce effects of exclusivity and luxury).

Although the term was not commonly applied to music until the early 1970s, in the 1960s the work of several composers was associated with Minimalism. Their compositional practices were not unrelated to activities in the visual arts: their features – such as static harmony, repetition, and the use of unconventional instruments – aimed to reduce the compositional medium to a pure minimum. Compositions that make use of modular or repetitive structures and patterns (for example, by Terry Riley, Steve Reich or Philip Glass) recall approaches by Minimalist artists who used the notion of an ordered, seemingly unsignifying grid as the basis for pure forms of expression free of interpretable meaning. Several composers – including La Monte Young and John Cage – saw their work become closely associated with the work of *Performance, *Fluxus and Conceptual artists.

Although, formally speaking, a Minimalist school of architecture does not exist, numerous modernist architects have sought purity and rigour in their designs which can loosely be termed Minimalist (see *Purism and *International Style). In this sense the severe style of Ludwig Mies van der Rohe (who famously stated 'less is more') can be classed as Minimalist; so too can the work of Mexican architect Luis Barragán (1902–88), whose own residence in Tacubaya, Mexico City (1947), is noted for its geometrical purity and bold colours. Painting, sculpture and architecture fused in Satellite City Towers (1957–58), the freeway monument designed by Barragán in collaboration with the sculptor Mathias Goeritz (1915–90). The five painted concrete towers outside Mexico City, also known as the Towers without Function, soar to heights ranging between 160 and 190 feet (49 and 58 metres).

In the 1980s a new generation of distinguished Japanese architects, which included Kazuo Shinohara (b. 1925), Fumihiko Maki (b. 1928), Arata Isozaki (b. 1931) and Tadao Ando (b. 1941), produced Minimalist work influenced as much by the classical style of Zen Buddhism as by European Modernism. Maki's National Museum of Modern Art in Kyoto (1986) provides a good example, with its restrained granite and glass façade inspired, according to the architect, by the clarity of Kyoto's city grid.

The *High-Tech architects also share some of the aims and techniques of the Minimalists. This affinity resulted in collaboration between the sculptor Sir Anthony Caro, the architectural firm of Foster and Partners and the engineering firm of Ove Arup and Partners on the Millennium Bridge (2000) in London. The suspension bridge was temporarily closed three days after it opened in order to correct its well-publicized 'wobble', which occurred when people first began to cross it. But it still functions beautifully as both a 'drawing in space' and a 'sculpitecture', the term Caro has applied to his architectural constructions since 1989.

Although the purity and intellectual nature of Minimalism went out of fashion in the 1980s art world, certain characteristics of the style entered the repertoire of a later generation of artists. By focusing on the effects of context and on the theatricality of the viewing experience, Minimalism exerted an indirect but powerful influence on later developments in Conceptual Art, Performance and *Installation, and provided a foil for the rise of *Postmodernism.

Key Collections

Chinati Foundation, Marfa, Texas
Modern Art Museum of Fort Worth, Texas
Montclair Art Museum, New Jersey
Museum Boijmans Van Beuningen, Rotterdam, the Netherlands
Museum of Modern Art, New York
Tate Gallery, London

Key Books

D. Judd, *Complete Writings, 1959–1975* (1975)
K. Baker, *Minimalism* (1988)
G. Battcock (ed.), *Minimal Art: A Critical Anthology* (Berkeley, CA, 1995)
M. Toy, *Aspects of Minimal Architecture* (1994)
D. Batchelor, *Minimalism* (1999)
J. Meyer, *Minimalism* (2001)

Conceptual Art

Being an artist now means to question the nature of art.

JOSEPH KOSUTH, ARTS MAGAZINE, 1969

Conceptual Art came into its own as a category or movement in the late 1960s and early 1970s. Also often called Idea Art or Information Art, the basic precept of Conceptual Art is that ideas or concepts constitute the real work. Whether in *Body Art, *Performance Art, *Installation, *Video Art, *Sound Art, *Earth Art or *Fluxus activities, the object, installation, action or documentation is acknowledged as no more than a vehicle for presenting the concept. At its most extreme, Conceptual Art forgoes the physical object completely, using verbal or written messages to convey the ideas.

The work and ideas of Marcel Duchamp (see *Dada) were a prime influence. What made him the definitive proto-Conceptual artist was his questioning of the rules of art; his inclusion of the intellect, body and viewer in both the making and receiving of art; and his privileging of the idea over traditional notions of style and beauty.

The explosion of Conceptual Art in the late 1960s was anticipated by several *Neo-Dada works and gestures:

American Robert Rauschenberg's *Erased De Kooning Drawing* (1953, made by erasing a drawing given to him by Willem de Kooning; see also *Combines) and his telegram portrait of Iris Clert – *This is a Portrait of Iris Clert if I say so* (1961); French *Nouveau Réaliste Yves Klein's attempt to fly, documented as *Leap into the Void* (1960), and his exhibiting and selling 'zones of immateriality' in 1958 and 1959; and Italian Piero Manzoni's (1933–63) signing people's bodies in 1961, and canning, labelling, numbering and signing ninety cans of his own excrement, *Merda d'artista* (Artist's shit, 1961). *Funk artist Ed Kienholz was describing his own work as 'concept tableaux' by 1963. In the same year, composer La Monte Young's *Anthology* was published with an essay, 'Concept Art', by Fluxus artist Harry Flynt (b. 1940), who attempted a definition:

> 'Concept Art' is first of all an art of which the material is concepts, as the material of e.g. music is sound. Since concepts are closely bound up with language, concept art is a kind of art of which material is language.

Conceptual Art was further defined by two of its leading practitioners, Americans Sol LeWitt (b. 1928) and Joseph Kosuth (b. 1945). In LeWitt's 1967 article 'Paragraphs on Conceptual Art', he defined Conceptual Art as that which 'is made to engage the mind of the viewer rather than his eye or his emotions', and declared that the 'idea itself, even if not made visual, is as much a work of art as any finished product.'

For Kosuth, the challenge for the artist was to discover and define the nature and language of art. In his manifesto-like 'Art after Philosophy' (1969) he wrote, 'the only vindication of art is art. Art is the definition of art.' His theories were informed by an interest in linguistic analysis and structuralism. Ad Reinhardt (an important artist for the *Post-painterly Abstractionists and *Minimalists) had

Left: **Joseph Kosuth, *One and Three Chairs*, 1965** Three equal parts – a chair, a photograph of it, and a printed dictionary definition – make up the piece. It is, in the words of one critic, 'a progression from the real to the ideal'. With LeWitt, Kosuth helped define the parameters of Conceptual Art.

Opposite: **Joseph Beuys, *The Pack*, 1969** Saved after a wartime plane crash by Tartars who wrapped his body in felt and fat, Beuys used these materials as artistic symbols of healing and survival. He cast himself as a teacher (he started the Free International University) and gathered a large personal following.

declared in 1961, 'What you can say about art is it is art. Art is art and everything else. Art like art is nothing but art. What is not art is not art.' Kosuth's early example of Conceptual Art, *One and Three Chairs* (1965–66), was intended to make the viewer aware of the linguistic nature of art and reality, and of the interplay between an idea and its visual and verbal representation.

Although defined first in New York, the term was soon applied to a variety of artists, transforming Conceptual Art into a vast international movement. The following artists were closely associated with Conceptual works: Americans John Baldessari (b. 1931), Robert Barry (b. 1936), Mel Bochner (b. 1940), Dan Graham (b. 1942), Douglas Huebler (b. 1924), William Wegman (b. 1942) and Lawrence Weiner (b. 1940); Germans Joseph Beuys (1921–86), Hanne Darboven (b. 1941), Hans Haacke (b. 1936) and Gerhard Richter (b. 1932); Japanese Shusaku Arakawa (b. 1936) and On Kawara (b. 1932); Belgian Marcel Broodthaers (1924–76); Dutch Jan Dibbets (b. 1941); Britons Victor Burgin (b. 1931) and Michael Craig-Martin (b. 1941); the Art & Language group in Britain and New York and the Paris-based French and Swiss artists of BMPT, particularly Daniel Buren (b. 1938, see also *Site Works). Large survey exhibitions were documenting Conceptual activity by 1969; the term earned formal recognition with the 1970 exhibition 'Conceptual Art and Conceptual Aspects' at the New York Cultural Center, and was further established with the 'Information' exhibition at the Museum of Modern Art, New York, in 1970.

Much Conceptual Art takes the form of documents, written proposals, films, videos, performances, photographs, installations, maps or mathematical formulae. Artists consciously used formats that are often visually uninteresting (in a traditional art sense) in order to focus attention on the central idea or message. The activities or thoughts presented could have taken place elsewhere spatially or temporally, or

even simply in the viewer's head. Implicit was a desire to demystify the creative act and to empower both the artist and the viewer beyond the concerns of the art market.

Lawrence Weiner quit painting in 1968 and turned his attention to writing proposals in books or directly on gallery walls. The 'title' of each piece explains how the piece was planned and how it could be envisaged in each viewer's imagination, allowing for multiple personal versions of the work. As Weiner put it: 'Once you know about a work of mine, you own it. There's no way I can climb into somebody's head and remove it.' Weiner's preoccupation with language was common to many Conceptual artists such as Kosuth, Barry, Baldessari and Art & Language. As with *Pop artists Robert Indiana and Ed Ruscha, whose words also functioned as images, the works lent themselves to being reproduced and stressed the fact that both images and words can be decoded and read.

Although Sol LeWitt distinguished himself first as a Minimalist, he insisted that this was a conceptual form. As well as writing his seminal essays on Conceptual Art, LeWitt created some of its best-known pieces. He expressly aimed to remove all elements of chance and subjectivity, creating serial works composed of numbers and letters to be read as narratives, and Wall Drawings, whose network of lines were applied by any willing assistant following LeWitt's precise instructions.

While many early Conceptual artists were preoccupied with the language of art, during the 1970s others looked outwards, producing work that included natural phenomena (Barry, Dibbets, Haacke and Earth artists); narrative and story-telling tinged with humour or irony (Arakawa, Baldessari, Kawara and Wegman); exploring the power of art to transform lives and institutions (Beuys, Buren and Haacke); and work that pursued a critique of the power structures of the art world, and the more general social, economic and political conditions of the wider world (Broodthaers, Buren, Burgin and Haacke). What most Conceptual works share is an appeal to the viewer's intellectual faculties – what is art? Who determines what it is? Who decides how it is exhibited and criticized? This reflects the growing politicization of many artists during the period that saw the Vietnam War, student protests, assassinations, the civil rights struggle and the rise of feminism, the anti-nuclear movement and the environmental movement.

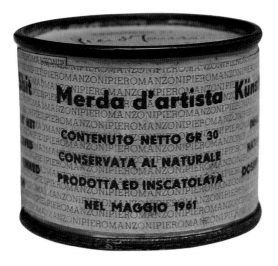

Left: **Piero Manzoni, *Merda d'artista no. 066* (Artist's Shit no. 066), 1961** Manzoni canned, labelled, numbered and signed ninety cans of his own excrement. The mechanically sealed cans were sold according to the day's price of their equivalent weight in gold.

Opposite: **Marcel Broodthaers, *Museum of Modern Art, Department of Eagles, XIXth Century section*, Brussels, 1968–69** Broodthaers's fictitious museum is a long-running pastiche that is both artistic and political in intent, making us re-examine the nature of objects for public display, and public display itself.

Beuys, a sort of modern shaman, staged highly personal – and often confrontational – events in which he dramatized such issues. When asked why he mixed art and politics, he replied, 'Because real future political intentions must be artistic.'

In 1970 Baldessari burned his previous artistic production and turned to Conceptual Art. The following year he made his first *I Will Not Make Any More Boring Art* pieces, in which the surface is covered with the same repeated phrase, as if for a school punishment. He spoke for many in expressing his exasperation with the prevailing dominance of Minimalism and Post-painterly Abstraction and their increasingly distant relationship to the real world. Works by Haacke, Buren and Broodthaers destroy the myth that art and culture exist in a separate, apolitical sphere. Their installations and pieces draw attention to the authority of the institutions of art. By examining their impact on art production and reception, the artists expose the way in which art can be made to work – as a commodity fetish, a mode of conferring status or a tool of concealment.

Haacke's socio-political, information-based work is concerned with the ideologies of art institutions (see also Postmodernism). With poll pieces such as *MOMA-Poll* (1970), Haacke invited visitors to cast ballots in response to a question. The content of the work depended on the responses provided by the viewers themselves. Buren's work looks at the way galleries and museums direct both the viewer and the art object. He displays his vertically striped canvases or posters in different contexts: in museums, on billboards, banners or sandwich boards, drawing attention to the role that context plays in identifying an object as 'art' as well as the reciprocal relationship – the power of art to transform a space or context into a place worthy of art (see also Site Works).

Broodthaers, a poet who to turned art in the mid-1960s,

conducts a critique of the status of art and museums and considers the condition of representation through puzzle-like works in which words, images and objects are constantly interacting. Broodthaers's interest in wordplay also acknowledged the influence of his artistic ancestors, Duchamp and René Magritte (whom he met in 1940, see *Magic Realism). Between 1968 and 1972 he founded a *Museum of Modern Art, Department of Eagles* in his house in Brussels. The first section entitled *XIXth Century*, consisted of posters, post-cards, packing crates and inscriptions, all of which showed eagles. Later, in 1972, along with the *Section of Figures*, the exhibits were shown with Magritte-like labels that read: 'This is not a work of art.' Broodthaers's fictitious museum challenged the viewer to consider the factors that determine whether an object may be considered a work of art, and to question the version of history presented by a museum's collection: is it any less of a fiction than Broodthaers's museum? When he closed his museum, Broodthaers explained that he was 'playing the part sometimes of a political parody of artistic events and sometimes of an artistic parody of political ones' and that this is 'what the official museums do…. Though with the difference that the fiction can be used to evoke not only the reality but also what hides behind it.'

Conceptual Art peaked during the mid-1970s, after which it was eclipsed by the rise of artists whose interest lay in the traditional materials of art and the expression of emotions (see *Transavangardia and *Neo-Expressionism). There was, however, a strong revival of interest in Conceptual Art by artists who emerged in the 1980s, of whom many were associated with Postmodernism. Conceptual Art ideas continue to underlie much contemporary art; many artists whose work cannot be easily categorized have been called Conceptual artists, such as Susan Hiller (b. 1942), Peter Kennard (b. 1949), Juan Muñoz (1953–2001), Gabriel Orozco (b. 1962) and Simon Patterson (b. 1967).

Key Collections
Art Gallery of Ontario, Toronto, Ontario
DeCordova Museum and Sculpture Park, Lincoln,
Massachusetts
Hood Museum of Art, Hanover, New Hampshire
Housatonic Museum of Art, Bridgeport, Connecticut
Museum of Modern Art, New York
Tate Gallery, London

Key Books
U. Meyer (ed.), *Conceptual Art* (1972)
L. Lippard (ed.), *Six Years: The Dematerialization of the Art Object 1966–72* (1973)
M. Newman and J. Bird (eds), *Rewriting Conceptual Art* (1999)
A. Alberro and B. Stimson (ed.), *Conceptual Art: A Critical Anthology* (Cambridge, MA, 1999)
A. Rorimer, *New Art in the 60s and 70s* (2001)

Body Art

If Minimalism was so great, what could I do?
What was missing was the source. I had to reveal the source.

VITO ACCONCI

Body Art is art which uses the body, usually the artist's own, as a medium. Since the late 1960s, it has been one of the most popular and controversial forms of art, and has spread across the world. In many ways it represents a reaction against the impersonality of *Conceptual and *Minimalist Art. As Vito Acconci (b. 1940) stated, what was missing from much of the art of the period was the corporeal presence of the maker of art. But Body Art can also be seen as an extension of Conceptual Art and Minimalism. In cases where it takes the form of a public ritual or a performance, it also overlaps with *Performance Art, though it is frequently created in private and then communicated to the public via documentation – such as the *Autopolaroids* of American Lucas Samaras (b. 1936), which in effect turn the viewer into a voyeur. Audiences of Body Art experience a range of roles, from passive observer to voyeur, to active participant. Extremely emotional responses are elicited from them by works that are intentionally alienating, boring, shocking, thought-provoking or funny.

Several key figures provided Acconci's generation with influential examples. One was Marcel Duchamp (see *Dada), whose premise – that anything could be used as a work of art – first introduced the body as material. Another was Yves Klein (see *Nouveau Réalisme), whose *Anthropometries* of 1960 used female bodies as 'living brushes'. A third was Piero Manzoni (see Conceptual Art), who in 1961 signed his name on the bodies of several people to create a series of *Living Sculptures*. A number of early Body Art pieces seem to have sprung directly from these sources. American Bruce Nauman's (b. 1941) *Self-Portrait as a Fountain* (1966) acts as a homage to Duchamp's famous 'fountain', and extends the Duchampian precept to include the artist himself as a work of art. As Nauman put it, 'The true artist is an amazing luminous fountain.' The body is a recurring theme in Nauman's work, whether translated into neon or video. His work explores the body in space, the psychological nuances and power games of human relationships, body language, the body of the artist as a source material and the self-searching narcissism of the artist.

The fusion of art and life central to Body Art has been taken to humorous extremes by the British artists Gilbert (b. 1943) and George (b. 1942). Where Manzoni turned others into 'living sculptures', they turned themselves into 'living sculptures' and, by implication, transformed their whole lives into art. In *The Singing Sculpture* of 1969, also known as *Underneath the Arches*, they declared 'We shall never cease to pose for you, Art.' Like Nauman and his fountain, Gilbert and George raise fundamental questions – what is art, and who should decide? – while acknowledging, and gently mocking, the pretensions of artists and the art world.

American painter, performance artist, film maker and writer Carolee Schneemann (b. 1939) also uses the 'body as a source of knowledge' in controversial works that have social, sexual and art-historical resonances. One of her best-known pieces was *Meat Joy* (see ill. p. 223), performed in New York and Paris in 1964, a multimedia orgiastic spectacle of blood and paint-drenched male and female performers writhing around with raw fish and chicken. While certainly a reflection of some of the prominent socio-political issues of the 1960s – sexual and female liberation – Schneemann's piece

Left: **Bruce Nauman, *Self-Portrait as a Fountain*, 1966–67**
With conscious reference to Duchamp's famous upturned urinal (*Fountain*, 1917), Nauman follows Duchamp's insistence that anything could be made into art. The image includes the artist performing within the frame of art, rather than remaining outside as mere producer.

Opposite: **Chris Burden, *Trans-fixed*, 23 April 1974** The artist is shown 'crucified' on the back of a Volkswagen. Practitioners of Body Art have gone to various lengths – including sadomasochism and self-mutilation – to convey physical interaction with art and the world, often in terms of oppression and victimization.

can also be read as a challenge to the male-dominated art world, a progression from, and subversion of, Klein's performance painting. In *Anthropometries* (see ill. p. 211), an immaculately dressed male (Klein) directed the actions of the female nudes; in *Meat Joy* Schneemann claimed that directorial power as a woman, orchestrating the animalistic behaviour of both men and women – taking off the tuxedo and making art that is as messy as life itself.

These three works encapsulate many of the characteristics of Body Art. They question and present a variety of interpretations of the role of the artist (the artist as a work of art and as a social and political commentator), and of the role of art itself (art as an escape from daily life, art as an exposé of social taboos, art as a means of self-discovery, art as narcissism). The body provides a powerful means for exploring a whole range of issues, including identity, gender, sexuality, illness, death and violence. The works range from sadomasochistic exhibitionism to communal celebrations, from social commentary to comedy.

Some of the most disturbing Body Art was made during the student uprisings and civil rights protests concerning the

Vietnam War and Watergate in the late 1960s and 1970s. Against a background of atrocity and corruption, which was highlighted by the American media, Acconci, Dennis Oppenheim (b. 1938) and Chris Burden (b. 1946) created high-risk, self-abusive, painful works with sadomasochistic overtones. In Europe similar territory was explored by English artist Stuart Brisley (b. 1933), Serbian Marina Abramovic (b. 1946), Italian Gina Pane (1939–90) and Austrian Rudolf Schwarzkogler (1941–69). Their extreme actions were often feats of endurance and survival, involving self-mutilation and ritualized pain. Violence and masochism are aspects of Body Art that have not abated. They continue, for instance, in the work of French multimedia performance artist Orlan (b. 1947) who proudly proclaimed, 'I am the first artist to use surgery as a medium and to alter the purpose of cosmetic surgery.' Perhaps most harrowing, and poignant, were the sadomasochistic performances of American Bob Flanagan (1952–96), who used ritualized pain to gain power over the suffering caused by his illness, cystic fibrosis.

If Flanagan's work makes us face the fear of illness, pain and death, and Orlan's work questions cultural norms of beauty, the photographic self-portraits of the ageing, naked body from 1984 by American John Coplans (b. 1920) force us to confront our own fear of ageing, and draw attention to society's attitude that youth equals beauty. At the end of the twentieth century new technologies widened the scope of Body Art. *Corps étranger* (Foreign Body, 1994), by Palestinian-born artist Mona Hatoum (b. 1952), is a video of an endoscopic journey through her own body. *Self* (1991) is a series of body casts of the English artist Marc Quinn (b. 1964) made from his frozen blood. Quinn said in 1995, 'the self is what one knows best and least at the same time…casting the body gives one an opportunity to "see" the self.'

Marc Quinn, *Self* (detail), 1991 Quinn saved up eight pints of his own blood (the average amount in a human body) which he cast and froze in his own image. It is a startling study in self-portraiture, as well as of vitality and mortality.

Key Collections
Kemper Museum of Contemporary Art, Kansas City, Missouri
Museum of Contemporary Art, Los Angeles, California
Saatchi Collection, London
Tate Gallery, London

Key Books
R. Goldberg, *Performance Art: From Futurism to the Present* (1988)
S. Banes, *Greenwich Village 1963: Avant-Garde Performance and the Effervescent Body* (1993)
A. Jones, *Body Art: Performing the Subject* (Minneapolis, MN, 1998)
A. Rorimer, *New Art in the 60s and 70s* (2001)

Installation

Installation art, whether site-specific or not, has emerged as a flexible idiom.

DAVID DEITCHER, 1992

Installation art shares its origins in the early 1960s with *Assemblages and Happenings (see *Performance Art). At that time the word 'environment' was used to describe such works as the tableaux of *Funk artist Ed Kienholz, the inhabitable Assemblages of *Pop artists George Segal, Claes Oldenburg and Tom Wesselmann, and the Happenings of Allan Kaprow, Jim Dine, Red Grooms and others. These environments engaged with their surrounding space – a flagrant rejection of traditional art practice – and incorporated viewers into the works. Expansive and encompassing, they were intended as catalysts for new ideas, not receptacles of fixed meanings.

Art of such fluidity and provocation was instantly popular: from the 1960s onwards, Installation was developed, in many different ways, by many different artists (see Pop Art, *Op Art, *Fluxus, *Minimalism, Performance Art, *Sound Art, *Kinetic Art, *Situationist International, *Conceptual Art, *Earth Art, *Arte Povera and *Site Works). The trend was not confined to any one country. In Paris, in 1958, *Nouveau Réaliste Yves Klein exhibited an empty gallery space entitled *Le Vide* (The Void), which was 'answered' two years later by fellow Nouveau Réaliste Arman with *Le Plein* (Full), the same gallery completely filled with rubbish. The 'Environments, Situations, Spaces' exhibition at the Martha Jackson Gallery, New York, in 1961 was another early show devoted to what would come to be called Installation art.

Installations were not completely new in the 1960s. Artists earlier in the twentieth century had created environments, though primarily to extend painting into three dimensions. The *Elementarist restaurant in Strasbourg, the *Merzbau* of *Dadaist Kurt Schwitters and Italian Lucio Fontana's (1899–1968) environments of fluorescent and neon lights during the 1940s are three examples. The *Surrealists, with their flair for theatricality, were particularly influential. From Surrealist exhibitions came the idea of installation as the creative conception of the exhibition as a whole. At the 1942 Surrealist exhibition in New York, Dadaist Marcel Duchamp constructed a labyrinth of string wound around the screens on which the paintings were installed, an intervention – the so-called *Mile of String* – which required viewers actively, not passively, to participate in viewing the works. Duchamp was the great example of the artist as curator and master of ceremonies, planning installations of his own works in fine detail, including the

posthumous exhibition in 1969 of *Etant Donnés* (on which he had worked in secret for twenty years), at the Philadelphia Museum of Art.

Installation art has quickly come to encompass an extremely diverse range of works. Temporary works, such as Christo and Jeanne-Claude's famous packages (both b. 1935; see Earth Art) are one sort. An early work by the Christos, *Rideau de Fer* (Iron Curtain), built as a response to the Berlin Wall (erected in 1961), shows the unmissable effectiveness of Installation art. On the night of 27 June 1962, 240 brightly coloured oil drums were erected into a barrier to block off the rue Visconti – a surprisingly beautiful visual statement as well as a powerful political one. Often installations are made for specific exhibitions, such as the enormous installation, *Hon* (Swedish: she), for the Moderna Museet in Stockholm in 1966 by Niki de Saint Phalle (see Nouveau Réalisme), Jean Tinguely (see Kinetic Art) and Finnish artist Per Olof Ultvedt (b. 1927). A giant reclining pregnant woman, which viewers entered between the legs, housed a funfair-type environment complete with a movie theatre, a bar, a lovers' corner, and hostesses to welcome visitors. Installations have also been made by artists involved with *Video or Sound Art, or those pursuing a more Conceptual bent, such as Gabriel Orozco (b. 1962) and

Marcel Duchamp, *Mile of String*, 1942 The work was installed at the New York Surrealist exhibition. Early examples of Installation art (although the term was not coined until the 1960s) were often theatrical interventions in an art environment; by necessity they were often ephemeral performances.

Juan Muñoz (1953–2001). They can be autobiographical, such as the work of Tracey Emin (b. 1963), or commemorative of the imagined lives of others, such as the work of Christian Boltanksi (b. 1944), Sophie Calle (b. 1953) and Ilya Kabakov (b. 1933). They can also be interventions into architectural spaces, such as the cuts made into buildings by Gordon Matta-Clark (1943–78).

Since the 1970s, commercial galleries and alternative spaces throughout the world – for instance the De Appel gallery in Amsterdam, New York's PS1 Museum, Pittsburgh's Mattress Factory, London's Matt Gallery – have supported Installation art. Major museums, such as the Musée d'Art Contemporain in Montréal, the Museum of Modern Art in New York, the Museum of Contemporary Art in San Diego and the Royal Academy of Art in London, have all staged

Above: **Barbara Kruger, *Untitled*, 1991** Kruger's messages use posters and billboards, as well as all-enveloping installations or montages of words and pictures that challenge and deconstruct prevailing attitudes; her works do not allow the viewer to accept the status quo easily or without thinking.

Opposite: **Maurizio Cattelan, *La Nona Ora* (The Ninth Hour), 2000** First made for a museum exhibition in Basel, the work raised a storm of controversy when transferred to London's Royal Academy show 'Apocalypse' in 2000. A waxwork of Pope John Paul II is shown as if struck down by a meteor (or an 'act of God').

important exhibitions of Installation art. In 1990 the Museum of Installation opened in London.

Installations can be site-specific (see Site Works), or intended for different locations. *La Nona Ora* (The Ninth Hour, 1999) by Maurizio Cattelan (b. 1960) was originally made for a museum exhibition in Basel, but was equally effective when reconstructed at the Royal Academy of Art, London, for 'Apocalypse' the following year. The humour, the pathos and the ambivalence of the life-size wax figure, the shattered ceiling, the red carpet and velvet rope all survived the relocation, raising the same issues: the blindness of faith, the nature of miracles and the power and elevation of religion (and art). In the same exhibition, *Shelter* (1999) by Darren Almond (b. 1971) actually turned on another location: Auschwitz. The sculptural reproductions of the original bus stops outside the prison camps were due to be re-sited there after the show while the originals were removed to an exhibition in Berlin. Their destination was a powerful reminder of the continuity of everyday routines outside the site of one of the twentieth century's greatest tragedies. Installation has proved an extremely potent genre for activist artists, such as Robert Gober (b. 1954), Mona Hatoum (b. 1952) and Barbara Kruger (b. 1945, see also *Postmodernism). Kruger's 1991 installation at the Mary Boone Gallery in New York

covered the walls, ceiling and floor with images and texts about violence against women and minorities, an all-encompassing environment that surrounded and yelled at visitors.

During the 1980s and 1990s Installation artists began to mix media and styles within the same installations. At first sight they appear to be made up of unrelated pieces, but they are held together by a central theme. Canadian Claude Simard (b. 1956) assembles figurative paintings, sculptures, objects and elements of Performance in the same show. Exhibiting a freedom from commitment to a particular style or medium worthy of Duchamp, he uses whatever means are necessary to work through his project of memory, identity, autobiography and history. In an article in 1996, 'The Web of Memory', he commented, 'My art is a series of devices I construct to appease a rather spoiled inner child…I have tried to expunge memories, mock them, and reinterpret them, but they will not disappear.' Installations at the Musée d'Art Contemporain de Montréal, Quebec (1998) and the Jack Shainman Gallery in New York (1999) were made up of pieces which stood alone, but also interacted, creating, as

Claude Simard, Installation view, Jack Shainman Gallery, New York 1999 Simard's installations present an agglomeration of objects, paintings and sculpture (carved wooden sculptures, portrait busts, puppets, digital photographs, records, sunflowers) to explore themes of memory and identity.

one critic said, a 'museum of the psyche' – the psyche not only of Simard, but of the small rural town in Quebec where he grew up.

At the turn of the century Installation art is established as a major genre, with many artists producing work that can be described as Installations. Indeed, as the practice of installation has grown, its very flexibility, and the sheer variety of the work it encompasses, has made it a general rather than a specific term.

Key Collections
Hamburger Kunsthalle, Hamburg, Germany
Kemper Museum of Contemporary Art, Kansas City, Missouri
The Mattress Factory, Pittsburgh, Pennsylvania
Saatchi Collection, London
Solomon R. Guggenheim Museum, New York
Tate Gallery, London

Key Books
N. De Oliveira, N. Oxley and M. Archer, *Installation Art* (1994)
Blurring the Boundaries. Installation Art 1969–96
 (exh. cat., Museum of Contemporary Art, San Diego, CA, 1997)
J. H. Reiss, *From Margin to Centre: The Spaces of Installation Art* (Cambridge, MA, 1999)

Super-realism

I want to deal with the image it [the camera] has recorded which is... two-dimensional, and loaded with surface detail.

CHUCK CLOSE, 1970

Not a defined movement as such, Super-realism was one of many names (including Photo-realism, Hyperrealism and Sharp-Focus Realism) applied to a particular type of painting and sculpture that became prominent during the 1970s, especially in the USA. During the heyday of abstraction, *Minimalism and *Conceptual Art, certain artists turned to creating illusionistic, descriptive, representational painting and sculpture. Most of the paintings copy photographs and many of the sculptures are constructed from body casts. At the time, the work was popular with dealers, collectors and the general public, but was rejected by many art critics as being regressive. With the passage of time, however, it is easier to see Super-realism's affinities – the characteristically cool, impersonal appearance, the preoccupation with common or industrial subject matter – with the contemporaneous movements of *Pop Art and Minimalism. Similarly, the attention to detail, careful craftsmanship and almost scientific approach to the making of art can be traced

back through the *Precisionists to the *Neo-Impressionists of the previous century. In different ways, Super-realist painting also acknowledges the impact that photography has had on painting since *Impressionism.

The major practitioners of Super-realism in painting were the US-based British artist Malcolm Morley (b. 1931), Americans Chuck Close (b. 1940), Richard Estes (b. 1936), Audrey Flack (b. 1931), Ralph Goings (b. 1928), Robert Cottingham (b. 1935), Don Eddy (b. 1944) and Robert Bechtle (b. 1932), British-American John Salt (b. 1937), German Gerhard Richter (b. 1932) and the Zebra Group of artists in Hamburg – Dieter Asmus (b. 1939), Peter Nagel (b. 1942), Nikolaus Störtenbecker (b. 1940) and Dietmar

Richard Estes, *Holland Hotel*, 1984 Estes works from several photographs of a scene, combining aspects of them to create images that are of uniform sharp focus, seemingly more 'true' than a photograph. The hall-of-mirrors effect, created by the reflective glass, confounds the viewer's perception of space.

of the affluent middle classes and ocean liners, such as *SS Amsterdam in Front of Rotterdam* (1966). Many of his images were taken from postcards, snapshots, travel posters and brochures, and he often included white borders to acknowledge the source and to heighten the 'artifactual' effect.

Perhaps the best-known Super-realist is Chuck Close, whose huge, billboard-scale portraits of his friends and of himself have become famous. Close created these images with an airbrush and a minimal amount of pigment to achieve a smooth photograph-like surface. The attention to detail in this painstaking process is visible in the bulges, pores and hairs of the sitters and in the retention of the out-of-focus areas of the photograph. The combination of the large-scale and 'impersonal' technique creates images that are at once monumental, intimate and distinctly Close's own.

In contrast, human beings rarely figure directly in Estes's pictures, although their presence is implied by the objects and surroundings in his city scenes, or by their reflections in the sheets of glass which are a trademark of his work. Unlike most of the other Super-realist painters, Estes works from several photographs of a scene, combining aspects of them to create images that are of uniform sharp focus, seemingly more 'true' than a photograph. The hall-of-mirrors effect, created by the reflective glass, confounds the viewer's perception of space and begs the questions of what is real, what is reality? Goings's glossy images of highway culture and mass-produced objects – cars, trucks, diners and trailers – also lack obvious human presence and exude a solitude or loneliness reminiscent of Edward Hopper (see *American Scene).

Audrey Flack is best known for her revival of the vanitas in images that, far from confirming the neutrality of photographs, specifically exploit their emotional, nostalgic and symbolic associations. Her vividly coloured, elaborate still-life scenes, which often combine objects associated with female vanity and reminders of death, are disturbing meditations on narcissism and materialism.

Gerhard Richter's 'photo-paintings' are based on 'found' photographs from newspapers and magazines or his own snapshots. He transfers them onto canvas and blurs them with a dry brush to incorporate their graininess, deliberately bringing out the flaws of amateur photography. His soft-focus, romantic images of landscapes, figures, interiors,

Ullrich (b. 1940). These artists worked in different ways and portrayed a variety of subjects – portraits, landscapes, cityscapes, suburbia, still lifes and leisure scenes of the middle classes. Although their technique was seen as anonymous and machine-like at the time, examined more closely their works have as much an individual signature quality as the most expressionist artwork.

What made the work so new and of its time was the way in which it called attention to the impact that media images – photographs, commercial advertising, television or films – have on our perception of reality. The works, especially the paintings, are not derived directly from contact with the real world, but from images of it, raising issues of reality and artificiality. A Super-realist painting is not life, but life twice removed – an image of an image of life. This double deception, combined with an often overwhelming intensity of detail, lends the works a distinctly unreal, or surreal, quality, and led the American art historian and critic William Seitz to suggest the term 'artifactualism' as a more appropriate name.

Although the work of the Super-realists can be grouped together, closer examination reveals idiosyncrasies of technique and subjects. Malcolm Morley, who coined the term 'Super-realism' in 1965, painted photograph-like paintings

Above: **John Ahearn, *Veronica and her Mother,* 1988** Ahearn's sculptural portraits of residents of the South Bronx, New York, are sometimes installed on the walls of buildings in the area. 'The basic foundation for the work is art that has a popular basis, not just in appeal, but in its origin and meaning…. It can mean something here, and also in a museum.'

Opposite: **Chuck Close, *Mark,* 1978–79** Close created these images by transferring a photograph onto a grid and then painting square by square with an airbrush and a minimal amount of pigment to achieve the smooth photograph-like surface.

still lifes and abstractions, seem to reconcile painting and photography, abstraction and illusionism, and draw attention to the way painting and photography colour our perceptions of reality and of the past.

Super-realist techniques were applied to sculpture as well as to painting. The impact of the 'verist sculptures' of the Americans Duane Hanson (1925–96) and John De Andrea (b. 1941) was summed up in a review: 'Abstraction had been attacked many times before, but never as comprehensively.' Both sculptors cast from life, but whereas De Andrea's nudes are the young, attractive ideal, Hanson's groupings of different types of ordinary Americans, such as *Tourists* (1970), can be read as commentary or humorous self-awareness. His figures are from direct casts, constructed in reinforced polyester resin and fibreglass, and dressed in real clothes. The resulting effect is an amazing, but unsettling, likeness.

Other more recent sculptors could also be termed Super-realists, such as the Americans John Ahearn (b. 1951) and Rigoberto Torres (b. 1962) and the London-based Australian sculptor Ron Mueck (b. 1958). Ahearn and Torres's sculpture-relief-portraits of residents of the South Bronx in New York are constructed from moulds in dental plastic taken from the neighbourhood characters, then cast in fibreglass and painted. Shown to acclaim in art galleries, they have also been installed on the walls of the buildings in the neighbourhood, becoming, literally, a part of the surroundings from which they sprang.

While Ahearn and Torres's sculptures record particular people of a specific time and place, Mueck's sculptures explore more universal types. They are not, in fact, directly cast from people, but from maquettes based on friends and relatives and modelled in clay. Eerily life-like, yet either radically miniaturized or drastically enlarged, they enhance the figures' emotional qualities, and give the viewer an impression of being Alice in Wonderland or Gulliver. *Ghost* (1998), the figure of a seven-foot pre-pubescent girl in a baggy swimsuit, powerfully conveys the awkwardness and self-consciousness that can be experienced by an adolescent girl.

Key Collections
Fine Arts Museums of San Francisco, San Francisco, California
National Gallery of Scotland, Edinburgh, Scotland
Tate Gallery, London
Whitney Museum of American Art, New York

Key Books
C. Lindey, *Superrealist Painting and Sculpture* (1980)
L. K. Meisel, *Photo-Realism* (1980)
M. Morley, *Malcolm Morley* (exh. cat., Tate Gallery Liverpool, England, 1991)
R. Storr, et al., *Chuck Close* (1998)
A. Rorimer, *New Art in the 60s and 70s* (2001)

Anti-Design

WE HAVE CHOSEN TO BYPASS THE DECAYING BAUHAUS IMAGE WHICH IS AN INSULT TO FUNCTIONALISM.

ARCHIGRAM, 1961

Anti-Design, Radical Design and Counter-Design are terms used to describe a number of 'alternative' architecture and design practices of the 1960s and 1970s, particularly the British group Archigram and the Italian studios Archizoom and Superstudio. Like their contemporaries (see *Postmodernism) these Anti-designers rejected the principles of high modernism (see *International Style) and in particular the elevation of an object's aesthetic function over its social and cultural role. Questioning conventions of design and challenging the influence of big business and politicians, they addressed the needs of individuals in a radical, visionary way.

The earliest of these groups, Archigram (1961–74), comprised the young London-based architects Peter Cook (b. 1936); David Greene (b. 1937); Michael Webb (b. 1937); Ron Herron (1930–94); Warren Chalk (b. 1927) and Dennis Crompton (b. 1935). The name, a contraction of the words Architecture and Telegram, conveyed the notion of an urgent message to a new generation. Their originality had precedents in the utopian visions of the pioneers of modernism, such as Bruno Taut and Die Gläserne Kette (The Glass Chain; see Arbeitsrat für Kunst), and their ideas received impetus from a number of contemporary developments, namely Reyner Banham's influential *Theory and Design in the First Machine Age* (1960); U. Conrads and H. G. Sperlich's *Fantastic Architecture* (published in English in 1963); Constant's vision of the new city (see *Situationist

International) and Richard Buckminster Fuller's innovative ideas for travel and housing (see *Neo-Dada). Drawing on these influences, Archigram embraced expendability, recycling, portability and individual choice in their plans for the Second Machine Age. As no developers or bankers could be persuaded that their vision of the future (a mobile world both technological and Arcadian) was commercially viable, their architectural output took the form of drawings, collages and models. However, projects such as *7* (1963), *Plug-in City* (1964–66) and *Cushicle* (an inflatable suit containing water, food, radio and television, 1966–67) were internationally inspiring and started what writer Michael Sorkin described as a trend to put 'the fun' back into 'functionalism'.

Archizoom (its name an explicit homage to Archigram) and Superstudio were both founded in Florence in 1966. Members of Archizoom (1966–74) included Andrea Branzi (b. 1939), Gilberto Corretti (b. 1941), Paolo Deganello (b. 1940), Dario and Lucia Bartolini and Massimo Morozzi. Superstudio (1966–78) included Cristiano Toraldo di Francia, Alessandro and Roberto Magris, Piero Frasinelli and Adolfo Natalini. Ettore Sottsass (see Postmodernism) and Joe Colombo (1930–71) were also important figures for the Italian Anti-Designers. Embracing *Pop art, kitsch and style revivals (for instance, *Art Deco and *Art Nouveau), they designed furniture as playfully irreverent as Archizoom's *Mies Chair* of 1969, which disputed the very notions of 'good design' and 'good taste' current in Italy during the 1950s (see *Organic Abstraction). They also conceived plans for flexible cities of the future in which technology would free the nomadic population from the constraints of wage labour.

All three groups disbanded during the 1970s, partly as a result of the economic depression and partly because of the disillusionment caused by the misuse of new technologies. Their influence, however, has been considerable. The delight in experimentation and technological innovation was manifested in the work of the *High-Tech movement, and Postmodernism followed their rejection of orthodox modernism. A closer focus on the dynamics of urban environments is characteristic of many contemporary architects, such as Dutchman Rem Koolhaas (b. 1944). The influence of the original Anti-Designers can also be felt in recent collectives involved in urban regeneration projects, such as the all-women London-based Muf (founded 1993) and the Dutch group West 8 (f. 1987). The contemporary designer's challenge is now not merely one of formal design, but one of facilitating, or choreographing, the natural flow and use of public spaces, and this perhaps constitutes Anti-Design's greatest legacy.

Ron Herron, *The Walking City Project*, 1964 Recalling unrealizable projects of early twentieth-century architects, Archigram designer Herron's space-age mobile cities also suggested to many the technology of survival – his huge, sophisticated capsules roaming through the ruins of a city in the aftermath of a nuclear strike.

Key Collections
FRAC Centre, Orléans, France
Malaysian Exhibition, Commonwealth Institute, London
Museum of Modern Art, New York

Key Books
P. Cook, *Experimental Architecture* (1970)
A. Branzi, *The Hot House: Italian New Wave Design* (1984)
D. A. Mellor and L. Gervereau (eds), *The Sixties, Britain and France, 1962–1973: The Utopian Years* (1996)
B. Lootsma, *SUPERDUTCH: New Architecture in the Netherlands* (2000)

Supports-Surfaces

The important thing is not the form but the idea, the spirit of Abstraction.

NOEL DOLLA, 1993

Supports-Surfaces was a group of young French artists who exhibited together from around 1966 to 1972, a time of violent political change for France and its colonies (with wars in Indochina and Vietnam, and unease about encroaching American cultural imperialism). Committed to revolutionary social change (most of the group were Maoists), they deconstructed the act of painting to its essential properties, the canvas and stretchers (the frame on which the canvas is stretched), in an attempt to loosen the grip of the art market on the work and to divest art of its symbolic and romantic qualities.

They also employed unusual materials in their work, such as pebbles, rocks, waxed cloths and cardboard; they fused colour directly with the supports (be they canvases or stretchers); they rolled, folded, wrapped, crushed, burned and dyed works, and left them in the sun; and, when exhibiting, they placed the works directly on the floor or hung them without either a stretcher or a frame.

The principal members of the group were Daniel Dezeuze (b. 1942), Patrick Saytour (b. 1935) and Claude Viallat (b. 1936), though for exhibitions they were joined by a number of other young French artists: François Arnal (b. 1924), Pierre Buraglio (b. 1939), Louis Cane (b. 1943), Marc Devade (1943–83), Noël Dolla (b. 1945), Toni Grand (b. 1935), Bernard Pagès (b. 1940), Jean-Pierre Pincemin (b. 1944) and Vincent Bioulès (b. 1938), who belatedly gave the group its name for an exhibition held in 1970 at ARC (Animation, Recherche, Confrontation), Musée d'Art Moderne de la Ville de Paris.

Part of their project was to demystify art and bring it closer to ordinary people. Claude Viallat was matter-of-fact in describing the artists' work: 'Dezeuze painted stretchers without canvases, I painted canvases without stretchers, and Saytour painted the image of the stretchers on the canvas.' At a time when figuration was considered the style of revolutionary politics (see *Socialist Realism), the group was unusual, indeed deliberately provocative, in preferring abstraction. In a way they were reclaiming the utopian agendas or 'spirit' of the pioneers of abstraction (see, for instance, *Constructivism, *De Stijl and *Concrete Art). They were also challenging the formalist interpretations of modernist art put forward by the American critic Clement Greenberg (see *Post-painterly Abstraction).

Like many *Conceptual and *Arte Povera artists, who

used the language of *Minimalist or formalist art in order to subvert it, they rejected the image of the painter as a 'genius' and art as 'special', reserved exclusively for an elite. Instead, they took their art to the people by organizing numerous open-air exhibitions in small towns outside the traditional art circuit, particularly in the south of France. They were, however, under no illusion that 'the people' would understand their aims and they took great pains to theorize and explain their works, which were accompanied by numerous posters and treatises.

Turning to other disciplines, such as linguistics and psychoanalysis – 'sciences which do not place themselves outside ideology', as they claimed – these artists hoped to effect a critical examination of painting itself, including its history, the materials used and its structures. Their journal, *Peinture/Cahiers théoriques*, which was founded as the mouthpiece of the group in 1971, theorized their position and brought them close to a number of Conceptual artists, such as those associated with Art & Language. However, their art was never secondary to their theories. In a sense their work is a fusion of a formalist commitment to 'painting', a Conceptualist commitment to the 'idea' and a socialist commitment with political change.

A combination of high expectations and differing political

Exhibition at the Galerie Jean Fournier, 15–22 April 1971
Dezeuze, Saytour, Valensi and Viallet were represented at this show, which emphasized their crafts and skills of construction. Not all their shows took place in galleries; indeed, the group was known for exhibiting outdoors.

agendas soon threatened the cohesiveness of the Supports-Surfaces group. In June 1971, a number of the artists resigned and the last Supports-Surfaces exhibition was held in Strasbourg in April 1972. Despite the brevity of the group's existence, Supports-Surfaces made a significant impact on the French art scene and continues to prove influential. The 1990s witnessed a wider dissemination of their ideas outside France. In 1998 their work was included in a major exhibition at the Guggenheim Museum in New York and a touring group exhibition has taken their work to the Palazzo delle Esposizione in Rome (1999), and to the Pori Art Museum in Finland (2000). In 1999 a conference organized in conjunction with an exhibition at the Gimpel Fils gallery in London, brought together a number of the artists, who helped present their work and ideas to a new audience.

Key Collections
ARC, Musée d'Art Moderne de la Ville de Paris, Paris
Centre Georges Pompidou, Paris
Museé d'Art Moderne, Saint-Etienne, France

Key Books
D. A. Mellor and L. Gervereau (eds), *The Sixties, Britain and France, 1962–1973: The Utopian Years* (1996)
S. Hunter, 'Faultlines: Buraglio and the Supports/Surfaces – Tel Quel axis', *Parallax*, vol. 4, no. 1 (January 1998)
M. Finch, 'Supports/Surfaces', *Contemporary Visual Art Magazine*, no. 20 (1998)

Video Art

As collage technique replaced oil paint, so the cathode-ray will replace the canvas.

NAM JUNE PAIK

In the 1960s, as *Pop artists were introducing imagery from mass culture into galleries, and the technologies of movement and sound were being explored (see *Kinetic Art and *Sound Art), a group of artists took on the most powerful new mass medium – television. From 1959 *Fluxus artist Wolf Vostell (1932–98) and Korean-born American artist and musician Nam June Paik (b. 1932) began to include televisions in their installations. However, the symbolic birth of Video Art occurred later in 1965 when Paik purchased Sony's new Portapak hand-held video camera. First-generation Video artists appropriated the rich syntax of the language of television – spontaneity, discontinuity, entertainment – in many cases to expose the dangers of such a culturally powerful medium. Paik in particular subjected it to his irreverent wit, stating: 'I make technology ridiculous.'

Bill Viola, *Nantes Triptych*, 1992
Both the subjects – birth and death – and the form – the triptych – are central to the European Christian tradition of art that is many centuries old, but the use of video instead of painting provokes a different set of responses in the viewer.

The development of Video Art was influenced by several intellectual trends, and in Paik's videos *Marshall McLuhan Caged* (1967) and *A Tribute to John Cage* (1973) the artist paid tribute to two important figures. Avant-garde composer John Cage (see also *Neo-Dada, *Performance Art and *Fluxus) was one of the first to advocate the use of new technologies in art. In *Understanding Media: Extensions of Man* (1964), Canadian author Marshall McLuhan (1911–80) proposed that changing the means of communication had changed perception itself, from a visual orientation to a multi-sensory one. 'The job of art is not to store moments of experience,' he wrote, 'but to explore environments that are otherwise invisible.' For McLuhan, as for William Blake whose work he cited, art was a way of 'uniting all the human faculties, aspiring to the unity of the imagination.' 'The medium is the message' became his famous watchword.

Early Video artists fused global communication theories with elements of popular culture to produce video tapes, single- and multi-channel productions, international satellite installations, and multi-monitor sculptures. Paik often collaborated on pieces with other artists, notably with avant-garde cellist Charlotte Moorman (1933–91). In *TV Bra for Living Sculpture* (1969) Moorman played compositions by Paik and others, wearing a 'bra' made of two miniature tele-vision sets – soon dubbed 'boob tubes' – on which the images changed with the varying tones of the music.

By the end of the 1960s, commercial galleries were beginning to support Video Art. In 1969 the Howard Wise Gallery in New York hosted a landmark exhibition, 'TV as a Creative Medium' which, with *TV Bra for Living Sculpture*, included work by Ira Schneider (b. 1939), Frank Gillette (b. 1941), Eric Siegel (b. 1944) and Paul Ryan (b. 1944). Howard Wise (1903–89) subsequently founded Electronic Arts Intermix (EAI) to provide a tape distribution service and editing facility for artists. EAI now holds one of the most important collections of Video Art in the USA. Public television stations, such as Boston's WGBH, also supported Video Art, and a creative relationship soon grew up between artists and commercial television. Many techniques and special effects, now commonplace in television and music videos, particularly in post-production, were first invented by artists such as Paik and Dan Sandin (b. 1942). Sandin developed the Sandin Image Processor (IP) in 1973, which electronically alters video images and explores the dynamics of colours. Other early Video artists and technical pioneers include the husband-and-wife team of Steina (b. 1940) and Woody (b. 1937) Vasulka, who developed many electronic devices to aid artists, including the Digital Image Articulator.

Video Art became increasingly sophisticated as new production techniques were developed.

Due perhaps to the flexibility of the new medium and to the intimacy with which it could address issues of female identity, it appealed to a large number of women, among them Dara Birnbaum (b. 1946), Ana Mendieta (1948–86), Adrian Piper (b. 1948), Ulrike Rosenbach (b. 1949) and Hannah Wilke (1940–93). As Performance artist Joan Jonas (b. 1936) explained, 'Working with video enabled me to develop my own language…. Video was something for me to climb into and explore as a spatial element and with myself inside of it.' Younger female Video artists, such as Pipilotti Rist (b. 1962), Amy Jenkins (b. 1966) and Alex Bag (b. 1969) have continued this tradition. In *Turbulent* (1998), Iranian Shirin Neshat (b. 1957) produced a poignant testimonial to the different status afforded men and women in her country.

By appropriating the tools of information technology, Video artists were able to undermine the authority of media stereotypes, whether of gender, sexuality or race. American artist Matthew Barney (b. 1967) has explored issues of male identity and pleasure, and Briton Steve McQueen (b. 1966) has provided more complex and sensitive representations of the black male than the traditional two-dimensional portrayals found in the mainstream media. In fact, Video Art has attracted a broad range of practitioners with widely different agendas, and it is able to encompass the humorous narrative sketches of William Wegman (b. 1943) and the mirrored architectural environments of Dan Graham (b. 1942), as easily as the verbal-visual games of Gary Hill (b. 1951) or the split-screen juxtapositions of Canadian Stan Douglas (b. 1960).

The 1980s saw the formation of video and new media departments in major museums and universities around the world. At the same time, a new generation of artists who specialized in Video was beginning to emerge. Their work gradually developed to become more sophisticated, and a major shift occurred in the role of the artist. Early productions often featured the artist in the role of performer or behind the camera, but the artist now took on the role of producer or editor, structuring meaning in post-production. Bill Viola (b. 1951) has made sophisticated large-scale video

installations of scenes and events which are often intensely private, emotional experiences, such as heart surgery, birth or death.

The merging of video with the computer which has developed since the late 1980s, along with further technological advances in projection have led to the creation of larger and more complex Video Art. The liberating of video from its black box allows for the monumental projections of Viola and for the innovative work of American Tony Oursler (b. 1957), who brings to life inanimate objects by projecting onto them talking heads which speak directly to the viewer. His work can be comical, poignant or occasionally terrifying; the talking bull's testicles in the 'Spectacular Bodies' exhibition at The Hayward Gallery in London (2000) notoriously upset many children who saw it. In an even more ambitious project of the same year, *The Influence Machine*, Oursler turned his projections onto the outdoor environment, transforming London's Soho Square into a 'psycho-landscape'. Talking trees and buildings, talking heads appearing in puffs of smoke, lights, sounds and spectres, exerted a powerful combined effect.

Above: **Tony Oursler, *The Influence Machine*, 2000**
Oursler's outdoor projections converted London's Soho Square into a 'psycho-landscape', invoking the 'spirit' of the site, with speaking trees and buildings, Wizard-of-Oz-like talking heads, lights, sounds and spectres all producing the eerie thrill of a large outdoor séance.

Opposite: **Naim June Paik, *Global Groove*, 1973** 'I make technology ridiculous', Paik said. First-generation Video artists like himself appropriated the rich syntax of the language of television – spontaneity, discontinuity, entertainment – in order to expose the dangers of such a culturally powerful medium.

Key Collections
Electronic Arts Intermix, New York
Museum of Modern Art, New York
Tate Gallery, London
Whitney Museum of American Art, New York

Key Books
D. Hall and S. J. Fifer (eds), *Illuminating Video: An Essential Guide to Video Art* (1990)
L. Zippay, *Artist's Video: An International Guide* (1992)
B. London, *Video Spaces: Eight Installations* (1995)
M. Rush, *New Media in Late 20th-Century Art* (1999)

Earth Art

Why not put the work outside and further change the terms?

ROBERT MORRIS, 1964

Earth Art, also known as Land Art or Earthworks, emerged in the late 1960s as one of the many trends expanding the boundaries of art in terms of materials and sites. Unlike *Pop Art, which rejected tradition by embracing urban culture, Earth Art moved out of the city, taking the environment as its material. It coincided with a growing interest in ecology and an awareness of the dangers of pollution and the excesses of consumerism. In the words of a psychoanalyst, quoted in *Art in America* in 1969, Earth Art was, 'The manifestation of a desire to escape the city that is eating us alive, and perhaps a farewell to space and earth while there are still some left.' In a sense, much Earth Art is a form of preservation, for if a piece of land is consecrated as art it can be saved from development. This is a desire to preserve not only the environment but also the human spirit: works often explicitly evoke the spirituality of archaeological sites, such as Native American burial grounds, Stonehenge, crop circles and the giant hill figures etched into the hills of England.

Many Earth artists so far have been British and American, and the influence can be seen of a strong landscape tradition (in the case of British art) and of the romance with the West (in American art). In the USA, where Earth Art first emerged, leading figures have included Sol LeWitt (b. 1928); Robert Morris (b. 1931); Carl Andre (b. 1935); Christo and Jeanne-Claude (both b. 1935); Walter De Maria (b. 1935); Nancy Holt (b. 1938) and her husband Robert Smithson (1938–73); Dennis Oppenheim (b. 1938); Richard Serra (b. 1939); Mary Miss (b. 1944); James Turrell (b. 1943); Michael Heizer (b. 1944) and Alice Aycock (b. 1946). In Europe, British artists Richard Long (b. 1945), Hamish Fulton (b. 1946) and Andy Goldsworthy (b. 1956), and Dutch artist Jan Dibbets (b. 1941), have been prominent.

Some of these pioneers were also affiliated with *Minimalism. Indeed, Earth Art could be seen as an extension of the Minimalist project: where Minimalists confronted gallery spaces, Earth Artists confronted the land itself. It is also true that many of their works employ the geometric language of Minimalism, whether taking the form of immense

sculptures in the land (Aycock's maze-like constructions or Holt's architectural works) or monumental sculptures made from the land (De Maria's cuts into the ground or Heizer's and Turrell's excavations). Other works, which use photographs, diagrams or written texts to record temporary interventions in the land, have affinities with *Conceptual Art (De Maria, Dibbets, Fulton, Goldsworthy, LeWitt, Long and Oppenheim). Still others, showing an interest in salvaging and recycling waste, share themes with Junk Art (see *Assemblage) and *Arte Povera.

Earth Art became established as a movement with the 'Earth Works' exhibition at the Dwan Gallery in New York in 1968. Organized by Smithson, it included photographic documentation of projects, such as LeWitt's *Box in a Hole* (1968) – the burial of a metal box in the ground at Visser

House, Bergeyk, Netherlands – and De Maria's *Mile Long Drawing* (1968) – two perpendicular chalk lines drawn in the Mojave Desert in California. This was followed by the 'Earth' exhibition at Cornell University's art museum in Ithaca, New York, in 1969. The gallery owner Virginia Dwan (see also *Pop Art) was an early supporter of Earth Artists; without her patronage many Earth Art projects would not have been realized. Since 1974, the Dia Arts Foundation (now the Dia Center for the Arts) has also funded projects.

The sites of Earth Art have often been remote. Documentation of Richard Long's walks in places such as Lapland or the Himalayas, during which he constructed lines or mounds out of materials at hand, such as rocks or timber, invite the viewer imaginatively to reconstruct his progress through these romantically desolate regions. Due to the sheer size and availability of as yet undestroyed territory in the USA, many monumental Earth artworks are in the deserts, mountains and prairies of Southwest America. Heizer, for example, abandoned painting in 1967 to head West, looking for 'that kind of untouched, peaceful, religious space in the desert that artists have always tried to put into their work.' Since the move, Heizer, who comes from a family of geologists and archaeologists, and has spent time visiting numerous ancient sites in Egypt, Peru, Bolivia and Mexico, has produced

Above: **Robert Smithson, *Spiral Jetty*, 1970**
A twenty-year lease ensured the creation of Smithson's best-known work, a spiral road of black basalt stones and earth that projects into the waters of the Great Salt Lake, Utah, reddened by algae and chemical waste.

Opposite: **Walter De Maria, *The Lightning Field*, 1977**
The dramatic landscape is an essential component of *The Lightning Field*. Even without lightning, the piece highlights the elemental forces of nature, as the poles shimmer in the early morning light and disappear under the intense sunlight of midday.

Double Negative (1969–70), a trench a third of a mile long carved out of the Virginia River mesa in Nevada, and the even more ambitious *City*, begun in 1970, when Dwan bought the land for it in an isolated spot in Garden Valley, Nevada. The first phase of the work, comprising *Complex One* (1972–74), *Complex Two* (1980–88) and *Complex Three* (1980–99), took almost thirty years to build. Heizer began phase two in 2000.

Robert Smithson's most famous work, *Spiral Jetty* (1970), is situated in an abandoned industrial site on the Great Salt Lake, Utah. With funding from Dwan, he transformed the industrial wasteland destroyed by oil prospectors into perhaps the most famous and romantic of all Earthworks. Smithson was fascinated with the physical concept of entropy, or 'evolution in reverse', the self-destroying as well as self-regenerating processes of nature and the possibilities of reclamation. *Spiral Jetty*, a work in which nature was reclaimed for art, and which, without intervention, will eventually be reclaimed by erosion for nature, explores these themes. For most of its existence, the fluctuating water levels of the lake have meant that *Spiral Jetty* has been engulfed, only occasionally making cameo appearances above water – it is almost entirely known through photographs and a film made early in its life.

Walter De Maria is another seminal Earth artist. In 1977 the Dia Center for the Arts commissioned two of his best-known works, *The New York Earth Room* and *Lightning Field*. *The New York Earth Room* is an interior earth sculpture of 280,000 lbs (127,300 kilos) of rich black-brown earth in a pristine urban white gallery space, bringing the texture and

the pungent aroma of the country into the city. *Lightning Field*, located in an area of high desert ringed by mountains in New Mexico, consists of 400 steel poles arranged so as to form a level grid measuring one mile by one kilometre. The poles are needle-tipped to encourage lightning from the summer storms common to the area. According to De Maria, 'Isolation is the essence of Land Art.'

Christo and his partner Jeanne-Claude have been working together since the 1960s to bring their monumental temporary environmental works – whether urban or rural – to fruition (see Installation). Since Christo's early career, his great theme has been the packaging or draping of things as a way of temporarily transforming them. Executed on a vast scale, the works combine elements of astounding spectacle and heroic effort. *Wrapped Coast – One Million Square Feet, Little Bay, Sydney, Australia* (1969); *Valley Curtain, Rifle, Colorado* (1970–72); *Running Fence, Sonoma and Marin Counties Coast in California* (1972–76); *Surrounded Islands, Biscayne Bay, Greater Miami, Florida* (1980–83) and *The Umbrella, Japan-USA* (1984–91) have all been notable for the massive collaborative efforts they entailed, from the financing of the projects (the Christos accept no commissions, and raise money through the sale of preparatory drawings, models of projects, etc.) to the negotiation of legal permission, to the actual execution of the works. Once in place, they operate outside the market, as they are unable to be bought or sold, and are freely visible by all.

The Conceptual and ephemeral nature of much Earth Art means that often it can only be known through documentation. The remote locations or lack of maintenance of built works has meant that many of them are also known primarily through photographs. This is changing, however, as greater efforts are being made to preserve the permanent sites and provide better facilities to access them.

Christo and Jeanne-Claude, *Wrapped Coast, Little Bay, Australia,* 1969 One million square feet (93,000 square metres) of Erosion Control fabric and 36 miles (58 kilometres) of polypropylene rope were employed in this work. The coast remained wrapped for ten weeks from 28 October 1969, before all materials were removed.

Key Collections
Dia Center for the Arts, Beacon, New York
Tate Gallery, London

Key Locations
A. Aycock, *A Simple Network...*, Far Hills, New Jersey
W. De Maria, *Lightning Fields*, Catron County, New Mexico
M. Heizer, *City*, Garden Valley, Nevada
M. Heizer, *Double Negative*, Overton, Nevada
R. Smithson, *Broken Circle/Spiral Hill*, Emmen, The Netherlands
R. Smithson, *Spiral Jetty*, Great Salt Lake, Utah
R. Smithson and R. Serra, *Amarillo Ramp*, Amarillo, Texas
J. Turrell, *Roden Crater*, Sedona, Arizona

Key Books
A. Sonfist, *Art in the Land* (1983)
J. Beardsley, *Earthworks and Beyond* (1989)

Site Works

I am for an art...that does something other than sit on its ass in a museum.

CLAES OLDENBURG, 1961

Since the 1950s, artists have created works that specifically engage with their context, taking art out of museums and into the streets and countryside (see for instance *Fluxus, *Conceptual Art and *Earth Art). Throughout the 1960s, the phrase 'site-specific' was increasingly used to describe work by *Minimalist, Earth and Conceptual artists, such as Hans Haacke (see Conceptual Art and *Postmodernism) and Daniel Buren (b. 1938).

In the same period a community arts movement developed which supported the belief that art should be available to more than the privileged few, and a decade later this led local and national governments in Europe and the USA to fund public art projects. Although not all these projects are related to their surroundings, the interest in site and context spread to the field of public art and resulted in an increasing number of Site Works. Site-specific works explore the physical contexts in which they are placed – whether galleries, city squares or hilltops – so that they form an integral part of the works themselves. In public art the work is no longer considered as a monument, but as a means of transforming a site, and emphasis is placed on the collaborative nature of projects which unite artists, architects, patrons and the public.

In 1977, the Art-in-Architecture programme of the United States General Services Administration, one of the largest patrons of public art in the USA, commissioned *Batcolumn* from *Pop artist Claes Oldenburg (b. 1929), a steel baseball bat rising from the centre of Chicago almost 100 feet (30 metres) into the air. *Batcolumn* is a classic example of the way a Site Work operates. It is perfectly suited to its location in practical ways (the open latticework steel construction allows it to survive the gales of the Windy City), but at the same time it alludes to what might be called the character of the region, acknowledging the local steel industry and the engineering achievements of the *Chicago School. Conceptually, it not only calls to mind the city's devotion to the national pastime of baseball, but also, with a gentle mockery typical of Oldenburg, the bat is made to resemble a policeman's truncheon to serve as

Richard Serra, *Tilted Arc*, Federal Plaza, New York 1981
Serra himself admitted that his work was disruptive, deliberately so: 'I want to direct the consciousness of the viewer to the reality of the conditions: private, public, political, formal, ideological, economic, psychological, commercial, sociological, institutional.'

a reminder of Chicago's historical reputation for violence and corruption.

If Oldenburg's *Batcolumn* was a triumph for the Art-in-Architecture programme, *Tilted Arc* by Richard Serra (b. 1939) proved to be a disaster. The huge steel blade, measuring twelve feet (3.6 metres) in height, 120 feet (36.5 metres) in length and weighing 72 tons, was erected in 1981 in Foley Square, New York, for the Federal Plaza building complex. In relation to its site, the elegant curve of the blade interacted with the decorative design of the square itself and drew attention to the uniform grid of Manhattan. It attracted considerable controversy from the start. On the one hand it was praised by critics, who, like Michael Brenson, saw in its assertive use of unadorned steel references to ships, cars and trains, and the role that the steel industry played in shaping America. As Serra noted,

although the work was heavy itself, it was intended to appear weightless, to represent a delicate balance between the sculpture and the space, and the sculpture and the viewer, which continually shifted as viewers moved around it. But walking around it was precisely the problem for some users of the square. Stretching across the plaza, the 'iron curtain' forced commuters to make a short detour. Though part of Serra's purpose may have been to create a thought-provoking reference to an iron curtain elsewhere, a furious protest followed and, despite a court case in which Serra stated that any alteration or relocation would destroy the work as it had been conceived, *Tilted Arc* was eventually removed in 1989 under the cover of night (ironically, the same year the 'other' iron curtain, the Berlin Wall, came down).

Though the art world was outraged by the decision to remove *Tilted Arc*, valuable experience was gained concerning public involvement in Site Works. During the 1980s, public art agencies were established in Europe and the USA to facilitate negotiations between artists, architects, the public, regulating bodies and funding bodies, and to consult users of public spaces.

A hostile reception was also given, at least initially, to one of the installations that transformed Paris in the 1980s, Daniel Buren's *Deux Plateaux* (1985–86), situated in the courtyard of the Palais Royal. When the revolutionary Conceptualist transferred the trademark stripes from his familiar temporary installations to a grand permanent site, it provoked as much outrage from progressives who accused him of selling out, as from reactionaries who objected to the defacement of a much-loved monument. However, Buren's work has since come to be appreciated as an intelligent transformation of an ugly car park into a magical public space. The truncated striped columns, situated over an underground canal, lead viewers to the columns of the Palais Royal itself, and at night the red and green lights on the upper level create a runway effect, while blue fluorescent lights colour the steam escaping from underground.

In recent years public sculpture and site-specific works have become increasingly common in cities around Europe and the USA. In 1997, the city of Münster in Germany hosted the 'Sculpture Projects' exhibition for which over seventy international artists were invited to transform the city into a sculpture park. Projects have multiplied in the

Opposite: **Claes Oldenburg and Coosje van Bruggen,** ***Batcolumn*, 1977** Oldenburg noted that a building turned upside down would look like a 'bat balanced on its handle' – thus his *Batcolumn* inverts industrial architecture of the region to form a symbol of pleasure, in the form of a baseball bat.

Below: **Daniel Buren, *Deux Plateaux*, 1985–86** Freestanding cement and marble columns of various heights, lights and a sunken artificial stream have transformed the courtyard of the Palais Royal in Paris. Much criticized at first, over time the public have grown fond of the area.

UK thanks to an increase in funding since the inception of the National Lottery. As elsewhere, these Site Works are often located not in the major cosmopolitan cities, but in more culturally, industrially and politically challenging areas. One example, *The Angel of the North* (1998) by Antony Gormley (b. 1950), is sited on a hill above a former colliery pithead bath in Gateshead, in north-east England. Built from 200 tons of steel it towers at 65 feet (20 metres) in height, with a wingspan of 177 feet (54 metres). Both the physical site of the sculpture – the mine and the hill, which reminded Gormley of a 'megalithic mound' – as well as the spirit of the place – a 'celebration and visibility of industry'– are vital to the success of the monument, which has been embraced by the public as a place to visit and as a testimony to the history of the area and its people.

Key Monuments

D. Buren, *Deux Plateaux*, Palais Royal, Paris
A. Gormley, *The Angel of the North*, Gateshead, England
C. Oldenburg, *Batcolumn*, Chicago, Illinois

Key Books

M. Gooding, *Public Art: Space* (1998)
Richard Serra Sculpture 1985–1998 (exh. cat., The Museum of Contemporary Art, Los Angeles, 1998)
G. Celant, *Claes Oldenburg and Coosje van Bruggen: Large-Scale Projects* (1995)
R. Serra, *Writings and Interviews* (1994)

Arte Povera

The vertigo of igloos and fruits, the flight of stones on the blue horizon, the melting of ice and crazy colour.

GERMANO CELANT, 1985

Arte Povera (impoverished art) was the term coined by Italian curator-critic Germano Celant (b. 1940) in 1967 to refer to a group of artists with whom he had worked since 1963: Italians Giovanni Anselmo (b. 1934), Alighiero e Boetti (1940–94), Pier Paolo Calzolari (b. 1943), Luciano Fabro (b. 1936), Mario Merz (b. 1925), Marisa Merz (b. 1931), Giulio Paolini (b. 1940), Pino Pascali (1935–68), Giuseppe Penone (b. 1947), Michelangelo Pistoletto (b. 1933), Gilberto Zorio (b. 1944) and Greek-born Jannis Kounellis (b. 1936).

The name alludes to the 'humble' (or 'poor') non-art materials that the artists used in their *Installations, *Assemblages and *Performances, such as wax, gilded bronze, copper, granite, lead, terracotta, cloth, neon, steel, plastic, vegetables and even live animals. The name cannot be taken too literally, as many of the materials employed are not inexpensive and have a rich tradition in other disciplines. The works themselves are sumptuously layered, complex, often extravagant and frequently composed of

Opposite: **Michelangelo Pistoletto, *Golden Venus of Rags*, 1967–71** The fusion of Classical and contemporary imagery features in much Arte Povera work, as does the ambiguous quality of Pistoletto's work, which poses the question: is the idealized, perfect past preferable to the colour and chaos of the present?

Above: **Mario Merz, *Igloo*, 1984–85** Made of various materials (in this case plate glass, steel, netting, plexiglas and wax), Merz's igloos sustain various interpretations. According to Germano Celant, a Merz igloo is 'a shelter and a cathedral of survival, from the politics of art as much as from the winds.'

sensuous materials. The artists were not from Italy's impoverished southern regions, but from the industrially thriving north; their works do not address the condition of the poor, but highlight abstract notions, such as the moral impoverishment of a society driven by the accumulation of material wealth.

Celant and the artists he championed came of age during a period of economic boom and increasing commercialization in the art world. It was a highly politicized period, notable for the 1968 and 1969 revolts by students and workers; as Kounellis commented, 'In 1962–63, we were already '68ers and in '68 we were already established politicians.' Arte Povera was the Italian response to the general spirit of the times, as artists were pushing back the boundaries of art, expanding the use of materials and questioning the nature and definition of art itself as well as its role in society. They shared many of these interests with others of the period, such as the *Neo-Dada, *Fluxus, Performance and *Body artists.

Arte Povera works are characterized by unexpected juxtapositions of objects or images, by the use of contrasting materials, and by the fusion of past and present, nature and culture, art and life. Dialogues with history run through many of them. Pistoletto's *Venus of the Rags* (1967), a plaster reproduction of a classical Venus, measuring 70 inches (180 centimetres) in height, facing a mound of rags, reflects the fabric of Italian society in which the surreal juxtapositions of the *Pittura Metafisica painters are a part of everyday life. Paolini and Kounellis deconstruct previous beliefs – such as those of ancient Rome and Greece – in order to investigate the symbolic meanings and associations that survive through time. Kounellis's 1969 exhibition at the Galleria l'Attico, Rome, in which he showed *Horses* (1969) – twelve live horses tethered in the gallery – dramatized the ongoing relationship between nature (represented by the horses) and culture (art gallery), the past (the horse symbolizing the classical past) and the present (the white gallery). Anselmo's assemblages of vegetables and granite blocks reveal the effects of hidden forces, such as gravity and decay, which were highly topical issues in the late 1960s, a period marked by growing environmental awareness. Fabro's *Italy* series – reliefs of the map of Italy in different rich materials, such as gilded bronze, fur or glass, which are hung upside down – draw attention to the economic and cultural wealth of Italy and to a world gone mad, or turned upside down.

Mario Merz is best known for his igloos, which he has been constructing in a variety of materials since 1968. They have been interpreted in a number of different ways: as a reference to a lost past when man and nature were in harmony; as a memorial to the ancient nomadic tribes that invaded Italy and fused barbarian culture with the over-refined

decadence of Rome; or as a post-apocalyptic vision of life after a nuclear holocaust. In this interpretation the igloos provide the perfect habitat for the city of the future envisioned by Merz's fellow Italians in Archizoom and Superstudio (see *Anti-Design).

From the first, Celant was the group's organizer and theorist. He managed their first exhibition in 1967 at the Galleria La Bertesca, Genoa, and wrote his manifesto 'Arte Povera: Notes for Guerrilla Warfare' which was published at the same time in *Flash Art*. In it he stressed the artists' aim of 'shattering existing cultural codes' by concerning themselves primarily with the physical qualities of the medium and the mutability of the materials. Their work was 'poor' in the sense that it was stripped of associations imposed by tradition; in this, Celant was drawing on the 'poor theatre' of Polish director Jerzy Grotowsky (1933–99), who had attempted to redefine the relationship between actor and audience by removing all non-essential barriers, such as costumes, make-up, sound and light effects. It also constituted a direct challenge to the *Situationist International, which, by the time of the events of 1968, had more or less abandoned artmaking.

Celant spread the word about the movement through his book *Arte Povera*, which was published in 1969 in Italian and English; Arte Povera was quickly included in international exhibitions of *Conceptual and Process Art. Although distinctively Italian, Arte Povera work explores concerns and interests shared with artists elsewhere, such as German Joseph Beuys (see Conceptual Art); French Bernard Pagès (see *Supports-Surfaces); and the British sculptors Richard Deacon and Bill Woodrow (see *Organic Abstraction), Anish Kapoor (see *Neo-Expressionism), and Tony Cragg (b. 1949), who recycles man-made urban debris into brightly coloured wall and floor sculptures.

Key Collections
Kunstmuseum Liechtenstein, Vaduz, Liechtenstein
Kunstmuseum Wolfsburg, Germany
Museo d'Arte Contemporanea, Rivoli, Italy
Tate Gallery, London

Key Books
G. Celant, *Arte Povera* (1969)
Italian Art in the 20th Century: Painting and Sculpture 1900–1988 (exh. cat., Royal Academy of Arts, London, 1989)
A. Boetti and F. Bouabré, *Worlds Envisioned: Alighiero e Boetti and Frédéric Bruly Bouabré* (exh. cat., Dia Center for the Arts, New York, 1995)

Postmodernism

*The rediscovery of ornament, colour, symbolic connections
and the treasure trove of the history of form.*

VOLKER FISCHER, 'DESIGN NOW' EXHIBITION, FRANKFURT, 1988

Although it is a notoriously contentious term, Postmodernism is generally used to refer to certain new forms of expression in the arts of the last quarter of the twentieth century. It was originally applied to architecture in the mid-1970s to describe buildings that abandoned clean, rational, *Minimalist forms (see also *International Style) in favour of ambiguous, contradictory structures enlivened by playful references to historical styles, borrowings from other cultures and the use of startlingly bold colours. A typical architectural example is Piazza d'Italia (1975–80) in New Orleans, by American architect Charles Moore (1925–93). It is a tour de force of the architectural type, revelling in its theatricality and presenting a witty montage of Classical architectural motifs in the form of a stage set.

By the 1980s, the term Postmodernism was also being used to describe diverse developments in design and the visual arts, in works that drew on popular culture for their imagery (the world of commerce, for instance), as in the work of Richard Prince (b. 1949). Other works drew on dissimilar elements placed together (text with images, objects with graphics), as found in work by Tim Rollins (b. 1955) and K.O.S. (Kids of Survival); and – unlike certain kinds of modernist art – there were also works that engaged directly in social and political issues.

Freedom is now just going to be sponsored – out of petty cash (1990), by German-born *Conceptual artist Hans Haacke, brought together several disparate elements to make its polit-

**Hans Haacke, *Freedom is now just going to be sponsored –
out of petty cash*, 1990** As German big business moved into former East Germany after the Berlin wall came down, Conceptual Artist Hans Haacke converted one of the old observation posts into an unsettling signpost of the future.

ically charged point: it consisted of an observation tower left standing in Potsdamerplatz after the fall of the Berlin Wall, topped by the Mercedes Benz automobile logo – which may be read as a brand-name symbol of capitalism in what was West Germany. A text from J. W. von Goethe, 'Art remains art', stands as a monumental epitaph.

The continuing debate over the nature – or even the existence – of Postmodernism is a fierce one. In many ways, Postmodernism is both a rejection of modernism and a continuation of it. Ad Reinhardt (see *Post-painterly Abstraction) had asserted that art has no connection with everyday reality, its only business being with formal issues of line and colour. But in the sphere of the visual arts, an eclectic, politically engaged assemblage – such as Judy Chicago's (b. 1939) installation *The Dinner Party* (1974–79) – emphatically seeks to break the limitations of Reinhardt's modernist dogma. However, modernism contained strands that were other than 'formalist', and Postmodernism continued the experimentation that began with Marcel Duchamp and developed through *Dada, *Surrealism, *Neo-Dada, *Pop Art and *Conceptual Art.

In 1966, two books heralded some of the key Postmodernist ideas. In his *Architettura della città* (1966; English edition *The Architecture of the City*, 1982), Italian architect Aldo Rossi (1931–97) argued that, in the context of historic European cities, new buildings should adapt old forms rather than create new ones. The second, the polemical *Complexity and Contradiction in Architecture* (1966) by American architect Robert Venturi (b. 1925), advocated 'messy vitality' and parodied the famous modernist phrase 'Less is more' by declaring that, on the contrary, 'Less is a bore'. This message was certainly taken to heart by the team who designed the exuberant Groninger Museum (1995) in the Netherlands, Italian designer-architects Alessandro Mendini (b. 1930) and Michele de Lucchi (b. 1951), French designer Philippe Starck (b. 1949), and the Viennese architectural firm of Coop Himmelblau (f. 1968).

Diversity of materials, styles, structures and environments are characteristic of Postmodernism which cannot be defined by one single style. Various examples of Postmodernism include the *High-Tech Hong Kong and Shanghai Bank Headquarters (1979–84) designed by the Englishman Sir Norman Foster (b. 1935), with its tubular steel trusses;

the Museo Nacional de Arte Romano in Spain (1980–86) by Spaniard Rafael Moneo (b. 1937), built in the Classical style out of handcrafted brick; the Portland Public Services Building (1980–82) by American Michael Graves (b. 1934), which features bright pastel colours and oversized keystones; and the Grande Arche de la Défense in Paris (1982–89) by Dane Johan Otto von Spreckelsen (1919–87), a monumental concrete cube dressed in glass and white Carrara marble. Wilfully individual in terms of style, these works nevertheless share the sense of adventure typical of Postmodernist architecture in the 1980s and 1990s.

Designers, no less than architects, embraced the techniques of Postmodernism. From the 1960s, a dissatisfaction with the order and uniformity associated with the *Bauhaus led to innovations, as designers experimented with colours and textures and borrowed decorative motifs from the past in an approach also known as 'adhocism'. The Italian designer Ettore Sottsass (b. 1917; see also *Anti-Design) is a central figure whose pioneering designs culminated with work for the group Memphis, which he founded in Milan in 1981. The choice of the group's name suggests its eclectic approach.

Above: **Cindy Sherman, *Untitled # 90*, 1981**
Sherman has commented on her own work: 'These are pictures of emotions personified, entirely of themselves, with their own presence. I'm trying to make other people recognize something of themselves rather than me.'

Opposite: **Charles Moore, *Piazza d'Italia*, New Orleans, 1975–80**
Historical references, deployed with panache, wit and warmth, played a central role in much of Moore's architecture. The fancy of such associations was one reason for the hostility given to his work by modernists of the previous generation.

Bob Dylan's song 'Memphis Blues' was played during the group's first meeting, and the rich and unlikely mixture of associations it seemed to offer – American blues, Tennessee, Elvis Presley – instantly appealed to Sottsass and his fellow members. Memphis's anti-functional *Carlton Bookcase* (1981) is typically outrageous, staking everything on visual impact. Similar developments occurred in graphic design, where expression and intuition – and occasionally anarchy – took precedence. The influence of German-born Wolfgang Weingart (b. 1941) spread from Basel, Switzerland, through the rest of Europe and eventually to the USA. Neville Brody (b. 1957) in Britain, Studio Dumbar (founded in 1977) in the Netherlands and Javier Mariscal (b. 1950) in Spain, all produced avant-garde typographical designs in the 1980s and 1990s.

Where modernism aimed to create a unifying moral and aesthetic utopia, Postmodernism celebrated late twentieth-century pluralism. An aspect of this pluralism touches on the nature of the mass media and the universal proliferation of images in print and electronic form – which French thinker Jean Baudrillard (b. 1929) has referred to as 'an ecstasy of communication'. If we perceive reality through representations, do these representations actually become our reality? What then is truth? In what sense is originality possible? These are notions that have crucially influenced architects, artists and designers. In much Postmodernist work the main focus is on the question of representation: motifs or images from past work are 'quoted' (or 'appropriated') in new and unsettling contexts, or stripped of their conventional meanings ('deconstructed') by artists as varied as Mike Bidlo

(b. 1953), Louise Lawler (b. 1947), Sherrie Levine (b. 1947) and Jeff Wall (b. 1946). Kitsch can be transformed into high art, as in *Rabbit* (1986) by Jeff Koons (b. 1955, see also *Neo-Pop), a sculpture cast in glossy stainless steel from a cheap inflatable Easter rabbit.

Two artists in the USA, Julian Schnabel (b. 1951) and David Salle (b. 1952), began to employ Postmodernist techniques in the late 1970s, appropriating and superimposing images and objects from popular films and magazines. The palimpsests of Schnabel's broken crockery and Salle's ghostly overlapping figures create a startling juxtaposition which raises the question of their combination. Their work is richly expressive, and they are often referred to as *Neo-Expressionists, and compared to artists of the *Transavanguardia.

In the visual arts, as in architecture and design, Postmodernism has aimed to express the experience of living at the end of the twentieth century, and it has often engaged directly with social and political issues. Starting with the idea that art has formerly served a dominant social type – the white, middle-class male – Postmodernist artists have chosen to highlight other identities previously marginalized, in particular environmental (see *Earth Art), ethnic, sexual and feminist identities. In a variety of ways, these have become key themes in Postmodernist work.

Jean-Michel Basquiat (1960–88), born in the USA of Haitian and Puerto Rican parents, started out as a graffiti artist in the late 1970s, using the tag SAMO (Same Old Shit). His angry, confrontational designs that protested against racial prejudice among other things, combined scrawled pictures of African mask-like faces with scenes of New York street life and crossed-out messages. 'Black people are never portrayed realistically, not even portrayed, in

(b. 1945), Jenny Holzer (b. 1950) and Cindy Sherman (b. 1954) used a variety of Postmodern means to address questions of female identity. Kelly's long-term project *Post Partum Document* (1973–79) was originally conceived as an installation in six consecutive sections. Describing her relationship with her son during the first five years of his life, examining both his entrance as a male into a social world and her own changing role as a mother, this art work has been widely exhibited and strongly debated since the 1970s.

Kruger (see also *Installation), formerly the chief graphic designer at *Mademoiselle*, produced a series of photo-montages that stylishly combine images with unsettling captions, such as *Untitled ('Your gaze hits the side of my face')*, 1981, in which conventionally unexamined aspects of social behaviour (such as men looking at women) are exposed to scrutiny. Holzer (the first woman to represent the USA at the Venice Biennale in 1990) became famous for her aphorisms (for instance, 'Protect me from what I want') which are relayed to the public via means as various as electronic advertising hoardings, the internet and stickers placed on parking meters.

Sherman is the subject of her own photographs, but the series she has produced – *Untitled Film Stills* (1977), for example – are not concerned with self-portraiture. Rather she poses as a figure in recognizable scenes – from B-movies, girlie magazines, television programmes, Old Master paintings – effacing her own identity to bring into question the stereotypes she adopts.

The term Postmodernism will continue to provoke debate, particularly as there is no universal definition of modernism to define it against, and its meaning will undoubtedly change as the historical perspective on it grows longer. For the time being, its very complexity and contingency seem suited to the varied, unsettling and sometimes uncategorizable work it seeks to explain.

modern art', he said. Drawn with magic markers on walls outside New York galleries, his graffiti soon attracted the attention of the art world, and he was notably associated with Andy Warhol (see *Pop Art). But Basquiat's rise to fame was as catastrophic as it was swift. In 1984 he signed with the Mary Boone gallery, one of the most glamorous venues of the New York art scene; four years later he was dead as the result of a heroin overdose.

Death is also a dominant theme in Postmodernist art, and so too is the question of sexual identities, in particular the identity of gay men. Like Basquiat, Keith Haring (1958–90) began as a graffiti artist, and his bright cartoon figures, equally effective on walls, canvas, T-shirts or badges, were a feature of his work until his death from AIDS in 1990. David Wojnarowicz (1954–92), another AIDS victim, made the illness a central subject of his work. *Sex Series* (1988–89) brought together negative photographs and texts to chronicle the trauma of AIDS in a society that Wojnarowicz saw as uncaring.

In the 1970s and 1980s, especially in the USA, women artists such as Mary Kelly (b. 1941), Barbara Kruger

Above: **Ettore Sottsass, Carlton Bookcase, Memphis, 1981**
'To me,' Sottsass wrote, 'doing design doesn't mean giving form to a more or less stupid product for a more or less sophisticated industry. Design for me is a way of discussing life, sociality, politics, food – and even design.'

Opposite: **Judy Chicago, *The Dinner Party*, 1974–79**
A homage to women in history, Chicago's installation was a collaborative effort involving over one hundred women in its production. It was also hugely popular: over 100,000 people saw it when it opened at the San Francisco Museum of Modern Art in 1979.

Key Collections
Kunstmuseum, Wolfsburg, Germany
Museum of Contemporary Art, Chicago, Illinois
Museum of Modern Art, New York
New Museum of Contemporary Art, New York
Tate Gallery, London

Key Books
H. Foster (ed.), *The Anti-Aesthetic, Essays on Post-Modern Culture* (1983)
M. Lovejoy, *Postmodern Currents: Art in a Technological Age* (1989)
M. Kelly, *Post-Partum Document* (1999)

High-Tech

The poetry of the hydraulic engineering.

SIR NORMAN FOSTER

High-Tech architecture exalts and exploits new technologies for both practical purposes and visual impact, using forms and materials expressive of modern industrial technology rather than traditional building materials. Since 1983, when the British journal *Architectural Review* devoted an entire issue to High-Tech, the term has been applied to buildings by many different architects. The two most prominent practitioners associated with it are the British architects Sir Norman Foster (b. 1935) and Sir Richard Rogers (b. 1933).

Like some of their contemporaries in design, such as Archigram and Archizoom (see *Anti-Design), the High-Tech architects looked back further than the *International Style to the modernism of the *Futurists, *Expressionists and Russian *Constructivists to find inspiration. American inventor-designer Buckminster Fuller (see also *Neo-Dada) was an important influence. Foster met Fuller in 1968, and it was the start of a long friendship and collaboration that lasted until Fuller's death in 1983. Fuller's visionary humanistic view of technologically sophisticated design is discernible in the approach taken by both Foster and Rogers, who have insisted that technology is not an end in itself, but a means of solving social and ecological problems.

Foster and Rogers met while studying at Yale University, USA, in the early 1960s. In 1963, after returning to England, they founded the firm Team 4 with two architect sisters, Wendy (later Foster's wife) and Georgie Cheesman. Their Reliance Control factory in Swindon (1965–66, demolished 1991) won the group international recognition and was

retrospectively designated the beginning of the High-Tech movement. This early work combined the restrained elegance – for which Foster would become known – with the structural directness associated with Rogers. In 1967 the group disbanded, with Wendy and Norman forming Foster Associates and Rogers going into partnership with the Italian architect and designer Renzo Piano (b. 1937).

Collaboration between architects and structural and civil engineers is a key feature of High-Tech architecture. The engineering skills of Ove Arup and Partners, founded by Ove Arup (1895–1988) in 1949, have been crucial to numerous architectural projects, for example the Expressionist Sydney Opera House (1956–74) by Dane Jørn Utzon (b. 1918), projects by Peter and Alison Smithson (see *New Brutalism) and many of Rogers's and Foster's projects. Another firm prominent in High-Tech work is Anthony Hunt Associates, who were involved in the Reliance Control Factory project.

The first great monument of High-Tech was the Georges Pompidou Centre in Paris (1971–77), built by Rogers and

Above: **Piano and Rogers, Georges Pompidou Centre, Paris, 1971–77** With the engineering expertise of Ove Arup, Piano and Rogers achieved technological sophistication and flexible interior space in a building whose surrealistic and playful appearance recalls one of Jean Tinguely's machines (see Kinetic Art).

Opposite: **Foster and Partners, Hong Kong and Shanghai Banking Corporation Headquarters, 1979–86** According to Foster, the rocket-launcher-like forms of the building were influenced by sources outside the traditional building industry, such as 'military establishments coping with mobile bridges to take tank loadings.'

Piano (with Ove Arup), which famously sited all the services and structural elements on the outside of the building, in order to create extra space inside. Despite its bold modern design which bore no relation to its context, the building quickly became a popular success. A vivid structural expressiveness and an affinity with industrial architecture became the trademark features of Rogers's later projects (Richard Rogers Partnership was founded in 1977 with his wife Su Rogers), such as the Lloyd's Building, London (1978–86,

with Ove Arup), the Lloyds Register of Shipping, London (1995–99, with Anthony Hunt) and the Millennium Dome in Greenwich, London (1996–99, with Ove Arup), the largest single public assembly building in the world, with a roof made of Teflon-coated fibreglass.

Foster, meanwhile, became known for elegantly designed, precise buildings. The Sainsbury Centre for the Visual Arts in Norwich, England (1978, extension 1988–91, with Anthony Hunt); the Hong Kong and Shanghai Banking Corporation (HSBC) headquarters in Hong Kong (1979–86 with Ove Arup); the world's largest airport, Hong Kong International Airport (1992–98, with Ove Arup); and the Millennium Bridge (2000, with Ove Arup, see *Minimalism) are all celebrated examples. An earlier work, the Willis Faber & Dumas Building in Ipswich, England (1970–74, with Anthony Hunt), already shows Foster's characteristic sense of community. At the time, Ipswich had virtually no social facilities, and the building – with its indoor swimming pool, rooftop restaurant and curving glass facade – was, as Foster commented, 'a social revolution'.

Buildings by other architects have also been described as High-Tech. The Schlumberger Research Facility in Cambridge, England, by Michael Hopkins and Partners (1984, with Anthony Hunt), the Institut du Monde Arabe in Paris, by Jean Nouvel (1987), Waterloo International Terminal in London by Nicholas Grimshaw and Partners (1993, with Anthony Hunt) and the London Eye (2000) by Marks Barfield Architects are a few examples. A comparable use of new technology is also a feature of buildings by Frank Gehry (b. 1929) and Zaha Hadid (b. 1950). Michael McDonough's e-House2000, a high-tech, web-based, environmentally appropriate house, located near the Catskills in New York, and developed in collaboration with engineers, builders, manufacturers, scientists and environmentalists, applies some techniques pioneered by the High-Tech architects.

Key Monuments
Foster Associates, Hong Kong Shanghai Banking Corporation, Hong Kong
Jean Nouvel, Institut du Monde Arabe, Paris
Renzo Piano and Richard Rogers, Pompidou Centre, Paris
Richard Rogers Partnership, Lloyds Building, London

Key Books
C. Davies, *High-Tech Architecture* (1988)
Norman Foster: Buildings and Projects, 6 vols (1991–98)
K. Powell, *Structure, Space and Skin: The Work of Nicholas Grimshaw and Partners* (1993)
R. Burdett (ed.), *Richard Rogers Partnership: Works and Projects* (1995)
K. Powell, *Richard Rogers: Complete Works* (1999)

Neo-Expressionism

I got sick and tired of all that purity, wanted to tell stories.

PHILIP GUSTON

Neo-Expressionism was one of the many strains of *Post-modernism that emerged at the end of the 1970s and was partly the result of widespread dissatisfaction with *Minimalism, *Conceptual Art and the *International Style. The cool and cerebral approach of those movements along with their preference for purist abstraction were flouted by the Neo-Expressionists who embraced the so-called 'dead' art of painting and flaunted all that had been discredited – figuration, subjectivity, overt emotion, autobiography, memory, psychology, symbolism, sexuality, literature and narrative.

By the early 1980s, the term was in use to describe the new painting in Germany by artists such as Georg Baselitz (b. 1938); Jörg Immendorf (b. 1945); Anselm Kiefer (b. 1945); A. R. Penck (b. 1939); Sigmar Polke (b. 1941) and Gerhard Richter (b. 1932, see also *Super-realism); it was also applied to the so-called Ugly Realists, such as Markus Lüpertz (b. 1941), and to the Neue Wilden (New Wild Ones), such as Rainer Fetting (b. 1949). After the international exhibitions 'A New Spirit in Painting' held in London in 1981 and 'Zeitgeist' in Berlin, 1982, the term came to encompass other groups: Figuration Libre (Free Figuration)

Above: **Anselm Kiefer, *Margarethe*, 1981**
Kiefer often uses non-art materials in his paintings (in this example, straw) to enrich his surfaces. The aesthetic arena of the canvas becomes a place where traumatic political and historical issues can be addressed.

Opposite: **Gerhard Richter, *Abstraktes Bild (860-3)*, 1999**
'When I paint an Abstract Picture,' Richter wrote in 1985, 'I neither know in advance what it is meant to look like nor, during the painting process, what I am aiming at. Painting is consequently an almost blind, desperate effort.'

in France, *Transavanguardia in Italy, and a number of artists in the USA: the New Image Painters, such as Jennifer Bartlett (b. 1941), Eric Fischl (b. 1948), Elizabeth Murray (b. 1940) and Susan Rothenberg (b. 1945); the so-called 'Bad Painters' Robert Longo (b. 1953), David Salle (b. 1952, see *Post-modernism), Julian Schnabel (b. 1951, see Postmodernism) and Malcolm Morley (b. 1931, see Super-realism). Others not associated with any particular group were soon termed Neo-Expressionists, including Dane Per Kirkeby (b. 1938); Miquel Barceló (b. 1957) from Spain; Italian Bruno Ceccobelli (b. 1952); French Annette Messager (b. 1943); Canadian Claude Simard (b. 1956, see *Installation); and in Britain, Frank Auerbach (b. 1931), Howard Hodgkin (b. 1932), Leon Kossoff (b. 1926) and Paula Rego (b. 1935).

The term Neo-Expressionism expanded to cover a shared tendency rather than a specific style – as did *Expressionism earlier in the twentieth century. Broadly speaking, Neo-Expressionist work is characterized by technical and thematic features. The handling of materials tends to be tactile, sensuous or raw, and vibrantly expressive of emotions. Subjects frequently display a deep involvement with the past, either collective history or personal memory, explored through allegory and symbolism. Neo-Expressionist work draws on the history of painting, sculpture and architecture, employing traditional materials and themes. As a result, the influence of Expressionism, *Post-Impressionism, *Surrealism, *Abstract Expressionism, *Art Informel and *Pop Art is very apparent. Important contemporary figures included German Conceptual artist Joseph Beuys (1921–86), whose examples of political involvement and handling of expressive materials were particularly inspirational, and American Philip Guston (1912–80), the Abstract Expressionist who shocked the art world in the late 1960s with his conversion to boldly figurative comical work.

In Germany the influence of the German Expressionists has been understandably strong. Penck's vigorously expressive prints and paintings of stick figures and hieroglyphics are reminiscent of *Die Brücke; Richter's abstractions of the 1980s layer the violently expressive colours of Die Brücke with the more lyrical tones of *Der Blaue Reiter, producing both crisp and muted abstraction. A reflection on the symbolism that abstraction and colour have carried throughout history, they also memorialize the utopian aspirations of the pioneers of German modernism – a reminder, perhaps, of the necessity of art, despite, or because of the overwhelming traumas of twentieth-century history. For German artists of

the 1980s, no less than for the German artists of the early twentieth century, 'art is the highest form of hope'. In fact, a large part of German Neo-Expressionist work of the 1980s explicitly confronts the problematic period of Germany's post-World War II history, when, for much of the time, it was a divided nation. Kiefer's idealized political paintings, richly textured (often incorporating straw, tar, sand and lead) and layered with references to German and Nordic mythology, have directly addressed Nazism, the war and German identity and nationhood. In his paintings Kiefer forces the redemption or rehabilitation of society: 'The more you go back, under, the further forward you can go.'

In America, Neo-Expressionist artists have taken up the struggle with the American way of life. Schnabel, for instance, works intensively with images 'quoted' from history (films, photographs, religious iconography), to produce huge, vigorous paintings which incorporate materials such as rugs, driftwood, ponyskin and – most famously – broken crockery. Eric Fischl's paintings depict voyeuristic, disturbing, soft-porn psychodramas of white, affluent suburban America, which dramatize the dangers of the vacuity and conformity inherent in the American suburban dream.

Conformity is also a subject of the British artist Jenny Saville (b. 1970). Her Rubenesque nudes, for which she herself is often the model, question standards of beauty and 'good taste' even more strongly than Fischl's work. In a period that has seen an increase in eating disorders, harmful dieting and cosmetic surgery, her paintings, reminiscent of the work of Larry Rivers (see *Neo-Dada), stand as unconventional and defiant celebrations of the human body.

The emergence of Neo-Expressionism during the 1980s also provided an opportunity to rehabilitate artists of an older generation who had long been working in an Expressionist mode. Americans Louise Bourgeois (b. 1911), Leon Golub (b. 1922) and Cy Twombly (b. 1929); British Lucian Freud (b. 1922); French Jean Rustin (b. 1928) and Austrian Arnulf Rainer (b. 1929) are all artists whose work has retrospectively been adopted as Neo-Expressionist.

The term Neo-Expressionism has also been applied to sculptors and architects. Buildings such as the Sydney Opera House (1956–74) by Dane Jørn Utzon (b. 1918), the sculptural stores built in the USA during the 1970s by the multi-disciplinary organization SITE (f. 1969) and Frank Gehry's (b. 1929) Guggenheim Museum in Bilbao, Spain (1997) have also been described as Expressionist. American Charles Simonds (b. 1945); British Antony Gormley (b. 1950, see also *Site Works), Anish Kapoor (b. 1954) and Rachel Whiteread (b. 1963); Czech Magdalena Jetelová (b. 1946); German Isa Genzken (b. 1948) and Polish Magdalena Abakanowicz (b. 1930) are all sculptors whose works contain Expressionist features. Though the works are

Anish Kapoor, *1000 Names*, 1982

Kapoor has commented: 'While making the pigment pieces, it occurred to me that they form themselves out of each other. So I decided to give them a generic title, *1000 Names*, implying infinity, a thousand being a symbolic number.'

vibrant colours, limestone, slate, sandstone and mirrored surfaces. It is the materials that prompt the viewer to reflect on the physical and spiritual components of the human condition. His works, which he has described as 'signs of a state of being', often contain voids, as he explained in 1990:

> I find myself coming back to the idea of narrative without storytelling, to that which allows one to bring in psychology, fear, death and love in as direct a way as possible…This void is not something which is of no utterance. It is a potential space, not a non-space.

In Genzken's work there is an echo of the utopian Expressionist art and architectural projects of the past (see, for instance, *Arbeitsrat für Kunst, *Der Ring and *Bauhaus). Her dollhouse-scale sculptures of concrete ruins of the mid- to late 1980s evoke a whole history of heroic building types and materials, from the Roman to the modernist German buildings of the 1920s and the minimalist cubes of the International Style after World War II. Her sculptures, which appear bombed-out, seem tinged with anger, sorrow and wistfulness; they remind the viewer of a war that not only killed millions of people but also destroyed their dreams. Whiteread's *House* (1993), a concrete cast of the interior of a condemned council house in London's East End, itself destroyed in January 1994, was an expressive memorial to the ideals and failures of the social housing projects of the past. Genzken's ruins and Whiteread's monument acknowledge the destruction of the utopian dream in art and architecture. SITE's peeling buildings seem to offer the only feasible response: to strip away the false layers of misused styles to rediscover the original goals. They pay homage to the dream and make a plea to keep the faith, asserting that the failures of the past need not condemn the present to cynicism, or preclude the belief that art and architecture can play an active role in creating a better future.

varied, ranging from the abstract to the figurative, from the austere to the sensuous, and from the minute to the monumental, they are always emotionally charged. Kapoor is an outstanding example of a sculptor working with a variety of expressive materials, which include pure powdery pigment in

Above: **Eric Fischl, *Bad Boy*, 1981**
Fischl has said that 'the whole struggle for meaning since the 1970s has been a struggle for identity…a need for self.' His unsettling snapshots of suburban life (derived from photographs) are narratives filtered through his artistic and emotional self.

Below: **Jenny Saville, *Branded*, 1992**
Saville's huge canvases seem to barely contain her bulging female nudes. Seen from below, and often decorated with contour lines or writing, they are confrontational and compelling representations of femininity and the body.

Key Collections
Museum of Modern Art, New York
Solomon R. Guggenheim Museum, New York
Stedelijk Museum, Amsterdam, the Netherlands
Tate Gallery, London

Key Books
D. Salle, *David Salle* (1989)
G. Celant, *Anish Kapoor* (1996)
J. Gilmour, *Fire on Earth: Anselm Kiefer and the Post-Modern World* (Philadelphia, PA, 1990)
L. Saltzman, *Anselm Kiefer: Art After Auschwitz* (Cambridge, UK, 1999)

Neo-Pop

Neo-Pop (or Post-Pop) refers to the work of a number of artists who emerged on the New York art scene during the late 1980s, particularly Ashley Bickerton (b. 1959), Jeff Koons (b. 1955), Alan McCollum (b. 1944) and Haim Steinbach (b. 1944). One of the many strains of *Postmodernism, Neo-Pop reacted to the dominance of *Minimalism and *Conceptual Art during the 1970s. Using 1960s *Pop Art methods, materials and images as a starting point, Neo-Pop also reflected the heritage of Conceptual Art in its sometimes ironic and objective style.

This dual inheritance is demonstrated in the media-based photographic work of the American self-taught artist Richard Prince (b. 1949), in language works by Jenny Holzer (b. 1950, see *Postmodernism), in McCollum's painted objects and in Steinbach and Koons's use of found popular imagery.

Other twentieth-century art movements showed continuing influence, especially in the use of found objects and readymades (see *Dada). Belgian Leo Copers's objects, for instance, appear as Dada-Pop-Conceptual hybrids. In Britain, Michael Craig-Martin's (b. 1941) wall drawings, Julian Opie's (b. 1958) computer graphic-style images and large toy-like sculptures, and Lisa Milroy's (b. 1959) lovingly painted rows of consumer goods took on the legacy of Pop Art. Steinbach's formica-covered shelves bear objects purchased from a shop, displayed in reverent arrangements; the assemblages comment on our worship of material possessions and the way we choose them as a part of our identity. Recalling Minimalist sculptures as well as department store display shelves, they draw attention to how deeply both Pop art and Minimalism have been absorbed into the wider cultural arena.

The term Neo-Pop could also be used to describe the late work of two artists who helped shape the language of Pop Art, namely Jasper Johns (see *Neo-Dada) and Roy Lichtenstein (see Pop Art). Throughout their careers, both Johns and Lichtenstein enacted homages to respected artists in their work. In their late works, however, they incorporated images of their own art as well, perhaps as an acknowledgment of the popular recognition that many of their own works found, some becoming as well known as the popular cultural imagery that they first drew on.

Koons (see also Postmodernism) became notorious in the 1980s for his elevation of kitsch into high art. His work *Balloon Dog* (1994–2000) is a shiny red steel sculpture measuring over ten feet (three metres) in height, whose sheer scale and detail of construction stand in absurd contrast to its subject, yet lend it an awesome presence. Recalling Claes Oldenburg's ironic monumentalizing of Pop Art (see Pop Art and *Site Works), Koons transformed the ephemeral child's toy into a massive, durable monument.

Jeff Koons, *Two Ball 50/50 Tank*, 1985
Koons's statements are nearly as well known as his works. 'A viewer might at first see irony in my work,' he has written. 'But I see none at all. Irony causes too much critical contemplation.'

Other artists who were creating Pop-inflected work at the end of the twentieth century include American Cady Noland (b. 1956), Russians Vitali Komar (b. 1943) and Alexander Melamid (b. 1945, see *Socialist Realism) and British artists Damien Hirst (b. 1965), Gary Hume (b. 1962) and Gavin Turk (b. 1967). Turk's *Pop* (1993) is a lifesize wax self-portrait dressed as Sid Vicious (member of the punk band the Sex Pistols) dressed in the outfit associated with Vicious's version of Frank Sinatra's 'My Way', in the pose of Elvis Presley as a cowboy, as portrayed by Andy Warhol, encased in a glass box. *Pop* exposes the myth of creative originality, and reflects on the rise of pop music, pop art, the pop star, and the artist as pop star. It serves as a memorial to the pioneers of self-promotion who helped the media to transform them from mere people into icons.

Key Collections
Modern Art Museum of Fort Worth, Texas
Museum of Fine Arts, Boston, Massachusetts
San Francisco Museum of Modern Art,
 San Francisco, California
Sintra Museu de Arte Moderna, Sintra, Portugal
Tate Gallery, London

Key Books
The Jeff Koons Handbook (1992)
J. Johns and K. Varnedoe, *Jasper Johns:
 Interviews and Writings* (1996)
N. Rosenthal, et al., *Sensation* (exh. cat., Royal
 Academy of Arts, London, 1998)

Transavanguardia

…the artist, like the tightrope dancer, goes in various directions, not because he is skilful but because he is unable to choose only one.

MIMMO PALADINO, 1985

The Italian art critic Achille Bonito Oliva named the Italian version of *Neo-Expressionism Transavanguardia ('beyond the avant-garde'), in an article in *Flash Art* in October 1979; it has been since used to refer to work produced in the 1980s and 1990s by a group of artists comprising Sandro Chia (b. 1946), Francesco Clemente (b. 1952), Enzo Cucchi (b. 1949) and Mimmo Paladino (b. 1948). Their work marks a return to painting characterized by a certain violence of expression and handling, and by an air of romantic nostalgia for the past. Colourful, sensual and dramatic, they convey a real sense of relish in the rediscovery of the tactile and expressive aspects of the materials of painting.

The name given to the movement by Bonito Oliva implied that the artists had gone beyond, or superseded, the progressive nature of the avant-gardes of the twentieth century. Together with their German and American Neo-Expressionist counterparts, their work challenged the dominance of *Conceptual and *Minimal art and, in the work of the Italians, it was also regarded as a reaction against the more puritanical aspects of *Arte Povera. The artists' rejection of the concept of a 'right way' forward for art (especially one that seemed to value purity to the exclusion of all else) and their enthusiastic embrace of a medium that had long been declared 'dead' (painting), had a liberating effect that can be traced in the works and statements of the artists.

In combining and transforming past traditions of form and content, the art of the Transavanguardia draws specifically on Italy's rich cultural heritage. In Chia's paintings, heroic images that seem to float in time and space, one often senses that the whole of the history of art and of culture is being brought into play. The figure of the artist, usually present in the pictures, is seen as both hero and circus clown, and the situations in which he participates appear exuberant, yet melancholic. Explaining his attitude towards the role of painting in 1983, Chia wrote:

In this place, surrounded by my paintings and my sculptures, I am like a lion-tamer amongst his beasts and I feel close to the heroes of my childhood, close to Michelangelo, Titian and Tintoretto. I'll make these sculptures and these paintings dance on only one leg to my music and for my pleasure.

Cucchi's dark landscapes, while evoking his home town of the Adriatic port city of Ancona in central Italy, are closest in feeling to the northern *Expressionists of the early part of the twentieth century. The portrayal of nature's power and of man's insignificance recalls the visionary landscapes of Emil Nolde.

Above: **Enzo Cucchi, *A Painting of Precious Fires*, 1983**
The Adriatic port city of Ancona, where Enzo Cucchi's family has farmed for generations, provided him with a setting of landslides and stubble-burning which takes on an apocalyptic energy in his paintings.

Opposite: **Artists of the Transavanguardia**
From left to right: Sandro Chia, Nino Longobardi, Mimmo Paladino, Paul Maenz, Francesco Clemente and his wife, Wolfgang Max Faust, unidentified, Fantomas, Gerd de Vries, Lucio Amelio. One of the 'three Cs', Enzo Cucchi, is missing.

If Cucchi seems to revive the notion of the artist as a visionary, the eclectic work of Clemente takes the Expressionist precept of art as a vehicle for self-expression to a new level. Like the work of Vincent van Gogh (see *Post-Impressionism) and Egon Schiele (see *Expressionism), Clemente's images function as psychological self-portraits, often depicting the artist as an isolated, misunderstood hero. Drawing on a wide range of influences and sources of inspiration, the images intertwine religious symbolism, autobiography, cultural history and art history in an often erotic personal vision of an obsessive journey from self-expression to self-exposure.

Paladino's art similarly traverses time and styles, but in an almost archaeological fashion. In his paintings and sculptures the past and present are fused, the living brought together with the dead, Catholic rituals mixed with pagan rites, symbols, humans and animals assembled in archaic figuration. The sense of freedom in Paladino's smorgasbord approach is captured in a statement he made in 1985:

Art is like a castle with many unfamiliar rooms filled with pictures, sculptures, mosaics, frescos, which you discover with amazement in the course of time. The way Conceptual Art goes through this castle is very clearly defined. Mine is not, but mine runs parallel. I can choose. The old questions about image and representation have, in my opinion, been swept aside by abstract art. I can simultaneously take up a relationship in my pictures to Matisse and Malevich without there being a relationship between them.

With their inclusion in important exhibitions at the Kunsthalle in Basel, the Venice Biennale in 1980 and the Royal Academy in London in 1981, the artists of the Trans-avanguardia became rapidly well known and accepted in the international art world as a group of significance. Solo exhibitions in Europe and the USA followed soon after, as did international reputations.

Key Collections
Ball State University Museum of Art, Muncie, Indiana
Museo di Capodimonte, Naples, Italy
Solomon R. Guggenheim Museum, New York
University of Lethbridge Art Gallery, Alberta, Canada

Key Books
A. Bonito Oliva, *The Italian Transavantgarde* (Milan, 1980)
M. Auping, *Francesco Clemente* (1985)
E. Avedon, *Clemente: An Interview* (1987)
Italian Art in the 20th Century: Painting and Sculpture 1900–1988 (exh. cat., Royal Academy of Arts, London, 1989)

Sound Art

What is the relationship between man and the sounds of his environment and what happens when those sounds change?

R. MURRAY SCHAFER, THE TUNING OF THE WORLD, 1977

Sound Art (or Audio Art) achieved significant recognition as a category by the late 1970s, and was well known by the 1990s, when artists all over the world were involved in works that used sounds. The sounds can be natural, man-made, musical, technological or acoustic, and the works can take the form of *Assemblage, *Installation, *Video, *Performance and *Kinetic Art as well as painting and sculpture.

The origins of Sound Art can be traced to early in the twentieth century. The relationship between music and art was a driving force behind the development of abstraction (see *Der Blaue Reiter, *Orphism and *Synchromism). The 'art of noises' was explored by *Futurists and *Dadaists, and developed by American composer John Cage in the 1950s. Cage cited Robert Rauschenberg's *White Paintings* of 1951 – which he described as 'airports for lights, shadows and particles' – as a major inspiration for his 'silent' piece, *4'33"* (1952). Redefining 'music' as any combination of sounds and noises, Cage was an influential figure for visual artists of the 1950s and 1960s, particularly those associated with *Beat, *Neo-Dada, *Fluxus and Performance, movements which in turn were influential for Sound and Performance artists Laurie Anderson and Robert Wilson in the 1970s.

Rauschenberg's career (see also Neo-Dada, *Combines, Performance and Conceptual Art) includes some notable

sound pieces: *Broadcast* (1959), a combine painting with three radios behind the canvas and two tuning knobs on the surface; *Oracle* (1962–65), a sculptural sound environment made in collaboration with Swedish engineer Billy Klüver (b. 1927); and *Soundings* (1968), a massive plexiglas screen with concealed lights activated by the sounds of viewers to reveal images of tumbling chairs. *Soundings* was made with engineer members of E.A.T. (see *GRAV), an organization that facilitated artists' experiments with new technologies.

A number of early Sound works were exhibited at the Cordier & Ekstrom gallery, New York, in 1964, 'For Eyes & Ears'. It included noise-making objects by Dadaists Marcel Duchamp and Man Ray, a sound installation by Klüver, works by contemporary practitioners such as Rauschenberg and Kinetic artists Jean Tinguely and Takis, and collaborative works by artists and composers, and artists and engineers.

American Lee Ranaldo (b. 1956) and British-born Brian Eno (b. 1948) have produced bodies of visual art that are enriched rather than defined by their musical backgrounds.

Christian Marclay, *Guitar Drag*, 2000
The fifteen-minute video of an (amplified) electric guitar being pulled behind a pick-up truck along the dirt roads of Texas not only produces an extraordinary noise but also brings to mind a whole range of references, from lynchings to road movies.

Eno has worked with Sound Artists, such as Anderson, and other visual artists, such as Mimmo Paladino (see *Trans-avanguardia). Just as Anderson, Ranaldo and Eno have fused aspects of high art and popular culture, much recent Sound Art is nurtured by club culture and the use of electronic music and sampling. Britain's Robin Rimbaud, alias Scanner, creates sound collages for clubs, exhibitions, radio and television. He also collaborates with artists such as Austrian Katarina Matiasek (b. 1965) and British Paul Farrington, alias Tonne. The exhibition 'Sonic Boom: The Art of Sound' at the Hayward Gallery in London, 2000, highlighted the increasing numbers of contemporary artists using sound in connection with the visual arts. Sound Art alerts the viewer to the multi-sensory experience of perception. As a flexible and still relatively unexplored medium, Sound Art is subject to new developments in digital technology and the internet.

Key Collections
Kunsthalle, Hamburg, Germany
Museum Ludwig, Cologne, Germany
Stedelijk Museum, Amsterdam, the Netherlands

Key Books
Voice Over: Sound and Vision in Current Art (exh. cat., Arts Council of England, 1998)
K. Maur, *The Sound of Painting* (Munich, 1999)
Sonic Boom: The Art of Sound (exh. cat., Hayward Gallery, London, 2000)

Internet Art

An aesthetic of poaching, tricking, reading, speaking, strolling, shopping, desiring.

DAVID GARCIA AND GEERT LOVINK, MEDIA ACTIVISTS, 1997

Has Internet Art (Interactive Art, Web Art or net.art), the newest form of digital art, finally put an end to styles in art? According to some, 'isms' – avant-garde movements succeeding each other in evolutionary sequences – are no longer possible in a technological format that allows both artist and viewer such extraordinary freedom of creativity.

The World Wide Web, launched in 1989 by British scientist Timothy Berners-Lee (b. 1955) to aid physicists working at the European Laboratory for Particle Physics, became a forum for art practice in the mid 1990s, when there were still only around 5,000 users with their own sites. However, in the last few years of the twentieth century, a huge increase in numbers of users facilitated rapid growth of Internet Art. Developments have been global, appropriately enough for a medium that is itself universally accessible. Post-Communist East Europeans, for example, were among the earliest participants: the Ljudmila media centre in Slovenia, funded by George Soros's Open Society Institute, was innovative in combining space for artists' sites with initiatives in education.

Internet Art is, above all, democratic, and interactivity is its key feature. Images, text, motion and sound, assembled by artists, can be navigated by viewers to create their own multimedia montages of which the ultimate 'authorship' is open to question. Viewers become users. *My Boyfriend Came Back From the War* (1996) by Russian Olia Lialina (b. 1971) puts both personal and political history at the forefront, with a repertoire of images and texts that are sequenced by the viewer to create different versions of a doomed love affair. British systems analyst Heath Bunting, who started Irational.org (its name suggesting subversion in a world of corporate rationality) in 1994, has exploited the Web's interconnectedness in other ways. His *King's-Cross Phone-In* posted on the Web the telephone numbers of thirty-six phone booths in and around the railway station in London, inviting viewers to call and chat to commuters, injecting an unexpected note of sociability – and anarchy – into business routine. The project also showed how protean Internet Art can be, fluently interconnecting with other art forms, such as *Performance Art.

For artists, the internet offers a new mode of distribution and a new medium with its own unique features. One feature is the technology itself, which forms the artists' materials.

Jake Tilson, Selection of screens from *The Cooker*, 1994–99
(www.thecooker.com) Tilson's ongoing project brings together an exotic collection of 'found objects', such as travel photographs, recordings of background noise in restaurants and lists of statistics for the viewer to assemble in almost infinite combinations.

Making visible codes that are usually hidden, such as HTML (hypertext mark-up language), has been one tactic, revealing the apparent chaos of technology (see, for instance, www. jodi.org). Use of vector-based web authoring tools (such as Macromedia Flash) is another. Unlike pixel-based processes, such as digitized photography, vector-based forms can be scaled to any size, without loss of quality. Peter Stanick (b. 1953, www.stanick.com) produces high-impact, *Pop-like digital paintings of New York street scenes, which he sees as continuing the mechanical approach of Pop artists Roy Lichtenstein and Andy Warhol. Other artists experiment with colour palettes specific to web technology, those arising from machine technology as opposed to the physical properties of pigment, such as the hexadecimal colour palette – 256 web-safe colours made up of red, green and blue (the three colours that comprise a single monitor pixel).

Jake Tilson's (b. 1958) ongoing work *The Cooker* (begun in 1994) highlights another key feature of Internet Art: its ability to make extraordinary geographical connections, between both artists and audiences. As Buckminster Fuller (see also *Neo-Dada and *Anti-Design) predicted in the 1960s, technology has had the effect of bringing the world into our backyards. Tilson's *The Cooker* features an astonishing range of images, texts and other experiences from around the world relating to the general theme of food. 'Macro Meals', for instance, allows the viewer sitting at his terminal to visit India and 'order' breakfast on the Rajasthan Express, seeing images of the train and the food, and even hearing the sounds of the meal being prepared and consumed.

Practitioners of Internet Art come from a variety of backgrounds: some have fine arts training, others come from the fields of business, technology and graphic design. Äda'web (whose archive can now be found at the website for the Walker Art Center, Minneapolis, see under Key Sites below) has its roots in the mainstream art world. Benjamin Weil, its curator, has been active in inviting established artists such as Jenny Holzer (see *Postmod-

ernism) and Lawrence Weiner (see *Conceptual Art) to collaborate with his designers in creating sites. Holzer's site *Please Change Beliefs*, which invites viewers to 'improve' truisms (such as 'Expiring for Love is Beautiful but Stupid'), shows how the interactive nature of the internet can extend an established art by bringing into play viewers' own ideas.

John Maeda, Director of the Aesthetics and Computation Group at the Massachusetts Institute of Technology (MIT) Media Laboratory, trained first as a computer scientist at MIT, then studied art and design in Japan. The source of much of his art is technology and the subject is often the interplay between man and machine, seamlessly blending visual art and computer science, often with an optical dynamism reminiscent of *Op Art. Many Internet projects, inevitably, depend on collaboration between artists and technicians (see also Neo-Dada and *GRAV) as well as interactivity between artists and viewers.

Internet Art still continues to develop, and there will undoubtedly be many changes in the future, not least of which will be brought about by the technological progress; artists are therefore obliged – or enabled – to change their practice as the medium changes. As the internet is integrated with television, and viewed on a larger screen in a more comfortable atmosphere, one challenge for Internet Art will be its new relationship and association with television, video and entertainment.

Key Sites
Dia Center for the Arts, New York: www.diacenter.org
Guggenheim, New York: www.guggenheim.org
Institute for Contemporary Arts, London:
 www.newmediacentre.com
Musée d'Art Contemporain, Montreal: www.macm.qc.ca
Museum of Modern Art, New York: www.moma.org
Tate Gallery, London: www.tate.org.uk
Walker Art Center, Minneapolis: www: walkerart.org

Key Books
C. Sommerer, L. Mignonneau, *Art@Science* (1998)
M. Rush, *New Media in Late 20th-Century Art* (1999)
J. Maeda, *Maeda@Media* (2000)

**Olia Lialina, *My Boyfriend Came Back from the War*, 1996
(www.teleporticia.org/war)** Interactive sites like Olia Lialina's display an affinity with both film and literature, but with the crucial difference that the viewer controls the unfolding of images and text to create new versions of the story.

200 KEY STYLES: A DICTIONARY

* indicates a cross-reference to one of the main entries (pp. 14–288);
‡ indicates one of the 200 entries in this section.

Abbaye de Créteil Community of French artists and writers briefly established at Créteil, France, 1906–8. The new techniques they explored (a simplification of imagery) led to later avant-garde styles such as *Cubism. Marinetti, who visited the community in 1907, drew on their ideas in his theories of *Futurism.

ABC Left-wing architectural group formed in Basel, Switzerland in 1924. Russian El Lissitzky, Dutch Mart Stam and Swiss architects Hannes Meyer, Emil Roth, Hans Schmidt and Hans Wittwer dedicated themselves to designing functionalist, socially relevant buildings, usually in a *Constructivist fashion.

Abstraction-Création International group of artists founded in Paris in 1931 and active until 1936. It promoted abstract art – a form of free expression in a time of increasing political repression – and by the time the group dissolved, members and friends numbered over 400, including many of the most famous artists of the day.

Action Painting Term applied to the work of *Abstract Expressionist artists, especially Jackson Pollock and Willem de Kooning, whose 'gestural' canvases were supposed to express an *Existential element of the artist's personality achieved through the evidently impulsive application of materials; thereby also reminiscent of *Art Informel.

Actionism – see ‡Vienna Action Art

Adhocism Term used to describe the *Postmodernist practice in architecture and design of using and combining pre-existing styles and forms to create a new entity. Title of a book by Charles Jencks and Nathan Silver, published in 1972.

Aeropittura (Italian: aeropainting) The art of the second-generation *Futurists whose work was preoccupied with describing or evoking flight. Announced in 1929, its leading artists – Gerardo Dottori, Tato, Bruno Munari and Fillia – publicized their work in manifestos and exhibitions until the collapse of Italian Fascism in 1944.

Aesthetic Movement Term applied in the 1870s and 1880s in the fine and decorative arts. J. A. M. Whistler and Dante Gabriel Rossetti (see also *Decadent Movement, ‡Japonisme) produced work that sought pleasure in beauty and the autonomy of art.

Affichistes Name adopted by Raymond Hains and Jacques de la Villeglé to refer to their method of art-making since 1949 – making collages from fragments of torn posters (affiches) from the city walls, a method also practised by Mimmo Rotella and François Dufrêne. Later associated with *Nouveau Réalisme.

AfriCobra (African Commune of Bad Relevant Artists) Founded by muralists Barbara Jones-Hogu and Jeff Donaldson. Movement of African American artists who produced high-quality screenprints in fluorescent colours, promoting the doctrine of 'black art for every black home in America'.

Agitprop (Russian abbr.: *agitatsionnaya propaganda*, agitational propaganda) Russian popular art form after the 1917 Bolshevik Revolution. Drawing on folk art as well as developments in modern art (*Futurism, *Suprematism and *Constructivism), artists transformed cities with theatrical events, banners, posters, sculptures, monuments and paintings on trains, trams, walls and buildings, proclaiming the new regime.

AkhRR, AKhR (Association of Artists of Revolutionary Russia) Association formed in Moscow in 1922. Rejecting the legacy of *Suprematism – abstraction – the group advocated a return to figurative realism. Soon had branches throughout the country and government support. Although abolished in 1932, their heroic realism and focus on everyday life paved the way for *Socialist Realism.

Allianz Group of Swiss avant-garde artists, including Max Bill, Walter Bodmer and Richard Lohse, founded in 1931 and active until the 1950s. Group exhibitions and publications brought their work, which relates to *Concrete art and *Constructivism, to the public.

Allied Artists Association (AAA) British group formed by critic Frank Rutter in 1908 to organize annual open exhibitions of international work by progressive artists, like the Parisian ‡Salon des Indépendants. Held from 1908 to 1914 the exhibitions introduced a number of new European developments into the UK.

American Abstract Artists (AAA) Association of abstract painters and sculptors formed in New York in 1936, in reaction to the dominant realistic styles (see *American Scene and *Social Realism). Like the European group ‡Abstraction-Création, the AAA was dedicated to supporting and promoting abstract art in the USA through exhibitions, lectures and publications. By the 1950s it had over 200 members.

American Craft movement American movement after World War II which was aimed at reviving craft traditions through university arts programs, many taught by ex-*Bauhaus students; influential into the 1970s and 1980s.

American Gothic – see *American Scene

Angry Penguins Australian avant-garde magazine and artistic and literary movement of the 1940s. The Melbourne-based group included Arthur Boyd, Max Harris, Sidney Nolan, John Perceval, John Reed and Albert Tucker. Their work is broadly *Expressionist and figurative, and reflects their interest in *Surrealism. Many later became members of the ‡Antipodean group.

Antipodean group Australian group of artists formed in 1959, active until 1960. The Antipodean Manifesto, compiled by art historian Bernard Smith, promoted figurative painting by prominent Australian artists including Arthur Boyd and Clifton Pugh. With Sidney Nolan and Russell Drysdale, whose work spanned *Surrealism and aboriginal art, the group was influential throughout the second half of the twentieth century.

The Apostles of Ugliness – see *Ashcan School

Architext Title of a Japanese periodical and an architectural group founded in 1971 in opposition to ‡Metabolism, rejecting doctrinaire or totalitarian aspects of modernism and promoting pluralism.

Art and Freedom (Arabic: Al-fann wa'l-hurriyya) Egyptian group of *Surrealists founded in 1939. Painters Ramsis Yunan, Fu'ad Kamil, Kamil al-Talamsani, and poet Georges Hunain were inspired by André Breton's Paris group; their manifesto – 'Vive l'Art Dégénéré' (Long Live Degenerate Art) – promoted artistic freedom.

Art & Language Group of British artists and the name of the journal through which they conducted a theoretical analysis and critique of the relationship between art, society and politics, turning theory and criticism into a type of *Conceptual Art. Founded in Coventry in 1968 by Terry Atkinson, David Bainbridge, Michael Baldwin and Harold Hurrell. By 1976 over two dozen members in England and New York.

Art autre (French: Other Art) Term coined by critic Michel Tapié after World War II to refer to art inspired by children's art, naive art and ‡Primitivism, as well as Vasily Kandinsky and *Existentialism. Often used synonymously for *Art Informel and ‡Tachisme.

Art Workers' Coalition (AWC) Pressure group formed in 1969 in New York. Included *Minimalists Carl Andre and Robert Morris, *Conceptual artists Hans Haacke and Dennis Oppenheim, critics Lucy Lippard and Gregory Battcock, among many others. Lobbied museums and galleries to close in protest against the Vietnam War, agitated for artists' rights and for change in museums' policies to include artists in decision-making processes and to increase exhibition space for women and minorities.

Arte Cifra (Italian: Code Art) Italian art tendency developed in opposition to *Conceptual Art and *Arte Povera to express the subconscious encoded in painting. Associated with the work of Sandro Chia, Francesco Clemente, Enzo Cucchi and Mimmo Paladino (see *Transavanguardia).

Arte Generativo Argentinian painting styles of the 1950s characterized by analytical works based on geometric abstraction, following in the tradition of ‡Arte Madí of the 1940s. Eduardo Macentyre and Miguel Angel Vidal produced a manifesto in 1960; their work pursues powerful analyses of line and colour.

Arte Madí Argentinian/Uruguayan art movement of the 1940s, whose manifestos drew together painters, sculptors, writers and musicians in a *Constructivist mode. Carmelo Arden Quin and Gyula Kosice studied the purity of plastic forms; Rhod Rothfuss's shaped canvases prefigure American abstract art techniques.

Arte Nucleare (Italian: Nuclear Art) Movement formed in 1951 by Enrico Baj, Joe Colombo and Sergio Dangelo in Milan, later joined by former *CoBrA artist Asger Jorn. They experimented with *Surrealist automatism and gestural abstraction to create paintings that represented the condition of post-war life in the 'nuclear landscape'.

Arte Programmata (Italian: Programmed Art) Term coined by writer Umberto Eco in 1962 to refer to those artists of the 1960s pursuing ‡Nouvelle Tendance ideas – such as the members of ‡Gruppo N and ‡Gruppo T. Explored movement, optical phenomena and viewer interaction (see *Kinetic Art and *Op Art).

Atelier 5 Architectural firm founded in Berne, Switzerland, in 1955. Original members were Erwin Fritz, Samuel Gerber, Rolf Hesterberg, Hans Hostettler and Alfredo Pini. Early work showed the influence of Le Corbusier and *New Brutalism. Known for their successful low-rise, high-density housing outside Berne.

Atelier Populaire (French: Popular Workshop) Name used by group of striking students from the Ecole des Beaux-Arts de Paris in 1968. They produced over 350 posters, designed and printed anonymously and distributed around the city as a weapon in the struggle for educational reform and to show solidarity with striking factory workers. The strong graphic images and slogans have become visual emblems of the events of May 1968.

Auto-destructive art Art designed to transform or destroy itself, in which the act is an integral part of the creative process, such as *Kinetic artist Jean Tinguely's self-destroying machines. During the 1960s London-based artist Gustav Metzger wrote manifestos, organized lectures, demonstrations and the Destruction in Art Symposium in London (1966).

Les Automatistes Montreal-based group of abstract painters active 1940s–c. 1954. The title came from Paul-Emile Borduas's *Automatisme 1.47* in the group's second exhibition in Montreal in 1947. Other members included Marcel Barbeau, Roger Fauteaux, Pierre Gaureau, Fernand Leduc, Jean-Paul Mousseau and Jean-Paul Riopelle. Inspired by *Surrealist automatism and committed to abstraction, an exhibition in Paris in 1947 brought their work to the attention of French painter and promoter Georges Mathieu (see *Art Informel).

Bad Painting Name of an exhibition of figurative paintings held at the New Museum in New York in 1978. Term came to refer to those painters whose work seemed deliberately crude and abrasive through the use of odd, contrasting materials and colours in order to thwart the concept of 'good taste'. See *Neo-Expressionism.

Barbizon School French group of painters of the mid-nineteenth century whose plein air approach to landscape painting directly influenced the *Impressionists.

Bay Area Figuration Movement of the 1950s in the San Francisco Bay Area in northern California, led by artists such as Elmer Bischoff, Joan Brown, Richard Diebenkorn and David Park. Their deliberate return to figurative subject matter reflected the influence of the *Beats and a rejection of East Coast *Abstract Expressionism.

Black Expressionism Figurative style developed in African American art of the 1960s and 1970s. Influenced by *Abstract Expressionism, ‡Color Field Painting and ‡Hard-Edge Painting, the movement grew out of political unrest and civil rights protests; the work often incorporated political slogans and made prominent use of black, red and green (from the Black Nationalist flag).

Black Mountain College Arts college situated in Black Mountain, North Carolina, 1933–57. John Cage, Merce Cunningham, Buckminster Fuller and poets associated with the *Beat generation were among those who taught there, as well as many former *Bauhaus teachers and students. Fostered an atmosphere of community and experimentation. Famous students included Robert Rauschenberg (see *Neo-Dada), Ray Johnson (see *Fluxus, ‡Mail Art), Kenneth Noland (see *Post-painterly Abstraction) and Cy Twombly (see *Neo-Expressionism).

Black Neighborhood Mural Movement Originating in Chicago in the early 1960s, a form of non-museum oriented art that transformed certain run-down areas in Detroit, Boston, San Francisco, Washington, D.C., Atlanta and New Orleans.

Blok Group of Polish *Constructivists active in Warsaw 1924–26, including Henryk Berlewi, Katarzyna Kobro and Wladyslaw Strzeminski. Spread their ideas through exhibitions and eleven issues of magazine, *Blok*. Disagreements between those advocating a 'laboratory' Constructivism and those who believed in the artist as designer, maker and manufacturer led to the group's dissolution, with many joining the ‡Praesens group.

Bloomsbury Group An informal association of friends, mostly artists and writers, including Virginia Woolf, E. M. Forster, Clive Bell, Vanessa Bell, Roger Fry, Duncan Grant and John Maynard Keynes. Many lived in the Bloomsbury area of London from around 1907 until the late 1930s. Promoted the decorative arts (see ‡Omega Workshops) and new art movements, particularly *Post-Impressionism.

Blue Four (German: Die Blaue Vier) German group of artists founded in 1924 at the *Bauhaus, consisting of Vasily Kandinsky, Paul Klee, Alexei von Jawlensky and Lyonel Feininger. Formerly associated with *Der Blaue Reiter, the group exhibited together for about ten years, especially in the USA, Germany and Mexico.

Blue Rose (Russian: Golubaya Roza) Group of Russian painters active 1904–08; title of a Moscow exhibition in 1907. Associated with Nikolay Ryabushinsky's *Golden Fleece* magazine, and characterized by otherworldly *Symbolism (especially images of flowers), artists included Mikhail Vrubel and Viktor Borisov-Musatov. See also *World of Art.

BMPT Paris-based group of French and Swiss artists (from the initial letters of their surnames), active as a group 1966–67. Daniel Buren, Olivier Mosset, Michel Parmentier and Niele Toroni enacted a *Conceptual critique of the cult of the artist and originality; they drew attention to the reception of art and the aura that art confers on a place or individual.

Bowery Boys Nickname for a group of young artists in New York who lived near each other on the Bowery during the 1960s. Most associated with *Minimalism, such as Tom Doyle, Eva Hesse, Sol LeWitt, Robert Mangold, Dan Flavin and Robert Ryman and critic Lucy Lippard. Many met while working at the Museum of Modern Art and went on to show at the Dwan Gallery.

Camden Town Group Group of British painters formed in 1911 at the instigation of *Impressionist Walter Sickert. Included Walter Bayes, Spencer Gore, Duncan Grant, Augustus John and Wyndham Lewis, among others. Through their work they introduced *Post-Impressionism into the UK. After three exhibitions in 1911–12, merged with a number of smaller groups to become the ‡London Group.

Canadian Automatistes – see ‡Les Automatistes

The Canadian Group of Painters Expanded group formed after the dissolution of the ‡Group of Seven in 1933. Continued the nationalist-landscape emphasis of the earlier group and dominated Canadian art until the 1950s when challenged by the ‡Painters Eleven and ‡Les Automatistes. Disbanded in 1969.

Cercle et Carré (French: Circle and Square) Movement found in Paris in 1929 by writer Michel Seuphor and painter Joaquín Torres-García. Through a large group exhibition and a periodical, promoted *Constructivist tendencies in abstract art in opposition to the dominance of *Surrealism. Although short-lived (ended in 1930), its promotion of abstract art was taken up by the ‡Abstraction-Création group.

Chicago Imagists Figurative expressionist painters in Chicago, late 1960s and 1970s. Particularly drawn to *Outsider Art, many were enthusiastic collectors. Encompassed the ‡Hairy Who and others such as Don Baum, Roger Brown, Eleanor Dube, Phil Hanson, Ed Paschke, Barbara Rossi and Christina Ramberg.

Cold Art (German: Kalte Kunst) Term used from the 1950s to refer to art derived from mathematical formulae, often in geometric arrangements of colours. Associated also with *Op Art and *Kinetic Art, it is often used to describe the work of Swiss painters Karl Gerstner and Richard Paul Lohse.

Color Field Painting Style of *Abstract Expressionist painting that employs unified areas of colour. Term derives from the writings of critic Clement Greenberg in the mid-1950s. Used to refer to work by Barnett Newman, Mark Rothko, Clyfford Still and others, in contradistinction to 'gestural' painting (or ‡Action painting, e.g. by Jackson Pollock). Later associated with ‡Hard-Edge Painting, *Minimalism and *Op Art.

Common-Object Artists – see *Neo-Dada

Computer Art Umbrella term from the 1950s and 1960s which became outmoded as the use of computers increased. Early examples include computer-generated images whose sophistication developed progressively through the 1970s, eventually following notions of interactivity in the 1980s, creating links with other forms (film, *Video Art, *Internet Art) which have largely superseded the term itself.

Continuitá Italian group of artists formed in 1961, partly by ex-members of abstract art group ‡Forma. Embracing various styles from *Expressionism to

formalism, later members included Lucio Fontana and Giò Pomodoro. Advocated a return to great Italian art, and a sense of continuity within the production and environment of the artwork itself.

Coop Himmelblau Viennese architectural group founded in 1968 by Wolf D. Prix, Helmut Swiczinsky and Rainer Michael Holzer. Their interest in conceptual architecture led to imaginative utopian designs evoking aggression and tension: their Groninger Museum, Groningen, the Netherlands, is designed to rust away. They exhibited at the 1988 Deconstructivist Exhibition in New York.

Corrente Anti-Fascist Italian art movement, active 1938–43, named after a Milan-based journal. Opposed to ‡Neo-classicism (see *Novecento Italiano) and geometric abstraction. Members included Renato Birolli and Renato Guttuso. After World War II many joined the ‡Fronte Nuovo delli Arti.

Crafts Revival Revival of interest in the crafts ideal, particularly strong in Britain, the USA and Scandinavia, since the 1950s. Concentration on quality and individuality, and use of materials associated with industrial design in a one-off mode marked the return of the designer-maker.

Cubist-Realism – see *Precisionism

Cubo-Futurism Russian style of *Cubism practised by Natalia Goncharova, Mikhail Larionov, Kasimir Malevich, Liubov Popova, Vladimir Tatlin and Nadezhda Udaltsova between 1912 and 1916, particularly engaged with architectonic figures and cylindrical forms. See also *Jack of Diamonds and *Rayonism.

Danish Modern Term coined during the 1950s when Danish furniture design achieved international renown for meticulous craftsmanship and attention to detail. It suggests the aesthetic of elegant sculptural forms and the retention of natural finishes characteristic of work by Nana and Jorgen Ditzel, Finn Juhl, Arne Jacobsen and Borge Mogensen.

Dau al Set (Catalan: seven-sided die) Catalan group established in 1948 by writers and artists inspired by *Dada and *Surrealism, especially the art of Miró and Klee. Members (who included Antoni Tàpies and Joan-Josep Tharrats) concerned themselves particularly with the subconscious, the occult and magic.

Deconstructivist architecture Influenced by French philosophical ideas of deconstruction, a tendency of architectural *Postmodernism that challenges accepted modes of building, experimenting with three-dimensional representations that often invoke fantasy (‡Coop Himmelblau) or dislocate received ideas of history and function as expressed through architecture.

Degenerate art (German: Entartete Kunst) Defamatory title of a 1937 exhibition mounted in Munich by Nazi propaganda minister Goebbels, showing avant-garde art (esp. by those associated with *Expressionism, *Dada, *Bauhaus, *Neue Sachlichkeit, *Constructivism) in a declared attempt to rid Germany of impure foreign influence. Some 16,000 works were confiscated and 5000 burnt by order. Avant-garde artists who remained in Germany were forbidden to paint or to exhibit.

Devetstil Group The name, from a combination of the words meaning 'nine' and 'forces', of a left-wing avant-garde group of architects, painters, photographers, writers and poets, in Czechoslovakia. Founded by critic Karel Teige and active 1920–31, its members included Josef Chocol, Jaroslav Fragner, Jan Gillar, Josef Havlicek, Karel Honzík, Jaromír Krejcar, Evzen Linhart and Pavel Smetana. Advocated injecting poetry and lyricism into utilitarian functionalism.

Divisionism Term coined by *Neo-Impressionist Paul Signac to describe application of colour in patches

or dots (see also ‡Pointillism). Technique adopted by *Les Vingt, Matisse, Klimt, Mondrian and early work by the *Futurists. See also *Orphism, *Fauvism.

Donkey's Tail (Russian: Oslinyy Khvost) Russian group of painters active 1911–15 led by Mikhail Larionov and Natalia Goncharova (see *Jack of Diamonds, *Rayonism) preferring traditional Russian art forms to German and French influences.

Eccentric Abstraction Name of an exhibition organized by American critic Lucy Lippard in New York in 1966. The term was applied to sculptors such as Louise Bourgeois, Eva Hesse, Keith Sonnier and H. C. Westermann, whose work showed affinities with *Minimalism, but had an erotic, sensual or humorous twist and an *Expressionist, *Dadaist or *Surrealist sensibility.

Ecole de Nice (French: School of Nice) Community of artist-friends located in and around Nice during the 1960s. Stylistically diverse, including *Nouveau Réalistes Arman, Yves Klein and Martial Raysse, and *Fluxus members Ben, George Brecht and Robert Filliou, amongst others, the name was to indicate the fact that interesting and important work could be made and shown beyond the Paris–New York axis.

The Eight American painters who joined Robert Henri in 1907 in reaction to the National Academy of Design's exclusive exhibition policy. Henri, Arthur B. Davies, William Glackens, Ernest Lawson, George Luks, Maurice Prendergast, Everett Shinn and John Sloan organized an independent exhibition in New York in 1908. With individual styles that ranged from urban realism (see *Ashcan School) to *Impressionism, *Post-Impressionism and *Symbolism, they made a stand for stylistic freedom and artistic independence.

Equipo 57 (Spanish: Team 57) Spanish group of artists formed in Córdoba in 1957, active until 1966. José Ceunca, Angel Duarte, José Duarte, Agustín Ibarrola and Juan Serrano worked together collectively and anonymously along lines similar to others of the ‡Nouvelle Tendance, with whom they were included in numerous international exhibitions throughout the 1960s.

Equipo Crónica (Spanish: Chronicle Team) Group of Spanish artists formed in Valencia in 1964 and dissolved in 1981. Members included Rafael Solves and Manolo Valdés. Rejecting the subjectivity of expressive abstraction, they worked collaboratively and figuratively, producing *Pop-inflected work in a graphic style that incorporated familiar images from European art history; they opposed Franco's regime.

Equipo Realidad (Spanish: Reality Team) Spanish artists Jordi Ballester and Joan Cardella worked together in Valencia as Equipo Realidad from 1966–76. Like ‡Equipo Crónica, they produced figurative works to critique Spanish society and politics. Used the language and imagery of the mass media to draw attention to the role of advertising and propaganda in Franco's Spain. Part of the European ‡Figuration Narrative movement.

Európai Iskola (Hungarian: European School) Formed in Budapest by Imre Pan in 1945 to defend new artistic developments and to promote 'synthesis between East and West'. Close ties with *Surrealist André Breton; organized 38 exhibitions, including ones with ‡Skupina Ra and ‡Skupina 42, as well as Surrealists in Romania and Austria. Disbanded in 1948 due to attacks from those supporting official cultural policy, although continued to meet occasionally underground with Pan, his brother, poet A. Mezei, and Lajos Kassák (see *Hungarian Activism).

Euston Road School English group of painters named by critic Clive Bell in 1938. William Coldstream, Claude Rogers, Victor Pasmore and others reacted against *Surrealism and abstraction, painting

in a realist style on urban themes. Coldstream's teaching at the Slade 1949–75 was influential; Pasmore later turned to abstract art.

Experiments in Art and Technology (E.A.T.) Founded in 1966 by American *Neo-Dada artist Robert Rauschenberg and engineers Billy Klüver and Fred Waldhauer for multimedia artists wanting to incorporate new technologies into their work by matching artists with engineers and scientists. By 1968 around 3000 members worldwide. By the mid-1990s had aided in the production of over forty collective projects. See also *GRAV.

Factual Artists – see *Neo-Dada

Fantastic Realism Name given to the style of Vienna-based Austrian artists Erich Brauer, Ernst Fuchs, Rudolph Hausner, Wolfgang Hutter and Czech-born Anton Lehmdem, who came to prominence around 1945. Characterized by *Surrealist style tinged with minute realism and an interest in the work of the fantastic painters of the past, such as Bruegel the Elder and Hieronymus Bosch.

Feminist Art Workers Californian *performance group active 1976–80. Toured California and the Midwest with performances and workshops addressing violence against women, equal rights, female identity and empowerment. Members included Nancy Angelo, Candace Compton, Cherie Gaulke, Vanalyn Green and Laurel Klick.

Figuration Libre (French: Free Figuration) Term coined by the artist Ben (see *Fluxus) to describe a trend in French painting in the early 1980s in the work of artists such as Jean-Michel Alberola, Jean-Charles Blais, Rémy Blanchard, François Boisrond, Robert Combas and Hervé Di Rosa. Marked a return to painting, figuration and popular culture (see *Neo-Expressionism, *Neo-Pop and *Transavanguardia). Takes its inspiration from youth culture, comics, television, advertising and rock music.

Figuration Narrative (French: Narrative Figuration) Term used by French critic Gérald Gassiot -Talabot to distinguish a strain of the European ‡Nouvelle Figuration of the 1960s in which the depiction of time was a defining feature. Work by Arroyo, Leonardo Cremonini, Dado, Peter Foldès, Peter Klasen, Jacques Monory, Bernard Rancillac, Hervé Télémaque and Jan Voss draw on cinema and comic strips.

Forces Nouvelles French group of painters founded in Paris in 1935, largely as an exhibition group returning to tradition, nature and still life. Continued until 1943.

Forma Italian group founded in 1947 by self-proclaimed 'formalists and Marxists', who opposed the ‡Fronte Nuovo delle Arti. Members (including Carla Accardi, Piero Dorazio and Giulio Turcato) developed abstract art influenced by Giacomo Balla (see *Futurism), and several went on to found ‡Continuità.

Fronte Nuovo delle Arti Italian group of artists founded in 1946 to revitalize Italian art after the demise of *Futurism and *Pittura Metafisica during World War II. Its diverse styles followed naturalism, abstraction and late works by Picasso; the work of prominent members (including Renato Guttuso, Emilio Vedova and Alberto Viani) was characterized by politically engaged social realism.

General Idea Canadian *Conceptual art group formed in Toronto in 1968 by Michael Tims (alias A. A. Bronson), Ron Gabe (alias Felix Partz), and Jorge Saia (alias Jorge Zontal). Working under their pseudonyms in exhibitions, performances, installations and publications, they seek to call attention to and subvert the pretensions of the art world and North American culture in general.

Glasgow School Three distinct classifications often confused by the same name: (1) Glasgow-based group of painters in the late nineteenth century, also known as the Boys, who rejected the authority of the Scottish Royal Academy in Edinburgh; (2) late nineteenth-century French-influenced realist painters led by William Yorke Macgregor; (3) term sometimes associated with architect Charles Rennie Mackintosh, denoting early twentieth-century Scottish *Art Nouveau style influenced by the *Arts and Crafts movement.

Gran Fury American activist art collaborative formed in 1988 by artists and designers affiliated with ACT-UP (AIDS Coalition to Unleash Power). Through provocative information-based posters, exhibitions and interventions, the group seeks to attack prejudice and indifference and raise awareness about the AIDS epidemic and gay and lesbian rights.

Green architecture Approach to designing with respect for the immediate and global environment. The aim is to strike a harmonious balance between the built and natural environments with economical, energy-saving, environmentally friendly, sustainable strategies for development that take into account the needs of the community. Stemming from concerns mooted by Buckminster Fuller and Frank Lloyd Wright early in the twentieth century, it has grown into an international movement.

Green Mountain Boys Nickname for group that formed around critic Clement Greenberg in the 1960s and supported his formalist aesthetic (German *Berg*: mountain). Included artists Paul Feeley, Helen Frankenthaler, Morris Louis, Kenneth Noland, Jules Olitski and Anthony Caro, critic Rosalind Krauss, dealer André Emmerich, among others. Curator Alan Solomon used the name to allude to Greenberg and Bennington College in Vermont, where many of the artists taught.

Group of Plastic Artists – see ‡Skupina Vytvarnych Umelcu

Group of Seven Canadian group of painters formed in 1920, disbanded in 1933. Lawren Harris, A. Y. Jackson, and J. E. H. MacDonald, among others, mostly based in Ontario, claimed to have created a genuinely 'Canadian' art with their stylized landscape paintings of the northern territories. Despite resentment from artists in other territories, particularly Quebec, they were successful and popular, expanding to become the ‡Canadian Group of Painters.

Group X Group formed in London after World War I by British painter and writer Wyndham Lewis and American painter and illustrator Edward McKnight Kauffer in an attempt to carry on the spirit of *Vorticism. Included former Vorticists Jessica Dismorr, Frederick Etchells, William Roberts, Edward Wadsworth and others such as Frank Dobson and Charles Ginner. Disbanded after an exhibition at the Mansard Gallery in 1920.

Gruppo N Group of Italian artists formed in Padua in 1959, included Alberto Biasi, Ennio Chiggio, Toni Costa, Edoardo Landi and Manfredo Massironi. Throughout the 1960s supported experimental art, particularly of a *Concrete, *Kinetic and *Op tendency. Disbanded in 1967.

Gruppo T Milan-based group of Italian artists formed in 1959, active until 1968. Members included Giovanni Anceschi, Davide Boriani, Gianni Colombo, Grazia Varisco and Gabriele de Vecchi. Interested in *Kinetic Art and viewer interaction. Included in the ‡Nouvelle Tendance exhibitions in Europe.

Guerrilla Art Action Group (GAAG) One of the most radical activist art groups of the Vietnam era. Formed in New York in 1969 by Jon Hendricks, Jean Toche, Poppy Johnson, Joanne Stamerra and

Virginia Toche. Through manifestos, press releases, performances-actions, art strikes and street protests, they agitated for political and social change. Disbanded in 1976.

Guerrilla Girls New York-based activist group of anonymous women artists, formed in 1985 with the motto: 'We intend to be the conscience of the art world.' Strategies used to unmask and critique individuals and institutions in the art world which exclude or under-represent women and minorities, include plastering posters around New York City with statistical reports and appearing in public on panels and lectures wearing gorilla masks and miniskirts.

Gutai Group (Japanese: Concrete Group) Japanese group of young avant-garde artists founded by Jiro Yoshihara in Osaka in 1954, active until 1972. Members included Akira Kanayama, Sadamasa Motonaga, Shuso Mukai, Saburo Murakami, Shozo Shimamoto, Kazuo Shiraga and Atsuko Tanaka. Their output ranged from *Art Informel paintings to *Kinetic, *Performance Art and *Earth Art. Exhibitions, manifestos and a periodical brought their work and ideas to an international audience.

Hairy Who Exhibition group of six artists in Chicago in the late 1960s: James Falconer, Art Green, Gladys Nilsson, James Nutt, Suellen Rocca and Karl Wirsum. Drew on advertising, comics, adolescent humour and *Outsider Art to produce a *Surrealist-*Funk-*Pop hybrid art. Associated with the ‡Chicago Imagists.

Halmstadgruppen (Swedish: Halmstad Group) Group formed in 1929 by six Swedish artists from Halmstad – Sven Johnson, Waldemar Lorentzon, Stellan Mörner, Axel Olson, Erik Olson and Esaias Thorén. Particularly known for their support of *Surrealism during the 1930s, when they were the major Swedish participants in various international Surrealist exhibitions.

Happenings 'Something to take place; a happening' (Allan Kaprow, 1959). The term inspired work by a variety of *Conceptual and *Performance artists including Kaprow, members of *Fluxus, Claes Oldenburg, Jim Dine; combined elements of theatre and gestural painting.

Hard-Edge Painting Term coined in 1958 as an alternative to 'gestural abstraction', but used to describe works comprised of separate large flat forms (Ellsworth Kelly, Kenneth Noland, Barnett Newman, Ad Reinhardt). See also *Abstract Expressionism, *Post-painterly Abstraction.

Harlem Renaissance African American movement derived from the 1920s 'New Negro' movement in New York. Although at first mainly a political and literary group, prominent painters (Aaron Douglas, Meta Vaux Fuller, Palmer Hayden) incorporated African imagery into portrayals of Harlem life.

Hi Red Center Japanese artists Jiro Takamatsu, Genpei Akasegawa and Natsuyuki Nakanishi were active in Tokyo from 1962–64, performing street actions and *performances critical of post-war Japanese culture. The name was formed from the Americanized versions of the first syllables of their names: Taka (high), Aka (red) and Naka (center). A number of their pieces were recreated in New York with members of *Fluxus.

Imaginistgruppen (Swedish: Imaginist Group) Swedish group found by C. O. Hultén, Anders Österlin and Max Walter Svanberg in 1946, active until 1956. Other members included Gösta Kriland, Bertil Lundberg, Bengt Orup, Bertil Gado, Lennart Lindfors and Gudrun Åhlberg-Kriland. Stressing the importance of the imagination in the creative process, they used *Surrealist styles and techniques, and were included in Surrealist and *CoBrA exhibitions.

Independent Group Group of artists founded at the Institute of Contemporary Arts (ICA) London between 1952 and 1953. Members included architects (Alison and Peter Smithson, see *New Brutalism) and artists (Richard Hamilton, Eduardo Paolozzi) whose influence had a notable effect on British *Pop Art.

Inkhuk (from Russian: Institut Khudozhestvennoy Kultury, Institute of Artistic Culture) Soviet art research institute (1920–26) founded by members of ‡Narkompros, Moscow. Key members were Vasily Kandinsky, Vladimir Tatlin, Kasimir Malevich, also Alexander Rodchenko, Liubov Popova and Varvara Stepanova.

Intimisme Term referring to paintings of 'intimate' private domestic interiors, typically by Pierre Bonnard and Edouard Vuillard at the end of the nineteenth century. Both artists belonged to the *Nabis; their subject matter evolved into a quiet meditative style also concerned with decorative pattern.

Japonisme Term used to indicate the recurring influence of Japanese art on Western (particularly European) art groups, especially the *Nabis, the *Post-Impressionists, *Arts and Crafts, *Art Nouveau and the *Expressionists. Printmaking techniques, particularly woodcuts, were a regular focus of attention.

Jeune Peinture Belge (French: Young Belgian Painting) Brussels-based group of avant-garde artists active 1945–48. Formed by critic Robert Delevoy and lawyer René Lust to support contemporary art, its members included the future *CoBrA artist Pierre Alechinsky and Gaston Bertrand, Anne Bonnet, Pol Bury, Marc Mendelson and Louis Van Lint, among others. Their work showed the influence of Flemish *Expressionism and introduced aspects of *Art Informel.

Junk Art Critic and curator Lawrence Alloway began using the term in 1961 to refer to paintings and sculptures made out of worthless materials and urban refuse, such as the *Combines of Robert Rauschenberg and the *Assemblages by many *Nouveau Réalistes, *Neo-Dada, *Beat and *Funk artists. The interest in everyday objects and the environment led into ‡Happenings and *Pop Art.

Light Art Art in which light is a major component came to art world attention in 1966–68 with a number of important international exhibitions. Major practitioners include those working with neon, such as Stephen Antonakos, Chryssa, Bruce Nauman (see *Body Art) and *Nouveau Réaliste Martial Raysse, and those creating environments and spectacles, such as *Minimalist Dan Flavin and members of ‡Zero and *GRAV.

London Group British society formed in 1913 from smaller groups, such as the ‡Camden Town Group, to organize joint exhibitions in opposition to the conservatism of the Royal Academy. Founder-members included many future *Vorticists; later members of the ‡Bloomsbury Group were influential.

Luminism (1) American landscape painting of the nineteenth century, seen as a precursor of *Impressionism; (2) term applied to Belgian *Neo-Impressionism after the demise of *Les Vingt; also developed in the Netherlands with *Fauvist characteristics.

Lyrical Abstraction (French: Abstraction Lyrique) Term introduced after 1945 by French painter Georges Mathieu to describe a mode of painting that resisted all formalized approaches, to convey spontaneous expressions of cosmic purity. Wols, Hans Hartung and Jean-Paul Riopelle were among those associated with the term. See also *Art Informel.

Machine Aesthetic Term applied to art and architecture that celebrates the machine as a source of beauty. The *Futurists and the *Vorticists welcomed

the machine age and the promise of technological transformation that it brought. Le Corbusier (see *Purism) pursued formal idealism through the machine, and in the late twentieth century *High-Tech architects continued to explore the theme.

Machine Art Russian *Constructivist tendency of the 1920s that set the mastery of technology against bourgeois romantic notions of art. Vladimir Tatlin's Monument to the Third International and his flying machine *Letatlin* express the pursuit of power and sheer technical passion behind the construction of progressive art.

Mail Art (or Correspondence Art) Term first used in the 1960s to describe artworks sent through the post, especially by American artist Ray Johnson, and other artists associated with *Fluxus, *Nouveau Réalisme and the ‡Gutai group. Exploring the possibilities of communication between the artist, the public and the market, Mail Art has also been linked with *Performance Art and *Conceptual Art.

Matter Painting – see *Art Informel

Mec Art The term (short for mechanical art) began to be used around 1965 to describe the work of Serge Béguier, Pol Bury, Gianni Bertini, Alain Jacquet, Nikos and Mimmo Rotella, among others. Promoted by French critic Pierre Restany, who saw the 'language of mass communication' as the starting point of their work. They used photomechanical processes to alter rather than reproduce images, in order to subvert the language of the mass media. Their work was prominent in major exhibitions throughout Europe until around 1971.

Metabolism The manifesto, 'Metabolism 1960: Proposals for a New Urbanism', heralded a new movement in Japanese architecture. Members included Kiyonori Kikutake and Kisho Kurokawa. The group promoted understanding of organic change in urban environments, as implied by the borrowed biological term they adopted for their name.

Mexican Muralists Modern art movement that flourished in Mexico from around 1910 into the 1950s. The Muralists sought to create a socially and politically committed popular public art based on a fusion of European styles and native traditions. Diego Rivera, José Clemente Orozco and David Alfaro Siqueiros are the best known. They all painted major murals in the USA during the 1930s, which were particularly influential for the *Social Realists.

Minotaurgruppen (Swedish: Minotaur Group) Swedish *Surrealist group formed in 1943 in Malmö. Its members, C. O. Hultén, Endre Nemes, Max Walter Svanberg, Carl O. Svensson and Adja Yunkers, had one exhibition together in Malmö before the group was dissolved later in 1943. Hultén and Svanberg continued to support Surrealism as founder-members of the ‡Imaginistgruppen.

Mono-ha (Japanese: School of Things) Name given to a prominent sculptural trend in Japan 1968–72, in the work of artists such as Susumu Koshimizu, U-fan Lee, Nobuo Sekine, Kishio Suga and Katsuro Yoshida. Their work usually took the form of assemblages of found and natural materials or temporary site-specific interventions in the environment. The emphasis on the expressive qualities of materials, on the relationships between parts of an object and with an object and its surrounding space, was shared by a number of *Minimalist, *Arte Povera and *Earth artists.

Monster Roster Chicago-based artists during the late 1940s and 1950s working in a figurative expressionist mode, reflecting the influence of native Chicago artist Ivan Albright's *Magic Realism, Jean Dubuffet's *Art Brut and *Outsider Art. George Cohen, Cosmo Compoli, Ray Fink, Joseph Gato, Leon Golub, Ted Halkin, June Leaf and Seymour

Rosofsky were among those dubbed the 'Monster Roster' by painter Franz Schulze in 1959.

Movimento Arte Concreta (MAC) Italian *Concrete Art movement founded by Atanasio Soldati, Bruno Munari, Gianni Monnet and Gillo Dorfles in 1948 in Milan. Lucio Fontana and Giuseppe Capogrossi were also associated with the movement. Other groups formed in Turin, Naples and Florence. Rejected both the heritage of *Novecento Italiano and the social realism of the era in favour of a rational abstraction. Disbanded in 1958.

Multiples Term coined in the mid-1950s to refer to series of artworks in mostly limited editions. Used by *Fluxus and *Pop artists, they were conceived for reproduction or distribution.

Nancy School Emile Gallé and his followers in Nancy in France, including Emile André, Eugène Vallin, Jacques Grüber, Louis Majorelle and the Daum Brothers, Auguste and Antonin. Known for their elegant, exquisite *Art Nouveau furniture and glass-ware inspired by nature, Roman and ancient art and art of the Near and Far East.

Narkompros (Russian abbr.: Narodnyy Komis-sariat Proveshchen-iya, People's Commissariat for Enlightenment) Soviet government agency formed in Russia in 1917. Several members of the avant-garde served in the fine arts department (*Constructivists, *Suprematists, ‡Cubo-Futurists); they quit in about 1920, when the agency began to follow Communist Party ideology ever more closely.

National Romanticism Term used from the late nineteenth century to designate art and architecture rooted in a given region. Particularly prevalent in Germany and Scandinavia into the twentieth century, linked to the revival of native folk art and indigenous architectural forms, and hence also to certain aspects of nationalist politics.

National Socialist Art (or Nazi art) After 1933 Hitler's National Socialist party severely regulated the creation and exhibition of new art, effectively banning avant-garde styles and promoting German Renaissance and Romantic styles typical of salon painting of the nineteenth century. Public sculpture (and architecture) aimed to foster monumental heroic ideas based on nationalist versions of history that endorsed aggression in the service of the Reich.

NATO (Narrative Architecture Today) Group formed by architect and interior designer Nigel Coates in London in 1983, with Tom Dixon and Daniel Weil. Embraced the use and reuse of modern imagery. Stressed that design – interior, furniture, architecture, town planning – could and should tell stories, in favour of providing pleasure and interest over efficiency.

Nederlandse Experimentele Groep (Dutch: Experimental Group) Group of Amsterdam artists, including Karel Appel, Eugène Brands, Constant, Corneille, Anton Rooskens and Theo Wolvecamp, formed in 1948. Through their journal *Reflex* they promoted the more expressionist tendencies of *Art Informel principles. Influenced by the work of Jean Dubuffet (see *Art Brut) and resisted the sterility of geometric abstraction. Joined others later in the year in Paris to become *CoBrA.

Neo-classicism Trend in art and architecture recalling ancient Greek and Roman ideals. In the late nineteenth and early twentieth centuries, those who touched on neo-classical themes included Picasso (around 1914), *Pittura Metafisica artists, architects in Italy and Germany, especially between the world wars, and later, several exponents of *Postmodernism.

Neo-Dada Organizers Group of Japanese artists active in Tokyo 1960–63, included Genpei Akasegawa, Shusaku Arakawa (see *Conceptual Art),

Tesumi Kudo, Tomio Miki and Masunobu Yoshimura. Taking a more aggressive stance than the ‡Gutai Group, they sought to destroy artistic conventions with ‡Junk Art that showed the influence of Robert Rauschenberg and Jasper Johns (see *Neo-Dada) and street actions.

Neo-Geo Name given to the work of painters such as Peter Halley, Peter Schuyff, Philip Taaffe and Meyer Vaisman, whose paintings of the 1980s revived the forms of various types of geometric abstraction (see *Op Art, *Concrete Art and *Post-painterly Abstraction), seemingly to parody and challenge the utopian aspirations of early practitioners of geometric abstraction.

Neo-Liberty Term used, originally in derision, to describe the revival of *Art Nouveau (called Stile Liberty in Italy) forms during the late 1950s and 1960s in Italy. The curvilinear furniture, lighting and interior designs of Franco Albini, Gae Aulenti, Vittorio Gregotti and Carlo Mollino (see *Organic Abstraction) reflected the influence of *Pop Art and design as well as Stile Liberty.

Neo-Plasticism Piet Mondrian's pamphlet *Le Néo-Plasticisme* (1920) described his style of abstract painting, incorporating flat planes of white, grey and primary colours, between black horizontal and vertical lines in an attempt to attain a universal form capable of expressing cosmic truths. See *De Stijl.

Neo-Primitivism Folk-derived style of painting which flourished in Russia from around 1908–12. Characteristic work by *Jack of Diamond members Natalia Goncharova, Mikhail Larionov and the Burliuk brothers, fused aspects derived from European avant-garde movements, such as *Fauvism and *Impressionism, with the traditions of native folk art and children's art.

Neo-Realism Term variously applied throughout the twentieth century, especially in Britain and France, to refer to artists painting in a representational style, reacting against abstraction. In France in the 1920s and 1930s it referred to an unofficial group characterized by the work of André Dunoyer de Segonzac. In Italy the term was associated with Renato Guttuso's social realist paintings. Not connected with *Nouveau Réalisme of the 1960s.

Neue Künstlervereinigung München (German: New Artists' Association of Munich) Exhibiting group founded in 1909. Prominent members included Vasily Kandinsky, Alexei von Jawlensky, Gabriel Münter, Franz Marc and Alfred Kubin. Kandinsky and Marc left in 1911 to organize the *Blaue Reiter exhibition, signalling the end of the group in 1912.

Neue Wilden (German: New Savages, New Wild Ones) Term used in Germany during the 1980s to refer to *Neo-Expressionists working in Berlin and Cologne, such as Luciano Castelli, Rainer Fetting, Salomé, Helmut Middendorf and Bernd Zimmer.

New Image Painting Term covering a wide variety of styles, but marking the widespread return to figuration in painting of the 1970s and 1980s (see also *Neo-Expressionism) in the USA by artists such as Nicholas Africano, Jennifer Bartlett, Neil Jenney, Robert Moscowitz, Donald Sultan, Susan Rothenberg and Joe Zucker. Also the title of an exhibition held at the Whitney Museum of American Art in New York in 1978, 'New Image Painting'.

New Perceptual Realism Term used to describe figurative realist painting during the 1960s by artists such as Alex Katz, Alfred Leslie, Philip Pearlstein and Neil Welliver. Their work was a rejection of not only abstraction, but also painterly figuration, the commercial subject matter of *Pop Art and the mechanical means used by Pop and *Super-realist artists.

New Realism Term used during the late 1950s and 1960s to encompass the range of reactions to *Abstract Expressionism and *Art Informel by artists turning their backs on abstraction and overt emotionalism in favour of a cooler approach and a return of the figure and literalism. See *Neo-Dada, *Nouveau Réalisme, *Pop Art, *Super-realism and ‡New Perceptual Realism.

New York Five Loose association of five New York-based architects who came to prominence during the late 1960s and 1970s: Peter Eisenman, Michael Graves, Charles Gwathmey, John Hejduk and Richard Meier. They looked back to the early European avant-garde – movements such as Le Corbusier's *Purism, Giuseppe Terragni's Rationalism (see *M.I.A.R.) and Gerrit Rietveldt's *De Stijl – to develop their purist style.

New York Realists – see *Ashcan School

New York School – see *Abstract Expressionism

Nouvelle Figuration (French: New Figuration) Term coined by the critic Michel Ragon to describe the figuration emerging in Europe during the 1960s by artists such as Valerio Adami, Gilles Aillaud, Eduardo Arroyo, Erró, Peter Klasen, Jacques Monory, Peter Stämpfli, Antonio Recalcati and Hervé Télémaque. It was seen as both a reaction to the dominance of abstraction and *Nouveau Réalisme and a challenge to American *Pop Art.

Nouvelle Tendance (French: New Tendency) Movement founded in Zagreb in 1961 by Brazilian painter Almir Mavignier, Serbian critic Marko Mestrovich and Croatian director of the Zagreb Gallery of Contemporary Art, Bozo Bek. Led to a series of international exhibitions throughout Europe which united the various groups of artists around the world experimenting with *Concrete, *Kinetic and *Op Art, such as *GRAV, ‡Gruppo T and ‡Gruppo N and ‡Zero.

Nul (Dutch: Zero) Group begun by Dutch artists Armando, Jan Henderikse, Henk Peeters and Jan Schoonhoven in 1960. Named after German ‡Zero group and exhibited together with them often, as well as with *GRAV, ‡Gruppo T and ‡Gruppo N. Rejected the expressionism of the 1950s and advocated looking at reality and ordinary things anew, with work that stresses anonymity, repetition and ordering. Active as a group until 1967.

Nyolcak (Hungarian: The Eight) Hungarian avant-garde group of artists active 1909–12. Róbert Berény, Béla Czóbel, Dezso Czigány, Károly Kernstok, Ödön Márffy, Dezso Orbán, Bertalan Pór and Lajos Tihanyi joined forces to oppose the subjectivity and sentiment of the *Impressionist style holding sway and to advance the cause of art with a social function that was relevant to modern society. Cleared the way for the even more radical group of *Hungarian Activists.

Omega Workshops Name given in 1913 by artist and critic Roger Fry to a company producing works of applied arts, attracting artists later associated with *Vorticism (Wyndham Lewis, Henri Gaudier-Brzeska) and the ‡Bloomsbury Group (Duncan Grant, Vanessa Bell). Omega Workshops disbanded in 1919.

Organic architecture
Title of an essay by Frank Lloyd Wright in 1910, who thereafter called his work 'organic'. His definition described the integration of the building with its environment or site and respect for the inherent qualities of building materials. German architect and theorist Hugo Häring used the term to indicate a search for natural forms unlimited by academic geometry.

Osma (Czech: The Eight) Prague-based group of painters formed in 1906 and active until 1911, when a number went on to found ‡Skupina Vytvarnych Umelcu. Vincenc Benes, Friedrich Feigl, Emil Filla, Max Horb, Otokar Kubín, Bohumil Kubista, Willy Nowak, Emil Artur Pittermann-Longen, Antonín

Procházka and Linka Scheithauerová were sometime members. Exhibitions in 1907 and 1908 sought to invigorate Czech art by promoting expressionist handling and an emphasis on colour.

Painters Eleven Group of eleven Canadian artists based in Toronto, including Jack Bush, Jock Macdonald, William Ronald and Harold Town. Formed in 1953, active until 1960. Through collective exhibitions of their abstract paintings they challenged the dominance of the landscape painters of the ‡Canadian Group of Painters and raised awareness of international developments in abstract art.

Pattern and Decoration Movement of the 1970s which defiantly embraced and exalted qualities damned by formalist supporters of purist abstraction – pattern, decoration, ornament, content and associations with crafts, folk arts and 'women's work'. A group was formed in New York in 1976 by Miriam Schapiro and Robert Zakanitch. Others included Valerie Jaudon, Joyce Kozloff, Robert Kushner, Kim MacConnel and Ned Smyth.

Phalanx Exhibiting group founded in 1901 in Munich by Vasily Kandinsky and others, with strong social concerns (e.g. equal access for women members). Associated with members of the Darmstadt artists' colony (see *Jugendstil) and the Berlin Secession. The twelfth and final show was held in 1904.

Les Plasticiens Montreal-based group of Canadian painters, including Louis Belzile, Jean-Paul Jérôme, Fernand Leduc, Fernand Toupin and Rodolphe de Repentigny, active 1955–59. In contrast to the expressive abstraction of the prevailing ‡Automatistes, they advocated a more formalist approach like that of the *Post-painterly Abstractionists. The name was chosen to honour Piet Mondrian and Theo van Doesburg's ‡Neo-Plasticism (see also *De Stijl).

Pointillism Painting technique of applying dots of pure colour (instead of mixing on the palette) to achieve maximum intensity. Notably used by *Neo-Impressionist Georges Seurat, developed by Paul Signac (see ‡Divisionism).

Polymaterialists – see *Neo-Dada

Praesens Group of Polish artists and architects in Warsaw, active 1926–39, many formerly members of ‡Blok. Founded by architect Szymon Syrkus and organized exhibitions in Warsaw and abroad. The group stressed the functional aspects of art, the central role of architecture in art and close co-operation between artists and architects in work characterized by the use of geometric forms and primary colours.

Pre-Raphaelite Brotherhood (PRB) Mid-nineteenth century group of British painters inspired by Italian artists working before the era of Raphael. Championed by critic John Ruskin, later exponents included Dante Gabriel Rossetti, Edward Burne-Jones, Walter Crane and Evelyn de Morgan. Influenced *Symbolists, *Les Vingt, *Salon de la Rose+Croix; associated with *Arts and Crafts.

Primitivism Term used to describe art that employs primitive elements or forms. Early modern twentieth-century artists (*Cubists, *Expressionists) were profoundly influenced by African and Oceanic arts; in the late twentieth century other modes of Western art (*Earth Art, *Performance Art) were sometimes based on real or imagined primitivistic rituals.

Process Art Term used broadly in the 1960s and 1970s in an attempt to expand the definition of a work of art to include its actual creation. Encompassing several activities (*Performance Art, *Installation, film), the study of process itself becomes part of the evolution of the work.

Psychedelic Art The term 'psychedelic style' was coined in 1966 at an LSD conference in San Francisco

to describe art made under the influence of hallucinogenic drugs or that which tried to simulate a drug-induced altered state. Most often took the form of paintings, posters and light and sound environments.

Puteaux Group Term used to refer to the informal group of artists who gathered at the studio of Jacques Villon and Raymond Duchamp-Villon in the Paris suburb of Puteaux 1911–13 to discuss aspects of *Cubism. Included Robert Delaunay, Marcel Duchamp, Juan Gris, Fernand Léger, Frantisek Kupka, Francis Picabia, Albert Gleizes and Jean Metzinger, among others. Organized a large group exhibition in 1912 in Paris, 'Salon de la ‡Section d'Or', which brought Cubism to a wide audience.

Quadriga Group of German *Art Informel painters active in Frankfurt am Main 1952–54. Members included Karl Otto Götz, Otto Greis, Heinz Kreutz, Bernard Schultze and Emil Schumacher. Influenced by *CoBrA, *Art Informel and *Abstract Expressionism.

Radical Design Tendency of the late 1960s and 1970s in architecture and design. Like *Anti-Design, but with even stronger political motivation and commitment to reconnect architecture and design with a radical social function. Sought to subvert the tenets of 'good design' and ‡'techno-chic' associated with Western capitalism and embraced 'bad taste', popular taste and user-intervention. Most visions of studios such as Archigram, Archizoom, Superstudio and ‡UFO were undeveloped.

Rationalism – see *M.I.A.R.

Rebel Art Centre Founded in 1914 by Wyndham Lewis as an alternative to Roger Fry's ‡Omega Workshops, and comprising several ex-members of Fry's group. Inspired by Marinetti's Italian *Futurists, the group met and exhibited only a few times before it dissolved; Lewis and others went on to develop *Vorticism.

Regionalism American representational painting movement of the 1930s. Its three best-known exponents, Thomas Hart Benton, John Steuart Curry and Grant Wood, were associated with the *American Scene. Nationally acclaimed during the Depression, the movement was over by World War II.

Revolutionary Black Gang – see *Ashcan School

Salon des Indépendants Open exhibition established by the Société des Artistes Indépendants, a group formed in 1884, whose original members included a number of *Neo-Impressionist and *Symbolist artists opposed to the official Salon. The rules of the new Salon stipulated that any artist could exhibit upon payment of an entrance fee without being subjected to a selection committee.

School of London Term that was originally attributed to R. B. Kitaj in 1976, and the title of a 1987 British Council touring exhibition; it has also been used to refer informally to artists including Michael Andrews, Frank Auerbach, Francis Bacon, Lucian Freud, Kitaj and Leon Kossoff.

School of Pont-Aven Informal group of artists around Paul Gauguin named for Breton village where they worked (although no formal school was ever formed). Name associated with *Synthetism and *Cloisonnism.

Scottish Colourists Scottish group of painters active 1910–30; named in retrospect to refer to S. J. Peploe, Leslie Hunter, F. C. B. Cadell, and later J. D. Fergusson. Influenced by the Glasgow Boys (see ‡Glasgow School), their visits to France and Italy had a strong effect on their work, notably in the use of colour.

Scuola Romana (Italian: Roman School) Name for a loose association of artists that were working in Rome between the two world wars. Rejecting the ‡neo-classicism of the *Novecento Italiano, their work reflected the influence of the more expressionist

painters of the *Ecole de Paris and the *Magic Realists. Mario Mafai and Scipione are considered the founders of the School.

Section d'Or Name taken from the theory of proportion in art (golden section), referring to a group of artists exhibiting in Paris in 1912: Jacques Villon, Raymond Duchamp-Villon, Marcel Duchamp, Juan Gris, Fernand Léger, Francis Picabia and others associated with *Cubism (see also ‡Puteaux Group).

Serial Art (or Systems Art) Art exploring repetition, progressive variation or *Minimalist simplification, from Monet's series (e.g. of Rouen cathedral, haystacks, see *Impressionism) through to the work of *Conceptual artists in the twenty-first century. Names particularly associated with the term include Josef Albers, Carl Andre, Sol LeWitt and Andy Warhol.

SITE (Sculpture in the Environment) Multi-disciplinary architecture and environmental arts organization launched in New York in 1969 by James Wines. Other partners include Allison Sky, Emilio Sousa and Michelle Stone. SITE's mission is to make buildings that are a union of art and architecture and to use the language of architecture to create new building types to enliven the built environment. See *Neo-Expressionism.

Situationism Group of British abstract artists whose name derives from the title of a London exhibition in 1960. The eighteen artists included William Turnbull, Gillian Ayres and John Hoyland. Their work, so large as to fill the viewer's space, created a 'situation' in which he or she was involved.

Situationists – see *Situationist International

Skupina 42 (Czech: Group 42) Alliance of Prague-based Czech painters, sculptors, photographers and poets, including Frantisek Gross, Frantisek Hudecek, Jiri Kolár, Johan Kotík, Bohmír Matal and Jan Smetana, active 1942–45. Their work shows the heritage of *Surrealism, but rejects the unconscious in favour of depicting the world around them. The bleak outskirts of Prague and decaying machinery were prominent themes to convey man's *Existential condition.

Skupina Ra (Czech: Group Ra) Group of Czech *Surrealist artists who met in Rakovnik (from which they took their name) in Bohemia in 1937. Joseph Istler, Bohdan Lacina and Václav Tikal, amongst others, promoted modern art with a touring exhibition and an anthology-manifesto during World War II and after until political pressure forced the group to disband in 1949.

Skupina Vytvarnych Umelcu (Czech: Group of Fine, or Plastic, Artists) Avant-garde group active 1911–14 in Prague formed after the demise of ‡Osma: included artists Vincenc Benes, Emil Filla and Otto Gutfreund, architects and designers Josef Čapek, Josef Chochol, Josef Gočár, Vlastislav Hofmann, Pavel Janák and Otokar Novotny. Through exhibitions and its own journal promoted *Cubism in painting, sculpture, architecture and design.

Société Anonyme Inc. Pioneering organization founded by Katherine Dreier, Marcel Duchamp and Man Ray (see *Dada) in New York in 1920 to promote international avant-garde art in the USA. By 1940 the association had arranged over 80 exhibitions throughout the USA, produced an extensive programme of lectures and publications and established an important permanent collection of modern art, which was given to Yale University in 1941. Ended in 1950.

Sots Art
Style of unofficial art in Russia during the 1970s and 1980s practised by Komar and Melamid, Erik Bulatov, Ilya Kabakov, Dmitry Prigov, Aleksy Kosolapov and Leonid Sokov. Both the name and the style use a fusion of *Socialist Realism and *Pop Art to

criticize and mock the myths and ideologies of both the Soviet Union and the USA.

Spazialismo (Italian: Spatialism) Movement founded by Lucio Fontana in Milan in 1947 to put into practice his belief that art should use new technologies and other tactics to move away from the flat canvas. Fontana's own work uses television and neon lighting, and his later canvases are slit or punctured to create a sense of three-dimensionality .

Spur (German: track, footprints) German group of artists founded in Munich in 1958. Aimed to combine elements of *Art Informel with gestural figuration. Influenced by *CoBrA and encouraged by Asger Jorn, the group was accepted by the *Situationist International in 1959 before being expelled in 1962. Joined the Wir group to form the Geflecht group in 1967.

St Ives School Community of artists who spent time living and working in St Ives, Cornwall, in southwest England: Naum Gabo, Barbara Hepworth and Ben Nicholson during the 1940s, later joined by Terry Frost, Patrick Heron, Roger Hilton, Peter Lanyon and Bryan Wynter. Came to refer a type of gestural abstract landscape painting. Tate Gallery St Ives opened in 1993 to house the work of the St Ives artists.

Stuckism Neo-conservative movement started in the UK in 1999 by artists Billy Childish and Charles Thomson. Thomson derived the name from an insult hurled at Childish by his ex-girlfriend, ‡YBA Tracey Emin ('Your paintings are stuck, you are stuck!'). Calling themselves 'the first remodernist art group', they agitate against *Postmodernism, *Installation and *Conceptual Art – favoured by the YBAs – and promote conservative painting techniques and a rebirth of spirituality in art.

Studio Alchymia Gallery and exhibition space set up by architect Alessandro Guerriero in Milan in 1979, which evolved into a design studio. Extended the ideas of the ‡Radical Design movement of the 1960s with an anti-modernist stance and celebration of the vernacular of the everyday. Notable members of the studio included Ettore Sottsass, Michele de Lucchi, Andrea Branzi and Alessandro Mendini (see also *Postmodernism).

Stupid Group Cologne-based group of German artists formed in 1920 by Willy Fick, Marta Hegemann, Heinrich and Angelika Hoerle, Anton Räderscheidt and Franz Seiwert. Previously associated with *Dada, they broke away to attempt a more Communist-oriented 'proletarian' art to address sociopolitical events.

SUM Icelandic group of avant-garde artists active 1965–75. Guided by Dieter Roth (see *Fluxus), Jon Gunnar Arnason, Hreinn Fridfinnsson, Kristjan and Sigurdur Gudmundsson, Sigurjon Johansson and Haukur Dor Sturluson, brought *Neo-Dada, *Pop Art, *Fluxus and *Arte Povera ideas to Iceland.

Tachisme (from French *tâche*, blot, stain) Term coined by critic Michel Tapié to indicate a form of expressive, gestural abstract art (esp. in France in the 1950s). Often used synonymously with *Art Informel, the term is also associated with ‡Art autre, *Art Brut, *Lettrism and ‡Lyrical Abstraction.

Team X (Team Ten, Team 10) International group of architects formed in 1956 at CIAM's (Congrès Internationaux d'Architecture Moderne, see *International Style) tenth conference. Attempted to introduce a more humanistic tone to modern architecture (see *New Brutalism). Met until the early 1980s.

Techno-chic Term used to describe the aesthetic of sleek, slick, exclusive, luxurious Italian design of late 1950s and 1960s. The style was characterized by sculptural forms and the use of black leather, chrome and highly finished plastics for furniture and lighting to convey notions of wealth, status and 'good taste'.

Tecton Architectural firm founded in London in 1932, disbanded in 1948. Included Anthony Chitty, Lindsey Drake, Michael Dugdale, Valentine Harding, Denys Lasdun, Berthold Lubetkin, Godfrey Samuel and Frances Skinner. Buildings of the 1930s, such as those for London Zoo, Highpoint I and Highpoint II apartment blocks, and the Finsbury Health Centre in London, made them the most important practitioners of the *International Style in Britain.

The Ten (1) Group of American painters exhibiting 1898–1919, influenced by *Impressionism; associated with The ‡Eight; (2) group of painters in both abstract and figurative styles exhibiting 1935–39 including Adolph Gottlieb and Mark Rothko (see *Abstract Expressionism).

Tendenza Neo-Rationalist urban design movement (see *M.I.A.R.) initiated by Italian architects Aldo Rossi (see *Postmodernism), Giorgio Grassi and Massimo Scolari, which appeared in Italy and Switzerland during the late 1960s.

Tonalism American style of painting 1880–1920. Exponents included J. A. M. Whistler (see *Decadent Movement), Thomas Wilmer Dening, and Dwight W. Tryon. Characterized by restrained palette and soft tones; sometimes suggestive of *Symbolist work.

UFO Group founded in Florence in 1967 to further the propositions of radical design. Members included architects, designers and intellectuals, such as writer Umberto Eco. Part of the ‡Radical Design movement.

Ugly Realists Term used to refer to work of a number of painters in Berlin during the 1970s, such as K. H. Hödicke, Bernd Hoberling, Markus Lüpertz, Wolfgang Petrick and Peter Sorge. Work ranged from *Neo-Expressionist to a critical realism reminiscent of the *Neue Sachlichkeit painters.

Unism System of painting developed by ‡Blok artists Wladyslaw Strzeminski and Henryk Stazewski in Poland in 1927. Striving for optical unity and influenced by *Suprematism, they went even further in their quest for a pure, non-objective art, with abstract paintings with an all-over pattern, anticipating the rise of minimal painting of the 1960s (see *Post-painterly Abstraction).

Unit One British group of painters, sculptors and architects formed in 1933 by Paul Nash (see *Neo-Romanticism) to promote modern art and architecture in England. Members included Wells Coates, Barbara Hepworth, Henry Moore and Ben Nicholson. After one exhibition and a book in 1934 the group dissolved due to disputes between supporters of abstraction and those of *Surrealism.

Unovis (Russian: Champions of the New Art) Group of artists and designers, including Ilya Chashnik, Vera Eermolaeva, Nina Kogan, El Lissitzky, Nikolai Suetin and Lev Yudin, formed by Kasimir Malevich in Vitebsk in 1919–20. Supporters of Malevich's *Suprematism, Suprematist ideas and designs were applied to porcelain, textiles and architectural designs. Manifestos, publications and exhibitions spread the word and other branches were formed in Moscow, Odessa, Orenburg, Petrograd, Samara, Saratov and Smolensk. Active until 1927.

Urban Realism – see *Precisionism

Utility Furniture British furniture produced from 1943 under the guidance of Gordon Russell. Simple, wooden furniture based on traditional, sensible shapes and sound construction, a result of *Arts and Crafts principles transferred to mass-production to provide high-quality, low-priced goods during and after World War II.

Verism (1) Italian art movement of the second half of the nineteenth century, treating contemporary themes in contrast to ‡Neo-classicism; (2) cool socio-political

tendency of German *Neue Sachlichkeit reacting against *Expressionism.

Vienna Action Art (German: Wiener Aktionismus) Group of Austrian *performance artists (principally Günter Brus, Otto Muehl and Hermann Nitsch) active 1961–69. Their ritualistic actions flouted sexual and ethical conventions, and sometimes led to prosecution, as it did in London in 1966, when images of male genitals were projected on a lamb's carcass as it was disembowelled.

Worpswede School German artists' colony near Bremen started in 1889 to paint en plein air; artists' group founded there in 1897. Prominent members included Fritz Mackensen, Otto Modersohn and his wife Paula Modersohn-Becker (see also *Expressionism), whose death in 1907 hastened the end of the group in 1908.

YBAs (Young British Artists) British artists who emerged during the late 1980s and quickly rose to national and international prominence, such as Jake and Dinos Chapman, Tracey Emin, Marcus Harvey, Damien Hirst, Gary Hume, Sarah Lucas, Ron Mueck, Chris Ofili, Simon Patterson, Marc Quinn, Jenny Saville, Sam Taylor-Wood, Gavin Turk, Gillian Wearing and Rachel Whiteread. Name from the series of 'Young British Artists' exhibitions held at the Saatchi Gallery in London beginning in 1992.

Zebra German group of artists founded in Hamburg in 1965 in reaction to *Art Informel. Cool graphic style often based on photographs (see *Super-realism). Members included Dieter Asmus, Peter Nagel, Nikolaus Störtenbecker and Dietmar Ullrich.

Zen 49 Munich-based group of German artists, including Willi Baumeister, Rupprecht Geiger, Hans Hartung, Otto Ritschl, Theodor Werner and Fritz Winter. The name was chosen to mark a general understanding and sympathy with Zen Buddhism and the date of foundation, 1949. Committed to abstract art and regenerating German art by reconnecting with the tradition of artistic freedom and experimentation of *Der Blaue Reiter and the *Bauhaus. Exhibitions in Germany and the USA brought them within the orbit of *Art Informel. The group was active until 1957.

Zero Informal alliance of young international artists formed in 1957 in Düsseldorf by the artists Otto Piene and Heinz Mack, joined by Günther Uecker. Rejecting the subjectivity of *Art Informel and *Existentialism, embraced *Nouveau Réalisme, *Kinetic and ‡Light Art. Technological optimism linked their work with their contemporaries in ‡Nul, *GRAV and ‡E.A.T. Dissolved in 1967.

LIST OF ILLUSTRATIONS

Dimensions of works are given in centimetres and inches, height before width a=above, b=below, c=centre, l=left, r=right

1 Piero Manzoni, *Living Sculpture*, 1961. Archivio Opera Piero Manzoni. © DACS 2002 **2–3** detail of 277 **6l** see 14 **6cl** see 38 **6c** see 54 **6r** see 70 **6r** see 76 **7cl** see 79 **7c** see 100 **7r** see 115 **8l** see 152 **8cl** see 194 **8cr** see 238 **8r** see 244 **9l** see 253 **9cl** see 269 **9c** see 273 **9cr** see 280b **9r** see 287 **10l** see 16r **10cl** see 46 **10c** see 116 **10cr** see 131 **10r** see 136 **11l** see 183 **11cl** see 203 **11c** see 236 **11cr** see 278 **11r** see 285 **12** Pissarro in his studio in Eragny, *c.* 1897. Claude Bonin Pissarro Archives **14** Auguste Rodin, *Crouching Woman*, 1880–82. Bronze, George Rudier cast, 95.3 x 63.5 x 55.9 (37½ x 25 x 22). BG Cantos Art Foundation, Beverly Hills, California **15** Claude Monet, *Impression, Sunrise, c.* 1872–73. Oil on canvas, 47.9 x 62.9 (18⅞ x 24¾), Musée Marmottan, Paris. Photo Studio Lourmel **16l** Edgar Degas, *Woman Having Her Hair Combed*, c.1886. Pastel, 74 x 60.6 (29⅛ x 23⅞).The Metropolitan Museum of Art, New York. Bequest of Mrs H. O. Havemeyer, 1929. The H. O. Havemeyer Collection (29.100.35) **16r** Pierre-Auguste Renoir, *Madame Portalis*, 1890. University of Harvard, Fogg Art Museum, Cambridge, Massachusetts **17** Berthe Morisot, *Boats under Construction*, 1874. Oil on canvas, 32 x 41 (12⅝ x 16⅛). Musée Marmottan – Claude Monet, Paris **19c** Philip Webb, The Red House, Bexley Heath, Kent, 1859 **19b** The Grange, Fulham, London. Interior showing two Philip Webb tables, Madox Brown's version of the 'Sussex' chair and William Morris *Fruit* wallpaper. **20** Gustav Stickley, Spindle settee constructed of quarter sawn American white oak, 1905–7. Collection Beth and David Cathers **21** C. F. A. Voysey, Wallpaper incorporating a self-caricature as a demon, design of 1889. RIBA, London **23** D. H. Burnham Co., Reliance Building, Chicago,1891–95 **24** Louis Sullivan, Carson Pirie Scott & Co., Chicago, 1899 and 1903–4 **25** Fernand Khnopff, *Caresses. of the Sphinx (The Sphinx)*, 1896. Oil on canvas, 50 x 150 (19¾ x 59). Musées Royaux des Beaux-Arts, Brussels **26** Fernand Khnopff, *Les XX*, Poster for the 1891 exhibition. Photo E. Tweedy **27** Georges Seurat, *Sunday Afternoon on the Island of La Grande Jatte*, 1883–86. Oil on canvas, 207.6 x 308 (81 x 120). The Art Institute of Chicago Helen Birch Bartlett Memorial Collection 1926.224 **28l** Georges Seurat, *Final Study for 'Le Chahut'*, 1889. Oil on canvas, 70.8 x 46.7 (27⅞ x 18⅜). Albright-Knox Art Gallery, Buffalo, New York, General Purchase Funds, 1943 **28r** Michel-Eugène Chevreul, *Premier cercle chromatique*, from *Des Couleurs et de leurs applications aux arts industriels.* Paris, 1864 **29** Paul Signac, *Portrait of Félix Fénéon in 1890, against a Background Rhythmic with Beats and Angles, Tones and Colours*, 1890. Oil on canvas, 73.5 x 92.5 (29 x 36½). Private collection, New York. © ADAGP, Paris, and DACS, London 2002 **30** Aubrey Beardsley, Cover design for *The Yellow Book*, Volume 1, 1894 **31** James Abbott McNeill Whistler, End-wall panel from *Harmony in Blue and Gold: The Peacock Room*, 1876–77. Oil paint and metal leaf on canvas, leather, and wood, dimension of the room 424.8 x 1010.9 x 608.3 (167⅞ x 398 x 239). Freer Gallery of Art, Smithsonian Institution, Washington, D.C. **32** Sir Lawrence Alma-Tadema, *The Roses of Heliogabalus*, 1888. Oil on canvas, 132 x 214 (52 x 84¼). Whitford & Hughes **33** Hector Guimard, Bastille Métro station, Paris, cast iron and glass, *c.* 1900. Photo Roger-Viollet **34** Victor Horta, Wrought-iron staircase, Hôtel Tassel, Brussels, 1893. Photo © Reiner Lautwein/artur. © DACS 2002 **36** Charles Rennie Mackintosh, Chair, *c.* 1902 **37** Alphonse Mucha, *Gismonda*, 1894. Poster, 74.2 x 216 (29¼x 85). © ADAGP, Paris, and DACS, London 2002 **38** Antoni Gaudí, Pinnacle of one of the towers of the Sagrada Familia, Barcelona, 1883. Photo © AISA-Archivo Iconográfico, Barcelona **39** Antoni Gaudí, Güell Park, Barcelona, 1900–14. Photo © AISA-Archivo Iconográfico, Barcelona **40** Antoni Gaudí, Casa Milà, 1905–10. Photo Institut Amatller d'Art Hispànic, Barcelona **41** Gustav Moreau, *The Apparition*, 1876. Watercolour, 106 x 72 (41¾ x 28⅜). Musée du Louvre, Paris **42** Edvard Munch, *Puberty*, 1894. Oil on canvas, 151.5 x 110 (59⅝ x 43¼). Nasjonalgalleriet, Oslo. © Munch Museum/Munch-Ellingsen Group, BONO, Oslo, DACS, London 2002 **43** Odilon Redon, *Orpheus, c.* 1913–16. Pastel, 70 x 56.5 (27½ x 22¼). Cleveland Museum of Art. Gift from J. H. Wade **45** Henri de Toulouse-Lautrec, *Divan Japonais*, 1893. Poster, 79.5 x 59.5 (31¼x 23⅜). V&A, London

46 Vincent van Gogh, *Self-Portrait*, 1889. Oil on canvas, 65 x 54 (25⅝ x 21¼). Musée d'Orsay, Paris **47** Paul Cézanne, *Mont Sainte-Victoire*, 1902–4. Oil on canvas, 69.8 x 89.5 (27½ x 35¼). Philadelphia Museum of Art, The George W. Elkins Collection **49** Emile Bernard, *The Annunciation*, 1889. Collection Stuart Pivar. © ADAGP, Paris, and DACS, London 2002 **51a** Maurice Denis, *Homage to Cézanne*, 1900. Oil on canvas, 180 x 240 (70⅞ x 94½). Musée d'Orsay, Paris. © ADAGP, Paris, and DACS, London 2002 **51b** Pierre Bonnard, *France-Champagne poster*, 1891. Colour lithograph, 78 x 50 (30¾ x 19¾). © ADAGP, Paris, and DACS, London 2002 **52** Edouard Vuillard, *Misia and Valloton*, 1894. Oil on canvas. Collection Mr & Mrs William Kelly Simpson, New York. © ADAGP, Paris, and DACS, London 2002 **54** Paul Gauguin, *Vision After the Sermon: Jacob Wrestling with the Angel*, 1888. Oil on canvas, 73 x 92 (28¾ x 36¼). National Gallery of Scotland, Edinburgh **55** Paul Gauguin, *Day of the Gods (Mahana No Atua)*, 1894. Oil on canvas 68.3 x 91.5 (26⅞ x 36). Helen Birch Bartlett Memorial Collection, 1926.198. The Art Institute of Chicago **56** Carlos Schwabe, *The Virgin of the Lilies*, 1899. Watercolour, 97 x 47 (38¼ x 18½). Private collection **58** August Endell, Façade of Atelier Elvira, Munich, (destroyed); 1897–1898. Photo Dr Franz Stoedtner **59a** Josef Hoffmann, The logotype for the Wiener Werkstätte **59b** Gustav Klimt, *Beethoven Frieze* (detail), 1902. Case in paint on stucco, inlaid with various materials, total height and length 220 x 2400 (86⅝ x 944¾). Österreichische Galerie, Vienna **60** Josef Hoffmann, Palais Stoclet, Brussels, 1905–11. Bildarchiv Foto Marburg **61** Joseph Maria Olbrich, Poster for the second Secession exhibition, 1898–99. Lithograph, 85.5 x 50.5 (33⅝ x 19¾). Collection Mr and Mrs Leonard A. Lauder **62** Léon Bakst, Stage design for *Schéhérazade*, 1910. Musée des Arts Decoratifs, Paris. Photo L. Sully-Jaulmes **63** Léon Bakst, *The Red Sultana*, 1910. Private Collection **64** Matisse working in his Hôtel Regina Studio, Nice, on the ceramic project *The Virgin and the Child* for the Chapel of the Rosary in Venice, 1950. Photo Hélène Adant. Musée National d'Art Moderne, Centre Georges Pompidou, Paris. © Succession H. Matisse/DACS 2002 **66** Henri Matisse, *Joy of Life (Bonheur de vivre: Joie de vivre)*, 1905–06. Oil on canvas, 174 x 238 (68½ x 93¾). © The Barnes Foundation, Merion, Pennsylvania. © Succession H. Matisse/DACS 2002 **67** André Derain, *Three Figures Sitting on the Grass*, 1906. Oil on canvas, 38.1 x 54.9 (15 x 21⅝). Musée d'Art Moderne de la Ville de Paris. © ADAGP, Paris, and DACS, London 2002 **68** Raoul Dufy, *Street Decked with Flags (The Fourteenth of July at Le Havre)*, 1906. Oil on canvas, 46.5 x 38 (18¼ x 15). Courtesy Fridart Foundation. © ADAGP, Paris, and DACS, London 2002 **69** Maurice de Vlaminck, *The White House*, 1905–6. Oil on canvas, 45 x 55 (17¾ x 21¾). Private Collection. Photo Gallerie Schmit, Paris. © ADAGP, Paris, and DACS, London 2002 **70** Egon Schiele, *Nude Girl with Crossed Arms*, 1910. Black chalk and watercolour, 44.8 x 28 (17⅝ x 11⅛). Graphische Sammlung Albertina, Vienna **71** Paula Modersohn-Becker, *Self-Portrait on her Sixth Wedding Anniversary*, 1906. Oil on panel, 101.8 x 70.2 (40 x 27⅝). Kunstsammlungen Böttcherstrasse, Bremen **72** Oskar Kokoschka, *Bride of the Wind (The Tempest)*, 1914. Oil on canvas, 181 x 122 (71¼ x 48). Öffentliche Kunstsammlung Basel, Kunstmuseum, Inv. 1745. Photo Öffentliche Kunstsammlung Basel **73** Emil Nolde, *Prophet*, 1912. Woodcut, printed in black, composition 32.1 x 22.2 (12⅝ x 8¾) The Museum of Modern Art New York. Given anonymously (by exchange). Photograph © 2002 The Museum of Modern Art, New York **74** Erich Mendelsohn, Einstein Tower, 1919–21. Potsdam. Photo Dr Franz Stoedtner **75a** Erich Heckel, *Two Men at a Table*, 1912. Oil on canvas, 96.8 x 120 (38⅛ x 47¼). Kunsthaus, Hamburg. © DACS 2002 **75b** Ernst Ludwig Kirchner, *The Painters of Die Brüke*, 1926. Oil on canvas, 168 x 126 (66⅛ x 49⅝). Museum Ludwig, Cologne. Copyright by Ingeborg & Dr Wolfgang Henze-Ketterer, Wichtrach/Bern **76** Ernst Ludwig Kirchner, *Poster: Die Brücke*, 1910. Kaiser Wilhelm Museum Krefeld. Copyright by Ingeborg & Dr Wolfgang Henze-Ketterer, Wichtrach/Bern **77** Ernst Ludwig Kirchner, *Five Women in the Street*, 1913. Oil on canvas, 120 x 90 (47¼ x 35½). Wallraf-Richartz Museum, Cologne. Copyright by Ingeborg & Dr Wolfgang Henze-Ketterer, Wichtrach/Bern **78** Lewis W. Hine, Eight-year-old Children Shucking Oysters. Photograph. Library of Congress, Washington, D.C. **79a** George Bellows,

Stag at Sharkey's, 1909. Oil on canvas, 92.1 x 122.6 (36¼ x 48¼). The Cleveland Museum of Art, Hinman B. Hurlbut Collection **79c** John Sloan, *Hairdresser's Window*, 1907. Oil on canvas, 81 x 66 (31⅞ x 26). Wadsworth Atheneum, Hartford, Connecticut, The Ella Gallup Sumner and Mary Catlin Sumner Collection **80** Peter Behrens, AEG Turbine Factory, 1908–9. Berlin. © DACS 2002 **81** Weissenhofsiedlung, Stuttgart, 1927. Includes work by Le Corbusier, J. J. P. Oud, Mies van der Rohe **82** Walter Gropius, Sleeping compartment of Mitropa carriage, *c.* 1914 **83** Peter Behrens, AEG electric table-fan, 1908. © DACS 2002 **84l** George Braques, *Viaduct at L'Estaque*, 1908. Oil on canvas, 72.5 x 59 (28⅝ x 23¼). Musée National d'Art Moderne, Centre Georges Pompidou, Paris. Gift of Mr and Mrs Claude Laurens. © ADAGP, Paris, and DACS, London 2002 **84r** Pablo Picasso, *Still Life with Chair-Caning*, 1911–12. Oil and pasted paper simulating chair-caning on canvas, surrounded by rope, oval, 27 x 35 (10⅝ x 13¾). Musée Picasso, Paris. © Succession Picasso/DACS 2002 **85** Juan Gris, *Violin and Guitar*, 1913. Oil on canvas, 100 x 65.5 (39⅜ x 25¾). Private Collection **86** Fernand Léger, Stage model for *La Création du Monde (The Creation of the World)*, 1923. Dansmuseet, Stockholm. © ADAGP, Paris, and DACS, London 2002 **87** Emil Králícek and Matej Blecha, Lamp-post, Prague, 1912–13. Photo AKG, London/Keith Collie **88** Carlo Carra, *Horse and Rider* or *The Red Rider*, 1913. Ink and tempera on paper pasted on canvas, 26 x 36 (10¼ x 14⅛). Riccardo and Magda Jucker Collection on loan to Pinacoteca di Brera, Milan. © DACS 2002 **89** Giacomo Balla, *Rhythm of a Violinist*, 1912. Oil on canvas, 75 x 52 (29½ x 20½). Collection Mr and Mrs Eric Estorick. © DACS 2002 **90l** Marinetti and Marchesi in Turin with Marinetti's portrait by Zatkova. Photograph.**90r** Alberto Boccioni, *Unique Forms of Continuity in Space*, 1913. Bronze, 111.4 x 88.6 x 40 (43⅞ x 34⅞ x 15¾). Galleria Civica d'Arte Moderna, Milan **91** Sant'Elia, *La Città Futurista*, from 'Manifesto of Futurist Architecture', 1914 **92** Mikhail Larionov, *The Soldiers* (second version), 1909. Oil on canvas, 88.2 x 102.5 (34¾ x 40⅜). Los Angeles County Museum of Art, Los Angeles. © ADAGP, Paris, and DACS, London 2002 **93** Ilya Mashkov, *Portrait of a Boy in an Embroidered Shirt*, 1909. Oil on canvas, 119.5 x 80 (47 x 31½). The State Russian Museum, St Petersburg **94** August Macke, *Lady in a Green Jacket*, 1913. Oil on canvas, 44.5 x 43.5 (17½ x 17⅛). Museum Ludwig, Cologne **95** Franz Marc, *The Large Blue Horses*, 1911. Oil on canvas, 104.8 x 181 (41¼ x 71¼). Walker Art Centre, Minneapolis, Minnesota. Gift of the T.B. Walker Foundation, Gilbert M. Walker Fund, 1942 **96** Vasily Kandinsky, *Improvisation, 'Klamm'*, 1914. Oil on canvas, 110 x 110 (43¼ x 43¼). Städtische Galerie im Lenbachhaus, Munich. © ADAGP, Paris, and DACS, London 2002 **97** Paul Klee, *Föhn in the Marcs' Garden*, 1915. Watercolour on paper mounted on cardboard, 20 x 15 (⅞ x ⅞). Städtische Galerie im Lenbachhaus, Munich. © DACS 2002 **98** Morgan Russell, *Synchromy in Orange: To Form*, 1913–14. Oil on canvas, 342.9 x 308.6 (135 x 121½). Albright-Knox Art Gallery, Buffalo, New York. Gift of Seymour H. Knox, 1958 **99** Photograph of a roadster painted in imitation of a design by Sonia Delaunay, and model wearing a matching coat and hat, 1925 **100** Robert Delaunay, *Formes circulaires, Soleil Lune (soleil et lune, simultané, n. 2)* 1913 (dated 1912 on painting). Oil on canvas, 134.5 (53) diameter. The Museum of Modern Art, New York. Mrs Simon Guggenheim fund. Photograph © 2002 The Museum of Modern Art, New York. © L & M SERVICES B.V. Amsterdam 20010409 **101** Sonia Delaunay, Cover design of fabrics for a book by Ricciotto Canudo, 1912. © L & M SERVICES B.V. Amsterdam 20010409 **102** Natalia Goncharova, *Airplane over a Train*, 1913. Oil on canvas, 55 x 83.5 (21⅝ x 32¾). State Museum of the Visual Arts of Tatarstan, Kazan. © ADAGP, Paris, and DACS, London 2002 **104** Kasimir Malevich's paintings exhibited at the 0.10 Gallery, St Petersburg, 1915 **105** Kasimir Malevich, *Suprematist Painting*, 1917–18. Oil on canvas, 97 x 70 (38½ x 26½). Stedelijk Museum, Amsterdam **106** Konstantin Melnikov, The Rusakov Club, Moscow, 1927 **107** Vladimir Tatlin, Monument to the Third International, 1919. National Museum, Stockholm. © DACS 2002 **108a** El Lissitzky, *Beat the Whites with the Red Wedge*, 1919–20. Poster, 48.5 x 69.2 (19⅛ x 27⅛). Stedelijk Van Abbemuseum, Eindhoven. © DACS 2002 **108b** Spread from Russian Constructivist journal, *Lef.* Varvara Stepanova sports clothes (left) and Rodchenko logo designs (right), 1917.

© DACS 2002 **110** Giorgio de Chirico, *Place d'Italie*, 1912. Private Collection, Milan. © DACS 2002 **112** Wyndham Lewis, *Timon of Athens*, 1913. Pencil, black & brown ink wash, 34.5 x 26.5 (13½ x 10½). Photo courtesy Anthony d'Offay Gallery, London. © Estate of Mr G.A. Wyndham Lewis **113** Lajos Kassák, *Bildarchitektur* (Pictorial Architecture), 1922. Oil on cardboard, 28 x 20.5cm (11 x 8). Hungarian National Gallery, Budapest. **114** Michael de Klerk, Eigen Haard Estate, in the Spaarndammerbuurt, Amsterdam West, 1913–20 **115** Marcel Duchamp, *Fountain*, 1917, replica 1963. Porcelain urinal, h 33.5 (13¼) Indiana University Art Museum. © Succession Marcel Duchamp/ADAGP, Paris, and DACS, London 2002 **116** Jean (Hans) Arp, *Collage Made According to the Laws of Chance*, 1916. Collage, 25.3 x 12.5 (10 x 4⅞). Kunstmuseum, Basel. © DACS 2002 **117** Hannah Höch, *Cut with the Cake Knife*, c.1919. Collage, 114 x 89.8 (44⅞ x 35⅜). Staatliche Museen, Berlin © DACS 2002 **118** Opening of First International Dada Fair at Dr Otto Burchard's Gallery, Berlin, June 1920. Photograph **120** Le Corbuiser, Interior of the *Pavillon de l'Esprit Nouveau* at the Exposition Internationale des Arts Décoratifs, Paris, 1925. © FLC/ADAGP, Paris, and DACS, London 2002 **121** Gerrit Rietveld, Schröder House, Utrecht, The Netherlands 1924–25. © DACS 2002 **122a** Piet Mondrian, *Composition A; Composition with Black, Red, Grey, Yellow and Blue*, 1920. Oil on canvas, 91.5 x 92 (36 x 36½). Galleria Nazionale d'Arte Moderna, Rome. Su concessione del Ministero per i beni e la Attività Culturali. © 2002 Mondrian/Holtzman Trust c/o Beeldrecht, Amsterdam, Holland & DACS, London **122b** Gerrit Rietveld, *Red-Blue Chair*, reconstruction, c. 1923. © DACS 2002 **123** Theo Van Doesburg, photograph and sketches relating to Van Doesburg's painting, *The Cow* from Van Doesburg, *Grundbegriffe der Neuen Gestalteten Kunst*, 1925. British Architectural Library/RIBA, London. © DACS 2002 **124** Le Corbusier with model of the Palace of the Soviets, 1931. Photo AKG, London / Walter Limot, 1931. © FLC/ADAGP, Paris, and DACS, London 2002 **126a** Woodcut illustration for a pamphlet issued by the Arbeitsrat für Kunst, April 1919. Probably executed by Max Pechstein. © DACS 2002 **126b** Bruno Taut, Glass Pavilion, 1914. Deutscher Werkbund exhibition, Cologne, 1914 **127** Bruno Taut, Glass Pavilion, stairs, 1914. Deutscher Werkbund exhibition, Cologne, 1914 **129** Hans Richter, *Vormittagsspuk* (Ghosts Before Breakfast), 1927. 11 minutes, silent. Estate of Hans Richter. Steven Vail Galleries **130** Walter Gropius, Bauhaus building, between the main building and the technical teaching block on the opening day, Dessau, Germany, 1925–26 **131l** Joost Schmidt, Poster for the Bauhaus exhibition of 1923. Bauhaus-Archiv/Museum für Gestaltung, Berlin. © DACS 2002 **131r** Oskar Schlemmer as Türke in his *Triadic Ballet* 1922. Oskar Schlemmer Archive, Stuttgart © 2001 The Oskar Schlemmer Theatre Estate, I-028824 Oggebbio, Italy **132a** Peter Keler, cradle, 1922. Staatliche Kunstsammlungen, Weimar **132b** Brandt and Hein Briedendiek, Bedside lamp designed for Körting and Mathiesen. 1928. Bauhaus-Archiv/Museum für Gestaltung, Berlin **134** Charles Demuth, *Modern Conveniences*, 1921. Oil on canvas, 65.4 x 54.3 (25¾ x 21⅜). Columbus Museum of Art, Ohio. Gift of Ferdinand Howald (31.137) **136** Tamara de Lempicka, *Self-Portrait (Tamara in a Green Bugatti)*, c. 1925. Oil on wood, 35 x 26 (13¾ x 10¼). Private collection, Paris. © ADAGP, Paris, and DACS, London 2002 **137** A. M. Cassandre, *Normandie*, 1935. Lithographic poster, 62 x 100 (24¾ x 39⅜). © Mouron. Cassandre. All rights reserved **138l** William Van Alen, Chrysler Building, New York, 1928–30. Photo © Paterson **138r** The New York Skyline at the Bal des Beaux Arts, 1932. Kilham Collection, Drawings and Archives Department, Avery Architectural and Fine Arts Library, Columbia University, New York **139l** Sloan & Robertson, Washroom, 52nd storey, Chanin Building, New York, 1928–29. Photo Angelo Hornak **139r** Oliver Percy Bernard, Entrance foyer of the Strand Palace Hotel, London,1930 **140** Marc Chagall, *Birthday*, 1915. Oil on canvas, 81 x 100 (31⅞ x 39⅜). The Solomon R. Guggenheim Museum, New York. © ADAGP, Paris, and DACS, London 2002 **141** Amedeo Modigliani, *Seated Nude*, 1912. Oil on canvas, 92.1 x 60 (36¼ x 23⅝). The Courtauld Institute of Art, London **142** Adolf Loos, Kärntna bar interior, Vienna, 1907. © DACS 2002 **143** Le Corbusier, Villa Savoye, Poissy, France. 1928–29.

Photo © CH. Bastin & J. Evrard. © FLC/ADAGP, Paris and DACS, London 2002 **144** Oscar Niemeyer, National Congress Building, Brasilia, 1960 **145l** Ludwig Mies van der Rohe, Lake Shore Drive Apartments, Chicago, Illinois, 1948–51. Photo Ezra Stoller, Esto. © DACS 2002 **145r** Philip Johnson, Glass House, New Canaan, Connecticut, 1949. Photo courtesy Philip Johnson **146** Mario Sironi, *Paesaggio urbano* (Urban Landscape), 1921. Oil on canvas, 50 x 80 (19⅞ x 31½). Pinacoteca di Brera, Milan. Gift of Emilio and Maria Jesi. © DACS 2002 **148** Bruno Taut, The Hufeisensiedlung (Horse-shoe estate), Berlin-Neukölln, with Martin Wagner, 1925–30. Landesbildstelle, Berlin **149** George Grosz, *Daum Marries her Pedantic Automation George in May 1920: John Heartfield is Very Glad of It*, 1920. Watercolour, collage, pen, pencil, 41.9 x 29.8 (16½ x 11¾). Galerie Nierendorf, Berlin. © DACS 2002 **150l** Otto Dix, *Cardplaying War-Cripples*, 1920. Oil on canvas with montage, 109.9 x 87 (43¼ x 34¼). Private Collection. © DACS 2002 **150r** John Heartfield, *Adolf, the Superman; Swallows Gold and Spouts Junk*, 1932. Photomontage, 35.4 x 24.6 (13⅞ x 9⅝). Galleria Schwarz, Milan. © DACS 2002 **151** Max Ernst, *At the Rendez-vous of Friends*, 1922. Oil on canvas, 130 x 195 (51⅛ x 76¾). Ludwig Museum, Cologne. © ADAGP, Paris, and DACS, London 2002 **152** Joan Miró, *Summer*, 1938. Gouache on paper, 75 x 55.5 (29½ x 21¾). Private collection. © ADAGP, Paris, and DACS, London 2002 **153** Salvador Dalí, *Téléphone-Homard* (Lobster Telephone), c. 1936. Assemblage, 18 x 12.5 x 30.5 (7⅛ x 4⅞ x 12). Private Collection. © Kingdom of Spain, universal heir of Salvador Dalí, DACS 2002. © Gala-Salvador Dalí Foundation, by appointment of the Kingdom of Spain, DACS, 2002 **154** Man Ray, *Anatomies*, 1929. Gelatin-silver print, 22.6 x 17.2 (8¾ x 6¾) The Museum of Modern Art, New York. Gift of James Thrall Soby. Copy Print © 2002 The Museum of Modern Art, New York. © Man Ray Trust/ADAGP, Paris and DACS, London 2002 **155** Van Doesburg, Café L'Aubette, Strasbourg.1928–29. Photo courtesy Frank den Oudsten. © DACS 2002 **156** Guiseppe Terragni, Novocomum flats, Como,1927–28 **158** Guiseppe Terragni, Casa del Fascio, Como, 1932–36 **160** Max Bill, *Rhythm in Four Squares*, 1943. Oil on canvas, 30 x 120 (11¾ x 47¼). Kunsthaus Zurich. © DACS 2002 **161** Paul Delvaux, *The Hands (The Dream)*, 1941. Claude Spaak Collection, Paris. © Foundation P. Delvaux – St Idesbald, Belgium/DACS, London 2002 **162** René Magritte, Cover of *Minotaure*, No. 10, 1937. Gouache. © ADAGP, Paris, and DACS, London 2002 **163** Edward Hopper, *Approaching a City*, 1946. Oil on canvas, 68.9 x 91.4 (27 x 36). The Phillips Collection, Washington, D.C. **164** Grant Wood, *Stone City, Iowa*, 1930. Oil on wood panel, 77 x 101.5 (30¼ x 40). Joslyn Art Museum, Omaha, Nebraska. © Estate of Grant Wood/VAGA, New York/DACS, London 2002 **165** Norman Rockwell, *Freedom from Want*, 1943. Oil on canvas, 116.2 x 90.2 (45¾ x 35½). Norman Rockwell Museum, Stockbridge, Massachusetts. Printed by permission of the Norman Rockwell Family Trust Copyright © 1943 the Norman Rockwell Family Trust **166** Margaret Bourke-White, *At the Time of the Louisville Flood*, 1937. Gelatin silver print, 24.6 x 34 (9¹¹⁄₁₆ x 13¾). Whitney Museum of American Art, New York. Gift of Sean Callahan 92.58. Courtesy the Estate of Margaret Bourke-White **167** Ben Shahn, *Years of Dust*, poster issued by Resettlement Authority, c.1935. Library of Congress, Washington, D.C. © Estate of Ben Shahn/VAGA, New York/DACS, London 2002 **169** Vera Mukhina, *Industrial Worker and Collective Farm Girl*, 1937. Bronze, h 158.5 (62½). The State Russian Museum, St Petersburg. © DACS 2002 **170** Komar and Melamid, *Double-Portrait as Young Pioneers*, 1982–83. Oil on canvas, 182.9 x 127 (72 x 50). Courtesy Ronald Feldman Fine Arts, New York. Photo D. James Dee **171** Paul Nash, *Totes Meer (Dead Sea)*, 1940–41. Oil on canvas, 101.6 x 152.4 (40 x 60). Tate Gallery, London. Presented by the War Artists Advisory Committee 1946 **172** Jackson Pollock in his studio, East Hampton, Long Island. Photo Hans Namuth **174** Madge Gill, *Untitled*, c. 1940. Ink on card, 20.3 x 7.6 (8 x 3). Courtesy Henry Boxer Gallery, Richmond, England **175** Jean Dubuffet, *The Cow with the Subtile Nose*, from the *Cows, Grass, Foliage* series,1954. Oil and enamel on canvas, 88.9 x 116.1 cm (35 x 45¾). The Museum of Modern Art, New York. Benjamin Scharps and David Scharps Fund. Photograph © 2002 The Museum of Modern Art, New York. © ADAGP, Paris,

and DACS, London 2002 **177a** Germaine Richier, *Water*, 1953–54. Bronze, 144 x 64 x 98 (56¾ x 25¼ x 38⅝). Tate Gallery, London. © ADAGP, Paris, and DACS, London 2002 **177b** Jean Fautrier, *Hostage*, 1945. Oil on paper laid down on canvas, 35 x 27 (13¾ x 10½). Private Collection. Photo courtesy Sotheby's. © ADAGP, Paris, and DACS, London 2002 **178** Alberto Giacometti, *Man Walking III*, 1960. Galerie Maeght, Paris. © ADAGP, Paris, and DACS, London 2002 **179** Francis Bacon, *Figure in Movement*, 1976. Oil on canvas, 198 x 147.5 (78 x 58⅛). Private Collection, Geneva. © Estate of Francis Bacon/ARS, NY, and DACS, London 2002 **180** Nek Chand, *Massed Villagers, second phase of the Rock Garden*, 1965–95. Chandigarh, India. Photo © Maggie Jones Maizels. Courtesy Raw Vision **181** Isamu Noguchi, Table, c.1940, manufactured by Herman Miller, 1947 **182** Archille Castiglioni, *220 Messadro*, 1957. Tractor-seat stool. Zanotta S.p.A., Milan. Photo Masera **183** Henry Moore, *Reclining Figure*, 1936. Elm wood, length 106.7 (42) Wakefields City Art Gallery & Museum. The works reproduced on pages 11 and 183 have been reproduced by permission of the Henry Moore Foundation **184** Hans Hartung, *Untitled*, 1961. Oil on canvas, 80 x 130 (31½ x 51¼). Private Collection. © ADAGP, Paris, and DACS, London 2002 **185** Wols, *The Blue Phantom*, 1951. Oil on canvas, 73 x 60 (28¾ x 23⅝). Ludwig Museum, Cologne. © ADAGP, Paris, and DACS, London 2002 **186** Patrick Heron, *Cadmium with Violet, Scarlet, Emerald, Lemon and Venetian*, 1969. Oil on canvas, 198.1 x 397.5 (78 x 156½). Tate Gallery, London. © Estate of Patrick Heron 2002. All rights reserved DACS **187** Georges Mathieu, *Mathieu from Alsace goes to Ramsey Abbey*. Oil on canvas. Private collection **188** Arshile Gorky, *The Liver is the Cock's Comb*, 1944. Oil on canvas, 186 x 250 (73¼ x 98⅜). Albright-Knox Art Gallery, Buffalo, New York. Gift of the artist, 1964. © ADAGP, Paris, and DACS, London 2002 **189a** Mark Rothko, *Black on Maroon*, 1958. Oil on canvas, 266 x 381 (105 x 150). Tate Gallery, London. © Kate Rothko Prizel & Christopher Rothko/DACS 1998 **189b** Willem de Kooning, *Two Standing Women*, 1949. Oil on board, 74.9 x 66.7 (29½ x 26¼). Los Angeles County Museum of Art, Collection Mr and Mrs Norton Simon, Los Angeles. © Willem de Kooning Revocable Trust/ARS, NY, and DACS, London 2002 **190** Jackson Pollock, *Blue Poles*, 1952. Oil, enamel and aluminium paint with glass on canvas, 212.9 x 489 (6 ft 11⅛ in x 16 ft 0½ in). National Gallery of Australia, Canberra © ARS, NY, and DACS, London 2002 **191** David Smith, *Cubi XVIII*, 1964. Stainless steel, height 298.7 (117⅝). Courtesy The Marlborough Gallery, New York. © Estate of David Smith/VAGA, New York/DACS, London 2002 **192** Isidore Isou, *Treatise on Drivel and Eternity*, 1950–51. 35mm film, black & white with sound. Musée National d'Art Moderne, Centre Georges Pompidou, Paris **193** Corneille, 1960, Atelier Rue Santeuil, Paris. Photograph Cor Dekkinga, France **194** Karel Appel, *Questioning Children*, 1949. Gouache on pinewood relief 87.3 x 59.8 x 15.8 (34¾ x 23½ x 6¼). Tate Gallery, London. © DACS 2002 **196** Jess, *Tricky Cad, Case I*, 1954. Notebook of 12 collages with hand-written title page and blank end pages, each collage 24.1 x 19 (9½ x 7½). Courtesy of Odyssia Gallery, New York **197** Alexander Calder, *Four Red Systems (Mobile)*, 1960. Painted metal and wire, 195 x 180 x 180 (76¾ x 70⅞ x 70⅞). Louisiana Museum of Modern Art, NY, Carlsbergfondet, Humlebaek, © ARS, NY, and DACS, London 2002 **198l** László Moholy-Nagy, *Light Space Modulator*, 1930. Kinetic sculpture of steel, plastic, wood and other materials with electric motor, 151.1 x 69.9 x 69.9 (59½ x 27½ x 27½). Gift of Sibyl Moholy-Nagy. © President and Fellows, Harvard College, Harvard University Art Museums. Courtesy Hattula Moholy-Nagy **198r** Jean Tinguely, *Homage to New York*, 1960. Mixed media, destroyed. Photo © David Gahr 1960. © ADAGP, Paris, and DACS, London 2002 **200** John Bratby, *Table Top*, 1955. Oil on board, 123.5 x 123.5 (48⅝ x 48⅝). Portsmouth City Museums. Courtesy Patti Bratby **201** Rauschenberg in his Front Street studio, New York, 1958. Photographer unknown. Photo courtesy Statens Konstmuseen, Stockholm. **202** Larry Rivers, *Washington Crossing the Delaware*, 1953. Oil, graphite and charcoal on linen, 212.4 x 283.5 (83⅜ x 111⅝). The Museum of Modern Art, New York. Given anonymously. Photograph © 2002 The Museum of Modern Art, New York. © Larry Rivers/VAGA, New York/DACS, London 2002 **203** Jasper Johns, *Flag, Target with Plaster Casts*, 1955. Encaustic and

collage on canvas with objects, 129.5 x 111.8 x 8.8 (51 x 44 x 3½). Collection David Geffen, Los Angeles. © Jasper Johns, VAGA, New York/DACS, London, 2002 **204** Larry Rivers and Jean Tinguely, *Turning Friendship of America and France*, 1961. Oil on canvas, metal, 204 x 104 x 81 (80⅜ x 41 x 31⅞). Musée des Arts Décoratifs, Paris. © Larry Rivers/VAGA, New York/DACS, London 2002. © ADAGP, Paris, and DACS, London 2002 **205** Robert Rauschenberg, *Bed*, 1955. Combine painting: oil and pencil on pillow, quilt, and sheet on wood supports, 191.1 x 80 x 20.3 (75½ x 31½ x 8). The Museum of Modern Art, New York. Gift of Leo Castelli in honour of Alfred H. Barr, Jr. Photograph © 2002 The Museum of Modern Art, New York. © Robert Rauschenberg/DACS, London/VAGA, New York 2002 **207** Jack Lynn and Ivor Smith, Park Hill, Sheffield, 1961 **208** Edward Kienholz, *Portable War Memorial*, 1968. Environmental construction with operating Coke machine, 289 x 243.8 x 975.4 (114 x 96 x 384). Museum Ludwig, Cologne. © Kienholz Estate. Courtesy of L.A. Louvre, Venice, California **209** Bruce Conner, *BLACK DAHLIA*, 1960. Mixed media assemblage, 67.9 x 27.3 x 7 (26¾ x 10¾ x 2¾). Collection Walter Hopps, Houston. Photo by George Hixson. Courtesy Michael Kohn Gallery, Los Angeles **210** Arman, *Accumulation of Cans*, 1961. Enamel pitchers in plexiglas showcase, 83 x 142 x 42 (32⅝ x 55¾ x 16½). Museum Ludwig, Cologne, Ludwig Donation. © ADAGP, Paris, and DACS, London 2002 **211** Yves Klein, *Anthropometries of the Blue Period*, 9 March 1960. Galerie Internationale d'Art Contemporain, Paris. Photo Shunk-Kender. © ADAGP, Paris, and DACS, London 2002 **212** Niki de Saint Phalle, *Venus de Milo*, 1962. Plaster of Paris on chickenwire construction, colour, 193 x 64 x 64 (76 x 25¼ x 25¼). © ADAGP, Paris, and DACS, London 2002 **214** Pinot Gallizio, *Le Temple de Mécréants*, 1959. Oil on canvas, environment. Installation at the Centre Georges Pompidou, Paris, 1989 **215** Louise Nevelson, *Royal Tide IV*, 1959–60. Wood, spray-painted with gold-coloured solutions, 35 parts, 323 x 445.5 x 55 (127¼ x 175¼ x 21¾). Museum Ludwig, Cologne, Ludwig Donation. © ARS, NY, and DACS, London 2002 **216** Joseph Cornell, *L'Egypte de Mlle Cléo de Mérode: cours élémentaire d'Histoire Naturelle*, 1940. Courtesy Leo Castelli Gallery, New York. © The Joseph and Robert Cornell Memorial Foundation/VAGA, New York/DACS, London 2002 **217** Richard Hamilton, *Just What Is It That Makes Today's Homes So Different, So Appealing?* 1956. Collage, 26 x 25 (10¼ x 9¾). Kunsthalle, Tübingen, Sammlung. Prof. Dr Georg Zundel. © Richard Hamilton 2002. All Rights Reserved, DACS **218** David Hockney, *I'm in the Mood for Love*, 1961. Oil on board, 127 x 101.6 (50 x 40). Royal College of Art Collection, London. © David Hockney 1961 **219** Andy Warhol, *Orange Disaster*, 1963. Silkscreen ink on synthetic polymer paint on canvas, 76.5 x 76.2 (30½ x 30). Collection Francesco Pellizzi. © The Andy Warhol Foundation for the Visual Arts, Inc./ARS, NY, and DACS, London 2002 **220** Jonathan De Pas, Donato D'Urbino and Paolo Lomazzi, *Joe Sofa*, manufactured by Zanotta in 1971. Studio De Pas, D'Urbino, Lomazzi **221** Roy Lichtenstein, *Mr Bellamy*, 1961. Oil on canvas, 143.5 x 107.9 (56½ x 42½). Collection of the Modern Art Museum of Fort Worth, Texas. The Benjamin J. Tillar Memorial Trust, acquired from the Collection Vernon Nikkel, Clovis, New Mexico. © Estate of Roy Lichtenstein/DACS 2002 **222** Yves Klein, *Leap into the Void*, 1960. Photograph by Harry Shunk. © ADAGP, Paris, and DACS, London 2002 **223** Carolee Schneemann, *Meat Joy*, 1964. First performed 29 May 1964, Festival of Free Expression, American Centre, Paris. Photo Al Giese. Courtesy the artist. © ARS, NY, and DACS, London 2002 **224** Yayoi Kusama 'Anti-War' Naked Happening and Flag Burning at Brooklyn Bridge, 1968. Performance. © Yayoi Kusama. Courtesy Robert Miller Gallery, New York **225** Laurie Anderson, *Wired for Light and Sound*, from *Home of the Brave*, New York, 1986. Photo John Lindley. Courtesy the artist **227** Julio Le Parc, *Lunettes pour une vision autre*, 1965. Photographs by André Morain. Private collection. © ADAGP, Paris, and DACS, London 2002 **228** George Maciunas, Dick Higgins, Wolf Vostell, Benjamin Patterson, Emmet Williams performing Philip Corner's *Piano Activities* at Fluxus Internationale Festspiele Neuester Musik, Wiesbaden 1962. Photo Harmut Rekort **229** Yoko Ono, *A Grapefruit in the World of Park...*, 24 November 1961. Carnegie Recital Hall, New York. Photo George Maciunas.

Courtesy of the Gilbert and Lila Silverman Fluxus Collection Foundation, Detroit **230** Bridget Riley, *Pause*, 1964. Emulsion on board, 111.5 x 106.5 (45½ x 41⅞). Private collection. Prudence Cuming Associates Ltd. © The Artist **231** Victor Vasarely, *Vega-Gyongiy-2*, 1971. Acrylic on board, 80 x 80 (31½ x 31½). Private collection. © ADAGP, Paris, and DACS, London 2002 **232** Kenneth Noland, *First*, 1958. Acrylic on canvas, 122 x 127 (48 x 50). Knoedler Kasmin Ltd. © Kenneth Noland/VAGA, New York/DACS, London 2002 **233** Frank Stella, *Nunca Pasa Nada*, 1964. Oil on canvas, 270 x 540 (106¼ x 212⅝). The Lannan Foundation, New York. © ARS, NY, and DACS, London 2002 **234** Photograph byTseng Kwong Chi of Keith Haring drawing in the New York City Subway, 1982. © Muna Tseng Dance Projects, Inc., New York **236** Donald Judd, *Untitled*, 1969. Brass and coloured fluorescent plexiglass on steel brackets, 295.9 x 68.6 x 61 (116½ x 27 x 24). Hirshhorn Museum and Sculpture Garden, Smithsonian Insitution, Washington, D.C. Gift of Joseph H. Hirschhorn, 1972. Art © Donald Judd Foundation/ VAGA, New York/DACS, London 2002 **237** Dan Flavin, *Fluorescent light installation*, 1974. Kunsthalle Cologne. © ARS, NY, and DACS, London 2002 **238** Carl Andre, *Equivalent VIII*, 1966. Firebricks, 12.7 x 68.6 x 229.2 (5 x 27 x 90¼). Tate Gallery, London. © Carl Andre/VAGA/DACS, New York/DACS, London 2002 **239** Foster and Partners, The Millennium Bridge, London. Photographer Jeremy Young/GMJ **240** Joseph Kosuth, *One and Three Chairs*, 1965. Wood folding chair, photographic copy of a chair and photographic enlargement of dictionary definition of a chair; chair 82 x 37.8 x 53 (32⅜ x 14¾ x 20¾); photo panel, 91.5 x 61.2 (36 x 24⅛); text panel, 61.2 x 62.2 (24 x 24⅝). The Museum of Modern Art, New York. Larry Aldrich Foundation Fund. Photograph © 2002 The Museum of Modern Art, New York. © ARS, NY, and DACS, London 2002 **241** Joseph Beuys, *The Pack*, 1969. Volkswagen bus with 20 sledges, each carrying felt, fat and a flashlight. Collection Herbig, Germany. © DACS 2002 **242** Piero Manzoni, *Merda d'artista no. 066* (Artist's shit no. 066), 1961. Metal can, 4.8 x 6.5. (1⅞ x 2½) © DACS 2002 **243** Marcel Broodthaers, *Museum of Modern Art, Department of Eagles, XIXth Century section*, Brussels, 1968–69. Photograph © Gilissen. © DACS 2002 **244** Bruce Nauman, *Self-Portrait as a Fountain*, 1966–67. Colour photograph, 50 x 60 (19¾ x 23¾). The Gerald S. Elliott Collection of Contemporary Art. © ARS, NY, and DACS, London 2002 **245** Chris Burden, *Trans-fixed*, 23 April 1974, Venice, California. Photo Charles Hill. Courtesy the artist © Chris Burden **246** Marc Quinn, *Self* (detail), 1991. Blood, stainless steel, perspex and refrigeration equipment, 208 x 63 x 63 (81⅞ x 24¹³/₁₆ x 24¹³/₁₆). Photo The Saatchi Gallery, London. Courtesy Jay Jopling/White Cube **247** Marcel Duchamp. Photograph of the installation for the exhibition for the 'First Papers of Surrealism', an exhibition for the Coordinating Council of French Relief Societies, New York, 1942. © Succession Marcel Duchamp/ADAGP, Paris, and DACS, London 2002 **248** Maurizio Cattelan, *La Nona Ora* (The Ninth Hour), 2000. Carpet, glass, wax, paint, life-size figure. Installation view: Royal Academy of Arts, London. Photograph Attilio Maranzano. Courtesy Anthony d'Offay Gallery, London **249** Barbara Kruger, *Untitled*, 1991. Mixed media. Courtesy Mary Boone Gallery, New York. Photograph Zindman/Fremont **250** Claude Simard, Installation view, 1999. Jack Shainman Gallery, New York **251** Richard Estes, *Holland Hotel*, 1894. Oil on canvas, 114 x 181 (45 x 71½). Louis K Meisel Gallery, New York. Photo Steve Lopez. © Richard Estes/VAGA, New York/DACS, London 2002 **252** John Ahearn, *Veronica and her Mother*, 1988. Oil on fibreglass, 180 x 90 x 90 (71 x 35½ x 35¾). Contemporary Realist Gallery, San Francisco. Courtesy Alexander and Bonin, New York **253** Chuck Close, *Mark*, 1978–79. Acrylic on canvas, 274.3 x 213.4 (108 x 84) Private Collection, New York. © Chuck Close **255** Ron Herron, *Walking City Project*, 1964 **256** Exhibition at the Galerie Jean Fournier, 15–22 April, 1971. Works produced in the summer of 1970 by Dezeuze, Saytour, Valensi and Viallat were represented in this show. Galerie Jean Fournier collection. **257** Bill Viola, *Nantes Triptych*, 1992. Installation on three screens with projection from behind. Musée des Beaux-Arts de Nantes. Courtesy of the artist **258** Nam June Paik, *Global Groove*, 1973. Video tape, colour, sound, 28 mins. Reproduction permission courtesy Nam June

Paik and the Holly Solomon Gallery **259** Tony Oursler, *The Influence Machine*, 2000. Installation. Photo: Aaron Diskin/Courtesy of Public Art Fund. Courtesy of the artist and Metro Pictures. **260** Walter De Maria, *The Lightning Field*, 1977. 400 stainless-steel poles with solid, pointed tips, situated in a rectangular grid array, 1 mile x 1 kilometre, Catron County, New Mexico. Courtesy Dia Center for the Arts. Photo John Cliett **261** Robert Smithson, *Spiral Jetty*, 1970. Rock, earth, and salt crystals, coil 457.2 x 3.81 m (1,500 x 15ft). Now submerged. © Estate of Robert Smithson/VAGA, New York/DACS, London 2002 **262** Christo and Jeanne-Claude, *Wrapped Coast, Little Bay, Australia*, 1969. One million square feet of Erosion Control fabric and 36 miles of polypropylene rope. The coast remained wrapped for a period of 10 weeks from 28 October 1969, then all materials were removed and the site returned to its original condition. Photo Harry Shunk. © Christo 1969 **263** Richard Serra, *Tilted Arc*, Federal Plaza, New York, 1981. Corten steel 366 x 3658 x 6 (144¼ x 1440¼ x 2⅜). Courtesy of The Pace Wildenstein Gallery, New York. © ARS, NY, and DACS, London 2002 **264** Claes Oldenburg and Coosje van Bruggen, *Batcolumn* 1977. Steel and aluminium painted with polyurethane enamel, 29.46 x 2.97 m (96 ft 8 in. x 9 ft 9 in.) diameter on base 1.22 x 3.05 m (4 ft x 10 ft) diameter. Harold Washington Social Security Center, 600 West Madison Street, Chicago © Claes Oldenburg. All rights reserved **265** Daniel Buren, *Deux Plateaux*, 1985–86. 260 free-standing cement and marble columns of various heights, lights and a sunken artificial stream. Palais Royal, Paris. © ADAGP, Paris, and DACS, London 2002 **266** Mario Merz, *Igloo*, 1984–85. Plate glass, steel, netting, plexiglas and wax, 100 x 250 x 300, (39¾ x 98¼ x 118¼). The Gerald S. Elliott Collection of Contemporary Art **267** Michelangelo Pistoletto, *Golden Venus of Rags*, 1967–71. Concrete with mica and rags, 180 x 130 x 100 (70⅞ x 51⅛ x 39⅜). Courtesy the artist **269** Hans Haacke, *Die Freiheit wird jetz einfach gesponsert – aus der Portokasse* (Freedom is now just going to be sponsored – out of petty cash), 1990. Exhibited at Die Endlichkeit der Freiheit DAAD, Berlin, 1990. Courtesy John Webber Gallery, New York. Photo Werner Zellien. © DACS 2002 **270** Charles Moore, *Piazza d'Italia*, New Orleans, 1975–80. Photograph Moore/Andersson Architects, Austin, Texas **271** Cindy Sherman, *Untitled # 90*, 1981. Colour photograph, 61 x 121.9 (24 x 48). Edition of 10. Collection of the artist. Courtesy the artist and Metro Pictures, New York **272** Judy Chicago, *The Dinner Party*, 1974–79. Mixed media 14.63 x 12.8 x 91.4 m (48 x 42 x 3 ft). Photograph © Donald Woodman. © Judy Chicago 1979 **273** Ettore Sottsass, Carlton Bookcase, Memphis, 1981. HPL Print laminate. Photo Aldo Ballo **274** Piano and Rogers, Georges Pompidou Centre, Paris, Photo © AISA-Archivo Iconográfico, Barcelona **275** Foster and Partners, Hong Kong and Shanghai Banking Corporation Headquarters, 1979–86. Photo Ian Lambot **276** Anselm Kiefer, *Margarethe*, 1981. Oil and straw on canvas, 280 x 380 (110 x 150). Courtesy Anthony d'Offay Gallery, London **277** Gerhard Richter, *Abstraktes Bild (860-3)*, 1999. Oil on canvas, 102 x 82 (40⅛ x 32¼). Collection of the Artist. © Gerhard Richter **278** Anish Kapoor, *1000 Names*, 1982. Mixed media, pigment. Private Collection. **280a** Eric Fischl, *Bad Boy*, 1981. Oil on canvas, 168 x 244 (66 x 96). Private Collection. Courtesy Mary Boone Gallery, New York **280b** Jenny Saville, *Branded*, 1992. Oil on canvas, 213.4 x 182.9 (84 x 72). The Saatchi Gallery, London **281** Jeff Koons, *Two Ball 50/50 Tank*, 1985. Glass, steel, distilled water, basketballs, 159.4 x 93.3 x 33.7 (62¾ x 36¾ x 13¼). Ex-Saatchi Collection. © Jeff Koons **282** Photograph from left to right: Sandro Chia, Nino Longobardi, Mimmo Paladino, Paul Maenz, Francesco Clemente and his wife, Wolfgang Max Faust, unidentified, Fantomas, Gerd de Vries, Lucio Amelio **283** Enzo Cucchi, *Un quadro di fuochi preziosi* (A Painting of Precious Fires), 1983. Oil on canvas with neon, 298 x 390 (117½ x 153). The Gerald S. Elliott Collection of Contemporary Art. Courtesy of Galerie Bruno Bischofberger, Zurich **285** Christian Marclay, *Guitar Drag*, 2000. DVD projection with sound, running time 15 minutes. Courtesy Paula Cooper Gallery, New York **287** Jake Tilson, Selection of screens from website *The Cooker*, 1994–99. Courtesy Jake Tilson http://www.thecooker.com **288** Olia Lialina, *My Boyfriend Came Back From the War*, 1996 (www.teleportacia.org/war)

INDEX

Main entries are in bold; references to illustrations are in *italics*.

Aalto, Aino Marsio 183
Aalto, Alvar 143, 183
Abakanowicz, Magdalena 279
Abbaye de Créteil **289**
ABC **289**
ABC Art *see* Minimalism
Abramovic, Marina 246
Abstract Expressionism 17, 30, 94, 97, 154, 160, 165, 166, 176, 182, 186–87, **188–91**, 193, 202, 204, 205, 208, 210, 219, 222, 226, 230, 232, 233, 279
Abstraction-Création 101, 123, 160, **289**
Acconci, Vito 223, **244**, 246
Action Painting 189, **289**
Actionism, Aktionismus
 see Vienna Action Art
Actions *see* Performance Art
Adam, Paul 27
Adami, Valerio 220;
 see also Nouvelle Figuration
Adhocism 271, **289**
Adler, Dankmar 23–24
Aeropittura 91, **289**
Aesthetic Movement **30–32**, 36, **289**
Affichistes **289**
AfriCobra **289**
Agam, Yaacov 198
Agar, Eileen 154
Agitprop **289**
Ahearn, John 254; *252*
AkhRR, AkhR **289**
Albers, Josef **132–33**, 230, 232;
 see also Serial Art
Albright, Ivan 162;
 see also Monster Roster
Alechinsky, Pierre 193;
 see also Jeune Peinture Belge
Alighiero e Boetti 266
Allianz **289**
Allied Artists' Association **289**
Alloway, Lawrence 216, 217, 220;
 see also Junk Art
Alma-Tadema, Sir Lawrence 31, *32*
Almond, Darren 249
Aman-Jean, Edmon 56
American Abstract Artists **289**
American Craft movement **289**
American Gothic, American Scene 80, 147, 149, **163–65**, 219
American-Type Painting 188
Amiet, Cuno 77
Analytical Cubism 84
Anderson, Laurie **225**, *225*, 284, 286
Ando, Tadao 239
Andre, Carl **236–38**, *238*, 260; *see also* Art Workers' Coalition, Serial Art
Andreani, Aldo 147
Angrand, Charles 28
Angry Penguins **289**
Anquetin, Louis 25, 48, **49–50**, 51, 54
Anselmo, Giovanni 266, 268
Anti-Design 254–55
Antin, Eleanor 223
Antipodean group **289**
Anuszkiewicz, Richard 230
Apollinaire, Guillaume 69, 87, 98, 99–101, 103, 111, 151
Apostles of Ugliness, The
 see Ashcan School
Appel, Karel **193–95**, *194*; *see also* Nederlandse Experimentele Groep
Apple, Jacki 223
Arad, Ron 183
Aragon, Louis 119
Arakawa, Shusaku 242; *see also* Neo-Dada Organizers
Arbeitsrat für Kunst 73, **126–28**, 129, 130, 142, 147
Archigram 214, **254–55**, 274
Archipenko, Alexander 87, 141
Architext **289**
Archizoom 214, **254–55**, 268, 274
Arensberg, Walter and Louise 115, 134
Arman **210**, **212–13**, *210*, 216, 247; *see also* Ecole de Nice
Arnal, François 256
Arneson, Robert 209
Arp, Jean (Hans) 96, **153**, 156, 181–82, 198, **115–16**, *116*, **118**, 123
Art & Language 242, 256, **289**
Art and Freedom **289**

Art autre 187, **289**
Art Brut **174–76**, 180, 187, 206, 217
Art Deco 20, 36, 37, 61, 101, 154, **135–39**, 221, 255
Art Informel 154, 160, 176, **184–87**, 188, 210, 222, 226, 279
Art Nouveau 16, 20, 24, 30, 32, **33–37**, 38, 40, 44, 48, 50, 51, 55, 57, 58, 60, 61, 62, 71, 73, 75, 81, 114, 135, 181, 221, 255
Art Workers' Coalition **289**
Artaud, Antonin 153, **175**
Arte Cifra **289**
Arte Generativo **289**
Arte Madí **289**
Arte Nucleare 187, **289**
Arte Povera 118, 256, **266–68**, 282
Arte Programmata **289**
Arts and Crafts **19–22**, 26, 35, 38, 50, 57, 58, 60, 61, 62, 74, 75, 81, 111, 135, 142, 217
Artschwager, Richard 236
Ashbee, C. R. 26, 35, 58, 61
Ashcan School 44, 48, **78–80**, 163, 166
Asmus, Dieter 251
Assemblage 118, 181, 196, **215–16**, 228, 247, 266, 284
Atelier 5 **289**
Atelier Populaire **289**
Athey, Ron 223
Atkinson, Lawrence 111
Atkinson, Terry *see* Art & Language
Atwood, Charles 23, *23*
Audio Art *see* Sound Art
Auerbach, Frank 279
Aurier, Albert 41, 54
Auto-destructive art **290**
Automatistes, Les 187, **290**
Aycock, Alice 260–61
Ayrton, Michael 170
Baader, Johannes 118
Bacon, Francis **177–78**, *179*;
 see also School of London
Bad Painting 279, **290**
Bag, Alex 259
Baillie Scott, M. H. **20**, 35, 58
Bainbridge, David *see* Art & Language
Baj, Enrico 216; *see also* Arte Nucleare
Bakema, Jacob 206
Baker, Josephine 136
Bakst, Léon **62–63**, *62*, *63*, 135
Baldessari, John 242–43
Baldessari, Luciano 157
Baldwin, Michael *see* Art & Language
Ball, Hugo 115–16
Balla, Giacomo 89–90; *89*
Ballin, Mogens 50
Banfi, Gianluigi 159
Banham, Reyner 254
Barbier, George 136
Barbizon School 15, **290**
Barceló, Miquel 279
Bardi, Pietro Maria 157
Barlach, Ernst 73
Barney, Mathew 259
Barragán, Luis 239
Barry, Robert 242
Bartlett, Jennifer 279; *see also* New Image Painting
Bartning, Otto 126, 147–48
Bartolini, Dario 255
Bartolini, Lucia 255
Baselitz, Georg 276
Basile, Ernesto 37
Basquiat, Jean-Michel 272–73
Baudelaire, Charles 30–31, 41, 43, 56, 66
Baudrillard, Jean 271
Bauhaus 22, 35, 58, 61, 74, 83, 97, 105, 109, 113, 121, 122–23, **130–33**, 135, 142, 155, 222, 230, 271
Bay Area Figuration **290**
Bayer, Herbert 133
Bazille, Jean-Frédéric 14
Baziotes, William 188, 191
BBPR 159
Beardsley, Aubrey 26, *30*, **32**, 35
Beat Art 176, **195–96**, 201, 208, 216, 217, 222, 227, 284
Beauvoir, Simone de 176
Bechtle, Robert 251
Beckett, Samuel 176

Beckmann, Max 149
Behne, Adolf 126
Behrendt, Walter Curt 148
Behrens, Peter 57–58, **81–83**, *80*, *83*, 131, 142, 147
Bel Geddes, Norman 139
Bell, Clive 47; *see also* Bloomsbury Group, Euston Road School
Bell, Larry 236
Bell, Vanessa 48; *see also* Bloomsbury Group, Omega Workshops
Bellamy, Richard 221
Belling, Rudolph 126
Bellmer, Hans 153–54
Bellows, George 79–80, *79*
Ben *see* Ben Vautier
Benglis, Linda 183
Bengston, Billy Al 219
Benois, Alexandre 62–63
Benton, Thomas Hart 98, **164–65**, 190; *see also* Regionalism
Bérard, Christian 170
Berg, Alban 129
Berg, Max 73
Berger, John 200
Berghe, Frits van den 72
Bergson, Henri 85, 89, 101
Berlage, Hendrik Petrus 114, 123
Berman, Eugene 170
Berman, Leonid 170
Berman, Wallace 195–96
Bernard, Emile 25, 41, 45, 47, 48, **49–50**, *49*, 53–54
Bernard, Oliver *139*
Berners-Lee, Timothy 286
Bernhardt, Sarah 36
Bernstein, Michèle 213
Bertelé, René 186
Bestelmeyer, German 148
Beuys, Joseph *241*, **242–43**, 268, 279
Bickerton, Ashley 281
Bidlo, Mike 271
Bildarchitektur 113
Bill, Max 160; *see also* Allianz
Bing, Siegfried 33, 36
Biomorphic Abstraction
 see Organic Abstraction
Bioulès, Vincent 256
Birnbaum, Dara 259
Bishop, Isabel 166
Bissière, Roger 187
Black Expressionism **290**
Black Mountain College 195–96, 222, 229, **290**
Black Neighborhood Mural Movement **290**
Bladen, Ronald 236
Blake, Peter 217
Blake, William 170, 258
Blaue Reiter, Der 70, 91, **94–97**, 100, 279
Blecha, Matej 86
Bleyl, Fritz 74
Bloch, Albert 95
Block, Der 148
Blok **290**
Bloomsbury Group 48, **290**
Bloy, Léon 73
Blue Four 97, **290**
Blue Rose 63, **290**
Blume, Peter 162
BMPT 242, **290**
Boccioni, Umberto 88–91, *90*
Boch, Anna **25**, 29, 48
Bochner, Mel 242
Böcklin, Arnold 56, 63
Body Art 118, 223, 240, **244–46**, 268
Bogart, Bram 184
Bogosian, Eric 255
Boguslavaskaya, Kseniya 105
Boiffard, Jacques-André 154
Bolotowsky, Ilya 160
Boltanski, Christian 249
Bomberg, David 111
Bonatz, Paul 148
Bonnard, Pierre 37, 48, **50**, 51, *51*, *53*; *see also* Intimisme
Bonnefoi, Geneviève 184
Bontecou, Lee 201, 212, 216
Bortnyik, Sándor **113**, 231
Bouret, Jean 178
Bourgeois, Louise 279; *see also* Eccentric Abstraction

Bourgeois, Victor 83
Bourke-White, Margaret 166, *166*
Bowery Boys **290**
Bradley, William 37
Bragaglia, Antonio Giulio 90
Brancusi, Constantin **141**, 181, 238
Brandt, Marianne *132*, 133
Branzi, Andrea 255;
 see also Studio Alchymia
Braque, Georges 66, **83–87**, *84*, 88, 96, 99, 134, 140
Brassaï **141**, 154, 174
Bratby, John **199–201**, *200*
Brecht, Bertolt 129
Brecht, George 228;
 see also Ecole de Nice
Brenson, Michael 263
Breton, André 119, **151**, **154**, 175, 189, 190, 192
Breton, Jacqueline 154
Breuer, Marcel 133, 144
Briedendiek, Hein *132*
Brisley, Stuart 246
Brodsky, Isaak 168
Brody, Neville 271
Broodthaers, Marcel 242–43, *243*
Brown, Carolyn 223
Brown, Ford Madox 20
Brown, Trisha 223
Bruce, Patrick Henry 98
Brücke, Die 69, 70, 71, 73, **74–77**, 94, 126, 279
Brunelleschi, Umberto 136
Bryen, Camille 184, 187
Bucci, Anselmo 147
Buffet, Bernard **178**, 200
Buffet-Picabia, Gabrielle 99
Bullock, Angela 199
Bunting, Heath 286
Buñuel, Luis 153
Buraglio, Pierre 256
Burchfield, Charles 163–64
Burden, Chris **245**, 246
Buren, Daniel 242–43, 263, **265**, *265*;
 see also BMPT
Burgin, Victor 242
Burliuk, David **92–93**, 94–95;
 see also Neo-Primitivism
Burliuk, Vladimir **92–93**, 94;
 see also Neo-Primitivism
Burne-Jones, Edward 19, 20, 32, 43;
 see also Pre-Raphaelite Brotherhood
Burnham, Daniel H. 23, *23*
Burri, Alberto 184, 216
Burroughs, William 195
Bury, Pol **198–99**; *see also* Jeune Peinture Belge, Mec Art
Buthaud, René 136
Butler, Reg 178
Cabanne, Pierre 140
Cage, John 201–02, **222**, 229, 239, 258, 284; *see also* Black Mountain College
Caillebotte, Gustave 14
Calder, Alexander 182, *197*, **198–99**
Calle, Sophie 249
Calzolari, Pier Paolo 266
Camden Town Group **290**
Camoin, Charles 66
Campendonk, Heinrich 95, 129
Campigli, Massimo 147
Camus, Albert 176
Canadian Automatistes
 see Les Automatistes
Canadian Group of Painters, The **290**
Cane, Louis 256
Capek, Josef 87; *see also* Skupina Vytvarnych Umelcu
Cardinal, Roger 180
Caro, Sir Anthony 236, 239, *239*;
 see also Green Mountain Boys
Carrà, Carlo *88*, **88–91**, **109–11**, 147
Carrington, Leonora 154
Casorati, Felice 111, 147
Cassandre *137*, 138
Cassatt, Mary 14, 18
Castelli, Leo 221
Castiglioni, Achille 182–83, *182*
Cattaneo, Cesare 159
Cattelan, Maurizio *248*, 249
Caulfield, Patrick 217
Caxton, John 170
Ceccobelli, Bruno 279
Celant, Germano 266, 268
Cendrars, Blaise 99

Cercle et Carré **290**
César 210, 212
Cézanne, Paul 14, 16, 25, **45**, **47**, *47*, **48**, 51, 67, 69, 83–84, 134
Chagall, Marc 63, 105, *140*, **141**, 153
Chalk, Warren 254
Chamberlain, John **201**, 212, 237; *see also* Black Mountain College
Chand, Nek *180*, 181
Chapman, Jake and Dinos 210; *see also* YBAs
Charchoune, Serge 119
Chareau, Pierre 136
Chase, William Merritt 18
Chashnik, Ilya 105; *see also* Unovis
Cheesman, Georgie 274
Chessman, Caryl 209
Cheval, Le Facteur 180–81
Chevreul, Michel-Eugène 27, *28*
Chia, Sandro 282–83, *282*; *see also* Arte Cifra
Chiattone, Mario 90
Chicago Imagists **290**
Chicago School **23–24**, 142, 263
Chicago, Judy 269, *272*
Childs, Lucinda 225
Chirico, Giorgio de **109–11**, *110*, 147, 153, 161, 162, 170
Chitty, Gary 225
Chochol, Josef 87; *see also* Devetstil, Skupina Vytvarnych Umelcu
Christo and Jeanne-Claude 210–11, 247, **260**, **262**, *262*
Chryssa 212; *see also* Light Art
CIAM 123, 143, 145
Clair, René 119
Clemente, Francesco 282–83; *282*; *see also* Arte Cifra
Clert, Iris 240
Cloisonnism 47, 48, **49–50**, 54
Close, Chuck 251–52, *253*
Coates, Robert 188
Cobden-Sanderson, T. J. **22**, 26
CoBrA 154, 176, 187, **193–95**, 213
Coburn, Alvin Langdon 111–12
Cocteau, Jean 147
Cold Art **290**
Colla, Ettore 216
Colombo, Joe 255; *see also* Arte Nucleare
Color Field Painting 189, **290**
Combines 204, **205–06**, 223, 284
Common Object Painting 220
Common-Object Artists *see* Neo-Dada
Computer Art **290**
Conceptual Art 204, 221, 223, 225, 238, **240–43**, 244, 248, 251, 256, 263, 269, 276, 281, 282, 284
Concrete Art 123, **159–60**, 230, 233
Conner, Bruce 208–10, *209*
Conrads, U. 254
Constable, John 15
Constant **193**, **213–14**, 254; *see also* Nederlandse Experimentele Groep
Constructivism 30, 63, 87, 91, 93, 103, 105, **106–09**, 113, 122–23, 132, 155, 157, 160, 198, 216, 222, 229, 230, 236, 238, 274
Continuitá **290**
Cook, Peter 254
Cool Art *see* Minimalism
Coop Himmelblau 269, **290**
Copers, Leo 281
Coplans, John 246
Corinth, Lovis 18
Cormon, Fernand 48, 49
Corneille 193; *193*; *see also* Nederlandse Experimentele Groep
Cornell, Joseph 135, **216**, *216*
Corner, Philip *228*
Corot, Camille 15
Corrente **290**
Corretti, Gilberto 255
Costa, Lúcio 143
Cottingham, Robert 251
Counter-Design 254
Courbet, Gustave 15, 41
Crafts Revival 22, **290**
Cragg, Tony 268
Craig-Martin, Michael 242, **281**
Crane, Walter 22, **25–26**, 33, 35, 37; *see also* Pre-Raphaelite Brotherhood
Crawford, Ralston 134
Crompton, Dennis 254
Cross, Henri-Edmond 28, 66

Crotti, Jean 119
Csáky, Joseph 87
Cubism 44, 47, 67, 71, 75, **83–87**, 88–89, 92, 98, 99, 102, 106, 111, 113, 118, 119, 122, 134, 135, 189, 216, 233
Cubist-Realism *see* Precisionism
Cubo-Futurism 93, 102, 103, **290**
Cucchi, Enzo 282–83, *283*; *see also* Arte Cifra
Cunard, Nancy 101
Cunningham, Merce 202, 222; *see also* Black Mountain College
Curry, John Steuart 164–65; *see also* Regionalism
Dada 53, 87, 90, 91, 97, 113, **115–19**, 123, 134, 150, 151, 153, 183, 187, 189, 192, 198, 202, 205, 211, 213, 216, 222, 229, 230, 269, 281, 284
Dalí, Salvador 40, **153–54**, *153*
Danish Modern **290**
Darboven, Hanne 242
D'Aronco, Raimondo 37
Darwin, Charles 35
Dau al Set **291**
Daum, Antonin 36; *see also* Nancy School
Daum, Auguste 36; *see also* Nancy School
Davie, Alan 187
Davies, Arthur B. **44**, 79, 98; *see also* The Eight
Davis, Gene 232
Davis, Stuart 79
De Andrea, John 254
De Kooning, Willem 178, 187, **188–91**, *189*, 240; *see also* Action Painting
De Lucchi, Michele 269; *see also* Studio Alchymia
De Maria, Walter 260–62, *260*
De Pas, D'Urbino e Lomazzi *220*, 221
Deacon, Richard 183, 268
Debord, Guy 193, **213–14**
Debussy, Claude 18, 26
Decadent Movement **30–32**, 36, 44, 48, 61, 95
Deconstructivist architecture **291**
DeFeo, Jay 195–96
Deganello, Paolo 255
Degas, Edgar *16*, **17–18**, 45, 47, 48, 63
Degenerate art 58, 150, **291**
Deineka, Alexander 168
Deitcher, David 247
Delaunay, Robert 71, 93, 95, 96, 97, 99, **100–101**, *100*, 136; *see also* Puteaux Group
Delaunay, Sonia **99–101**, *99*, *101*, 136
Delorme, Raphaël 136
Delvaux, Paul 162; *161*
Delville, Jean 56
Demuth, Charles 134–35, *134*
Denis, Maurice 25, 41, 45, **50**, **51**, *51*, **53**, 56
Depero, Fortunato 90
Derain, André 45, **66–67**, *67*, **69**, 86
Deschamps, Gérard 210
Deskey, Donald 138–39
Deutscher Werkbund 35, 58, **80–83**, 126, 130, 142, 143, 147–48, 157
Devade, Marc 256
Devetstil Group **291**
Dewey, John 131; *see also* Black Mountain College
Dezeuze, Daniel 256, *256*
Diaghilev, Sergei **62–63**, 101, 103, 135
Dibbets, Jan 242, **260–61**
Dickinson, Preston 134
Dine, Jim **201**, 216, **219–20**, 222, 247; *see also* Happenings
Direct Art *see* Performance Art
Dismorr, Jessica 111; *see also* Group X
Divisionism 27–29, **291**
Dix, Otto **149**, *150*, 166
Dolla, Noël 256
Domela, César 160
Domènech i Montaner, Lluís 38
Domergue, Jean Gabriel 136
Donati, Enrico 154
Dongen, Kees van 66, 69, 77
Donkey's Tail 93, **291**
Dostoyevsky, Fyodor 75, 151

Dotremont, Christian 193
Douglas, Stan 259
Dowd, Robert 220
Dubois-Pillet, Albert 28–29
Dubuffet, Jean **174–76**, *175*, 184, 186, 206, 215, 217
Ducasse, Isidore 151, 192
Duchamp, Marcel 86, 87, 99, *115*, **116**, **118–19**, 134, 198, 202, 205, 211, 216, 228, 230, 238, 240, 243, 244, 247, *247*, 250, 269, 284; *see also* Puteaux Group, Section d'Or, Société Anonyme, Inc.
Duchamp, Suzanne 119
Duchamp-Villon, Raymond 87; *see also* Puteaux Group, Section d'Or
Dudreville, Leonardo 146
Dufrêne, François 193, 210; *see also* Affichistes
Dufy, Raoul *66*, *68*, 136
Dujardin, Edouard 50
Dunand, Jean 136
Dupas, Jean 136
Durand-Ruel, Paul 16, 56
Dwan, Virginia 221, 261–62
E.A.T. *see* Experiments in Art and Technology
Eakins, Thomas 78
Eames, Charles and Ray *182*, 221
Earth Art 238, 240, **260–62**, 263
Eccentric Abstraction **291**
Eckmann, Otto 57
Eco, Umberto 197; *see also* Arte Programmata, UFO
Ecole de Nice **291**
Ecole de Paris **140–41**, 164, 186, 193
Eddy, Don 251
Eermolaeva, Vera 105; *see also* Unovis
Eesteren, Cor van 155–56
Eggeling, Viking 129
Eight, The 44, 48, 79–80, **291**
Elementarism 123, **155–56**, 159–60, 247
Elmslie, George Grant 22
Emin, Tracey 249; *see also* YBAs
Endell, August **57–58**, *58*, 82
Eno, Brian 284, 286
Ensor, James 25, **44**, 70, 71
Environments 247
Epstein, Elizabeth 95
Epstein, Jacob 111
Equipo 57 **291**
Equipo Crónica **291**
Equipo Realidad **291**
Ernst, Max 111, **118**, *151*, **153–54**, 189
Erté 136
Estes, Richard 251–52, *251*
Etchells, Frederick 111; *see also* Group X
Európai Iskola **291**
Euston Road School **291**
Evans, Walker 166
Existential Art **176–79**, 184, 186, 187, 188, 195, 200, 206, 233
Experiments in Art and Technology 223, 226, 284, **291**
Expressionism 37, 40, 44, 48, 55, 69, **70–74**, 77, 82, 87, 94, 100, 111, 113, 114, 122, 126, 131, 135, 149, 177, 187, 188, 195, 274, 279, 280, 283
Exter, Alexandra 108
Eyck, Aldo van 206
Fabre, Jan 225
Fabro, Luciano 266, 268
Factual Artists *see* Neo-Dada
Fahlström, Öyvind 220
Falk, Robert 92–93
Fantastic Realism **291**
Farber, Viola 223
Farrington, Paul 286
Faulkner, Charles 20
Fautrier, Jean **175–77**, *177*, 184, 186
Fauvism 18, 44, 45, 47, 48, 55, **66–69**, 70, 73, 75, 77, 84, 86, 92, 95, 135, 189
Feininger, Lyonel **97**, 126, 129, 131, 132; *see also* Blue Four
Felixmüller, Conrad 149
Feminist Art Workers **291**
Fénéon, Félix 26–28, 54
Ferber, Herbert 191
Fetting, Rainer 276; *see also* Neue Wilden

Figini, Luigi 156–57, 159
Figuration Libre 276, **291**
Figuration Narrative **291**
Filiger, Charles 56
Filiou, Robert 228; *see also* Ecole de Nice
Filla, Emil 87; *see also* Osma, Skupina Vytvarnych Umelcu
Finch, Alfred William **25**, 29
Fini, Leonor 154
Finley, Karen 223
Finster, Howard 181
Finsterlin, Hermann 126, 128
Fiocchi, Mino 147
Fischer, Theodor 81–82
Fischer, Volker 269
Fischl, Eric 279, *280*
Fitzgerald, F. Scott 135
Flack, Audrey 251–52
Flanagan, Bob 246
Flaubert, Gustave 43
Flavin, Dan 236–38, *237*; *see also* Bowery Boys, Light Art
Fletcher, Robin 225
Fluxus 223, **228–29**, 232, 239, 240, 268, 284
Flynt, Harry 240
Follet, Paul 136
Follett, Jean 216
Fontana, Lucio 247; *see also* Continuitá, Movimento Arte Concreta, Spazialismo
Forces Nouvelles **291**
Ford, Henry 134
Forma **291**
Foster, Sir Norman 239, 269, **274–75**; *239*, *275*
Foster, Wendy (Cheesman) 274
Francia, Cristiano Toraldo di 255
Frank, Josef 83
Frank, Robert 196
Frankenthaler, Helen 232; *see also* Green Mountain Boys
Frankl, Paul T. 139
Frasinelli, Piero 255
Frette, Guido 156
Freud, Lucian **177–78**, 279; *see also* School of London
Freud, Sigmund 59, 151, 153, 189
Freundlich, Otto 129
Frey, Viola 209
Friesz, Othon 66
Fronte Nuovo delle Arti **291**
Fry, Roger 45, 48, 111; *see also* Bloomsbury Group, Omega Workshops
Fuller, Buckminster 202, 204, 255, 274, 288; *see also* Black Mountain College
Fuller, Loïe 36
Fulton, Hamish 260–61
Funi, Achille 146
Funk Art 196, 201, **208–10**, 217, 227
Futurism 29, 71, 87, **88–91**, 93, 101, 102, 106, 109, 111, 113, 116, 122, 134, 135, 147, 155, 156, 216, 222, 229, 230, 274, 284
Gabo, Naum **106**, **108–09**, 118, 160, 198; *see also* St Ives School
Gachet, Paul, Dr 15
Galas, Diamonda 223
Gallé, Emile 36; *see also* Nancy School
Gallén-Kallela, Akseli 22, 77
Gan, Alexei 108
Garcia, David 286
García-Rossi, Horacio 226
Garden City movement 20, 58
Gaudí, Antoni **38–40**, *38*, *39*, *40*, 73, 114, 182
Gaudier-Brzeska, Henri 111–12; *see also* Omega Workshops
Gaugin, Paul 16, 25, 30, 35, 41, 45, 47, 48, 50, 51, **53–55**, *54*, 55, 67, 69, 70, 75; *see also* School of Pont-Aven
Gausson, Léo 29
Geflecht *see* Spur
Gehry, Frank 275, 279
General Idea 225, **291**
Genet, Jean 176–78
Genzken, Isa 279–80
Gerasimov, Alexander 168
Gerasimov, Sergei 168
Giacometti, Alberto 153, 177–78, *178*
Gilbert & George 244
Gilhooly, David 209

Gill, Madge 174, *174*
Gillette, Frank 258
Ginsberg, Allen 195
Glackens, William 78–80;
 see also The Eight
Glaser, Milton 221
Glasgow Four 35
Glasgow School 58, **291**
Glass Chain **128**, 130, 254
Glass, Philip 225, 239
Gleizes, Albert **86**, 93;
 see also Puteaux Group
Gober, Robert 249
Gocár, Josef 87; *see also* Skupina
 Vytvarnych Umelcu
Goeritz, Mathias 239
Goings, Ralph 251–52
Goldberg, RoseLee 223
Golden Fleece 48, 63, 92
Goldsworthy, Andy 260–61
Golub, Leon 279; *see also*
 Monster Roster
Goncharova, Natalia 48, 63, **92–93**, 96,
 102–03, *102*; *see also* Cubo-Futurism,
 Donkey's Tail, Neo-Primitivism
Gonzalez, Julio 141
Goode, Joe 220
Gore, Spencer 48; *see also*
 Camden Town Group
Gorin, Jean 160
Gorky, Arshile 154, **188**, **190**; *188*
Gormley, Antony **266**, 279
Gottlieb, Adolph 188, 190;
 see also The Ten
Graham, Dan 242, 259
Gran Fury **291**
Grand, Toni 256
Grant, Duncan 48; *see also* Bloomsbury
 Group, Camden Town Group, Omega
 Workshops
Grassroots Art 180
GRAV 30, 38, **226–27**, 230–32
Graves, Michael 271;
 see also New York Five
Gray, Eileen 136
Gray, Spalding 225
Greaves, Derrick 199
Green architecture **292**
Greenberg, Clement 191, 232–33, 256;
 see also Green Mountain Boys
Greene, Charles 22
Greene, David 254
Greene, Henry 22
Green Mountain Boys **292**
Grenander, Alfred 82
Gris, Juan 83, **85–87**; *85*; *see also* Puteaux
 Group, Section d'Or
Grooms, Red 222, 247
Gropius, Walter 35, 82–83, *82*, 126, 128,
 129, **130–33**, *130*, **142**, **144**, 148,
 155, 206
Gropper, William 166
Grosz, George 109, 111, 118,
 149–50, *149*, 166
Grotowsky, Jerzy 268
Groult, André 136
Group of Plastic Artists (Skupina
 Vytvarnych Umelcu) 87, **295**
Group of Seven **292**
Group X **292**
Gruber, Francis 176
Gruppo 7 142, **156–57**
Gruppo N **292**
Gruppo T **292**
Güell y Bacigalupi, Don Eusebi 38, 40
Guerrilla Art Action Group **292**
Guerrilla Girls **292**
Guggenheim, Peggy 191
Guglielmi, Louis 162
Guimard, Hector *33*, 36
Guston, Philip **188**, 276, 279
Gutai Group 187, 222, **292**
Gutfreund, Otto 87; *see also* Skupina
 Vytvarnych Umelcu
Guttoso, Renato 200; *see also* Corrente,
 Fronte Nuovo delle Arti,
 Neo-Realism
Haacke, Hans 199, **242–43**, 263, **269**,
 269; *see also* Art Workers' Coalition
Hadid, Zaha 275
Haesler, Otto 148
Hains, Raymond 210;
 see also Affichistes
Hairy Who **292**

Halmstadgruppen **292**
Hamilton, Cuthbert 111
Hamilton, George Heard 18, 149
Hamilton, Richard 217, *217*;
 see also Independent Group
Hanson, Duane 254
Hantaï, Simon 184
Happenings 196, **222–23**, 247, **292**
Hard-Edge Painting 232, **292**
Hare, David 191
Häring, Hugo 129, 147–48;
 see also Organic architecture
Haring, Keith 273; *234*
Harlem Renaissance **292**
Hartlaub, Gustav F. 149
Hartung, Hans 184, *184*, 187;
 see also Lyrical Abstraction, Zen 49
Hassam, Childe 18
Hatoum, Mona 246, 249
Hausmann, Raoul 118, *118*
Hay, Deborah 223
Hayden, Henri 86
Heartfield, John **118**, 150, *150*
Heckel, Erich **74–75**, 77, 96, 126; *75*
Hefferon, Phillip 220
Heim, Jacques 136
Heizer, Michael 260–62
Held, Al 232
Hélion, Jean 160
Hennings, Emmy 116
Henri, Robert **78–80**, 164;
 see also The Eight
Henry, Charles 28
Hepworth, Barbara 160, **181–82**;
 see also St Ives School, Unit One
Herbin, Auguste 86, 160
Herms, George 208, 216
Heron, Patrick 184, *186*;
 see also St Ives School
Herron, Ron 254, *255*
Herzfelde, Weiland 118
Hesse, Eva 183; *see also* Bowery Boys,
 Eccentric Abstraction
Hevesy, Iván 113
Higgins, Dick 228–29, *228*
High-Tech 239, 255, 269, **274–75**
Hilberseimer, Ludwig 126, 133, 148
Hill, Gary 259
Hiller, Susan 243
Hilton, Roger 187;
 see also St Ives School
Hine, Lewis W. *78*, 80
Hi Red Center **292**
Hirst, Damien 210, 282; *see also* YBAs
Hitchcock, Henry-Russell 142, 144
Höch, Hannah *117*, 118
Hockney, David 217, *218*
Hodgkin, Howard 279
Hodler, Fernand 44, 57
Hoffmann, Josef 22, **59–61**, *59*,
 60, 81–82, 135
Hoffmann, Ludwig 148
Hofman, Vlastislav 87; *see also*
 Skupina Vytvarnych Umelcu
Hofmann, Hans 188–89
Holabird, William 23
Holden, Charles 115
Holmes, John Clellon 195
Holt, Nancy 260–61
Holzer, Jenny **273**, *281*, 288
Homme-Témoin 176, **178**, 200
Hopper, Edward 79, **163–65**,
 163, 252
Horn, Rebecca 223
Horta, Victor 26, *34*, **35**
Howard, Ebenezer 20
Howell, William 206
Hueblar, Douglas 242
Huelsenbeck, Richard **115**, **118**, 216
Hughes, Patrick 232
Hugo, Valentine 154
Hulme, T. E. 111–12
Hume, Gary 282; *see also* YBAs
Hundertwasser 187
Hungarian Activism **113**, 132, 231
Huszár, Vilmos 121–22
Huxley, Aldous 135
Huysman, Joris-Karl 15, 30–31,
 43, 44 73

Ibels, Henri-Gabriel 50
Ibsen, Henrik 53
Idea Art *see* Conceptual Art
Image, Selwyn 22
Imaginistgruppen **292**

Immendorf, Jörg 276
Impressionism **14–18**, 27, 41, 44,
 45, 48, 53, 60, 66, 70, 75, 77,
 78, 84, 85, 100, 251
Independent Group 217, **292**
Indiana, Robert 134, **219**, 221, 242
Information Art *see* Conceptual Art
Inkhuk **292**
Installation 216, 239, 240, **247–50**,
 266, 284
Interactive Art *see* Internet Art
International Modernism
 see International Style
International Movement for an Imaginist
 Bauhaus 213
International Style 23, 61, 83, 105, 109,
 123, 133, **142–45**, 148, 157, 206, 221,
 274, 276, 280
Internet Art **286–88**
Intimisme **292**
Intimists 53; *see also* Intimisme
Intuitive Art 180
Ioganson, Karl 108
Iribe, Paul 136
Isou, Isidore 192–93, *192*
Isozaki, Arata 239
Itten, Johannes **131–32**, 155
Jack of Diamonds **92–93**, 102
Jackson, Martha 221
Jacobsen, Arne 183;
 see also Danish Modern
Jacobsen, Robert 198
Jacquet, Alain 220;
 see also Mec Art
Janák, Pavel 87; *see also* Skupina
 Vytvarnych Umelcu
Janco, Marcel 116
Janis, Sidney 219
Japonisme **292**
Jarry, Alfred 53
Jawlensky, Alexei von 63, 93, **97**;
 see also Blue Four, Neue
 Künstlervereinigung München
Jeanneret, Charles-Edouard
 see Le Corbusier
Jeanneret, Pierre 120–21
Jenkins, Amy 259
Jenney, William Le Baron 23
Jensen, Georg 37
Jess 195–96, *196*
Jetelová, Magdalena 279
Johns, Jasper **201**, *203*, **204**,
 205, 212, 219, 233, 281
Johnson, Philip 142–45, *145*
Johnson, Ray 219, 229; *see also* Black
 Mountain College, Mail Art
Johnston, Jill 223
Jonas, Joan 225, 259
Jones, Allen 217
Jorn, Asger 193, 213–14;
 see also Arte Nucleare
Judd, Donald 236–38, *236*
Judson Dance Theater 223
Jugendstil 22, 33, **57–58**, 60,
 75, 80, 81
Jung, Carl 189
Junk Art 118, 216, **292**
Kabakov, Ilya 249; *see also* Sots Art
Kahler, Eugen 95
Kahn, Gustave 28, 43
Kahn, Louis I. 206–07
Kandinsky, Vasily 63, 93, **94–97**,
 96, 98, 99, 100, 103, 122, 129,
 131–32, 160, 181, 187, 188, 190; *see*
 also Blue Four, Inkhuk, Neue
 Künstlervereinigung München, Phalanx
Kapoor, Anish 183, 268, *278*, **279–80**
Kaprow, Allan 202, 216, **222–23**, 247;
 see also Happenings
Kassák, Lajos 113, *113*;
 see also Európai Iskola
Katz, Alex 219; *see also* New
 Perceptual Realism
Kawara, On 242
Keler, Peter *132*
Kelly, Ellsworth 232;
 see also Hard-Edge Painting
Kelly, Mary 273
Kennard, Peter 243
Kerouac, Jack 195–96
Kertesz, André 141
Khnopff, Fernand **25**, *25*, *26*,
 44, 57, 60

Kidner, Michael 230
Kiefer, Anselm 276, *276*, 279
Kienholz, Ed **208–10**, *208*, 216,
 240, 247
Kiesler, Frederick 123, 154
Kinetic Art 30, 160, **197–99**, 222, 226,
 232, 284
King, Phillip 236
Kirchner, Ernst Ludwig **74–77**,
 75, *76*, *77*, 96
Kirkeby, Per 279
Kitaj, R. B. 217; *see also* School
 of London
Kitchen Sink 176, **199–201**
Klee, Paul **94–97**, *97*, 100, 129, 131–32,
 153; *see also* Blue Four
Klein, César 128
Klein, Yves **210**, *211*, **212–13**, **222**, *222*,
 237, 240, 244, 246, 247;
 see also Ecole de Nice
Klerk, Michel de 114, *114*
Klimt, Gustav **59–61**, *59*, 71, 72
Klimtgruppe 71
Kline, Franz **188–89**, 196
Klutsis, Gustav 108
Klüver, Billy 226, 284; *see also*
 Experiments in Art and Technology
Knave of Diamonds *see* Jack of Diamonds
Knowles, Alison 228
Koch, Alexander 58
Koch, Kenneth 195
Kok, Antony 121–23
Kokoschka, Oskar 61, **70–72**, *72*, 141
Kolár, Jiri 87; *see also* Skupina 42
Kolbe, Georg 126
Kollwitz, Käthe 126, 129, **149**
Komar, Vitali **168**, **170**, *170*, 282;
 see also Sots Art
Konshalovsky, Piotr 92–93
Koolhaas, Rem 255
Koons, Jeff 272, **281**, *281*
Körösfoi-Kriesch, Aladár 22
Kossoff, Leon 279; *see also* School
 of London
Kosuth, Joseph 240, *240*, 242
Kounellis, Jannis 266, 268
Kozloff, Max 219–20
Králícek, Emil 86
Kramer, Jacob 111
Kramer, Pieter Lodewijk 114
Krasner, Lee 188
Kreis, Wilhelm 81
Kruger, Barbara 118, **249–50**, *249*, 273
Kubin, Alfred 94–96; *see also* Neue
 Künstlervereinigung München
Kubista, Bohumil 77; *see also* Osma
Kupka, Frantisek 97, 98, **99–101**;
 see also Puteaux Group
Kuprin, Alexander 92
Kusama, Yayoi 223, *224*
La Fresnaye, Roger de 86
La Rochefoucauld, Comte Antoine de 56
Lachaise, Gaston 37
Laeuger, Max 81
Laktionov, Alexander 168
Lalique, René 36
Lampérth, József Nemes 113
Lancia, Emilio 147
Land Art *see* Earth Art
Lange, Dorothea 166
Lanskoy, André 187
Lanyon, Peter 187; *see also*
 St Ives School
Larco, Sebastiano 156
Larionov, Mikhail 48, 63, **92–93**, *92*, 96,
 102–03; *see also* Cubo-Futurism,
 Donkey's Tail, Neo-Primitivism
Larsson, Carl 22
Lasdun, Denys 206; *see also* Tecton
Lassaw, Ibram 191
Latham, John 216
Laurens, Henri 87, 120
Lautréamont, Comte de 151
Laval, Charles 54
Lawler, Louise 272
Lawson, Ernest 79; *see also* The Eight
Le Corbusier 83, **119–21**, *120*, *124*, 135,
 142–45, *143*, 157, 206, 213;
 see also Machine Aesthetic
Le Fauconnier, Henri 86, 93
Le Parc, Julio 226, *227*
Léger, Fernand **86**, *86*, 93, 99, 119, *120*,
 121, 135, 136, 140, 211; *see also*
 Puteaux Group, Section d'Or

Lehmbruck, Wilhelm 73
Lemaître, Maurice 193
Lemmen, Georges 25, 29
Lempicka, Tamara de 136, *136*
Lentulov, Aristarkh 92–93
Leonidov, Ivan 109
Lepape, Georges 136
Lermontov, Mikhail 44
Leroy, Louis 14
Lethaby, William 22
Lettrism 187, **192–93**, 201, 228
Lettrist International 193, 213
 Leutze, Emanuel 204
Levin, Kim 233
Levine, Sherrie 272
Lewis, Wyndham 48, **111–12**, *112*;
 see also Camden Town Group, Group
 X, Omega Workshops,
 Rebel Art Centre
LeWitt, Sol 236, **240**, **242**, **260–61**;
 see also Bowery Boys, Serial Art
Lhote, André **86**, 93, 136
Lialina, Olia 286, *288*
Libera, Adalberto 156–57
Libre Esthétique, La 22, **25–26**
Lichtenstein, Roy **219–20**, *221*,
 281, 288
Liebermann, Max 18
Liebnecht, Karl 128
Light Art **292**
Lipchitz, Jacques 87, 120
Lipton, Seymour 191
Lissitzky, El 63, 105, **108–09**,
 108, 118, 123, 132, 155;
 see also ABC, Unovis
Live Art *see* Performance Art
London Group **292**
Long, Richard 260–61
Longo, Robert 225, 279
Loos, Adolf 59, **142**, *142*, 144
Lorjou, Bernard 178
Louis, Morris 232; *see also* Green
 Mountain Boys
Lovink, Geert 286
Lowry, L. S. 199
Lozowick, Louis 134
Lubetkin, Berthold 143; *see also* Tecton
Lucas, Sarah 210; *see also* YBAs
Luce, Henry 164
Luce, Maximilien 28
Luckhardt, Hans 128, 148
Luckhardt, Wassili 128, 148
Ludwig of Hesse, Grand Duke Ernst 58
Lugné-Poë, Aurélien-Marie 53
Luks, George 78–80; *see also* The Eight
Luminism **292**
Lüpertz, Markus 276; *see also*
 Ugly Realists
Luxemburg, Rosa 128
Lye, Len 199
Lynn, Jack *207*
Lyrical Abstraction 184, **292**
M.I.A.R. 142, **157–59**
Macdonald, Frances 35
MacDonald-Wright, Stanton **97–98**, 165
Machine Aesthetic 121, 134, 157,
 211, **292**
Machine Art **293**
Maciunas, George 228–29, *228*
Mack, Heinz 226;
 see also Zero
Macke, August **94–96**, *94*, 100
Mackintosh, Charles Rennie 20, **35**, 58,
 60, 61, 135; *36*;
 see also Glasgow School
Mackintosh, Margaret Macdonald **35**, 58
Mackmurdo, Arthur Heygate
 20, 22, **35**
MacMurtrie, Chico 199
Maeda, John 288
Magic Realism **161–62**, 208
Magnelli, Alberto 160
Magris, Alessandro 255
Magris, Roberto 255
Magritte, René 30, 153, **161–62**, *162*,
 170, 243
Mail Art 228–29, **293**
Majorelle, Louis 36; *see also*
 Nancy School
Maki, Fumihiko 239
Malerba, Gian Emilio 146
Malevich, Kasimir 93, 96, 102–03,
 103–05, *104*, *105*, 106, 109, 236,
 284; *see also* Cubo-Futurism, Inkhuk,
 Unovis
Mallarmé, Stéphane 41, 43
Malraux, André 176–77
Man Ray 79, **116**, **118–19**, **153–54**,
 154, 230, 284; *see also* Société
 Anonyme, Inc.
Manet, Édouard 15, 18, 45
Mangold, Robert 232;
 see also Bowery Boys
Manguin, Henri-Charles 66
Manship, Paul 37
Manzoni, Piero *2*, *242*, **240**, 244
Marc, Franz **94–97**, *95*, 100, 149;
 see also Neue Künstlervereinigung
 München
Marcks, Gerhard 126, 131–32
Marclay, Christian *285*
Marcoussis, Louis 86
Marden, Brice 232
Mare, André 136
Maré, Rolf de 119
Marey, Etienne-Jules 89, 99
Marinetti, Filippo **88–91**, *90*, 116
Marini, Marino 147
Mariscal, Javier 271
Marisol 216, 219
Marks Barfield Architects 275
Marquet, Albert 66
Marsh, Reginald 166
Marshall, P. P. 20
Martin, Agnes 232
Martin, Charles 136
Martin, Kenneth 160
Martin, Mary 160
Martine Style 136
Martini, Arturo 147
Marussig, Piero 146
Mashkov, Ilya 92–93, *93*
Masson, André **153–54**, 189
Mathieu, Georges 184, 187, *187*;
 see also Lyrical Abstraction
Matiasek, Katarina 286
Matisse, Henri 30, 43, 45, *64*,
 66, **66–67**, **69**, 73, 75, 84,
 93, 97, 134, 140, 284
Matta **153**, 189
Matta-Clark, Gordon 249
Matter Painting 184
Maus, Octave 25–26
May, Ernst 148
McCollum, Allan 281
McDonough, Michael 275
McKnight Kauffer, Edward 112;
 see also Group X
McLean, Bruce 225
McLuhan, Marshall 202, 258
McNair, Herbert 35
McQueen, Steve 259
Mec Art **293**
Medalla, David 199
Medunetsky, Konstantin 108
Meier-Graefe, Julius 58
Melamid, Alexander **168**, **170**, *170*, 281;
 see also Sots Art
Melnikov, Konstantin 109; *106*
Memphis 271
Mendelsohn, Erich **73–74**, *74*, 114–15,
 126, 129, 147–48
Mendieta, Ana 259
Mendini, Alessandro 269;
 see also Studio Alchymia
Merlau-Ponty, Maurice 176
Merz, Mario 266, *266*, 268
Merz, Marisa 266
Messager, Annette 279
Metabolism **293**
Metzinger, Jean **86**, 93;
 see also Puteaux Group
Mexican Muralists 166, **293**
Mey, Johann Melchior van der 114
Meyer, Adolf 80, *130*, 132, 142, 148
Meyer, Hannes 133; *see also* ABC
Michaux, Henri 184, 186
Middleditch, Edward 199
Mies van der Rohe, Ludwig *81*, 83,
 118, 129, 133, **142–45**, *145*,
 147–48, 206, 239
Milroy, Lisa 281
Minimal Painting 232
Minimalism 105, 135, 160, 191,
 204, 216, 220, 223, 225, 230,
 233, **236–39**, 243, 244, 251, 256, 260,
 263, 269, 276, 281, 282
Minne, George 25
Minnucci, Gaetano 157
Minotaurgruppen **293**
Minton, John **170**, 199, 201
Miró, Joan *152*, **153**, 181–82, 190
Miss, Mary 260
Mitchell, Joan 232
Miyajima, Tatsuo 199
Modernisme 33, **38–40**
Modersohn-Becker, Paula 71, *71*;
 see also Worpswede School
Modigliani, Amedeo 141, *141*
Moholy-Nagy, László 30, 113, **132–33**,
 198, *198*, 230
Mollino, Carlo 182; *see also* Neo-Liberty
Mondrian, Piet 118, **121–23**,
 122, 155, 198, 199;
 see also Neo-Plasticism
Moneo, Rafael 271
Monet, Claude **14–18**, *15*, 25,
 45, 63, 69; *see also* Serial Art
Monfried, Daniel de 54, 67
Mono-ha **293**
Monory, Jacques 220; *see also* Figuration
 Narrative,
 Nouvelle Figuration
Monster Roster **293**
Moore, Albert 31
Moore, Charles 269, *270*
Moore, Henry 171, **182**, *183*;
 see also Unit One
Moorman, Charlotte 258
Morandi, Giorgio 111
Moréas, Jean 41
Moreau, Gustave 31, **41**, *41*, **43**,
 56, 63, 66, 73
Morellet, François 226
Morisot, Berthe 14, *17*, 18
Morley, Malcolm **251–52**, 279
Morozov, Ivan A. 69
Morozzi, Massimo 255
Morris, Robert 223, **236–38**, 260;
 see also Art Workers' Coalition
Morris, William **19–20**, *19*, 24, 26, 31,
 35, 60, 131
Moser, Koloman 22, **59–61**
Mosset, Olivier *see* BMPT
Motherwell, Robert 119, **188–91**, 229
Movimento Arte Concreta **293**
Mucha, Alphonse 36, *37*
Muche, Georg 131–32
Mueck, Ron 254; *see also* YBAs
Mueller, Otto 77
Muf 255
Mukhina, Vera 168–69, *169*
Multiples **293**
Munch, Edvard 35, *42*, **44**, 70,
 75, 193
Muñoz, Juan 243, 249
Münter, Gabriele 94; *see also* Neue
 Künstlervereinigung München
Murray, Elizabeth 279
Musil, Robert 59
Mussolini, Benito 91, 146–47,
 157, 159, 162
Muthesius, Hermann 22, **80–82**
Muzio, Giovanni 147
Muybridge, Eadweard 89
Nabis 35, 43, 44, 45, 50, **50–53**,
 55, 70, 74, 84
Nadar, Félix 14
Nadelman, Elie 37
Nagel, Peter 251
Nakian, Reuben 191
Namuth, Hans 190
Nancy School 36, **293**
Narkompros **293**
Nash, Paul 170–71, *171*;
 see also Unit One
Nasisse, Andy 180–81
Natalini, Adolfo 255
National Romanticism 38, **293**
National Socialist Art **293**
NATO **295**
Naturalists 61, 71
Nauman, Bruce 244, *244*;
 see also Light Art
Naumann, Friedrich 80–81
Nazarenes 51, 99
Nederlandse Experimentele Groep **293**
Neo-classicism 24, 82, 157, 159, **293**
Neo-Dada 162, 196, **201–04**, 205, 208,
 211, 217, 220, 221, 222, 228, 238,
 240, 268, 269, 284
Neo-Dada Organizers **293**
Neo-Expressionism 272, **276–80**, 282
Neo-Geo **293**
Neo-Impressionism 25, **26–30**, 35, 44,
 45, 53, 54, 66, 69, 70, 98, 99, 100,
 122, 230, 251
Neo-Liberty **293**
Neo-Plasticism 155, 121–23, **293**
Neo-Pop 281–82
Neo-Primitivism 93, 102–03, **293**
Neo-Realism **293**
Neo-Romanticism 170–71
Nervi, Pier Luigi 145
Neshat, Shirin 259
Net.art *see* Internet Art
Neue Künstlervereinigung
 München **293**
Neue Sachlichkeit 74, 147,
 149–50, 161
Neue Wilden 276, **293**
Neutra, Richard 144
Nevelson, Louise *215*, 216
Nevinson, C. R. W. 111–12
New Brutalism 145, **206–7**
New Image Painting 279, **294**
New Perceptual Realism **294**
New Realism 220, **294**
New Realists 219–20
New Wave cinema 220, 238
New York Correspondance School 229
New York Five 159, **294**
New York Realists
 see Ashcan School
New York School *see* Abstract
 Expressionism
Newman, Barnett **188**, **190–91**, 232;
 see also Color Field Painting,
 Hard-Edge Painting
Nicholson, Ben 160; *see also* St Ives
 School, Unit One
Niemeyer, Adelbert 81
Niemeyer, Oscar 143, *144*
Niestlé, J. B. 95
Nietzsche, Friedrich 71, 75, 111
Noguchi, Isamu *181*, 182
Noland, Cady 282
Noland, Kenneth 232, *232*; *see also* Black
 Mountain College, Green Mountain
 Boys, Hard-Edge Painting
Nolde, Emil **71**, *73*, 75, 77, 96, 126,
 141, 171, 193, 283
Nouveau Réalisme 154, 162, 201, 202,
 210–13, 221, 222, 228
Nouveau Roman 220, 238
Nouvel, Jean 275
Nouvelle Figuration **294**
Nouvelle Tendance 226, **294**
Novecento Italiano 111, **146–47**,
 156, 157
Novembergruppe 126, **128–29**,
 130, 147
Novotny, Otokar 87; *see also* Skupina
 Vytvarnych Umelcu
Nul **294**
Nyolcak **294**
Obrist, Hermann **57–58**, 75
Odeon Style 139
O'Hara, Frank 195
O'Keefe, Georgia 134–35
Olbrich, Joseph Maria 58, **59–61**,
 61, 73, 81
Oldenburg, Claes 176, 196, 201, 216,
 219, 221, 222–23, 237, 247, **263**,
 264, 281; *see also* Happenings
Olitski, Jules 232; *see also* Green
 Mountain Boys
Oliva, Achille Bonito 282
Olivetti, Adriano 159
Olsen, Charles 222
Omega Workshops 111, **294**
Ono, Yoko 228, *229*
Op Art 30, 160, 199, 221, 226,
 230–32, 288
Opie, Julian 281
Oppenheim, Dennis 246, 260–61;
 see also Art Workers' Coalition
Oppenheim, Meret 154
Oppi, Ubaldo 146
Organic Abstraction **181–83**, 190
Organic architecture 24, **294**
Orlan 246
Orozco, Gabriel 243, 247
Orozco, José Clemente 166;
 see also Mexican Muralists
Orphic Cubism *see* Orphism

Orphism 30, 87, 95, 98, **99–101**, 102, 111, 230
Orr, Douglas 206
Osborne, John 199
Osma **294**
Ossorio, Alfonso 174
Otis, Elisha Graves 23
Oud, J. J. P. 83, **121**, **123**
Oursler, Tony 259; *259*
Outsider Art 174, **180–81**
Ove Arup & Partners 239, **274–75**, *274*, *275*
Ozenfant, Amédée 119–21
Pagano, Giuseppe 157, 159
Pagès, Bernard 256, 268
Paik, Nam June 228–29, **257–58**, *258*
Painters Eleven **294**
Paladino, Mimmo **282–84**, *282*, 286; *see also* Arte Cifra
Palatnik, Abraham 199
Palestrina, Giovanni Pierluigi da 56
Paling Stijl 33
Palmer, Samuel 170
Pane, Gina 246
Pankok, Bernhard 57
Panton, Verner 183, 221
Paolini, Giulio 266, 268
Paolozzi, Eduardo 178, 216, **217**; *see also* Independent Group
Paris 1925 135
Paris, Harold 208
Parker, Cornelia 199
Parmentier, Michel *see* BMPT
Pascali, Pino 266
Pascin, Jules 141
Pasmore, Victor 160; *see also* Euston Road School
Pater, Walter 31
Pattern and Decoration **294**
Patterson, Benjamin *228*
Patterson, Simon 243; *see also* YBAs
Paul, Bruno 57, 81, 82
Paxton, Steve 223
Pechstein, Max 77, 96, 126, *126*, **128**
Péladan, Sâr Joséphin 44, 56–57
Penck, A. R. 276, 279
Penone, Giuseppe 266
Pepper, Beverly 236
Performance Art 154, 191, 204, 216, 217, **222–25**, 228, 238, 239, 240, 244, 266, 268, 284, 286
Perí, László 113
Permeke, Constant 72
Perriand, Charlotte 121
Persico, Edoardo 157, 159
Peterhans, Walter 133
Petitjean, Hippolyte 28
Pevsner, Anton **106**, **108–09**, 160
Pevsner, Nikolaus 20, 115
Phalanx **294**
Photo-realism *see* Super-realism
Piacentini, Marcello 159
Piano, Renzo 274–75, *274*
Picabia, Francis 86, 99, **116**, **118–19**, 134; *see also* Puteaux Group, Section d'Or
Picard, Edmond 25–26
Picasso, Pablo 45, 69, **83–87**, *84*, 88, 93, 96, 99, 134, 140, 153, 202
Piene, Otto 226; *see also* Zero
Pincemin, Jean-Pierre 256
Pinot-Gallizio, Giuseppe 213, *214*
Piper, Adrian 223, 259
Piper, John 170
Pisis, Filippo de 110
Pissarro, Camille *12*, **14**, 25, 26, 28, 29, 45, 47
Pissarro, Lucien 26, 28
Pistoletto, Michelangelo 266, *267*, 268
Pittura Metafisica **109–11**, 147, 157, 161
Pizzinato, Armando 200
Plasticiens, Les **294**
Poe, Edgar Allan 43, 56
Poelzig, Hans **73**, 82–83
Point, Armand 56
Pointillism 27–28, **294**
Poiret, Paul 136
Poliakoff, Serge 187
Polke, Sigmar 276
Pollini, Gino 156–57, 159
Pollock, Jackson 165, *172*, 187, **188–91**, *190*, 202, 206; *see also* Action Painting

Polymaterialists *see* Neo-Dada
Ponge, Francis 176–77
Ponti, Gio 145, **147**
Poons, Larry 230
Pop Art 30, 134, 135, 162, 170, 204, 206, 209, 211, 216, **217–21**, 230, 233, 238, 251, 255, 260, 269, 279, 281, 288
Popova, Liubov 93, 105, **108**; *see also* Cubo-Futurism, Inkhuk
Portaluppi, Piero 147
Post-Impressionism 44, **45–48**, 50, 60, 66, 70, 71, 77, 84, 92, 111, 113, 140, 279
Postmodernism 40, 145, 204, 207, 214, 233, 238, 243, 255, **269–73**, 276, 281
Post-painterly Abstraction 160, 191, 201, 220 230, **232–33**, 236, 238, 240
Post-Pop *see* Neo-Pop
Pound, Ezra 111–12
Praesens **294**
Prairie School 22, 24, 142
Precise Realism *see* Magic Realism
Precisionism 87, 112, 121, **134–35**, 162, 163, 251
Prendergast, Maurice **48**, *79*; *see also* The Eight
Pre-Raphaelite Brotherhood 19, 20, 32, 51, 53, 170, **294**
Previati, Gaetano 29, 44, 57
Primary Structures *see* Minimalism
Primitivism **294**
Prince, Richard 269, 281
Prinzhorn, Hans, Dr 174
Process Art 268, **294**
Productivism *see* Constructivism
Progressivism 38
Prouvé, Victor 36
Psychedelic Art 221, **294**
Pugin, Augustus W. N. 19
Puig i Cadafalch, José 38
Puni, Ivan 105
Purcell, William Gray 22
Purism 113, **119–21**, 142, 147
Puteaux Group **294**
Puvis de Chavannes, Pierre **43**, 51, 63
Puy, Jean 66
Quadriga 186, **294**
Quinn, John 112
Quinn, Marc 246, *246*; *see also* YBAs
Radical Design 254, **294**
Rainer, Arnulf 187, 279
Ranaldo, Lee 284, 286
Ranson, Paul 50
Rauschenberg, Christopher 223
Rauschenberg, Robert 199, **201**, *201*, *205*, **204–06**, 212, 216, 219, **222–23**, 226, 237, 240, **284**; *see also* Black Mountain College, Experiments in Art and Technology, Junk Art
Rava, Carlo Enrico 156
Ravel 18
Rayism *see* Rayonism
Rayonism 87, 91, 93, **102–03**, 222
Raysse, Martial 210, 220; *see also* Ecole de Nice, Light Art
Read, Herbert 178
Rebel Art Centre 111–12, **294**
Rebeyrolle, Paul 178
Redon, Odilon 25, 31, 35, **43**, *43*, **44**, 45, 51, 56
Regionalism 164–65, 189, **294**
Régnier, Henri de 28
Rego, Paula 279
Reich, Steve 239
Reinhardt, Ad 160, 188, 232, 240, 269; *see also* Hard-Edge Painting
René, Denise 159–60
Renoir, Pierre-Auguste **14**, **16–17**, *16*, 25, 45
Restany, Pierre 140, 210–12; *see also* Mec Art
Reth, Alfred 86
Revolutionary Black Gang, The *see* Ashcan School
Ribemont-Dessaignes, Georges 119
Richards, M. C. 222
Richards, Paul 225
Richier, Germaine **176–77**, *177*, 187
Richter, Gerhard 242, **251–52**, **254**, **276**, *278*, **279**
Richter, Hans **116**, **118–19**, 123, 129,

129
Rickey, George 199
Ridolfi, Mario 157
Riemerschmid, Richard 57–58, 81–82
Rietveld, Gerrit 122–23, *121*, *122*
Riis, Jacob 80
Riley, Bridget 30, **230**, *230*, **232**
Riley, Terry 239
Rilke, Rainer Maria 71
Rimbaud, Arthur 41, 151, 153
Rimbaud, Robin 286
Ring, Der 83, 142, **147–48**
Rippl-Rónai, József 50
Rist, Pipilotti 259
Rivera, Diego 166; *see also* Mexican Muralists
Rivera, José de 160
Rivers, Larry 196, **201**, *202*, *204*, **204**, 205, 219, 221, 279
Roberts, William 111–12; *see also* Group X
Roche, Martin 23
Rockwell, Norman 165, *165*
Rodchenko, Alexander 105, **106**, **108–09**, *108*; *see also* Inkhuk
Rodia, Simon 180–81
Rodin, Auguste *14*, **18**, 25, 60
Rogers, Sir Richard 274–75, *274*
Roh, Franz 161
Rollins, Tim, and K. O. S. 269
Rood, Ogden 27
Root, John Wellborn 23, *23*
Rops, Félicien 25, **44**
Rosenbach, Ulrike 259
Rosenberg, Harold 141, 189, 191
Rosenquist, James 219
Rossetti, Dante Gabriel 19–20; *see also* Aesthetic Movement, Pre-Raphaelite Brotherhood
Rossi, Aldo 269; *see also* Tendenza
Rosso, Medardo 18
Roszak, Theodore 191
Rotella, Mimmo 210; *see also* Affichistes, Mec Art
Roth, Dieter 228; *see also* SUM
Rothenberg, Susan 279; *see also* New Image Painting
Rothko, Mark **188**, *189*, **190–91**, 232; *see also* Color Field Painting, The Ten
Rouault, Georges 43, 45, 57, 66, **73**, 140
Rousseau, Blanche 44
Rousseau, Henri 95
Roussel, Ker-Xavier 50
Roy, Pierre 153, 162
Rozanova, Olga 105, **108**
Rudolph, Paul 206
Ruhlmann, Jacques-Emile 136
Rumney, Ralph 213
Ruscha, Edward **220**, 242
Ruskin, John 18, 19, 31, 131, 217; *see also* Pre-Raphaelite Brotherhood
Russell, Morgan 97–98, *98*
Russolo, Luigi 88, 90
Rustin, Jean 279
Ryan, Paul 258
Ryder, Albert Pinkham 44
Rydingsvard, Ursula von 183
Ryman, Robert 232; *see also* Bowery Boys
Saarinen, Eero 145, **182–83**
Saarinen, Eliel 22, **145**
Sabatier, Roland 193
Sacco, Nicola 166, 209
St Ives School **295**
Saint Phalle, Niki de **210**, *212*, **213**, 222, 247
Saint-Point, Valentine de 90
Salle, David 272, 279
Salon de la Rose+Croix 41, 44, **56–57**
Salon des Indépendants 69, 100, **295**
Salt, John 251
Samaras, Lucas 208, **216**, 244
Sandin, Dan 258
Sant'Elia, Antonio **90–91**; *91*, 123
Sarfatti, Margharita 146–47
Sartre, Jean-Paul 154, 176–78, 186
Satié, Alan 193
Satie, Erik 56, 119
Saunders, Helen 111

Saville, Jenny 279, *280*; *see also* YBAs
Savinio, Alberto 110
Saytour, Patrick 256, *256*
Schad, Christian 149
Schäfer, Carl 73
Schafer, R. Murray 284
Schamberg, Morton **116**, 134
Scharoun, Hans 83, 128, 148
Scharvolgel, J. J. 81
Schawinsky, Xanti 159
Scheeler, Charles 134–35
Scheerbart, Paul 126, 128
Scheper, Hinnerk 133
Schiaparelli, Elsa 154
Schiele, Egon 61, *70*, **71–72**, 283
Schindler, Rudolph M. 144
Schlemmer, Oskar 111, **131–32**, *131*
Schlichter, Rudolf 149
Schmidt, Joost *131*, 133
Schmidt, Karl 80–81
Schmidt-Rottluff, Karl **74–75**, 77, 126
Schmitthenner, Paul 148
Schnabel, Julian 272, 279
Schneemann, Carolee 216, 223, *223*, **244**, **245**
Schneider, Ira 258
Schoenmaekers, M. J. H. 122
Schöffer, Nicolas 199
Schönberg, Arnold 59, 94–95
School of Amsterdam 40, **114–15**, 123
School of London **295**
School of Paris *see* Ecole de Paris
School of Pont-Aven 50, **295**
Schopenhauer, Arthur 111
Schortjesarchitectuur 114
Schreyer, Lothar 131–32
Schröder-Schräder, Truus 123
Schuffenecker, Emile 53–54
Schultze-Naumburg, Paul 81, **148**
Schumacher, Fritz 81–82
Schuyff, Peter 232; *see also* Neo-Geo
Schwabe, Carlos 56, *56*
Schwarzkogler, Rudolf 246
Schwitters, Kurt 109, **118**, 202, 205, 216, 247
Scott, Tim 236
Scottish Colourists **295**
Scuola Metafisica 110–11
Scuola Romana **295**
Section d'Or **295**
Segal, George **219**, 247
Segantini, Giovanni 29, 44, 89
Seitz, William C. 215–16, 230, 252
Self, Colin 208
Selz, Peter 178
Séon, Alexandre 56
Serial Art **295**
Serpan 184
Serra, Richard 236, 260, **263**, *263*, **265**
Sérusier, Paul 41, 45, **50**, **51**, **53**, 56
Seurat, Georges 16, 25, **26–30**, *27*, *28*, 41, 45, 47, 51, 54; *see also* Pointillism
Severini, Gino **88–91**, 123
Sezessionstil 33, 60
Shahn, Ben 150, **166–67**, *167*, 209
Sharp-Focus Realism *see* Magic Realism, Super-realism
Shattuck, Roger 216
Shaw, Norman 20
Shchukin, Sergei 69
Sherman, Cindy 118, *271*, **273**
Shinn, Everett 78–80; *see also* The Eight
Shinohara, Kazuo 239
Short, Elizabeth 208
Sickert, Walter 18; *see also* Camden Town Group
Siegel, Eric 258
Signac, Paul 16, 25, **26–30**, *29*, 45, 66; *see also* Divisionism, Pointillism
Simard, Claude **250**, *250*, 279
Simonds, Charles 279
Simultanism 100, 101
Siqueiros, David Alfaro 166; *see also* Mexican Muralists
Sironi, Mario 111, **146–47**, *146*
Siskind, Aaron 191
Sisley, Alfred 14
SITE 279–80, **295**
Site Works 263–66
Situationism **295**

Situationist International 193, 195, 201, **213–14**, 228, 268
Situationists *see* Situationist International
Skupina 42 **295**
Skupina Ra **295**
Skupina Vytvarnych Umelcu **295**
Slevogt, Max 18
Sloan & Robertson *139*
Sloan, John **78–80**, *79*, 166; *see also* The Eight
Smet, Gustave de 72
Smith, David 191, *191*
Smith, Ivor *207*
Smith, Jack 199
Smith, Richard 217
Smith, Tony 236
Smithers, Leonard 32
Smithson, Alison **206**, 217, 274; *see also* Independent Group
Smithson, Peter **206**, 217, 274; *see also* Independent Group
Smithson, Robert **260–62**, *261*
Snelson, Kenneth 160, 199
Sobrino, Francisco 226
Social Realism 80, 149, 150, 162, 163, **166–67**, 189, 208, 219
Socialist Realism 105, 109, 147, 166, **168–70**, 184, 191, 193
Société Anonyme Inc. **295**
Soffici, Ardengo 88
Solomon, Alan 223; *see also* Green Mountain Boys
Sommaruga, Giuseppe 37
Sorkin, Michael 255
Soros, George 286
Soto, Jesús Raphael 199
Sottsass, Ettore 255, **271**, *273*; *see also* Studio Alchymia
Soulages, Pierre 184
Sound Art 240, 247, **284–86**
Soupault, Philippe 119
Soutine, Chaim 141
Soyer, Moses 166
Soyer, Raphael 166
Spazialismo **295**
Sperlich, H. G. 254
Spilliaert, Leon 73
Spoerri, Daniel **210**, 216, 228–29
Sprecklesen, Johann Otto von 271
Spur **295**
Staël, Nicolas de 187
Stain Painting 232
Stalin, Joseph 168
Stam, Mart 83; *see also* ABC
Stanczak, Julian 232
Stanick, Peter 288
Stankiewicz, Richard 201, 212, 216
Starck, Philippe 269
Stein, Gertrude 69
Stein, Joel 226
Stein, Leo 69
Steinbach, Haim 281
Stella, Frank **232–33**, *233*, 237, 238
Stella, Joseph 91
Stenberg, Georgii 108
Stenberg, Vladimir 108
Stepanova, Varvara 106, 108–09, *108*; *see also* Inkhuk
Stickley, Gustav 22; *20*
Stieglitz, Alfred 115, 135
Stijl, De 30, 109, 113, 132, 142, 155, 159–60, **121–23**
Stil' Modern, Stile Floreale, Stile Liberty, Stile Nouille 33
Still, Clyfford 188, 190–91; *see also* Color Field Painting
Stirling, James 206
Stölzl, Gunta 133
Storr, John 139
Störtenbecker, Nikolaus 251
Strindberg, August 53
Stuckism **295**
Studio Alchymia **295**
Studio Dumbar 271
Stupid Group **295**
Style des Vingt 33
Style Métro 36
Style moderne 135
Süe, Louis 136
Suetin, Nikolai 105; *see also* Unovis
Sullivan, Louis **23–24**, *24*, 37, 142, 144, 206
SUM **295**

Super-realism 135, 162, 221, 232, **251–54**
Superstudio **254–55**, 268
Supports-Surfaces 256–57
Suprematism 63, 93, **103–05**, 106, 109, 113, 123, 160, 236
Surrealism 30, 40, 43, 44, 53, 55, 73, 87, 97, 110, 111, 119, 140, **151–54**, 161–62, 170–71, 174, 177, 180, 182, 183, 187, 189, 192–93, 195, 202, 211, 213, 216, 222, 247, 269, 279
Survage, Léopold 86
Sutherland, Graham 170
Swanson, Gloria 101
Sylvester, David 178, 199
Symbolism 28, 30–32, 36, **41–44**, 45, 50, 51, 54, 55, 56–57, 60, 61, 66, 70, 71, 73, 85, 94, 95, 98, 99
Synchromism 30, 87, **97–98**
Synthetic Cubism 85
Synthetism 45, 50, 51, **53–55**, 62
Systemic Painting 232; *see also* Serial Art
Taaffe, Philip 232; *see also* Neo-Geo
Tachism 184, **295**
Taeuber-Arp, Sophie 116, 156
Takis **199**, 284
Tange, Kenzo 206
Tanguy, Yves **153**, 181, 189
Tanning, Dorothea 154
Tapié, Michel 174, 175, 184, 186–87; *see also* Art autre, Tachism
Tàpies, Antoni 184; *see also* Dau al Set
Tatlin, Vladimir 93, 103, **106–09**, *107*, 198, 238; *see also* Cubo-Futurism, Inkhuk, Machine Art
Taut, Bruno 82–83, **126–28**, *126*, *127*, 130, 147–48, *148*, 254
Taut, Max 83, 147
Tchelitchew, Pavel 170
Team 4 274
Team X 145, **295**
Techno-chic **295**
Tecton 143, **295**
Ten, The **295**
Tendenza **295**
Terragni, Giuseppe 143, **156–59**, *156*, *159*
Tessenow, Heinrich 82
Teutsch, János Máttis 113
Thek, Paul 208
Thiebaud, Wayne 220
Tiffany, Louis Comfort 36–37
Tihanyi, Lajos 113; *see also* Nyolcak
Tilson, Jake *287*, 288
Tilson, Joe 217
Tinguely, Jean 30, *198*, **199**, 204, *204*, **210**, 247, 284; *see also* Auto-destructive art
Tobey, Mark 188
Tonalism **296**
Tooker, George 162
Toorop, Jan 29, 44, 57
Toroni, Niele *see* BMPT
Torres, Rigoberto 254
Tosi, Arturo 147
Toulouse-Lautrec, Henri de 25–26, 35, 37, **45**, *45*, **47**, **48**, 49, 50, 53
Transavanguardia 272, 279, **282–84**
Trapani, A. 103
Trotsky, Leon 151
Trucco, Matté 91
Tsvetayeva, Marina 103
Tucker, William 236
Tudor, David 222
Tudor-Hart, Ernest Percyval 98
Turk, Gavin 282; *see also* YBAs
Turnbull, William 178; *see also* Situationism
Turner, J. M. W. 15
Turrell, James 260–61
Tusquets, Oscar 183
Tutankamen 135
Twachtman, John 18
Twombly, Cy 279; *see also* Black Mountain College
Tzara, Tristan **115–16**, **118–19**, 153–54, 192
Ubac, Raoul 154
Udaltsova, Nadezhda 105; *see also* Cubo-Futurism
UFO **296**
Ugly Realists 276, **296**

Uitz, Béla 113
Ullrich, Dietmar 252
Ultvedt, Per Olof 223, 247
Unism **296**
Unit One **296**
Unitary Objects *see* Minimalism
Unovis 105, **296**
Urban Realism *see* Precisionism
Utility Furniture **296**
Utrillo, Maurice 141
Utzon, Jorn 274, 279
Valensi, André *256*
Vallin, Eugène 36; *see also* Nancy School
Vallotton, Félix 45, 50
Valmier, Georges 86
Valtat, Louis 66
Van Alen, William 138, *138*
Van de Velde, Henry 25–26, 29, **35**, 57–58, 60, 73, 82, 114, 131
Van der Leck, Bart 121, 123
Van Doesburg, Nelly 118, 160
Van Doesburg, Theo **121–23**, *123*, 132, **155–56**, *155*, 159–60
Van Gogh, Vincent 16, 25, 30, **45–48**, *46*, *49*, 67, 70, 75, 175, 286
Van Rysselberghe, Théo **25**, 29
Van Velde, Bram 177
Van't Hoff, Robert 121–23
Vantongerloo, Georges 121–23
Vanzetti, Bartolomeo 166, 209
Vasarely, Victor 30, 199, 226, **230–31**, *231*
Vasulka, Steina and Woody 258
Vaughan, Keith 170
Vautier, Ben 228; *see also* Ecole de Nice, Figuration Libre
Vauxcelles, Louis 66, 84, 98
Vedova, Emilio 187; *see also* Fronte Nuovo delle Arti
Venturi, Robert 269
Verhaeren, Emile 25
Verheyden, Isidor 25
Verism **296**
Verkade, Jan 50
Verlaine, Paul 41
Vesnin, Alexander, Leonid and Victor 108–9
Viallat, Claude 256; *256*
Video 240, 247, **257–59**, 284
Vieira de Silva, Maria Elena 187
Vienna Action Art 223, **296**
Vienna Secession 25, 33, 35, **59–61**, 81
Villeglé, Jacques de la 210; *see also* Affichistes
Villon, Jacques 86, 87; *see also* Puteaux Group, Section d'Or
Vingt, Les 22, **25–26**, 29, 33, 35, 44, 48, 50, 60
Viola, Bill 257, 259
Viollet-le-Duc, Eugène Emmanuel 38
Visionary Art 174, 180
Vladimirsky, Boris 168
Vlaminck, Maurice de 45, **66–67**, *69*, *69*
Vollard, Ambroise 45, 69
Vorticism 87, 91, **111–12**, 155
Vosey, Charles **20**, *21*, 35, 37
Vostell, Wolf 228, *228*, 257
Vrubel, Mikhail Ivanovich **44**, 103; *see also* Blue Rose
Vuillard, Edouard 37, **50–53**, *52*; *see also* Intimisme
Wadsworth, Edward 111–12; *see also* Group X
Wagemaker, Jaap 184
Wagner, Martin 144, 148
Wagner, Otto 60–61
Wagner, Richard 56
Wain, John 199
Walden, Herwarth 71–72, 95
Waldhauer, Fred 226; *see also* Experiments in Art and Technology
Walker, Maynard 163–65
Wall, Jeff 272
Warhol, Andy **219–20**, *219*, 282, 288; *see also* Serial Art
Wärndorfer, Fritz 61
Washington Color Painters 232
Watts, Robert 228
Web Art *see* Internet Art

Webb, Michael 254
Webb, Philip 19–20, *19*
Wegener, Paul 73
Wegman, William 242, 259
Weil, Benjamin 288
Weill, Kurt 129
Weiner, Lawrence **242**, 288
Weingart, Wolfgang 271
Weininger, Otto 111
Weir, Julian Alden 18
Wesselmann, Tom **219**, 247
West 8 255
Westermann, H. C. 216; *see also* Eccentric Abstraction
Whistler, John Abbott McNeill 18, 25, **30–31**, *31*, 43, 63; *see also* Aesthetic Movement, Tonalism
Whiteread, Rachel 279–80; *see also* YBAs
Whitman, Robert 223
Wijdeveld, Theodorus 114
Wilde, Oscar 32, 48, 53
Wilder, Billy 182
Wiley, William T. 209
Wilke, Hannah 259
Williams, William Carlos 134
Williams, Emmett 228–29, *228*
Wils, Jan 121–23
Wilson, Martha 213
Wilson, Robert 225, 284
Wir *see* Spur
Wise, Howard 258
Wojnarowicz, David 273
Wölfli, Adolf 174
Wolman, Gil J. 213
Wols 184–87, *185*; *see also* Lyrical Abstraction
Wood, Grant 164–65, *164*; *see also* Regionalism
Woodrow, Bill 183, 268
Woolf, Virginia 18, 48; *see also* Bloomsbury Group
World of Art 44, 48, **62–63**, 92
Worpswede School 71, **296**
Wright, Frank Lloyd **22**, 24, 123, 142, 145, 145; *see also* Organic architecture
Wright, Willard Huntington 98
Wyeth, Andrew 165
Yakulov, Georgii 108
YBAs **296**
Yevonde, Madame 136
Young, La Monte **228**, 239, 240
Youngerman, Jack 232
Yudin, Lev 105; *see also* Unovis
Yvaral 226
Zaccarini, John-Paul 225
Zadkine, Ossip 87
Zayas, Marius de 115
Zebra 251, **296**
Zehnerring 147
Zen 49 186, **296**
Zero 226, **296**
Zhdanov, Andrei 168
Zola, Emile 15
Zorio, Gilberto 266